THE PUBLISHER GRATEFULLY ACKNOWLEDGES THE GENEROUS
SUPPORT OF THE ART ENDOWMENT FUND OF THE UNIVERSITY OF
CALIFORNIA PRESS FOUNDATION, WHICH WAS ESTABLISHED BY A
MAJOR GIFT FROM THE AHMANSON FOUNDATION.

SACRED FOUNDERS

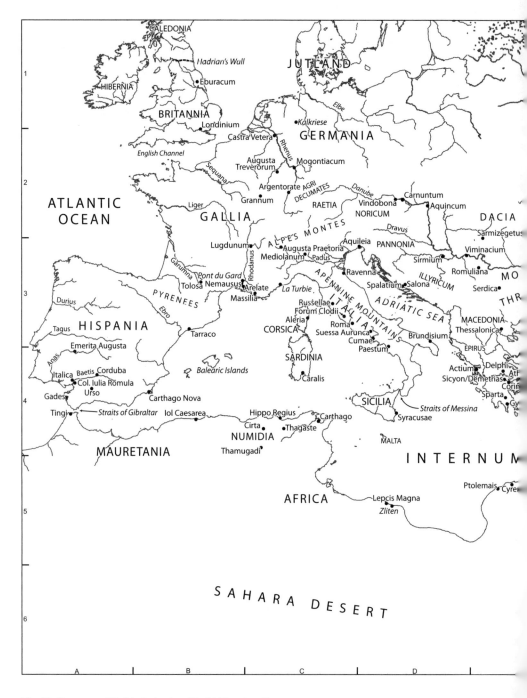

The Mediterranean World. © Ancient World Mapping Center 2014.

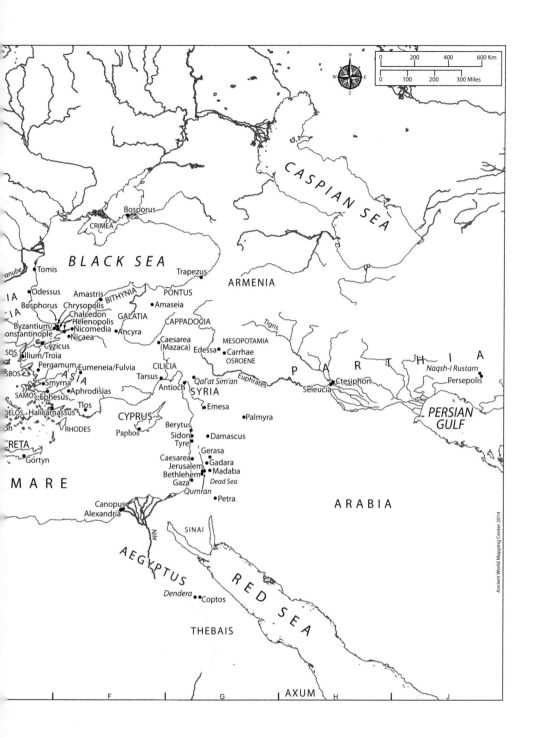

CASPIAN SEA

BLACK SEA

CRIMEA

Bosporus

Tomis

anube

Odessus

Trapezus

ARMENIA

Amastris

BITHYNIA

PONTUS

Chrysopolis

Amaseia

Bosphorus

Chalcedon

GALATIA

Helenopolis

CAPPADOCIA

Byzantium/

Nicomedia

Ancyra

onstantinople

Nicaea

Caesarea

(Mazaca)

Edessa

Carrhae

MESOPOTAMIA

OSROENE

Tigris

Cyzicus

SOS

llium/Troia

Pergamum

Eumeneia/Fulvia

CILICIA

Tarsus

Euphrates

Naqsh-I Rustam

ASIA

Smyrna

Aphrodisias

Qal'at Sim'an

Antioch

SYRIA

Seleucia

Ctesiphon

Persepolis

SAMOS

Ephesus

SBOS

Halicarnassus

Tlos

Emesa

DELOS

RHODES

Palmyra

CYPRUS

Berytus

PERSIAN

GULF

RETA

Górtyn

Paphos

Sidon

Tyre

Damascus

MARE

Gerasa

Caesarea

Gadara

Jerusalem

Madaba

Bethlehem

Gaza

Dead Sea

Qumran

Petra

ARABIA

Canopus

Alexandria

Nile

SINAI

AEGYPTUS

RED SEA

Dendera

Coptos

THEBAIS

AXUM

P A R T H I A

Ancient World Mapping Center 2014

SACRED FOUNDERS

Women, Men, and Gods in the Discourse of
Imperial Founding, Rome through Early Byzantium

Diliana N. Angelova

UNIVERSITY OF CALIFORNIA PRESS

University of California Press, one of the most distinguished university presses in the United States, enriches lives around the world by advancing scholarship in the humanities, social sciences, and natural sciences. Its activities are supported by the UC Press Foundation and by philanthropic contributions from individuals and institutions. For more information, visit www.ucpress.edu.

University of California Press
Oakland, California

Library of Congress Cataloging-in-Publication Data

Angelova, Diliana, author
 Sacred founders : women, men, and gods in the Roman and early
Byzantine discourse of imperial founding / Diliana N. Angelova.
 p. cm.
 Includes bibliographical references and index.
 ISBN 978-0-520-28401-2 (cloth, alk. paper) — ISBN 978-0-520-95968-2
(pbk., alk. paper)
 1. Rome—History—Empire, 30 B.C.–476 A.D. 2. Imperialism—Religious
aspects. 3. Imperialism—Social aspects. 4. Empresses—Religious life. I.
Title.
DG231.A73 2014
937.009′9—dc23 2014030661

Manufactured in the United States of America

24 23 22 21 20 19 18 17 16 15
10 9 8 7 6 5 4 3 2 1

In keeping with a commitment to support environmentally responsible and sustainable printing practices, UC Press has printed this book on Natures Natural, a fiber that contains 30% post-consumer waste and meets the minimum requirements of ANSI/NISO Z39.48-1992 (R 1997) (*Permanence of Paper*).

To Noah,
Alethea, and
Brian, with love

CONTENTS

PART III. CHRISTIANITY AND THE FOUNDING DISCOURSE

ILLUSTRATIONS

MAPS

FIGURES

ACKNOWLEDGMENTS

This book has been many happy years in the making, and it is with great pleasure that I recognize the individuals and institutions that helped me bring it into the world. I've had superb mentors and teachers. My debts to them are enormous. Annemarie Weyl Carr steered the first stage of this project (an master's thesis at Southern Methodist University) with peerless generosity, encouragement, and wisdom. She continues to be a role model. Ioli Kalavrezou, my dissertation advisor at Harvard University, provided years of unfailing support. Combining exacting standards with inimitable charm and humor, she impressed on me early on the importance of balancing work with a rich personal life. Her example in breaking boundaries of various kinds is always with me. I am grateful to Michael McCormick for being so generous with his time and for sharing with me his vast knowledge of the ancient and the medieval world. I am a far better scholar thanks to his instruction and example. Throughout my Harvard years, Rabun Taylor was a close advisor and a friend. I thank him for his deft improvements of my often errant prose. His erudition and knowledge have saved me from more than one mistake. Gloria Ferrari Pinney sparked in me a passion for Greek art. She guided me into a number of intriguing topics, and I'm grateful for her insights. Carmen Arnold-Biucchi patiently and generously guided me through important numismatic questions. She drew my attention to many coins that proved critical to my arguments.

Colleagues at the three institutions have supported me intellectually and otherwise. A score have read the manuscript in its various incarnations, and have helped me improve it. I'll never forget Pamela Patton and Eric White's warm welcome to me, and to

my growing family, at SMU. Bonnie Wheeler and Jeremy Adams generously included me in the medieval community on campus. I'm grateful for the friendship of Carol and the late David Weber. The congenial environment at the University of Colorado at Boulder helped me made huge strides in turning the dissertation into a book. In this, I've benefited from the advice, creativity, and generosity of Noel Lenski, Beth Dusinberry, Marjorie McIntosh, Kirk Ambrose, Elissa Guralnick, and Jackie Elliott. On a number of occasions, I've leaned on Martha Hanna, Virginia DeJohn Anderson, and Fred Anderson for advice. Peter Boag and Susan Kent have been staunch allies. To all of them I'm profoundly grateful.

The fertile intellectual environment at the University of California, Berkeley, and of the UC community more broadly, proved key to the final stages in the conceptualization, expansion, and writing of the book. My colleagues Marian Feldman, Beate Fricke, Erich Gruen, Christopher Hallett, Maria Mavroudi, Carlos Noreña, Michele Salzman, and Andrew Stewart have all left their distinctive imprints on the present book. They have suggested structural changes, flagged omissions, corrected mistakes, supplied references, and warmly disagreed on various points of argument. In so doing they pushed me in the best possible way to improve the final product. I much appreciate their recommendations, engagement, and encouragement. I also thank kindly my colleagues from the California Consortium For the Study of Late Antiquity for their welcome and encouragement: Emily Albu, Catherine Chin, Beth DePalma Digeser, Harold Drake, Susanna Elm, Claudia Rapp, and Michele Salzman. I've benefited as well from the advice, generously given, of John Dillon, Steve Justice, Emily Mackil, and Maureen Miller. Heartfelt thanks go to Stephanie Pearson and Andrew Griebeler, doctoral students at UCB, for reading the manuscript and making valuable suggestions. I thank Paige Walker, a UCB graduate, for her help with research. In Susanna Elm I've found an advocate, a mentor, and a friend. She has supported this book and its author in more ways than I can possibly repay. I'm grateful also to Mary Elizabeth Berry for the invaluable help she's given me since I arrived at Berkeley. My sincere thanks also go to Maria Mavroudi for her unflagging support.

With typical generosity, Anne McClanan, one of the University of California Press readers, offered valuable advice and helped with the final stages of the process. I'm much obliged to her, and to the two anonymous readers engaged by UCP. Many times I've relied on Alicia Walker and Amanda Lyster for their advice and creative energies, and I thank them abundantly. I've profited from the suggestions and encouragement of Ivan Drpic, Anna Kartsonis, Asen Kirin, Kriszta Kotsis, Cécile Morrisson, Philip Rousseau, and Jean-Michel Spieser.

Generous grants from Harvard University, University of Colorado, Boulder, and the University of California, Berkeley, have aided in the research and writing of his book. In the last few years, I've especially benefited from a Hellman Family Research Grant, a Mini-Conference Grant from the Institute for International Studies, a GROUP Summer Apprenticeship from the Doreen B. Townsend Center of the Humanities, and a Humanities Research Fellowship, all from UC Berkeley.

The long and arduous task of acquiring images and copyright permissions would have come to a screeching halt had it not been for the cheery efficiency with which various institutions and my own department have handled my requests. I'm particularly indebted to Robbi Siegel from Art Resource, Katherine Anderson from the British Museum, Dale Tatro and Travis Merkel from the Classical Numismatic Group, Carmen Arnold-Biucchi and Isabella Donadio from the Harvard Art Museums, Daria Lanzuolo from DAI-Rome, Anja Slawisch from DAI-Istanbul, Prof. Dr. Jürgen Malitz from Numismatische Bilddatenbank Eichstätt, and to John McChesney-Young and Linda Fitzgerald from History of Art, UCB. I am also pleased to acknowledge my debt to Ross Twele from the Ancient World Mapping Center for creating the beautiful maps for this book, and to Bill Nelson for drawing the plans for various buildings and city parts.

Special thanks go to the stalwart and discerning Eric Schmidt and to Maeve Cornell-Taylor from the University of California Press. Stephanie Fay and Andrew Frisardi worked wonders with the text, Miriana Bozkova, each in their own way. Cindy Fulton led the book through production expertly and efficiently. I thank her and the wonderful people at IDS for the beautiful typesetting. I'm grateful to Roberta Engleman for creating the index and for her patience.

The blessings of friendship and family have lightened the labor of writing this book. I thank (in chronological order) Vicky Boldrini, Nina Ninova, Marina Kaneti, Alicia Walker, Lauren Clay and Leor Halevi, Beth Dusinberry, Petia Romanova, Courtney Williams, Jackie Elliott, Heather and Matthew Gerber, Magdalena Parera and Mark Healey, Leslie Teicholz, Michelle and Chris Carter, Renea and Matt Smith, Jack Hayden and Serene Daro for many pleasant hours in which the present book was not the subject of our conversations. My gratitude for my parents, Slavka and Nikova Angelovi, is beyond words. Their love—while they lived and now only as memory—continues to give me strength and inspiration. Family, in the United States and Bulgaria, has been a continued source of cheer and sympathy, despite my prolonged bouts of book-absorption. Mary and Larry DeLay have encouraged this project in more ways than I can count. Being with Miriana Bozkova, Sylvi Nedelcheva, Sofi Rashkova, Nedi Stoyanova, and Lilly Vassileva has always made me feel at home. I miss them more than they know. I thank my sister and fellow art historian, Vessela Anguelova, for invaluable moral support, camaraderie and exacting editorial assistance in the final stages of completion of this book. She saved me from many mistakes. My spouse, Brian DeLay, has been a patient and ardent enthusiast from the start. The book mobilized and tested his many talents as a historian, husband, and father. I learned a lot from him and the present book is all the better for his numerous suggestions, exacting reading, musical talents, hearty laughter, and devotion.

Sacred Founders is dedicated to my children, Noah and Alethea, and to Brian, joy and loves of my life.

ABBREVIATIONS

Abbreviations of ancient authors and ancient and modern works follow the *Oxford Classical Dictionary*.

ACO *Acta conciliorum oecumenicorum*. Ed. E. Schwartz. Berlin: W. de Gruyter, 1927–32.

AE *L'année épigraphique*. Revue des publications épigraphiques relatives a l'antiquité romaine. Paris: Presses Universitaires de France, 1888– .

ANRW *Aufstieg und Niedergang der römischen Welt: Geschichte und Kultur Roms im Spiegel der neueren Forschung*. Ed. H. Temporini. Berlin: W. de Gruyter, 1972- .

BHG *Bibliotheca hagiographica graeca*. 3 vols. Ed. F. Halkin. Brussels: Société des Bollandistes, 1957.

BM British Museum.

BMC British Museum Catalogue. *A Catalogue of the Greek Coins in the British Museum*. Ed. G. F. Hill. Bologna: A. Forni, 1965.

BMCRE *Coins of the Roman Empire in the British Museum*. Ed. H. Mattingly. London: British Museum, 1962.

Cameron-Hall	*Eusebius: Life of Constantine.* Trans. and commentary by A. Cameron and S. G. Hall. Oxford: Oxford University Press, 1999.
CIG	*Corpus inscriptionum graecarum.* Ed. A. Boeckh et al. Berlin: Deutsche Akademie der Wissenschaften zu Berlin, 1828–77.
CIL	*Corpus inscriptionum latinarum.* Berlin: G. Reimerum, 1862.
CNR	*Corpus nummorum romanorum.* 18 vols. Ed. A. Banti and L Simonetti. Florence: A. Banti and L. Simonetti, 1972–79.
Dewing	*The Arthur S. Dewing Collection of Greek Coins.* Ed. L. Mildenberg and S. Hurter. New York: American Numismatic Society, 1985.
FGrH	*Fragmenta historicorum graecorum.* Ed. K. Müller. Paris: Firmin-Didot, 1841–70.
H/AM	Harvard University Art Museums.
Gnecchi	F. Gnecchi. *I medaglioni romani.* 3 vols. Milan: V. Hoepli, 1912.
IG	*Inscriptiones graecae.* 13 vols. Berlin: G. Reimer, 1873.
IGR	*Inscriptiones graecae ad res romana pertinentes.* 3 vols. Ed. R. Cagnat, J. Toutain, et al. Paris: Leroux, 1906–27.
ILCV	*Inscriptiones latinae Christianae veteres.* 4 vols. Ed. E. Diehl. Berlin: Weidmann, 1961–67.
ILS	*Inscriptiones latinae selectae.* 3 vols. Ed. H. Dessau. Chicago: Ares Publishers, 1979.
IRT	*The Inscriptions of Roman Tripolitania.* Ed. J. M. Reynolds and J. B. Ward Perkins, in collaboration with S. Aurigemma at al. Rome: British School at Rome, 1952. Enhanced electronic reissue by G. Bodard and C. Roueché (2009). Available online at Inscriptions of Roman Tripolitania: http://inslib.kcl.ac.uk/irt2009/.
LIMC	*Lexicon iconographicum mythologiae classicae.* Ed. H. C. Ackermann and J.-R. Gisler. Zurich: Artemis, 1981–97.
LSJ	H. G. Liddel, R. Scott, and H. S. Jones. *A Greek-English Lexicon.* Oxford: Clarendon Press, 1996.
LTUR	*Lexicon topographicum urbis Romae.* 6 vols. Ed. E. M. Steinby. Rome: Quasar, 1993–2000.

Neue Pauly	*Der Neue Pauly: Enzyklopädie der Antike.* Ed. H. Cancik and H. Schneider. Stuttgart: J. B. Metzler, 1996–2003.
NPNF	*A Select Library of the Nicene and Post-Nicene Fathers of the Christian Church.* 2nd series. Ed. P. Schaff and H. Wace. 14 vols. Peabody, Mass.: Hendrickson Publishers, 1994.
OCD	*The Oxford Classical Dictionary.* Ed. S. Hornblower and A. Spawforth. Oxford: Oxford University Press, 1996.
ODB	*The Oxford Dictionary of Byzantium.* 3 vols. Ed.-in-chief, A. Khazdan. Oxford: Oxford University Press, 1991.
OLD	*The Oxford Latin Dictionary.* Ed. P. G. W. Glare. Oxford: Clarendon Press, 2002.
PG	*Patrologiae cursus completus: Series graeca.* Ed. J.-P. Migne. Paris, 1857–66.
PIR	*Prosopographia imperii romani.* Ed. L. Petersen. Berlin: W. de Gruyter, 1966.
PL	*Patrologiae cursus completus: Series latina.* Ed. J.-P. Migne. Paris, 1844–64.
PO	*Patrologia orientalis.* Turnhout, Belgium: Brepols.
RE	*Real-Enzyklopädie der klassischen Altertumswissenschaft.* Ed. A. Pauly, G. Wissowa, and W. Kroll. Stuttgart: J. B. Metzler, 1903–78.
RG	*Res Gestae Divi Augusti.* Ed., trans., and commentary by A. Cooley. Cambridge: Cambridge University Press, 2009.
RIC	*Roman Imperial Coinage.* 10 vols. Ed. H. Mattingly, C. H. Sutherland, et al. London: Spink and Son, 1923–84.
RPC	*Roman Provincial Coinage.* Ed. A. M. Burnett, M. Amandry, and P. Pau Ripollès. London and Paris: British Museum and Bibliothèque Nationale, 1998.
RRC	M. Crawford. *Roman Republican Coinage.* London: Cambridge University Press, 1974.
PLRE	A. H. M. Jones, J. R. Martindale, and J. Morris. *The Prosopography of the Later Roman Empire.* Cambridge: Cambridge University Press, 1971–92.
SEG	*Supplementum epigraphicum graecum.* Amsterdam: J. C. Gieben, 1923– .
SHA	*Scriptores historiae Augustae.*

Syll.	*Sylloge inscriptionum graecarum.* 3rd ed. Ed. F. H. von Gaertringen. Leipzig: S. Hirzelium, 1915–24.
TAM	*Tituli Asiae Minoris.* Ed E. Kalinka et al. 5 vols. Vienna: Österreichische Akademie der Wissenschaften, 1901–78.

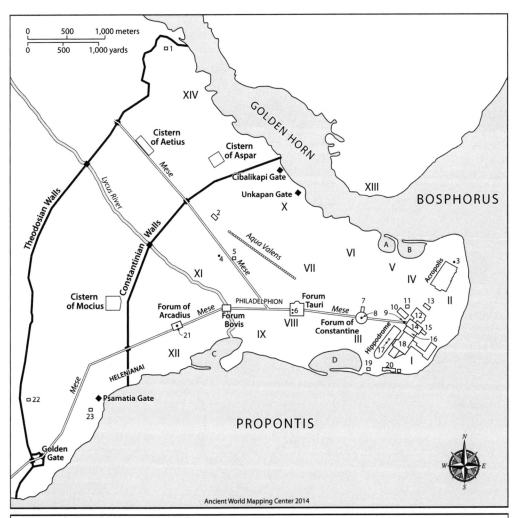

0 500 1,000 meters
0 500 1,000 yards

□ 1

XIV

GOLDEN HORN

Cistern of Aetius

Cistern of Aspar

Cibalikapi Gate ◆

Unkapan Gate ◆

X

XIII

BOSPHORUS

Mese

Lycus River

Theodosian Walls

Constantinian Walls

Aqua Valens

□ 2

• 4
5 □

VI

VII

V

A B

Acropolis
• 3

IV

II

XI

Cistern of Mocius

Forum of Arcadius Mese

Mese

PHILADELPHION

Forum Bovis

VIII

Forum Tauri

:6

IX

Forum of Constantine

III

Mese

7 11 10 □ 13
8 9 12
□ 14 15
16

Hippodrome
17
18
I

□ 21

XII

C

D

19 □ 20 □

Mese

HELENIANAI

◆ Psamatia Gate

□ 22

□ 23

PROPONTIS

Golden Gate

N
W E
S

Ancient World Mapping Center 2014

1. Church of the Theotokos in Blachernai
2. Church of the Holy Apostles
3. Column of Tyche
4. Column of Marcian
5. Church of H. Polyeuktos
6. Arch of Theodosius
7. Curia

8. Column of Constantine
9. Milion
10. Basilica
11. Church of the Theotokos in Chalkoprateia
12. Church of H. Sophia
13. Church of H. Eirene
14. Augustaion

15. Curia (Magnaura)
16. Baths of Zeuxippus
17. Obelisk of Theodosius
18. Great Palace
19. Church of SS. Sergius and Bacchus
20. Palace of Justinian
21. Column of Arcadius

22. Monastery of H. Menas
23. Church of SS. Karpos and Papylos

A. Neorion Harbor
B. Phosphorion Harbor
C. Harbor of Theodosius
D. Harbor of Julian/Sophia

MAP 1

Constantinople in late antiquity. Constantinople's Regiones are marked with Roman numerals. ©
Ancient World Mapping Center 2014.

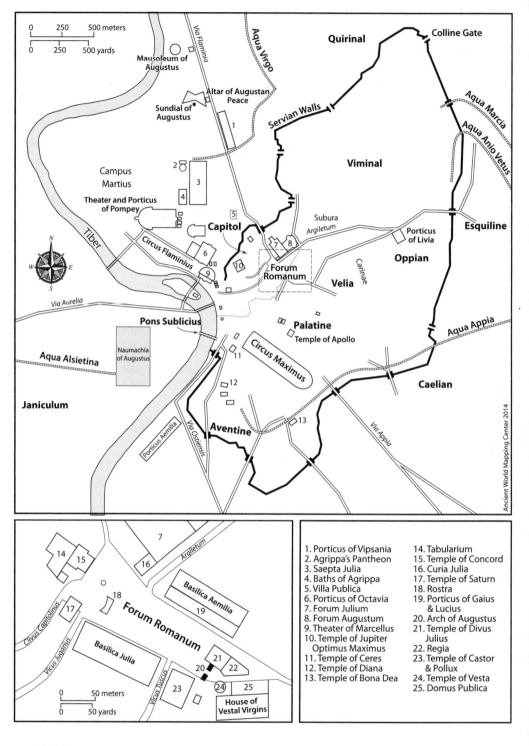

MAP 2

Rome in the year 14 C.E. © Ancient World Mapping Center 2014.

Map labels (main map):

Via Flaminia
Aqua Virgo
Quirinal
Colline Gate
Mausoleum of Augustus
Altar of Augustan Peace
Sundial of Augustus
Servian Walls
Viminal
Aqua Marcia
Aqua Anio Vetus
Campus Martius
Theater and Porticus of Pompey
1
2
3
4
5
Capitol
Subura
Argiletum
Porticus of Livia
Esquiline
Circus Flaminius
6
7 8
Oppian
Forum Romanum
Carinae
Velia
9
Tiber
Via Aurelia
Palatine
Temple of Apollo
Aqua Appia
Pons Sublicius
11
Circus Maximus
Aqua Alsietina
Naumachia of Augustus
Caelian
Janiculum
12
13
Porticus Aemilia
Via Ostiensis
Aventine
Via Appia

N W E S

Ancient World Mapping Center 2014

Scale: 0 250 500 meters / 0 250 500 yards

Forum Romanum inset:

14
15
16
7
Argiletum
18
Basilica Aemilia
19
17
Clivus Capitolinus
Vicus Jugarius
Forum Romanum
Basilica Julia
Vicus Tuscus
21 22
20
23
24 25
House of Vestal Virgins

Scale: 0 50 meters / 0 50 yards

Legend:

1. Porticus of Vipsania
2. Agrippa's Pantheon
3. Saepta Julia
4. Baths of Agrippa
5. Villa Publica
6. Porticus of Octavia
7. Forum Julium
8. Forum Augustum
9. Theater of Marcellus
10. Temple of Jupiter Optimus Maximus
11. Temple of Ceres
12. Temple of Diana
13. Temple of Bona Dea
14. Tabularium
15. Temple of Concord
16. Curia Julia
17. Temple of Saturn
18. Rostra
19. Porticus of Gaius & Lucius
20. Arch of Augustus
21. Temple of Divus Julius
22. Regia
23. Temple of Castor & Pollux
24. Temple of Vesta
25. Domus Publica

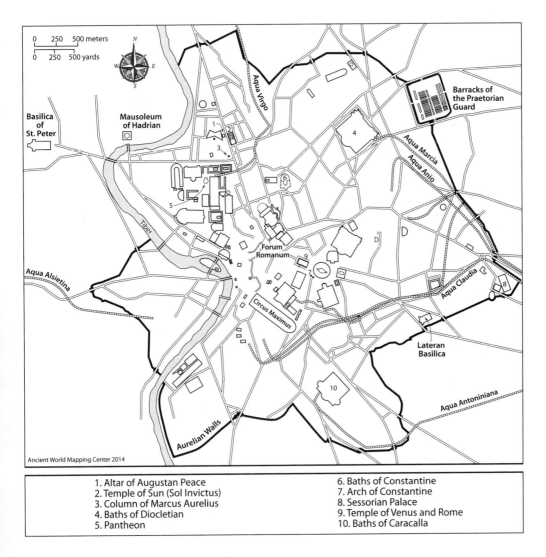

Scale: 0 250 500 meters / 0 250 500 yards

N
W E
S

Aqua Virgo

Basilica of St. Peter

Mausoleum of Hadrian

Barracks of the Praetorian Guard

Aqua Marcia
Aqua Anio

1. (Altar of Augustan Peace)
2. (Temple of Sun)
3. (Column of Marcus Aurelius)
4
5
6
7
8
9
10
D

Tiber

Aqua Alsietina

Forum Romanum

Circus Maximus

Aqua Claudia

Lateran Basilica

Aqua Antoniniana

Aurelian Walls

Ancient World Mapping Center 2014

1. Altar of Augustan Peace
2. Temple of Sun (Sol Invictus)
3. Column of Marcus Aurelius
4. Baths of Diocletian
5. Pantheon
6. Baths of Constantine
7. Arch of Constantine
8. Sessorian Palace
9. Temple of Venus and Rome
10. Baths of Caracalla

MAP 3

Rome at the time of Constantine. © Ancient World Mapping Center 2014.

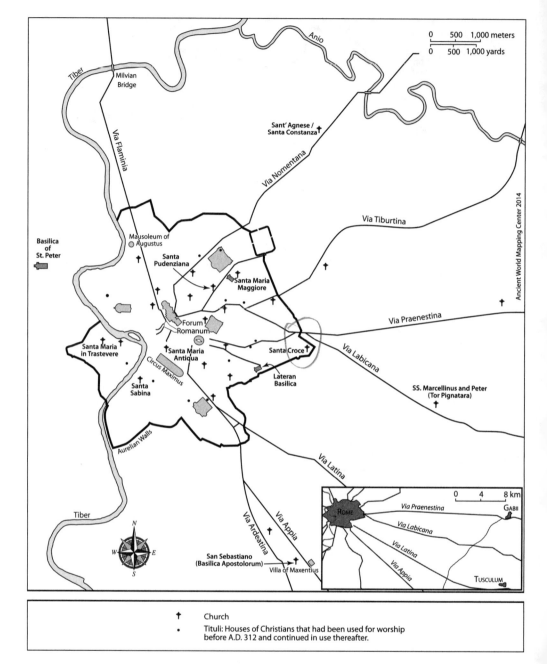

Anio

Tiber

Milvian
Bridge

Sant' Agnese /
Santa Constanza

Via Flaminia

Via Nomentana

Via Tiburtina

Basilica
of
St. Peter

Mausoleum of
Augustus

Santa
Pudenziana

Santa Maria
Maggiore

Via Praenestina

Forum
Romanum

Santa Maria
in Trastevere

Circus Maximus

Santa Maria
Antiqua

Santa Croce

Via Labicana

Santa
Sabina

Lateran
Basilica

SS. Marcellinus and Peter
(Tor Pignatara)

Tiber

Aurelian Walls

Via Latina

N
W E
S

Via Ardeatina

Via Appia

San Sebastiano
(Basilica Apostolorum)

Villa of Maxentius

0 500 1,000 meters
0 500 1,000 yards

Ancient World Mapping Center 2014

0 4 8 km

ROME

Via Praenestina

GABII

Via Labicana

Via Latina

Via Appia

TUSCULUM

† Church

• Tituli: Houses of Christians that had been used for worship
before A.D. 312 and continued in use thereafter.

MAP 4

Rome's churches, fourth to fifth centuries. © Ancient World Mapping Center 2014.

INTRODUCTION

Late antique Constantinople teemed with imperial images. Statues of emperors and empresses stood sentinel in its public squares, glistening mosaics of the imperial family adorned the walls of churches and public monuments, and tapestries of the imperial couple graced the capital's unmatched cathedral, the majestic Hagia Sophia (fig. 1).[1] By now, such large-scale images have vanished, and the living urban fabric to which they belonged has been undone by conquest and by time. Today, except in Ravenna and Rome, only the miniature cognates of these great representations remain, in such objects as coins or ivory panels bearing imperial likenesses.

We learn about the great vanished urban images mostly from textual sources such as the *Parastaseis syntomoi chronikai*, an early eighth-century description of the city, which offers a precious overview of these lost effigies.[2] The account identifies them by location, often providing details of their medium, patrons, and history. Statues of emperors and their wives adorned all the public places in the city. Images of Constantine, who founded Constantinople in 330, could be seen everywhere.[3] Many of them paired him with his mother, Helena, the most frequently represented of all Byzantine imperial women.[4] Her images could be found in the city's most exalted places. Three statues of her, one of porphyry, another of ivory, and a third of bronze inlaid with silver, stood in Hagia Sophia. An even more prominent statue of her once adorned the Augustaion, the square between the Great Palace, the Zeuxippus Baths, and Hagia Sophia (map 1).[5] Helena's joint statues with Constantine were all strategically placed in important public squares. One statuary group stood in the Forum of Constantine; another group, with a cross,

1

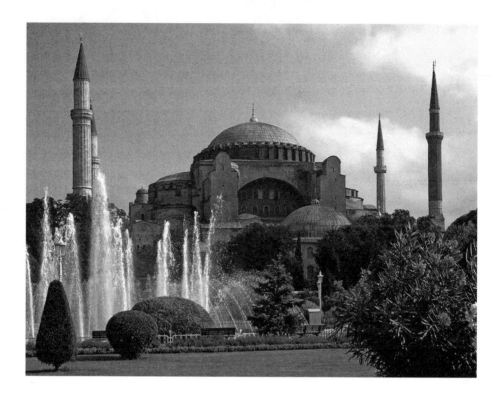

FIGURE 1

Hagia Sophia, built 532–37, Istanbul. Photo: Dennis Jarvis.

looked down from the roof of the Milion, in the northeastern corner of the Augustaion, from which all distances in the empire were measured; a third, at the Philadelphion Square, featured Constantine and Helena seated on thrones and accompanied by Constantine's sons; a fourth, in the Forum Bovis, on the eastern Mese, the main street of the city, showed the two figures with a monumental cross between them; and a fifth, in the Church of the Theotokos, depicted them with Christ and the Virgin Mary.[6]

The cross towering in the Forum Bovis group suggests why the eighth-century city gave pride of place to statues of Constantine and Helena together. They were celebrated as a pair because of Helena's finding of the True Cross in Jerusalem, a legend accepted as historical fact by the Byzantines.[7] The earliest extant version of this tale, dated to an oration from 395, explains that Helena sought the cross of the Crucifixion on her own initiative, found it, brought it to her son, and converted him to Christianity.[8] Bishop Ambrose of Milan, the author of this text, goes so far as to insist that the Augusta Helena's actions made her and her illustrious son cofounders of the Christian empire. Ambrose's writings could thus help explain the recurrent statues of Helena and Constantine extant in the early eighth century: together, mother and son had founded the Christian Roman Empire.

One will not, however, find that explanation in current scholarship. Though scholars have discerned certain political overtones in Ambrose's speech, the partnership between Helena and Constantine has not received appropriate attention.[9] Except for the historical personages involved and Helena's traveling to Jerusalem, Ambrose's account of Helena is deemed a rhetorical construct with no relation to real events. More generally, scholarship on the legacy of Helena and Constantine has taken little interest in the discovery of the True Cross as a rationale for the pair's extravagant and enduring commemoration, emphasizing instead the religious importance they assumed long after their deaths.[10] Scholars believe that Constantine emerged as a paragon for later emperors as he proceeded to sainthood. His reputation rose following the emperor Heraclius's retrieval of the True Cross and its return to Jerusalem in 629. Thereafter, Constantine's fame flourished, thanks to the emphasis by the Iconoclasts (726–843) on the veneration of the cross.[11] According to this logic, joint commemorations of Constantine and Helena could emerge only in the eighth or the ninth century, as a consequence of historical developments. To explain why, in the centuries immediately following his death, Constantine had very little appeal as an imperial exemplum, historians point to the crimes he committed against his own family.[12] The emperor had ordered the deaths of his firstborn son, Crispus, and his wife, Fausta. The phenomenon of "New Constantines," emperors who vied to emulate the original Constantine, emerged only when the emperor's sainthood had superseded the memory of his crimes. According to the scholarly consensus, then, Constantine became an imperial paragon a few centuries after his death, and not as a consequence of his own commendable actions but for religious reasons.[13]

One problem with this interpretation is that the images of Constantine and Helena described in the *Parastaseis* have little or nothing to do with their sainthood.[14] That account instead treats Constantine and Helena just like other imperial figures.[15] Furthermore, the carefully drawn analyses of the "New Constantines" all but ignore Helena, notwithstanding her manifest importance to Constantine's memory.[16]

Evidence suggests that in the collective memory of the Byzantines, Constantine and Helena represented the emblematic imperial pair well before the seventh century. From the fourth to the sixth centuries, the names Constantine and Helena were given to the reigning imperial couple far more frequently than scholars have realized. The emperor Marcian and his wife, the Augusta Pulcheria, were the first "New Constantine" and "New Helena," acclaimed at the Universal Council of the Church at Chalcedon in 451.[17] When the Augusta Verina crowned her brother Basiliscus in 475, one circus faction applauded her as "the orthodox Helena."[18] Justin I (r. 518–27) was acclaimed "New Constantine."[19] Justin II (r. 565–78) and Constantine were hailed together as "new apostles."[20] Justin II and his wife, Sofia, were likened to Constantine and Helena in a poem related to the gift of a cross relic.[21]

The linking of emperors and empresses to Constantine and Helena, in other words, occurred long before the pair had secured sainthood. Religion offers an inadequate explanation for cherishing the first imperial couple's storied names. In three instances, the

timing of the bestowal relates to a coronation. That was the case of Verina's being called the "orthodox Helena," and in that of Tiberius and his wife, Ino. John of Ephesus relates that when Tiberius became the official heir to the throne in 574, Justin II conferred on him the new name, solemnly pronouncing, "Henceforward be thy name called Constantine; for in thee shall the kingdom of the great Constantine be renewed." When Tiberius's wife was elevated to the rank of Augusta several years later, the joyous crowd acclaimed her "Helena" and "Anastasia," the first name pointing to Helena as a paradigm, the second implying resurrection.[22] The cheering masses saw Ino as Helena reborn or even as resurrection personified. The names Constantine and Helena thus symbolized the best in rulers; their very names became among the most prized of imperial honors. That Constantine's and Helena's statues were so prominently on display in the early eighth century thus testifies to the enduring hold the emperor and his mother exercised over the early Byzantine rulers' conceptions of themselves and others' perceptions of them.

Ambrose bears closer reading. In late antiquity Constantine *and* Helena seem to have become the paradigm for later rulers because the Byzantines considered them founders of the Christian Roman Empire. The idea of dual founders, a man and a woman, became a major generative force in conceiving and symbolically articulating rulership. This book excavates the origins of this idea in the early Roman Empire and traces its significance through the early centuries of the Byzantine era. It contends that Constantine and Helena drew upon a deep well of precedent. Their images, deeds, names, and memory knitted together and animated the Christian phase of an enduring, long-lived, and complex Mediterranean discourse of founding, which included textual *and* visual statements that helped articulate and legitimate imperial authority.

In the postheroic age of the ancient Mediterranean world, the highest honors mortals could aspire to were those bestowed on city founders. Only the founding of a city could legitimately be considered a godlike act, and only founders could deserve to have their human faults overlooked and receive divine honors. I propose that, for these reasons, founding came to be a significant component of both legitimating and presenting the authority of Hellenistic kings and queens, and its honors and rewards became embedded in a Roman discourse about founding. Augustus and his supporters (for example, the Augustan poets) drew on Roman and Hellenistic ideas of founding to explain and justify Augustus's exceptional authority in the state. The logic of founding, shaped according to Roman criteria, realities, and foundation myths, informed the presentation of imperial authority in images, honors, and buildings.

This Roman imperial discourse made direct, forceful claims about both founding and founders. Augustus was hailed as *conditor*, founder, and Constantine, as the *fundator quietis*, founder of peace (fig. 2).[23] Some hundred of the twenty-three hundred surviving emperors' statue bases from Augustus to Commodus are inscribed with the words meaning founder: *conditor, ktistēs, oikistēs*.[24] In these instances the words seem to naturalize the claims about founding, taking them for granted, rather than argue or assert them. Similar founding claims were made on monuments such as imperial tombs, or

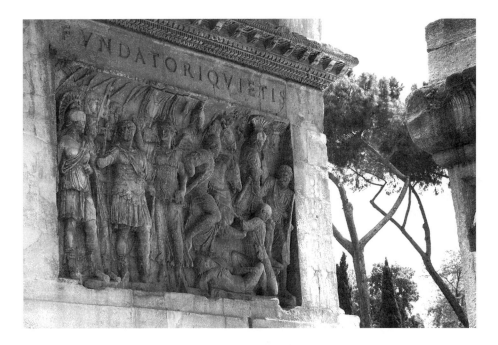

FIGURE 2

Constantine crowned by Victory, welcomed by Roma, reused Trajanic marble reliefs from the passageway, the Arch of Constantine, 315. Inscription: *FVNDATOR QUIETIS*. Photo: Author.

with such titles as Augustus and *mater patriae*. More humble references to founding cite, for example, an imperial person's building of a church, a bath, or a road. Whether grand or modest, ideas about founding coursed through such works like blood through the body.

The imperial discourse of founding, like cultural practices and symbolic systems more generally, was gendered, whether or not it centered women.[25] Not every statement in that discourse expressed the same attitudes about gender broadly or about the rights and prerogatives of empresses in particular, though women play a far more visible role in the discourse of founding than in other discourses. Gender shaped the discourse of founding in two distinct ways. First, from the time of Augustus to that of Constantine, imperial women came to be honored as female founders of the land and, second, to be associated with goddesses and their characteristics. Although there were variations in the imperial presentations and honors from one reign to another, the gendering of the discourse and the definition of founding remained the same.

Constantine brought about meaningful changes, so that the terms of the discourse were transformed after 324. He revised the etiological myth at the center of the discourse by founding Constantinople. The eponymous capital announced the Christian emperor as the progenitor of a new imperial tree. The emperor empowered his mother

Helena, investing her with unprecedented real authority, and in so doing he remade the gendered terms of the discourse. Constantine and Helena emerged as co-founding imperial partners of the Christian empire, and as a result Christian imperial women came to assume the trappings of power and to wield concrete authority in unprecedented ways. Finally, by supporting Christianity, Constantine admitted new contributors to the founding discourse. Christian bishops molded that discourse to their own ends, often defying, critiquing, or undermining imperial self-presentation and honors. Moreover, by introducing the notion of imperial piety, they sought to discipline imperial power to Christian hierarchy.[26] In the Christian era, then, the imperial discourse of founders changed profoundly. But even that change adhered to the basic "anonymous rules" that had informed imperial honors and symbolism for centuries.[27]

This book is my attempt to recover those rules. The first three chapters establish the book's core thesis and put it in motion. Chapter one introduces the central idea of imperial discourse of sacred founding, from its Hellenistic roots through Augustus. The next chapter explores the Princeps' audacious self-fashioning by scrutinizing two of his most revealing statements as a founder, the Mausoleum of Augustus and the *Res Gestae* (*Deeds of the Deified Augustus*). Chapter three turns to the Augusta Livia in order to demonstrate that the imperial discourse of founding was gendered, and to argue for its urgent and enduring relevance to the pagan emperors and empresses who followed.

When he brilliantly reimagined the discourse of founding at the dawn of the imperial Christian era, Constantine both drew inspiration from Augustus across the centuries *and* mobilized a living discursive tradition that still resonated throughout the empire. Chapter four explains that Constantine's founding acts were both traditional in their symbolic language and radically innovative, not least in how they invested Helena with concrete imperial agency. Chapters five and six assess Helena's empowering precedent for later empresses, arguing that the Christian Augustae became co-ruling female founders of the land chiefly through their urban development of Constantinople and other cities. Chapter seven turns to the shifting imperial insignia and ritual that underscored the growing partnership between male and female imperial founders.

The last section of the book analyzes the role of Christianity and the bishops in the discourse of founders. Chapter eight explains how Eusebius and later bishops variously accommodated and assailed core principles within the discourse of imperial founding, such as imperial sacredness. Chapter nine evaluates the growing significance of church building for male and female rulers. Chapter ten argues that the cult and the images of the Virgin Mary emerged in close conversation with the discourse of imperial founding. Finally, the epilogue surveys the continuities and the dynamism of the discourse of founding through a reinterpretation of the exquisite mosaics at San Vitale.

THE FOUNDING DISCOURSE
OF IMPERIAL ROME

1

FOUNDING, POWER, AND AUTHORITY
Mediterranean History and Augustan Innovations

It was February 395 when Ambrose (ca. 339–97) delivered his speech to commemorate the recent death of the Emperor Theodosius I (r. 379–95).[1] Ambrose evoked Christian eternity, describing a paradise where Constantine, the first Christian emperor, welcomed the newly deceased Theodosius with an embrace. But the imaginative heart of the oration is a story about the origins of the Christian monarchy; and in Ambrose's telling, that story has less to do with Constantine than with his mother, Helena.[2] The bishop explains that Helena received inspiration from the Holy Spirit to look for the cross on which Christ had been crucified. Reflecting on the motivation for her quest, Ambrose says that Helena contrasted her own privilege with the dilapidated artifacts of Jesus's lifetime: "Shall I be covered with golden ornaments, and the triumph of Christ by ruins?"[3] He then recounts how Helena traveled to the Holy Land, unearthed the True Cross, and ordered that a diadem and a bridle be made from the nails with which Christ had been crucified. These she sent to her son, who "used both, and transmitted his faith to later kings." Ambrose concludes that "the beginning of the faith of emperors is the holy relic which is upon the bridle. . . . Thereafter, the succeeding emperors were Christians, except Julian alone."[4] Thus had Helena fulfilled the prophecy of Zechariah 14:20 about the coming of the Christian kingdom.[5] In Ambrose's telling, the story of Helena's finding of the cross, woven out of both legendary and historical threads, became the foundation myth of the Christian Roman Empire. Helena's pious resolution and inspired sense of mission made the monarchy Christian.

This remarkable story about Helena's founding can only be understood by looking into gendered ideas about imperial founders, ideas that predate Ambrose's oration by centuries.

aition: story of origin

continuing discourse

The bishop's aition (story of origins) of the Christian Roman Empire, an account centered on a female and a male ruler, was a Christian restatement of the central myth in a discourse of imperial founding that went back to Augustus. Augustus did not invent this discourse. He elaborated and put his unique stamp on an existing Mediterranean (Roman and Hellenistic) discourse of founding. The first emperor wove into this discourse an image of himself as Rome's new founder and of Livia, his wife, as his female counterpart. All emperors who came after would seek to be founders in the Augustan mold.

LIVIA AND AUGUSTUS: THE PRE-CHRISTIAN FOUNDERS

Ambrose vs. pagan poet

Ambrose's aition of the Christian Roman Empire offers an alternative to the traditional pre-Christian way to measure time and conceive of the empire's beginnings. Three years after Ambrose's funerary oration, Claudian, a pagan poet, traced a course of imperial history quite different from that of Ambrose. Dedicating a hymn to the marriage of the emperor Honorius, Theodosius's younger son, and Maria, the daughter of Serena and Stilicho (all of them Christians whom Ambrose knew personally), the poet traces the imperial lineage back to Livia. The relics that connect the present to the past in Claudian's hymn are different from those in Ambrose's oration. Claudian wrote that the groom's gifts for the bride were "jewels once worn by noble Livia of old and all the proud women of the imperial house."[6] Clearly the two men offered divergent accounts for the origins of the empire and for interpretations of the past that influenced the present. For Ambrose, the history of the Christian empire began with a relic and a pair of pious rulers, Helena and Constantine. A Crucifixion relic—not Livia's jewels—signified the continuity of the Christian empire. By contrast, for the pagan poet, imperial history commenced with Livia and, implicitly, Augustus. The proof was the transmission of family heirlooms from one empress to the next.

The alternative myths, Christian and pagan, with their implied connection of origins, lineage, and the measurement of time, have much to tell about the role of founding and gender in the presentation of imperial authority. Similarities between the first Augustus and Rome's founders, Romulus (Rome's founder) and Aeneas (the father of the Latin people), have been amply documented by ancient and modern authors.[7] Livia was considered similarly as a founder of a new generation and as mother of the Roman people, though these characterizations have been little noted.

Although Livia had no Virgil, the honors she received are suggestive. An inscription from Tlos (Lycia, Asia Minor), dated traditionally to the reign of Claudius (41–54 C.E.), announced the establishment of a cult to Livia at Tlos.[8] This cult included processions (*pompas*), sacrifices (*thusias*), and athletic competitions (*agōnas*), divine honors that recognized Livia's founding act and rewarded it accordingly.[9] The inscription states: "She [Livia] created [*sunestamenē*] the race of the *Sebastoi* [Augusti] [*sebastōn genos*] in accordance with the most sacred succession of the manifested gods, a house incorruptible and immortal for all time."[10] Although the first few lines of the inscription and some portions

of the text are missing, enough survives to deduce that the city of Tlos, very much like Ambrose three centuries later, exalted a female founder, Livia, the first Augusta (14 C.E.), rather than her husband, the first Augustus (27 B.C.E.). The text states that Livia was given divine honors for binding together (*sunestamenē*) a new *genos*, a Greek noun meaning both "ethnos" and "generation." Thus she was honored for establishing the "ethnos/ generation of the Augusti."[11] This formulation transcends the personal, because for the Roman Senate, according to official documents, the state was in the care of the Augustan family. A senatorial decree from the year 20 C.E. specifies: "the welfare of the empire has been placed in the guardianship [*custodia*] of the [Augustan] *domus*."[12] Livia's actions affected not just the imperial family but the entire state. More than Augustus's wife and Tiberius's mother, Livia was a founder of a new generation. As Helena, by her inspired quest for the cross, founded the line of the Christian emperors, Livia, according to the Tlos inscription, was the originator of all Augusti, and with them, the age of the Augusti, the imperial age.

The significance of these ideas is evident when the Tlos inscription is read in relation to two famous passages from Virgil's poetry. The comparison suggests that the conceptual link between parenting of times and generations was relevant in the Latin West as well as in the Greek-speaking East. The Tlos inscription echoes two Virgilian predictions that similarly connect people/ethnos with time. In his *Fourth Eclogue* (39–38 B.C.E.), Virgil prophesies a new age (dating it to 40 B.C.E.), and connects it to the birth of a child (4.10).[13] He refers to this period as a *saeculum,* a Latin noun that, like the Greek *genos,* relates to both people and time: "the body of individuals born at a particular time, a generation."[14] *Saeculum* can thus be translated as "generation," or as "ethnos/race/family."[15] Virgil sees this "new race/ethnos/progeny" (*nova progenies*), descended from gods, as a "golden people" (*gens aurea*) living in the age of Apollo (*Ec.* 4.7–10).[16] Virgil writes:

> Now is come the last age of Cumaean song; the great line of the centuries begins anew. Now the Virgin returns, the reign of Saturn returns; now a new generation descends from heaven on high. Only do you, pure Lucina, smile on the birth of the child, under whom the iron brood shall at last cease and a golden race spring up throughout the world! Your own Apollo now reigns!

The poem makes no direct reference to Augustus, though some scholars have suggested that the phrase "tuus iam regnat Apollo" (now your Apollo reigns) can be understood as Augustus assimilated to Apollo.[17] Servius, Virgil's fourth-century commentator, equated the Apollo of this passage with Sol, so that the age the Sibyl foretold was the age of Apollo Sol.[18] The man hailed in the *Fourth Eclogue* as the progenitor of the new generation/era is named by Virgil in his *Aeneid* (19 B.C.E.). There the poet identifies Augustus, scion of a divine people, as the founder of a "golden race [*ethnos*]/age."[19] These are the terms and the message of the Tlos inscription, which therefore describes Livia similarly to Virgil's presentation of Augustus.

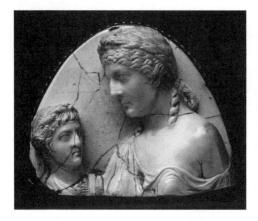

FIGURE 3

(above) Cameo portrait of Livia with the features of Venus Genetrix, holding a bust of Augustus or Tiberius, 14–37 C.E., turquoise, 3.1 (h) x 3.8 (w) x 1.6 (d) cm. Boston Museum of Fine Arts, 99.109. Photo: Courtesy of Stephanie Pearson and Laure Marest-Caffey.

FIGURE 4

(right) Marble statue of Venus Genetrix, first to early second century C.E., marble, 164 (h) cm. A Roman copy after a Greek original by Callimachus (fl. 410–400 B.C.E.), acc. no. MA525. Photo: Hervé Lewandowski. Musée du Louvre, Paris, France. Photo Credit: RMN-Grand Palais / Art Resource, N.Y.

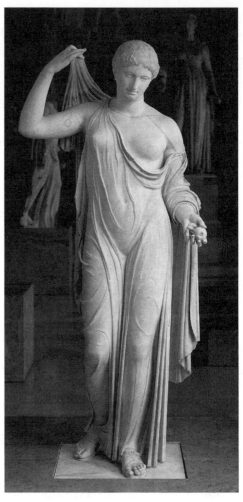

Styling Livia and Augustus as progenitors of new generations/ages resonates with the honorary titles proposed by the Roman Senate for the imperial pair. After the death of Augustus (in 14 C.E.), the senators discussed giving Livia the unprecedented title "mother of the fatherland" (*mater patriae*).[20] Twelve years earlier, they had recognized Augustus as father of the fatherland (*pater patriae*).[21] At the assumed time of the Tlos inscription, Augustus was already worshiped in Rome as the divinity Divus Augustus. Livia became the Roman goddess Diva Augusta in 42 C.E., during the reign of her grandson Claudius, but she was probably accorded religious honors unusual for mortals as early as 29 B.C.E.[22]

Other indications of the exalted place accorded Livia include a cameo presenting her as a New Venus, dating to a time before the Tlos inscription and perhaps before even the senatorial proposal of 14 C.E.[23] It was likely produced in Rome, and intended for elite

consumers, the kind of people Livia and Augustus associated with.[24] In this carved turquoise gem from the Boston Museum of Fine Arts, Livia holds a bust of Augustus or Tiberius (her son) (fig. 3). Her distinct physiognomy—a slightly aquiline nose, high cheekbones, and a pointed chin—are all easily discerned. But the artist aimed at something more than a recognizable portrait, presenting Augustus's wife as a double of the goddess Venus Genetrix, the progenitor of the Roman people. The garment slipping seductively off Livia's left shoulder recalls a familiar detail of the goddess's iconography, going back to the fifth century B.C.E. (fig. 4).[25] In the cameo, however, the Livia Venus is a figure of authority in relation to the male figure. The habitual mother-child posture alluded to in the composition takes on a new meaning, forged through the incongruous age of the "child" and the relative sizes of the figures. The image projects Livia's authority and/or seniority over the male "child."

These examples suggest broadly that Livia and Augustus were honored, both in Rome and in the provinces, as the female and male progenitors of new generation/age, and of the commonwealth. Moreover, Livia's and Augustus's imagined roles invite consideration of those attributed to Helena and Constantine in Ambrose's oration. Helena and Constantine emerge as correlates to Livia and Augustus, like them partners in forging for the state a new generation/age. Ambrose offered a Christian reading of two old notions. He signaled an alternative pair of founders and the arrival of a Christian-appropriate new generation/age. At the same time, he conjured an alternative yet familiar vision of heaven, as a place still populated with emperors and empresses but empty of imperial gods.

CITY FOUNDING AND LEGITIMATE AUTHORITY:
THE HELLENISTIC EAST AND ROME

In the ancient world one of the most prestigious feats for a mortal was to generate a new people. Birthing a race/ethnos was bound conceptually to founding a city, which involved creating a new people and the coming of a new era. City founders commanded honors rivaled only by those bestowed on gods and heroes. Deities such as Apollo, Dionysus, Artemis, Athena, Hera, Zeus, and a hero such as Heracles (Hercules) were reputed founders of a number of cities.[26] Pre-Hellenistic Greek cities celebrated their "parents" or founding gods by worshiping them and minting coins with their image.[27] The city of Athens, to give one example among many, showed on its coinage the head of its founding deity, the goddess Athena.[28] Neither Athens, the eponymous city, nor its eponymous people existed until she gave them her name. Like their divine counterparts, the human founders of cities (some of whom had divine parents) were thought of as parents to those cities and authors of an eponymous age or generations; they were deified for their accomplishments.[29] Some of these human founders received the exceptional privilege of an ample burial ground in the agora, cultic honors at their graves, and games.[30]

Rome was no different from the Greek world in conceptualizing and honoring founders. It too was once a city-state. In late republican Rome, elite families competed to associate themselves with illustrious genealogies, linking themselves to the founders.[31] Before Augustus, the landscape of founding myths, variants of those myths, and genealogies was vastly more diverse.[32] Augustus, with his own actions, such as the design of his forum, and, with the help of such authors as Virgil and, to a lesser extent, Livy, pruned these various myths to one coherent narrative about Aeneas and Romulus, as related to Augustus, a narrative that became the imperial story of Rome's foundation.[33] Still, Rome's founders were no different than their Greek counterparts, as presented in the textual and other sources. Virgil casts Aeneas in the mold of a Greek oikist from the age of colonization.[34] Venus-born Aeneas undertook a twofold task, to found a new city and to father a new ethnos, the *genus Latinum* (Verg. *Aen.* 1.5–6). Aeneas's "progeny," accordingly, were called "sons of Aeneas" and "Aeneades."[35] Before he founded cities in Latium, there were no "Aeneades." Aeneas's reward for courageous deeds was deification.[36] Material and literary evidence suggests that Aeneas was worshiped as Lar Aeneas, and Jupiter Indiges, an honor echoing the deification of Greek founders.[37] Romulus was a less positive figure than Aeneas.[38] He had caused the death of his brother, Remus, who had challenged him over the founding of Rome (Livy, 1.1.7), and had also orchestrated the abduction of the Sabine women. But Romulus founded the eponymous city of Rome, and he was called "father of the Roman people" (Livy, 1, *praef.*). The Romans were named after their "father." Because there were no Romans before Romulus, he ushered in the age of the Roman people/race. Romulus too became god after his death. At some point before the Augustan age, the deified Romulus fused with the god Quirinus.[39] There were no corresponding stories for Rome's female ancestors. Unlike Augustus, who could be styled a new Aeneas or a latter-day Romulus, Livia could look to no Roman foremother provide a legitimating precedent for honoring her as divine.[40] The Romans did not celebrate their mortal founding mothers other than in a most general way, such as the festival of the Consualia, which ancient authors linked to Romulus's abduction of the Sabine women.[41] But among Rome's divine ancestors was Venus. She was hailed as *princeps generis,* the first in the family of the Romans (Ovid, *Fasti* 1.40) to Mars, the "father of the father of the Roman people" (Livy, 1, *praef.* and 1.1.7) though the pair had no child in common. It was Romulus who bound the two divine lineages, his Trojan ancestry having been established in the Roman imagination as early as the 340s B.C.E.[42]

It was therefore no mortal woman but Venus who helped conceptualize Livia's unprecedented honors. The mechanism of the connection calls for situating Livia's honors in relation to a preexisting Mediterranean discourse of city founding that rationalized deification and divine characteristics for nonfounders and for women. That wider context helps explain how and why Livia came to be identified as a progenitor of the Augustan Roman race. Livia's divine honors, though relevant to the Roman context, followed a logic that went back to the Hellenistic kings and queens. By careful manipulation, patience, sheer longevity, and reference to precedents, Augustus succeeded in applying this logic first to himself, and then to Livia.

The Hellenistic monarchs had presented and legitimated their power (acquired by conquest and/or diplomacy) in the idiom of city founding. Alexander of Macedon led the way. During his conquest, he founded more than twenty Alexandrias.[43] His successors followed suit, on a more modest scale.[44] Greeks believed that exceptional mortals, saviors, benefactors, and founders of cities deserved divine honors.[45] The Hellenistic monarchs built on these widely held beliefs in their conquests. They promoted the idea that the king was *sōtēr* (savior), *euergetēs* (benefactor), and *ktistēs* (creator/founder) of his people.[46] In turn, the conquered cities, because they preferred honoring a founder and a benefactor to celebrating a tyrant, used the same idiom with reference to their conquerors.[47] They could do so because the origination of cities was closely linked to the concepts of paternity and deliverance, the utmost benefaction.[48] Founding, an act tantamount to engendering a city and a nation, thus became notionally connected to saving the polity from extreme danger.[49] A savior could be hailed as a new founder and worshiped as a god. From there, as the career of King Demetrius I of Macedonia, Poliorcetes ("City-besieger"; 337–283 B.C.E.) demonstrates, cities had to make only a short leap to lavish honors on the female members of the new founder's family.

The Ptolemies offer a paradigmatic example of how rulers harnessed an entire dynasty the prestige and cultic honors due to founders: they joined Alexander's cult at Alexandria to the worship of their own family. With the rise of lifetime divine honors bestowed on Hellenistic royals, Rome and the Greek-speaking East parted ways in how they conceptualized and honored human founders. With the likely exception of Julius Caesar, at the beginning of Octavian's political ascent, no Roman man or woman had been awarded divine honors since the original founders.[50] The same could not be said of Hellenistic rulers and their families.[51]

The honors for Demetrius Poliorcetes, the conqueror and king of Athens, illustrate the link between saving, founding, and benefaction and the savior's family. When Demetrius appeared with his fleet at Piraeus, the port of Athens, promising to restore the ancient government of the city, the population responded by hailing him as their "savior" and "benefactor."[52] In 304/303 B.C.E., the Athenians even let him reside at the Parthenon, where he shared space in the temple with Athena (Plutarch, *Demetrius* 23).[53] The same city also offered him godlike honors (athletic games, procession, and sacrifice), named a month after him, and instituted a festival to commemorate him (Diodorus Siculus, 20.46.2; Plut. *Dem.* 12). When in 303 B.C.E. Demetrius convinced the citizens of Sicyon to move their city, they named the new polity after him and offered him honors as "founder."[54] His favorite lover, the courtesan Lamia, bestowed on the city the gift of a Stoa Poikile, a painted porch, a monument that no doubt deliberately named in such a way to evoke the celebrated Stoa Poikile in Athens.[55] Both Lamia and Demetrius's preferred wife, Phila, also received cultic honors and were syncretized to Aphrodite.[56] The kind of honors bestowed on Demetrius and his female partners indicates that Demetrius and his family were honored like city-founding gods (Plut. *Dem.* 11-12). But whereas the link between Demetrius's extraordinary favors to the city and the cultic honors

benefactions + honors [handwritten]

accorded him is clear, such a link between benefaction and honors can be detected for only one of the women associated with him, Lamia.

Under the Ptolemaic rulers of Egypt, the disconnect between accomplishments and honors became a common practice. Cultic honors were increasingly distanced from achievements as founding and divine honors came to include and thereby legitimate an entire dynasty of rulers. The Ptolemies accomplished this notional leap by tying their dynasty to Alexander, the founder of Alexandria to whom they were unrelated, and by celebrating their dynasty's founders as gods.[57] The Ptolemies cultivated the notion of a blood line of men and women who were divine by relationship to Alexander and also divine in their own right. This self-presentation was anchored in Alexander's cult and tomb, the divine honors the family established for itself, and Ptolemaic coin iconography. The tomb and divine honors were not incompatible.

Alexander's tomb in Alexandria was known alternatively as either the *Sēma* or the *Sōma*.[58] Calling it the Sēma likened it to the tumuli of such Homeric heroes as Hector.[59] Calling it the Sōma, a term said to derive from the phrase "the body of Alexander" (Strabo, 17.1.8),[60] makes reference to Alexander's remains. That expression, in turn, may owe something to the adventurous manner in which the Ptolemies acquired those remains. Ptolemy I Sōtēr(Savior) (r. 367/366–282 B.C.E.) probably snatched Alexander's body as it processed from Babylon to Macedonia.[61] Diodorus Siculus (active ca. 60–50 B.C.E.) reports that Ptolemy reserved a special precinct (*temenos*) for the body and instituted "sacrifices worthy of demigods" (*thusiais hērōikais*).[62] The Ptolemies, unrelated to Alexander, used the conqueror's body for dynastic purposes.[63] They were all buried not too far from it on the grounds of the royal palace (Strabo, 17.1.8).[64] The nearness implied affinity. Even before Alexander's hearse arrived in Alexandria, Alexander himself was revered in the city as its founder, *ktistēs*.[65] The Ptolemies capitalized on that reverence. The symbolic value they derived from the relic originated in the honors Alexander commanded as founder of Alexandria. The body helped establish a hero cult, which soon became dynastic.[66] The Ptolemies fashioned Alexander as the founder of both their capital city and their own dynasty. Ptolemy II Philadelphus (Sister-loving) (308–246 B.C.E.) and his sister and wife Arsinoë II Philadelphus (Brother-loving) (ca. 316–270 B.C.E.) were worshiped in Alexander's temple in Alexandria, where the priests of the temple served both cults.[67] The Ptolemaic king and queen, because of their association with the founder of Alexandria, were celebrated as his successors in the divine act of founding a city; Alexander, in turn, was styled the founder of the Ptolemaic dynasty. Because he founded the city of Alexandria, and the Ptolemies succeeded him in ruling it, they continued, in a sense, the founder's divine family.[68]

Numismatic portraits of both Ptolemy I, the Macedonian founder of the dynasty, and Arsinoë II, its most important female progenitor, refer to Alexander, underscoring affinity. Ptolemy I sports Alexander's wavy hairdo; Arsinoë is featured with the horn of Ammon that is a staple of Alexander's iconography on coinage (figs. 5, 6, and 8).[69] The horn connects Arsinoë to two Egyptian gods that appeared in the shape of a ram, Ammon

importance of body [handwritten]

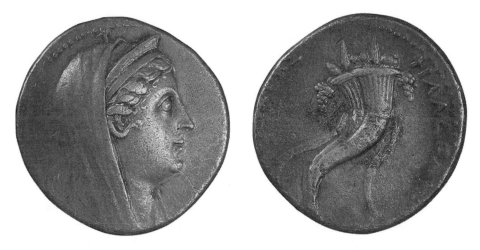

FIGURE 5

Decadrachm of Ptolemy II, Alexandria, 260–250 B.C.E., silver. Obv.: Veiled head of Arsinoë II
Philadelphos diademed wearing *stephanē* with ram's horn around her ear and lotus-tipped scepter over
shoulder. Rev.: Double cornucopia. Reverse legend: ARSINOĒS PHILADELPHOU. H/AM, Gift of Mrs.
Schuyler Van Rensselaer, 1933.9. Imaging Department © President and Fellows of Harvard College.

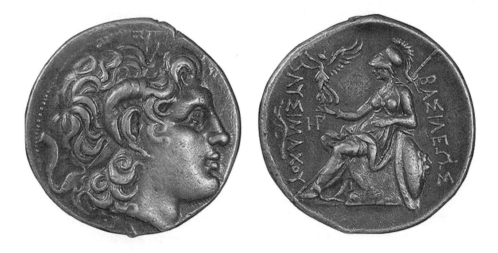

FIGURE 6

Tetradrachm of Lysimachus, 297–281 B.C.E., silver. Obv.: Diademed head of the deified Alexander with
the horn of Ammon. Rev.: Athena enthroned, holding Nike/Victory and spear, and resting elbow on a
shield. Reverse legend: BASILEŌS LYSIMACHOU; HP. H/AM, Arthur M. Sackler Museum, Loan from the
Trustees of the Arthur Stone Dewing Greek Numismatic Foundation, 1.1965.1349. Thompson 48.
Imaging Department © President and Fellows of Harvard College.

and Mendes, and to Alexander.[70] According to the legend, Ammon, syncretized to Zeus, fathered Alexander the Great.[71] A numismatic portrait of Alexander with the horn of Ammon behind his ear first appeared on the coinage of his successors, Ptolemy I and Lysimachus of Thrace (fig. 6).[72] The horn, as a sign of Ammon and Mendes and of Alexander as god, indicates that Arsinoë, like the eponymous founder of Alexandria, had also merited deification. Indeed, her divine names included "beloved of the ram (the god of Mendes)."[73] The double cornucopia, a symbol of abundant harvest and an attribute of the deity Good Fortune (Agathē Tychē), shown on the reverse of coinage minted in Arsinoë's name, testifies to the prosperity Arsinoë brings as a goddess (fig. 5).

Arsinoë's cult cannot be explained by her accomplishments, unlike that of Ptolemy I, whose divine name, "Savior" (Sōtēr) resonates with the epithet that may have been given him originally by the Rhodians for saving them from Demetrius (Pausanias, 1.8.6).[74] Her cult took various shapes. Arsinoë was associated with the Greek and Egyptian pantheons.[75] She was also worshiped as herself in Alexandria, and in Philadelphia, the city bearing her name.[76] In the end, the variations of her cultic honors, assimilation to those of both Egyptian and Greek deities (such as Mendes, Ptah, Hathor [fig. 7], Aphrodite, Hera, and Demeter), ensured her wide appeal in the Mediterranean world. Like Alexander, Arsinoë had cities named after her, many of them ports in the Aegean and the Red Sea.[77] Small votive plaques inscribed with her name were found throughout the Ptolemaic empire. Arsinoë's dual role as a revered dynastic ancestor and a city founder no doubt helped ensure the persistence of her image on Ptolemaic coinage and the popularity of her cult.[78] Even though, traditionally, deeds determined a city's decision regarding the bestowal of cultic honors, with monarchies that decision came to rest with the family.[79]

Arsinoë's cultic honors can thus be explained only dynastically. Her divinity was justified by lineage, not deeds.[80] But although Arsinoë's case illustrates the transition from cults initiated by a city to dynastic cults, those dynastic cults still had to be presented cogently. Arsinoë's cults were not simply those of Egypt, where worship of a ruler was an established tradition. They were also those of the Greek world, where such a practice was a novelty. For that reason, the mechanism for justifying her divinity and that of her family is worth examining. The famous gold octadrachm of Ptolemy II (r. 285–246 B.C.E.) and Arsinoë II (queen of Egypt, 280/279–270 B.C.E.) sheds light on the dynasty's absorption of the discourse of founding. The coin advances a divine line of founders (fig. 8).[81] The obverse shows the jugate portraits of the espoused siblings, above them the legend ΑΔΕΛΦΩΝ, "of the siblings." The reverse represents the jugate portraits of their parents, Ptolemy I and Berenice I, with the legend ΘΕΩΝ, "of the gods." In earlier examples the two words appear together on the obverse.[82] ΘΕΩΝ ΑΔΕΛΦΩΝ, "of the gods-siblings," is the genitive plural form of the cult name of Ptolemy II and Arsinoë II. The cult name of their parents was Theoi Sōtēres.[83] In 280 B.C.E., Ptolemy II had established a cult to his father, Ptolemy I, as Sōtēr, "Savior God."[84] About eight years later, in 272/271 B.C.E., Ptolemy instituted a separate cult to himself and Arsinoë II, the Theoi Adelphoi, or "Sibling Gods."[85] The priests serving the living Theoi Adelphoi also took care of Alexander's cult.[86]

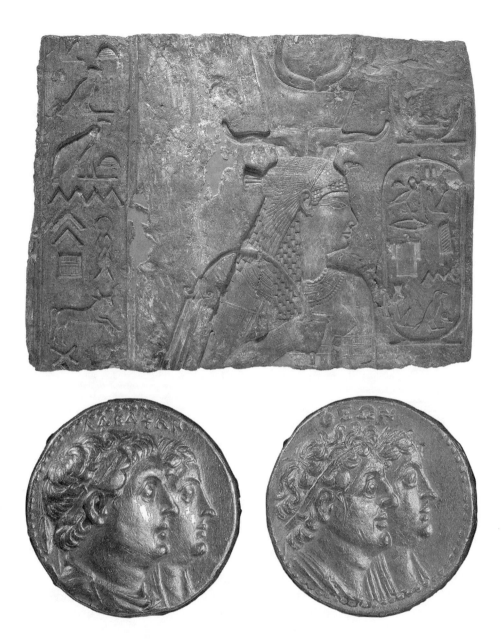

FIGURE 7

(top) Relief of Queen Arsinoë II as Hathor, Ptolemaic, after 270 B.C.E., carved limestone, with red ocher, charcoal black, and Egyptian blue on chalk; 42.5 (h) × 57.7 (w) × 7.5 (d) cm. H/AM, Gift of Mr. and Mrs. Samuel H. Lindenbaum, 1983.96. Imaging Department © President and Fellows of Harvard College.

FIGURE 8

(bottom) Octadrachm (*mnaieion*) of Ptolemy II, struck after 272 B.C.E., gold. Obv.: Jugate busts of Ptolemy II and Arsinoe II with a shield to the left. Rev.: Jugate busts of Ptolemy I and Berenice I. Obverse legend: ADELPHŌN. Reverse legend: THEŌN. Svorōnos 1904–8, no. 603. H/AM, Loan from the Trustees of the Arthur Stone Dewing Greek Numismatic Foundation, 1.1965.2752. Imaging Department © President and Fellows of Harvard College.

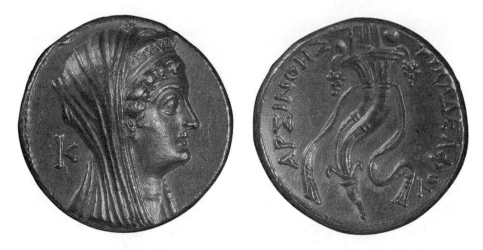

FIGURE 9

Octadrachm (*mnaieion*) of Ptolemy VI, 180–145 B.C.E., gold. Obv.: Bust of Arsinoë II wearing *stephanē* and veil; the letter *K*. Rev.: double cornucopiae bound with fillet; border of dots. Reverse legend: *ARSINOĒS PHILADELPHOU*. Svorōnos 1904–8, 1498. H/AM, Loan from the Trustees of the Arthur Stone Dewing Greek Numismatic Foundation,1.1965.2762. Imaging Department © President and Fellows of Harvard College.

The coin thus refers to the cult of parents and siblings, connecting the rulers with their deified ancestors, and with Alexander, in a powerful statement of dynastic continuity and political legitimacy. The parents are honored as gods because they were "saviors," the qualities of the male ruler imparted over the queen. The cult name of the siblings indicates not accomplishments, but familial connection. It rationalizes the cult to the children with blood relations, and goes against the view that Hellenistic cults rewarded accomplishments.[87] Visually, the portraits convey the idea of dynasty in the emphatic family resemblance of father and son, mother and daughter. Except for a slight line around the mouth of Ptolemy I and three delicate horizontal lines on the neck of Berenice, the older couple is scarcely distinguishable from the younger. The jugate positions of the heads bespeak harmony between both the reigning consort and his sister-wife and their deified ancestors. The joint portraits also suggest that royal authority comprises a male and a female ruler. In their royal partnership, based on familial relationship and marriage, the king takes precedence and is accordingly depicted in the foreground. Nonetheless, Arsinoë received many of the king's privileges. Besides sharing the place of honor on her brother's coinage, she shared his cultic honors, and the throne name *philadelphos*, or "brother-lover."[88] The Ptolemaic kings after Ptolemy II reinforced the idea of a race of divine founders by continuing to mint coins in the names of Ptolemy I and Arsinoë II (fig. 9).[89]

A city-founding ideology bound to both dynasty and divinity is reflected the cultic names of the entire Ptolemaic dynasty. Two of the twelve Ptolemaic kings and queens adopted as names Theoi Euergetai (Benefactor Gods): Ptolemy III and Berenice II; Ptolemy VIII

and Cleopatra II and III; and two were Theoi Sōtēres (Savior Gods) (Ptolemy I and Berenice I).[90] Throne and cult names referring to familial relationships and divine characteristics are also common: Theoi Philadelphoi (Ptolemy II and Arsinoë II), Theoi Philopateres (Ptolemy IV and Arsinoë III), Theoi Philomēteres (Ptolemy VI and Cleopatra II), Theoi Philomēteres and Sōtēres (Ptolemy IX and Cleopatra II and III).

Livia's honors as the progenitor of a divine race fit into the Hellenistic model in which founding legitimated both rule and dynasty. As with Arsinoë II, however, the model does not explain why Romans in the post-Augustan period would find such honors acceptable, but not the citizens of republican Rome. The transformation of opinion and tradition resulted from Augustus's efforts over several decades to present himself as a new founder of Rome, an endeavor deeply indebted to the Hellenistic exempla. He succeeded in adapting the Hellenistic model in ways that his contemporaries enthusiastically welcomed and elaborated upon.

Although the Romans had no cherished mortal female founders, Roman tradition paved the way to bestowing founding honors on empresses by granting them first to nonfounders. Because Romans honored the saviors of the state as founders, a city such as Rome could have more than one father and more than one savior. Camillus, who saved Rome from the Gauls, was hailed as "Romulus," "parent of the fatherland," and a "second founder of the city."[91] The Roman general Marius was called "the third founder of Rome" for his victories over Germanic tribes.[92] In the late republic a few Roman citizens, including Augustus's adoptive father, Julius Caesar, received the honorifics *pater patriae* and *parens patriae*,[93] epithets that also had religious significance in that apotheosis was an expected award for saviors and for founders.[94] Julius, a few years before his assassination, was celebrated as "savior" and "benefactor" of all Greece.[95] If the connection between such epithets and cult was logical from a Greek point of view, it remained alien to Rome. Julius's demise testifies to Rome's stout resistance to worshiping mortals in their lifetime.[96] That element of Roman culture did not change with Augustus. Indeed, he respected it, fastidiously refusing any divine honors in Rome, though he welcomed them in the Greek-speaking East.[97] Even so, he paved the way for his posthumous deification in Rome, first by fashioning himself as Rome's founder by means of his actions, a strategy that satisfied Roman tradition and prevented a backlash like that visited upon Julius.[98] At the same time, following Julius's example in part, he promoted his lineage, which included not only his ancestors but also his descendants. Like the Ptolemies, he cultivated a divine line of godlike founders, the meritorious descendants of Rome's founders, who partly through association with Augustus would ensure Rome's perpetual golden age. This in itself was a significant change from the Roman republican tradition.

The transformations Augustus effected in the public sphere did not happen overnight. Indeed, his ambitions regarding the female gender became possible only after his death. His success in including Livia in the discourse of founders depended on his own self-fashioning as Rome's new founder, scion of a divine line of founders, himself the progenitor of a new generation/age who deserved divine honors for his accomplishments.

Augustus's successful self-fashioning, readily discernible in his titles, had its beginnings in the years after Actium. The most important event of those years was Octavian's relinquishing his absolute powers in the state, a move that made him, in the eyes of the senate and the people of Rome, a savior of citizens (*RG* 34.1).[99] As his reward for "saving the citizens" he was given the title "Augustus." This honorary name must be regarded as a synonym for "Founder." The element of founding in Octavian's first and most important title underscores the import of two monuments from the post-Actium era: the Temple of Apollo Palatinus and Augustus's mausoleum, with the posthumously added *Res Gestae Divi Augusti*, or *Deeds of the Deified Augustus*. Octavian's choice of Apollo as patron deity and the Palatine temple must be understood as Octavian's reverence for the divine protector of city founders. The gargantuan mausoleum must then be seen as aspiring to present Octavian as Rome's new founder. Augustus's *Res Gestae* (13–14 C.E.), the report of his accomplishments posted after his death on the mausoleum, therefore should be regarded as expressing Augustus's ambition for posthumous deification for his founder's achievement.

Octavian's titles and the two monuments attest that the emperor is akin to Romulus, Aeneas, and Alexander. At the same time, in refusing to be called "Romulus," or "king," or "god" in his lifetime, Augustus emphasized the difference between those founders and himself. His novel titulature underscored his superiority. But, even as he jettisoned the idea of monarchy, he transformed the republic into a de facto monarchy.[100] The founding framework allowed him to expect posthumous deification, a founder's honor, and also to nurture the idea of a family tree of founders, related by blood (which includes adoption) and merit, "the family of the Augusti."

After Augustus, in theory (if not in actuality) every emperor was the founder/father of the land in the current generation.[101] The emperor was expected to behave like a good father/progenitor/founder of the land, protecting the city of Rome and its empire in times of war, governing it well in peacetime, and giving generously to the city of Rome.[102] Augustus's power enabled him to fashion his particular image, but the pattern he established endured because of the "anonymous rules" that defined and naturalized his statements of power. In other words, the Augustan discourse of power was persuasive only because its core ideas had long been in effect in the Roman and the Mediterranean Hellenistic context. He leaned more heavily, if cautiously, on the Hellenistic discourse,[103] and that set the stage for Livia's honors.

TITLES OF FOUNDING: DIVINE LINEAGE AND MERIT

Augustus's most cherished honors—Augustus, *pater patriae*, and *princeps*—had connections to Rome's founders. In 27 B.C.E., months after Octavian had saved the republic, the senate awarded him the honorary title Augustus (venerable, worthy of honor). The sources tell us that the title Augustus was a substitute for Romulus (Suet. *Aug.* 7.2; with Dio Cass. 53.16.7; *RG* 34.2).[104] The senator who proposed it argued that Augustus had a more honorable meaning, "inasmuch as sacred places too, and those in which anything is consecrated

by augural rites are called august, from the increase (*auctus*) in dignity, or from the movements or feeding of the birds, as Ennius (239–169 B.C.E.) also shows when he writes: 'Afterward by augury august illustrious Rome was founded'" (Suet. *Aug.* 7.2).[105] Another source, the *Epitome of Florus,* relates a senatorial proposal to call Octavian Romulus for "founding the empire" (2.34.66). The senators, however, rejected that name, preferring Augustus, because it "was deemed more holy and venerable, in order that, while he still dwelt upon earth, he might be given a name and title which raised him to the level of a deity."[106] The title Augustus also signified the moment when Octavian relinquished his *potestas* over the state, afterward possessing only *auctoritas* (authority) (*RG* 34).[107]

The noun *auctoritas* is related to the title Augustus. Its meanings include "right of ownership" and "right or power to authorize or sanction," but like "augury" and "august," it derives ultimately from the verb *augeo,* to increase in quantity, dignity, and size.[108] In other words, it means "to make greater than before," doing which makes one an *auctor.* Although augmenting and founding may seem dissimilar, in the eyes of the Romans, Rome, once Romulus had founded it, continued to be improved by the kings and magistrates who came after him. Like founding and saving, founding and renewing were linked notionally. The act of augmenting, making better, increasing in value can be connected to Romulus's transformation of Rome from a piece of land marked by a plough to a polity of citizens. Numa's religious policy, his calendar, his closure of the Temple of Janus, and other peacetime accomplishments were also augmentations, meant to demonstrate, in the eyes of Rome's neighbors, that that the city in their midst was more than a military camp (Livy, 1.1.19–21). Another augmentation of the res publica came with the reforms of Servius Tullius, who instituted the census and reformed the method of taxation as well as the citizenship requirements (Livy, 1.1.42–44). The *res publica* was improved by augmentation multiple times in Rome's history when new territories were added. Beautifying the city also augmented it. Suetonius quotes an undated decree that relates Augustus's wish to be *auctor* of the state: "May it be my privilege to establish the State in a firm and secure position, and reap from that act the fruit that I desire; but only if I may be called the author (*auctor*) of the best possible government, and bear with me the hope when I die that the foundations which I have laid for the State will remain unshaken."[109] Octavian had augmented the state by adding the immensely rich Egypt to its territories and restored/saved the polity in 27 B.C.E., unprecedented deeds that elevated him above ordinary mortals and earned him the founder's title Augustus.

The honorific Augustus received in 2 B.C.E., *pater patriae,* father of the fatherland, also appealed to collective memory of Romulus, the first *pater* of Rome (*RG* 35.1).[110] *Princeps,* or leader, referred to Augustus's authority in the state. It conjured images of the *principes,* the most worthy Roman statesmen (*RG* 13).[111] But *princeps* also overlapped with *pater* and with Augustus, in the sense of "creator." A princeps could be a first citizen, and also the first in the family.[112] Venus was the *princeps generis,* the first in the family of the Romans (Ov. *Fast.* 1.40). The titles Augustus, pater, and princeps all suggested Augustus's paternity of the state "writ large," likening him to Rome's parents:

Mars and Venus, and Romulus and Aeneas.[113] Even though Augustus's family claimed descent from Venus and from Mars, the gods and their deified descendants Romulus and Aeneas belonged to all Romans.[114]

In outlining his similarity to and difference from previous founders, Augustus insisted on both lineage and merit. The decoration of the Forum of Augustus (inaugurated in 2 B.C.E.) constituted the most grandiose expression of that dual emphasis.[115] The program suggested both Augustus's divine lineage from Rome's founders and his merit, passed through the generations like a family trait. These two characteristics—merit and lineage—defined Augustus's highest honor, "Father of the Fatherland."

The Forum of Augustus enclosed a large open space with covered colonnades (fig. 10). The porticoes integrated two sizable semicircular exedras, one featuring a statuary group of Aeneas leaving Troy, and the other, Romulus.[116] The statues have not survived but have been reconstructed from contemporary images found in other media.[117] On the Aeneas side, statues of prominent and lesser members of the Julian family lined the covered porticoes. Facing them were statues of the most illustrious Roman men (the *summi viri*) (SHA [*Scriptores historiae Augustae*] *Severus Alexander* 28.6-7). The individual pediment of the statues listed each man's achievements.[118] The square terminated at the Temple of Mars Ultor, Mars the Avenger. The cella's temple housed statues of Venus, Mars, and Julius Caesar. The temple of the pediment showed Mars in the center of the composition, accompanied by Venus, Fortuna, Roma, Romulus, and the personifications of the river Tiber and Mons Palatinus.[119] Somewhere in the forum, very likely in the middle, stood a gilded quadriga, labeled *pater patriae* (*RG* 35.1).

The facing exedras reflect the duality of Augustus's ancestry, gods and city founders, his Romulean and his Trojan/Julian ancestry (fig. 10). At the funeral of the *princeps,* the *imagines* (portraits) of ancestors that followed his catafalque included Romulus (Dio Cass. 56.34.3). Octavian became one of the Julians/Iulii through his adoptive father, Julius Caesar. Julius in turn traced his family name to Iulus-Ascanius, the son of Aeneas, and thus considered Venus his guardian deity.[120] Caesar favored Venus in the dual role of Genetrix, and of Victrix, the Victorious One (fig. 11).[121]

The forum's decorative program resonates with Virgil's *Aeneid,* published seventeen years earlier, particularly the idea of Augustus as a double of the Trojan Aeneas.[122] In scholarship the epic poem has endured as the lens through which to view the forum's messages, because Virgil's version of Roman's past privileges and embroiders on stories of Rome's origins through an Augustan lens. This is also how Augustus's forum fashioned Roman history, drawing attention to Romulus, Aeneas, and his own family.[123] In the Augustan age alternative founders, genealogies, and founding myths faded out of the picture.[124] Virgil emphasized the Trojan origins of Augustus and all Romans;[125] whereas the Forum of Augustus endeavored to place equal emphasis on the dual ancestry of Augustus's and Rome's family tree.[126]

The point of the decorative program was to frame Augustus's achievements in the context of the totality of Roman history up to that moment, using Aeneas, Romulus, the

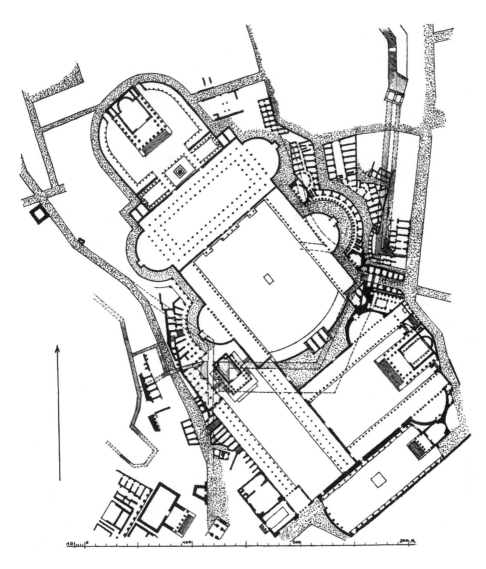

FIGURE 10
Imperial Fora (clockwise from top): Forum of Trajan, Forum of Augustus, Forum Transitorium, Forum
of Julius Caesar, Rome, ground plan. Photo Credit: Deutsches Archäologisches Institut—Rome. A. v.
Gerkan, D-DAI-Rom 39.880.

Julians, and the *summi viri* as coordinates. The forum's narrative can be read as tracing
the origins of the princeps, from the gods Venus and Mars, shown on the pediment,
through their heroic children Aeneas and Romulus, represented in the exedras (fig. 10).
In it Augustus emerges as the blood relative of two national heroes, and their heir
in accomplishments. The Julian ancestors especially underscored the importance of
lineage.

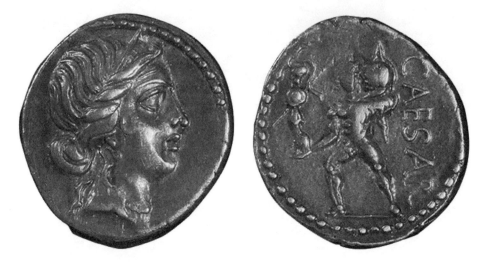

FIGURE 11

Denarius of Julius Caesar, Africa, 47–46 B.C.E., silver. Obv.: Head of Venus wearing *stephanē* Rev.: Aeneas holding Palladium (statuette of Pallas Athena) and carrying his father Anchises on his shoulder. Reverse legend: *CAESAR* vertically. H/AM, Transfer from the Alice Corinne McDaniel Collection, Department of the Classics, Harvard University, 2008.115.142. *RRC* 458/1. Imaging Department © President and Fellows of Harvard College.

Augustus is said to have proclaimed that he honored the *summi viri* with statues and inscriptions of their deeds so that he might "attain the standard set by those worthies of old" (Suet. *Aug.* 31.5).Yet Augustus's symbolic presence in the forum did not imply equality; it trumpeted Augustus's superiority.[127] Although the precise location in the forum of the long-lost glittering quadriga with the sign *pater patriae* is unknown, it is safe to assume that the chariot was placed to maximize its visual impact. If it was in the middle, as reconstructions position it, it stood out against an impressive background. Its very difference from other elements of the forum's decoration—its material and spatial discontinuity with the colonnades—suggested that Augustus surpassed previous exemplars of Roman excellence, which pointedly included Romulus and Aeneas.[128] He bested them, as the sign on his chariot suggested, by being "father of the fatherland." The honorific locates Augustus's achievements in founding, and, given the composition and content of the program, gestures implicitly toward greater posthumous awards.

DIVINATION TO DEIFICATION

What these awards were and what city founding meant in first-century Rome can be gleaned from the textual sources that recount the deeds of Romulus and Aeneas. Although the careers of the two city founders differed in their details, as the sources

describe them, their trajectories were similar. At the same time, the founders' careers, meaningfully and seemingly deliberately, resonate in crucial ways with Augustus's public self-presentation. Late first-century ideas about Rome's founders and founding therefore cannot be considered without accounting for Augustus's own self-presentation.[129] The Augustan inflections of these narratives are here taken to indicate that Augustus breathed new life into Rome's foundational myths.[130] Octavian's actions and building activities shortly after Actium invited pointed comparisons to the first founders, and, at the same time, affected contemporary readings of Romulus's and Aeneas's careers, such as those found in Livy and in Virgil.

In brief, founding, as reconstructed from the contemporary literary sources, appears to be a divinely sanctioned accomplishment in which a god's son undertakes to establish a city. The founder identifies the proper location by divination, a ritual that in turn reveals his destiny as a founder. Once the city is established, the founder rewards his patron god handsomely. He also augments the city by expanding its territory, governing wisely, and performing pious acts. Difficult tasks and choices mark the road to establishing a city's existence and ensuring its prosperity. The founder surmounts them all, and for his services to the commonwealth the gods reward him with deification.

Divination mattered a great deal in the career of Rome's founders. Romulus sought to understand the will of the gods by divination.[131] The flight of twelve vultures augured both the site of his future city and the gods' choice of him over his brother Remus as founder of Rome. Romulus's augury was the original instance of the *augurium salutis,* the augury of safety (Ennius, *Annales,* fragment 155; Suet. *Aug.* 7.2). The will of the gods successfully interpreted, the founder ploughed the contour of its future walls, a boundary which at the time probably coincided with the pomerium, the sacred limit of the city.[132] He then sacrificed to the gods the two oxen that had helped him in this task (Plut. *Rom.* 11; Ov. *Fast.* 4.825–26). Next came the recruitment of new citizens, in part by abducting women from the neighboring areas, wars with the neighbors to defend his city, and the establishment of the city's first governing institution, the Roman Senate (Livy, 1.1.8–10). Romulus seemed to have a taste for power. He appointed himself three hundred bodyguards and twelve lictors (Livy, 1.1.15, 1.1.8). According to some traditions, the disgruntled senators tore Romulus to pieces in the Field of Mars (Livy, 1.1.16).[133] Yet, he was forgiven all his crimes and indulgences in the context of his greatest feat, the founding of Rome. Livy, for instance, considers Romulus's achievements—his wisdom in founding the city of Rome and strengthening it in war and in peace—commensurate with the divine origins and the divinity attributed to him after death (Livy, 1.1.15). According to Livy, after "these outstanding immortal achievements," *immortalibus editis operibus,* Romulus disappeared without a trace from an assembly held at the Campus Martius. In the common version he then descended from the sky to proclaim Rome's future greatness and to confirm his becoming a god (1.1.16).[134] Despite his personal skepticism, Livy still relates that the senators hailed Romulus "a god, the son of a god, the King and Father of the City of Rome" (Livy, 1.1.16).

Aeneas's career, as related by Virgil, followed a similar pattern of divination, wars associated with city founding and nation building, and finally deification. Rather than Romulus's twelve vultures, twelve piglets nursing from a white sow revealed to the son of Venus the site of his Latin city (Verg. *Aen.* 8.42–46). Before receiving this propitious sign, the Trojan, like a score of Greek founders, sought help from the Apollonian oracles, his earliest attempts to establish a city having failed miserably.[135] In Virgil's epic, Aeneas also looks for Apollo's guidance through the Sibyl of Cumae (6.42–155). He implored Delian Apollo for the hallmarks of a lasting city:

> Grant us, god of Thymbra, an enduring home; grant our weary band walls, and a race, and a city that shall abide; preserve Troy's second fortress, the remnant left by the Greeks and pitiless Achilles! Whom should we follow? Whither do you bid us go? Where fix our home? Grant, father, an augury, and inspire our hearts! (*Aen.* 3.84–89)

The Temple of Delos, like the one at Delphi, was well known for its sanctuary to Apollo, which may or may not have had an oracular shrine.[136] The prayer resonates with Romulus's founding efforts, highlighting the importance of divination (*augurium*) and of reliable city walls (*moenia*). It asks for the gift of a nation (*genus*).

As in the Greek tradition, the historical sources relate that Rome's human founders, though gods (and therefore immortal), had their own tombs. Livy's account of Aeneas's deification mentions, without elaboration, that the Trojan hero was buried by the river Numicus (Livy, 1.1.2).[137] According to a tradition recorded in Varro that implies a parallel between Romulus and Greek founders such as Theseus, who was interred in the agora, Romulus had a tomb in the forum.[138] Livy likewise corroborates that Romulus had a tomb within the city of Rome (1.1.111). As with Alexander and other city founders, the tombs did not preclude divine honors.

In the broadest sense, the founders in Rome's history shared similar characteristics, approached challenges in similar ways, and labored over similar tasks. Aeneas and Romulus were both the progeny of a god and mortal, they both employed divination to establish their cities, struggled with the task of nation building, and protected their cities in war and peace. Their extraordinary accomplishments were rewarded with posthumous divinity. Yet, both of them had tombs.

DIVINATION AND THE TEMPLE OF PALATINE APOLLO

A similar arc of founding efforts defines Augustus's career. *Divi filius*, son of the deified Julius Caesar since 43 B.C.E., Octavian's career from then onward bears all the markings of a fulfilled prophecy. The year 31 B.C.E. is his year of complete triumph over his adversaries. Two years later, in 29 B.C.E., began his program of symbolically refounding

Rome with the *augurium salutis*, the augury of total peace (Tacitus, *Annals* 12.23; Dio Cass. 51.20.4).[139] This augury could be commenced only when the *res publica* was at peace (Dio Cass. 37.24.1–2). An inauspicious *augurium salutis* boded ill for the times ahead, as when a failed augury of safety preceded the Catiline conspiracy (Cicero, *De divinatione* 1.47). Octavian took this capricious augury after a hiatus of several decades, his gesture highlighting the herculean task of bringing peace to the commonwealth (Tac. *Ann.* 12.23). A similarly styled attention-grabber was his closure of the doors of the Temple of Janus, an undertaking which signified universal peace (*RG* 13; Dio Cass. 37.24.1–2).[140] The following year, 28 B.C.E., the year that Augustus held his sixth consulship, he completed three significant tasks. He inaugurated the Temple of Apollo on the Palatine, erected his mausoleum, and, together with Agrippa (63–12 B.C.E.), his fellow consul, conducted a census. Little has been made of the relationship between these acts and the *augurium salutis*, which preceded them, yet all four of these enterprises defined Octavian as a new founder much earlier and much more forcefully than recognized before. The choice of Apollo as a patron god was steeped in Greek and Hellenized Roman understanding about the god's role in the founding of cities. The census spoke to Octavian's efforts at nation building. He and Agrippa recorded a nearly four-fold increase in the number of citizens from the previous census (*RG* 8.2).[141] With the census, Octavian could claim a symbolic renewal of the Roman race, a key dimension of city founding. The Temple of Apollo symbolized the Augustan refounding of Rome. It was a gift offering for the prophecy that had singled Octavian out for the task of refounding Rome and for the protection that helped him accomplish it. The Mausoleum of Augustus, examined in the next chapter, claimed the most coveted of founding honors, immortality.

The Temple of Apollo on the Palatine has not survived, but its foundations have been excavated (fig. 12 and map 2).[142] The temple was erected on the site of Octavian's property on the Palatine Hill in Rome (Velleius Paterculus, *Historiae romanae* 2.81; Dio Cass. 49.15.5, 53.1.3; Suet. *Aug.* 29). According to the archeologists' findings, the house and temple were connected by a convenient ramp (fig. 12), a view now disputed.[143] If the house and the temple were in close proximity, the two structures and the ramp would have given the impression that the lavish Temple of Apollo was Augustus's household sanctuary.[144] One finds such close arrangements of a ruler's house and a temple in Hellenistic palaces, but not in those of Rome.[145]

The temple was constructed of gleaming Luna marble and it was surrounded by porticoes (*RG* 24.2; Propertius, 2.31; and Suet. *Aug.* 29; Horace, *Carmina* 1.31). Little remains of the decoration of the temple or the colonnades, but textual sources help explain the extant fragments. A few statues from the porticoes survive; they represent the Danaids, the fifty daughters of Danaus, who killed their husbands/first cousins on their wedding night (Prop. 2.31.4, Ovid, *Tristia* 3.1.61–62). Some terracotta relief panels with mythological scenes were found near the temple but their location in the original decorative program remains unknown. Subjects represented include a *betyl*, an

FIGURE 12

Ground plan for the House of Augustus and the Temple of Apollo, first century B.C.E., Palatine Hill, Rome. Drawn by Bill Nelson.

aniconic representation of Apollo shaped like a pillar, and the struggle between Hercules and Apollo over the Delphic tripod (figs. 13 and 14).[146] The textual sources speak of an altar with a statue of Apollo and four oxen in front of the temple (Prop. 2.31.5–8). The ancient authors also note that the ivory doors of the sanctuary depicted two of Apollo's more famous feats: the slaying of the Niobids, children of Niobe killed to punish their mother for her hubris, and the expulsion of the Celts from the Apollonian sanctuary in Delphi (Prop. 2.31.12–16). The cella of the temple housed statues of Apollo and Diana and their mother, Leto. All three statues were made by famous Greek sculptors (Pliny, *Naturalis historia* 36.23, 36.32, 36.24).[147] On the roof stood a chariot of the Sun (Prop. 2.31.11).

Although Augustus made a vow to build a Temple to Apollo in 36 B.C.E., several years before Actium, his victory there dominates modern interpretations of the sanctuary and its decoration.[148] The argument for the Actian victory as key to the Palatine temple rests

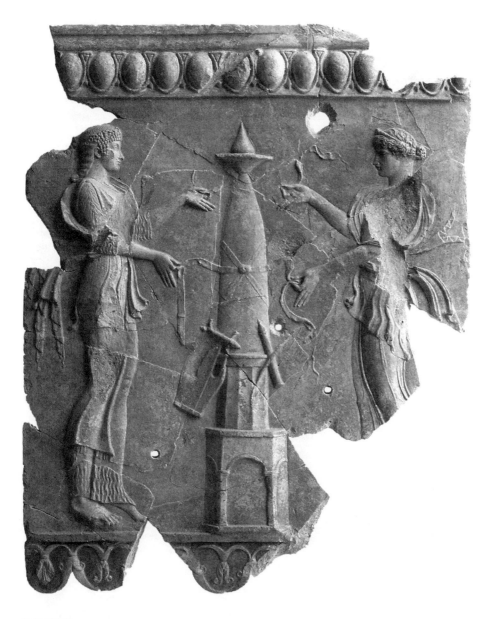

FIGURE 13

Two female figures fastening a ribbon on a betyl with a kithara (Apollo's attribute) attached to it, ca. 28
B.C.E., painted terracotta relief, 75 (h) x 61 (w) cm., Temple of Apollo, Palatine Hill, Antiquarium del
Palatino, Rome. Photo credit: Werner Forman / Art Resource, N.Y.

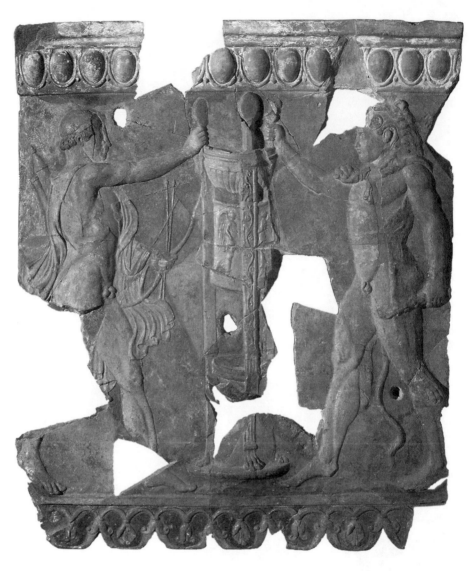

FIGURE 14

Apollo and Hercules fighting over the Delphi tripod, ca. 28 B.C.E., painted terracotta relief, 74 (h) x 62 (w) cm., Temple of Apollo, Palatine Hill, Antiquarium del Palatino, Rome. Photo credit: Scala / Art Resource, N.Y.

largely on literary testimonials, which refer to Apollo as Actius and Actiacus.[149] The myths detailing triumphs over barbaric or hubristic antagonists, such as Apollo's victories over Hercules, the Celts, or the Niobids, have been considered allegories of Augustus's naval victory over Antony and Cleopatra. Scholars have pointed out that other interpretations of the Temple of Palatine Apollo, unrelated to the victory, are possible, but Actium maintains its hold on discussions of the site.[150] Two analyses have offered robust

explanations for supplanting the military associations of the Palatine temple with others.[151] One of them links Augustus's Temple of Apollo to Apollo Agyieus, the protector of roads and cities, as well as to Phoebus Apollo, Apollo associated with the Sun.[152] The terracotta Campana panels with the *betyl,* the cone-topped shaft of Apollo Agyieus, constitute the chief evidence of this connection (fig. 13). The other analysis, challenging the focus on Actium in interpretations of the Palatine temple, places Octavian's temple in the Roman tradition of building temples with the help of divination, a tradition devoid of military symbolism.[153]

Augustus's vow to build the Temple of Apollo five years before the Battle of Actium remains the primary argument against interpretations that relate the structure exclusively to Actium. Indeed the temple and its decoration helped frame the Actian victory as one event in an ongoing relationship between Apollo and Augustus. Even though some scholars have pointed to strong similarities between Palatine Apollo and Apollo Delphinus, they have missed the connection to Apollonian prophecy and city founding.[154] The battle's significance folds into a multidimensional presentation of Apollo that invokes his help in victory as well as divination and city founding.

When lightning had struck Augustus's property, consultation with the *haruspices* (Cic. *De div.* 1.33, on the method), the Etruscan diviners of prodigies, revealed that Apollo had claimed that land. As a result, the temple was erected and dedicated to the god, and the land was claimed as public property (Suet. *Aug.* 29.3; Dio Cass. 49.15.5). The proximity of the temple to Octavian's house; the interpretation of a god's will by divination; and the honoring of Apollo are the elements that in combination reveal unambiguously that Apollo, having singled out Octavian for some urgent purpose, bypassed traditional norms governing the relationship between human dwellings and temples of the gods. Of the four dimensions of Apollo highlighted in the decoration and contemporary sources -- Apollo Phoebus, Apollo Delphinus, Apollo Agyieus, and Apollo Actiacus -- the first two relate to Apollo's instrumentality in city founding.[155]

APOLLO PHOEBUS/APOLLO HELIOS

Roman poets, including those who wrote about the Palatine temple, habitually named Apollo Phoebus, meaning "radiant" or "shining," a Latinized form of the Greek term *Phoibos,* thus connecting him to the syncretized divinity known as Apollo the Sun, or Apollo Helios in Greek and Apollo Sol in Latin.[156] Some have regarded the syncretism as a predominantly late-Roman phenomenon.[157] The evidence suggests, however, that the syncretism of Apollo and Helios occurred much earlier. Varro (116–27 B.C.E.), the scholar of the Latin language, remarks on the dual, Latin and Greek, etymology of the name Sol Apollo (*De lingua latina* 5.68),[158] thus evincing an early syncretized divinity. In an ode by Horace (65–19 B.C.E.), when Phoebus returns, he chases the stars away (*Carm.* 3.21.24); in other words, Apollo takes on the role of the sun. Ovid (43 B.C.E.–17 C.E.) echoes this connection when he refers to the new day as Apollo's full disk (*Fast.* 5.420).

This overlapping matters because Phoebus Apollo has been linked to the establishment of new cities, whereas Apollo Helios figures prominently in an important Roman prophecy about the new generation. One of the earliest written testimonies to Apollo's talent for establishing cities, Callimachus's *Hymn to Apollo* (*Hymn* 2), 55–59, written in the early to mid-third century B.C.E., states: "And Phoibos [Apollo] it is that men follow when they map out cities. For Phoibos evermore delights in the founding of cities, and Phoibos himself doth weave their foundations. Four years of age was Phoibos when he framed his first foundations in fair Ortygia near the round lake."[159]

The influential Hellenistic poet considers Phoebus Apollo the god of city founding, an honor Apollo deserved for founding the city of Ortygia when he was a child.[160] Apollo's city-founding qualities, however, must be related more broadly to two types of engendering: ethnogenesis and the reckoning of time, both implied in the Latin word *saeculum*. As noted earlier, in the ancient world, to establish a new city meant to create a new ethnos/nation of people, whose eponymous progenitor was the founder (whether male or female).

This logic connecting city-founding, ethnogenesis, a bright new age, and Apollo in turn can be applied to Apollo the Radiant, his protégé, Augustus, and a late-republican prophecy about the coming of the era of Apollo Helios. The Etruscan diviner Volcatus, having uttered that prophecy, died (Servius on *Ecl.* 9.46). Both Mark Antony and Augustus featured Sol on their coinage.[161] Mark Antony's denarii with Sol suggestively pair an image of the god with a radiate crown and Mark Antony wearing the priestly garb of an augur and holding the augur's crooked staff. In the context of contemporary prophecy and the logic of divination (it is revealed only to the chosen one), the composition alludes to Mark Antony's divining and therefore inaugurating of the age of Sol. Mark Antony in that instance evoked Romulus's augury, and connected it to the beginning of a new era, centered on himself.

An oblique reference to the connection between the new age, Sol, and Augustus is found on a rare silver coin, probably minted in Spain, and dated to 18–16 B.C.E. (fig. 15).[162] The obverse shows a head of Augustus in profile. The reverse depicts a figure with a radiating crown floating in the air, Augustus's birth sign Capricorn, and the legend AVGVSTVS.[163] The iconography can be understood as Sol ushering in the new age with the birth of Augustus, a reading strengthened by the suggested date for this coin, which coincides roughly with the official celebration of the new age, the Secular Games of 17 B.C.E., some of which took place at the Temple of Apollo.[164] The priestly colleges that celebrated the games were considered priests of Apollo.[165]

The age of Apollo Helios, as prophesied by Volcatus and celebrated by Virgil, can be understood as a new era in which Augustus, imitating Apollo Sol/Helios, founded anew the city of Rome and inaugurated a new golden generation. The astronomer Manilius, a contemporary of Augustus, a man concerned with connections between the movement of celestial bodies and historical events, claimed that Rome was founded under the sign of Libra. He added that under that same sign, "Caesar was born who now founded the city in a better way" (*qua genitus Caesar melius nunc condidit urbem*).[166]

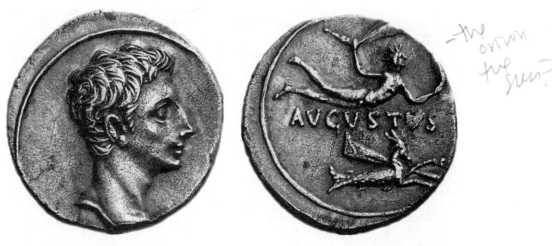

FIGURE 15

Denarius of Augustus, Colonia Patricia (?) ca. 18–17/16 B.C.E., silver. Obv: Head of Augustus. Rev.: Sol with a radiate crown floating, and capricorn with a cornucopia on its back. Reverse legend: *AVGVSTVS*. *RIC* I Augustus 124. Photo credit: Courtesy of Jürgen Malitz and the Numismatische Bilddatenbank Eichstätt.

Phoebus and Pythius thus should receive more attention as markers of the Palatine Apollo's identity than the unusual Apollonian epithets for the god of the temple, such as Actiacus. More broadly, references to Helios/Sol in Augustan art as well as in Octavian's Temple of Apollo in Rome must be connected to Apollo Helios, known also as Apollo Phoebus, the city-founding god. The chariot of the sun that Propertius describes on top of the Temple of Apollo (2.31.11) should be seen as belonging to Apollo Sol, rather than the separate deity Sol. (Ovid interpreted Sol and Luna as Apollo and his sister, Diana [Ov. *Fast.* 3.109–110].) The rationale for including the chariot of Apollo the Sun can then be related to the prophecy of the age of Apollo Helios, which Augustus inaugurated. This new age was celebrated in such monuments as the Ara Pacis Augustae, the Altar of the Augustan Peace, which shows Augustus at the head of a procession that also includes priests, senators, and members of the imperial family, including Livia, striding toward a panel of a fertility goddess with two children and stepping on a acanthus frieze, both symbolizing the era's abundance and peace (fig. 16).[167]

THE SIBYLLINE BOOKS

Prophecy was not simply an element of the temple's decoration, corresponding to one of Apollo's beneficial powers; it was central to the temple's mission. Its centrality is reflected in Augustus's transfer to the Temple of Apollo of the books containing the prophecies of the Sibyl, Apollo's priestess. These books were consulted only in moments of great

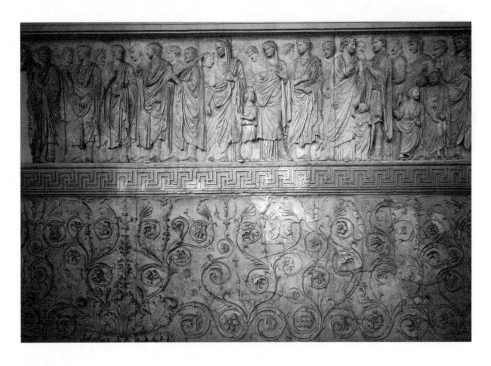

FIGURE 16

Procession and acanthus frieze, Ara Pacis Augustae, 13–9 B.C.E., marble relief, south side, Museum of the Ara Pacis, Rome. Photo Credit: Nimatallah / Art Resource, N.Y.

danger to the state or unusual portents. To interpret them was the task of a special priestly college composed, at its largest, of fifteen men, the *quindecimviri sacris faciundis* (literally, fifteen men to perform sacred actions).[168] An elegy of Tibullus (c. 55–19 B.C.E.) on the occasion of Messallinus's induction into the college speaks of the prophecy of Rome's founding, as uttered by the Sibyl at Apollo's urging and written down on a scroll (Tibullus, 2.5). The poem exhibits distinct similarities with Virgil's rendition of Rome's founding, including the prophecy to Aeneas, and Apollo's role in it. A case has been made that the Virgilian echoes in this poem suggest that the poem was finished after the publication of Virgil's *Aeneid,* and the work should therefore be dated to about 18 or even 17 B.C.E.[169] Tibullus's urging the god to appear as he was at the dawning of the Olympian gods' age makes this suggestion attractive, as it connects the dawning of the new era with Apollo's prophecy, and the celebration of the Secular Games in 17 B.C.E.[170] Significantly, the college of the *quindecimviri* organized the Secular Games, and Messalinus is listed as a participating priest.[171] A date closer to the games is therefore probable. The date is important insofar that it suggests a close connection between the Temple of Apollo, the new age, and the Sibylline books. Tibullus beseeches Apollo to teach the secrets of this text to Messalinus, implying that such a scroll existed, though he does not specify where it was housed. For the most part, however, the books remained locked in the Temple of Capito-

line Jupiter.[172] In 12 B.C.E., the year he became *pontifex maximus,* chief of all the priestly colleges, Augustus transferred the Sibylline books from the Temple of Jupiter to the pedestal of Apollo's statue in the god's Palatine temple (Suet. *Aug.* 31; Verg. *Aen.* 6.72; Serv. on *Aen.* 6.72). But, as early as 17 B.C.E., the *princeps* may have had secured some of those books of prophecies, especially those related to Rome's foundation, for the Temple of Palatine Apollo.

Augustus most likely moved the books to control their content, as he controlled other elements of Rome's religious life. He was a member of both the augurate and the college of fifteen priests responsible for the Sibylline books.[173] Augury and other signs of divination figure prominently in Augustus's actions,[174] and Suetonius reports his faith in prodigies and reliance on *haruspices,* especially before 27 B.C.E. (Suet. *Aug.* 29). Moreover, Augustus was keenly interested in controlling the priesthoods and filling them with his own men. Because of his respect of tradition and magnanimity to Lepidus, the sitting *pontifex maximus,* overseer of all the priestly colleges, Augustus assumed the position only after Lepidus died (*RG* 10.2).[175] The removal of the books in that year was surely related to Augustus's becoming *pontifex maximus.*[176] But religious traditionalism only partly explains Augustus's placing the books of prophecy in the Temple of Apollo.

The removal of the books constituted a radical innovation that must have seemed a threat to the existing order,[177] for Augustus not only transferred the Sibylline books but also purged them (Suet. *Aug.* 31; Tac. *Ann.* 6.12). These acts must have been seen as permissible and indeed necessary only in a specific context. The logic of breaking a venerable tradition must be sought in the inauguration of a new era, which, like the founding of Rome, Apollo foretold and protected. The arrival of the Apollonian era called for removing the faulty and contradictory prophecies still clogging the Sibylline books, which Apollo (through his priests) had every right to correct.

APOLLO DELPHINUS, DIVINATION, CITY FOUNDING, AND THE PALATINE TEMPLE

Prophecy and founding likewise intertwine in the Delphic references of the temple's decoration. Aspects of the temple's iconographic program that evoked Delphian Apollo include the sculptural group from the cella, the terracotta reliefs with the tripod, and the ivory doors with the expulsion of the Celts from Delphi. The Augustan poets noted the similarities between Delphian Apollo and the cult statue of Apollo in the cella of the Palatine temple. There, according to Propertius (fl. 28–16 B.C.E.), "between his mother and his sister the god Pytho (Pythius) himself, wearing a long cloak, plays and sings" (Prop. 2.31.15–16). Clad in a long belted peplos and a mantle, Apollo was shown playing the kithara. Pliny (*HN* 36.25) attributed the work to Scopas (ca. 370–330 B.C.E.).[178] The statuary group references the founding of the sanctuary of Apollo at Delphi. It represented the celebration after Apollo's victory over Python for control of the oracular shrine. The iconography suggests that Apollo Palatinus was a double of Apollo Delphinus.

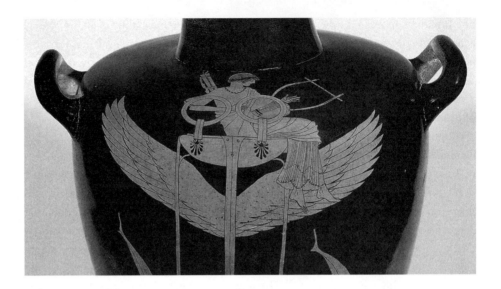

FIGURE 17
Berlin painter, Apollo seated on the Delphi tripod, 500–480 B.C.E., red-figure hydria, 52 cm., Museo Gregoriano Etrusco, Vatican Museums. Photo credit: Scala / Art Resource, N.Y.

At Delphi, Apollo's priestess, the Pythia, delivered the god's oracles while seated on a tripod. A Greek vase showing Apollo seated on a tripod alludes to the oracular ritual as the priestess was only the conductor of Apollo's prophecy (fig. 17). The tripod itself stood for Delphi and was therefore considered an appropriate votive gift for Apollo Delphinus.[179]

The equation of Apollo's tripod and Delphi comes across also in the iconography of the fight between Apollo and Hercules. In images representing the conflict between god and hero for possession of Delphi, the sanctuary is rendered visually as Pythia's seat/tripod.[180] The theme of Apollo's possession of the sanctuary also appears in the terracotta relief in which Apollo struggles over the tripod with Hercules, another contender for the shrine (fig. 14). Like the triumph over Python, the tripod gave its possessor power over the numinous qualities of the site, particularly its relationship to divination. The visual evocations of Delphian Apollo in the Palatine temple thus drew attention to Apollo's gift of prophecy.

The similarities of Apollo Palatinus to Apollo Delphinus, along with the notional correspondence between the Battle of Actium and contention over Delphi, convey Augustus's likeness to Apollo and posit a resemblance between Octavian's enemies and the thieving Hercules or unruly barbarians. The sources noted how like Apollo Augustus was, and report that Augustus even took on the guise of the deity at a banquet.[181] Servius remarked that a statue of Augustus represented him with Apollo's insignia (on *Ec.* 4.10). The semblance between god and protégé deepened when, a few months after the dedication of

FIGURE 18

Denarius of Augustus, Colonia Patricia, 20–19 B.C.E., silver. Obv.: Bare head of Augustus. Rev. Two laurel trees. Reverse legend: *CAESAR AVGVSTVS*. *RIC* I Augustus 268. H/AM, Gift of the daughters of Florence and Mason Hammond, 2003.100.9.7. Imaging Department © President and Fellows of Harvard College.

Apollo's temple, the senate voted to plant a pair of laurels in front of the *princeps*'s house.[182] Laurels, which connoted sacredness, were traditionally planted in sanctuaries, especially those of Apollo.[183] In Octavian's case, the senate bestowed both the trees and the title Augustus, with its implications of sacredness, augury, and founding.[184] Augustus proudly commemorated the two laurel trees on his coinage (fig. 18).[185] In other words, Augustus honored Delphian Apollo, claimed Apollo Sol as his patron god, and in the association gained characteristics attributed to his patron deity.

The choice of Apollo, seemingly unusual in the Roman context, becomes legible once it is remembered that Apollo's prophesies designated founders and determined the location of Greek colonies.[186] Delphian Apollo could identify as founders visitors who consulted him on unrelated matters. Aeneas's city-founding expedition is guided by Delian Apollo's prophecy. Actian Apollo is linked to both the Delphian and the Delian sanctuaries (Prop. 4.6.25–36). Aeneas seeks the god's prophecy through the Sibyl of Cumae (6.42–155). As elsewhere in the *Aeneid*, Virgil sets up Augustus as a new Aeneas, and the promises Aeneas makes to Apollo can be read as acknowledging Augustus's own actions. The Trojan prays to Apollo and then vows him gifts that replicate Augustus's own, including the marble temple that honored Apollo and his sister; "sacred days," most likely a reference to the Actian games; and a dedicated place for the Sibylline books:[187]

> And you, most holy prophetess, who foreknow the future, grant—I ask no realm unpledged by my fate—that the Teucrians may rest in Latium, with the wandering gods and storm-tossed powers of Troy. Then to Phoebus and Trivia will I set up a temple of solid marble, and festal days in Phoebus's name. You also a stately shrine awaits in our realm, for here

I will place your oracles and mystic utterances, told to my people, and ordain chosen men,
O gracious one. (Verg. *Aen.* 6.65–74)[188]

Writing at least a decade after the dedication of the Palatine Temple of Apollo, Virgil
seems to be interpreting Aeneas's prayer through Augustus's accomplishments, particu-
larly the Palatine temple. The passage describes the temple that Aeneas promised
to Apollo as a gift to the god for his help in the founding of New Troy. By analogy,
Augustus's Temple of Apollo was his offering in thanksgiving for the founding of
Rome. Aeneas's promise to deposit the god's prophecies in the temple may be read
proleptically, as a reference to Augustus's as yet unrealized intention to transfer the Sib-
ylline books.

Virgil's emphasis on the role of divination in city founding and on Augustus as a
double of the Trojan prince parallels elements of Apollo's address to Augustus in Prop-
ertius's fourth *Elegy* (ca. 16 B.C.E.).[189] The poet describes the Battle of Actium in the
framework of Rome's founding. He calls Augustus the Trojan Quirinus (4.6.21), cleverly
combining references to Augustus's descent from the Trojan Aeneas and the kings of
Alba Longa and to Romulus, deified as Quirinus. Apollo summons his protégé and
rouses him to fulfill his destiny: "O Savior of the world, who sprang from Alba Longa,
Augustus, proved greater than your Trojan ancestors, . . . now conquer at sea: the land is
already yours: my bow battles for you, and all this load of arrows on my shoulders is
on your side. . . . Free Rome from fear. . . . Unless you defend her, it was an evil hour
that Romulus, seeking omens for his walls, beheld the birds on the Palatine" (Prop.
4.6.37–44).[190]

Apollo thus warns that if Augustus fails to win the Battle of Actium, Romulus's city
will fall. But because Apollo wholeheartedly backs the scion of the Alban kings, Romu-
lus's foundation augury will come to pass. Clearly Propertius implicates Apollo in both
the divination and the victory. In urging Augustus to act, the god frames the conse-
quence of inaction as tantamount to a misreading of Romulus's augury. Had Augustus
failed at Actium, it would have been as if Romulus had failed to comprehend what the
flight of birds was telling him about the site of his future city. Propertius's elegy thus
suggests that the Palatine Temple to Phoebus Apollo was a votive offering for the god's
help in Augustus's refounding of Rome.

APOLLO AND THE POMERIUM

In Roman tradition, any new founding, or refounding, results in an extension of the
pomerium (the line demarcating the augurally constituted city, a religious boundary).[191]
Indeed, the sources relate that Augustus did extend it (Tac. *Ann.* 12.23; Dio Cass. 55.6.6),
but they do not specify when.[192] The principle of pomerial augmentation suggests that
one extension most likely followed Actium and the conquest of Egypt (*RG* 27.1). The
sources note that the *pomerium* was changed only infrequently, and that such a change

extension of boundaries

was contingent on significant military victories that added new territories to the realm (Tac. *Ann.* 12.23; SHA *Aurel.* 21.10–12). Indeed, Tacitus (ca. 56–after 118 C.E.) connects chronologically Claudius's augury of safety with a pomerial extension and conquest (Tac. *Ann.* 12.23). A similar sequence can be read into Augustus's actions, although no markers remain from the Augustan pomerial extensions.

Non-extant sculptures can be considered as referring to an Augustan extension of the pomerium. This includes a statuary group from the Temple of Apollo and Augustus's coinage from about the time of the sanctuary's foundation. Four statues of oxen, said to have been made by Myron, the renowned classical Greek sculptor (Prop. 2.31.7–8), once surrounded the altar at the Palatine Temple of Apollo.[193] Myth associates Apollo with the fertility of the flocks.[194] The four bovines thus relate to the god's potency as an agricultural deity. But in the Roman context, the statues surrounding Apollo evoked also the *pomerium*. According to Tacitus, a bronze statue of a bull marked one corner of the Romulean *pomerium* (Tac. *Ann.* 12.24), which began with the Forum Boarium. The bull, in Tacitus's testimony, referred to the animal's use for ploughing the boundary of the city (*Ann.* 12.24). The oxen at the Temple of Apollo can be connected to other examples of ploughing beasts of burden circa 28 B.C.E. that are likewise associated with Apollo, Augustus, the *pomerium,* and city founding.

Coins in a series of denarii minted in the West and dated to 29–27 B.C.E., depict Apollo, with Octavian on the reverse (fig. 19),[195] shown veiled and tilling the ground with two oxen. The legend reads *IMPERATOR CAESAR*. The long-haired image of Apollo bears Augustus's facial features, suggesting that, in taking on the augural role, Augustus becomes akin to "Augur Apollo" (Hor. *Carm.* 1.2.32).[196] The ploughing links the augural skills to founding, which in the context of the first century B.C.E. should be understood as referring to a pomerial extension.[197] That this extension refers to Rome rather than some other city suggests the missing ethnic in the coin's legend. The ethnic, normally indicating the location of the mint, generalize the founding effort, and allude to the center, Rome. Coins with the same iconography were also minted later (fig. 20).[198] In the later issues, Augustus does not resemble Apollo, but the obverse features a *lituus* and a *simpulum,* the symbols of the augur.[199] Linking Apollo to Augustus, showing ploughing without identifying the city must thus be connected more generally to the princeps' extension of Rome's *pomerium* that signified founding and could be undertaken only after such military victories as the one at Actium, which added Egypt to Rome's *dominium.* Likewise, the coin series of Augustus with just an augural staff displayed along with his head should be interpreted not merely as referring to Augustus's membership in the augural college, but to founding through augury, Apollonian and Romulean style.[200] Cicero (106–43 B.C.E.) remarked that "Romulus, the father of this City, not only founded it in obedience to the auspices, but was himself a most skillful augur" (*De div.* 1.2). Just as the sight of twelve vultures revealed to Romulus his destiny as the founder of Rome, twelve vultures appeared auspiciously when Augustus assumed his first consulship in 43 B.C.E.—an early indication that he was destined to refound Rome.[201]

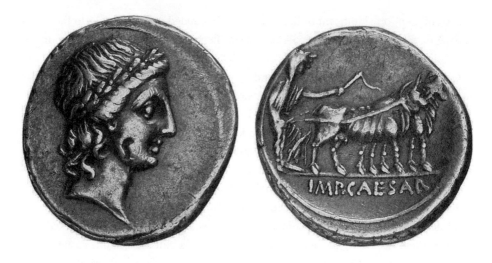

FIGURE 19

Denarius of Augustus 29–27 B.C.E. Obv.: Head of Octavian with the features of Apollo, laureate, ringlets falling down neck. Rev.: Octavian, veiled and laureate, driving a yoke of oxen, holding plough handle in right hand and whip in left hand. *Reverse legend: IMP. CAESAR. BMCRE* 1: no. 638, pl. 15.17. Photo credit: Courtesy of Jürgen Malitz and the Numismatische Bilddatenbank Eichstätt.

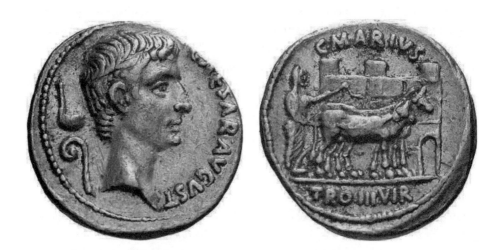

FIGURE 20

Aureus of Augustus, 13 B.C.E., gold. Obv.: Head of Augustus, simpulum and lituus to the left. Rev.: Augustus, veiled and togate, ploughing with two oxen; walls of city and a city gate in the background. Obverse legend: *CAESAR AVGVST.* Reverse legend: *C MARIVS TRO III VIR. BMCRE* 1: no. 109. Photo credit: Courtesy of Jürgen Malitz and the Numismatische Bilddatenbank Eichstätt.

The Palatine temple, then, signified interconnected aspects of Augustus's refounding of Rome. Its decoration referred to divination as the means to comprehend the will of Apollo, the patron of city founders. The myths of Apollo overcoming barbaric or hubristic adversaries can be taken as symbols of Augustus's victory with the god's help. And just as the *princeps*'s contemporaries saw the victor akin to both Aeneas and Romulus, the victory at Actium over Antony and Cleopatra must be compared to the battles fought by the founders to defend their city, as in and of itself a saving/founding act. This victory brought peace to Rome and secured for Egypt's fabulous wealth for the empire. The Palatine temple was a votive gift from Augustus to Apollo, the radiant god of light, a city founder and an augur, for his help in the refounding of Rome and the ushering of a new golden age, which the naval victory at Actium made possible.

Every emperor, Apollo-like, refounded/augmented the realm. The longevity of this idea can be gauged by an important landmark in Rome: the Sol colossus, which Nero commissioned and Hadrian moved next to the Amphitheatrum Flavium, the Colosseum.[202] Insofar as it can be reconstructed from the sources, the statue was regularly updated to show the features of the reigning emperor in the guise of Apollo Sol.[203]

2

THE FOUNDER'S TOMB
AND POSTHUMOUS HONORS

The Mausoleum of Augustus was one of the first and most lasting structures Augustus commissioned to stake his claim as Rome's founder (figs. 21 and 22). This monument made an audacious statement in the discourse of founding, with consequences for Augustus and the emperors who followed him. To its enduring potency as a symbol of a founder testified centuries later Constantine's tomb in Constantinople.

The Mausoleum of Augustus and the *Res Gestae,* the inscription that the princeps composed for display on bronze tablets in front of the tomb (Suet. *Aug.* 101.4), were the two parts of a monument conceived as a whole. Each part belongs to a different phase of Augustus's career. Octavian erected the mausoleum in 28 B.C.E., soon after his defeat of Antony and Cleopatra in 31 B.C.E. He was thirty-five years old at the time. Memories of his oftentimes ruthless suppression of opponents during the preceding decade were still fresh in the minds of contemporaries, and his political future remained uncertain. Even so, Augustus's mausoleum far exceeded any Roman precedent. Though it was smaller than the Egyptian pyramids, in the Greek world only the Mausoleum at Halicarnassus, considered one of the Seven Wonders of the Ancient World (Plin. *HN* 36.4.30), was larger. In 28 B.C.E. Augustus's ambition far outpaced his achievements, and the tomb at that time must have appeared premature at best. Indeed, decades passed before Augustus's stature was commensurate with his mausoleum. The moment, some thirty years later, when he was named a *pater patriae* would have been a more fitting time to construct a tomb of such size.

When Augustus composed his *Res Gestae,* in contrast, he was in full command of the polity, having transformed Roman society and the city of Rome in the previous four

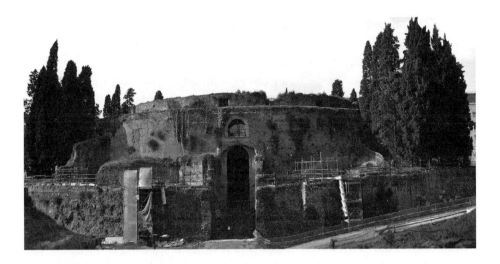

FIGURE 21
Mausoleum of Augustus, first century B.C.E., exterior. Photo: Author.

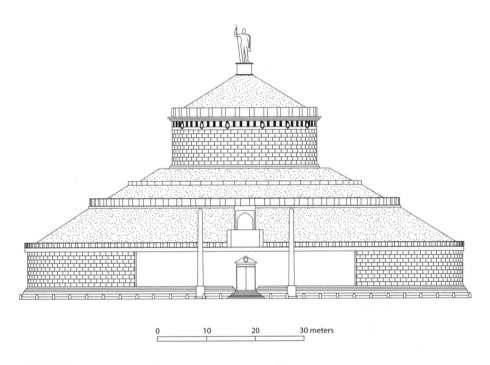

0 10 20 30 meters

FIGURE 22
Mausoleum of Augustus. Reconstruction drawing by Bill Nelson, after H. von Hesberg.

decades. This chapter thus begins by examining the mausoleum in the context of Augustus's other initiatives from 28 B.C.E. and reads the *Res Gestae* as the founder's capstone to his tomb, which also served his individual and dynastic ambitions.

The mausoleum owes its significance to its occupants, its location, its closest parallels, and its larger historical context. No evidence remains of when or how Augustus decided to build his sepulcher. Suetonius (ca. 70–ca. 130 C.E.) reports that he completed it during his sixth consulship (Suet. *Aug.* 100.4). It was used for the first time in 23 B.C.E. for the ashes of Marcellus (42–23 B.C.E.), Augustus's nephew, but work on it continued for some years afterward.[1] The ashes of Octavia, Marcellus's mother, were deposited next, followed by those of Agrippa, Augustus's friend, collaborator, and son-in-law.[2] The mausoleum then received the remains of Livia's son Drusus, Augustus's grandsons and adopted sons, Gaius and Lucius, and, in 14 C.E., those of Augustus himself.[3]

The mausoleum had a circular shape and resembled a mound composed of two stacked cylinders (fig. 22). The bottom drum had a diameter of about eighty-nine meters;[4] its height, approximately forty meters, was second only to that of the Mausoleum at Halicarnassus (fig. 23).[5] A smaller drum, about thirty meters in diameter, surmounted it. Two obelisks stood at the entrance. The area between the two drums was planted with trees (Strabo, 5.3.8). A bronze statue of Augustus stood atop the monument,[6] around which spread a public park with plentiful trees and alleys for leisurely walks (Strabo, 5.3.8) (fig. 22). Strabo refers to the area behind the mausoleum as *alsos,* a grove, a term habitually applied to sacred groves of the gods, with or without a temple.[7] The sacred connotations of the grove around the mausoleum are taken for granted by Dio Cassius (ca. 164–after 229 C.E.), who labels the monument a *hērōon,* a burial place for a divinized mortal, or *Augusteion,* a term that likewise suggests cult (56, 33.2, 63.26.5).[8] According to Strabo (ca. 64–after 21 B.C.E.), the location Octavian chose for his mausoleum, on the Campus Martius near the Tiber, was the holiest area in the city (5.3.8).[9] After 28 B.C.E., this Field of Mars received other important monuments of the Augustan age, such as the Ara Pacis Augustae, erected by senatorial decree, and the Horologium Augusti, a gigantic sundial whose gnomon was an Egyptian obelisk from Heliopolis (map 2).[10]

Like the *Res Gestae* it displayed, the mausoleum has stimulated a wide-ranging scholarly debate about its purpose and significance. Most researchers use dynastic and monarchical terms to explain Augustus's motives in building such a self-aggrandizing monument.[11] The arguments they present in support of their interpretations are based on the monument's extraordinary dimensions, the occupants of the tomb, the time when it was erected, and its architectural precedents, especially the mausoleum at Halicarnassus and the tomb of Alexander the Great (356–23 B.C.E.; r. 336–23 B.C.E.) in Alexandria. In early twentieth-century scholarship the three years between Actium and 27 B.C.E. (when Octavian became Augustus) were considered the Era of Romulus. Historians thought that Octavian behaved in that period as an absolute monarch,[12] and they considered the tomb the grandest proof of Augustus's monarchical aspirations. From that perspective, in erecting it, Augustus followed the example of "oriental satraps and pharaohs."[13] Both the

eastern and the dynastic dimensions of the mausoleum have emerged in other studies. One suggests that the term *mausoleum* for Augustus's tomb was borrowed from the Mausoleum of Halicarnassus.[14] According to the author of that study, the word was not used in Rome prior to 28 B.C.E. He suggests that Augustus probably settled on it thanks to advice from L. Munatius Plancus (praetor, 47 B.C.E.; censor, 22 B.C.E.), who had spent some time in the East and had advised Octavian to take the name Augustus rather than Romulus (Suet. *Aug.* 7.2; Vell. Pat. *Hist.* 2.91.1–2).[15] Other scholars advance the view that Alexander's tomb in Alexandria had inspired Augustus, a hypothesis made attractive by Augustus's keen interest in Alexander. While he was in Alexandria, Octavian had had the conqueror's tomb opened to inspect his remains (Suet. *Aug.* 18).[16]

Not everyone accepts the eastern and dynastic interpretations of the mausoleum. The imprecise date of the monument means that Augustus could have planned the tomb before Actium. That possibility has prompted an interpretation that relates the tomb's significance to the rivalry between Octavian and Mark Antony, according to which the mausoleum was Octavian's answer to Mark Antony's desire, stated in his will, to be buried in faraway Alexandria, beside Cleopatra, the Egyptian queen.[17] Antony's expressed desire, to contemporary observers, seemed tantamount to abandoning Rome, and perhaps transferring the center of the empire to the Nile.[18] Predictably, it stirred anti-Antony sentiments, which had been Augustus's intention and his primary reason for leaking the contents of the will to the Roman Senate. The mausoleum could be interpreted, then, as a calculated response to Antony's testament, a patriotic rather than an absolutist and a dynastic emblem.[19]

All these analyses have drawbacks, already noted in the literature.[20] That neither Marcellus nor Agrippa belonged to Augustus's family, the Iulii, undermines the idea of a dynastic tomb, if dynasty is conceived of narrowly as coextensive with a particular family. Moreover, despite the connection through nomenclature, the association of Augustus's mausoleum with the Mausoleum at Halicarnassus is made doubtful by their different shapes, the Mausoleum at Halicarnassus having been a square monument (fig. 23). Alexander's tomb may have inspired Augustus, but the Alexandrian tomb has not been found.[21] It is possible that it was a rotunda. Renditions of Alexandria's cityscape found on a floor mosaic and oil lamps prominently depict a round building as one the city's landmarks (fig. 24). This building has been interpreted as Alexander's tomb.[22] The idea of a rotunda comes across in Lucan's poetry. The first-century Roman poet refers to Alexander's sepulcher as a tumulus and a cave (10.19). For these reasons and for typological connections to Hellenistic round buildings, scholars have argued for links between the mausoleum and Hellenistic architecture, which had been used to serve Roman funerary rituals of circumambulation and sacrificial libations, first to the genius of the living emperor, and then to the Divus Augustus.[23] To these observations connecting the mausoleum to Hellenistic precedents can be added one more: Hellenistic monarchs fashioned their public image in the idiom of city founding, which included founders' tombs, and dynasty. The two tombs most frequently referred to in relation to Augustus's

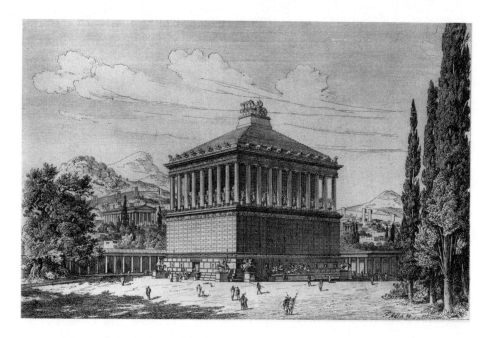

FIGURE 23

Mausoleum of Halicarnassus, 353 B.C.E., reconstruction after Adler. Photo credit: Foto Marburg / Art Resource, N.Y.

mausoleum—the Mausoleum at Halicarnassus and Alexander's tomb—illustrate the connection and thereby help define the conceptual framework for Augustus's tomb.

In the Greek world, the Mausoleum at Halicarnassus may have been one of the earliest attempts to link a dynasty, a city, and a tomb (fig. 23). It is thought to commemorate Mausolus (r. 377/376–353/352 B.C.E.), a non-Greek but Hellenized dynast from Caria, though it remains unclear whether he was actually buried there and who built the monument.[24] This square building (forty meters by forty meters at its base) was located in a sizable sacred precinct, or *temenos,* in the city.[25] It was topped by a chariot. A different well-known Greek sculptor decorated each side of the monument. The surviving fragments of colossal freestanding statues indicate that the represented figures included gods, such as Apollo, and male and female figures wearing contemporary Persian sleeved upper garments (fig. 25).[26] Archeologists have interpreted the decorative program, particularly the mixing of divinities and humans, as a visual history of the Carian dynasty, which supposedly originated from Apollo Helios, Apollo syncretized to the Sun God. The reliefs "bridged history and myth," thereby helping legitimate a dynasty.[27]

The central location, the sacred precinct around it, and the remains of sacrificial animals on the side have led to the conclusion that the tomb imitated earlier Greek practices, according to which the founders of colonies alone were permitted burial in the city, near the agora.[28] Founders, historical or mythical, could be worshiped and given honors such

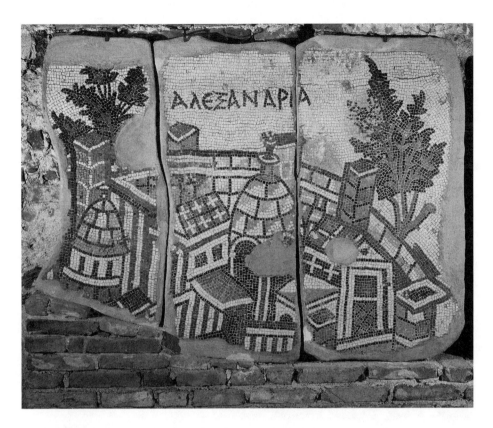

FIGURE 24

The city of Alexandria in Egypt, cityscape showing a rotunda (Alexander's tomb?) in the center, detail from a sixth-century floor mosaic, Church of St. John, Gerasa, Archeological Museum, Jordan. Photo credit: Erich Lessing / Art Resource, N.Y.

as athletic contests dedicated to them.[29] Mausolus was credited with founding Halicarnassus by *synoikism*, the bringing together of several communities into one city.[30] Such was the testimony of Strabo, Augustus's contemporary, who referred to an earlier Greek source. Some modern scholars disagree with Strabo's assessment. Principal investigators of the Halicarnassus monument, however, believe that it celebrated Mausolus as the divinized *oikistēs*, or founder, of Halicarnassus, that, indeed, the tomb was a *hērōon*, a place to worship a hero.[31] The cultic dimension of this monument has proved the hardest to defend, for no textual evidence—no inscriptions or special decree—exists to support it.[32] Because textual evidence does not always survive, privileging texts as the only proof of divine honors could mean neglecting important clues about the intent of the structure's builder.

The Mausoleum at Halicarnassus offers some signs of its inhabitant's status. For centuries, the tomb was recognized as one of the most extraordinary buildings in the ancient world. It resembled an Egyptian pyramid, a vessel for the remains of a god, and

FIGURE 25

Statues from the Mausoleum at Halicarnassus, ca. 350, marble. Female figure: "Artemisia"/queen? 237 cm., acc. no. 1857,1220.233. Male figure: "Mausolus," 300 cm., acc. no. 1857,1220.232. British Museum, London. Photo: Author.

like a pyramid, it was named after the individual it contained.[33] Like a temple, it had a *temenos*, surrounding it. The decoration of the tomb linked the family of this individual to the gods. The chariot at the summit of the monument suggested that the driver, presumably Mausolus, was either close to heaven or ascending to it. No textual evidence exists for a cult of Mausolus, and the sacrificial remains on the site come from one massive slaughter rather than sacrifices made in the course of many years, yet the monument

itself suggests the honoring of the entombed like a divine being, a god proper, or a hero, a mortal deified for his accomplishments.[34] Even if a cult to Mausolus is dismissed, it could be argued that the Mausoleum at Halicarnassus was planned as a sacred building and celebrated not only Mausolus but also his ancestors, underscoring the family's divine origins. In the time of Augustus, we know, some observers considered it a city founder's tomb, and it was famous as one of the Seven Wonders of the World.[35]

Calling Octavian's sepulcher a "mausoleum" testifies to the name's symbolic capital, which outweighed negative connotations, such as Mausolus's royalty. The name gestures to the complexity of Rome's relationship to Hellenistic culture and royal practices.[36] In the late republic, educated Romans were fluent in Greek literary and artistic traditions.[37] They were likewise familiar with Hellenistic political thought, which fueled a conversation about deifying deserving mortals.[38] The writings of late-republican intellectuals such as Cicero demonstrate the diffusion of that idea.[39] Occasionally Roman envoys and magistrates would receive cultic honors in the East.[40] During the late republic, rival generals introduced some Hellenistic honors, as in the case of the coins and honors for Mark Antony's wives (Fulvia and Octavia), and Octavian's sister and wife (the same Octavia and Livia).[41]

Like Roman generals before him, Octavian observed the system of Hellenistic honorifics during his campaigns and travels and was influenced by it.[42] He vacillated between rejecting and adopting Hellenistic practices. In the years preceding and following Actium, Octavian fashioned himself as somewhat of an opposite to Mark Antony, the chief adopter of Hellenistic traditions.[43] An enduring consequence of his distancing himself and his rule from Hellenistic royal models was the scarcity of coins minted in Livia's name, though her idealized profile did appear on Roman coins.[44]

Nevertheless, while rejecting elements of Hellenistic culture, Augustus took others for granted. In selectively adapting Hellenistic ideas, he was like other public figures.[45] The Palatine Temple of Apollo evinces his preference for the Greek god of city founders, and the mausoleum exemplifies the adoption and adaptation of Hellenistic ideas and symbols.

The Roman sources speak of tombs for Romulus and Aeneas,[46] and Livy reports that Aeneas's sepulcher was by a river.[47] But neither of their tombs was called a mausoleum. Although we do not know what information Augustus had about the Mausoleum of Halicarnassus prior to building his own grandiose tomb, he must have had reasons to name his own tomb a mausoleum, and they can be gleaned from a consideration of the other tomb Augustus's mausoleum is said to have emulated: Alexander's sepulcher. We know that Alexander's tomb exhibited indisputable affinities to the Mausoleum at Halicarnassus, in that it was used for dynastic and etiological narratives. It also served as the bridge between the city-founding god Alexander and the Ptolemaic dynasty. The first royal cults were connected to tombs.[48] By the time of Augustus, three hundred years after Alexander's death, the tombs of heroized founders of cities, including Alexander's—as well as assimilations and other links between royals and divinities—had for centuries

functioned as statements that legitimated authority.[49] Augustus and his contemporaries were no doubt well versed in these ideas. On Roman soil, a tradition of honoring new Roman founders as fathers, saviors, akin to the first founder, tightly connects saving, founding/renewing, and fathering to divinity. That Rome's founder was the paradigm for these connections is evident in the writings concerning the Romulus's deification.[50] Thus Augustus's precocious haste to build a magnificent tomb ringed by a sacred grove must be considered in light of the ideas that animated a Mediterranean discourse of city founders.

The Mausoleum of Augustus, without slavish copying of any precedent (though it displayed commonalities with significant cultural symbols and practices), signified that Augustus was a founder of Rome. It was a new monument animated by a venerable tradition. When Augustus built his tomb, he could base his claim to such an edifice only on success in ending the civil wars. He had yet to relinquish his powers to the Roman Senate. With the mausoleum he projected an image of certainty that with hindsight looks both arrogant and prophetic.[51] The name, the round shape, and the enormous size recall features of the Mausoleum of Halicarnassus, round Hellenistic temples, and the tumuli of Homeric heroes.[52] The family and members of the extended family buried inside bring it closer to descriptions of the Ptolemaic sepulchers surrounding Alexander's tomb. By the time of Tiberius's death, the mausoleum contained the urns of Marcellus, Agrippa, Drusus the Elder, Lucius Caesar, Gaius Caesar, Augustus, Germanicus, and Livia.[53] Annual sacrifices before the mausoleum were offered for the deceased,[54] and the grove behind it had numerous associations with sacredness.

The obelisks, symbolic representations of sun rays (Plin. *HN* 36.14), marked the edifice as related if not explicitly dedicated to the rising and eternal sun. Augustan parallels to these smaller examples are found at the Horologium Augusti and the Circus Maximus. Augustus dedicated the obelisk at the Horologium to Sol.[55] The Augustan obelisk at the Circus Maximus (Plin. *HN* 36.14.71, 36.15. 72–73) also had solar connections in that, according to Tertullian (c. 160–c. 225), the entire hippodrome was dedicated to the sun.[56] In the case of the Mausoleum of Augustus, symbols of the rising sun were deployed to suggest eternal life. It was an Egyptian custom to place obelisks in front of temples, but Pliny reports of two temples in Alexandria to defied non-Egyptians which had obelisks associated with them. One was the Arisonoeum, the temple of the deified Arsinoë, the other the Caesareum, the temple of the deified Julius Caesar (Plin. *HN* 36.68–69).[57] Just as the statue of Mausolus atop his mausoleum visually suggested his ascent to the gods, the statue of Augustus at the pinnacle of his tomb, soaring to an impressive height and probably colossal, presented Octavian as above ordinary mortals, a godlike hero who would join the gods after his death, and would become immortal like the eternal sun.[58] Denarii of Octavian minted between 29 B.C.E. and 27 B.C.E. may show the statue type that stood atop of the mausoleum. The statue had a rostral column for a pedestal. It represented a nude hero, holding a lance, and standing on a pedestal studded with ships' prows, or rostra, suggestive of a naval victory (fig. 26).[59] After Augustus's

FIGURE 26

Denarius of Augustus, 29–27 B.C.E., silver. Obv.: Head of Octavian, laureate. Rev.: Statue of Octavian in the nude, except for cloak, holding spear in right hand and parazonium (a type of dagger) in left hand, standing on a rostral column, ornamented at sides with prows of ships and in front with two anchors. Reverse legend: *IMP CAESAR*. *BMCRE* I: no. 633, pl. 15.15. Photo credit: Courtesy of Jürgen Malitz and the Numismatische Bilddatenbank Eichstätt.

deification, this statue was updated with a solar crown,[60] and such updating no doubt occurred with the statue on the mausoleum. With the mausoleum, Augustus seems to have initiated and invited a particular kind of honoring, related to his meritorious accomplishment, and suggestive of divinity and eternity. The round shape of the mausoleum and the two obelisks in front of it marked the edifice as sacred to Sol and anticipated Augustus's apotheosis decades later. When the solar crown was at last positioned on the head of the statue crowning the mausoleum, Augustus had truly risen as an equal to the immortal Sun, the first Divus Augustus in the Roman pantheon.

In a sense, like the Forum of Augustus, built decades later, the mausoleum intertwined Augustus's lineage and merit. But the perspective on time differs in the two monuments. Whereas in the Forum he looked backward to a line of illustrious predecessors whom he had bested, with the mausoleum Octavian looked forward as the unsurpassed new founder of Rome onto a new generation of founders of whom he was the first.

A FINAL REWARD FOR THE NEW FOUNDER: THE *RES GESTAE*

Many of the undertakings and honors of Augustus's long life fold into the rubric of founding. In the early years of his reign, nothing communicated his status as founder more forcefully than his mausoleum. Its two parts, the building itself and the *Res Gestae*,

can be interpreted as the alpha and the omega of Augustus's career as a new and superior founder of Rome. The mausoleum stands as one of the first statements of his ambition; among the last was the *Res Gestae,* the Achievements of Augustus, the text he ordered displayed on the mausoleum after his death.[61] The monuments and honors between unify the perspective the pair provides on the elemental and indispensable notion of Augustus as both a new city founder and a founder of a new line of founders, the Augustan race.

No source reveals better than the *Res Gestae* (hereafter *RG*) how Augustus understood his life's achievements and his legacy. By his own account, the princeps wrote this document just a year before he died, requesting that it be inscribed in bronze.[62] The senate fulfilled the request, and the document in the end was displayed not only on Augustus's mausoleum in Rome but in many other places, though it has best withstood the passage of time on the Temple of Roma and Augustus in Ankara (Ancyra).[63] The *RG* exists in a Latin version and a Greek translation, which had been redacted to tone down the imperialism of the Latin original. The document has no exact literary precedents.[64] Its brevity—it consists of only thirty-five paragraphs—and dry descriptive style suggest distance and impartiality.

The text has allowed interpreters to see in it quite dissimilar things. Some have taken it as an emblem of Augustus's traditionalism and good republican values in matters of government, religion, and public service. Others have interpreted it as a programmatic explanation of the workings of the new regime, a manual for Tiberius, Augustus's adopted son and successor.[65] Many analyses have stressed the traditional aspects of the princeps's actions and achievements.[66] A much older view considers the *RG* Augustus's bid for deification.[67] A revival of that older idea has judged "Augustus' *Res Gestae* the Roman counterpart to Euhemerus," whose work (active early third century B.C.E.) rationalized deification as a reward for conquest and benefaction.[68] Euhemerus's writings, translated by Ennius, was known in Augustus's time. Previous arguments for seeing the text of the *Res Gestae* as an argument for apotheosis dwell more on literary precedents than on the document itself; that is, its intended location, the time of its release, the medium on which it was inscribed, or, finally, its targeted audience. But Augustus arranged the account of his achievements for a specific audience, bringing the text to a climactic point to achieve a singular objective.

The Roman Senate was the audience Augustus targeted in the *Res Gestae.*[69] From the time and place it was read first (Suet. *Aug.* 101), to the material of the first copy and its content, the document addresses laws and lawmakers. The princeps intended that the *RG* be read posthumously, along with his will, at a meeting of the Roman Senate. That being the case, it is safe to assume that the hoped for response had to do with the timing, Augustus's instructions, and the text's content. Even though other individuals had already been interred in the mausoleum, he chose it as the place of publication, insisting on bronze tablets for the text, bronze being an esteemed material of great antiquity, its value greater than that of silver and gold (Plin. *HN* 34.1). Indeed, in Pliny's

examples, bronze seems embedded in critical dimensions of Rome's institutions and magistracies: soldier's pay (*aera militum*), tribunes of the treasury (*tribuni aerarii*), the public treasury (*aerarium*), and Numa's third collegium, the organization of bronze workers (*collegium aerarium fabrum*).[70] Bronze was also the material used for the publication of law decrees. It conveyed authority, eternity, and sacredness.[71] Bronze, in other words, imparted venerability to the text of the *Res Gestae*, thanks to its relationship to Rome's governance, use in the publication of law decrees, and perceived sacredness.

All of those associations are connected to the audience for the *RG*, its content, and its objective. The structure of the work is revealing. The text, as preserved in the copy from Ankara, starts with a brief description (*RG* 1). The first cluster of deeds encompasses Augustus's service to the state and the positions to which the senate appointed him (*RG* 1–8). The princeps's honors from the senate follow (*RG* 9–14). Next, Octavian recounts accomplishments that relate broadly to his largesse (*RG* 15–24): his personal monetary gifts to the Roman plebs, soldiers, and the treasury (*RG* 15–18); and presents to the city of Rome and the state in the form of buildings and games (*RG* 19–24). The deeds left for last include Augustus's campaigns against pirates, his expansion of the state's boundaries, his founding of colonies, his recovery of lost military standards, and the peace and honor his diplomacy achieved for Rome (*RG* 25–33). The penultimate paragraph underscores the title Augustus, and the honors the princeps received during his sixth and seventh consulships (*RG* 34). And the final paragraph describes the title *pater patriae*, father of the fatherland, which the senate bestowed on him during his thirteenth consulship (*RG* 35).

There are a number of ways to group these accomplishments. This chapter organizes them in three thematic units. The first defines Augustus's role in the state with respect to his faithfulness to its institutions and traditions. The second enumerates the deeds Augustus undertook on his own initiative. The third recounts his most important honors. Paragraphs 2 to 14 list accomplishments of the first type in the context of Augustus's membership in the Roman Senate, including his thirteen consulships, the thirty-seven times his received tribunician powers, the twenty-one times he was *imperator*, and his refusal of dictatorship and other extreme powers (*RG* 4–6). His priesthoods also fall into this group, his role as a *princeps senatus, pontifex maximus, augur*, various other priestly offices (*RG* 7), as well as his work as a censor (*RG* 8). According to the implicit logic of the document, Augustus's service deserves and receives corresponding senatorial honors: five-year prayers for his health, sacrosanctity in perpetuity, altars, closure of the Temple of Janus, and honors for his adoptive sons, Gaius and Lucius Caesar (*RG* 9–14). In these paragraphs of the text, Augustus emphasized his great efforts to abide by Roman tradition and law, even when his fellow senators contravened them. His rejection of extraordinary prerogatives underscores his integrity and the constitutional nature of his powers. In effect, however, Augustus's senatorial prerogatives are unmatched. The magistracies Augustus held—their number, variety, and duration—had no precedent. Similarly, no equivalent existed to the many sacrifices, prayers, and altars vowed in his honor.

The refusal of the most extravagant senatorial honors cast the others as traditional, even though Augustus revised the roll call of the senate three times, undoubtedly affecting thereby the outcomes of that body's deliberations.[72]

By touting Augustus's faithfulness to tradition and the senatorial dispensation that gave him his authority, the first section of the *Res Gestae* set the stage for the accomplishments detailed in the second part. The second section omits any explicit mention of senatorial approval, and Augustus seems to have undertaken the deeds recounted there mostly on his own initiative. Indeed, in the *RG*, references to the Roman Senate exhibit a telling consistency, unnoted by modern scholars, that divides the document into two main parts and a grand finale. In the first fourteen paragraphs of the text, Augustus mentions the senate eighteen times. Paragraphs 15 to 33 mention it only twice. Clearly Augustus chose the accomplishments of the second section to illustrate something other than his dedication to the commonwealth and its tradition, the *mos maiorum*. The accomplishments named include services to the state, broadly defined, with a distinct emphasis on Augustus's largesse to various social groups. He identifies several areas in which he had improved the lives of citizens. His monetary donations went to individuals and the state. The gifts of new buildings and the restoration of old ones improved the urban fabric. His provision of lavish entertainments enhanced Roman citizens' quality of life. Augustus's care for the old and for new colonies benefited the army. Recovering lost standards and engaging in clever diplomacy boosted the reputation of the state. Purging the sea of pirates and protecting the boundaries increased the state's security. Extending the boundaries of the state through conquest is an essential aspect of renewing the *res publica*, the new territories evincing the claim and right to be considered a founder in the new generation. All of these accomplishments in peacetime and times of war, presented as originating in Augustus's initiative, can be seen as coextensive with his *auctoritas*, the authority received in exchange for augmenting the state's well-being. In other words, military accomplishments or benefactions belong to a larger category. Tellingly, Augustus's augmentations conclude with the two titles Octavian received from the senate, both of which relate to founding and to the first founder. The two main parts of the *RG* can thus be read as explanations of the document's conclusion.

The title Augustus belongs to the earlier part of Octavian's reign (27 B.C.E.), but a senatorial decree made him *pater patriae* a quarter century later, in 2 B.C.E.[73] He held both titles for sixteen years. Even though the sources mention that the title Augustus, conferred to celebrate Octavian as a new founder of the city, was an alternative to the name Romulus, and despite the intimate relation of that honor to augury and sacredness, Romulus is not mentioned in the *RG*. His legacy registers nonetheless in the appellations Augustus and *pater patriae*, separated by twenty-five years.[74] Like Livy's assessment of Romulus's deeds, the *RG* accounts for both Augustus's acts of war and his acts in peacetime. Evidently, the combination, not just victories in war, mattered to Augustus. Similarly significant (though it remains unstated) is that Augustus was better than Romulus in that he was not king. Indeed, he relinquished power over all things (*potens rerum*

FIGURE 27

Denarius of Augustus, Colonia Patricia, 19 B.C.E., silver. Obv.: Head of Augustus. Rev.: Oak wreath with legend on three lines. Obverse legend: *CAESAR AVGVSTVS*. Reverse legend: *OB CIVIS SERVATOS*. *RIC* I Augustus 77a. H/AM, Arthur M. Sackler Museum, Unspecified Collection, 1979.429.52. Imaging Department © President and Fellows of Harvard College.

omnium, and *potestas*) to possess only *auctoritas* (authority) (*RG* 34).[75] And in the very moment when he did so, he received the title Augustus, an alternative to Romulus. By becoming Augustus rather than Romulus he signaled his difference from Rome's first king, making his choice of the title Augustus a symbolic rejection of monarchy, and committing himself to restoring the republican form of government.

It is no surprise that the senate hailed that commitment to restitution as an act of saving the state. In addition to bestowing on Octavian the honor of the title Augustus, the senate mandated that the steps to the door of his house be decorated with laurels, that a *corona civica* (an oak wreath) be suspended above his door, and that a *clipeus virtutis* (a shield inscribed with Augustus's virtues) be displayed in the Curia Iulia (the Senate House).[76] The senatorial gifts of the *corona civica* and the laurels appeared soon after on Augustus's coinage (figs. 27 and 18). The twin laurels, represented side by side, usually stood in front of a temple. Those given to Augustus by the senate imparted their sacredness to his house,[77] suggesting that the inhabitant deserved reverence like that given to a god—that is, that Augustus was godlike. The oak wreath likewise related to a deity, because the oak tree was Jupiter's signature plant. A characteristic coin shows the wreath with the legend *OB CIVIS SERVATOS* (literally, for the citizens having been saved) (fig. 27). Other versions of the same coin feature the legend *SPQR* (Senatus Populusque Romanus; [by decree of] the Senate and the People of Rome);[78] the legend suggests that the oak wreath designates a savior, whereas the SPQR implied the restored mandate of the senate. Another coin from about 18 B.C.E. frames the saving as a founding by referring to

Augustus as the "parent savior" (*parens conservator*) of the Roman Senate and the Roman people.[79]

Like the title Augustus, the term *parens conservator*, and the related *pater patriae* evoke founding. The late-republican notion of "parent savior" of the land implied beliefs that restoring the state to its old customs after a period of turmoil was tantamount to refounding it, and that any individual responsible for such a renewal should be identified with Romulus.[80] As I have already observed, *pater patriae* and *parens patriae* suggested how saving, founding, and sacredness were intertwined. Before Augustus, the terms had been used for Romulus and for some republican magistrates, including Augustus's adoptive father, Julius Caesar.[81] Like the title Augustus, *pater* and *parens patriae* communicated sacred stature like that of Romulus, by means of ideas associated with fatherhood: protecting and founding. At the same time, the dual connection, to Romulus and Caesar, suggested Augustus's posthumous prospects. Both exemplars were gods in the Roman pantheon. The literature on the deification of Romulus emphasizes his merit.[82] He was the first Roman to become a god for his extraordinary achievements. Julius Caesar likewise achieved immortality posthumously, becoming *divus*.[83] Even Cicero, the staunchest defender of republican tradition, in the passage where he contemplated his own deification, compared himself to Romulus (*In Catilinam* 3.2).

Unlike the first founder, however, later imitators shied away from Romulus's royal prerogatives. Scipio (185/184–129 B.C.E.) makes this clear when reasoning that calling Romulus guardian, god, or father was preferable to calling him king, master, or lord.[84] At the same time, other Romans had claimed the titles Romulus, father, and founder. Antimonarchical sentiments, on the one hand, and existing precedents such as Marius being called "third founder," on the other, explain why Augustus avoided explicit references to Romulus or even such words as *conditor* (founder).[85] The name or title Romulus would have alluded dangerously to royalty, whereas *conditor* was already used for others and therefore stressed sameness rather than the difference. That Octavian coveted the title Augustus, by contrast, conveys that outstanding difference much better than the "Fourth founder," which would have described his place in the roster of founders.[86] The *RG* neglected Romulus intentionally. Unlike Romulus, who was king, Augustus relinquished his *potestas*, and thereby surpassed even the first founder by rejecting the monarchy, and with it the notion that one man could lord over Roman citizens. Augustus's intentions, however, were not lost on his contemporaries. One friendly contemporary historian called him *conditor* and *conservator* (savior) (Vell. Pat. *Hist.* 2.60.1); another (Manilius, *Astronomica* 4.774) asserted that Augustus had "founded the city" (*condidit urbem*) "in a better way."[87]

In the Roman Republic the idea of a savior/founder existed without the monarchy, though divinity was not confirmed for these later founders. Julius Caesar's recognition as *divus* supplied the needed precedent by normalizing posthumous divinity for Rome's *parentes*. Consequently, for Romans of the Augustan age, posthumous divinity, the highest reward for founders/fathers, was stripped of its monarchical connotations (Romulean

and Hellenistic).[88] This idea of divinity without the monarchy appears in the works of contemporary writers. Horace argued that Augustus was a god on earth because he added Britain and Persia to the "weight of the empire."[89] Nicolaus of Damascus (64–after 4 B.C.E.) concurred, noting that Augustus's divine honors had compensated him "for the magnitude of his virtue and his benefactions."[90]

In the context of the *RG*, which is exclusively concerned with deeds and rewards, deification for merit acquires fresh significance. The entire document justifies Augustus as founder. The progression from constitutional deeds and rewards to extraordinary personal initiatives to, finally, highest rewards given only to founders gestures toward the moment after Augustus's death when the senate was meant to read the *RG*. As Augustus had rightly surmised, that was the moment the senate would consider his worthiness to become a god.

Reporting on that moment much later, Dio Cassius's (ca. 164–after 229) account seems to complete the *Res Gestae* by adding the logical (unwritten) conclusion. The historian suggests that service to the commonwealth has earned Augustus divine honors. Dio Cassius's explanation comes from the funeral oration for Octavian delivered by his adopted son Tiberius. Shortly after the beginning of his speech, Tiberius stated that Augustus had surpassed two great role models—Alexander of Macedon and Romulus.[91] Before his death Augustus had famously remarked that he had found a city made of clay and left one made of stone, a reference, as Dio alleged, not to buildings, but to the strength of the empire (56.30.3–4). Echoing the *Res Gestae*, Dio made clear how Augustus accomplished that feat: the princeps saved the commonwealth from war and spared the lives of most of his opponents (56.38.1, 56.40.7). He took it upon himself to guard and preserve the provinces (56.40.2); he used his wealth to repair public works and to build new ones (56.40.4–5); he especially cared for the Roman people by providing entertainment, nourishment, amnesty, and safety from evildoers and natural disasters (56.41.4). Augustus demonstrated the value he placed on families by giving financial rewards to married couples who had children and to veterans (56.41.6–7). "It was for all this," Tiberius concluded, "that you made him your leader, and father of the people [*patera dēmosion*], honored him with many marks of esteem, . . . and that you [the senators] finally made him a demigod [*hērōa*] and declared him immortal [*athanaton*]." He ended by insisting that Augustus's spirit should be glorified forever as that of a god (*theou*).[92]

Given the evidence at hand, Augustus's lifetime accomplishments, as compiled in the *RG* by Augustus, were presented to the Roman Senate as testimony for a final well-deserved posthumous reward. The prize that Augustus had in mind rewarded him for the extraordinary services he delivered to the state. It is linked to the function of the mausoleum, and to the material on which the *RG* was inscribed. It is also connected to existing notions about Augustus's sacredness, to ideas about acquiring divinity for merit, and to the titles Augustus and *pater patriae*. This reward was most certainly deification.

By definition, deification awarded for meritorious actions excludes the family. From the beginning of his rule, however, Octavian sought legitimacy, if not divinity, in part through his lineage. Early in his career, he forged his political legitimacy partly by means of his relation with Julius Caesar, his adoptive father and a state god.[93] He styled himself *divi filius*, son of the deified (that is, son of Julius Caesar), and *Imperator Caesar*,[94] the latter not a traditional name but one that, in combining a magistracy and a family name, hints at an inheritance of both lineage and prerogatives. The intertwining of lineage and other elements was similarly underscored in the Forum of Augustus. Nurturing the notion of a family of founders, with himself as its most illustrious member, Augustus paved the way for the acceptance of a different rationale for divine honors—the idea of divinity as a family trait.

In the Augustan age, with Augustus's encouragement, divinity became acceptable as a characteristic transferable from one generation to the next.[95] The *Aeneid* was one of the first textual sources to speak of divinity as a characteristic of Augustus's family. Anchises, Aeneas's father, uttered the oracle that Caesar and all descendants of "the house of the Iulii" will become gods, and Augustus, the scion of this divine race, will found (*condet*) the golden age (*aurea saecula*).[96] The idea of a divine race complicates the notion that one wins divine honors by merit; parentage mattered, too.[97] All the instances when Augustus advertised his divine parentage must be seen then as lending legitimacy to a future cult (see fig. 10). Virgil was not alone in styling divinity hereditary. We find the same concept in Ovid, in book 15 of the *Metamorphoses*, where Ovid states that Caesar is god, but that his true achievement was that he had fathered Augustus:

> For there is no work among all Caesar's achievements greater than this, that he became the father of this our Emperor. Is it indeed a greater thing to have subdued the sea-girt Britons, to have led his victorious fleet up the seven-mouthed stream of the papyrus-bearing Nile, to have added the rebellious Numidians, Libyan Juba, and Pontus, swelling with threats of the mighty name of Mithridates, to the sway of the people of Quirinus, to have celebrated some triumphs and to have earned many more—than to have begotten so great a man? With him as ruler of the world, you have indeed, O heavenly ones, showered rich blessings upon the human race! So then, that his son might not be born of mortal seed, Caesar must needs be made a god. (*Met.* 15.750–61)[98]

Augustus had to have a divine father; personal worthiness, though important, seemed a less necessary condition. The notion of divine ancestry opened the door to a rationale for deification that broadly embraced the family, its male and its female members. That a god, or a man who hoped to be a god one day, needed a divine family had implications for conceptualizing parentage and gender in the imperium.

The princeps's adoption of his grandsons and Tiberius conferred no constitutional authority on them.[99] But the adoption did open the doors to unusual honors. Consider

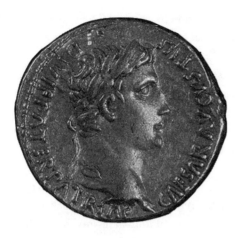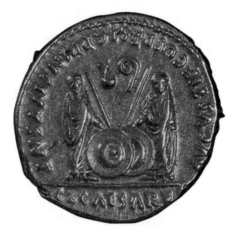

FIGURE 28

Aureus of Augustus, Lugdunum (Lyons), 7–6 B.C.E., gold. Obv.: Laureate head of Augustus to r. Rev.: Gaius and Lucius Caesar, togate, veiled, standing facing on l. and r. respectively. Each rests a hand on one of two shields, which stand upright on the ground between them; behind the shields, two crossed spears; spears, a *simpulum* on left and a *lituus* on right turned inwards. Obverse legend: *CAESAR AVGVSTVS DIVI F PATER PATRIAE.* Reverse legend: *C L CAESARES AVGVSTI F COS DESIGN PRINC IVVENT. BMCRE* 1: no. 513. H/AM, Transfer from the Harvard College Library, Bequest of Robert Nixon Toppan, 1880, 1976.40.2. Imaging Department © President and Fellows of Harvard College.

how Augustus provided for his adopted sons Gaius Caesar (20 B.C.E–4 C.E.) and Lucius Caesar (17 B.C.E.–2 C.E.). Following their adoption, in 17 B.C.E., the boys received magistracies much earlier than was customary for their age, and Augustus organized games in their honor (*RG* 15 and 22). The equestrians honored the boys with shields and spears and the title *principes iuventutis* (the first among the youth),[100] and the two boys appear with their titles and other honorary tokens on a well-known coin type (fig. 28). The obverse shows a bust profile of Augustus; the reverse represents the two boys standing with their shields and spears in a composition recalling the Dioscuri. A few years later the brothers were made consuls designate (one in 5 B.C.E. and the other in 2 B.C.E.), but such expectations for their future were most likely in the works as early as 13 B.C.E.[101] In the *RG*, the princeps explains that the honors of Gaius and Lucius, whom he calls "my sons," were rewards for his own accomplishments. If the sons' honors proceeded from the father, then family, rather than the sons' deeds, guaranteed their honors and achievements. That logic had an effect on the public image of the women in Augustus's family and on the discourse of founding more broadly.

Adoption gave Gaius and Lucius a divine family lineage and marked them as possible successors to Augustus. Augustus's immediate successor, Tiberius, also belonged to the Augustan line through Augustus, who had adopted him, and through his mother, whom Augustus adopted posthumously into the Julian family (Suet. *Aug.* 101.2). Emphasis on

family lineage inevitably lessened the import of deeds and constitutional honors. *Princeps iuventutis* would endure as a designation that would be given to imperial sons with or without the name/title Caesar.[102] In tune with that ancient tradition, Constantine too would be "princeps of the youth," as would his sons.[103] The title signaled a promise that the imperial line would be renewed in the next generation. A coin minted by the emperor Probus (276–82), circa 277, potently illustrates how the imperial family tree, connecting all emperors in kinship and qualities, began with Romulus.[104] On its reverse the coin shows the she-wolf nursing Romulus and Remus and the legend ORIGINI AVG (to Augustus's origins).

For Augustus, promoting links to the founders Romulus and Aeneas, and to his own divine family, brought political dividends. These figures helped him style himself and be seen by others as a new godlike and sacred founder. Ancient Roman history thus helped explain his unusual position as a man of extraordinary authority who did not hold office.[105] The titles Augustus and *pater patriae* were broad enough to imply generalized responsibilities for the state. They connoted founding and divinity without evoking the odious words *king* and *monarchy*. The titles became standard for the emperors who followed Augustus. More than other titles, they epitomized the prerogatives of the princeps, as Augustus interpreted them. They recognized the emperor as an exceptional citizen, a benefactor and savior of the realm, and therefore a sacred progenitor in the mold of Romulus.

Every emperor who followed inherited the discourse of founding and was thus understood as a founder, a human who by virtue of his authority and agency came closest to the gods. The discourse dictated that each emperor should behave and be perceived as a new sacred founder of the land—an Augustus. The default assumption was that an Augustus would aspire to be a savior, a benefactor, a true *pater patriae* in the tradition of the first founders.[106] The more ambitious emperors strove to inaugurate their own age of renewal, which they signaled in the iconography of their coins, their choice of patron gods, the building programs they initiated, and their way of honoring their families. The emperor Nero belongs to the category of ambitious new founders, active molders of the discourse. Known for his excesses, he was ambitious to present himself as a new founder, employing solar iconography to do so.[107] Trajan was another determined founder. His massive forum in Rome must be read as a statement of founding ambitions that competed with earlier such statements in its innovations, such as the famous column containing his urn, with reliefs documenting his major achievements.[108] Similarly, Hadrian strove to compete with Augustus as founder by instituting a program of renewal for the city of Rome and building his own round mausoleum. The emperor Commodus (166–92), with a reputation that rivals Nero's, was also driven to mold the discourse of founding in memorable ways. In 192, he refounded Rome as Colonia Aeterna Felix Commodiana.[109] Relying on the ancient and "anonymous rules" of the imperial discourse, Commodus affirmed their vitality two centuries after Augustus. As was appropriate for

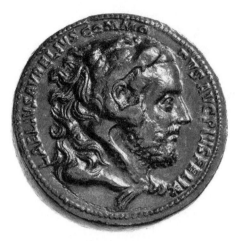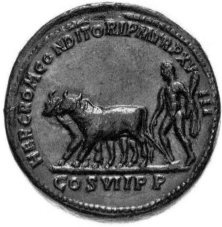

FIGURE 29

Bronze medallion of Commodus, Rome, late 192. Obv.: Head of Commodus in the guise of Hercules, wearing lion's skin headdress tied around neck. Rev.: Emperor, as Hercules, advancing left, holding club and lion's skin in left hand, guiding with his right hand a yoke of oxen. Obverse legend: *L AELIVS AVRELIVS COMMODVS AVG PIVS FELIX*. Reverse legend: *HERC ROM CONDITORI PM TR P XVIII, COS VII P P* in exergue. Gnecchi 1912, 2:54, no. 23. Photo credit: Courtesy of Classical Numismatic Group, Inc., www.cngcoins.com.

a founder, he received a thousand-pound gold statue showing him with a bull and a cow, referring to the Romulean tradition of ploughing the walls of a new city. The statue recalled Augustus's ploughing coinage as well as the statuary group at Apollo's Palatine temple. Bronze medallions may have copied that statue. They represented the emperor as Hercules tilling the land with two bovines and the legend "To Hercules the Founder of Rome" (fig. 29).[110] Commodus adopted a vast number of names, including Hercules, renamed all the months in his own honor, and demanded that the era he inaugurated be called the golden age (Dio Cass. 73.15.6). His images incorporated solar symbolism (fig. 30), and he adopted Sol's divine epithet *invictus* (unconquered).[111] Commodus behaved like other imperial founders, striving to present his reign as a golden age, and himself as a new godlike founder, relying in these ambitions on a well-worn understanding what founding was, and how it needed to be presented. Yet his ambition to rename Rome in his honor, the means through which he hoped to accomplish it (relying in part on association with Hercules), and his ultimate failure reveal something important about the Roman discourse of imperial founding. In Rome, the Romulean myth on which this discourse was based could not be supplanted with other ones. Even though Hercules appears in Rome's ancient foundation legends, a new name for the city was no longer possible.[112] Commodus's unsuccessful refounding was a lesson to future founders who would veer too far off script.

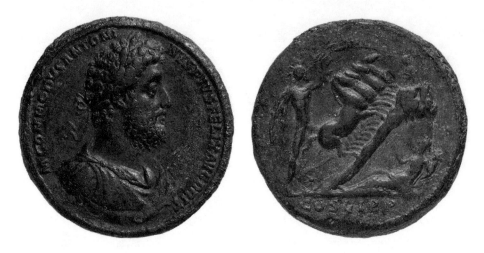

FIGURE 30

Bronze medallion of Commodus, 189–91. Obv.: Bust of Commodus. Rev.: Sol with a radiate crown rises from the sea on a chariot with four horses. Tellus/Earth holding a cornucopia and reclining. Obverse legend: *M COMMODVS ANTONINVS AVGVSTVS BRIT*. Reverse legend: *COS VI PP*. Gnecchi 1912, 2:52, no. 3. Photo credit: Courtesy of Jürgen Malitz and the Numismatische Bilddatenbank Eichstätt.

In the decades of political instability that characterized the century before Constantine, the message of renewal continued to be propagated. Almost a fifth of the third-century imperial coinage (issued by the thirty-five emperors who ruled from 193 to 284) featured the legend *saeculum aureum,* proclaiming the dawn of a golden age with the succession of each new emperor and celebrating its benefits: *felicitas* (happiness), *pax* (peace), *securitas* (security), and *salus* (well-being).[113] Mars, the father of Rome's founder, continued to be represented on the emperors' coinage.[114] Except during the Tetrarchy, the troublesome third century saw a renewal of interest in Sol Apollo, whose image appeared on imperial coinage that evoked the golden age, the immortality (*aeternitas*) of Augustus and the empire, and imperial and divine *providentia* (foreknowledge).[115] In the third century, emperors were regularly shown on their coins wearing a diadem of solar rays,[116] an attribute that signaled the renewal that the emperor, a man with the qualities of the eternal and unconquered Sol, would bring to the empire.[117]

Along with such established markers of their ambitions and merit, state renovators after Augustus cultivated a public image that connected them to the line of the Augusti as a source of greatness. Augustus's tomb and the Forum of Augustus became the most visible expressions of this thinking. Augustus, in particular, treated his lineage from the founding gods of Rome as a most desirable trait. His emphasis on it paved the way for him to include both successors (natural or adopted sons) and women in the discourse of founding. Starting with Livia, imperial women came to be linked to Venus, the divine

mother of all Romans. Augusta became the female title for the sacred female founder of the land, Venus's double. The Augustae received honors as progenitors of the Roman people. With that change, the current father of the land appeared as a new and better founder, next in line to join his divine ancestors, having chosen the successors who would take his place. Every mother of imperial successors, natural or adoptive, correspondingly took on the public image of *mater patriae.*

3

WOMEN AND FOUNDING FROM LIVIA TO HELENA

Shortly after Augustus died in August of the year 14, the Roman Senate was asked to read the *Res Gestae* and Augustus's last will (Suet. *Aug.* 101). The *Res Gestae* made no mention of Livia or other women, but Augustus's will announced his posthumous adoption of Livia. If the adoption of Gaius and Lucius Caesar was motivated by the desire to continue the family tree of founders, the adoption of Livia strove to extend the honors of founders to the most important woman in Augustus's family. By bequeathing to Livia as his adoptive daughter the name Julia Augusta (Tac. *Ann.* 1.8), he at last recognized Livia officially as his female counterpart, a descendant of the Julii—the Augusta to his Augustus.[1] Even before Augustus's death, but especially after it, Livia received numerous honors from various quarters. The cumulative message that emerges from her statue dedications, coins, assimilation to goddesses, and other honors is that of a godlike progenitor of the realm, who deserves to be honored for her benefactions.

Livia's presentation drew upon a large and venerable repertoire of Hellenistic ideas about women's role in the image and legitimation of authority, some of which began to infiltrate Rome in the late 40s B.C.E. In the course of three decades, Roman elite women went from being virtually invisible in the public sphere to being presented as figures of godlike authority and agency. Livia became the face of this revolution, although Fulvia and Octavia made significant early appearances.[2] The first Augusta left a distinct mark on the discourse of founding that was unmatched until Helena. Her honors were a product of a process of resistance, appropriation, and new synthesis of how Roman women participated in the public presentation of imperial authority. Augustus played a major

part in this process, and so did the Roman Senate, client rulers, private individuals, and cities around the empire. The adoption resolved many of the inherent difficulties in bestowing honors upon women in Rome, in that it provided for Livia the pedigree and a title/name that allowed for her to be seen as a full member of the *divi genus*, "offspring/family of the deified."[3] Livia's adoption completed Augustus's interpretation of the founding of the Roman Empire by furnishing a sacred female founder in the current generation. In so doing he pushed the Roman symbolic language of power closer to that of the Hellenistic kingdoms. Livia and every empress after her filled the role of mother of the current generation of the imperial line they all were imaged as the goddess-progenitors of the Romans.[4] This presentation corresponded to the emperor's roles as the father of the imperial successors and *pater patriae*. Livia's images and honors implied the empress's participation in the imperial obligation to care for the commonwealth, and her beneficence was recognized with commensurate distinctions. Images that showed her in the guise of a goddess bespoke of divine qualities and high status. However, this public image did not necessarily imply practical responsibilities. Indeed, after Livia, scant evidence of any empress's concrete good works remains. It seems that the honors were bestowed as a matter of course, and the practice of according them, once established with Livia, needed little explanation.[5] Just as the title Augustus became standard for every emperor who succeeded Octavian, so too successive empresses were considered "mothers of the land." The empress occupied a niche in the public space with her images and honors, and, even though her achievements remained minimal, the qualities celebrated in her public persona construed her as a powerful sacred maternal founder who deserved divine honors and, ultimately, deification. To a lesser extent than Augustus, Livia herself as a paradigm continued to occupy a place in the discourse of founding. Claudian's epithalamium for the emperor Honorius and his bride, Maria, testifies to her relevance centuries later.

These conclusions come into view from investigating the main themes in the public image of Livia and the women who came after her. The analysis draws on a variety of sources—epigraphic, numismatic, artistic, and textual. Still, given the original output, the evidentiary material that survives is at best fragmentary—statue bases without statues, images on coins of long-destroyed temples and statues, and occasionally, chance survivals of complete statues or descriptions of non-extant buildings. In their own time, works honoring imperial women graced the public squares of various cities. Rituals and cultic honors testified to the high authority which contemporaries bestowed on those women. Today, however, the scholarship of the imperial public image tends to minimize the import of these eloquent witnesses by labeling them as "dynastic" and therefore specific to a particular reign or circumstance rather than being relevant to the conceptualization of imperial authority overall. This is partly due to a perceived secondary status of the material and archeological evidence in the writing of history.[6]

It is imperative that the material evidence for imperial women needs to be considered seriously and analyzed thematically. Such an analysis recovers the supradynastic ideas

FIGURE 31

Coin of Eumeneia, 41–40 B.C.E., bronze. Obv.: bust of Fulvia as winged Nike to r. Rev.: legend on three lines within ivy-wreath. Reverse legend: *PHOULOUIANŌN ZMERTORI* ("of the Fulvians"/Zmertorix [Philonidou]) the second gives the name of the magistrate. *RPC* 3140. H/AM, David M. Robinson Fund, 2002.232.2. Imaging Department © President and Fellows of Harvard College.

that animated cultural production over centuries. The textual sources are less useful in this respect because they traditionally exclude women. They are often misogynistic and skewed with respect to genre and the viewpoint of a single author. In other words, women's relevance to the discourse of imperial founders cannot be recovered by only or even mainly studying the ancient authors. This task requires a combined analysis of artworks, monuments, the built environment, and numismatic, epigraphic and textual sources.

WOMEN AND THE REPUBLICAN PRECURSORS TO FOUNDERS

Though republican Rome had absorbed Hellenistic culture to various degrees, in the Roman republic women did not participate in the symbolism of power. But changes were brewing in the Roman world that became evident with the long decline of the republic during the civil wars. If Julius Caesar's assassination precluded lifetime divinity for Roman leaders, the warring generals who came after him and competed for Rome's favor unprecedentedly enlisted their wives in a war of public opinion.[7] Fulvia was the first Roman woman to found a city and therefore to appropriate the conceptual link between city founding, ethnogenesis, and godlike characteristics.[8] She was the third wife of Mark Antony and the mother-in-law of Octavian. At the time of her marriage to Antony, Fulvia refounded Eumenea, a city in Phrygia, as Fulvia. The city consequently minted coins, dated 41–40 B.C.E., with her and her portrait (fig. 31).[9] The portrait depicts Fulvia in the guise of the winged goddess Victoria.[10] Octavian's defeat of Fulvia at Perusia

FIGURE 32

Aureus of Mark Antony with Octavia on the reverse, ca. 38 B.C.E., gold. Obv.: Head of Mark Antony. Rev.: Head of Octavia. Obverse legend: *M·ANTONIVS·M·F·[M·N·AVGVR·]IMP·TER*. Reverse legend: *COS·DESIGN·ITER·ET·TER·III·VIR·R·P·C*. RRC 533/3a. Photo credit: Courtesy of Jürgen Malitz and the Numismatische Bilddatenbank Eichstätt.

(Perugia) in 40 B.C.E. and her sudden death that same year removed her from the Roman political scene. But the coin series with a real woman's portrait evinces the growing significance of women in the public arena of the late republic.[11]

A few years later, the coinage of Mark Antony indicated the importance of his fourth wife, Octavian's sister Octavia, to his public image.[12] On coins of several series, dated to 39–36 B.C.E., Mark Antony and Octavia appear as a couple, either featured on the obverse and reverse (Octavia) of coins (fig. 32), or with heads conjoined or facing each other (fig. 33).[13] The legend on these coins is otherwise traditional, outlining Mark Antony's rank and office and identifying the moneyer. Octavia's name is omitted. She can be identified by her characteristic bun and the coin's date. Minting coins with Mark Antony and Octavia together suggested something more than marital accord. It advertised the harmonious relationship between Octavia's husband and her brother. Minting coins, featuring a woman, to commemorate that idea would have been unthinkable even a few years earlier.

AUGUSTUS, WOMEN, AND LIVIA'S PUBLIC IMAGE

Like Mark Antony, Octavian relied on women to gain political advantage, mostly by forming alliances with other important men.[14] Such a rationale prompted his first marriage, to Clodia, Fulvia's daughter, and his second, to Scribonia. Political motivation has been found even in his third nuptials, to Livia, a union allegedly fired by love.[15] Livia's first

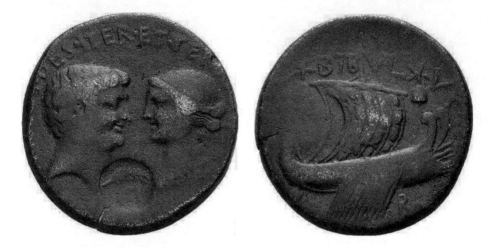

FIGURE 33

Dupondius of Mark Antony, with Mark Antony and Octavia, facing, on the obverse, 38–37 B.C.E.,
bronze. Obv: Confronted busts of M. Antony and Octavia; in lower field between the busts, counter-
mark IE and palm branch. Rev. (not shown): Two galleys under sail right; above, two caps of the
Dioscuri. Obverse legend: *[M·ANT·IMP·TER·COS]·DES·ITER·ET·TER·[III·VIR·R·P·C]*. Reverse
legend: *L·BIBVL—VS·[M·F·PR·DESIG]*. *RPC* 4090. Photo credit: Courtesy of Jürgen Malitz and the
Numismatische Bilddatenbank Eichstätt.

husband, Nero, fought against Caesar's heir in the civil wars. In fact, Livia, Nero, and
their son Tiberius barely escaped being captured by Octavian's army.[16] By marrying the
wife of a political enemy, Octavian aligned himself with a number of well-respected
clans.[17] His sister Octavia played a similar role. Her marriage to Mark Antony cemented
Octavian's political alliance with him. When Antony abandoned her, she again proved
useful this time in Augustus's war of public opinion against her former husband.[18]

Civic recognition for Livia and Octavia has been seen as a tactic in this war of public
relations. In 35 B.C.E., four years before Actium, Augustus arranged for Livia and Octavia
to be made sacrosanct (inviolable) like the tribunes, free from *tutela* (male guardianship),
and honored in statues representing them.[19] These were all special honors, and most
unusual for women. But Augustus may have had more in mind than immediate political
objectives.[20] He may have been seeking a constitutional way to institutionalize Livia's and
Octavia's positions in the state. Sacrosanctity and honorary statues were civic awards. But
because they had to be approved by the senate each year, sacrosanctity or other magisterial
powers provided only a temporary solution. Though Augustus had been allowed in a
particular political situation to obtain such awards for his wife and his sister, there was no
guarantee that he could do so in perpetuity. After 35 B.C.E., the next time the extant textual
sources record his special treatment of Livia was in 9 B.C.E., when upon the death of her
son Drusus, Augustus granted her statues and the honored position reserved for a mother
of three children, though she had only two (Dio Cass. 55.2.5–6). In bestowing this special

status, removing Livia from tutela, or male guardianship, Augustus circumvented custom, which required that such an honor come from the senate (Dio Cass. 55.2.6).[21] A poem of consolation circa 9 B.C.E. dedicated to Livia referred to her as *Romana princeps*, traditionally rendered in English as "first lady."[22] As with the title princeps for Augustus, *Romana princeps* should be considered more broadly, as a recognition of Livia as a symbolic progenitor. It demonstrates that in Augustus's era others saw Livia in a role analogous to his.[23] At the same time, it was probably clear to Augustus that such an official title or equivalent honors for Livia could not come from the "customs of the ancestors." He continued to seek an accepted and enduring way to recognize Livia's lofty status, even if he had to leave that task until after his death.

Augustus spelled out his solution in his will. The significance of his posthumous adoption of Livia cannot be overstated. The senate evinces it in proposing to erect an "Altar of Adoption" to honor it.[24] The adoption must be considered together with Augustus's *Res Gestae*. Both the will announcing the adoption and the *Res Gestae* were meant to be read after Augustus's death.[25] They constitute his legacy, and deserve equal attention. But whereas the *Res Gestae* has garnered great attention, the will has remained unjustifiably neglected. Augustus's testament presented a crucial mechanism for granting women an official, if honorary, rank in the state.

By Roman standards, the adoption of Livia is truly baffling. Roman men adopted other men to continue their line; but there are no attested adoptions of women in the republican period.[26] The only purpose of this will was that the name of the Iulii, descendants of Aeneas and Venus, and the Romulean epithet Augustus, became Livia's personal names. In adopting and renaming Livia, Augustus revealed much about the role he willed her in the legitimation of authority and about his own acceptance of hereditary monarchy.[27] The will complicates the male-centered image of imperial power promoted in the *Res Gestae*. It serves as a reminder that single documents, always created to serve particular objectives, give only a partial glimpse into a discourse. If the *Res Gestae* cherishes republican institutions and promotes Augustus as their guardian, Augustus's testament legally ratifies a notion contrary to republican principles. The will bestowed on a mere woman honors analogous to those accorded the first man in Rome for saving the state. The name Augusta follows the same logic that prompted Octavian to adopt from Julius Caesar the title/name *Imperator*. For years after his adoption by Julius Caesar, Augustus styled himself Imperator Caesar, combining a magistracy (that of the holder of the *imperium*, or *Imperator*) with a name (Caesar).[28] Augusta likewise was a title/name that associated Livia with Augustus, the founder and savior of the state. Lineage implicitly bestowed qualities. More surprising, Augustus made his grand gesture at a time when women were dependents of men; for instance, women were granted financial independence only by special exception.[29] For the entire period considered in this study, women legally "remained separated from all civic and public duties [*officiis*]."[30] Despite all the restrictions on the public honors and agency of women, Livia was honored lavishly before and especially after the adoption. Numerous dedications to her from all corners

of the empire testify to her prominence, and to the broader paradigm Augustus established in adopting her.

From 14 to 29 C.E., when Livia died at the age of eighty-seven, she used the name Julia Augusta.[31] Because she was one of the Iulii, the family of her deified husband/father, Livia could be imagined as a new Venus, the mother of the Romans and ancestor of the Iulii.[32] The importance of her new name is reflected in Tiberius's own association with the name Augustus. When Augustus adopted Tiberius (in 4 C.E.), the adopted son did not receive the honorific Augustus as part of his new name.[33] When Tiberius became emperor, he refused to accept the title Augustus.[34] It is no surprise then that the senators, according to Tacitus, thought it appropriate to confer on Tiberius the honorary title *Iuliae filius* (son of Julia) at the moment when they offered him supreme power.[35] *Iuliae filius* was an emblem of legitimacy that clearly paralleled Augustus's *divi filius*. We may deduce that Livia—because a member of the Julian clan and Augusta—was regarded of higher rank or authority than her son Tiberius, who did not acquire the title Augustus.

Livia's role in strengthening Tiberius's legitimacy gave her heightened visibility during her son's early reign.[36] She acted as his colleague on a number of occasions, in holding formal audiences, for example. And for a time official correspondence was addressed to and from both mother and son.[37] Livia had authority to decide on her own whether to allow her cult at Gytheion.[38] Statues were dedicated jointly to mother and son.[39] In one case, a statue group consisting of the deified Augustus, Livia, and Tiberius, Livia's name preceded that of Tiberius in the dedication.[40] By giving Livia the name/title Augusta, Augustus cleared the way to such extraordinary senatorial proposals as naming Julia Augusta *mater patriae*. With the benefit of hindsight, one can hypothesize that Augustus, who recognized the historical significance of precedents, saw the name Augusta as one Livia's successors could also inherit.

Livia wove the discourse of founding into her civic benefaction, including public buildings, philanthropy, and favors to cities. Her construction projects in Rome seem to have been associated broadly with women's interests, roles, and virtues. Livia's restoration of the Temple of Bona Dea Subsaxana on the Aventine Hill echoes her interest in the medicinal properties of plants (map 2, item 13).[41] Bona Dea was a goddess of medicine and fertility, whose Roman temple was a center for healing and contained a store of herbs of every kind.[42] No men were allowed inside its sacred precinct, nor could they be present at the goddess's rites.[43] The citizens of Forum Clodii, aware of Livia's interest in Bona Dea, vowed to present honey wine and cake to the village women of the community of Bona Dea on Livia's birthday.[44] Similarly, the textual sources offer a glimpse of Livia's interest in the therapeutic use of plants and the spread of her "brand" names. We know of her remedies for throat inflammation and chills. In addition to the laurels she grew so successfully at her villa, she also took an interest in figs, cultivating a special variety, called the "Liviana."[45]

Livia's other Roman projects—the repair of the Temple of Fortuna Muliebris and the Shrine to Concordia in the Porticus Liviae—likewise bespeak womanly virtues. The Tem-

FIGURE 34

Porticus Liviae with the Shrine of Concordia, ground plan. Drawing by Bill Nelson after the Marble Plan of Rome.

ple of Fortuna Muliebris was dedicated, in June of the year 7 C.E., to Coriolanus's mother and wife, by whose intercession Rome had been saved from bloodshed.[46] Livia's most important public work—the Shrine to Concordia in the Porticus Liviae, dedicated in January of 7 C.E.—also related to women.[47] The name of the precinct in which it was located suggests that Livia built it, though that claim is debated.[48] The rectangular porticus, surrounded by a double colonnade, measured 115 by 75 meters (fig. 34). The representation of the portico in the Marble Plan of Rome shows a large rectangular structure in the center of its courtyard, and smaller features at the corners, all of which may have been fountains. On the outside perimeter of the colonnade were semicircular and rectangular exedrae. Various shops stood beside the shrine, open to the streets around it. According to Ovid, Livia dedicated the Shrine to Concordia to her husband.[49] Ovid and Pliny admired the complex.[50] Pliny noted that a single vine covered all the walks of the open area.[51] Livia's shrine was a gesture of magnanimity toward the city of Rome aiming at beautifying the city, delighting its citizens, and glorifying its patron. The dedication to Concordia, the goddess of marital and social harmony, drew attention to Livia, and women more broadly, as guardians of both.[52] Taken together, Livia's repair of the Temple of Fortuna Muliebris and the building of the Shrine to Concordia emphasize women's conciliatory agency.[53]

Livia's preference for these projects must be connected to the venerable story of the Sabine women, who interfered to end the wars between their Roman husbands and their Sabine kin. The most important of these Sabine women was Hersilia, Romulus's wife. In supporting civic accord, Livia styled herself a new Hersilia and, in doing so, mirrored her husband's emulation of Romulus. As Livy (59 B.C.E.–17 C.E.) recounts in his *History of Rome,* Hersilia convinced Romulus to spare the lives of the men who had attacked Rome to retaliate for the abduction of their daughters (1.11). She even secured for the attackers the grant of Roman citizenship. Although Livy does not connect Hersilia to Livia, in book 14 of the *Metamorphoses* (8 C.E.), Ovid delineates a double parallel, linking Livia to Hersilia, and Augustus to Romulus. He construes the parallel to prophesy Augustus's impending deification. In the poem Romulus was deified because Mars (Romulus's father) supplicated Jupiter (14.805–828). Analogously, Hersilia became the goddess Hora on orders from Juno (14.829–851). Through Iris, Juno addresses Hersilia as "O queen, bright glory both of Latium and of the Sabine race, most worthy once to have been the consort of so great a man, and now of Quirinus" (14.832–34).[54] In the epithet *glory,* Ovid invokes Hersilia's most famous achievement but also celebrates her as a wife of a hero and a god. The poem does not mention Livia by name, a common trait of Augustan literature; Ovid refers to her only as Augustus's "sacred/morally pure wife" (*sancta coniux*) (15.836), when he prophesies Augustus's succession by Tiberius and his imminent ascent to divinity (15.869–870).[55] So the parallel between Hersilia and Livia and the hint about Livia's future deification remain subtle, but they would not have been lost in a work whose last two books treat three deifications—those of Romulus, Hersilia, and Caesar—and prophesy a fourth, that of Augustus. Moreover, in the *Fasti,* Ovid stated outright that Livia would become a deity (1.531–37).

Like Hersilia, who secured pardon and citizenship for her relatives, Livia intervened to save individuals and secure privileges for cities. She obtained amnesty for Plancina, who, with her husband Piso, had been accused of a capital crime.[56] Livia also rendered help to communities outside Rome. During Augustus's reign, she interceded with her husband on behalf of a Gaul, and on behalf of the people of Samos, securing for the Gaul a release from the payment of tribute and for the Samians the remission of taxes.[57] A marble pedestal for a bronze statue dedicated to Livia by Queen Pythodoris of Bosporus, a client Roman kingdom in the northern Black Sea, hails Livia as the queen's "benefactor."[58] In a different inscription, Pythodoris's husband, King Polemon, similarly referred to Augustus as "his benefactor."[59]

A decree of the senate known as *Senatus consultum de Pisone patre* specifies that Livia performed "many and great favors to men of each order [social class]."[60] Other sources state that she paid dowries for the daughters of senators and helped victims of fire.[61] Before Livia's time, in the Greek world, individual cities sometimes undertook to provide dowries for the daughters of citizens. There's a lone example of a woman, queen Laodice III, who arranged to do so for the citizens of Iasus, a city in Asia Minor.[62] Laodice supplied grain and promised other benefactions, hoping in so doing to aid in the "restoration of the city."[63] Livia presented herself as such a benefactor to Rome and other cities,

(handwritten marginal note): does it seem that women have more roles?

to the Roman Senate, and to the Roman people. She accomplished her acts of generosity either as Hersilia did, by interceding, or by acting on her own, through what the Roman Senate referred to as *plurimum posse* (vast influence). Her benefactions, like those of Laodice before her, benefited city and state.

Livia's magnanimity helps explain why the Roman senators sought to bestow civic honors on her. They suggested after Augustus's death that Livia be called *mater patriae* or *parens patriae* (progenitor/parent of the fatherland).[64] *Parens patriae* already existed as a civic title for extraordinary male citizens. Julius Caesar was the last to receive it. That the senators considered giving it to a woman constituted a startling departure from tradition.[65] The title *mater patriae* was another innovation.[66] Tiberius protested that both honors were too lavish, and neither prevailed.[67]

Nevertheless, the proposal itself suggests that the senators saw Livia's role as analogous to that of Augustus. The idea of their affinity—in some measure helped by the precedent of Augustus's titles—must have predated the senate's debates. For instance, Ovid remarks that Livia, in restoring a temple, imitated her husband (*Fast.* 5.157–58). Like her husband, she engaged in the construction and repair of buildings. She distributed benefactions. According to the *Senatus consultum de Pisone patre*, because of her generosity to the state and her great influence, she merited the right to grant clemency, a core imperial prerogative and virtue.[68] Given Livia's lifetime accomplishments and status as the wife of the princeps, the senators formalized an existing notion of Livia's position vis-à-vis Augustus. Dio's description of the senatorial deliberations, though written much later, strengthens this conclusion.

According to Dio, Livia deserved to be granted the title *mater patriae* for the reasons that validated Augustus's title *pater patriae*: "because she [Livia] had saved the lives of not a few of them [that is, the senators], because [she] had reared the children of many, and [she] had helped many to pay their daughters' dowries."[69] On account of these deeds, some called her mother of the fatherland (*mētera tēs patridos*), a title meant to thank Livia for being a savior of citizens, a mother to many, and a benefactor.[70] The same qualities are honored in the feminine title as those in the masculine title—those of city founders and founding gods: saving lives and providing benefactions to the commonwealth. Livia's candidacy for the title was assessed according to the expectations essential to the emperor's title *pater patriae*. Thanks to her generosity, Livia earned the honor of being called a female progenitor of the land.

Although the Roman senators failed to make Livia "mother of the land," they honored her in other ways.[71] They made her a priestess of the cult of Augustus and gave her a lictor (a civil servant appointed to guard magistrates), another innovation in ancestral tradition.[72] Probably seven years after Augustus's death, she accepted a *carpentum* (a two-wheeled carriage), an honor reserved for the Vestal Virgins.[73] When she died, Tiberius held a public funeral, but the senators deemed that gesture insufficient and decreed a year of mourning for all women.[74] They also wanted to deify her, but Tiberius forbade that honor, too. The substitute the senators devised as the most appropriate civic recognition of a

mater patriae was to build an arch in her honor.[75] Such a structure would have given the Augusta the same honor as successful Roman generals.[76] Again, Tiberius defeated the initiative by offering to construct the arch at his own expense and then failing to attend to it.

The senate was not alone in thinking of Livia as mother of the land. Throughout the empire she received dedications that directly or implicitly recognized her unique status as the female counterpart to Augustus.[77] The rationale that binds these disparate dedications goes beyond what the Roman Senate or Tiberius could or did approve. Like the honors given Augustus, Livia's honors rewarded her as a founder and as progenitor of the Roman ethnos. In Rome she was Venus-like; elsewhere she was often endowed with characteristics and attributes of local female deities, patrons of cities. Her perceived role as mother of the fatherland and a benefactor earned her divine honors, and her cult joined those of female deities of fecundity and civic deities.

The logic of Livia's various dignities can be explained with the anonymous rules of the Hellenistic discourse of imperial founding that Augustus and others shaped to Roman standards. With respect to the public face of power, the idiom of founding allowed for a more seamless cultural integration of the Hellenistic parts of the empire to the Latin ones.

LIVIA THE FOUNDER/PATRON OF CITIES

Intertwined notions of founding/generating, divine patronage of cities, and cultic honors for founders shaped most presentations and honors of Livia throughout the empire. The idea of the godlike benefactor appears in epigraphic sources. Livia is called *thea euergetis* (goddess benefactor) on the island of Thasos, and *euergetis tou kosmou* (benefactor of the universe) in Assos in the Troas.[78] The latter title assigned to Livia the same universal qualities as the title *mater patriae*. In fact, in a world understood as coterminous with the empire, the two appear interchangeable.[79]

More often, as with the Hellenistic queens, Livia's beneficent qualities were construed through assimilation to a city's patron goddess. The joint cult of the patron deity and Livia illuminates the interdependency of the empress's roles as a progenitor, savior, and protector. Giving Livia the name of the founding goddess and the goddess's priestess recognized her by association as a founder. There were priestesses to Livia in Mylae, Cyzicus, Larisa, Samos, Aphrodisias, Chios, and Attaleia.[80] At Mylae she was worshiped as *Ioulia Hera Sebastē* (Julia Hera Augusta).[81] In Samos one priestess served the cult of the Founder Hera and the cult of Julia Augusta.[82] In Paphos, the mythical birthplace of the goddess Aphrodite, she was honored as "New Aphrodite."[83] Livia's lifetime cult in Cyzicus too was linked to that of the patron goddess.[84] Livia *Sebastē Nikēphoros* (Augusta victory bringer) shared the temple and the powers of Athena Polias, the patron goddess of the city.[85] We see this same phenomenon in Attaleia (Pamphylia), where the cult of Livia was linked to the city's founding deity, *Thea Archēgetis Roma* (the Goddess Founder

FIGURE 35

Dupondius with Divus Augustus and Livia *genetrix orbis*, Colonia Romula, 15–16 C.E., bronze. Obv.: Divus Augustus wearing a radiate crown; six-rayed star above, thunderbolt to right. Rev.: Head of Livia set on globe, moon crescent above. *RPC* 73. Obverse legend: *PERM DIVI AVG COL ROM*. Reverse legend: *IVLIA AVGVSTA GENETRIX ORBIS*. Photo credit: Courtesy of Classical Numismatic Group, Inc., www.cngcoins.com.

Roma).[86] In Athens, long before her deification in Rome, she had a priestess and was assimilated to Hestia, Artemis Boulaia, Hygeia, and Pronoia.[87]

The same rationale guided the first Augusta's association to Tychai.[88] The Tyche/ Fortuna of the city was a deity that simultaneously personified the city and embodied its good luck.[89] The Tyche was in most places independent of the patron deity, but their spheres of agency overlapped.[90] In Sparta, for instance, the Tyche was called the founder of the city.[91] So when Gytheion in Greece celebrated Livia as "Tyche of the ethnos and the city," and dedicated a statue to her as a "manifested goddess, Tyche of the city," the language implied that Livia was syncretized to the city's founding goddess, and honored as a founder.[92]

LIVIA THE PROGENITOR

Assimilation to Venus/Aphrodite as well as to Demeter/Ceres highlight Livia's role as a mother and protector of cities, a source of abundance.[93] Two examples from Spain style Livia as a female progenitor of the land comparable to Venus Genetrix. The first one is an inscription from Anticaria, dated to the reign of Tiberius, and dedicated to Julia Augusta *genetrix orbis*.[94] The second example is a Tiberian coin from Hispalis (Colonia Iulia Romula) (fig. 35).[95] The obverse depicts the deified Augustus's head with a radiate crown surmounted by a star.[96] The reverse shows Livia's head on a globe with a crescent above her head. Livia was moon to Augustus's sun. The pairing and the legend *IVLIA AVGVSTA*

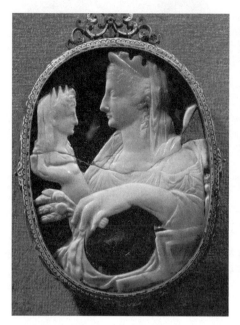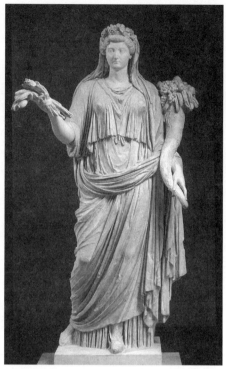

FIGURE 36

(left) Cameo portrait of Livia with the features of Ceres, holding a bust of Augustus, after 14 C.E., sardonyx, 9 cm., frame: second quarter of the seventeenth century, Kunsthistorisches Museum, Vienna, Inv. IX A 95. Photo credit: Erich Lessing / Art Resource, N.Y.

FIGURE 37

(right) Marble statue of Livia with attributes of Ceres, first century C.E., marble, 253 cm. Livia's right hand holds out sheaves of wheat and poppies, while her left hand holds a cornucopia overflowing with fruit. Her veiled head is crowned with flowers, and the knotted, beadlike strands of the wool (*infula*), associated with sacrifice, hang down on either side of her neck. Musée du Louvre, Paris, MA 1242. Photo credit: RMN-Grand Palais / Art Resource, N.Y.

GENETRIX ORBIS underscores Livia's association to Venus and to Augustus *pater patriae*.[97] Other cities outlined the same connection when they called Livia "New Aphrodite" and *Sebastē thea Aphroditē Livia*.[98] Assimilations to Venus were also visual (see figs. 3 and 4).

Livia's assimilations to Ceres/Demeter notionally link Livia to two aspects of the goddess's agency: fecundity and protection of cities.[99] The wreath of corn ears, corn stalks, and/or poppies—exemplary symbols of Ceres-brought abundance of nature—appear in many images of Livia, from statues to cameos and coins. Two well-known artworks include a cameo from the Kunsthistoriches Museum in Vienna, and an over-life-size marble statue of Livia in the Louvre (figs. 36 and 37).[100] The visual assimilation went

hand in hand with appropriating the goddess's epithets. Indeed, there are more than forty-five examples of such assimilations.[101] The base of a non-extant statue from an island near Malta states that the statue was dedicated to *Cereri Iuliae Augustae* (Ceres Iulia Augusta); a decree from Ephesus reads, *tēs Sebastēs Dēmetros Karpophorou* (of Augusta Demeter Karpophoros [the fruit bringer, an epithet for Demeter]); a third one, from Cyzicus, refers to Livia as *Thea Dēmētēr*.[102] One analysis of Livia's assimilation to Ceres/Demeter suggests that it offered an alternative to the official title *mater patriae*.[103] The date of those assimilations—they are Augustan and Tiberian—suggests that the idea of Livia *mater patriae*, imaged through Demeter/Ceres, was in circulation well before the senatorial proposal of 14 C.E.

The protective side of a mother of the land could also be represented through Demeter/Ceres. The goddess was considered instrumental in the defense of cities, an agency symbolized by a mural crown. The mural crown of Ceres appears as an attribute of Livia in two extant artworks. A three-meter-tall marble statue from the theater at Leptis Magna represents a standing full-bodied female figure with a crenelated crown (fig. 38).[104] The face, though idealized, bears three Livian traits—thin lips, pointed chin, and round eyes. The preserved inscription states that the statue, referred to as *sacrum*, a sacred object, was dedicated to Ceres Augusta. The statue stood in a small shrine. The epithet Augusta, along with Livia's recognizable physiognomic features interpret the statue as the deity Livia endowed with the qualities of Ceres. The cameo from Vienna likewise shows Livia Ceres wearing a crenelated mural crown (fig. 36). The statue and cameo underscore Livia's Ceres-like beneficent qualities; she is a bringer of fertility and defender of cities. Livia Ceres emphasizes powers that complement Augustus's. In ensuring peace through saving his country, he ushered an age of fertility; portraying Livia as a Ceres vests her with similar powers. She is the mother of the country to Augustus's father of the country.

Complementarity between Livia and Augustus was an objective sought on a few coins. It comes through in the coin from Colonia Iulia Romula, where Livia's moon crescent balanced Augustus's sun (fig. 35). Following the traditional reading that the sun and the moon shown together symbolize eternity, it may be inferred that the two Augusti, as a pair, would be eternally remembered, even though Livia was still living at the time.[105] Likewise, a dupondius from the reign of Tiberius (14–37 C.E.), minted in Leptis Magna, pairs Tiberius (or perhaps Augustus) with the living mother of the land. The obverse depicts a head in profile with the legend *IMP[ERATOR] CAESAR* (fig. 39). The reverse shows an image of Livia, enthroned, holding a patera (a flattened bowl, used for pouring libations) in her right hand and a scepter in her left, suggesting assimilation to a goddess. The iconography on this coin is seen on Roman coins (fig. 40) and provincial coins from the Tiberian reign (fig. 41), hinting at official intervention in their design. The legends of this series usually leave the seated woman unexplained with two exceptions. The legend of the Leptis Magna coin, however, labels it *AVGVSTA MATER PATRIAE* (Augusta mother of the fatherland), while a coin from Caesaraugusta in Spain identifies the woman as

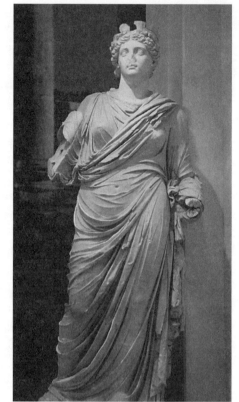

FIGURE 38

(right) Marble statue of Ceres Augusta wearing a crenelated/mural crown, ca. 35 C.E., Leptis Magna, 298 cm. Tripoli Museum, Libya, Inv. 208/54. Photo: Stephen R. Sizer.

FIGURE 39

(below) Bronze coin of Tiberius with Livia *mater patriae*, Leptis Magna, 14–37 C.E. Obv.: Laureate head of Tiberius. Rev.: Livia, veiled, seated right, holding long scepter in raised left hand and patera in extended right. Obverse legend: *IMP[ERATOR] CAESAR [AV(G) (COS)]*. Reverse legend: *AVGVSTA [MAT]ER PATRIA[E]*. RPC 849. Photo credit: Courtesy of Classical Numismatic Group, Inc., www. cngcoins.com.

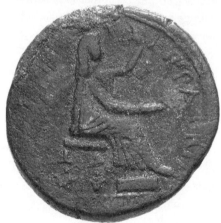

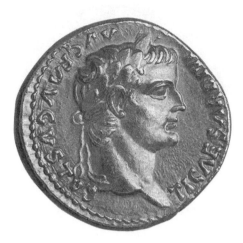
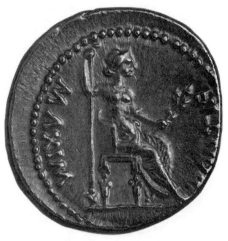

FIGURE 40

Aureus of Tiberius, Lugdunum (Lyons), gold, 14–37 C.E. Obv.: Laureate head of Tiberius. Rev.: Female figure (Livia?) seated on chair, holding a long scepter in her right hand and a branch in her left. Obverse legend: *TI CAESAR DIVI AVG F AVGVSTVS*. Reverse legend: *PONT MAXIM. RIC* I Tiberius 2, 29. H/ AM, Arthur M. Sackler Museum, J. P. Engelcke Coin Purchase Fund, 2012.212. Imaging Department © President and Fellows of Harvard College.

Livia (fig. 41). The Leptis coin thus celebrates Augustus and Livia as a couple with comparable and complementary qualities. The names and titles highlight their connection: Augustus, Augusta. Livia's title *mater patriae*, though unsanctioned by the senate, complements Augustus's *pater patriae*. Livia may have granted favors to Leptis Magna, because four of her statues were found in that city, three of them colossal and one showing her deified,[106] or the city may have honored her as a matter of course, for being the wife of Augustus and then mother of the Augustus who succeeded him. The Tiberian coins with similar iconography support the second idea (fig. 40).[107] Enthroned statues of Livia were dedicated in Paestum (fig. 42, together with Tiberius), Rome, Russellae, Ephesus, and Leptis Magna.[108] When at last Livia was deified, her iconography as *diva* mirrored that on the earlier Tiberian coins (fig. 43).[109]

Although Livia held no magistracies, she acquired divine honors, or was presented as a goddess, because her role was understood as that of the mother of the land. Livia's assimilation to goddesses and the cultic honors she received solved the problem of representing her exalted position, which lacked a Roman precedent and a constitutional prerogative. Livia could be a priestess but not a magistrate. Unlike Augustus *pater patriae*, the titles Augusta and *mater patriae*, though meant to acknowledge Livia's renewal of and care for the city, required no responsibilities. Both the male terms Augustus and *pater patriae* and their female equivalents implied the founding and renewal of the state in each generation. Calling the empress *mater, thea* (goddess), or Augusta/Sebastē or showing her

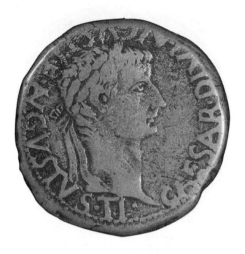
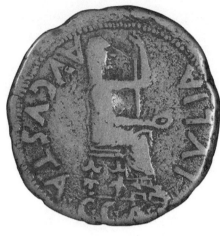

FIGURE 41

Coin of Caesaraugusta under Tiberius, 14–37 c.e., bronze. Obv.: Laureate bust of Tiberius. Rev.: Livia, draped, veiled, seated on a throne, holding patera in right hand and a scepter in left hand. Obverse legend: *TI CAESAR DIVI AVGVSTI F AVGVSTVS*. Reverse legend: *C.C.A. IVLIA AVGVSTA*. RPC 341. H/AM, Arthur M. Sackler Museum, the George Davis Chase Collection of Roman Coins, Gift of George Davis Chase, Professor of Classics and Dean of Graduate Study at the University of Maine, 1942.176.86. Imaging Department © President and Fellows of Harvard College.

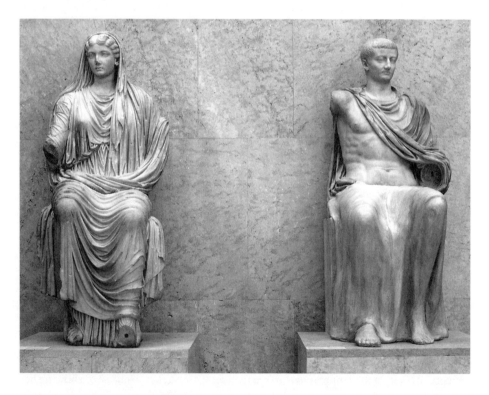

FIGURE 42

Marble statues of Livia and Tiberius enthroned, from Paestum, first century c.e., height of of Livia's 177 cm., Museo Arquelógico Nacional Madrid. Photo: Author.

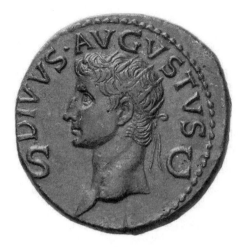
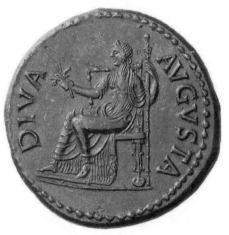

FIGURE 43

Dupondius of Claudius with Divus Augustus and Diva Augusta, ca. 42, bronze. Obv.: Radiate head of Augustus. Rev.: Livia seated left on throne, holding corn-ears and scepter. Obverse legend: *DIVVS AVGVSTVS SC*. Reverse legend: *DIVA AVGVSTA*. *BMCRE* I: no. 224. Photo credit: Courtesy of Jürgen Malitz and the Numismatische Bilddatenbank Eichstätt.

like a goddess must have seemed less disturbing than alternatives such queen, or a high-ranked magistrate. Coins and inscriptions never referred to the empress as a queen, even though Hellenistic queens, like Roman empresses, had been seen as goddesses.

With Livia, women's honors entered the discourse of imperial founding, and after her the empress's exalted status as progenitor of the imperial family and of the *res publica* continued to be defined by divine attributes and honors. Even so, Tiberius's opposition to his mother's honors seems to have had a lasting effect on the titles and the agency of imperial women. Livia's ambitious building projects established no precedents for her successors. With the possible exception of Faustina II and Julia Domna, most subsequent empresses received fewer honors. But when imperial women were honored, they were celebrated for the same qualities as Livia had been, that of progenitor, city founder, and benefactor.

AUGUSTA AND MOTHER TITLES

There were thirty-five Augustae between the first one and the early fourth century.[110] The name/title Augusta was by far the most important honor for imperial women, its significance revealed in the fact that the third-century political crisis yielded seven Augustae in a period of thirty-five years.[111] Through that title, each of these women claimed association to the first Augusta, Livia, and to the honor implied in the name when originally bestowed on Augustus: sacredness associated with founding and service to the state. To be an Augusta was to be a "sacred female founder."

cult of Mary and her numerous titles?

To the title Augusta, the Roman Senate added a few *mater* titles.[112] The first one was the title *mater castrorum* (mother of the military camps), a title bestowed posthumously on Faustina II in 174 C.E.[113] The Roman mint commemorated that honor by striking coins of Faustina with her image and her new title (fig. 44). The same title was awarded to a number of other empresses; Galeria Valeria was the last to bear it.[114] Along with the title, Julia Domna received a statue in her honor on the Roman Forum.[115] Julia Domna's reign brought other innovations. The founding mother of the Severan dynasty received three "mother titles": *mater Augustorum* (mother of the Augusti), *mater Senatus* (mother of the senate), and *mater patriae* (fig. 45).[116] Julia Domna's maternity embraced the army, its two commanders-in-chief (her sons Caracalla and Geta), the senate, and the state. Julia's official honors, though innovative, reflect Livia's legacy as a benefactor to "every rank" and progenitor of the emperor's successor and commander-in-chief. Six more Augustae received the title "mother of the senate."[117]

titles vs. actions

To judge from the variety of the honors empresses received, Dio's "job description" of *mater patriae* to a certain extent fits all imperial women. Yet all empresses were not mothers of the fatherland in equal measure; nor did all emperors equally deserve the title *pater patriae* in the eyes of their contemporaries. The discourse of founding did not motivate equally the cultural production of all imperial reigns. Factors such as length of reign, political motives, and personal preference affected both the commitment of individual women to their responsibilities as *mater patriae*, and their celebration by the community. The title Augusta, however, offered the best guarantee that an imperial woman would remain visible in the material record. Lavishness and variety of honors generally distinguished the careers of either widely admired *matres patriae*, such as Faustina II, or mothers of new imperial families like Julia Domna who needed to prove their fitness for the role.

merit + responsibility still important

EMPRESSES AS BENEFACTORS

or popularity

Dio argued that Livia merited the title *mater patriae* for saving lives and for providing nourishment and care for the people. Works of similar magnitude earned Augustus the distinction *pater patriae* and divine honors. The tokens in this reciprocal exchange between the emperor and the senate or the emperor and the cities of the empire were essential elements of imperial rule. Female members of the imperial family included in this system of exchange were usually honored by virtue of their position, and only occasionally for concrete benefactions. Livia received both types of honors. After her, actual benefactions became less common.

Imperial benefaction took two basic forms: the construction of public buildings and monetary largesse. Livia remained the most important female imperial builder in pre-Constantinian times, yet in her own generation, Octavia and Vipsania Polla were also builders, all of them having constructed porticoes.[118] But the list of public buildings sponsored by the generations of imperial women that followed pales in comparison with those

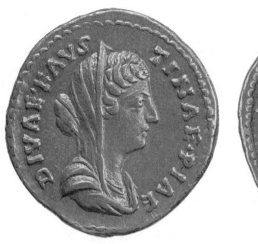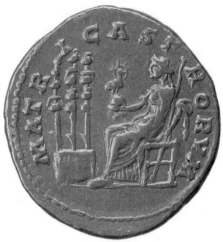

FIGURE 44

Aureus of Marcus Aurelius with Diva Faustina II as *mater castrorum*, 176–80, gold. Obv.: Bust of Diva Faustina, veiled, draped. Rev.: Diva Faustina, draped, seated, holding phoenix, with radiate nimbus, on globe right, in right hand and scepter; three legionary eagles set on base. *BMCRE* 4: no. 704, pl. 67.15. Obverse legend: *DIVAE FAVSTINAE PIAE*. Reverse legend: *MATRI CASTRORVM*. BM, 1867,0101.730. ©The Trustees of the British Museum. All rights reserved.

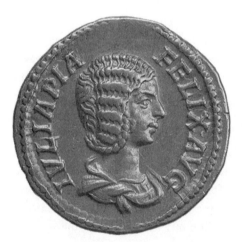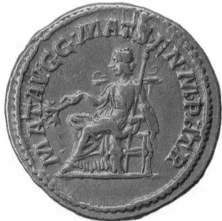

FIGURE 45

Aureus of Julia Domna as *mater augustorum*, *mater Senatus*, *mater patriae*, 211–17, gold. Obv.: Bust of Julia Domna, draped. Rev.: Julia Domna, draped, seated left, holding branch in right hand and scepter, nearly vertical, in left. Obverse legend: *IVLIA PIA FELIX AVG*. Reverse legend: *MAT AVGG MAT SEN M PATR*. *BMCRE* 5: no. 11 (type). BM, 1844,1015.224. ©The Trustees of the British Museum. All rights reserved.

initiated in Rome by the emperors or the first-generation imperial women. The fourth-century descriptions of Rome's fourteen *regiones* (regions) list a Basilica Matidiae et Marcianae in Regio IX. Nothing is known about the construction of this building, nor has its location been positively identified. The name suggests either a joint commission by Matidia (Augusta since 112, the mother of Sabina, Hadrian's wife) and Marciana (Augusta after 105, the grandmother of Sabina) or a building sponsored and dedicated by Hadrian (r. 117–38) to the two women, who were made *divae*. An inscription from Portus, Rome's port, attests to a bridge of Matidia, most likely the imperial niece, who may have owned property in that area.[119] Another inscription, from the Roman Forum, testifies to a structure that Sabina dedicated to the *matronae*, the married women.[120] It is unclear what this structure was, but it must have been important, because Julia Domna restored it. With her family, Julia also renovated the Temple of Fortuna Muliebris, the one Livia had renovated.[121] Evidently in forging her public persona she sought connections to these earlier Augustae. Under Septimius Severus, with the seemingly active engagement of Julia, were rebuilt the Aedes Vestae, the Temple of Vesta, and the Atrium Vestae, the Vestals' living quarters.[122] The evidence on these and other public buildings in other parts of the empire is scant. An inscription on a milestone from Suessa Aurunca in Italy reveals that Matidia II, half-sister of Sabina, commissioned there a road seven miles long. In the city, she focused on the water supply, enlarging the theater, and building a library, the Bibliotheca Matidiana (Library of Matidia).[123] This Matidia was also responsible for the renovation and construction of new buildings in two near-by cities.

From the brevity of this list, it is reasonable to assume that the Augustae were not expected to commission public buildings. In Rome the emperor and the senate dominated public commissions until the fourth century. In the provinces building was in the hands of the local *euergetai* (benefactors) and the civic councils. Women were among these builders and some of them left impressive monuments. Although there were few recorded female imperial commissions, the numerous assimilations of empresses to goddesses, the dedication of statues and altars to those empresses as gods, the divine honors they received, and the titles they were given, such as *euergetis* (benefactor), suggest that the empresses were considered benefactors of the realm but were able to fulfill that role solely because of their symbolic position as mothers of the fatherland and of the imperial house.

The evidence of the monetary largesse of empresses after Livia remains as scarce as that of their buildings. It is restricted to posthumous benefaction in the name of empresses and corollary, references to empresses as benefactors. Three empresses were honored as benefactors by having charities named after them. Antoninus Pius established the *puellae Faustinianae* (Faustina's food relief program for girls) in honor of his deceased wife, Faustina I (fig. 46). Marcus Aurelius instituted the *novae puellae Faustinianae*, honoring his wife, Faustina I's daughter, Faustina the Younger. Severus Alexander honored his mother Mamaea, naming programs for feeding girls and boys after her. The empress's name brought as much prestige to this institution as it did to her. [124]

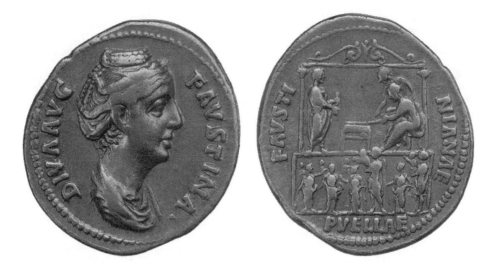

FIGURE 46

Aureus of Diva Faustina I with the *puellae Faustinae,* 141–61, gold. Obv.: Bust of Faustina I, draped, hair elaborately waved and coiled, with bands across the head, drawn up at the back and piled in a round coil on top. Rev.: Building on two levels. On first floor, Antoninus, togate, standing right, holding roll: in front of him, man seated left at table with second figure leaning over his shoulder: on ground floor, three women holding children, man standing left, holding child in arms, girl standing left, man standing left, holding up child in arms. Obverse legend: *DIVA AVG FAVSTINA.* Reverse legend: *PVELLAE FAVSTINIANAE. BMCRE* 4: no. 324. BM, 1912,0607.199. ©The Trustees of the British Museum. All rights reserved.

In a few instances the epigraphic evidence may correlate acts of largesse with divine lineage. An inscription on a marble block from the people of Thasos, dated to the years 16–13 B.C.E., describes Julia, the daughter of Augustus, as *dia progonōn euergetis* (a benefactor in the midst of the ancestors), which could be read as a reference to the ancestral gods.[125] A marble base from Kos dedicated to Drusilla, the sister of Caligula, features a similar phrase—*APHRODEITĒ NEA . . . EUERGETIS EK PROGONŌN* (New Aphrodite, benefactor from the ancestors)—but connects Drusilla firmly with Aphrodite.[126] The inscription celebrates Drusilla as a benefactor, the successor of the ancestral Aphrodite in the current generation. Inscriptions referring to Drusilla as New Aphrodite are also found in Athens, Cyzucus, Mytilene, Miletus, and Magnesia on the Maeander.[127] A similar connection referring to lineage may be read in the inscription celebrating Julia as preeminent benefactor in the midst of the ancestors. Monuments to *progonoi* (ancestors) had a long history in the Hellenistic world.[128] They commemorated families, often underscoring links to divine predecessors. The dedications to Julia and Drusilla can be read as a Roman iteration of *progonos* monuments, in which the imperial women received honors as ancestral benefactors by assimilation to Venus, the divine mother of the imperial family.

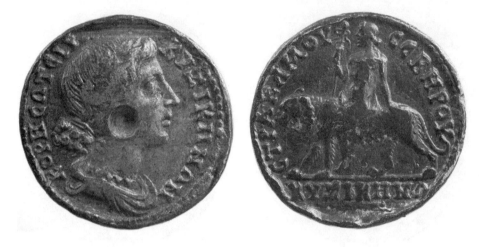

FIGURE 47

Coin of Cyzicus, ca. 170–80, bronze. Obv.: Kora Sōteira (Savior) with the features of Faustina II. Rev.: Nude Dionysus (youthful) seated on panther, holding thyrsus, resting arm on panther. Obverse legend: *KORĒ SŌTEIRA KYZIKĒNŌN*. Rev. legend: *STRA KAMOU SEVĒROU KYZIKĒNŌ[N]* (tooled). Photo credit: Roman Provincial Coinage Online, no. 9692, the Ashmolean Museum, at http://rpc.ashmus.ox.ac.uk/.

By contrast, the dedication from the base for a statue of Agrippina the Younger, the mother of Nero, implies a specific favor. It celebrates her as *euergetis tou damou* (benefactor of the people [of Kos]).[129] Similarly, a marble base in Mytilene (Lesbos) proclaims Julia I as *euergetis* on account of her service and goodwill toward the city.[130] Antonia Minor, Statilia Messalina, Domitia, Matidia Minor, and Sabina also received the epithet *euergetis*, in some cases linking them to Ceres.[131] That epithet is connected with the idea of saving in an inscription from Athens celebrating Statilia Messalina, the wife of Nero, as *sōteira kai euergetis* (savior and benefactor). The epithet *sōtēr* was used for emperors, often paired with *ktistēs* (founder) or *euergetēs*, but I know of only two instances of its use for an empress.[132] Both follow from assimilations to city goddesses. Kore Sōteira, the patron goddess of Cyzicus, appears in the likeness of Faustina II on bronze coins from that city.[133] The obverse of one of these coins shows a bust of Faustina wreathed with corn and wearing a necklace and the legend *KOPH ΣΩTEIPA KYZIKHNΩN* (Kore Savior; "of the citizens of Cyzicus") (fig. 47). In the second instance, Athens honored Julia Domna with cultic honors as *sōteira* of Athens in her joint cult with Athena Polias.[134] By the beginning of the third century the title *euergetis* no longer referred to empresses—very likely as a result of the civil wars, and the general decline in the fortunes of cities.

THE EMPRESS AS THE PROGENITOR AND FOUNDER

The Romans continued to celebrate the generative powers of empresses by assimilating them to deities and associating them with goddesses. Venus, particularly in her ancestral

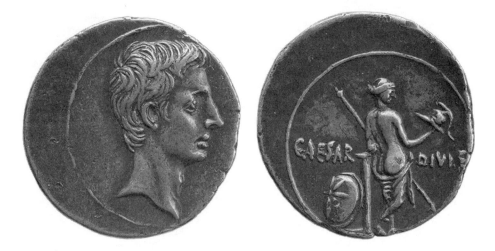

FIGURE 48

Denarius of Augustus, 32–29 B.C.E., silver. Obv.: Head of Octavian. Rev.: Venus, half-draped and standing turned right, leaning against column and holding helmet in right hand and transverse scepter in left; to left against column, shield on which is an eight-rayed star. Reverse legend: *CAESAR DIVI.F.* *BMCRE* I: no. 599. BM, R6150. ©The Trustees of the British Museum. All rights reserved.

role, was referred to frequently in relation to empresses, as was the case with Livia. An inscription from Eresos, on Lesbos, identifies Augustus's daughter, Julia, with Venus. This inscription probably dates to the time when Gaius and Lucius, being groomed to succeed Augustus, were consistently presented as descendants of Venus.[135] The inscription, from a two-meter-long block that must have belonged to a temple, reads: *IOULIA KAISAROS THUGATRI APHRODITĒ GENETEIRA* (to Julia, daughter of Caesar, Venus Genetrix).[136] Another inscription, on a pedestal at Ilium, referred to Livilla, wife of Drusus, as *APHRODEITĒ AGNEISIAS* (Aphrodite of Anchises—another way of saying Venus Genetrix). This particular assimilation may have been connected to Livilla's having given birth to twin boys, in 19 C.E.[137]

Venus was honored as the ancestral goddess of every emperor's family even after the end of the Julio-Claudian dynasty.[138] As Venus Victrix and Venus Genetrix, she was the female deity featured most commonly on imperial coinage, and, with the exception of Victoria/Nike, the one whose image endured longest on coinage.[139] Images in which Venus holds the arms of Mars appeared first on the coinage of Augustus (fig. 48), and although those coins lack an identifying legend, their iconography has been associated with Venus Victrix.[140] Venus Genetrix usually holds an apple. From the time of the Antonines, however, representations of the goddess as *genetrix* and *victrix* became iconographically very similar, implying a connection between Venus's roles as mother and as victory bringer.[141]

but had specifically been connected to them?

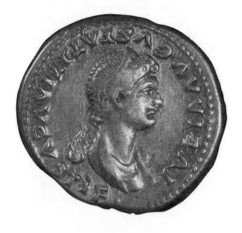

FIGURE 49

Denarius of Julia Titi, daughter of Titus, silver, 80–81. Obv.: Bust of Julia Titi, draped and diademed, with hair in long plait. Rev.: Venus standing to r., leaning on column, holding helmet and in r. hand and spear in l. arm. Obverse legend: *IVLIA AVGVSTA TITI AVGVSTI F.* Reverse legend: *VENVS AVGVST. BMCRE* 2: no. 55a. H/AM, Purchase through the generosity of Celia and Walter Gilbert, Claude-Claire Grenier, and the Marian H. Phinney Fund, 2005.115.118. Imaging Department © President and Fellows of Harvard College.

Venus was represented on the coinage of many empresses (figs. 49–51). Her dual role as military deity and progenitor is illustrated by the coinage of Julia Domna, whose titles formally recognized her as a female progenitor of the land. Because Julia's coinage was iconographically the same as that of other empresses, it can be used as an interpretative template. Julia's early coins depict her as both Venus Genetrix and Venus Victrix (fig. 50),[142] evidence that the new dynasty, of which Julia was the matriarch, wished to assert its legitimacy.[143] Julia, the wife of Septimius Severus, was the mother of his two sons and successors, Caracalla and Geta, assuring, with their birth, the continuity of the dynasty. Thus the whole empire depended in a sense on the empress's fecundity. It is no coincidence that the titles, bestowed on Julia later in her reign, presented her as a female progenitor. She was *mater augustorum, mater senatus, mater patriae* (mother of the Augusti, mother of the senate, mother of the fatherland), and *mater castrorum* (mother of the military camps) (fig. 45).[144]

The empresses' association with Venus on coins lasted until Fausta, Constantine's wife. She appears paired with an enthroned Venus Felix, Happy Venus, Venus who brings good fortune (fig. 51). Venus Felix recalled the enormous temple Hadrian designed and dedicated in Rome, next to the Colosseum, to Venus Felix and Roma Aeterna in 121 c.e. (map 3).[145] The temple brought new momentum to the notion of Venus as a founder and a patron goddess of Rome. With it appeared the new epithet of Venus, *felix*. This temple housed a silver statuary group of the empress Faustina II and her husband, the emperor Marcus Aurelius, shown as incarnations of Rome's founding gods Venus and

FIGURE 50

Aureus of Julia Domna, Rome, 193–96 (?), gold. Obv.: Bust of Julia Domna, draped. Rev.: Venus Victrix, standing, back turned, head right, drapery falling below hips, resting left arm on a column, holding apple in extended right hand and palm branch in left hand. Obverse legend: *IVLIA DOMNA AVG.* Reverse legend: *VENERI VICTR. BMCRE* 5: no. 424. H/AM, Gift of C. Ruxton Love, Jr., 1956.22.2. Imaging Department © President and Fellows of Harvard College.

FIGURE 51

Follis of Fausta, Trier, 307–8, bronze. Obv. Bust of Fausta, left. Reverse: Venus enthroned holding palm frond in left hand and globe? in right hand. Obverse legend: *FAVSTAE NOBILISSIMAE FEMINAE.* Reverse legend: *VENVS FELIX;* TR. BM, B.498. *RIC* 6 Constantine 756. ©The Trustees of the British Museum. All rights reserved.

FIGURE 52

As of Faustina II. Reverse: Venus and Mars, 161–76, bronze. Obverse: Draped bust of Faustina. Reverse: Venus, naked to waist, with both hands grasping r. arm of Mars, helmeted, holding round shield on l. arm and parazonium just below shield. Obverse legend: *FAVSTINA AVGVSTA*. Reverse legend: *VENERI VICTRICI*; SC left and right field. *BMCRE* 4: no. 999. H/AM, Transfer from Harvard College Library, 1976.40.468. Imaging Department © President and Fellows of Harvard College.

Mars, respectively.[146] A statue from Ostia may be a copy, and coins and medallions of Faustina II probably feature it on their reverse (fig. 52).[147] The statue represents Venus gently embracing Mars. It was a tradition for newly wedded couples to take their oaths in front of this statue, which owed its attraction to the positive associations of the gods, including their great personal appeal and their role in Rome's founding. The statue recognized the emperor as a new Mars, and the empress as a new Venus, in the sense that they were progenitors of the Roman people.[148] The fecundity of Faustina, who gave birth to thirteen children, most certainly aided this image of the imperial couple as progenitors.[149] If this hypothesis is correct, then the marriage oath common in Egypt, *epi Ioulias Sebastēs* (literally, "on Iulia Augusta," understood as "in the presence of Iulia Augusta"), may have invoked Livia as a patron of marriage because of her role as the progenitor of the imperial family,[150] a new Aphrodite, *princeps generis*, a *Romana princeps*.

By joining Venus Felix to Fausta, the Constantinian coin thus evokes the founding gods of Rome and Fausta's own role as the new female founder of the realm, who would bring a blessed new era of prosperity (fig. 51). In another instance, a painting mentioned in an oration, Fausta is assimilated to Venus presenting Constantine with a helmet.[151] This picture linked Fausta's marriage to Constantine with her conferring on him the *imperium* (as the daughter of the more senior emperor) and holding promise that the empire would continue.[152] In other words, Fausta-Venus embodied the promise of both Venus's aspects, *victrix* and *genetrix*.

The practice of naming cities after imperial women and associating cities with civic deities expressed the notion that empresses were the female progenitors of those cities and by extension their patron deities. Liviopolis, a city situated in the Pontus, belongs to the first category.[153] Herod Antipas first gave the name Livia to a city in Judea, later changing it to Julia.[154] Either the emperor or the empress herself or a local ruler could initiate such a naming. Cities named by an emperor include Plotinopolis (named for Plotina, wife of Trajan), two cities named Marciana (for Trajan's sister), and Faustinopolis (named after Faustina II).[155] Colonia Agrippinensis, named for Agrippina, the fourth wife of Claudius and the mother of Nero, falls into the third category, as does the city Iulias, named after Augustus's daughter, Julia.[156] In the period between Faustina II in the second century and Helena in the early fourth century, two other empresses were honored with cities named for them—Julia Domna and Cornelia Salonina, wife of Gallienus. Julia Domna gave her name, Iulia Augusta Pia, to the colony of Heliopolis; Leptis Magna adopted the epithet Saloniana.[157] The naming of a city after a member of an imperial family member has been interpreted as a mark of prestige and as an expression of thanks to the dedicatee.[158] That naming also recognized the imperial figure as the city's founder. Thus Livia, Plotina, Marciana, Faustina, Agrippina, Julia Domna, and Salonina did not simply lend their names to cities. They were—like Arsinoë, Amastris, and other Hellenistic queens before them—founders of the cities that bore their names. The empress who founded a city, then, was recognized as participating symbolically in the founding/renewing of the empire.

Assimilations to various patron goddesses of cities, such as Tyche/Fortuna, likewise conveyed the idea of founding.[159] The addition of a turreted crown and the horn of plenty to the portrayal of an empress suggested the Tyche's qualities—as in the mural crown on a head of Messalina (fig. 53),[160] and in a horn of plenty on the coins of Plautilla from Aegina and Sicyon.[161] Domitilla received a dedication as Tyche of Tanagra, in Boeotia, and was probably represented as Tyche on coins of Domitian from Alexandria inscribed TUCHE SEBASTĒ (Tyche Augusta).[162] Faustina I was also represented as the Tyche of Amastris, with a turreted crown, on a coin from that city (fig. 54).[163] Although the inscription on the reverse states simply SEBASTĒ, without giving the name of the Augusta, the portrait resembles Faustina's on their Roman coinage (fig. 46) so remarkably that it leaves no doubt which Augusta is imaged. Faustina II, the daughter of the elder Faustina, was called Tyche and Nike in an inscription from Marcianopolis (Moesia), and was named Tyche in an inscription on a portico from the island of Thera.[164] A bronze coin from Gerasa that pairs Faustina II with Artemis-Tyche shows the empress and goddess as mirror-images of each other (fig. 55). A coin from Nicaea in Bithynia likewise highlights Faustina's affinity to a Tyche by combining the empress's portrait on the obverse with Tyche's on the reverse.[165]

Julia Domna was another empress frequently assimilated to, and associated with, Tychai. On a coin of Septimius Severus from Laodicaea ad Mare, Domna's head appears on the reverse, within a distyle temple, as Tyche *Metropoleōs* (of the city [Troas]).[166] In an

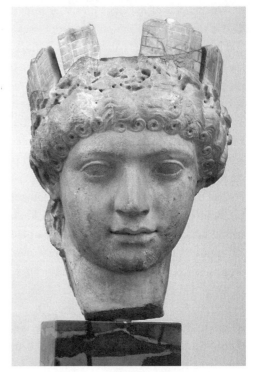

FIGURE 53

(right) Marble head of Valeria Messalina, first century C.E., 29.3 cm. Staatliche Kunstsammlungen, Dresden, inv. no. 358 Hm. Photo credit: bpk, Berlin / Staatliche Kunstsammlungen, Dresden / Art Resource, N.Y.

FIGURE 54

(below) Bronze coin of Faustina I, Amastris, ca. 139, BM. Obv.: Turreted, veiled, and draped bust of Tyche, head assimilated to portrait of Faustina I. Rev.: Nike/Victoria standing, holding Nike(?) and palm branch. Obverse legend: *AMASTRIS*. Reverse legend: *SEBASTĒ*. Photo credit: Roman Provincial Coinage Online, no. 4911, the Ashmolean Museum at http://rpc.ashmus.ox.ac.uk/.

Athenian inscription she is hailed as *Agathē* Tyche (Good Fortune).[167] Coinage of Caesarea, Damascus, Pautalia, and Smyrna combines Domna's portrait on the obverse with the Tyche of the city on the reverse,[168] and an inscription from Histria-Nicopolis in Moesia proclaims Domna "Tyche of the *oikoumenē* [the inhabited world]."[169] Such an honorific sums up the empress's official titles *mater senatus, castrorum, patriae* (mother of the senate, the army, the fatherland) in a different way. The appropriateness of pairing an

FIGURE 55

Copper alloy coin with Faustina II, ca. 145–76, Gerasa. Obv.: Bust of Faustina II. Rev.: Bust of Artemis-Tyche, draped, right, with quiver over shoulder. Obverse legend: FAUSTINA SEBASTĒ. Reverse legend: ARTEMIS TYCHĒ GERASŌN (Artemis Tyche of Gerasa) RPC 6611/1, BM, 1900,0707.39. ©The Trustees of the British Museum. All rights reserved.

empress and Tyche must have derived from the close notional links between Tyche's protection of cities and the empress as the protective mother of the realm.

Julia Domna was the only empress ever paired with the goddess Roma on imperial coinage. (Roma is otherwise shown exclusively on emperors' coinage, undoubtedly reflecting the goddess's militaristic role.) *Roma Aeterna* (eternal Rome), the cult statue of the temple of Venus and Roma, appeared on the reverse of Julia Domna's aurei and denarii, minted in the East about 193 (fig. 56).[170] On these coins Roma wears her characteristic helmet and holds a Victoria in her extended right hand and a scepter in her left. She sits on a shield. The choice of the unusual Roma on Domna's coins, like the images of Venus Victrix and Venus Genetrix, was most likely meant to affirm Domna's Romanness. It could not have been related to her later titles and building projects in Rome, because the legend IVLIA DOMNA AVG(VSTA) points to a date early in her reign. Similar coins were issued for the emperor.[171] The connection between an empress and the cult of Roma in Rome may anticipate Julia Domna's influence in matters of government.[172] Dio Cassius reports that during the reign of Caracalla, Julia was in charge of receiving petitions and Caracalla's correspondence in Greek and Latin, and that her name "in terms of high praise, together with [Caracalla's] and that of the legions" was included "in [the emperor's] letters to the senate, stating that she was well." Dio continues, "Need I add that she held public receptions for all the most prominent men, precisely as did the emperor?" (Dio Cass. 78.18.2–3). Overall, the empresses were associated with Tychai because that was an efficient way to present them as founders, benefactors, and protectors of cities.

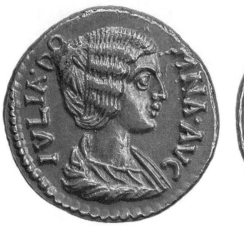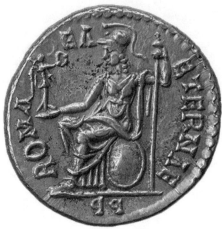

FIGURE 56

Aureus of Julia Domna with Roma Aeterna, Alexandria, 193–94 (?), gold. Obv.: Bust of Julia Domna, draped, head bare, facing right, hair waved in five horizontal ridges, large chignon at back. Rev.: Roma, helmeted, draped to feet, seated left on round shield, holding Victory on extended right hand and vertical scepter in left. Obverse legend: *IVLIA DOMNA AVG*. Reverse legend: *ROMAE AETERNAE*, two reversed *PP* in exergue. *BMCRE* 5: no. 333. BM, 1896,0608.41. ©The Trustees of the British Museum. All rights reserved.

DIVINE HONORS AND DEIFICATION

Of the three ways an empress was associated with the divine (assimilation, divine honors, and deification), assimilation to goddesses was most widespread, whether or not the senate named the empress Augusta. For instance, Valeria Messalina, third wife of the emperor Claudius, did not receive the title Augusta, yet a bronze coin from Nicaea in Bithynia calls her *Messaleina Sebastē Nea Hēra* (Messalina Augusta New Hera).[173]

Divine honors are rarer and in the Greek cities seem to have been related in some instances to actual favors and travel, and thus to have been more spontaneous than official deification.[174] Yet neither favors nor travel were prerequisites for receiving them. The cult of Livia at Gytheion was tied to the help she gave the city.[175] Valeria Messalina was linked to the cult of the local goddess of Nicaea, Demeter Karpophoros.[176] Other imperial women whose cultic honors were linked to those of civic deities include Julia Livilla and Julia Domna. Julia Livilla was the daughter of Germanicus and one of Caligula's sisters. As a new Nikēphoros, she was synthronos, or temple sharer, with Athena Nikēphoros and Athena Polias in Pergamum.[177] Julia Domna's joint cult with Athena Polias at Athens, established in thanks for Domna's assistance to an Athenian ambassador, was clearly tied to a concrete benefaction.[178] Gratitude was undoubtedly a chief motive for paying divine respects to Domitia, the wife of the emperor Domitian. A freedman of Domitia built a temple in Gabii in her honor, giving a donation of ten thousand sesterces on the condition

that a celebration be held annually on Domitia's birthday.[179] Livilla's cultic honors, as well as those conferred on Claudia Antonia, the daughter of Claudius, who had a priestess in Attaleia, could be attributed to existing traditions, namely the imperial cult at Pergamum and Livia's cult at Attaleia.[180] Neither Livilla nor Claudia was an Augusta.[181]

In these examples the awarding of divine honors could be ascribed to benefaction and tradition. But traveling was another important factor. Empresses who traveled were assimilated to divinities and received divine honors more frequently, perhaps because they personally bestowed their benefactions upon cities. Livia, the imperial woman with the most extensive record of assimilation to deities and divine honors, accompanied her husband on travels to Greece.[182] During the sojourn of Agrippina the Elder and Germanicus in Lesbos in 18 c.e., a coin was minted showing a bust of Germanicus on the obverse and Agrippina's bust on the reverse.[183] He was styled *Theos Germanikos* and she, *Thea Aiolina Agrippina*. Several inscriptions from that time refer to them as gods, associating Agrippina with Demeter.[184] One, a dedication from Lesbos refers to Agrippina as an *euergetēn gu[naika]*, a woman benefactor.[185] Statilia Messalina's honors as a goddess can also be connected to her husband Nero's trip to Greece.[186] The imperial *adventus*, or arrival, of Hadrian and Sabina in Alexandria in 130 c.e. occasioned the minting of a coin in which Isis and Serapis are shown greeting Hadrian and Sabina.[187] Alexandria issued coins of Sabina as Isis, Athena, and Eusebia, all dated to the years 130–31.[188] Julia Domna's travels similarly contributed to her numerous honors. A connection has been proposed between her coinage in Thrace and her travels through that region.[189]

In contrast to associations with the divine, the state honor of deification was closely monitored and influenced by the emperor and generally subject to dynastic and political goals. The senate's plan to deify Livia may be the only apotheosis that could be associated with a benefaction.[190] After Livia, merit, as defined for the first Augusta, became inconsequential. Family links (by blood or adoption) mattered much more. All the empresses who became state goddesses had a spouse or relative who reigned as emperor, most of whom would have benefited from a *diva* who was a close relation.[191] The first *diva* was Drusilla, the sister of Caligula. Caligula had named her heir to the empire during his illness in 37 c.e., an act interpreted as a desire to ensure the imperial succession through a future son of Drusilla.[192] Although her intended role was interrupted by her early death, Caligula's Roman temple in her honor and the placement of a colossal statue of her in the temple of Venus Genetrix evince her significance.[193] Claudius, by deifying Livia shortly after his accession, gained political capital and gave a sense of legitimacy to his rule, because Livia was his paternal grandmother.[194] He attempted to boost the prestige of his own lineage by offering a tribute to his female ancestor, a woman once presented as Venus Genetrix. The Flavian women were deified for similar reasons.[195] Similarly, Trajan and Plotina, the deified parents of Hadrian, helped the emperor construe himself as Trajan's legitimate successor (fig. 57).[196]

Although the senate initiated the motion for deification—a gesture that could be seen as the highest thanks to the empress for her lifetime's works—the decision to deify

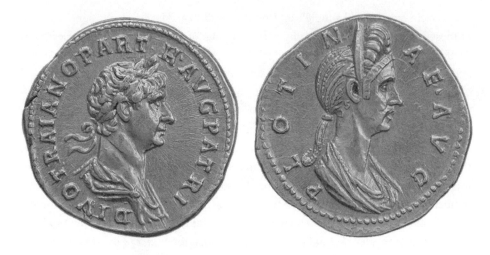

FIGURE 57

Aureus of Hadrian with Divus Traianus and Plotina Augusta, 117–18, gold. Obv.: Bust of Trajan, laureate, draped and cuirassed. Rev.: Bust of Plotina, draped right, hair in double *stephanē* on top and in queue at back. Obverse legend: *DIVO TRAIANO PARTH AVG PATRI*. Reverse legend: *PLOTINAE AVG*. BM, R.8041. *BMCRE* 3: no. 50. ©The Trustees of the British Museum. All rights reserved.

depended on the reigning emperor. That dependence is evident in the case of Livia, who was deified only under Claudius. Other examples of the emperor's agency in the process include Agrippina II, the unfortunate mother of Nero, who was assassinated on her son's orders, and accused posthumously of treason; Domitia, who outlived her husband Domitian; and Julia Soaemias and Julia Mamaea, whom mutinous troops killed, along with their respective sons Elagabalus and Alexander Severus.[197] In other cases empresses received *damnatio memoriae* (erasure of their memory).[198] The crisis of the third century, characterized by short reigns, wars, and the diminished political significance of the senate, seems to have precipitated the demise of the whole institution. The final blow came with the adoption of Christianity. But as we will see, the empress and the imperial family continued to emphasize a special relationship with the Christian god and his mother that imparted to them a status above ordinary mortals.

THE FOUNDERS' IMAGES

The titles *mater patriae* and *pater patriae* signify complementary roles modeled on the Roman idea of the family, whereas *Augustus* and *Augusta* imply an analogous standing with respect to the sacred and to city founding. Each pair of distinctions indicates a whole of two partners, an emperor and an empress. This notion of imperial power, as constituted by a godlike male progenitor and a godlike female partner, was expressed most eloquently in the pairing of the Augustus and the Augusta on coinage and in other media and by

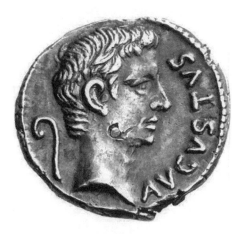

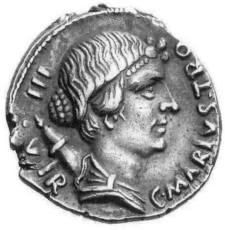

FIGURE 58

(above) Denarius of Augustus, 13 B.C.E. Obv.: Bare head of Augustus. Rev.: Bust of Diana wearing diadem with jewel on forehead, hair knotted at back; quiver seen behind neck. Obverse legend: *AVGVSTVS*. Reverse legend: *III VIR C MARIVS TRO. RIC* I Augustus 633. Photo credit: Courtesy of Jürgen Malitz and the Numismatische Bilddatenbank Eichstätt.

FIGURE 59

(left) Head of Livia, ca. 31 B.C.E., basanite, Musée du Louvre, Paris, MA 1223. Photo credit: Gianni Dagli Orti / The Art Archive at Art Resource, N.Y.

the association or assimilation of the Augusta to goddesses with powerful male partners, to whom the emperor was often assimilated.

Joint portraits on coinage, though minted sporadically, are common enough to suggest a widespread diffusion of the idea that a male ruler needed to have a female counterpart of certain complementary qualities. The joint portraits appeared first on Augustan coinage. A denarius of Augustus, dated to 13 B.C.E., the year the Ara Pacis was vowed (fig. 58), is an early example. The obverse shows Augustus with an augural staff, the reverse, the goddess Diana with her bow case. Although this goddess has been traditionally identified as bearing the facial features of Julia (Augustus's daughter and the mother of his grandsons),[199] Livia is more likely for iconographic reasons and family connections. The nodus at the top of the head (a plait folded over the head) and the bun at the nape of the neck are characteristic of Livia's portraits (fig. 59). In one variant of the series, the woman's face features an aquiline profile like that of Livia. Other coins from Augustus's reign that show Augustus and Livia together as a couple support the identification as Diana-Livia: those from mints in Ephesus;

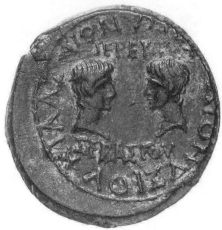

FIGURE 60

Coin of Magnesia ad Sipylum (Lydia) with Augustus and Livia and Gaius and Lucius Caesar, 2 B.C.E. Obv.: Jugate laureate head of Augustus and draped bust of Livia. Rev.: Confronted heads of Gaius and Lucius Caesar. Obverse legend: SEBASTOI (Augusti) MAGNĒTES APO SIPULOU. Reverse legend: DIONYSIOS DIONYSIOU KILAS IEREUS SEBASTOU (Dionysius Kilas, son Dionysius, priest of Augustus). RPC 2449. Photo credit: Courtesy of Jürgen Malitz and the Numismatische Bilddatenbank Eichstätt.

but the adoption initiated the process?

Smyrna; the coins of King Rhoimetalkes of Thrace; the Bithynian coins of the proconsul Granius Marcellus; the coins of Magnesia ad Sipylum (fig. 60), and the coins from Alabanda where the couple is shown facing each other and labeled *Sebastoi*.[200] There are joint portraits also from Tiberius's reign (see figs. 40–42). They likewise emphasize the complementarity between Augustus and his wife: Sol-Luna (fig. 35), *Theos Sebastos–Thea Sebastē* (fig. 61).[201] After Livia's deification, coins that commemorate it paired Divus Augustus with Diva Augusta (fig. 43). The statue of the new goddess was placed alongside that of her husband in his temple. Coins minted on the occasion of the temple's repair show the two statues of the *divus* and the *diva* enthroned in the cella (fig. 62).

The other reason for preferring Livia as the woman paired with Augustus as augur in the coin from 13 B.C.E. is family hierarchy. Portraits of Livia and Julia are similar.[202] And yet, in the logic of family obligations, the most important bond was the one between the husband and wife.[203] For instance, when Roman authors wanted to differentiate the nuclear family from the *domus* (the entire household), they used the expression *uxor liberique* (the wife and the children).[204] Through the lens of this hierarchy, in 13 B.C.E., Augustus's core family unit with Livia, his *uxor* (though not yet a Julian), would have been more important than Julia, his daughter.

The pairing of Augustus as augur with Diana, alluding to both Livia and Luna, should be understood as an early, cautious formulation of the idea of a female founder and the notion of imperial immortality in the association of Sol and Luna. This idea is fully realized more than two decades later on the Colonia Romula coin, which paired the deified

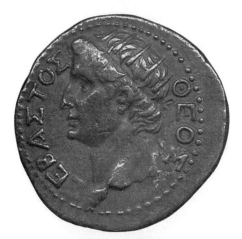

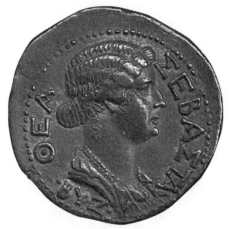

FIGURE 61

(above) Silver coin, Byzantium, 20–29(?). Obv.: radiate head of Augustus. Rev.: Bust of Livia, draped. Obverse legend: SEBASTOS THEOS. Reverse legend: SEBASTA THEA; BYZ in exergue. RPC 1779. BM, 1872,0709.34. ©The Trustees of the British Museum. All rights reserved.

FIGURE 62

(left) Sestertius of Antoninus Pius commemorating the restoration of the Temple of Augustus and Livia, 158–59. Obv. (not shown): Laureate head of Antoninus Pius. Rev.: Octastyle temple on podium of four steps, with two statues in front; in the center of the temple are two seated figures. Obverse legend: ANTONINVS AVG PIVS P P TR P XXII. Reverse legend: TEMPLVM DIVI AVG REST; SC; COS IIII in exergue. BMCRE 4: no. 2063. BM, R.13878. ©The Trustees of the British Museum. All rights reserved.

Augustus, who wears a solar crown, and Livia/Luna, the *genetrix orbis,* shown with a moon crescent (fig. 35). The symbols of the Sun and the Moon stood for eternity; at the same time, Sol and Luna were assimilated to Apollo and Diana.[205] In the Romula coin, the imperial pair, the god Augustus (assimilated to Sol) and the Luna-like Iulia Augusta signify eternity. But the iconography from 13 B.C.E. is less explicit. The augural staff alludes to Romulus's founding following the faithful augury. The reverses of some coins show the princeps ploughing, and the obverse depicts Augustus with the implements of augury (see figs. 19–20). By pairing the Apollo-like augur Augustus with the Livia-like Diana, the image subtly conveys the dawning of an eternally lasting new era.

The gold aurei and silver denarii of the emperor Nero from the years 64–66 C.E. communicate a similar message with the legend AVGVSTVS-AVGVSTA and through iconography (fig. 63).[206] The obverse depicts a head of Nero facing right. The reverse represents a male togate figure with a radiate crown, with patera in his right hand and a long scepter in his left. Other examples of Neronian coinage help identify this figure as Nero (fig. 64). The Augusta standing side by side to him is either Poppaea or Messalina (fig. 63).[207] Like Nero's

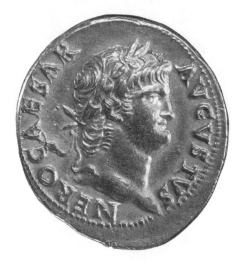

FIGURE 63

(above) Aureus of Nero, 64–65, gold. Obv.: Head of Nero, bearded and laureate, right. Rev.: Nero, radiate and togate, holding patera in right hand and long scepter in left, standing left beside empress (on his right), veiled and draped, holding patera in right hand and cornucopia in left. Obverse legend: *NERO CAESAR AVGVSTVS*. Reverse legend: *AVGVSTVS AVGVSTA*. *RIC* I Nero 44. BM, 1864,1128.248. ©The Trustees of the British Museum. All rights reserved.

FIGURE 64

(right) Aureus of Nero, 64–65, gold. Obv.: Laureate head of Nero (not shown). Rev.: Nero with radiate crown, standing, holding a laurel branch and Victory on globe. Obverse legend: *NERO CAESAR*. Reverse legend: *AVGVSTVS GERMANICVS*. *BMCRE* I: no. 56. Photo credit: Courtesy of Jürgen Malitz and the Numismatische Bilddatenbank Eichstätt.

crown of solar rays, she carries attributes associated with deities: in her left arm, a double cornucopia, in her right, a patera. Her iconography recalls that of Arsinoë II Philadelphos as a beneficent goddess.[208] The reverses of Arsinoë's coins also uniformly featured a double cornucopia (see figs. 5 and 9). Nero and the Augusta—endowed with the qualities of gods—ensured the eternity of the realm; he, like the rising sun, brought renewal to the land; she ensured its fertility. That these ideas were not just allegories aiming at presenting the imperial couple in the best possible way is attested by an inscription from Acraephia (Karditza) in Greece. It records Nero's decree bestowing freedom from taxation for all Greece, and the letter in response sent by the citizens of Acraephia. The text calls Nero "lord of the entire world," "father of the country and a New Helios (Sun)"; it styles Messalina "Goddess Augusta Messalina." The city decided to erect statues of Nero and Messalina in the cella of Apollo Ptois, worship Nero, and honor the imperial family with "every honor and piety"[209]

In later centuries pairings of the sunlike Augustus and the moonlike Augusta are found on coins of Hadrian and Sabina and in images of the Severan dynasty.[210] On one

FIGURE 65

(left) Aureus of Caracalla, 201, gold. Obv. (not shown): Head of Caracalla. Rev.: Jugate heads of Septimius Severus shown with a radiate crown like Sol and Julia Domna with a crescent as Luna. Reverse legend: *CONCOR-DIAE AETERNAE*. *RIC* 4/1 Caracalla 52. Photo credit: Courtesy of Jürgen Malitz and the Numismatische Bilddatenbank Eichstätt.

FIGURE 66

(below) Cistophoros of Claudius and Agrippina, Ephesus, 50–51, silver. Obv.: Laureate head of Claudius. Rev.: Bust of Agrippina II. Obverse legend: *TI CLAVD CAESAR AVG P·M· TR·P·X·IMP XIIX*. Reverse legend: *AGRIPPINA AVGVSTA CAESARIS AVG*. *RPC* 2223. Photo credit: Courtesy of Jürgen Malitz and the Numismatische Bilddatenbank Eichstätt.

exceptional coin of Caraccala, the older son of Septimius Severus and Julia Domna, father and mother, styled as the Sun and the Moon, are shown jugate with the legend *CONCORDIAE AETERNAE* (*FIG.* 65). The poet Oppian saw the imperial pair similarly. Severus was "light of the warlike, much-loved, sons of Aeneas"; Julia Domna personified the "Assyrian Cythereia" (Venus) and "the uneclipsed moon."[211] Besides these Sun-Moon pairings, the Augustus and the Augusta appear together on other coins from Rome and the provinces, the emperor on the obverse, and the empress on the reverse (figs. 66–68).[212]

Roman provincial coins were not minted regularly, with the result that not all emperors and empresses were featured in those issued.[213] Provincial coinage lacked the chronological sequence that characterized the Roman mint, and women were depicted less often in it than men. In some instances, the iconography of the provincial examples was influenced by the imperial mints, but modified it. This is the case with a bronze coin from Thessalonike that represents Tiberius on the obverse and a bust of Livia on the reverse.[214] The coin is reminiscent of the popular series of Tiberius with the seated Livia

FIGURE 67

Aureus of Domitian and Domitia, 82–83, gold. Obv.: Head of Domitian, laureate. Rev.: Bust of Domitia, draped, right, hair massed in front and in long plait behind. Obverse legend: *IMP CAES DOMITIANVS AVG P M*. Reverse legend: *DOMITIA AVGVSTA IMP DOMIT*. *RIC* 2/1 Domitian 148. BM, R.10758. ©The Trustees of the British Museum. All rights reserved.

FIGURE 68

Aureus of Caracalla and Plautilla, 202, gold. Obv.: Laureate, draped and cuirassed bust of Caracalla. Rev.: Draped bust of Plautilla. Obverse legend: *ANTON P AVG PON TR P V COS*, Reverse legend: *PLAVTILLAE AVGVSTAE*. *RIC* 4/1 Caracalla 66. Photo credit: Courtesy of Jürgen Malitz and the Numismatische Bilddatenbank Eichstätt.

on the reverse. By contrast, the mint of Thessalonike had chosen to show a bust of Livia with *Sebastē*, Greek for the title Augusta. In some places, such as Ephesus, it was traditional to show the Augustus and Augusta on the same coin (fig. 66).[215] The reverse of most of these Ephesian coins was typical in representing emblems of the cult of the Ephesian Artemis, such as stags, bees, and the goddess's cult statue.[216] One reverse, however, departed from this practice by making an explicit connection with Rome. The reverse of a coin with busts of Nero and Poppaea on the obverse shows a bust of Roma, turreted, and the legend *Romē* (Rome), sometimes above a bee.[217] The iconography portrays Nero and Poppaea as co-rulers of Rome. Another coin, with Claudius and Agrippina II, envisages the imperial union as a *theogamia* (theogamy), a marriage between gods.[218] Other mints similarly paired the male and the female founder of the land.[219]

In most of these examples the women occupy either the background, as in a jugate image, or the position at right, when they face the emperor, to indicate their lower status. Status is similarly connoted when the emperor appears on the obverse and the empress on the reverse.[220] There are exceptions to this rule in civic coinage, however; some coins give the place of honor to the woman. The reversal of priority can be seen on two related examples of the Antonine period, from Caesarea in Samaria. The first one shows a bust of Faustina II on the obverse, and Marcus Aurelius, veiled and sacrificing, on the reverse. A similar issue pairs Lucilla with the emperor Verus, who, on the reverse, veiled and togate, pours a libation on an altar.[221] In both instances, the precedence of the woman reflected a preeminence in rank. Faustina became Augusta before her husband Marcus Aurelius was Augustus, and the imperial succession was ensured through her. Marcus Aurelius reputedly stated that he would lose the *imperium* if he repudiated her.[222] In the second instance the priority of Lucilla may have reflected Verus's entry into the imperial family as the adopted son of Antoninus Pius. Engaged first to his daughter Faustina II (in 138), Verus then married his granddaughter Lucilla (ca. 161).[223]

The particular gendered understanding of imperial authority implied in the title Augusta and the pairing of the imperial couple on coins can also be seen in statue dedications, most clearly those of statues representing an emperor and an empress together, or the empress with other Augusti, not simply the imperial family. Such dedications emphatically emphasize that the empress deserved honors similar to those of the emperor and the other Augusti. An important study has collected evidence of such monuments for the Julio-Claudian period.[224] Among representative examples of pairings from the following period are the silver statues of Faustina II and Marcus Aurelius in the temple of Venus and Roma in Rome, and the statues of Plotina and Hadrian in Philippi, Macedonia.[225]

Modeling imperial authority after the notion of a male and a female founder can also be seen in the bestowal of divine honors and commemoration and the temple sharing. Here the paramount example is of Divus Augustus and Diva Iulia Augusta, whose statues as divi stood side by side in the Temple of Divus Augustus. Other include the cult at Gytheion in honor Divus Augustus, Tiberius and Livia; the divine honors offered Nero

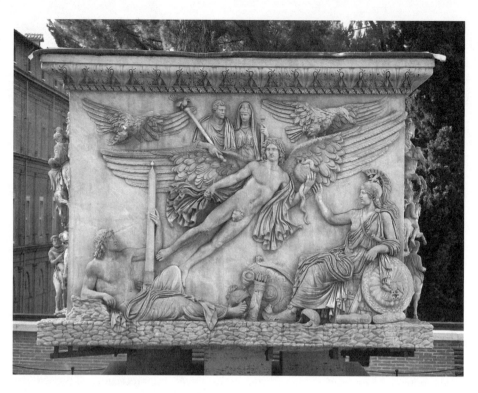

FIGURE 69

Apotheosis of Antoninus Pius and Faustina, Rome, 161, marble relief, 247 cm., detail from the base of the Column of Antoninus Pius, Vatican Museums, Vatican. Photo credit: Album / Art Resource, N.Y.

and Messalina in Acraephia; and the cult to Septimius Severus and Julia Domna in Athens.[226] In Rome, at the Roman Forum stood the Temple of the Divus Antoninus Pius and Diva Faustina. The Column of Antoninus Pius depicts the same couple, shown ascending to heaven together, even though Faustina died and was made diva before Antoninus (fig. 69).

Empress and emperor as paired founders were also represented as assimilated to paired gods, for example, Juno and Jupiter and Venus and Mars. The Augusta is compared to Juno, the queen of the gods and partner of Jupiter, in her aspect as *lucina* (protector of maternity) and as *regina* (queen). Associations to Juno/Hera reinforced an empress's position as the mother of the fatherland.[227] Livia and the empresses who followed were consistently assimilated to Juno/Hera,[228] most significantly when Livia and Augustus appeared as Juno and Jupiter—for example, in Ovid's poetry, where Livia is addressed as Juno, and Augustus is called Jupiter.[229] Later imperial couples continued to be associated with and/or assimilated to Juno and Jupiter in coinage, statues, and inscriptions that include dedications to Hadrian *Olympios* (Olympian), implying Zeus, and Sabina *nea Hēra Sebastē* (new Hera Augusta), and another dedication, in a temple, to

Jupiter Optimus Maximus Septimius Severus and Juno Regina Julia Domna.[230] Busts of Antoninus Pius and Faustina I on two sculpted roundels were supported by the token animals of Jupiter and Juno, an eagle and a peacock.[231]

Evidence of empresses and emperors depicted together and/or associated with Juno and Jupiter has been interpreted as a sign of spousal, familial, and dynastic harmony, and as a model for imitation.[232] Although all these nuances are certainly present in the images, the pairings suggest something more consequential. They envisage two constituents of imperial authority, a male and a female part, belonging to a father and a mother of the fatherland. In this vision, the empress is more than an amiable spouse or mother of imperial successors. She is the mother of the empire itself.

Livia's honors served as the template for all the mothers of the fatherland who followed. By closely associating the empress with deities, either through appropriation of divine attributes, incorporation of divine epithets into the empress's name, or cultic honors, these honors had important consequences for imperial iconography more generally. One must understand the impetus for these honors within the gendered discourse of imperial founding in order to appreciate the crisis in female imperial iconography precipitated by the adoption of Christianity.

CHRISTIAN TRANSFORMATIONS

4

THE CHRISTIAN FOUNDERS
CONSTANTINE AND HELENA

The Ambrosian aition of the Christian empire with which this book began dwells in the shadow of an earlier and more famous founding story. Eusebius finished his *Life of Constantine* shortly after the emperor's death.[1] In this account, a cross-shaped celestial vision with a sign "By this conquer!" and Christ's appearance in a dream before the Battle of the Milvian Bridge made Constantine a believing Christian.[2] Eusebius recognizes Helena's piety and authority elsewhere in the text, but the Augusta had no role in the empire's conversion.[3] Divine guidance and Constantine's pious resolve steered the emperor and empire toward Christianity. Modern histories of Constantine's conversion and of the beginnings of the Christian Roman Empire have been written from a Eusebian point of view. After all, Eusebius knew Constantine and wrote with the authority of a well-placed contemporary, directly informed by the emperor himself (*VC* 1.28). Therefore, though keenly aware of the many flaws in Eusebius's *Life of Constantine* as a historical source,[4] scholars have not questioned the bishop's insistence on a single male founder. Few exceptions aside, Eusebius's narrative of a Christian vision still remains central to interpreting Constantine's self-presentation and convictions.[5]

It is time to reevaluate Eusebius's narrative. We should resist its hermeneutical pull and refuse to foreground Constantine's Christian vision and conversion as an interpretative lens to the emperor's public image. The approach taken here is to consider Eusebius's testimonies as one source among many; forceful and informative, but deeply flawed. Eusebius's view of Constantine needs to be evaluated alongside other textual, visual, and epigraphic sources, as well as the built environment in Rome

and in Constantinople, all the while keeping in mind the ideas and biases each piece of evidence brings into the picture. Broadly, the available evidence can be classified into two types: how others saw Constantine and how Constantine presented himself. The first category includes Christian writers, such as Eusebius, and pagan orators, such as the anonymous panegyrist from Gaul who wrote a speech of praise for Constantine in the year 310. The second category of sources includes imperial coinage, honorary portraiture, Constantine's own or claimed contributions to urban development and the built environment, and the emperor's writing.[6] Studying the evidence aware of the categories to which it belongs helps us see Constantine's public image as profoundly traditional. Eusebius's novel story of a Christian vision right before the Battle of the Milvian Bridge stands as an outlier. At the same time, the evidence draws attention to Helena. Her responsibilities, if duly noted by Eusebius were unusual. But we must look to Ambrose (though he was not yet born when Constantine died), not Eusebius, to understand why Constantine stayed home while Helena toured the Christian Holy Land, commissioning churches.[7] Ambrose, not Eusebius, elucidates why the bishops, assembled in 451 for the Council of Chalcedon, hailed Pulcheria and Marcian as "New Helena" and "New Constantine."[8] Finally, we must look to Ambrose, not Eusebius, to understand why Constantinople was filled with statues dedicated to Helena, and to Helena and Constantine together.[9] Why such honor for Helena if, as Eusebius insisted, Constantine was the sole worldly author of the empire's conversion?

This chapter examines how Constantine transformed the discourse of imperial founders that Augustus had bequeathed to later emperors. He did so, first, by introducing a new imperial ancestral myth and religion and, second, by empowering Helena. To apply a linguistic analogy, Constantine's transformation with respect to religion was lexical, with respect to gender it was grammatical.

TRADITION AND INNOVATION IN CONSTANTINE'S PUBLIC IMAGE

Although Constantine and Helena planted the seeds of profound late antique transformations in the discourse of imperial founding, the tradition mother and son inhabited and worked with—of imperial presentation, buildings, and honors—originated with Augustus. Centuries separate Augustus from Constantine, yet the anonymous rules of the discourse of imperial founding that animated material culture and the built environment exhibited remarkable consistency. This consistency allowed for contingencies and for variations. There were good emperors, such as Trajan, Hadrian, and Marcus Aurelius, and despised ones, such as Caligula, Nero, Domitian, and Commodus. Periods of crises or peace, or a new dynasty, each colored the imperial message in differing ways.[10] Still, the key ideas about the emperor as a godlike founder of a new golden age, or about the reigning Augustus's fundamental virtues and qualities as well as the symbolic language that expressed them remained essentially the same.[11]

Overall, imperial honors (such as deification and periodic prayers for imperial well-being) and titles (such as Augustus and *pater patriae*) did not change. Imperial iconography, likewise, remained thematically the same, though over the long period there were changes in style and imperial fashions. During the entire pre-Christian period, empresses continued to be represented as fecund mothers, akin to recognizable goddesses.[12]

Constantine inherited this symbolic language of power and contributed to it. His debts are evident in his relationship with the divine, his religious and secular monuments, and his numismatic and other portraits. Consider first the gods. The emperor's reported visions—one of Apollo ca. 309–10, the other, in 312, before the Battle of the Milvian Bridge against Maxentius—continue a long tradition of emperors receiving divine signs, a tradition stretching back to Romulus and to Aeneas.[13] The specters of Romulus, Aeneas, and Augustus haunt Constantine's actions after he attained control of Rome in 312. Like his predecessors, he built a sanctuary to his patron god. In Roman historical memory, showing gratitude to one's victory god by building a temple went back to Romulus, who, according to Livy, established the first temple in the city, the temple to Jupiter Feretrius on the Capitoline Hill, after a victory over a neighboring king. In thanksgiving for the military triumph, Romulus deposited the spolia he had captured in war (Livy, 1.10) at the site where the temple would be built. Augustus followed that venerable custom, when after his triumph at Actium on the site of his camp he built a sanctuary to Apollo and founded the city of Nicopolis, or "Victory City" (Dio Cass. 51.1). The Constantinian Basilica (the present-day Basilica of St. John Lateran) rose on the site of the razed barracks of the imperial horse guards (who fought on the wrong side in the Battle of the Milvian Bridge) (map 4).[14] Though Constantine built a temple to a non-Roman and a non-Olympian god, and acted more like a universal bishop to the Christian Church, he still continued to hold the title *pontifex maximus*, chief priest of the Roman priestly colleges.[15]

The iconography of Constantine's coinage, though innovative in some ways, in others, appears conservative. Understandably it discontinues certain Tetrarchic messages and military fashions to distance the emperor from the entire period and its ideals, which Constantine helped repudiate by engaging in a civil war. In moving away from the Tetrarchs, Constantine's coin iconography partly seeks connections with Augustus.[16] Constantine's clean-shaven face is one such notable reference. After a long line of emperors whose facial hair varied from philosophers' beards to the stubble of soldiers, Constantine returned to the youthful Augustan fashion.[17] A silver medallion of Constantine, minted shortly before the emperor's death, makes an emphatic reference to Augustus (fig. 70). The obverse shows the emperor, who was at the time over sixty years of age, a young man with wavy hair, the style similar to that of Augustus (fig. 27). The legend simply reads *AVGVSTVS*. The reverse shows luscious oak wreath framing the name *CAESAR*. The coin could be mistaken for Augustan, if it were not for the aquiline nose, the heavenward gaze, and the diadem. Other of Constantinian coins, including his double portraits with Sol Invictus (fig. 71), copy more recent imperial coinage, such as that

FIGURE 70

Medallion of Constantine, Siscia, 336–37, silver. Obv.: Head of Constantine, wearing a bejeweled diadem. Obverse legend: *AVGVSTVS*, vertically. Reverse legend: *CAESAR* within laurel wreath. *RIC* 7 Constantine 259. Photo credit: Courtesy of Jürgen Malitz and the Numismatische Bilddatenbank Eichstätt.

FIGURE 71

Solidus of Constantine with Sol, Ticinum, 316, gold. Obv.: Jugate busts Sol, radiate, and Constantine, laureate, draped, cuirassed, raising right hand and holding globe in left, facing left. Rev.: Liberalitas, draped, standing front, head left, holding abacus in right hand and cornucopia in left. Obverse legend: *COMIS CONSTANTINI AVG*. Reverse legend: *LIBERALITAS XI IMP IIII COS P P P*; *SMT* in exergue. *RIC* 7 Constantine 53. BM, 1863,0713.1.

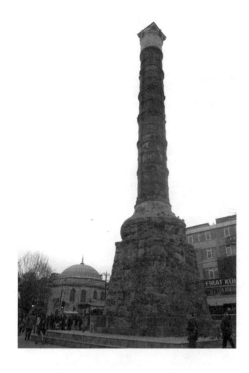

FIGURE 72
Remains from the porphyry Column of Constantine, Istanbul, ca. 330. Photo: Author.

of Probus (276–82).[18] Sol was also represented on the coinage of Constantius, Constantine's father.[19]

Constantine's statuary, especially the statue in the guise of Apollo Sol that once stood in Constantine's forum in Constantinople, likewise attests to the steadfastness of tradition. The statue was elevated on a porphyry column in the middle of the solar-shaped forum. It does not survive, though can be reconstructed relying on images that copied it.[20] The statue represented the emperor shown in heroic nudity, spear in one hand and a globe in the other, and a crown of sun rays on his head (figs. 72–74, map 1).[21] Constantine's forum statue with the spear and the solar halo had an Augustan parallel, a type that might have decorated the top of the Mausoleum of Augustus (see fig. 26 and chapter 2). Augustus's statue must have been a potent symbol, as Vespasian deemed it worthy of being featured on his coinage. After Augustus's deification, the statue was updated with a crown of solar rays to indicate divinity.[22] The iconography of the Constantinopolitan statue thus belonged to a rich tradition that went back to the deified Augustus. But in the intervening time had become a more general type, casting the honoree as a founder in the mold of the first deified imperial founder, who in his actions imitated Apollo Sol, and whose actions were blessed by Apollo (figs. 71, 74–75). Like Sol rising on his chariot, Constantine inaugurated the bright dawn of a new age, and like Sol, he ascended on a chariot to heaven to take his place among the gods.

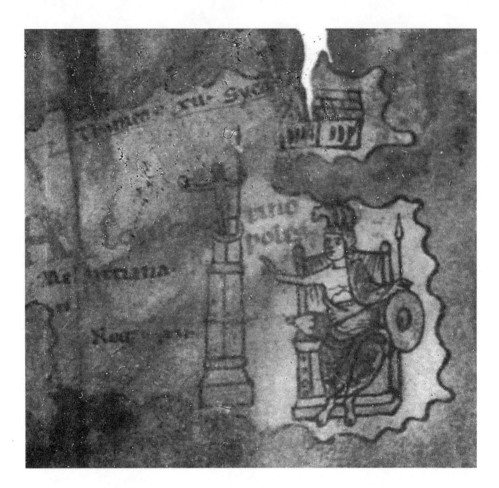

FIGURE 73

Column of Constantine from the *Tabula Peutingeriana*, drawing twelfth century, Museo Civico dell'Eta Cristiana, Brescia, Italy. Photo credit: DeA Picture Library / Art Resource, N.Y.

The emperor's claiming of Maxentius's building projects in Rome likewise evinces the continuity of imperial patronage.[23] His ambitious building projects in Constantinople, and other parts of the empire also link him to the first imperial founder.[24] But the same can be stated about many other emperors. In other words, Constantine sought specific connections with Augustus because the first emperor established a tradition. But that was a living tradition, a discourse that put emperors in a particular mold. That discourse molded Constantine's actions, even as the emperor made claims for renewing it by going back to its roots, all the way back to Augustus.

Constantine's adherence to the Romulean custom of ploughing the walls of a new city attests to the potency of this tradition. As noted by the fifth-century bishop and poet Paulinus of Nola, Constantine personally traced the walls of his capital.[25] But he is said to have used a lance rather than a plough to do so.[26] With that gesture Constantine

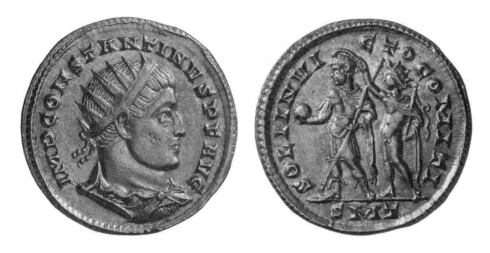

FIGURE 74

Medallion of Constantine, Ticinum, 320–21, gold. Obv: Radiate, draped, and cuirassed bust of Constantine. Rev.: Sol, radiate, standing left and holding whip, crowning Constantine, who holds a spear in left hand and globe in right hand. Obverse legend: *IMP CONSTANTINVS PF AVGVSTVS*. Reverse legend: *SOLI INVICTO COMITI; SMT* in exergue. *RIC* 7 Constantine 98. Photo credit: Courtesy of Jürgen Malitz and the Numismatische Bilddatenbank Eichstätt.

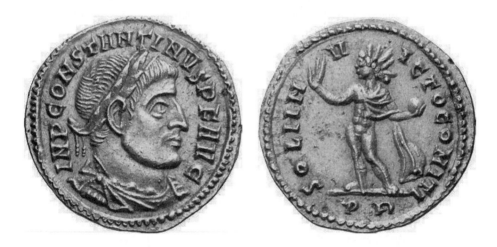

FIGURE 75

Gold coin of Constantine, ca. 312. Obv: Laureate, draped and cuirassed bust of Constantine. Rev.: Sol standing left, raising right hand and holding globe in left hand. Obverse legend: *IMP CONSTANTINVS PF AVG*. Reverse legend: *SOLI INVICTO COMITI; P R* in exergue. *RIC* 7 Constantine I.o. Photo credit: Courtesy of Jürgen Malitz and the Numismatische Bilddatenbank Eichstätt.

evoked Alexander and his "spear-won" Asian empire.[27] His forum statue thus alluded to both Alexander and Augustus.

But though it belonged to a type that showcased the emperor as a founder, it propagated a vastly different founding myth. Since Constantine marked the walls of a new capital rather than extended Rome's *pomerium,* the emperors who came after him and claimed to renew the capital could be compared only to Constantine, not to Romulus or to Augustus. The emperor's tomb at the Holy Apostles and Constantine's urban development strengthened the idea of a radically new imperial foundation. In Constantinople, the imperial tree of Augusti started with Constantine. Constantine's eponymous imperial city and its founder gave rise to the imperial honor most coveted by Christian emperors, "New Constantine."[28]

Constantine moved further away from tradition in other ways. He helped end the persecution of Christians, and aided the institution building and doctrine formation of the Christian Church.[29] Novelty was also founding a Constantinopolitan senate and filling its ranks in part with Roman senators; though seemingly on a lower level, the Constantinopolitan senate therefore emerged as a serious competitor to the senate of Rome. Constantine's city was likewise different from Rome, the contrast supplying the reason for establishing an eponymous capital. The new capital was free of memories and buildings commemorating past glories that in Rome intimidated new emperors and left them little room for leaving one's mark. Constantinople presented to Constantine almost limitless opportunities for inscribing himself in the urban fabric and steering the discourse of founding on his own terms.[30] He succeeded where Commodus, for example, had failed because Constantine, like Augustus, understood the power of precedent and tradition and knew how to harness both to his advantage.[31]

But the founder did not keep all the glory for himself. He recognized his mother, Helena, as cofounder of Constantinople by apportioning parts of the city's fabric to her. In the spacious square beside the imperial palace he erected a porphyry pillar on which he placed a statue of her (map 5).[32] Unlike Augustus, Constantine was not constrained by the *mos maiorum* (ancestral tradition). Indeed, his gesture recognized the long tradition of female founders. Yet he carried that tradition further.

Constantine, like Augustus, could have honored his father, the emperor Constantius, who had, after all, been Augustus; it was on his account, moreover, that Constantius's armies offered Constantine the purple. Helena had no imperial pedigree, and some authors report that she came from a very humble background.[33] Nevertheless, Constantine chose to lift her with him high above, so that together they overlooked the public space of the capital from their purple pillars. By giving preference to his mother, Constantine made an important statement about Helena herself and about gender, religion, and imperial authority more broadly. Religion accounts, in part, for the priority he gave to Helena, who was a Christian whereas Constantius had been a pagan. In establishing Helena as a partner, Constantine initiated a new female branch of founders. Rather than Venus Genetrix, the tree sprung from Helena. To be called "New Helena" was an honor

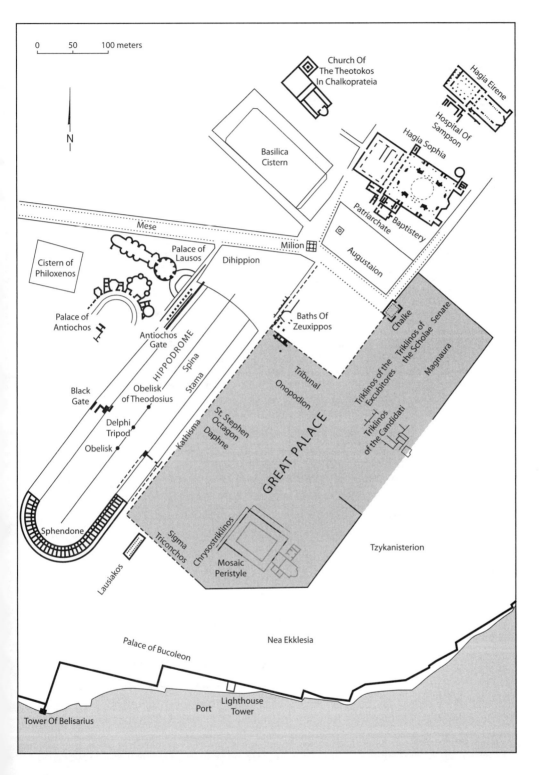

MAP 5

Area around the Great Palace, Constantinople. Drawn by Bill Nelson.

that imparted to the honoree the prestige of the first female imperial founder. Constantine enabled Helena to be more than a symbolic partner in government. From 312 until her death ca. 329, she resided in Rome and tended his interests there. In 324, the year Constantine became sole Augustus and donned an imperial diadem, a similar headband appeared on the coin portraits of his mother and his wife.[34] A Constantinian innovation, the jeweled diadem symbolized the royal rank that Constantine willingly shared with the Augustae.[35] The weight of meaning invested in the diadem is supported both by Eusebius, who attributed significance to it as an imperial token, and by Constantine, who bestowed responsibilities afterward on Helena.[36] The emperor dispatched his mother to inspect the Eastern provinces, giving her full authority over the imperial treasury during those travels.[37] Together with Constantine, Helena made donations to churches. On her own, Helena built other buildings, public and private.

All these Constantinian discontinuities and innovations with respect to the imperial capital, gender, and religion, steered the discourse of founding in new directions. Beginning with Constantine and Helena, this chapter and those that follow examine how the founders and their successors transformed the discourse of imperial founding through their palaces, churches, and other buildings, and through their largesse, rituals, and imperial insignia. Part 3 illuminates the role of the Christian bishops in molding the discourse of imperial founding to Christian ideas.[38] The imperial family and the bishops disagreed on a number of issues, such as their understanding of the emperor's and empress's place vis-à-vis honors and God. From the interaction between these divergent views, in the sixth century, emerged a new artistic and ideological synthesis of imperial power and religious imagery.

Together, Constantine and Helena fashioned the Christian discourse of founders, the emperor by transforming the central myth in the traditional discourse with his new capital, which enabled a new imperial genealogy; the Augusta by taking on emperor's prerogatives and insignia. Constantine's transformation—though dramatic—endured, in part because the emperor followed the rules of the founding discourse. Constantine succeeded because he promoted innovation by relying on deep-rooted tradition and its symbolic language.

CONSTANTINE AND THE DISCOURSE OF FOUNDING: APOLLO AND DIVINATION

How the emperor's contemporaries and the emperor himself saw and deployed the god Apollo Sol in relation to Constantine exemplifies this balanced approach to tradition and innovation. Two types of contemporary sources have stated through different means a close connection between Constantine and Apollo. In the year 310 an anonymous orator from Gaul spoke of a vision the emperor had received near a temple of Apollo.[39] This temple has been identified with the one near Grand [Vosges], France; it was a sanctuary at which Apollo Grannus delivered prophetic dreams through incubation.[40] The speech

defines Apollo as Constantine's partner (*tuum comitante*); at the same time it speaks of Constantine as a double of Apollo.[41] The orator, in C. E. V. Nixon's translation, said: "You saw, O Constantine, . . . your Apollo, accompanied by Victory, offering you laurel wreaths." According to the panegyrist, Constantine "saw and recognized" himself "in the likeness of him to whom the divine songs of the bards had prophesied that rule over the whole world was due." The orator thus put the emperor in an Augustan mold as a new Apollo. His language echoes Virgil's famous words about the Apollonian age, heralded by Augustus.[42] The orator also speaks of the goddess Victoria, who appeared with Apollo and offered the emperor laurel wreaths (*coronas laureas*), signifying an excessively long lifespan.[43]

Around the time of the oration and the reported vision, Constantine's coins started advertising the emperor's special relationship to Apollo the Sun (figs. 71, 74–75).[44] Sol has appeared on the coinage of Constantius as Caesar. The god did not dominate the father's coin iconography, but he too was imagined as bringing forward the golden age and "light."[45] Constantine's coin series, minted by the Constantinian mints of London, Trier, and Lyons, and elsewhere, featured Constantine with Apollo Sol and a legend identifying the god as *comes,* comrade or companion, to Constantine. The later examples showed Constantine with a crown of solar rays (figs. 71, 74–75). The iconography and the minting of these coins can be related to Constantine's vision near a temple of Apollo.

The iconographic connections between Apollo and Constantine endured for some years after 312, the date when Eusebius states that Constantine converted to Christianity on the eve of the Battle of the Milvian Bridge.[46] The imperial mints continued to churn out coins with Apollo Sol, the emperor's "comrade" as late as 325.[47] Both the event and the coins are unremarkable from the point of view of existing tradition of epiphanies to emperors and of imperial iconography, and perhaps could even be dismissed as nothing more than old-style imperial self-presentation.

However, the oration of ca. 310 and the Apollo Sol coins resonate with the iconography and inscription on a well-known contemporary monument. This is Constantine's Arch in Rome. The Roman Senate erected the triumphal arch in 315 to celebrate the emperor's victory over Maxentius.[48] The arch promotes an image of an Apollo-like and Apollo-inspired emperor and refers to Apollonian divination. When approached from a distance, the arch framed the colossal statue of Apollo Sol by the Colosseum. At the time, that statue bore Constantine's features (fig. 76).[49] On the arch were two images of Apollo (reused from earlier monuments), both related to Augustus and to divination. In the roundel on the north facade, Apollo appears on the pedestal, framed by two laurel trees (fig. 77), which allude to those flanking the doors of Augustus's house, and granted him along with the title Augustus by the Roman Senate. The relief refers to Delphian Apollo in that the god leans on his kithara, which is propped on a tripod with a snake coiling around it. The other image of Apollo, on the narrow side of the arch, represents Apollo Sol, doing his heavenly round on a chariot (fig. 78). The god's long flowing robes recall the kithara-playing Palatine Apollo (fig. 79).[50] The presence of Apollo on the arch, and of

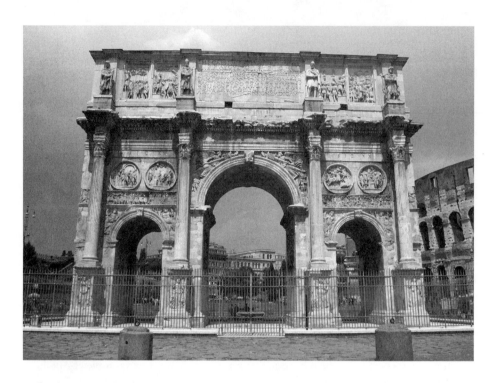

FIGURE 76
The Arch of Constantine, Rome, 315. Photo: Author.

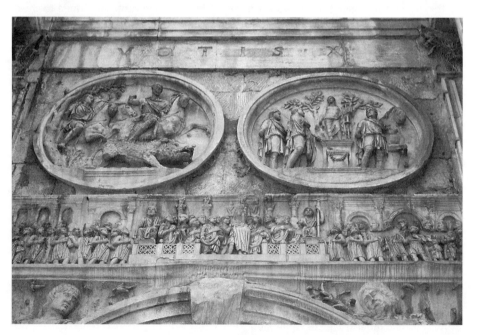

FIGURE 77
Constantine sacrificing to Apollo (right), showing emperor standing in front of an altar with a statue of
Apollo on top of it and laurel trees flanking it; Apollo leaning his left hand on a kithara, which stands
on a tripod with a coiled snake, Hadrianic, recut relief with Constantine's features. Detail from the Arch
of Constantine, Rome. Photo: Author.

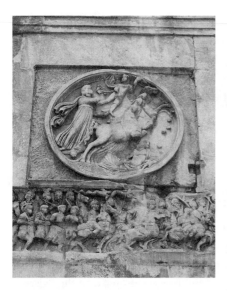

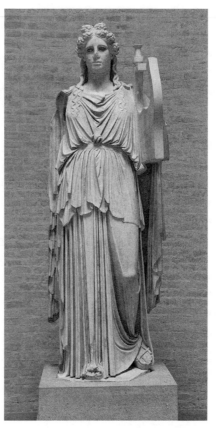

FIGURE 78
(above) Apollo/Sol ascending to heaven on a chariot, marble relief, Arch of Constantine, Rome. Photo: Author.

FIGURE 79
(right) Apollo with a kithara, known as the Barberini Apollo, marble statue, a likely copy of the cult statue at the Temple of Apollo Palatinus, Glyptothek, Staatliche Antiken-sammlung, Munich, Inv. 211. Photo credit: Vanni Archive / Art Resource, N.Y.

the colossal statue of Apollo Sol/Constantine next to it, invite a reconsideration of the famous phrase inscribed on that monument—*instinctu divinitatis*, "through instigation/ inspiration of the divinity"—as a reference to an Apollonian prophecy.[51]

Cicero's treatise *De divinatione* (On Divination) provides the rationale for that interpretation. There Cicero distinguishes two types of prophecy, artificial and natural.[52] In the artificial form, specially trained individuals read the will of the gods in signs, such as the flight of birds and animal entrails. Understanding natural prophecy required no training, because the prophet was possessed by the divinity or the divinity appeared to them while sleeping.[53] Cicero uses the phrase, *instinctu divino*, similar to the one on the Arch of Constantine, to denote a natural form of divination.[54] By extension, the wording of the inscription suggests that Constantine received a natural prophecy. The context of the arch beside the Colossus of Apollo the Sun, and the presence of two reliefs of Apollo on the arch (and one of his sister Diana), coupled with the absence of any Christian symbolism, suggest that the natural divination must be connected to Apollo.[55] Oracles

from Apollo were not artful, arrived at "by deduction" (*coniectura*), but "poured out through divine instigation and inspiration" (*instinctu divino adflatuque funduntur*).[56] Typically, Apollo spoke through a mediator, a priestess, a theurgist, or his own statue.[57] When the god spoke to Aeneas, prophesying his future challenges and victories in founding the new Troy, he did so through the Sibyl of Cumae (Verg. *Aen.* 6.42–105). "Inspired oracles" could also occur when the deity placed images in the mind of the seer rather than taking physical possession of her or his body.[58]

The phrase *instinctu divinitatis* on the Arch of Constantine in Rome could be understood as a natural form of divination that Constantine received from Apollo either through a prophet or a dream, a conclusion that draws attention to Constantine's vision of Apollo ca. 310. Leaving aside for the moment the historicity of the event that the anonymous orator and the inscription from Constantine's Arch refer to, it is clear that the Roman Senate saw Constantine in traditional terms. They flatter him by associating him to Aeneas, a recipient of a natural divination, and to the first Augustus, whose consultation with the haruspices led to the building of the Temple of Apollo on the Palatine Hill, and who moreover took great care to preserve and edit the Sibylline books, containing Apollo's prophecies related by the Sibyls. Like those earlier founders, Constantine is Apollo-inspired and Apollo-like.

Constantine's own presentation followed that traditional understanding of Apollo as the god of founders. His statue in the guise of Apollo Sol in the middle of his Constantinopolitan solar-shaped forum made the point unmistakably. The emperor embodied Apollo's characteristics through the act of founding. In addition to Apollo's imperial history, the god had also local significance for Constantinople. According to Strabo, Apollo instructed the Megarians where to found Byzantium (7.6.2). The act of founding indicated the dawn of a new era, in turn celebrated through solar symbolism. Constantine was not just a founder of a new city, but the founder of a new age. The poems of Publius Optatianus Porphyrius (in short, Optatian), dated to ca. 324, and presented to Constantine to celebrate the twentieth anniversary of Constantine's reign, portray the emperor as the bringer of a golden age, referring to him in one poem as "light of the golden age" and "light of Romulus."[59] Optatian reassures Constantine that Sol will continue to lend his support for the emperor (12.6), and that Constantine will deserve veneration equal to Sol's (18.25). Optatian's viewpoint matters because the poet endeavored to please Constantine with the explicit goal to be recalled from exile. He thus hit all the notes that presumably would have delighted Constantine. Pleasing the Augustus included assuring him ca. 324 that he would continue to enjoy Sol's support and that he would shine like Sol.[60] At the same time, *Poem 19* in the collection contains an in-text drawing of Christ's monogram, the Chi-Rho, and a ship, suggestive of the naval victory at Chrysopolis in 324 (fig. 80). The opening line of the poem states that "the heavenly signs" (*caelestia signa*) will be revealed to the reader in purple. Optatian seems to be referring obliquely to Constantine's vision and at the same time interpreting it as the Chi-Rho. The poem therefore resonates with Eusebius's narrative, in which, as per Christ's instruc-

XIX

FIGURE 80

Optatian, *Poem 19*. In-text drawings: *Chi-Rho*, *VOT XX*, a ship. After Polara 2004.

tions, Constantine ordered battle standards to be made, copying the heavenly apparition. Those were constructed in the shape of the cross with a wreath of precious stones fastened at the top, and the letters Chi and Rho inscribed in it, though Eusebius described no monogram as part of the actual vision.[61] Optatian's poetry collection succeeded in mollifying Constantine and the poet was recalled from exile and promoted to a city prefect (335–37).[62] In their own way, the poems testify to the religious ambivalence of Constantine's reign: Constantine relished the traditional symbolic language of identifying

imperial founders, of which imitation of Radiant Apollo was paramount, and, at the same time, asserted other religious allegiances.

The Christian emperor honored Apollo Sol and himself through that deity in two other ways. At least two statues of Apollo, Pythian and Sminthian, graced public squares in Constantinople.[63] In the Constantinopolitan Hippodrome, Constantine displayed several tripods spoliated for that purpose from the sanctuary of Apollo at Delphi.[64] The placement for these tripods was fitting, as, on analogy with the one in Rome, Constantine's Circus Maximus was a monument dedicated to the Sun (Tertullian, *De spectaculis* 8.1). The Delphian tripods marked that association, as did the obelisks erected later.[65] The objective in underscoring a link between the emperor, Hippodrome, and deity commemorated went beyond traditional imperial patronage of such places. The monuments chosen for the Hippodrome once again fashioned Constantine as a beneficiary of Apollo Sol. One of the tripods commemorated the Greek victory over Persia at Plataea in 479 B.C.E. (Herodotus, 9.81.1).[66] Parts of this monument can still be seen in present-day Istanbul at the site of the ancient Hippodrome (fig. 81). The Delphi tripods were gifts to Apollo, tokens of victory, that replicated the seat of the Pythia, a prophetess who communicated the god's will while seated on a tripod (compare with fig. 17).[67] The tripod, as noted earlier, signified Delphi and Apollonian prophecy more broadly.[68] The decoration of the Hippodrome, much like the Plataea tripod's original context, linked Apollo's intervention to victory. The victory in turn was contextualized as analogous to triumphs over eastern tyrants. The Plataean tripod, the emblem of the Greek victory over the Persian king Xerxes, was one such marker. Plutarch reports that an oracle by Delphian Apollo pointed the exact place where the joint army of the Greeks should meet the Persians in battle in order to win (*Aristides* 11.3–6). In gratitude for that crucial information, the Greeks dedicated from the spoils the tripod to Delphian Apollo. On display in the Hippodrome was another emblem of Apollo-enabled triumph over an "Eastern tyrant": the "ass and keeper" statue, which honored the divine portent Augustus (in hindsight) received before the Battle of Actium in the appearance of a man called Eutyches (Prosper) and his donkey Nikon (Victory) (Suet. *Aug.* 96).[69] Constantine spoliated this statue from Augustus's city of Nicopolis near Actium. These two statuary groups, each celebrating a victory over an eastern despot, suggest that Constantine wanted to present his defeat of Licinius similarly, imagining the eastern Augustus as a new Xerxes and a New Antony, thus making his own victory at Chrysopolis equal to the victories at Plataea and Actium. He insisted that Apollo was the god who aided him. Chrysopolis for Constantine, like Actium for Augustus, marked the beginning of the emperor's sole rule. As Actium enabled Augustus to extend Rome's pomerium, so Chrysopolis permitted Constantine to enlarge Byzantium's, refound the city as Constantinople, and build new walls three kilometers beyond the Severan ones (map 1).[70]

These conclusions about how Constantine and his contemporaries himself saw Apollo brings us to the thorny subject of the historicity of Constantine's visions: the pagan vision reported by the orator from Gaul and the Christian vision of a cross-shaped

FIGURE 81
Remains of the Plataea Tripod, originally from
Delphi, now at the Hippodrome site, Istanbul.
Photo: Dennis Jarvis.

trophy of light, found only in Eusebius of Caesarea in the *Life of the Emperor Constantine*
(1.28), and alluded to by Optatian and Lactantius.[71]

An important study has proposed that Constantine had one vision only, and that
occurred in 310. The emperor saw not a divinity but a solar halo that the emperor and the
anonymous orator took as a sign of Apollo.[72] Eusebius's account of a Christian vision in 312
must be compressing the time elapsed between the vision of 310 and the dream in 312, so
that seemingly Christ appeared to Constantine in a dream soon after the vision. The study
also proposes that the god from the testimony of the anonymous pagan orator, on the one
hand, and the Christian deity in the accounts of Eusebius and Lactantius, on the other, can
be reconciled with the notion of the *Summus Deus,* the Highest Divinity. Other interpreta-
tions smoothed the pagan-Christian divide by underscoring the connections between
Christ and Sol.[73] There exists still another possible way to reconcile the anonymous pagan
orator, who identifies Apollo in the vision of 310, and Eusebius and Lactantius, both of
whom mention a dream and interpret it in Christian terms. From a philosophical point of

view, a *Summus Deus* or Christ the Sun does bridge paganism and Christianity. But the leap in the context of the vision needs a different kind of mediation. It is possible to see Apollo (or his priests) as relating a prophecy whose true author was God.

Constantine provides the logic for this idea. In his *Oration to the Saints,* dated most recently to 325, Constantine elaborated on the role of the Erythraean Sibyl, the priestess of Apollo, in prophesizing Christ's advent.[74] The emperor states:

> But it rests with me also to commemorate foreign witnesses to the divinity of Christ. For these make it obvious that even those who blasphemed him knew in their minds that he was God and the child of God, if indeed they believe their own words. Now the Erythraean Sibyl, saying that she was born in the sixth generation after the flood was a priestess of Apollo, wearing a diadem on equal terms with the god whom she worshipped, in charge of the tripod round which the snake was coiled. She made predictions for those who consulted her, her parents having foolishy presented her for this kind of service, from which come indecent passions and nothing worthy of reverence, just as is reported of Daphne. And once, having fled into the sanctuaries of untimely superstition and become full of truly divine inspiration, she foretold in words what was to happen with respect to God, plainly revealing by the prefixing of the initial letters, which is called an acrostic, the history of Jesus' descent. (*Oratio ad coetum sanctorum* 18.2)[75]

The acrostic is "Jesus Christ, Son of God, Savior, Cross." The Erythraean Sybil, according to Constantine, though serving Apollo, announced the Savior's coming, becoming in that moment "full of divine inspiration" (*theias epipnoias . . . mestē*), recalling with these words those of the arch's inscription.[76] Constantine quotes portions of the *Eighth Sibylline Oracle* and Virgil's *Fourth Eclogue* and refers to Cicero's translation of the oracle into Latin.[77] He concludes his oration by stating that his service to God, "commenced with the inspiration of God [*ex epipnoias theou*]," a phrase close to the one in which he described the sibyl's inspiration.[78] The inspiration in Constantine's oration and the prophetess with the Christian message can be connected to the inscription on the Arch of Constantine, and the anonymous oration from ca. 310. The Gallic orator's description of that goddess states that Constantine's Apollo was accompanied by "Victory, offering [to Constantine] laurel wreathes" (*Victoria coronas tibi laureas offerentem*).[79]

The oration omits how the emperor "saw" the vision. Provided that Constantine was near the Temple of Apollo Grannus, a sanctuary known for prophetic dreams, the emperor may have seen the vision in a dream, as reported by Lactantius.[80] The solar halo hypothesis, on the other hand, is also quite plausible. A neglected reference in the *Patria* of Constantinople (a guidebook complied in the tenth century but based on earlier sources) mentions that in the Forum of Constantine there was a cross, shaped as "Constantine saw it in the sky, with gilded spherical apples at the ends."[81] The description fits the phenomenon of a solar halo, and the three spheres could also explain the laurel wreaths from the anonymous oration from 310.[82]

Eusebius tells us that after the vision, but before the dream, the emperor sought advice from "those initiated in the mysteries [*mustas*] of his teaching" (*VC* 1.32.1). The language describing these experts is vague and confusing. If they were taken as Christian priests, this would contradict Constantine's lack of knowledge of the god. How could Constantine have asked for Christian priests if he wondered who the deity of the vision was? Later in the same passage Eusebius is much clearer in his terminology and states that after the received explanation the emperor invited "priests of God" (*tou theou hiereas*) to serve as his councilors (*VC* 1.32.3). The confused passage allows to infer that whatever Constantine saw near a temple of Apollo in Gaul, he had "men initiated in the mysteries" explain the vision to him. Those men, if Apollo was somehow involved, would have been priests to Apollo. Ancient sources testify that experts were consulted even when the deity appeared personally.[83] The emperor's oration for the saints implies that "foreign witnesses" could communicate the words of the Christian God. Certainly the possibility of a Christian prophecy was not Constantine's own idea, but found in the writings of close contemporaries.[84] *Origen + Lac.*

This understanding helps reconcile the Apollonian elements in Constantine's vision with the Christian ones. Apollo was instrumental in revealing to Constantine his future greatness. As for Eusebius's Christian vision, it most certainly both embroiders and omits to conceal the facts of the actual event, especially Constantine's lingering paganism. Material and other evidence suggests that Apollo and Christ coexisted as patron *Apollo /* gods of Constantine, and he emulated them. This liberal vision of Constantine's faith *Christ* comes to light in the emperor's design of his city.

CONSTANTINE AND CONSTANTINOPLE'S IDENTITY

Even as Apollo and Christ are evoked in Constantine's urban plan, it is the glorification *urban Fabric* of the emperor that supplies the organizing principle of the urban fabric (map 1). The city had three major nodes, all of which centered on Constantine. The Great Palace celebrated the living emperor; the forum, with its statue of Constantine as Apollo Sol, *tradition +* glorified the emperor as the city's Apollo-like founder of the city and a new golden age; *innovation* and the Church of the Holy Apostles cast Constantine as the Christ-like founder of a new imperial era, who broke with Augustan traditions.

The Great Palace (see map 5), properly a palatial complex, included several public buildings in addition to the imperial apartments.[85] The center of this imperial complex was the Augustaion, a square dedicated to Constantine's mother, the Augusta Helena,[86] where a statue of her on a porphyry column once stood. On the palace side of the Augustaion sprawled the vast Hippodrome, built by Septimius Severus and reconstructed by Constantine. Adjacent to the Hippodrome were the Baths of Zeuxippus, which Constantine embellished with statuary.[87] The two nearby churches (attributed by some sources to Constantine), Hagia Eirene and Hagia Sophia, built north of the Augustaion,[88] were enmeshed in their imperial urban context.

complex of buildings—urban growth

The Forum of Constantine was located on the Mese, the city's main artery, just outside the walls of Septimius Severus (map 1). Where once the statue of the emperor had stood atop a porphyry column, at present only the twenty-five-meter-tall drum of the column remains (see fig. 72).[89] The forum's solar shape and the emperor's statue glorified Constantine as a founder in a traditional way, with the radiant crown of Apollo Sol.[90] The emperor's coins, the Peutinger map, and a sixteenth-century drawing of the reliefs from the base of the column give an idea of what that statue might have looked like (figs. 72–75).[91] Like Augustus's ploughing denarii, which showed Apollo with the features of Augustus, and like the colossus of the Sun near the Arch of Constantine, Constantine's statue in Constantinople and its oval enclosure presented Constantine rising like the sun to awake the world to a new golden age. Constantine's vision reverberated from the center to such places as Termessos (Asia), where a statue was dedicated "to Constantine, the all-seeing Sun."[92]

complex

The third node of urban growth was the complex of buildings organized around Constantine's mausoleum (map 1), which in present-day Istanbul is the site of the Conqueror's Mosque.[93] Much like the Great Palace, his tomb had an identity defined by its place in an imperial complex.[94] Although Eusebius conveys the idea that Constantine's tomb belonged to a complex, he obscures the mausoleum's surroundings to focus on its interior. Scholars have turned to this passage in Eusebius to determine whether Constantine erected for his tomb an imperial mausoleum or a cross-shaped church, or both.[95] The bishop's text asserts that in the building intended for Constantine's tomb his coffin lay surrounded by *thēkai*, the coffins or reliquaries of the apostles.[96] Because Eusebius says that the tomb had an altar, from the beginning, the building was both a church *and* a mausoleum.[97]

Although there is a lacuna in this passage, enough of it survives to suggest that this monument must have been spectacular—of great height, with marble veneer and gold leaf. Eusebius notes that the shrine of the apostles was surrounded by "an immense court [*aulē*] wide open to the fresh air; porticoes [*stoai*] surrounded it on four sides, porticoes that enclosed in their midst the atrium to the same shrine; imperial apartments [*oikoi basileioi*], baths [*tais stoais loutra*], and candle stores [*analamptēria*] stretched out in line [beside them], and a great number of lodgings [*pleista katagōgia*] were carefully completed for the custodians/guardians [*phrourois*] of the place [*topou*]."[98]

Eusebius suggests that the shrine was the focal point of a complex of structures, but he seems reluctant to name the complex, referring to it as a "place" (*topos*). What kind of place would require many keepers? In later times, this area was called Kōnstantinianai, a name that can be loosely rendered as "the neighborhood of Constantine's mansion."[99] One can infer that the bishop describes an imperial palatial complex that included a tomb doubling as a Christian church. Like the churches near the Great Palace— whether Constantine built them or not—the Holy Apostles was embedded in an imperial residential complex. There are examples of analogous complexes elsewhere in the empire: Diocletian's palace in Split, a complex which contained imperial apartments,

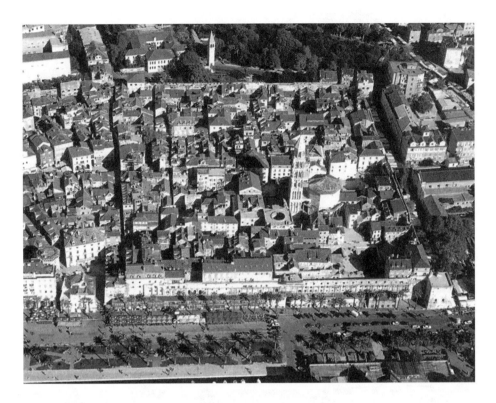

Site of Diocletian's Palace, outlined by the four streets of the current city block, aerial view, Split. Photo: Ina Vukic.

a reception hall, an emperor's tomb, baths, and a temple of Jupiter.[100] The Spoleto complex now occupies approximately four city blocks (fig. 82). Another analog is the Villa of Maxentius in Rome, a complex which featured a tomb within a four-sided peristyle courtyard, a Hippodrome, and a villa proper (fig. 83).[101] As for the custodians Eusebius mentions, Helena's palace complex in Rome contains the floor remains of typical Roman living quarters, decorated with simple black and white mosaics (fig. 84). These rooms are separated from the grand halls and abut the Aurelian walls. Most likely, this is where the caretakers of the Sessorian Palace lived, as their living accommodations cannot compare with what can be gleaned from Helena's accommodations, which featured massive reception halls decorated with enormous windows (fig. 85) and porphyry columns.

Eusebius downplayed the integration of the emperor's funerary monument to the palace complex purposefully, in order to deemphasize the function of Constantine's Mausoleum as a monument to the founder that presented him as a Christ-like figure. Given the placement of this founder's tomb in a circle formed by the Apostles; the urban context; the parallel between the coming of the Savior and Constantine's ascent to power; Constantine's statue that presented him as Apollo/Sol; and the preeminence of Christ in

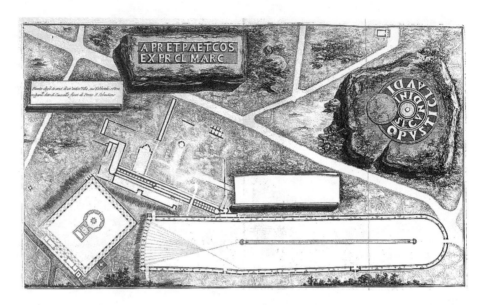

FIGURE 83

Villa of Maxentius, etching, plan by Piranesi 1756, 1:115.

FIGURE 84

Domus, Sessorian Palace, Rome. Photo: Author.

FIGURE 85
Aula, Sessorian Palace, Rome. Photo: Author.

images of him with the apostles, in which Christ invariably stands out as the most impor-
tant figure—given all this context, Constantine can be said to have presented himself as
more like Christ than like the apostles.[102] In its arrangement, Constantine's tomb resem-
bles the Holy Sepulcher, where Eusebius tells us the twelve columns around Christ's
tomb signified the twelve apostles.[103] Following in the footsteps of both Romulus and
Augustus, Constantine seems to have anticipated for himself the traditional award to city
founders of a heavenward ascent.[104] If the lavishness of the decoration, as related by
Eusebius, is any indication of advance planning, the emperor may have even determined
the design of his posthumous coinage that shows him on a heaven-bound chariot, remi-
niscent of Sol's, reaching to a Hand of God (fig. 86).[105]

Deification was surely one of the messages that Constantine's Christian tomb was
meant to convey. Consider the type to which that monument belonged. It stood on a
historical and symbolic continuum that stretched back to Augustus's mausoleum, the
container for the mortal remains of the first divus. However, Constantine's mausoleum
departed from the core messages of that historical continuum, because his burial city
was one he had named after himself and had made an imperial capital.[106] If the Tetrarchs
desired to disperse the notion of an imperial line, so entrenched in the period before,
Constantine embraced it with all its dynastic connotations.[107] However, Constantine's
mausoleum modified the intention of the original imperial mausoleum. It became an
imperial tomb for those who belonged not only to the Augustan line, but to the Constan-
tinian Christian line of the Augusti, all buried in the founder's eponymous capital.[108]

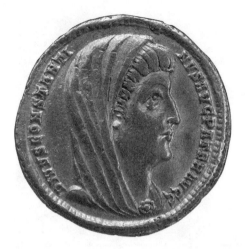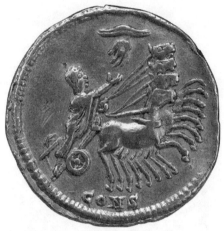

FIGURE 86

Solidus of Divus Constantinus, Constantinople, 337–40. Obv.: Bust of Constantine, draped, head, veiled. Rev.: Constantine, veiled, draped, in quadriga galloping right, grasping reins in left hand and raising right hand to grasp the hand of God, above. Obverse legend: *DIVVS CONSTANTINVS AVG PATER AVGG*. Reverse legend: *CONS in exergue*. *RIC* 8 Constans and Constantius p. 446 (obverse type). BM, 1986,0610.1. ©The Trustees of the British Museum. All rights reserved.

The emperor's mausoleum was probably the only Christian building completed in Constantinople at the time of the emperor's death. By planning to have his body interred in Constantinople, in a Christian tomb, the emperor signaled the creation of a new imperial line, and a new ethnos, that began with him: Constantine, the Christian Augustus. His tomb represents a lexical rupture in the discourse of imperial power that Constantine initiated with the new capital. The immense symbolic significance of the tomb comes through in the ardor with which the citizens of Rome demanded that Constantine be buried in their city (Euseb. *VC* 4.69). Constantine was both a shrewd student and conjuror of imperial precedent and an innovator of astonishing ambitions: to supplant Romulus and to replace Rome with Constantinople.

Another innovation of Constantine's steered the conversation about power in a new direction: his inclusion of his mother, Helena, in his founding efforts. He involved her by bestowing on her the diadem, a token of rule that he had donned after his momentous victory at Chrysopolis; he gave her the prerogative and the means to undertake construction activities like his own; he empowered her to act in his stead while traveling; and he charged her to oversee the building of churches in the Holy Land.

HELENA'S EXEMPLARY ACTIONS

Of all the honors available to Christian Augustae, few rivaled the appellation "New Helena." The Council of Chalcedon (451) inaugurated the honor when the assembled

bishops acclaimed the Augusta Pulcheria and her husband, the emperor Marcian, as "New Helena" and "New Constantine."[109] By the middle of the fifth century Helena and Constantine were widely esteemed as co-founders of the Christian state. Ambrose's late fourth-century etiology of the Christian monarchy, which makes Helena (b. ca. 250; Augusta ca. 325–ca. 330) a co-founder of the state, expressed not simply the bishop's own view but a common sentiment.

If we are to trust Eusebius, Ambrose, and the bishops attending the Council of Chalcedon, Constantine and Helena deserve commemoration above all for their piety. Eusebius and Ambrose accentuated Helena's imperial piety—Eusebius by emphasizing her building of churches, especially those honoring the life of Christ, and Ambrose by remarking the piety of her discovery and use of holy relics. The bishops at Chalcedon interpreted the Augusta's piety as the pursuit of orthodoxy. Later empresses emulated these characteristics in their patronage of cross-shaped and other churches, their search for holy relics, their abandonment of the pleasures of the court for the dusty roads to the Holy Land, and their engagement in theological debates.[110] Yet Helena's successors also emulated her in ways that had little or nothing to do with piety. Although scholars have almost entirely ignored Helena's secular buildings, later empresses drew inspiration from Helena's two public baths and two palaces, in Rome and Constantinople, as well as her founding of a city. We can infer this influence from their own building projects. Helena's works and the memory of her projects, both secular and religious, belong firmly in the category of imperial works. To privilege either secular or religious patronage above that overarching category skews the logic of imperial actions, of which giving was one of the most important. Like the emperor, the empress in the early Christian period was obliged by rank to give.

Literary sources and archeological remains attest to Helena's donations and the buildings she commissioned in Rome, Constantinople, Helenopolis, and the Holy Land. Because few of Helena's buildings have survived, little of their symbolic and practical value can be known. The authors who recorded Helena's undertakings pursued their own objectives, which were not always to Helena's advantage.

HELENA'S ROMAN IMPERIAL RESIDENCE

The most concrete evidence of Helena's actions comes from Rome. The Augusta focused on the suburban area around the Sessorian Palace, south of the Porta Praenestina, within the Aurelian walls, a short walk from the Lateran (maps 4 and 6).[111] The Severans were the last to invest in the palace complex before the fourth-century renovations of what was to be Helena's Roman residence from about 312, when Constantine defeated Maxentius, to 325–26, when she journeyed eastward.[112] The Severan palace complex comprised an impressive *aula* (fig. 85), a hippodrome (Circus Varianus), an amphitheater (the Amphitheatrum Castrense), a grand public entrance to the complex (so-called *porticus triumphi*), apartments, a vast park, and a public bath (map 6).[113] Constantine's interest in that palace, close to the Lateran complex and away from Rome's center, has been read

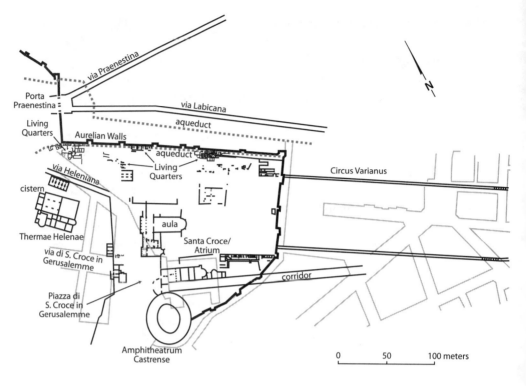

MAP 6

Area around the Sessorian Palace in the fourth century, Rome. Drawn by Bill Nelson.

as an indication of his intention, for religious and political reasons, to make it his official imperial residence,[114] But he did not linger in Rome, returning there only once after 312 to celebrate the twentieth anniversary of his reign.[115]

Helena's name, in contrast, is firmly associated with the palace and the buildings and land surrounding it. She is thus the likely initiator and supervisor of the Sessorian complex renovations dated to the reign of Constantine.[116] The entry in the *Liber Pontificalis* (Book of Pontiffs) for the Constantinian donations to churches records an endowment of 1,120 solidi to the Church of SS. Marcellinus and Peter, the site of Helena's mausoleum. The sum was income from Helena's property, "the fundum (estate) Laurentum close to the aqueduct with a bath and all the land from the Porta Sessoriana (Maggiore) as far as the via Praenestina, by the route of the via Latina as far as Mons Gabus."[117] The landmarks mentioned in this description—the aqueduct, the Porta Maggiore, via Latina, and via Praenestina—permit a partial reconstruction of this estate. The proximity of the unnamed bath to the aqueduct suggests that it was almost certainly the Thermae Helenae, situated within the Aurelian walls, between the Porta Maggiore and the Porta Latina (map 4 insert). The Mons Gabus, though not securely identified, has been considered the south boundary of the estate.[118]

The landmarks mentioned in the *Liber Pontificalis,* however, suggest another possible reading of the description. On the northern boundary of the estate, on the via Praenestina, a place known as Cabius/Gabii appears on the Peutinger map.[119] Its name and location make it plausible as the fourth coordinate of the property. If so, the boundaries of Helena's property would have formed a trapezoid, with Porta Maggiore and Porta Latina to the west, Gabii to the northeast, and the intersection of the road running between Gabii and the via Latina to the southeast (map 4 insert). The northern edge of the *fundus Laurentum* was the via Praenestina, which ran straight east to west. To the south, its limit was the via Latina, starting from the Porta Latina and running straight southeast eleven miles, then turning north and joining the via Latina at three different points.[120] The Aurelian Wall marked the eastern border, but the estate also included the Thermae Helenae, inside the wall. The eastern limit was the imaginary north-south line running from Gabii to the via Latina.

Because the empress Helena had a stronger attachment to the area than her son, as evinced by her property and building activity, she probably presided over and initiated such renovations in the imperial palace as the renovation of the Severan bath; the reorientation of the palace's focal point, away from the Hippodrome and the amphitheater; and the transformation of a grand imperial atrium, with magnificent porphyry columns, into a church.

The bath and its cistern have been excavated (map 6).[121] Though part of the palatial complex, the bath was public.[122] Helena restored it after it was damaged in a fire, and it became known as the Thermae Helenae.[123] Inscriptions on statue bases dedicated to Helena by the superintendent of the aqueducts in Rome in the year 330 suggest that the empress also repaired the nearby Aqua Alexandrina to supply her bath with water.[124]

The fourth-century renovations of the palace included the addition of a basilica (known as the Temple to Venus and Cupid), part of which is still standing (fig. 85). The palace church, restored several times, is known today as Santa Croce in Gerusalemme.[125] The Constantinian donations to that church, all from Italy, and the brick stamps date the church to before 324.[126] It was attached to the palace, and the excavators have concluded that Helena would have been able to attend services without being seen.[127] Around the basilica and the church stood other buildings, including another monumental entrance.[128] The new entrance to the complex probably stood in counterpoint to the older entrance, which connected the racehorse track and the amphitheater to the rest of the complex. The bath, located across from this newly renovated area, formed a more organic whole with the palace despite being separate from it, further suggesting a unified vision behind the renovations. This vision, as reconstructed from the remains, can only have been that of Helena, the owner of the neighboring estates.

The earliest textual sources mentioning the church and linking it to an imperial patron date to the sixth century.[129] The *Liber Pontificalis* identifies Constantine as the builder, whereas the *Gesta Xysti purgationis* refers to it as Basilica Eleniana, after the empress. The church was also known as Basilica Hierusalem, and Sessorium.[130] The dual attribution can be explained by source bias and by the timing of Helena's death. The

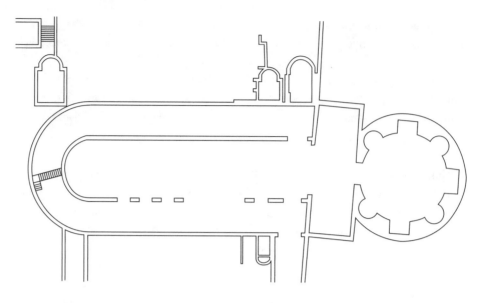

FIGURE 87
Church of SS. Marcellinus and Petrus with the mausoleum of Helena (rotunda), fourth century.
Ground plan by Bill Nelson.

Liber Pontificalis gives a minute account of Constantine's donations to the first Christian churches in Rome from a sixth-century perspective concerned with strengthening the papal claim over widely scattered estates and with underscoring papal authority. It is decidedly interested in Constantine, not Helena. The empress died in the East, where she is said to have gone to search for the True Cross and/or for the site of the Crucifixion.[131] The *Liber Pontificalis* mentions that a relic of the cross had been placed in the church from the beginning.[132] Although these claims appear in later sources, relics were indeed used to dedicate churches, not all of which were associated with martyrs' tombs.[133] Helena's death may have occurred before the dedication of her church. We know that Constantine was with her when she died (Euseb. *VC* 3.46.2). He was the beneficiary and the probable executor of her will, and he arranged a state funeral for her and a funeral procession to transport her body to Rome (Euseb. *VC* 3.3.46–3.47.1).[134] Helena's body arrived at its final resting place in about 329, at which time the relic was most likely deposited in her church.[135] That deposition, in turn, may have occasioned the official dedication of the church.[136] For these reasons, the *Liber Pontificalis* could consider Constantine the church's patron.

The entry in the *Liber Pontificalis* for the cemetery basilica of SS. Marcellinus and Peter also glosses over Helena's building initiative, as well as the mausoleum of Helena attached to it (fig. 87).[137] That structure stood about three miles from the Sessorian Palace, on the via Labicana, which runs along and between the via Praenestina and the via Latina, radiating like them from Rome's city gates (map 4). The complex of church and

mausoleum was thus built on Helena's property, the *fundus Laurentum*. A coin of Constantine from 324–26, embedded in the mortar of the mausoleum, and brick stamps suggest a date for the complex no later than 326. The basilica dates to the first quarter of the fourth century.[138] The endowment Constantine gave the Basilica of SS. Marcellinus and Peter, which came from the western empire, supports a date before 324. The initiative for the buildings of the complex, especially the church, however, is debatable. The *Liber Pontificalis* claims that Constantine founded the church, a claim supported by its exceptionally large endowment, whose total revenue, the *Liber Pontificalis* reported, was almost 90 percent of that generated by Constantine's Lateran endowment and five times greater than that of the church cum mausoleum of Constantine's daughter Constantia.[139] The rich endowment, along with such evidence as Helena's porphyry sarcophagus with its military scenes (fig. 88), has been read as indicating that Constantine, before his decision to refound Byzantium, had intended to use this complex of church and mausoleum as his own burial site and that the porphyry sarcophagus of his mother was initially intended for him.[140]

To view Constantine as the sponsor of the Basilica of SS. Marcellinus and Peter, however, neglects Helena's association with this part of the city and leaves unexplained Constantine's motives for choosing Rome and this particular building as his final resting place. From 312, when he came to rule Rome, to 324, when he won sole rule of the empire, Constantine spent little time in Rome, preferring other cities, partly, no doubt, of necessity.[141] To claim that he would have chosen SS. Marcellinus and Peter for his tomb ignores the one he built in Constantinople, as well as later imperial practice. There is no reason to assume that Constantine would have preferred burial in Rome beside the exorcist Marcellinus and the presbyter Peter, the patron saints of the church, to burial in the Roman tombs of St. Peter or St. Paul.[142] Indeed, Constantine's fifth-century successors chose St. Peter's for their tombs. In Constantinople, however, Constantine could ensure that the coffins or reliquaries of all twelve apostles surrounded his actual tomb.[143]

In the historical sources Helena's name has a stronger link with the Basilica of SS. Marcellinus and Peter.[144] The *Liber Pontificalis* states that the emperor's gifts to the basilica included the *fundus Laurentum* in Rome.[145] Some manuscripts of the *Liber Pontificalis* claim that Helena donated to the church a cup made of gold with her name on it, something she could have given even before her death.[146] The archeological data suggest a date for the planning and construction of the Basilica of SS. Marcellinus and Peter sufficiently early to support the assumption that the empress constructed the basilica attached to her own mausoleum. The basilica was completed not long after 326, at the height of Helena's power. Its rich endowment probably combined what Helena herself had left to the church and additional gifts from her son in her honor. If this reasoning is correct, the edifices Helena built or reconstructed in Rome included a palace, a palace church, a public bath, a large funerary basilica, and a mausoleum.[147] Such projects were also among her son's building priorities in Constantinople.

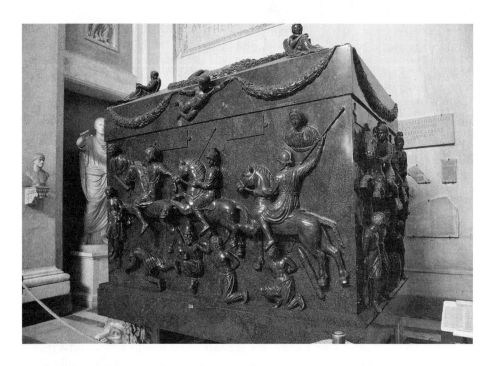

FIGURE 88

Porphyry sarcophagus of Helena, fourth century, 242 (h) x 268 (l) x 184 (d) cm., Vatican Museums.
Photo: Author.

HELENA'S BUILDINGS IN CONSTANTINOPLE:
EVIDENCE AND COLLECTIVE MEMORY

There is no clear evidence of what Helena built in Constantinople, nor is it known
when exactly she visited the city. She died before May 330, when Constantinople was
inaugurated as capital, but probably stopped in the city before and after her travels
to the Holy Land.[148] Her name is associated with two areas of the city, the Augustaion,
which Constantine named for her, and the Helenianai neighborhood (map 1). According
to sixth-century sources, Constantine honored his mother in the Augustaion, the
grand plaza in front of the palace, with a statue atop a porphyry column.[149] The Milion,
west of the Augustaion, was a tetrapylon from which all distances in the empire were
measured.[150] It imitated Augustus's Milliarium Aureum in Rome. A statuary group of
Constantine and Helena with a cross stood atop Constantinople's Milion, and a similar
statuary ensemble adorned Constantine's forum.[151] In the Philadelphion, a forum
northwest of the Augustaion, were enthroned statues of Constantine, Helena, and
Constantine's sons.[152] Forum Bovis, a square on the western branch of the Mese, contained
a statuary group of Constantine and Helena holding a cross.[153] At one time, the Senate
House was decorated with statues of the imperial mother and son.[154] A statuary group of

Constantine and Helena stood in most of Constantinople's major squares. Textual sources report that statues or other images of other emperors and empresses occasionally joined those of Helena and Constantine, as if to affirm their affinity.[155]

In Constantine's reign, the only other square in Constantinople comparable to the Augustaion, with Helena's column, was Constantine's forum, which connects with the Augustaion by way of the Mese. Helena's honorific column and square had no known precedent in Rome, where such places were constructed only for emperors. The Roman parallel would be the imperial fora: the Forum of Augustus, with Augustus's quadriga, inscribed *pater patriae* (see fig. 10); the Forum Iulium, with its statue of Caesar riding his favorite horse; the Forum of Trajan, with its massive column, decorated with reliefs of his accomplishments and containing his urn. The Augustaion and Helena's column thus had great symbolic importance.

The properties in Constantinople attributed to Helena included a palace, a church, and a bath. These formed a complex of linked buildings in the southwestern part of the city in a neighborhood known as ta Helenianai.[156] The waters of a stream that flowed under the church's altar supplied the bath.[157] This miracle-performing spring has been identified with the one still bubbling in the late 1970s in the foundation of the present Sulu Monastery, known in the Middle Ages as the Monastery of the Theotokos Periblep-tos.[158] A 1973 study of other possible patrons for the palace and church nonetheless argued, on the basis of chronology, that Helena, the mother of Constantine, was indeed the most likely builder of this palace-bath complex.[159] Although neither attribution can be dismissed, the study concludes that the later importance of the palace, combined with the extraordinary resources at Helena's disposal, makes her the most likely sponsor.[160]

The writings collected in the *Patria of Constantinople* that attribute numerous churches and monasteries to Helena and Constantine are, in general, historically inaccurate.[161] One building, however, merits attention. The *Patria* notes that Helena constructed a monastery in Constantinople dedicated to SS. Carpos, Papylos, Agathodore, and Agathonikos, Christian martyrs who died for their faith under the emperor Decius (r. 249–51).[162] Another text locates their church in the Helenianai. The remains of the monastery church are known and have been excavated,[163] and the archeological remains support the *Patria*'s description. The anonymous writer mentions various marbles and other materials used in the church's construction and claims that it imitated the Anastasis Rotunda, the tomb of Christ in Jerusalem's Church of the Holy Sepulcher.[164] Archeologists have dated the substructural remains of this church by their bricks to about 400.[165] The floor plan of the structure confirms that the building was a rotunda similar to Constantine's Anastasis Rotunda (fig. 89).[166] Fifth-century historical sources insist that the empress built Jerusalem's Martyrion, the building that contained the Anastasis Rotunda.[167] The date of SS. Carpos and Papylos precludes Helena as the sponsor, for she died several decades earlier. Nevertheless, the concordance of text and archeological remains indicates an early association between Helena, the Helenianai palace, the church of Carpos and his fellow

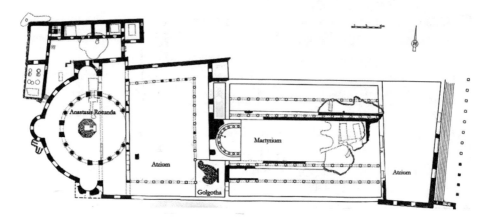

FIGURE 89

Constantinian Church of the Holy Sepulcher, Jerusalem. Drawn after V. Corbo by the author.

martyrs, the Anastasis Rotunda, and this neighborhood in Constantinople. The chronology of the connection must have started with the palace, which historical evidence dates to before 400.[168] If Helena built a palace and a bath along with a shrine, such patronage would have been in line with her undertakings in Rome. Later builders, imperial or otherwise, wanted to emphasize Helena's buildings in their own projects. The *Patria Constantinopoleos* makes another connection between Helena and this neighborhood, and the Christian Holy Land. The author relates that the empress built two churches in the neighborhood, the Gastria and the Bethlehem, and that she brought the relic of the True Cross into the city through the Psomatheas/Psamathia Gate, which is the gate just south of the Helenianai neighborhood.[169] Even if Helena had no links to that part of the city, once the Helenianai palace became imperial property in the late 300s, the name itself might have fostered the connection to her. Such a link would have brought prestige to the neighborhood and encouraged the construction of other buildings, especially churches.

That the empress Pulcheria, the "New Helena," showed an interest in this neighborhood offers indirect evidence of its importance in conjuring connections to Helena.[170] Although the Council of Chalcedon bestowed the epithet on Pulcheria two years before she died, she may have sought earlier to link herself with Helena.[171] This she accomplished by her own discovery of holy relics and her deposition of them at St. Thyrsus, in the vicinity of the Helenianai palace. The *Ecclesiastical History* of Sozomen describes the miraculous appearance to Pulcheria of the Forty Holy Martyrs of Sebaste (9.2). The event echoes Ambrose's narrative about the supernatural help Helena received in identifying correctly the relic of the True Cross.[172] In Pulcheria's case, the saints manifested themselves to her three times, gave her instructions, and helped her locate their relics. She donated a costly casket (*thēkē*) for the relics and organized a festival and procession for the deposition of the martyrs' relics at St. Thyrsus.[173] The gift and festivities highlighted

Pulcheria's piety, amply rewarded by the miraculous appearance of the saints, and set her own godly actions in the framework established by two worthy predecessors, the Augusta Helena and Pulcheria's mother, Eudoxia. Thirty years before Pulcheria, Eudoxia Augusta had led a triumphant procession carrying the relics of St. Thomas to Drypia.[174]

The timing and place of Pulcheria's display of piety are important, though Sozomen, who was an eyewitness, dated the translation of the saints' relics imprecisely, to the time of Proclus, who was bishop of Constantinople from 434 to 46.[175] In that twelve-year span, the other Augusta, Pulcheria's sister-in-law Eudocia, returned from the Holy Land (439) with relics of the Protomartyr Stephen.[176] Eudocia's *adventus* in the capital and the prestige of the relics and pilgrimage, all reminiscent of Helena, suggest that the two Augustae must surely have had the empress in mind during their pious pursuits.[177] In imitating Helena, they competed for prestige. The empresses' rivalry must have been gaining momentum, to judge by their discord two years later over issues of status.[178] Clearly, Pulcheria improved her public image and boosted her reputation vis-à-vis Eudocia's when she found the relics of the Forty Martyrs by a miraculous occurrence, as Helena had found and retrieved Christ's cross; and when she processed in pomp to deposit them, as her mother, Eudoxia, had done; and when she placed them in a neighborhood thick with Helena's memory.[179]

The extent of Helena's building in Constantinople may never be determined conclusively. And whether Helena actually sponsored a bath and churches dedicated to martyrs in the vicinity of her palace in Constantinople, as she had in Rome, may not matter. As Pulcheria's pious displays demonstrate, the social memory of Helena was more important than her real actions. By Pulcheria's time residences named for the empresses who inhabited them were common, and a Constantinopolitan palace called Helenianai could easily have been attributed to the Helena Augusta.

HELENOPOLIS

The historical sources have left other evidence for Helena's mixing of traditional statements of power with Christian piety in an urban context. The epitome of Philostorgius's *Church History* (published between 425 and 433) credits the empress with building the city of Helenopolis, on the Gulf of Nicomedia, at the spot to which a dolphin carried the remains of St. Lucian after his martyrdom.[180] Jerome and other ancient historians identify Helenopolis as Helena's native Drepana.[181] The city have been founded either before of after Helena's death. Philostorgius suggests that Helena built the city, implying that she was still alive at the time. Jerome's *Chronicle* (ca. 380) includes the puzzling statement that the city was named after Helena in honor of the saint, and dates the founding to 327, but does not mention whether this happened in empress's lifetime.[182] To judge from the late antique practice, the re-founding must have taken place while Helena was alive.[183] In either case, the name recognized the Augusta as a city founder of new type, one who cared about Christian martyrs. Perhaps the shrine Helena built in the city for Lucian's relics explains why the city bore her name to honor the saint. The choice of

Lucian fits well with Constantine's favoring of Arianism in his later years, and may also reflect Helena's pro-Arian sympathies.[184] Over time her association with the relics of Lucian faded in memory because of Lucian's heterodox theological leanings and the decline of the city, following the silting of the harbor.[185] Philostorgius's fifth-century narrative is important for the Christian element it brings in the aition for the founding of Helenopolis.

HELENA'S ACTIVITIES IN THE HOLY LAND

The textual sources attribute to Helena the building of three churches in the Holy Land. Each of them was linked to a specific location associated with the life and death of Christ. In the *Life of Constantine,* Eusebius attributes to the empress the Church of the Nativity in Bethlehem and the Church of the Ascension at the Mount of Olives near Jerusalem.[186] But he omits her visit to Jerusalem and her relationship to the Martyrion (fig. 89) the grand complex Constantine commissioned on the site where, according to Eusebius, the cave of the Resurrection was found. With the exception of the church historian Sozomen, who clearly follows Eusebius, most of the fourth- and fifth-century church historians who wrote of Helena's visit to Jerusalem attributed a role to the empress in building the Martyrion,[187] also known as the New Jerusalem, which enclosed both Christ's tomb and Golgotha. The late fourth-century pilgrim Egeria (ca. 380) notes that the Constantinian buildings in Jerusalem rose "under the supervision of [Constantine's] mother."[188] Church historians agree with Egeria's account, recording that Helena built a church on the spot where she found the True Cross and commissioned the silver casket that contained the relic.[189] The presence at the New Jerusalem of the relic of the cross has been inferred from Eusebius's oration "In Praise of Constantine," suggesting that even if the story of Helena's finding of the cross may have been invented, the empress could have acquired a piece of the relic while in Jerusalem.[190] In a letter to Sulpicius Severus, dated circa 402, Paulinus of Nola states that as soon as the empress received her son's permission to cleanse the sites "on which the Lord's feet had trod," she drained the "imperial purse" to construct churches at the sites of the Incarnation, Passion, Resurrection, and Ascension,[191] in other words, the Church of the Nativity in Bethlehem, the complex at Golgotha, and the Church of the Ascension on the Mount of Olives.

Besides Eusebius's suspect silences, no evidence supports the Augusta's building of the Martyrion.[192] One may speculate, based on Egeria's account, that because Helena stayed in the Holy Land, she could have visited the site where the Martyrion was being constructed or even supervised the project. The memory of Helena's visit can be seen as giving birth to the later tradition that the edifice was constructed by the Augusta. Whatever the case with the Martyrion, Helena's piety was tightly linked to her imperial obligation to God. Eusebius considers her visit "in the footsteps of the Savior" an offering of thanks to God for her son and her grandchildren, "the god beloved Caesars."[193] At the time when Helena visited the sacred places of Christianity, she inspected "with imperial

concern the eastern provinces with their communities and peoples."[194] Spreading the imperial religion to the provinces by commissioning adequate monuments parallels Constantine's building activities in Rome. Although Eusebius considered the Augusta's religious buildings and donations part of her imperial responsibilities, because he emphasized piety the full significance of Helena's visit and prerogatives can be missed.

Eusebius writes: "As she visited the whole east in the magnificence of imperial authority, she showered countless gifts upon the citizen bodies of every city, and privately to each of those who approached her; and she made countless distributions also to the rank of the soldiery with a magnificent [right] hand (*dexia megaloprepei*). She made innumerable gifts to the unclothed and unsupported poor, to some making gifts of money, to others abundantly supplying what was needed to cover the body. Others she set free from prison and from mines where they labored in harsh conditions; she released victims of fraud, and yet others she recalled from exile."[195]

The description highlights the lack of an intermediary for Helena's actions, something that has not been sufficiently noted. Unlike Livia, who had to ask Augustus or Tiberius to intercede so that she could accomplish her acts of clemency and benefaction, Helena distributed largesse and granted clemency in her own name.[196] She was the agent, not the intercessor.[197] Helena's magnanimity inflected her exercise of imperial prerogatives. The beneficiaries of her donations included strata of the population other than the less fortunate. Very much like an emperor, she gave to the army, perhaps coordinating this largesse, known as the *donativum*, with Constantine, for he entrusted her with authority over the imperial treasury.[198] "He [Constantine] even remitted to her [Helena] authority over imperial treasuries, to use them at will and to manage them at her discretion, in whatever way she might wish and however she might judge best in each case, her son having accorded her distinction and eminence in these matters too" (*VC* 3.47).

In the preceding century Julia Maesa's promises of money to the soldiers in exchange for restoring the empire to her family led to the downfall of Macrinus.[199] Helena's generosity to the army has given rise to the hypothesis that Helena had journeyed to the East to ensure political stability in the wake of Constantine's repression of pagan cults.[200] Whatever the reason, her agency is a turning point in the conversation about imperial power and women's role in it.

Helena's second paradigm-shifting gesture was to grant amnesty to prisoners and exiles, perhaps the victims of Licinius's persecution of Christians.[201] The Augusta's pardon likewise illuminated her agency. Only emperors could allow the return of exiled individuals or free those serving time in prison. They did so by imperial decree. One of Constantine's decrees, for example, pardoned all criminals to honor the birth of a grandchild.[202] Later pardons were occasioned by the celebration of Easter and by military victories.[203] In other words, Helena invoked the inherently imperial and highly political prerogative of granting clemency. *Clementia* (clemency) appears inscribed along with *Iustitia* and *Pietas* on the golden shield awarded Augustus by the senate.[204]

Helena's actions mimicked Constantine's. Like him she had a palace complex that included public buildings (a bath, a church) and private ones. Like him and probably a few times with him, she commissioned churches. She shared with him the imperial diadem. The Augusta exercised the emperor's rights of clemency and largesse to the army.[205] Such acts unequivocally signified in the public sphere that she shared the imperial authority with her son. Helena's precedent in royal gift giving and her assumption of imperial responsibilities as a co-ruler would empower the imperial women who succeeded her. Helena's and Constantine's successors looked to the founders' exemplary actions to model their own public image. The emblematic power of Constantine and Helena was still potent more than two centuries after their death. When in 574 Justin II declared his successor Tiberius Caesar and endowed him with the imperial dress and insignia, he is said to have spoken to him thus: "Henceforward be thy name called Constantine; for in thee shall the kingdom of the great Constantine be renewed."[206] Afterward Tiberius's name was indeed Constantine, while his wife was acclaimed Helena.[207] The chapter that follows examines the legacy of Constantine and Helena in the building and imperial honors of their successors.

5

CONSTANTINE'S AND HELENA'S LEGACY IN THE ORGANIZATION OF PUBLIC SPACE

Like Rome, Constantinople was a city shaped and adorned by emperors, who commissioned the city's most famous churches and sanctuaries, including the sublime Hagia Sophia, the Church of the Holy Wisdom of Christ. Yet in one respect Constantinople differed from the old capital: whereas emperors built pre-Christian Rome, fifth- and sixth-century imperial women had a vital role in developing Constantinople. Their patronage left its mark on the names of the city's neighborhoods, its baths and cisterns, its churches and hospices, and its palaces (map 1). That founding, far from haphazard, exhibited priorities. These remain opaque in a study of imperial buildings according to type but become clear in a study focused on particular buildings and the relationship between buildings. The late antique Constantinopolitan patterns that conditioned the urban fabric came from the partnership of male and female imperial founders.

Today it is impossible to see the early Christian urban fabric. Most of the buildings are gone, and only precious fragments exist of this tapestry and its richly embellished patterns. What we know about Constantinople's early history and topography comes primarily from textual sources, the most important of which is the fifth-century *Notitia urbis Constantinopolitanae*, the only source that lists buildings by city district, and that pays attention to secular buildings and where people lived. In most other sources buildings receive only a cursory mention, with next to nothing about their appearance. Sources often contradict one another about attributions to sponsors and even create entirely unhistorical ones. Although the precise patterns of Constantinople's urban fabric are impossible to determine from the existing evidence, it is nonetheless imprudent

to ignore them. The task requires a willingness to set sail on a sea of uncertainty and to chart a course by informed speculation. The results of such an enterprise, however, are rewarding as Constantinople comes into view as a city that developed around residences built by imperial men and imperial women.

By the sixth century there were some twenty-one such residences. The empresses before Helena owned villas outside Rome, but in the city itself no separate palaces were named for imperial women.[1] In Constantinople, empresses were owners of mansions and gave names to entire neighborhoods: Helenianai, the neighborhood of Helena; Pulcherianai, that of Pulcheria; Plakidias, that of Placidia; and Ioulianes, that of Juliana. These neighborhoods, eponymous little cities within the city, gave rise to other buildings and fashioned Constantinople as a city of emperors and empresses.

Availability of space differentiates the two imperial capitals. Constantinople, with vast tracts of available land, presented more building opportunities than Rome. Yet the mere availability of land does not explain the number of imperial residences per imperial person. The empress Pulcheria, for instance, owned two or perhaps three mansions. Even her sister Arcadia had two. Why?

In Constantinople palaces and other mansions did more than house members of the imperial family. The proliferation of such buildings in the fifth century stimulated the city's growth by providing the nuclei for new neighborhoods. At the same time, an empress's residence, with its auxiliary public and private buildings, imparted to its female owner some of the aura of authority and prestige of the Great Palace. And only in the early sixth century, with the building of Hagios Polyeuktos, did churches come to rival palaces as preeminent emblems of imperial majesty.

"A MANSION IS A CITY": THE GREAT PALACE AND OTHER RESIDENCES

The Great Palace furnished a template for subsequent imperial residences.[2] It was a complex that required auxiliary public buildings such as baths and churches.[3] The Constantinian palace complex included the residence, the nearby Baths of Zeuxippus, the Hippodrome, and the Augustaion square east of the palace[4] that linked all these buildings into an organic whole (map 5).[5]

In the centuries after Constantine, the Great Palace continued to grow. Procopius notes the presence of women's quarters.[6] At the time of the emperor Tiberius (r. 578–82) the palace included at least two sets of apartments for the imperial family, barracks for the guards, a monumental gateway, a grand banquet hall, a throne room, shrines, one or more gardens, stables, and various offices.[7] The premises of the palace also featured an area called a "hippodrome" (*hippodromion*) or a "covered hippodrome."[8] Perhaps, as in the imperial palace in Rome, this was just a garden shaped as racehorse track and used only for various ceremonies. Or, as Hesychius of Miletus (sixth century) reports, this hippodrome may have been used for part of its history by the imperial family for private

chariot races.[9] Its dimensions and location, like those of other palace buildings, can be reconstructed only conjecturally. Textual evidence and archeological remains suggest that most structures of the palace complex clustered around peristyle courtyards on terraces overlooking the Sea of Marmara (map 5).[10]

The buildings in and around the Great Palace exhibited important similarities to the original *palatium/palation*, Augustus's imperial residence on the Palatine Hill in Rome,[11] in their amenities and in the people charged to take care of them and the imperial family. In its three hundred years of use as the major imperial residence, the Palatine underwent several reconstructions. By the fourth century it included imperial apartments, temples, reception halls, dining halls, gardens, pools, several baths, and administrative rooms. These structures, like those reported for the palace in Constantinople, stood around colonnaded courtyards. The model for the Hippodrome in Constantinople—Rome's Circus Maximus—was adjacent to the palace, and a direct passage provided access to the imperial lodge, the *kathisma*.

The Roman palace employed a large number of people. An epigraphic study of Livia's household, next to that of the emperor, has identified a staff of guards and administrators of the first Augusta's financial assets, a variety of attendants for her bedroom, numerous slaves in charge of her transportation, many cooks and people responsible for the entertainment at her house, scores of wet nurses for the children of her household, five doctors, gardeners, grooms for her horses, couriers, and so forth.[12] There were also domestics assigned specific tasks in maintaining the house and producing textiles. A few of Livia's slaves and freedmen took care of her appearance.[13] The large number of Livia's domestics reveals the *palatium* as a self-sufficient unit in the city. More study is needed of the scale of the empresses' households after Livia. Still, all reconstructions of the Palatine complex by later emperors made it still grander and more spacious, suggesting that even more individuals lived there and took care of its upkeep and day-to-day functions.[14] The large population of the palace determined another characteristic: Rome's palatial complex, though self-sufficient, was encircled by public buildings. The Roman Forum lay to the north, the Circus Maximus to the south. In the larger vicinity there were public baths and porticoes.

The home of the emperor's family belonged to the class of the aristocratic mansion, but on a larger scale, to accommodate the state business performed there.[15] The historian Olympiodorus of Thebes remarked, in a work on the houses of the nobility in Rome published shortly after 425: "Each of the great houses [*megaloi oikoi*] of Rome contained within itself, . . . everything which a medium-sized city could hold, a hippodrome, fora, temples, fountains, and different kinds of baths. . . . One house is a town; the city hides ten thousand towns."[16] Aristocratic houses, then, also appear to have been self-sufficient. Indeed, self-sufficiency was an old Roman ideal.[17] When Libanius described the Daphne, the late-antique imperial palace in Antioch, as a "new city," he did not imply novelty, but measured the palace against the established ideal.[18] He also suggested that a cluster of buildings surrounded the palace and formed and organic whole with it, observing that

"the district in front of the palace shares the grandeur within, even though it is inferior to what is within."[19] Archeological excavations at Helena's Sessorian Palace confirm that buildings clustered around it, including private apartments, a public bath, and a church open to visitors (map 6). In Constantinople, the archeological remains of the palaces of Antiochus and of Lausus, north of the Hippodrome, similarly reveal buildings grouped around colonnaded semicircular porticoes (map 5).[20] The floor plan for the Palace of Antiochus indicates that the various parts of the complex were reached through one common entrance, an arrangement that indicates that these parts were designed to serve some public function.

Similar observations about the public and private uses of the many buildings making up a residence can be made about the Great Palace in Constantinople. Gardens, imperial apartments, baths, shrines, and the hippodrome inside the palace grounds would have been used by the imperial family and their selected guests alone.[21] The guards at the Chalke Gate and the barracks right behind it carefully monitored the traffic in and out of the palace to ensure its security and privacy (map 5). But some structures in the palace complex, including administrative offices, reception rooms, dining rooms, kitchen, and stables must have allowed a limited public access.[22] And all the buildings around the palace complex and connected to it were public. The emperor entered the Hippodrome from the palace; a passage linked the splendid Zeuxippus baths to the palace; the Augustaion square was adjacent to the palace; and the Church of Hagia Sophia stood across from it.[23] The crucial point is to understand the Great Palace and other late antique imperial palaces as complexes including private as well as public buildings. Insofar as the emperors constructed the public buildings outside the main gate, but near the palace, those buildings should be considered extensions of the palace, used by Constantinople's citizens and the palace's residents.

The numerous *palatini*—the people who resided in the Great Palace in Constantinople—included at least the personal staff of the emperor and the empress and state bureaucrats. When Julian (r. 360–63) purged the court, he targeted obsolete personnel inherited from his predecessor Constantius. Although Libanius no doubt exaggerated, his eyewitness account creates a vivid impression of the hustle and bustle of courtly life: "There were a thousand cooks, as many barbers, and even more butlers. There were swarms of waiters, even more eunuchs than flies around cattle in springtime and a multitude of drones of every sort and kind."[24] The modest style Julian espoused proved short-lived. The resident population of the palace continued to grow. One source mentions that a retinue of four thousand people accompanied the empress Theodora to the mineral springs. Perhaps not all of them resided in the palace, but many must have.[25] The *Theodosian Codex* stipulates that the *palatini* always accompanied the emperor, and there is no reason to think that the empress traveled with a different contingent.[26] Estimates put the smaller bureaucracy and court at Ravenna at about fifteen hundred people.[27] By comparison, the jobs in Livia's household for slaves and freedmen and freedwomen, estimated at eighty-four, seems small, though a larger number of people would have lived

at her residence at any one time.[28] Calculations based on the number of urns for the ashes of Livia's slaves and freedmen that were deposited in the *Monumentum Liviae*, the columbarium on the via Appia, estimate this number at about a thousand people.[29] Theodora's retinue dwarfs this figure, but both households comprised numerous people requiring many services. The difference between Livia's household (in the first century C.E.) and Theodora's (in the sixth century C.E.) and, by extension, the Palatine residence in Rome and the Great Palace in Constantinople was quantitative, not qualitative. Overall, the Great Palace was a self-sufficient unit of urban space, including public and private buildings and employing a large number of people.

This design of the urban fabric was replicated in lesser imperial mansions and aristocratic residences, usually called *domus* or *oikoi*.[30] The *Theodosian Codex* offers evidence suggesting the presence of commercial and other enterprises at the imperial residences. A statute dated to August 21, 418, stipulates payment of the lustral tax by all merchants and other property holders, regardless of their protection. The law targeted individuals belonging to the households of the Augusta Pulcheria and her sisters, the *nobilissimae* Arcadia and Marina.[31] If the *domus* of the imperial sisters included merchants and other proprietors, surely they also had personal secretaries and staff for their upkeep. Thus even a lesser imperial residence might have housed its own community; to operate and maintain it would have involved bringing goods and commercial activities right inside.

The aristocratic residence was also well-appointed. The mansion of the fifth-century widow Olympias, at ta Olumpiados, near Hagia Sophia, featured a *tribounarion* (most likely a type of court), a bath, adjoining houses, and a bakery.[32] The archeological remains from a palace identified as that of Antiochus (built ca. 410–20) reveal an imposing semicircular portico fifty-two meters in diameter (map 5).[33] The mansion of Lausus (built ca. 420–30) next to it had a domed rotunda and a dining hall with seven apses.[34] Similar archeological data are not available for other mansions, but what data there are indicate that these aristocratic residences resembled the imperial palaces, both in the facilities they featured and in the development of the urban space around them. A single *domus* and its closely related buildings, then, took up a significant portion of the city.[35] Analysis of the archeological remains of the Roman quarter near Termini suggests that those who owned the mansions uncovered there also held the adjacent commercial property, including a bath, and rented parts of it to others.[36] The general pattern was a cluster of connected buildings, bound by ownership.

Indirect evidence for the rental of property comes from Olympiodorus, who related that many Roman households (*oikoi*) boasted revenues of four thousand pounds from their properties.[37] Because that sum excluded income from agricultural produce, such as grain and wine (which would have amounted to a third of the whole), most of it would have come from other sources, such as commerce, rental properties, nonagricultural production, or some combination of them. Rentals could include either urban property or agricultural estates, though it remains unclear what the proportions might have been. Less is known about Constantinople, but a similar situation there can be inferred.

Housing for the imperial family, aristocrats, and the common people need not have been separated, because a *domus* attracted rather than repelled activities around it. One study describes Rome's urban fabric as "mixed," divided into a "series of cellular neighborhoods." The mingling of mansions with blocks of flats, public baths, latrines, and taverns defies the notion that rich and poor lived in separate neighborhoods.[38] Constantinople most likely had a similar arrangement. The aristocratic and/or imperial mansions brought cohesion to a neighborhood.

PALACES, MANSIONS, AND SACREDNESS

The symbolic difference between imperial and aristocratic residences was nonetheless significant, as an analysis of the "semiofficial" *Notitia* (ca. 425–30) helps clarify. This document records in Latin the major structures and officials in each of Constantinople's fourteen regions, making it the essential source for the buildings and topography of fifth-century Constantinople.[39] The praise of the emperor Theodosius in the introduction to the *Notitia* and the prominence of emperor's family in its listings have been taken to indicate imperial bias.[40] Indeed the emphasis on Theodosian Augustae and *nobilissimae* along with the arrangement of the items in this document seem to follow preconceived notions of their importance.

The *Notitia* lists the following named residences of imperial women: the palace (*palatium*) of Flaccilla; the palace and *domus* (mansion) of Galla Placidia; the residences of the three daughters of Arcadius and Eudoxia, including two *domus* of Pulcheria and one each for Marina and Arcadia, as well as a *domus* of their sister-in-law, Eudocia.[41] Two of the four palaces (*palatia*) in Constantinople recorded in the *Notitia* bear the names of Augustae, and all of the eight mansions (*domus*) recorded there are named for imperial women. Moving from east to west, the *Notitia* locates them as follows (map 1): a *domus* of Marina and a palace of Placidia Augusta were situated in Regio I, which was also the *regio* of the Great Palace; there was a *domus* of Pulcheria in Regio III, east of the Hippodrome; and Arcadia had a *domus* in Regio IX, east of Regio III. Further northwest, in Regio X, one of the largest districts of Constantinople, were a palace, three imperial mansions (*domus*), and 636 unnamed residences. Regio XI featured the palace of Flaccilla and the *domus* of the Augusta Pulcheria.[42] The precise locations of imperial residences the *Notitia* lists remain unknown, although it has been suggested that they all clustered along the Mese.[43] In the section that recapitulates all the buildings, the *Notitia* distinguishes between a *palatium,* a palace, and an imperial *domus, a* mansion; reveals the relative distribution of palaces and other residences of the imperial family in the city's fourteen *regiones;* and relates the significance of the imperial housing to that of other buildings. The hierarchy of the recapitulation signifies the symbolic value of imperial homes and relates it to that of other mansions and other buildings in the city. The biased document, in combination with other evidence, presents imperial residences as kernels of urban growth and stimuli for patronage.

The summary section of the *Notitia* begins with palaces (*palatia*), making no distinction between male and female imperial palaces or between *palatium magnum* (the Great Palace) and other *palatia*. The *palatia* thus included the Great Palace, a *palatium* in Regio XIV, and two palaces of women (Flaccilla and Placidia) (map 1).[44] After the count of palaces, the *Notitia* enumerated fourteen churches, followed by the list of six *domus divinae Augustarum* (mansions of the divine Augustae), three *domus nobilissimae* (mansions of the women with the rank of *nobilissima*, usually imperial daughters),[45] and eight *thermae* (baths). The catalog ignored the named residences of other aristocrats, neglecting even such impressive buildings as the residences of Antiochus and of Lausus,[46] though those are presumably included in a summary count of 108 mansions (*domu*) in Regio VIII. Another 636 unnamed *domus* are cataloged under Regio X, indicating no separation, at least in the *Notitia*, between lower-class and upper-class housing.[47] The summary count thus distinguishes between the two types of imperial residence and between imperial and other *domus*. In the *Notitia* the residences of the imperial women ranked higher than churches when they were *palatia* and lower than churches when they were *domus*. The Great Palace is not singled out in the summary count but listed simply as *palatium magnum*, suggesting its typological similarity to other *palatia*.[48] The women's palaces must also have carried some of the superhuman aura that surrounded the Great Palace, which legislative documents referred to as "sacred."[49] The ranking of churches over *domus* indicates that both scale and symbolic importance differentiated a palace from a *domus* (mansion). Churches were thought of as houses for the saints and God, they required special consecration rites, and their grounds provided sanctuary.[50] The *domus* lacked the sacred aura of palaces and churches. The hierarchy established in the *Notitia*, with a palace at the top, followed by a church and then a bath, corresponds to imperial priorities in the city; in urban development, palaces came first. By the mid-sixth century most *regiones* of the capital had either a palace or an imperial *domus* (map 1).

That distribution of imperial mansions suggests something more than the availability of land, clean air, and views of the sea, though such qualities remained desirable.[51] These residences, as little cities in the urban fabric, became nodes of growth, structuring the city's development. A panegyric for Theodosius I (r. 378–95) provides a glimpse of the logic guiding the larger imperial project. Speaking of the area outlined by the walls of Constantine, Themistius (ca. 317–388/389) remarked: "No longer is the vacant ground in the city more extensive than that occupied by buildings; nor are we cultivating more territory within our walls than we inhabit; the beauty of the city is no longer scattered over it in patches, but covers the whole area like a robe woven to the very fringe. . . . its former extremity is now its center."[52]

Filling Constantinople's empty tracts of land became a major task of the emperors. The weaving of Constantinople's urban fabric can be interpreted as a matter of prestige in which New Rome would meet (old) Rome's standards. The design of the Great Palace, which provided the pattern for this fabric, was replicated in imperial mansions more than twenty times. The walls of the city were the loom, the frame, on which emperors

and empresses wove the urban fabric, with boulevards and squares forming the strong warp and imperial residences, the embellishing weft. Emperors took care of the frame and the warp, men and women together wove the designs.

PALATIAL COMPLEXES IN CONSTANTINOPLE

After Constantine, the next emperor to build an imperial residence was Valens (r. 364–78). He commissioned the suburban imperial palace complex at the Hebdomon, about seven Roman miles west of the city,[53] which featured a mansion, a portico with unmatched views toward the Propontis, and a port. Over the centuries emperors built other structures in the neighborhood; Theodosius I, for example, built a large church dedicated to John the Baptist. The military detachments stationed at the Hebdomon would have been the primary consumers of goods and services in that area. A nearby eighth-century open reservoir the size of a soccer field indicates the extent of the needs of the palatial complex and military regiment stationed there.[54]

Similar buildings surrounded the suburban palace built by Leo I (r. 457–74) after the fire of 464 that devastated the Great Palace. The complex, located in the area now called Beşiktaş, included a mansion, a small port, a hippodrome, a portico, and a church.[55] These three (Great Palace, Hebdomon, Leo's Palace) examples demonstrate that imperial men's palaces entailed the construction of public buildings, such as baths, porticoes, hippodromes, and churches.

There is no significant difference between the residences of emperors and the Augustae, with one exception: the palaces and mansions of empresses did not include hippodromes,[56] while the palaces of emperors did.[57] Racecourses remained outside the sphere of female imperial patronage. A hippodrome may not have been the most important requirement for an imperial residence to be called palace. A residence designated a palace retained its political character at all times. An imperial decree from 406 testifies to this. It forbade the lodging of travelers in palaces, no doubt because of the buildings' symbolic significance.[58] During the Nika riot of 532 the insurgents intended to use either the palace of Flaccilla or the palace of Helena as the headquarters for the usurper Hypatios.[59] Neither featured a track for chariot races, yet either was considered equally suitable to be an imperial residence.

The contribution by imperial women to the urban fabric is more difficult to reconstruct. Each of their mansions requires its own focused study. But evidence retrieved from the few textual sources suggests a similar pattern of a palace with auxiliary buildings. Six residences—the mansions of Arcadia, Marina, Pulcheria, Anicia Juliana, Theodora, and Sophia—and the buildings in their vicinity demonstrate this point.

Helena seems to have pioneered the practice of named residences in Constantinople. By the early fifth century, there was an imperial palace named after Helena, ta Helenēs, south of the Porticus Troadensis, in Regio XII.[60] Beside it was a public bath, and nearby stood three churches. Arcadia (400–444) and her younger sister, Marina (403–49), were

not Augustae. They are remembered mostly for their religious devotion and the vow of virginity they took at the behest of their famous sibling, the empress Pulcheria. The *Notitia* reports one, *domus nobilissimae Arcadiae* (the mansion of the most noble Arcadia), in Regio IX and another in Regio X.[61] Arcadia also built a church, Hagios Andreas ta Arkadias (St. Andrew in the neighborhood of Arcadia).[62] The name of the church suggests that it was built in an existing neighborhood named ta Arkadias. It is uncertain which of Arcadia's two residences stood beside it.[63] And it remains unknown whether Arcadia sponsored any baths or other buildings in the vicinity. The seventh-century *Chronicon Paschale* (Easter Chronicle), a generally reliable source, claims that Arcadia founded (*ektise*) the well-known Arcadianae bath (*to dēmosion Arkadianas*) in Regio I.[64] This claim is contradicted, however, by another reliable source, the sixth-century chronicle of Marcellinus Comes, which attributes the Arcadianae baths to Arcadia's father, the emperor Arcadius (b. ca. 377; r. 383–408), and dates it to 394.[65] The differing attributions in the historical sources may be explained by the continuity of family patronage of a single building. Arcadius may have initiated the bath, and his daughter, who outlived him by thirty-six years, may have completed it. If Arcadius founded the bath and his daughter maintained it after his death, the daughter could easily have been given credit for it, especially because they bore variants of the same name.

Some evidence suggests that Arcadia and Marina cooperated in the development of the area around the Arcadianae baths, possibly continuing jointly their father's patronage. The *Notitia* locates in Regio I both Marina's mansion (*domus nobilissimae Marinae*) and the Arcadianae bath.[66] Other sources refer to the neighborhood around Marina's residence as ta Marinēs.[67] In the regionary catalog, the Thermae Arcadianae (the Arcadianae baths) are listed immediately after the mansion of Marina. The textual proximity may also indicate a spatial relationship between the two buildings. To a certain degree, the individual lists by *regio* in the *Notitia* adhere to a preconceived sequence, shared by more than one region. For instance, *balnea* (baths) in all instances precede *pistrinae* (bakeries).[68] But named structures elude this arrangement. Their sequence depends in part on location. The *lusorium* (mime theater) in Regio I is an example. It is the second item on the list, immediately after the Great Palace, and before the palace of Placidia. But the *lusorium* in Regio XV takes sixth place in the list and obeys a different logic.[69] Thus the *domus Marinae,* in addition to being in the same *regio,* may have been situated close to the Thermae Arcadianae to form an integrated imperial complex consisting of a residence, a bath, and probably other buildings. The *Patria* attributes the Church of Hagios Iōannēs hai Arkadianai (St. John at the Arcadianae) to Arcadius,[70] a mistake that probably arose because Arcadius and his daughters developed this area overall.

The residences of Augusta Pulcheria, the older sister of Arcadia and Marina, reflect both the scale of her ambitions and her impact on Constantinople's urban development. Pulcheria's *domus* were located in Regiones III, X, and XI. The *Notitia* situates two of them in noncontiguous *regiones,* one in Regio III and the other in Regio XI; the exact locations are unknown.[71] Regio III enclosed the Hippodrome and the area south of it to

the Sea of Marmara.[72] Regio XI lay in the city's center. The only inland district, this *regio* boasted the Church of the Holy Apostles and the palace of Flaccilla.[73]

Pulcheria's Church of St. Lawrence postdated the composition of the *Notitia* by approximately three decades; it was completed in 453. The chronicle of Marcellinus relates that Eudocia Augusta, Pulcheria's sister-in-law, placed there, in 439, the relics of Protomartyr Stephen.[74] Marcellinus describes the church as "unsurpassing work" (*inimitabili opere*).[75] Theophanes Continuatus locates it in the Poulcherianai, a neighborhood named after Pulcheria.[76] Two hypotheses exist for its location: that the church stood near the present Aşik Paşa Mescidi; and that it should be identified with a Byzantine structure not far from Aşik Paşa Mescidi.[77] According to the *Notitia*'s division of Constantinople, either hypothesis would put the church in Regio X, a northeastern area overlooking the Golden Horn.

The name of the neighborhood in which the church was built suggests that a residence of Pulcheria may have been there too. The survey of this neighborhood conducted in 1927 identified a wall that was interpreted as that of a palace then considered to have been that of Pulcheria.[78] The surveyor situated that palace between the Cibalikapi and Unkapan Gates (map 1).[79] In the fifth century, the *Notitia* cataloged three imperial residences in this area of the city: the *domus* of Pulcheria's grandmother Galla Placidia Augusta (d. 450), the *domus* of Pulcheria's sister-in-law, Eudocia (who left permanently for Jerusalem in 443), and the *domus* of Pulcheria's sister Arcadia.[80] Given the name of the neighborhood, hai Poulcherianai, Pulcheria either built another *domus* there or, more likely, inherited one of the three mansions mentioned in the *Notitia*. Arcadia died in 444, early enough so that the neighborhood around her mansion could have been renamed Poulcherianai after the new occupant. The splendid church would have been an additional argument for renaming the mansion and surrounding areas.

In addition to mansions and a church, a cistern is linked to Pulcheria. The *Notitia* makes no mention of a cistern of Pulcheria. The *Chronicon Paschale*, however, reports the inauguration of a cistern of Pulcheria in February of 421, during the consulship of Eustatius and Agricola, thus dating it to the four years preceding the composition of the *Notitia*.[81] Why would that work have excluded such an important structure?

Perhaps it was not excluded but included, under a different name. Again a tradition of familial patronage may provide an answer: the empress might have finished a project started by another member of her family. The *Notitia* mentions a cistern of Arcadius (*cisterna Arcadia*) and a cistern of Modestus (*cisterna Modestiaca*), both located in Regio XI.[82] The first is associated with the emperor Arcadius, Pulcheria's father, and the second with Domitius Modestus, a city prefect in 369.[83] That the cistern of Arcadius and the cistern of Pulcheria may be one and the same structure may explain the absence from the *Notitia*. The father may have been responsible for beginning, and the daughter for finishing, the construction of a single cistern, and the *Notitia* may simply have kept the name of the original builder, Arcadius. The use of the old name along with the new was not unusual.[84]

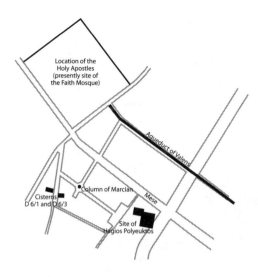

Location of the
Holy Apostles
(presently site of
the Faith Mosque)

Aqueduct of Valens

Cisterns
D 6/1 and D6/3

Column of Marcian

Mese

Site of
Hagios Polyeuktos

MAP 7

Area around the Church of the Holy Apostles, Constantinople, showing the location of the Column of Marcian and cisterns D 6/1 and D 6/3c. Drawn by Bill Nelson after Müller-Wiener 1977, Lageplan.

The *Notitia* gives no specifics about the location of the cisterns of Arcadius and Modestus, but lists them in succession. In the document's organizational logic, successive listing suggests physical proximity. Significantly, two Byzantine cisterns, located side by side, were uncovered in Regio XI (map 7),[85] where they must have served the water needs of this neighborhood. In addition to Pulcheria's *domus* there, the *Notitia* counts fourteen private baths, one *palatium,* 503 regular *domus,* four big porticoes, and four bakeries.[86] In building a cistern, Pulcheria responded to Constantinople's water shortages. Cisterns, like aqueducts, were essential for the baths. A cistern in a populous and important neighborhood would have brought significant political capital to the builder because it made a number of public buildings operational. In other words, Pulcheria's cistern had tremendous public value.

Considering buildings in this neighborhood in their urban context illuminates links between them that delineate an organic whole. The two cisterns in Regio XI are situated about eighty meters from the Column of Marcian (r. 450–57), Pulcheria's husband (map 7).[87] In the palimpsest of Constantinople's urban history such faint connections between buildings and patrons cannot be ignored. The prefect Tatianus dedicated the column with the statue of Marcian about 450–52, some twenty-eight to thirty years after the dedication of Pulcheria's cistern (fig. 90). The location of the column, like that of most such dedications, indicates its link to structures associated with the honoree. For Marcian, a man of comparatively humble background, that would have meant buildings associated with his exalted wife, Pulcheria. Having no imperial pedigree of his own, Marcian married into political legitimacy. It is unlikely that he or Tatianus would have neglected to advertise his links with Pulcheria's august family, especially with such a monument as a public column. That column was probably close to Pulcheria's palace in Regio XI,[88] and the imperative to erect it there would help explain its curious placement, out of the way, southwest of the main thoroughfare (map 7). Columns and squares dedicated by previous emperors were

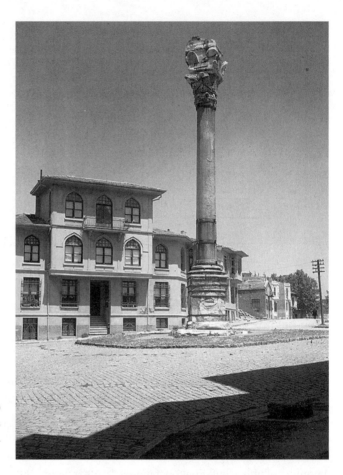

FIGURE 90
Column of Marcian, Istanbul. Photo
credit: Deutsches Archäologisches Institut—
Istanbul, 2433.

strategically placed on the city's major arteries. A desire to relate the column, and possibly square, to a preexisting structure or structures now buried beneath Istanbul explains the anomaly.[89]

Anicia Juliana's building activities represent another instance of imperial residences that stimulated urban growth. Juliana's property belonged to the area around the Holy Apostles, ta Konstantiniana. Ta Ioulianēs, where Juliana had built her residence, may have been north or northwest a short distance from the church she dedicated to the martyr Polyeuktos.[90] The empress Eudocia, Juliana's great-grandmother and Pulcheria's sister-in-law, commissioned the first church on the site of Hagios Polyeuktos, which may have been close to Eudocia's *domus* in Regio X (map 1).[91] South of St. Polyeuktos, on the other side of the baths, Juliana reconstructed and beautified the nearby Church of St. Euphemia in ta Olybriou, the neighborhood of her parents' residence.[92] The inscription in that church, preserved in the *Anthologia Palatina*, narrates how Licinia Eudoxia (Pulcheria's niece), "the daughter of Theodosius [II] erected and dedicated [this church] to God in acknowledgment of her rescue from distress," and afterward Placidia, her

dedicated and then adorned. [handwritten annotation]

daughter (Juliana's mother), "with her most blessed husband (Olybrius, Juliana's father) adorned [it]" (*Anth. Pal.* 1.12). [93]

By about 430, when Anicia Juliana's imperial ancestors still lived, Regio X already offered a host of amenities. A traveler could visit the Constantianae baths, a nympheum (a fountain), six big porticoes, nineteen bakeries, the spacious basilica to the martyr Acacius, and the aqueduct of Valens.[94] All these imply a sizable population and extensive opportunities for commercial and other business ventures. Juliana and her predecessors must have employed a number of people in their construction project. To judge from the archeological remains, Juliana's payroll for the building of Hagios Polyeuktos would have had to include sculptors, mosaicists, glass artisans, masons, carpenters, and scores of other construction workers. These people and their families needed housing, sustenance, and entertainment. The area around the lofty church and Juliana's mansion must have provided for some or for all of these.[95] The life of St. Polyeuktos written by Gregory of Tours (ca. 538–ca. 594) describes Juliana's income as coming from rents as well as harvests, suggesting that she owned both urban property and rural land. Surely Juliana took advantage of the commercial possibilities that the presence of so many people created.[96] The symbolic import of her patronage—not just her churches—can be gleaned from the inscription she placed on the exterior and interior of Hagios Polyeuktos, proclaiming that she modeled her actions on Constantine's.[97] Each palace, in a sense, imitated Constantine's founding efforts to develop the city to a high standard and to provide livelihood for numerous people. The location of Hagios Polyeuktos established more than one association with the founder. It stood right in the middle of the city, close to the Holy Apostles, Constantine's resting place. Its considerable height meant that it communicated visually with Constantine's church. Given Constantine's ambitious secular building program in Constantinople, Juliana's comparison implied much more than imitation in church building.

labor costs [handwritten annotation]

imitating secular buildings [handwritten annotation]

Theodora's palace at the Hieron, on the Asian side of the Bosphorus, suggests a similar, if subtler, reference to the founder. Procopius states that the amenities of the Hieron competed with those of the Great Palace.[98] An inscription preserved in the *Palatine Anthology* celebrates Justinian as its builder. But another inscription in the same source addresses the sovereigns (*koiranoi*), implying that Theodora too may have been engaged in its construction and stating that time will proclaim the virtue, power, and deeds of the rulers in eternity. Among those deeds was the construction of the palace with its amenities. The complex included porticoes (*stoai*), public squares/markets (*agorai*), public baths (*loutrōnas en dēmosiō*), a church of the Theotokos, a port, and an open cistern.[99] All of these, including the port, were built to serve the palace. The palace, which sparked the development of the area, symbolized imperial authority in that part of the city.

Another sixth-century imperial residence, possibly inspired by the Hieron, prompted the renewal of an older neighborhood. Before Justin II became emperor, he and his wife, Sophia, had a palace on the Propontis, east of the old port of Julian. The palace and the nearby port, reconstructed when the palace was built (ca. 565–67) or shortly after, carried

Sophia's name (map 1).[100] The *Patria* reports that Justin constructed the harbor and that four statues (*stēlai*) stood in the middle of it, representing Sophia and Justin; Arabia, their daughter; and Vigilantia, Justin's mother and Justinian's sister.[101] The neighborhood was referred to as ta Sophias and hai Sophiai.[102] Four churches were identified as located there, none connected to Justin or Sophia.[103] But just north of the palace Sophia commissioned her church to SS. Cosmas and Damian.[104] Theophanes, writing approximately three centuries after Sophia's time, mentions that in the year (569–70) Justin built a church to the holy healers Cosmas and Damian; he also restored a public bath and named it after Sophia.[105] This church is likely identical to the one commissioned by Sophia, but attributed by Theophanes to Justin. If so, then the palace in Sophia's name, the bath, and the church to Cosmas and Damian were probably in close vicinity to one another. The statues in the port suggest that the port may have been the couple's joint undertaking, so does the description of its building in the *Patria* (3.37), a text that credits Sophia with the initiative. In any event, Sophia's dedication of Cosmas and Damian not far from the palace indicates that she participated in developing this part of the city.

Indirect evidence from another palace named after Sophia, to *palation Sophianōn* (the Sophianai palace) lends support to this hypothesis. It too was constructed before Justin became emperor, on the Asian side of the Bosphorus.[106] An epigram in the *Palatine Anthology* explains that Justin, "our divine sovereign [*anax*], erected this palace for his most illustrious queen [*anassa*]."[107] In its description, type, and location, the gift resembles Justinian's gift of the Hieron palace to Sophia's aunt, Theodora, and may have been intended to imitate it. Though built for the empress, the Sophianai is identified as Justin's primary residence by Corippus, who describes it as a most wondrous creation, comparable to Hagia Sophia. The poet asserts that the two buildings, Hagia Sophia and the Sophianai, surpassed the Temple of Solomon.[108] Hagia Sophia was the house of God, and the Sophianae the house of the emperor.[109] Corippus's choice of the Sophianai, which the epigram testifies was built by Justin, over the Sophiae on the Propontis, subtly signals that the empress was in charge of the Sophiae and its adjacent buildings.

The mansions of imperial women actively structured the topography of Constantinople, and presented their owners along with the emperor as founders of the city in the current generation. The public and private buildings that grew around imperial mansions renewed the city by beautifying it, expanding the amenities available to its residents, and by creating jobs of various kinds. Imperial residential complexes thus exemplified the practical dimensions of founding the city anew.

6

IMPERIAL WOMEN AND CIVIC FOUNDING

Building palaces was the major but not the only way in which empresses shouldered the burden of urban renewal. They also commissioned porticoes and baths. Precedents existed in the Augustan period for porticoes built by women, but Helena pioneered female imperial bath building.[1] Both building types showcased the imperial women as exemplary city founders.

Porticoes and baths were critical to everyday life in any ancient Mediterranean city, and commissioning either for one's city was an act of extraordinary largesse. This was especially so in the imperial cities of Rome and Constantinople, where expectations were higher and where emperors competed vigorously with one another to aggrandize themselves by building magnificent public structures. The portico took various forms and housed multiple activities. It could be a freestanding structure, a colonnaded street, a large open space enclosed by colonnades, or a colonnade associated with another building.[2] Shops, law courts, gardens, and art galleries could be housed under its roof. Porticoes, in other words, provided a place for services important to the community, as well as a beautiful place to walk and socialize. Their monumentality signaled the grand ambitions for public presence in the city of those who built them. In the capitals, emperors habitually built porticoes as part of the imperial fora, in the grand public squares they erected in their own names and in front of public buildings.[3] Today almost nothing survives of the vast network of porticoed streets that once covered the Mediterranean city. A public bath, like a portico, was a social place that brought prestige to the person who commissioned it. Roman bath complexes were sheathed in marble and could spread over

several acres. They contained hot and cold pools, spacious gardens, statuary, exercise courts, and lecture rooms. They welcomed men and women.[4] About the imperial baths in Constantinople, much less is known—not even such basic information as their location, decoration, and size.[5] That baths remained essential to civic life as late as the sixth century becomes clear from the amount Justinian (r. 527–65) paid to heat them. Only the expenses for the army, administration, and fortifications consumed a larger sum than the upkeep of the baths.[6] That one of Justinian's chief concerns was to build baths in the reconquered western territories suggests they continued to be indispensable to everyday life in the late antique Mediterranean.[7]

A TRADITION OF PORTICOES

Empresses do not at first appear to have been serious contenders with the late antique emperors in the building of porticoes, which were usually associated with the emperors' fora. Galla Placidia's portico in Ostia seems to be the only one known.[8] Yet the sources allow the addition of another portico to this number—that of Theodora—and the possible identification of others. Precedents in the Augustan age for such female civic patronage underscore their significance as a gesture of civic, imperial, and female patronage. Two women in addition to Livia each built a portico in Rome: Octavia, Augustus's sister, and Vipsania Polla, Agrippa's sister.[9]

Livia's, Octavia's, and Vipsania's porticoes were imposing and well-known buildings in Rome. Octavia finished a portico begun by her son Marcellus,[10] some parts of which are still extant (fig. 91). Rectangular in shape, 119 meters wide and 132 meters long, it was elevated above the surrounding ground, no doubt to enhance the view, both from and of the building. Two gateways, each with six Corinthian columns, defined the entrances to the portico. The interior courtyard featured twin temples to Juno and Jupiter (fig. 92). The portico also contained a library; a curia, or meeting place, for the senate; and a *schola,* a school of rhetoric.[11] Famous paintings and statuary decorated it.[12] Pliny reports that a statue of Venus, "a work of extraordinary beauty" by the famous sculptor Phidias (490–430 B.C.E.), was located there.[13] He also notes that two statues, of Asclepius and of Diana, by Kephisodotos, said to have been the son of Praxiteles, stood inside the temple of Juno.[14]

The Portico of Vipsania was built (after 7 B.C.E.) in the Campus Agrippiae, close to the Pantheon. No archeological remains survive from the Portico of Vipsania, nor has its size or precise location been identified (map 2, see near 2).[15] Like the other two porticoes, it must have been a sizable structure, for troops were stationed there in the years 68–69.[16] This portico was known for the detailed map of the world it housed, and for its laurel plantings.[17] Although each of the three porticoes gained its reputation for different reasons, and even though the three differed somewhat architecturally, some of their commonalities invite attention. Visibility in the city seems to have been an important consideration for all of them, so that their size mattered. Colonnades of

FIGURE 91
Porticus of Octavia, entrance, etching by Piranesi. Photo credit: Piranesi 1745.

FIGURE 92
Porticus of Octavia, ground plan and elevation, etching by Piranesi. Photo credit: Piranesi 1756, 4:39.

gleaming marble, monumental entrances, or an elevated platform drew attention to these buildings, enticing viewers to enter and marvel at the premises. Lush green vegetation would have enhanced the pleasure of the walk. Works by famous artists, a world map, and other attractions further augmented the appeal of the buildings and spoke to their patrons' refined tastes, knowledge, and wealth. The temples illuminated and advertised their piety.

These porticoes were no different from those commissioned by men. The Porticus Pompeii, commissioned by Pompey and completed in 52 B.C.E., offers a good parallel. It was a large rectangular area, surrounded by a single colonnade, that featured rectangular and circular exedras in the interior, as well as a park with plane trees and a collection of famous paintings. Like Octavia's portico, it contained a curia for the senate.[18] In claiming public space so grandly, Livia, Octavia, and Vipsania highlighted their importance as civic founders.

Collective memory of illustrious people and places played a decisive role in imperial building. The older imperial tradition had not been rejected or forgotten, however, especially by someone like Galla Placidia, who had spent considerable time in Rome, and eventually became the reigning empress in the West.[19] In her building activities, Galla evoked the memory of Helena as well as the tradition that stretched back to Livia.[20] In the mosaics she commissioned at Church of St. John the Evangelist in Ravenna, Galla, who was not related to Constantine or Helena, conjured a lineage for herself that began with the first Christian emperor.[21] She included Constantine's portrait in the mosaics along with those of her own family members. Her other church in Ravenna, the one dedicated to the Holy Cross, and a mosaic commissioned in Santa Croce in Rome renewed Helena's memory as the person who discovered the True Cross and built Santa Croce in Rome.[22] Building the Ravenna church in a sense made Galla a "new Helena." But she seems to have had other role models in addition to Helena. Her time in Rome and the buildings that surrounded her there probably inspired her to build the portico in Ostia. Livia, Octavia, and Vipsania may have been on Galla's mind when she undertook this project. Porticus Placidianae reveals Galla's far-reaching aspirations similar to those of earlier buildings of this type. It was a two-hundred-meter-long building constructed in the Portus Urbis Romae, offering no doubt a pleasant place for promenades by the sea (map 8). It is identified by an inscription on a statue base found on the site. That base may have carried a statue of Placidia or another statue; the inscription specifies that it was "for the decoration of the Portico of Placidia."[23] Originally an inscription ran on the architrave of the building, of which little remains. The inscriptions and the extant carvings indicate Galla's pride in her building. The location she chose—the Portus Urbis Romae—maximized the prestige of the builders. The seaward entry into the city of Rome had been the pride of emperors. Both Nero (fig. 93) and Trajan had proudly displayed its colonnaded waterfront on their coinage.[24]

The thread of memory that links Galla with Livia and with Helena can be seen in another portico. Procopius writes in the *Buildings* of a courtyard (*aulē*), built near the

MAP 8

Portus Urbis Romae, fifth century. Drawn by Bill Nelson.

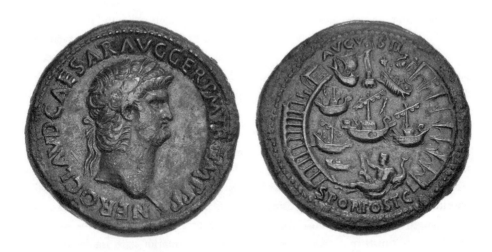

FIGURE 93

Sestertius of Nero, Rome, 64. Obv: Laureate head of Nero. Rev.: Port of Ostia with seven ships within the harbor. At the top is a pharus surmounted by a statue of Neptune. Below is a reclining figure of Tiber, holding a rudder and dolphin. To left is a crescent-shaped pier with portico, terminating with a statue within (a temple?). To the right is another crescent-shaped portico. In the middle are shown seven ships. Obverse legend: *NERO CLAVD CAESAR AVG GERM PM TR [P] [IM]P PP.* Reverse legend: *AVGVSTIS POR OST C. RIC* I Nero 182. Photo credit: Courtesy of Classical Numismatic Group, Inc., www.cngcoins.com.

Arcadianae bath in Regio I (map 1), which featured brilliant marble colonnades, statues of famous sculptors, and a vista wonderful to behold:[25]

> Up toward the eastern part of the city. This is called Arcadianae, and it is an ornament to Constantinople, large as the city is. There the emperor built a courtyard [aulē] which lies outside the city and is always open to those who tarry there for promenades and to those who anchor there as they are sailing by. . . . Columns and marbles of surpassing beauty cover the whole of it (the court), both the pavement and the parts above. And from these beams an intensely brilliant white light as the rays of the sun are flashed back almost undimmed. Nay more, it is adorned with great numbers of statues, some of bronze, some of polished stone, a sight worthy of a long description. One might surmise that they were the work of Pheidias the Athenian, or of the Sicyonian Lysippus or of Praxiteles. There also the empress Theodora stands upon a column which the city in gratitude for the court dedicated to her. The statue is indeed beautiful, but still inferior to the beauty of the Empress; for to express her loveliness in words or to portray it in a statue would be, for a mere human being, altogether impossible. The column is purple, and it clearly declares even before one sees the statue that it bears an empress [basilida]. (Procop. Aed. 1.11.1–9)

As with the Roman porticoes, the portico Procopius describes featured statuary of various kinds, presumably crafted by famous sculptors. Although Procopius identifies the builder of the portico as Justinian, he adds the curious statement that the city expressed its gratitude by honoring the empress Theodora with a statue placed on a porphyry column. If the emperor built the courtyard, why would the city thank the empress? Neither the monument, nor the statue, nor any inscription survives to compare with Procopius's text and tell us who its true patron may have been.[26] Among the surviving dedicatory inscriptions related to baths building, one commemorates the daughter of the builder rather than the patron himself.[27] But it is unusual. The customary logic of statue dedications, as well as Procopius's habit of denying Theodora her due, strengthens the case for attributing the portico to Theodora.

In Rome and Constantinople an imperially-sponsored building was traditionally named for its founder.[28] In both cities statues near the building usually honored the patron.[29] The Thermae Helenae in Rome carried the sponsor's name, Helena. Two statue bases for the empress were found not far from Helena's bath.[30] In the days of Constantine Tiberius (r. 578–82), Sophia (Augusta 565–ca. 602?), the consort of his predecessor Justin II, considered the commemorative value of a statue a powerful incentive for Tiberius to finish an ambitious watch pillar with an interior staircase begun by her husband.[31] The empress's projects adhered to the same naming and commemorative custom.

Procopius's systematic undermining of Theodora's accomplishments in the *Buildings* constitutes a further argument for doubting his attribution of the portico. That Procopius hated Theodora is no secret; he proved it by defaming her in the *Secret History*, a work

FIGURE 94

Columns from the nave with capitals carved with Theodora's (left) and Justinian's monograms in medallions, completed 537, marble, Hagia Sophia, Istanbul. Photo: Author.

that has overshadowed all other sixth-century sources, especially those favorable to the Augusta.[32] The ambitions of his *Buildings* differed from those of the *Secret History*. *Buildings* was written to praise and account for Justinian's accomplishments.[33] Yet even in this work composed for the emperor, Procopius's prejudice against Theodora seeps through. Comparisons with the remaining epigraphic evidence illustrate Procopius's systematic exclusion in it of the empress's and the emperor's patronage. The epigraphic and literary material includes much more than Procopius wanted his readers to know about Theodora's building initiatives.[34] His attempts to erase or hide them only emphasize their significance.

Procopius obscured Theodora's contributions to three key monuments of the city: the Church of Hagia Sophia, the Church of Hagia Eirene, and the Church of SS. Sergius and Bacchus, heralding Hagia Sophia as the greatest of Justinian's achievements. Theodora's monogram, chiseled on some of the church's column capitals, sometimes alternating with that of Justinian, however, reveals what Procopius omits (fig. 94). These numerous monograms translated into "of the emperor Justinian" (*Ioustinianou basileōs*) and "of Theodora Augusta" (*Theodōras Augoustas*).[35] Like the impressions of a signet ring, the monograms highlight the Augusta's co-sponsorship of the church (fig. 95). Curtains hanging in Hagia Sophia represented the imperial pair "joined together, here by the hand

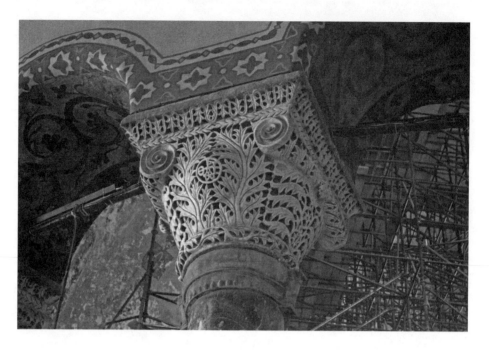

FIGURE 95
Column capital with Theodora's monogram carved in a medallion, completed 537, marble, galleries
Hagia Sophia, Istanbul. Photo: Author.

of Mary, the Mother of God, there by that of Christ."[36] A joint dedication by Justinian
and Theodora that was once inscribed on the church's altar suggests that the
building itself may have been their shared undertaking.[37] But that is not how it is
remembered. Whatever role Theodora had in the building—and the material
remains can only hint at it—has been undermined in the surviving literary evidence.
Procopius's ill will aside, he is not the only one to blame. Even in times of greater
enlightenment about gender equality the role of women is undermined when they
collaborate with men.[38]

Procopius's account of the Church of Hagia Eirene and the Church of SS. Sergius and
Bacchus represents two other instances in which he belittled Theodora. Column capitals
of Hagia Eirene were also carved with monograms reading "of the emperor Justinian"
and "of the Augusta Theodora," but Procopius breathes not a word about Theodora in
his description of the church (fig. 96).[39] The Church of SS. Sergius and Bachus still
features Justinian's and Theodora's monograms, which have been deciphered as "of
Theodora," "of Justinian," and "of the emperor."[40] Again, all personal names and title are
in the genitive case, indicating possession. The surviving dedicatory inscription, carved
on the architrave, attributes the church to the two Augusti (figs. 97 and 98). The evidence
suggests that even though the church was jointly dedicated, Theodora acted like the

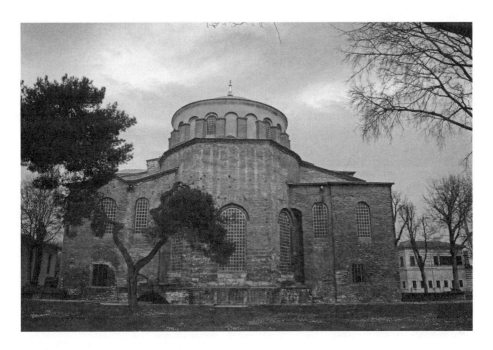

FIGURE 96

Church of the Hagia Eirene, exterior, Istanbul, sixth century. Photo: Author.

primary patron, using the building and the nearby palace to provide refuge for the Mono-physite monks under her protection.[41] Procopius omits such details when he describes the building.[42]

Procopius likewise remains silent about Theodora's patronage outside Constantino-ple. In Antioch, the empress rebuilt the city's Basilica of Anatolius, for which columns were sent from Constantinople. She also reconstructed "an extremely fine church for the archangel Michael."[43] In Carthage the Augusta had a bath named after her. Procopius attributes the building to Justinian, but the name suggests that Theodora commissioned it, or that at least it was a joint project.[44] An obvious example of the Augusti's co-sponsor-ship is a column capital from an unidentified monument at the Hebdomon. It is carved with both Justinian's and Theodora's monograms (fig. 99). The massive column capitals of the great Church of St. John the Theologian, in Ephesus, preserve Theodora's mono-gram as their only ornament (fig. 100). Characteristically, Procopius entirely omits the empress when he speaks of the builders of this imposing church, and gives credit for its construction only to the emperor.[45]

Procopius's selective testimonies call for caution. The pithy records of ancient histo-rians work best when they can be compared with other evidence, such as epigraphic and archeological sources, or with discernible patterns in building activities to which they may or may not conform. To judge by two criteria—honorary statues and

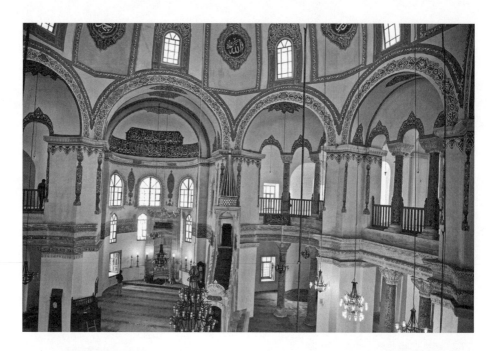

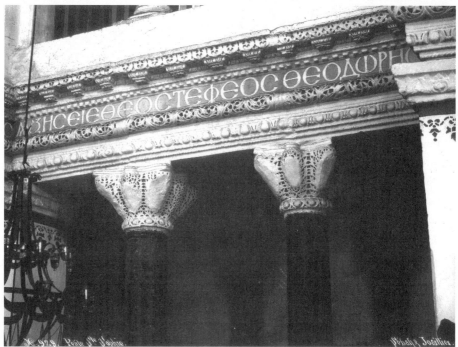

FIGURE 97

(top) Church of SS. Sergius and Bacchus, sixth century, interior, Istanbul. Photo: Author.

FIGURE 98

(bottom) Carved inscription on the marble entablature showing the phrase "God-crowned Theodora," Church of SS. Sergius and Bacchus, Istanbul. Photo credit: Deutsches Archäologisches Institut—Istanbul, 9791.

FIGURE 99

(left) Marble column capital with Theodora's (left) and Justinian's monograms, found in Bakirköy (Hebdomon), Istanbul, Archeological Museum, Istanbul. Photo: Author.

FIGURE 100

(below) Column capitals with Theodora's monogram from the Church of St. John the Theologian, sixth century, near Ephesus, Turkey. Photo: Nicholas V. Artamonoff, April 1940. Nicholas V. Artamonoff Collection, Image Collections and Fieldwork Archives, Dumbarton Oaks Research Library and Collection, negative number RZ17.

naming conventions—Theodora built the portico at the Arcadianae. Procopius's wording suggests that he may have been trying simultaneously to undermine the empress's contribution and to appease Justinian with a sycophantic exaltation of her beauty. Even so, the gift of a statue commemorates a giver. In turn the magnitude of the gift reciprocates the generosity of the donor. Theodora thus must have given the city a spectacular present, for the city thanked her generously in return by dedicating a statue in her honor. The type of the reciprocal gift underscores Theodora's link to Helena, because the Augustaion was another *aulē* where a statue of an Augusta stood on a porphyry column.

By the sixth century the Augustaion had been embellished with a colonnade and thereby differentiated from the surrounding buildings.[46] The earliest mention of the colonnade is in Procopius's *Buildings,* where it is described as an agora surrounded by a colonnade (*peristulos*).[47] Although the historian called it an *agora,* the Greek word for a forum, the Augustaion square bears similarities to both fora and porticoes. Like them, it enclosed a grand open space. The statue of Helena in the middle made it similar to other imperial squares, such as Trajan's in Rome, or Constantine's in Constantinople. Like a portico, it linked other buildings. Indeed, the Augustaion was the center of the city. It connected the main boulevard of the city, the Mese; the Baths of Zeuxippus; the city's cathedral, the Hagia Sophia; and the Chalke Gate, the main entry to the Great Palace. Its inclusion of a senate house recalls those at the porticoes of Octavia and Livia. Because the Augustaion encompassed the Chalke Gate, it can be viewed as a portico attached to the Great Palace (map 5).[48] Whether or not Helena built the Augustaion, in the collective memory of the city it honored the empress. Connection to Helena seems to have been prized as late as 612 or 613 when Martina, the wife of Heraclius, was crowned Augusta in the Augustaion.[49] In other words, the statue of Theodora on a porphyry column honored her not just as a benefactor, but as a female founder comparable to Helena.

There may have been other porticoes in Constantinople. One possible reason that they remain unknown is that this architectural type was associated in the city with other buildings. Colonnades covered most of Constantinople's central arteries, making it difficult to know where one ended and another began.[50] Porticoes were often associated with other buildings, such as baths, and thus, like the Portico of Theodora located next to the Arcadianae bath, formed part of a larger complex. The physical proximity suggests that Theodora's portico was deliberately built where it would provide shelter and enhance the pleasure of those going to the baths. Porticoes linked to baths include the Porticus Thermarum Traianum and the Porticus Europeae in Rome.[51] Those in the East include the East Bath–Gymnasium and the Hadrianic baths in Ephesus, the Porticus of Tiberius in Aphrodisias, the Harbor Bath–Gymnasium and the Porticus of Verulanus.[52] These examples suggest that imperial women could have built porticoes in connection with their baths.

IMPERIAL WOMEN AND BATH BUILDING

In Rome only one imperial bath was built by, and named for, a woman: the Thermae Helenae. By contrast, in Constantinople five baths bore the names of imperial women: those of Helena, the Thermae Anastasianae, Thermae Carosae, Thermae Eudoxianae, and the Baths of Sophia.[53] This change in the naming patterns must be correlated to the Christian empress's new role as a patron of the imperial capital. Bath building in Constantinople during the early Christian era, seems to have been a joint responsibility of the emperor and the empress.

The history of female imperial bath builders, however, so eloquently expressed in the names of the *thermae,* proves difficult to trace in the textual sources. The evidence is entirely textual, frustratingly vague, and at times confusing. Helena's baths in the Helenianai have already been discussed.[54] The *Notitia* locates the second of the Constantinopolitan baths, the Thermae Anastasianae, in Regio IX. Ammianus Marcellinus (fl. after 350) mentions in passing that the usurper Procopius stationed his legions at the baths of Anastasia, a sister of Constantine.[55] (Actually Anastasia was Constantine's half-sister, the daughter of Constantius and Theodora, about whom little is known. Most of Constantine's relatives on his father's side perished in the interregnum after Constantine's death.)[56] Although Ammianus Marcellinus, as a contemporary, is a credible source, later writers, such as the church historians Socrates and Sozomen, recognized this Anastasia as the daughter of Valens.[57] This identification fits because Valens's aqueduct would have supplied the baths with water. The testimony of church historians receives indirect support from the naming of another bath, the Thermae Carosae, for Valens's other daughter, Carosa.[58] The Baths of Carosa were in Regio VII.[59] Even if it is possible that two women, both named Anastasia, might have sequentially sponsored the building and the repair of the same bath, it is more likely either that Valens honored both daughters with baths in their names, or that the Anastasia and Carosa erected them on their own.

The source for the Baths of Eudocia, wife of Theodosius II, is the fifth-century *Notitia,* which locates them in Regio V.[60] It has been suggested both that Eudocia's baths were the same as the oldest baths in Constantinople, the baths of Achilles, which the *Notitia* omits, and that the empress probably restored the older Achilles baths and changed their name. But the new name did not get used and the building continued to be known under its old name. Bath building may have been a pet project for the Theodosian empresses and they may have competed with one another, just as they strove to outdo their predecessors in church building or relic collection. There had been baths named after Sophia. Theophanes, writing approximately three centuries after Sophia's time, mentions that Justin restored public baths there and named them after Sophia, in the same year (corresponding to 569–70) that he reports that the emperor built a church to the holy healers, Cosmas and Damian.[61] This is probably the same church that Sophia dedicated to the saints (see

chapter 9). If so, then obviously the later source automatically attributed the church to the male Augustus, and this may have been the case with the attribution of the bath.

Textual evidence for non-extant statues constitute another category of evidence that indirectly suggests the sponsorship by imperial women of repairs or additions to various baths. For instance, the imperial statues dedicated at the baths—such as those of Justinian, Theodora, and Sophia in front of the Zeuxippus baths—fall into this category.[62]

How can we know that women, and not their male relatives, built the baths named after them? The Baths of Helena in Rome attest to the strength of a building's name as indicating its sponsorship. Nevertheless, the sources, exclusively written by men and often separated in time by several centuries from the original construction, indicate both that baths were named after a woman and that women built baths that then bore their name.[63] But it remains a complex task to identify which was the case in the few baths bearing empresses' names, or even to confirm that the testimonies are trustworthy. The little evidence we have about empresses' finances suggests that they relied either on personal wealth or on the imperial treasury, or on both.[64] Still, it cannot be determined conclusively whether the empresses paid for their baths out of their own pockets, supervised the construction in any way, or were consulted in the design. Many of the nonimperial examples spell out what the bath builder gave and constructed, suggesting her energetic involvement in planning and building. Even though Roman empresses, with the exception of Helena, did not build baths in Rome, some women civic patrons did, by themselves or with their husbands. These examples suggest growing acceptance of women patrons of baths and of city renewal more generally.[65] Yet even if we assume that empresses did not build baths, but only allowed their names to adorn them, the flourishing of baths named for empresses in Byzantine Constantinople but not in Rome still needs to be explained.

In the post-Helena era, baths named after empresses identified the honorees as agents of urban renewal. Changes in the naming pattern broadly resonate with the new expectations for female imperial founders. At the same time, certain changes in the late antique bathing culture made bath building more attractive for women.

BATH BUILDING AND BATHING CULTURE IN LATE ANTIQUITY

No evidence suggests major changes in the "ethos" of bathing in late antiquity.[66] The baths continued to be associated with beauty, health, and pleasure. And the sexes continued to enjoy them together. There seem to have been no major differences in men's and women's bathing habits from Roman to Christian imperial times. The African Church father Tertullian (ca. 160–ca. 225) remarked famously that Christians were no different from other people in that they frequent the forum, the market, and the baths. He himself liked to bathe at the "proper and healthful hour." John Chrysostom (bishop of Constantinople 398–404) conveyed a similar sentiment when he classified bathing as one of life's necessities along with food.[67] The important role bathing played in the lives of both

Christians and pagans in fifth-century Constantinople is suggested by the existence there of 8 imperial and 153 private baths.[68]

Under Christian influence, however, bathing began to change with respect to nudity and to sacredness. Some Church writers emphasized bathing's healing and medicinal benefits and even linked bathing to spiritual cleanliness.[69] But they passionately denounced the Roman and early Byzantine practice of mixed bathing as fraught with potential for sexual encounters.[70] John Chrysostom denounced those women who flirted and caressed with men in the bath as stains upon the Church.[71] To steal the pleasure from bathing, new baths in the late antique period often sprouted close to churches, healing springs, and pilgrimage sites.[72] This was the case with the Blachernae baths in Constantinople.

Another significant change related to the bath's role in education. During the fourth century the ancient association between the palaestra and the baths declined. The palaestra, traditionally a common feature of an imperial bath, was a place for the exercise (in the nude or scantily clad) and the education of men.[73] The disappearance of this quintessential symbol of masculinity seems to have shifted the focus of bathing away from men and sports to less competitive and gentler pleasures. It is uncertain whether Helena's bath in Rome, its features like those of the grand imperial baths on a smaller scale, had a gymnasium in her time.[74]

Apart from these transformations, traditional ideas about the baths' relationship to beauty, pleasure, and sexual attraction continued to be celebrated.[75] The lay authors included in the *Palatine Anthology* emphasized the aesthetics of bath-related constructions, and the beauty of those who frequent the baths. One epigram compares the bathers to the Graces, Aphrodite, and Eros.[76] Another proclaims: "This bath is the playground of the Graces, for it only admits Graces to sport within it."[77] Works of art make similar comparisons. A well-known fourth-century silver box of a Christian woman associates bathing with the beauty of Aphrodite. The front side of the box sets up a visual comparison between its owner, Projecta, and Aphrodite, the goddess of love. The opposite side depicts Projecta's journey to the baths in the company of her servants (fig. 101). The baths occupy the center of the composition, Projecta advances from the left. The images suggest the beautifying effect of bathing. Projecta's servants carry vessels used in bathing (pitchers and buckets), and in primping (perfume boxes). At the same time, a prominently displayed inscription on the brim of the lid identifies Projecta and her husband as Christians.[78]

A floor mosaic from the vestibule to the baths of a fourth-century villa at Piazza Armerina in central Sicily similarly relates women, baths, and beauty. The mosaic shows the lady of the house going to the baths, accompanied by her servants, who, like those on Projecta's box, carry beautifying accessories. Procopius's admiring description of Theodora's portico at the Arcadianae bath also makes beauty the link between the bath, its portico, Theodora's statue, and the empress.[79]

The traditional elements of late-antique bathing culture discernible in the empresses' association with baths continued for centuries. An epigram describes Maria (possibly the

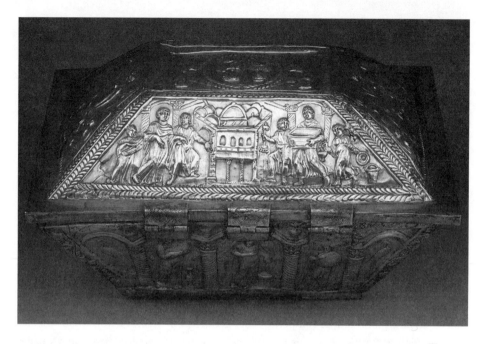

FIGURE 101

Projecta going to the baths with attendants, silver box, early fourth century, from Rome, 28.6 (h), 56 (l), 48.8 (w. widest point) cm. Inscription engraved on the brim of the lid: *SECVNDE ET PROIECTA VIVATIS IN CHRISTO* (Secundus and Proiecta, may you live in Christ.), BM, 1866,1229.1. ©The Trustees of the British Museum. All rights reserved.

wife of Honorius) as having a beauty as faultless as that of her bath.[80] In John Chrysostom's thinking, sensual pleasures belonged to the same category as bathing. In a homily written from exile and full of ire, he addressed the empress Eudoxia, whom he criticized on account of a silver statue erected in her honor, and thus caused his banishment: "You who enjoy baths and perfumes and sex with a male do battle with the pure and untouched church."[81] The historian Procopius, Theodora's nemesis, criticized Theodora for indulging in bathing, faulting her for "treating her body with more care than usual," by which he meant that she began each day by taking a long bath.[82] As baths in the Christian era shed certain associations (those of the competitive palaestra, for example) they emphasized others, like feminine beauty. Little wonder, then, that baths attracted the patronage of imperial women in the Christian era.

The social opportunities that baths provided for women offer an additional reason for the empresses' attraction to bath building. Women having left no accounts of their own experiences, all the evidence comes from male observers. Libanius and John Chrysostom disparaged female socialization in the baths. Both made belittling comments about chattering women in the baths. Other sources confirm that women used the baths as a place to meet with other women and also men. Some ascetics considered encounters with the

opposite sex while bathing a perfect opportunity to test one's virtue. According to the Church historian Evagrius, ascetics displayed their high morals by "constantly frequent[ing] the public baths, mostly mingling with women, since they have attained to such an ascendancy over their passions."[83]

Socializing in the bath correlates to another important social activity, displaying one's status. Images of women surrounded by the trappings of their social standing as they go to the baths suggest why empresses would have associated themselves with them: they were a prestigious location that gave the empresses opportunities to affirm their social status. The casket and the mosaic described above cast the progress of Projecta and the matron from the Piazza Armerina to the baths as a spectacle involving servants and the display of costly accessories, such as silver vessels and fabrics. These aristocratic processions may have mimicked imperial ones. Theodora's journey in 532 or 533 to the hot springs in Pythia (a distance of about 140 kilometers from Constantinople) offers suggestive evidence.[84] The four thousand people accompanying the empress made the trip a spectacle of conspicuous consumption. That she distributed donations along the way, in accordance with imperial custom, is confirmed by a note in Theophanes that the patrician Helias, the *comes largitionum* (count of the imperial largesse), accompanied her.

A final argument for the interest of empresses in building baths comes from the long-standing association between bathing and the treatment of illnesses. Empresses, according to the evidence, had a connection stronger than that of emperors to healing. Livia, as noted in chapter 3, was a patron of Bona Dea's temple and devised recipes for sore throat and cold limbs, and had a laurel and fig named after her. Two examples, in addition to Theodora's procession to the hot springs, link imperial women to healing waters and healing more generally. The first is the *Vienna Dioscurides*, the sixth-century codex presented to Juliana in gratitude for her church at the Honoratai.[85] Apparently the givers thought this medicinal codex an appropriate gift for an emperor's daughter and the patroness of a church. The second example is an inscription by the fifth-century empress Eudocia from a bath in the city of Gadara. Eudocia visited this bath during her pilgrimage to Palestine in 438–39. The Gadara baths had gained fame for their curative hot springs, especially effective for leprosy.[86] It was known as Thermae Heliae (Baths of [the prophet] Elijah).[87] The empress wrote a poem in Homeric hexameter, which she then had inscribed on a six-foot-wide marble slab and deposited in the baths, in a hall (fig. 102) alongside other, more modest, inscriptions. The poem praised the spring and possibly named the various parts of the baths.[88]

The gesture of depositing an inscription hints at more substantial largesse. It was customary to have an inscription chiseled in the pavement in exchange for a donation.[89] The Augusta probably helped pay for the baths' reconstruction after a devastating earthquake. The dates of her visit to Gadara and the timing of the earthquake support this suggestion. The excavators have concluded that the positioning of the slab "was planned and carried out in the course of far-reaching restoration works."[90] These works may have

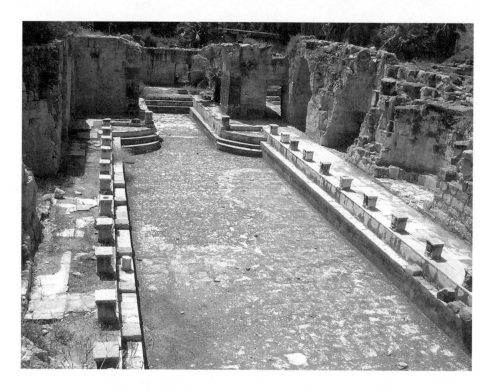

FIGURE 102

Hall of the Inscriptions, Roman baths, Gadara, Israel. Photo: Creative Commons Attribution 2.5 Israel.

been contemporary with those commissioned after the earthquake, which the main sponsor commemorated with an inscription. The letter forms of Eudocia's slab are similar to those of the main patron's. This indication of contemporaneity and the planning required to insert the empress's inscription indicate that Eudocia probably contributed significantly to the baths' reconstruction or beautification, possibly in the area where the slab bearing her inscription was placed.[91] Eudocia's patronage of these baths would have complemented her patronage of baths in Constantinople and Antioch.

Eudocia's poem presents an additional argument for donations to the Gadara baths and offers, at the same time, a rare glimpse into the personal attitude of an empress toward a bath. Whereas the majority of inscribed slabs that refer to it call it a "holy place," Eudocia's poem perceives it differently.[92] It conveys a sense of wonder at the spring, calling it "a new fiery ocean," a symbol of plenty, "Paean," the physician for the gods, "a life source," and a "provider of sweet dreams."[93] The poem extols the spring's healing properties, and makes only a single Christian reference to God, praising him and praying that he may save the spring for the benefit of men. In addition two crosses flank Eudocia's name on the marble slab. The empress's traditional pre-Christian, lighthearted attitude toward baths and bathing emerges from the discord between the poem's classical subject

and the contemporary Christian perceptions of this bath. Eudocia interpreted the spring's gifts in a cosmopolitan pagan framework. Her contemporaries saw it as holy.

This disconnect testifies to the complexities of a changing world. It would be easy to mistake the empress's penchant for the classical tradition and baths solely as matters of her personal tastes and classical upbringing. The urban environment Eudocia inhabited was her frame of reference, even while on pilgrimage. So her poem reflects the Constantinopolitan bathing culture. That Eudocia's urbanity did not undermine her pious pursuits, proves her Christian poetry in Homeric hexameter.[94] She remained interested in holy sites and relics,[95] returning from her journey to the pilgrimage sites in the Holy Land with the relics of St. Stephen.[96]

The baths at Gadara suggest that Christian attitudes toward bathing may be connected to places where healing waters converged with the miraculous healing associated with relics and holy places.[97] One of the most important of these places in early Byzantine Constantinople was the Blachernae church, where a bath with springs for the "purification of the flesh" stood beside a church housing the relic of the *maphorion* (veil) of the Theotokos (map 1). In the *Book of Ceremonies,* the emperor Constantine Porphyrogenitus (r. 913–59) described a ritual bathing that the emperor undertook in the pool of this bath on February 2, the feast of the Purification.[98] The sources mention the association of two empresses, Pulcheria and Verina, with the Blachernai complex, which had churches and a palace in addition to the baths. Some texts claim that Pulcheria built the main church of Theotokos *tōn Blachernōn,* an attribution now rejected as a later invention aimed at purging the memory of site's early Monophysite associations.[99] The church was built by Justin I. But earlier Leo I and his wife, Verina, completed a chapel there for the reliquary (*soros*) of the Virgin's veil, brought from Palestine in 473.[100] A mosaic, now lost, represented Leo and Verina, the latter holding her grandson Leo II, and their daughter Ariadne, affirmed their patronage of the sanctuary.[101]

To judge from the mosaic in the reliquary chapel, Leo I may have also been responsible, most likely with Verina, for an imperial dining hall on the site, the Triclinos of the Holy Soros. This would have been part of the imperial living quarters.[102] Anastasius, Ariadne's second husband, probably added one of the three main halls of the palace (Anastasikos, Okeanos, and Danubios).[103] The *Patria* attributes the Blachernae bath to Leo I.[104] An epigram in the *Palatine Anthology* explains the suitability of a spring near a sanctuary by connecting the purifying properties of the Blachernae spring to absolution from sin: "Here are fountains of purification from the flesh, here is redemption of errors of the soul."[105] An extreme example of an actual purification comes across in the miracle at the Helenianai's bath and the selectively scalding waters of its spring.[106]

Imperfect as it is, the existing evidence suggests that empresses and baths were associated, because of the opportunities baths provided for beautification, healing, socialization, and conspicuous consumption that related especially to women. In late antiquity, these traditional elements of bathing seem to have been given a fresh emphasis by the decline of the palaestra as an educational institution and by the Church's opposition to

FIGURE 103

Solidus of Pulcheria, Constantinople, 441–50, gold. Obv.: Bust of Pulcheria with a *manus dei* (hand of God) holding a wreath or a diadem. Rev.: Constantinople seated on throne, holding globus cruciger in right hand and scepter in left with a shield at left side and left foot on prow; in left field, star. Obverse legend: *AEL PVLCHERIA AVG*. Reverse legend: *IMP XXXXII CO XVII PP; CONOB* in exergue. H/AM, Bequest of Thomas Whittemore, 1951.31.4.159. Imaging Department © President and Fellows of Harvard College.

nakedness in public. Helena's two baths gave the empresses precedents for a sustained engagement with this type of public building.[107]

From the fourth though the sixth century, imperial women in Constantinople, in partnership with the emperor, engaged in the primary imperial responsibility of renewing the imperial capital by means of largesse and building. Unlike Rome, the Christian capital on the Bosphorus became in many ways a joint undertaking of the emperor and the women in his family. Instead of weaving clothes for the emperor, the early Christian empresses wove buildings into the urban fabric.[108] This change in the discourse of founding affected the bond between emperor and city in fundamental ways. A striking numismatic innovation, introduced in the reign of Theodosius II, forges an unprecedented link that recognized the imperial women's patronage of Constantinople. The obverse of the reigning Augustae and Theodosius II depicted the Tyche of Constantinople, demonstrating a connection between the empresses and the capital as intimate as that between the capital and the emperor (fig. 103).

Until that moment, only the emperor had enjoyed such a distinction. A silver medallion, minted in Constantinople in 330 on occasion of the founding of the city, shows on its obverse Constantine's head in profile, wearing a diadem with gems.[109] The reverse depicts the city's Tyche, Constantinopolis, seated on a high-back, bejeweled throne (fig. 104). In typical fashion for Tychai, she wears a mural crown on her head. Her left arm supports a cornucopia brimming with fruit; her right foot rests on a ship's prow. On later

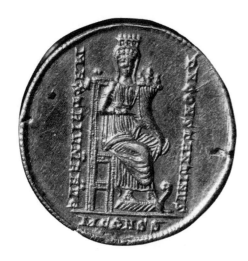

FIGURE 104

Constantinopolis, medallion of Constantine, minted to commemorate the inauguration of the city on May 11, 330, silver. Obv. (not shown): Head of Constantine wearing a bejeweled diadem, no legend. Rev.: Constantinopolis (personification of Constantinople), wearing a crenelated (turreted) crown and a veil, sits on a throne, feet on a ship's prow, holding a cornucopia in left arm. Reverse legend: *D N CONSTANTINVS MAX TRIVMF AVG*; *M CONS S* in exergue. Castello Sforzesco, Milan. Photo credit : Scala / Art Resource, N.Y.

coins that pair the emperor and his city, Constantinopolis is shown as a giver of victory. The gold medallion of Constantine's son and successor, Constantius II, dated to 360, shows on the obverse Constantius in military attire, holding a Victoria in his outstretched right hand. It is one example among many linking an emperor with the capital city. The reverse depicts Constantinopolis, with a globe surmounted by a Victory in her outstretched right hand. The visual communication between the image on the obverse and the one on the reverse leaves the viewer with the impression that Constantius receives his wreath of victory and imperial power from the hand of Constantinople. The bond between emperors and their capital was also expressed verbally. The fourth-century orator Themistius claimed that Constantinople's beauty mirrored that of the emperor Constantius.[110]

Thus the appearance of the personification of Constantinople on the reverse of Pulcheria's, Eudocia's, and Galla Placidia's coins from about 441–42 meant a great deal (fig. 103).[111] This pairing demonstrates the reality of imperial women's partnering with the emperor in the re-founding of the capital city. It is not surprising, then, that the reverse of these coins represents the city of Constantinople enthroned, holding a globe surmounted by a cross in her outstretched right hand, as if handing it over to the empress on the obverse.

The intimacy between empress and city that this coin series highlights manifested itself earlier, in the procession Eudoxia led to the shrine of St. Thomas in Drypia, for example. Huge throngs of Constantinopolitan citizens—in John Chrysostom's words, "countless nations of different tongues"—marched nine miles in the night, following the Augusta. Chrysostom exalts the steadfastness of the empress and the beauty of the nocturnal march, lit by lamps that rivaled the day. He concludes with the following remark: "Just as today we saw this woman who loves Christ with the city, so tomorrow we may behold the emperor who is beloved of God present with the army, offering the same

sacrifice."[112] He identifies the city with the empress, and the army with the emperor: "Just as she shares the *imperium* with him, so too does she share her piety and doesn't allow him to be without a role in her good works, but in every instance takes him on as a partner."[113] In Chrysostom's words Eudoxia "kept [the emperor] home" to avoid any possible confusion caused by the presence of his army. In this pious procession, the Augusta led the imperial city as a co-ruler. Remarkably, she did so humbly, divesting herself of all imperial insignia.[114] Still, her city followed.

7

KOINŌNIA
The Christian Founders' Legacy in the Symbolism of Authority

Koinōnia means partnership or fellowship. *Koinōnos* translates as partner.[1] *Koinōnia* could refer to the fellowship between bishops or the relationship between spouses.[2] These nouns and their derivatives could also have political meaning. Eusebius deploys *koinōnos* as a term for Constantine's imperial colleagues.[3] An influential treatise on speechwriting attributed to Menander Rhetor, and dated to the late third or early fourth century, favors the expression *koinōnos tēs basileias* (partner in the imperium) for the emperor's wife.[4] What *koinōnos* meant in the context of male imperial colleagues appears sufficiently clear, but what the partnership entailed for the imperial couple less so. Nevertheless, the available textual sources suggest that the concept of imperial *koinōnia* between an emperor and an Augusta evolved over the centuries. When the noun first appeared employed for a real couple, in an oration of praise for the Christian empress Eusebia, Julian, the author of the speech, defined *koinōnia* as Eusebia's participation in governing by advising the emperor on his plans and by encouraging his natural goodness and wisdom.[5] Julian had reason to be grateful to Eusebia, who as Constantius's spouse prevailed over the emperor to spare Julian's life. So in this case, *koinōnia* meant council that led to imperial clemency. In a later speech, Gregory of Nyssa's funerary oration for Flaccilla of the year 386, Flaccilla is called *koinōnos* of the emperor, but Gregory does not elaborate.[6] In the year 400 John Chrysostom supplied a more precise definition when he described the empress Eudoxia's imperial rank as sharing the imperium (*koinōnei tēs basileias*) with her husband Arcadius.[7] It is the same speech in which the Constantinopolitan bishop related the events of the midnight relic procession led by the empress. In that procession, the empress acted

independently from the emperor, but the two coordinated their appearances at the event.[8] In a near contemporary letter (403), Paulinus of Nola provides a faith-based definition of the partnership between the imperial couple and imperial power. He saw Helena as co-ruler (*conregnans*) with Constantine and argued that Constantine deserved to be *princeps* of Christ because of Helena's faith (*Helenae fide*) as much as his own.[9] The limits of that partnership are expanded further in a law of the emperor Justinian from April 15, 535. This law stated that in crafting it, Justinian had taken the counsel of his "well-beloved spouse, given us by God."[10] Despite detectable genre and authorial biases, these various textual sources suggest an evolving understanding of *koinōnia* to mean something more than conjugal fellowship. It came to refer to partnering in some aspects of governing. Over time it came to be that particular decisions taken by the emperor were effectively authored by two partners.

Imperial iconography, ritual, and imperial acclamations demonstrate a similar arc of increased responsibilities associated with imperial *koinōnia*. Most strikingly, late antique empresses acquired the emperor's imperial insignia, and got included into the concept of imperial victory. Augustae enjoyed their own solemn adventus (arrival) ceremonies and were honored with the self-abasing ritual of *proskunēsis*. Consequently, acclamations and public inscriptions begin to address the imperial couple jointly in the sixth century, in the manner reserved previously for male imperial colleagues. The gendered character of the founding discourse had changed.

The imperial diadem represents the first sign of this change. In 324, when Constantine became the sole ruler of the empire, he promoted Helena and Fausta to the rank of Augusta.[11] Shortly after the elevation, Helena's coinage, and to some extent Fausta's, introduced a headband encrusted with stones in the obverse portraits of the Augustae. In one typical example—a bronze coin of Helena—this headband, apparently made of segments inlaid with gems, seems to be integrated into the empress's coiffure (fig. 105).[12] This bejeweled band is significant for the timing of its adoption and its resemblance to the headband Constantine wears on his own coinage. The historical sources tell us that Constantine made the diadem a token of power.[13] The emperor's coins represent it prominently as a jeweled band fastened with ribbons at the back of the neck (see fig. 70). Only the ribbons differentiate the diadems of Constantine and Helena: those of the emperor look like distinct attributes, and those of the empress like part of her hairdo. Most scholars have read Helena's headband as merely decorative, with no connotations of power.[14]

Because contemporary textual sources remain silent on the question of whether the first Christian Augusta wore an imperial diadem, no interpretation can be conclusive. Nevertheless, all the ways in which Constantine honored and empowered Helena, as well as Fausta before her death, argue for the empress's band as the imperial diadem.[15] Later empresses imitated Helena. Given the importance of heirlooms, it might well have been that those empresses wore the very same diadem as Helena.

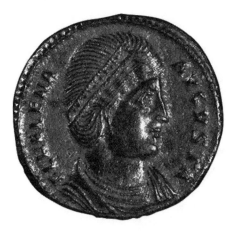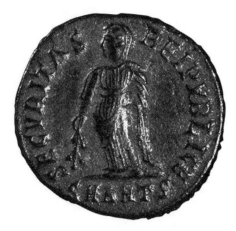

FIGURE 105

Follis of Flavia Julia Helena, Antioch, 325–26, bronze. Obv.: bust of Helena. Rev: Securitas. Obverse legend: *FL HELENA AVGVSTA*. Reverse legend: clockwise from lower left, *SECVRITAS REI PVBLICE* ("Security of the State"); in exergue *SM ANT S* (mintmark Antioch, workshop 2). *RIC* 7 Constantine 67. H/AM, Bequest of Thomas Whittemore, 1951.31.4.37. Imaging Department © President and Fellows of Harvard College.

THE CHRISTIAN EMPRESS'S ATTRIBUTES OF EARTHLY RULE

The Roman empresses had no particular tokens of rule, except the occasional borrowing of divine tokens, such as a crescent-shaped *stephanē* in their hair (see fig. 57). Augustae's coinage showed a head in profile with the inscribed title Augusta or Diva Augusta. With Helena, the coinage changed. The empresses after her eventually came to share all the emperor's attributes of power, except his battle gear. Those shared attributes included the imperial diadem, the imperial garment, the scepter, the globe, the imperial seat, and the rituals associated with power. The diadem appears again on the coinage of Aelia Flaccilla (r. 379–86), the first wife of Theodosius I (r. 379–95), who, like Helena, had a palace in Constantinople named after her (fig. 106).[16] Flaccilla's diadem featured segments studded with stones as well as beaded strings gathered low at the back of the head.[17] Along with the diadem, Flaccilla wore the traditional military cloak, the *paludamentum*. Her coinage shows it fastened at her right shoulder with a bejeweled fibula, in the imperial style.[18] Although some third-century Augustae may have worn this garment on their coinage, with Flaccilla it became standard for empresses.[19]

Before the garment appeared on Flaccilla's coinage, an empress appropriating the *paludamentum* was making a provocative gesture. Agrippina, the fourth wife of the emperor Claudius and the mother of Nero,[20] did so when she donned a golden *paludamentum* and presided with Claudius, also clad in the military cloak, over a naval spectacle,

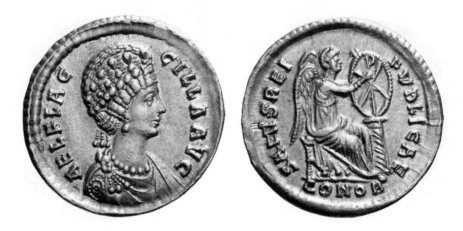

FIGURE 106

Solidus of Aelia Flaccilla, Constantinople, 383–86. Obv.: Aelia Flaccilla wearing a bejeweled diadem fastened at the nape of the neck with three pendants, earrings, a necklace, and a chlamys with a round fibula with three pendants. Rev.: A winged Victoria sitting on a chair and inscribing a shield, propped on a column, with a Chi-Rho. Obverse legend: *AELIA FLACCILLA AVG*. Reverse legend: *SALVS REI PVBLICAE; CONOB* in exergue. *RIC* 9 Theodosius 48. Photo credit: Courtesy of Jürgen Malitz and the Numismatische Bilddatenbank Eichstätt.

as though they were two generals commanding a battle.[21] On this occasion, and on another when she participated in a triumphal procession and received the same honors awarded her husband, Agrippina committed a serious offense. Tacitus—no friend of imperial women, to be sure, but in this case sticking to the official line—interprets Agrippina's missteps as signaling her desire for a partnership in the governing of the empire.[22] The empress's ambition for imperial honors equal to those of the Augustus, whether her husband or her son, eventually cost her her life. Nero began the list of charges compiled against her with the most serious—her hope for partnership in the imperium (*consortium imperii*)—followed by her demand for the allegiance of the praetorian guard, the senate, and the people.[23]

If indeed some third-century empresses were shown wearing this signature military garment, such images indicate a change in popular perception that must be attributed to the title *mater castrorum* (mother of the military camps), introduced for the first time in 175. The numismatic iconography created for that title showed the empress with the military standards for the first time (see fig. 44).[24] Still, the *paludamentum* became an accepted element of the Augusta's iconography only with Flaccilla, solidifying a process of appropriation that resulted, at the end of the fifth century, in the empress's acclamation as a victorious ruler.

The empress's attributes in the late fourth, fifth, and the early sixth centuries underscore the gradual masculinization of female imperial iconography. The Augustae claimed as their own, along with the *paludamentum*, the imperial purple, the scepter, the throne,

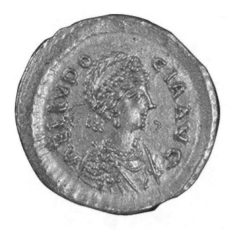

and the symbolic language of imperial victory. The purple mantle had been linked with rule since Hellenistic times.[25] An episode in the *Aeneid* makes evident its significance as a token of power: when Dido presents a purple mantle to Aeneas, that act signifies her desire to marry and share her city with him.[26] In late antiquity the grant of the purple *paludamentum,* known in Greek as *chlamus,* was one of the defining moments in the imperial succession.[27] The soldiers proclaimed Constantine the new emperor by clothing him in the purple.[28] On his funerary bed, Constantine wore the diadem and the purple garment.[29] Similarly, the newly elevated emperor Justin II received a bright purple chlamys, fastened with a golden brooch, as the last element of his imperial attire.[30] By the early fifth century John Chrysostom, describing the night procession to Drypia, could refer to the empress Aelia Eudoxia as "she who is wearing the diadem" (*to diadēma perikeimenē*) and who is "clothed in the purple garment" (*tēn porfurida peribeblēmenē*).[31] Though Chrysostom does not specify what her purple garment was, the *tremissis* of Eudoxia, dated to 444, demonstrates that it must have been the *paludamentum* (fig. 107).[32] The empress wears it fastened over the right shoulder by a round fibula with three pendants. In the only extant color image of an emperor and an empress wearing *paludamenta,* the apse mosaics of San Vitale in Ravenna, the Augusti Justinian and Theodora are distinguished from their retinues by the deep purple of their *paludamenta* and their opulent diadems of precious stones (figs. 108 and 109). Their shared attributes argue powerfully for their shared authority.[33]

 The scepter likewise came to signify the *koinōnia* of emperor and empress. Although it originally belonged to the gods, it became a token of imperial power, often identified

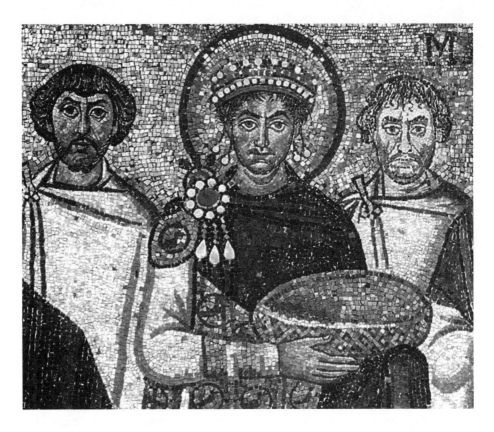

FIGURE 108

The emperor Justinian and two courtiers, detail, sixth-century mosaic, north wall of the apse, San Vitale, Ravenna. Photo credit: Alfredo Dagli Orti / Art Resource, N.Y.

with the empire itself. It entered imperial iconography through the association of the imperial family with divinities. Among the Roman empresses represented carrying it in the guise of a goddess were Livia (see figs. 39–41), Domitia, Faustina I, and Julia Domna.[34] The scepter probably became an official attribute of the emperor at the end of the third century.[35] The fifth-century rhetorician and historian Priscus illuminated its emblematic character by remarking that the emperor Valentinian deprived his sister Justa Grata Honoria of the "scepter of the empire" because of her intrigues with Attila, king of the Huns.[36] Agapetus the deacon, in his treatise on governing addressed to Justinian, wrote that God had invested the emperor with "the scepter of earthly rule" (to skēptron tēs epigeiou dunasteias).[37] Corippus also used the scepter as a symbol of the *imperium* when he remarked that Justin's love for Justinian surpassed that of a successor who had had his father's scepter (*sceptra patris*) from birth.[38] Verina (r. 457–84), the mother of Ariadne (Augusta ?474–513/515), was the first Christian empress shown carrying the scepter, on the bronze coinage of her husband, Leo I (r. 457–74).[39] Corippus illuminated the significance of the scepter in a pun on the empress Sophia and her name, which in Greek means wisdom.

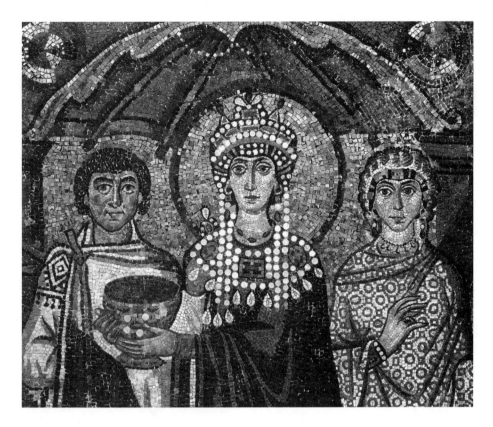

FIGURE 109

The empress Theodora flanked by a male and a female courtier, detail, sixth-century mosaic, south wall of the apse, San Vitale, Ravenna. Photo credit: Alfredo Dagli Orti / Art Resource, N.Y.

He claimed that even while the empress Theodora was ruling (*regebat*), the Church of Hagia Sophia (Holy Wisdom) in Constantinople was a sign that Sophia would have the scepter.[40] An ivory panel in the Bargello Museum in Florence, contemporaneous with or slightly predating Procopius's writings, shows an empress authoritatively holding a long scepter in her right hand in addition to the *globus cruciger* in her left (fig. 110).[41]

Like the scepter, the *globus cruciger*, symbol of Christian rule over the world, had a long history. It was adopted as an imperial token on the coinage of Theodosius II from the 420s, but the globe itself as a sign of rule had been used since republican times.[42] Initially it belonged to Roma and the Genius of the Roman people, but it achieved greater political significance in scenes of investiture that show either Jupiter or an emperor granting the globe to a new emperor as the foremost symbol of imperial domin-ion.[43] When Augustus picked Agrippa as his colleague in his tribunician power, coins minted in 13 B.C.E. showed them seated together on the same seat, each man holding a globe.[44] In the third and the fourth centuries the globe appears with greater frequency,

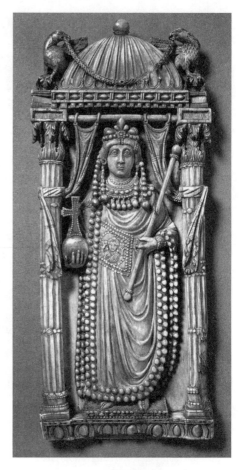

FIGURE 110

(right) Carved ivory panel with an empress, wearing a bejeweled diadem with pendants and a trefoil ornament, a necklace, a chlamys fringed with pearls and a tablion (square patch) with an image of an emperor holding a mappa (a piece of cloth), holding a globus cruciger in her right hand and a scepter in her left, and standing under a canopy with two eagles, holding a garland in their beaks, late-fifth to sixth century, 30 (h), 12.5 (w), 1.9 (d) cm., Museo Nazionale del Bargello, Florence. Photo credit: Scala / Art Resource, N.Y.

FIGURE 111

(below) Solidus of Justin I and Justinian I, Constantinople, April 4–August 1, 527, gold. Obv.: Justin (left) and Justinian (right) seated to front on a double throne of which uprights and crossbar are shown; both figures are nimbate, with trefoil ornament on their heads, their right hands making a speech gesture; each holds a globe in left hand and the left knee of each is advanced; cross between heads. Rev.: Angel facing, in tunic and pallium; in right hand a long cross; in left, a globe-cross; in r. field, a star. Obverse legend: *DN IVSTIN ET IVSTINIAN PP AVC*; in exergue: *CONOB*. Reverse legend: *VICTORI AAVC*, gamma; in exergue: *CONOB*. H/AM, Bequest of Thomas Whittemore, 1951.31.4.308. Bellinger and Grierson 1966, 3. Imaging Department © President and Fellows of Harvard College.

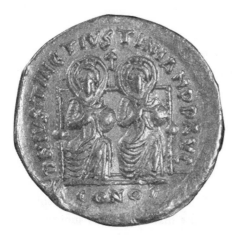

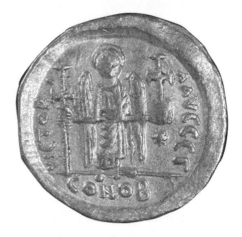

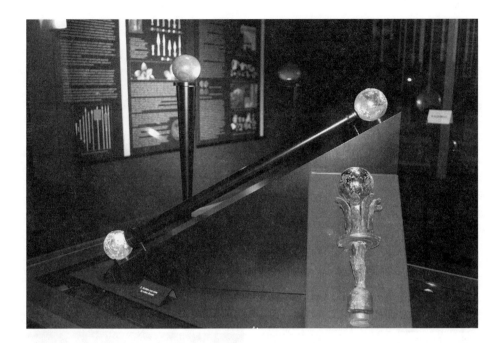

FIGURE 112
A bronze scepter topped with a sphere of blue chalcedony. Glass spheres in the background, fourth century. Found on the Palatine Hill. National Roman Museum, Rome. Photo: Author.

sometimes in combination with the scepter.[45] Coins from the fourth, fifth, and sixth centuries show the joint rule of two emperors by depicting them enthroned, holding the globe together, or carrying two separate globes (see fig. 111).[46] A cache of imperial insignia, including a scepter, lances and glass spheres, was recently discovered on the Palatine Hill, confirming their existence (fig. 112).[47] Procopius's description of the *globus cruciger* held by the emperor Justinian on his bronze equestrian statue in Constantinople dispels all doubts about its meaning. According to the writer, the globe signified Justinian's rule over the whole earth and sea, while the cross stood for the "emblem by which alone he has obtained both his empire and his victory in war."[48]

What is known of the emperor's attributes helps illuminate their importance for the Augusta. On the Florence and Vienna ivory panels the *globus cruciger* is held by an empress of the late fifth to early sixth century (see figs. 110 and 113). The coins of Justin II are the only known instance of an emperor and empress seated side by side on a throne: in some cases, the emperor carries the globe while the empress Sophia has the scepter (fig. 114), in others the Augusti hold the globe together, while each also carries a scepter.[49] The scepter and the *globus cruciger* signified the Christian rule and victory.[50]

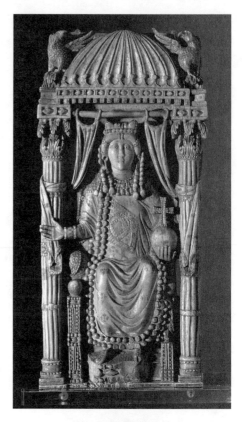

FIGURE 113

(right) Carved ivory panel with an empress seated on a lyre-back throne (rails visible behind the curtains) under a canopy two eagles perched on it, her right hand is opened in a gesture of largesse, her left hand holds a globus cruciger. The empress wears a bejeweled diadem with pendants and a trefoil ornament (now partly broken), a pearl-trimmed chlamys with a tablion with a rubbed image (an empress?), late fifth to sixth century, 26.5 (h), 12.7 (w), 1.9 (d) cm., Kunsthistorisches Museum, Vienna. Photo credit: Erich Lessing / Art Resource.

FIGURE 114

(below) Follis of Justin II, Cyzicus, 567–68, bronze. Obv.: Justin and Sophia facing, enthroned; cross between heads. Justin (left) holds a globus cruciger; Sophia a scepter. Rev.: *M*. Above, cross. Obverse legend: *DN IVSTININVS PP SA* (backward *Ns*). Reverse legend: large *M*. To left, *ANNO* (downward), *KYZ* in exergue. To right, *III* (*II* above *I*). Beneath, *A*. Bellinger and Grierson 1966, 117a. H/AM, Bequest of Thomas Whittemore, 1951.31.4.594. Imaging Department © President and Fellows of Harvard College.

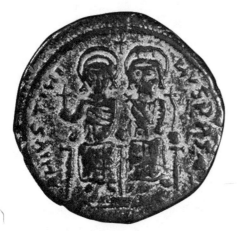

The throne, whose curving rails are visible on either side of the empress in the Vienna panel, stands as yet another attribute of imperial power that the sovereign shared with the Augusta (fig. 113).[51] The only surviving image of an emperor on a throne under a baldachin appears on the obverse of a coin of Domitian.[52] Philostorgius mentions that the empress Eusebia, wife of Constantius II, was seated on a lofty throne (*thronos*

hupsēlos).[53] A sixth-century description by Corippus of a canopied imperial throne demonstrates how the symbolism of the canopied throne forges the notion of the emperor as a cosmic ruler: "The imperial seat ennobles the middle of the palace, the seat having been surrounded by four extraordinary columns, over which a canopy of solid gold beyond measure, shining brightly and imitating the regions of the arching sky, covers the immortal head and the *solium* of the seated; the *solium* being decorated with gems and gold and proud purple. Four arches curve in themselves."[54]

Where the four arches in this description curved has been debated. In one interpretation they are taken as referring to the *sella curulis,* the folding chair of consuls not the throne.[55] But the celestial symbolism of this passage and the reference to the emperor as an immortal connect the canopied throne to the divine realm. Like the scepter and the globe, the imperial throne as a symbol was appropriated from the gods, especially Jupiter.[56] Forty-six enthroned imperial statues have survived for the period from Augustus to Constantine.[57] A coin of the emperor Trebonianus Gallus (r. ca. 252) depicts on its obverse a statue of the enthroned Juno seated under a ciborium supported by four columns.[58] The image represents a temple of Juno Martialis in Rome. But the composition resembles that of the Vienna ivory and corresponds to the description by Corippus, by whose time the baldachin had lost its pagan connotations, though its connection with divinity and heaven remained.

The ancient sources call the seat under the emperor's canopy either *solium* or *thronos.* This was a high-back chair that first appeared in imperial representations on a coin of Divus Augustus and Diva Augusta Livia, seated as an enthroned goddess (see fig. 43) and on cameos depicting the emperor as Jupiter.[59] The high-back throne is shown sporadically on imperial coinage, although by the third century it had likely replaced the traditional imperial seat, the *sella curulis,* a backless chair with folding legs.[60] Constantine drew attention to the throne by minting coins showing him seated frontally, and flanked by his sons.[61] Most examples of enthroned fourth- and fifth-century Augusti show two of them, seated together.[62] This is the case, for example, on the reverse of solidi of Valentinian I, Gratian, Theodosius I, Arcadius, Leo I, Justin and Justinian (see fig. 111), and in the upper register of a consular diptych from the fifth century.[63] Procopius employs the word *thronos* to define the emperor's seat in the hippodrome, and in the palace.[64] Corippus saw imperial power as synonymous with the royal throne (*regni solium*) and the scepter.[65]

Herodian (Hdn. 1.8.4), the third-century historian, attested that one of Lucilla Augusta's imperial privileges was to sit in the theater on a throne. A high-back throne is the seat of Julia Domna on her *mater patriae* coinage (see fig. 45). Still, as with emperors, imperial coins represent it rarely. Thus images of a living empress seated frontally on a high-back seat found on fifth-century coinage thus make a statement about the female person with respect to their authority. Galla Placidia (Augusta 421–50), for example, is depicted enthroned with a nimb and holding a scroll on a medallion from 426–30 (fig. 115). A solidus of Licinia Eudoxia (439–ca. 462), from 455, shows her on the obverse

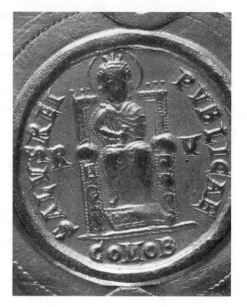

FIGURE 115

Medallion of Galla Placidia, Ravenna, 426–30. Detail of the reverse.
Obv.: Galla Placidia diademed. Rev.: Galla Placidia seated on a
bejeweled throne, wearing a diadem with a trefoil ornament, holding
a scroll, halo around her head. Obverse legend: *D N GALLA
PLACIDIA PF AVG*. Reverse legend: *SALVS REI PVBLICAE; R V;
COMOB* in exergue. *RIC* 10 Valentinian III 2009. Jean Vinchon
Numismatist, Paris. Photo credit: Gianni Dagli Orti / The Art Archive
at Art Resource, N.Y.

with a radiate crown on her head, while the reverse depicts her enthroned, holding a *globus cruciger* in her right hand and a long scepter surmounted by a cross in her left (fig. 116).[66] The throne in each instance draws attention to the imperial rank and the empress's commanding sacral presence. The Augustae, as the legends suggest, ensure the well-being of the state (*salus rei publicae*).

The empress ivory in Vienna indicates that the actual seat of the empress was likely covered with a baldachin supported by four columns. A reference to the empress Eudocia (423–60) implies a canopied throne. She is said to have praised Antioch while seated "inside [rather than on] an imperial throne of solid gold set with jewels."[67]

We may derive two conclusions from these examples of shared attributes of rule. First, most of the emperor's and the empress's imperial attributes can ultimately be traced to the iconography of the Greco-Roman gods. Second, the imperial tokens used by the Christian empress, such as the diadem, the imperial cloak, the scepter, the *globus cruciger*, and the throne, implied that the empress's authority was that of a co-emperor.[68]

ADVENTUS, LARGESSE, *PROSKUNĒSIS*

Three imperial prerogatives likewise underscored the co-rulership of the emperor and the empress: the ceremony for an *adventus,* the arrival of an imperial person; monetary largesse: and *proskunēsis* (a greeting indicating submission). The historical accounts suggest that empresses adhered to a protocol when entering a city or returning to the capital. That protocol included largesse. Helena's visit to the eastern provinces is a well-known female *adventus.* Eusebius talks of her donations in terms of *dexia megaloprepei,* a phrase

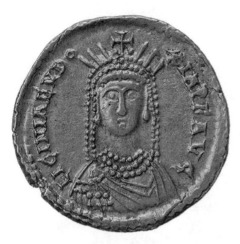
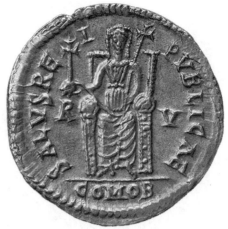

FIGURE 116

Solidus of Licinia Eudoxia, Ravenna, 455, gold. Obv.: Frontal bust of Licinia Eudoxia, who wears a radiate crown topped by a cross, bejeweled and pearled diadem, necklace, a fibula with three pendants, fastened over the right shoulder. Rev.: Licinia Eudoxia enthroned, holding a globus cruciger in her right hand and a scepter in her left. Obverse legend: *LICINIA EVDOXIA PF AVG*. Reverse legend: *SALVS REI PVBLICAE; R V* in right and left fields; *COMOB* in exergue. *RIC* 10 Valentinian III 2023. BM, 1860,0329.228. ©The Trustees of the British Museum. All rights reserved.

that describes a visual image of imperial largesse.[69] Eusebia, the wife of the emperor Constantius II (Helena's grandson), was another empress who distributed largesse. In 357, as she entered Rome she was welcomed according to Roman "custom" for such a reception, by the senate and the people.[70] Their preparations for her visit were costly and impressive. In return for the sumptuous welcome, Eusebia distributed largesse to the "presidents of tribes" and to the centurions.[71] During her travels to the Holy Land in the mid-fifth century, the empress Eudocia also opened her purse to various recipients. In Antioch she donated money to supply the grain fund and she rebuilt the Baths of Valens.[72] She delivered a speech in praise of Antioch in the city council chamber while seated on a bejeweled throne and received in thanks a gilded statue.[73] Eudocia's return to Constantinople from the East in 439 has also been interpreted as an *adventus*.[74] In 532/533, while traveling from Constantinople to the hot springs in Pythia with a large retinue, Theodora, accompanied by Helias, the *comes largitionum*, distributed largesse to churches, poorhouses, and monasteries on the way.[75] The only known example of an empress making the gesture of largesse, signified by the opened right hand, is the ivory panel with an empress from Vienna (see fig. 113).

But the gesture is also discernible in Anicia Juliana's portrait on folio 6 verso in the sixth-century Byzantine illuminated manuscript *Codex Vindobonensis medicus graecus* (figs. 117 and 118). The miniature represents the princess Anicia Juliana (ca. 462–ca. 530) distributing gold coins.[76] Although the portrait and the book to which it belongs

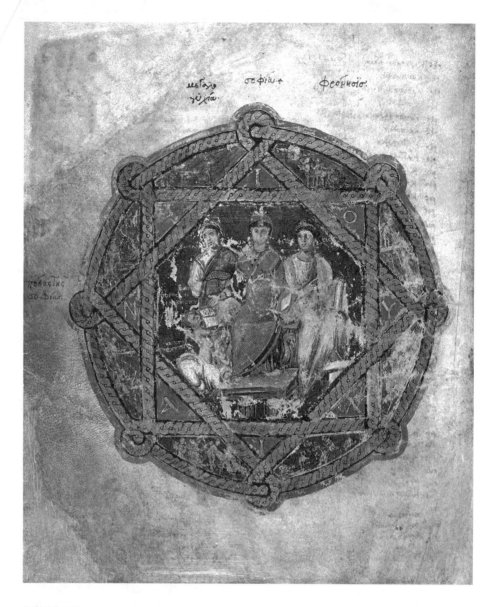

FIGURE 117

Anicia Juliana distributing largesse. Anicia Juliana sits on chair her right hand opened with gold coins flowing from it over a book held by a naked Eros holding a book and labeled "Desire for she who loves to build." In front of Eros kneels down a female figure, labeled "Thankfulness of the arts." The female figure to Juliana's right holds a bag of gold coins and is labeled "Generosity." The female figure to the left, labeled "Purpose/Foresight" holds a scrolls and makes a gesture of speech. Labels is miniscule date from a later period. Sixth-century manuscript illumination, Codex Vindobonensis Med. gr. 1, Österreichische Nationalbibliothek, Vienna, fol. 6v. Photo credit: DeA Picture Library / Art Resource, N.Y.

FIGURE 118

Anicia Juliana distributing largesse, sixth-century manuscript illumination, detail of Juliana's open hand giving out coins, Eros, and the "Thankfulness of the arts." Codex Vindobonensis Med. gr. 1, Österreichische Nationalbibliothek, Vienna, fol. 6v. Photo credit: DeA Picture Library / Art Resource, N.Y.

were tokens of gratitude for a church, the image notably lacks Christian symbolism. The inscription that ties it to the dedication of the church is hardly legible, dwarfed by the images themselves.[77] The imperial attributes with which the image endows Juliana refer less to an actual building than to the imperial tradition of building that Juliana represents. An emperor might be similarly shown as a perpetual victor in a general sense. The miniature construes Juliana's largesse as an essential token of her imperial standing.

As an act of obeisance, *proskunēsis* was at first reserved for the emperor.[78] Un umbrella term for postures that range from kneeling to full prostration, it was first mentioned as part of imperial ceremonies circa 260 but was performed for emperors before then.[79] In the Christian period *proskunēsis* was extended to Christ, Mary, and the saints.[80] We

know that empresses were also greeted with *proskunēsis*. Procopius (*Anecdota* 30.23) says that the empress Theodora received the first *proskunēsis* to an Augusta, but textual and visual evidence contradicts his assertion.

In April 450 the emperor Theodosius II wrote letters to his daughter, Licinia Eudoxia, and to Galla Placidia, Licinia's mother-in-law and Theodosius's aunt, addressing the two western Augustae as *proskunētē* (deserving of *proskunēsis*, worshipful).[81] He calls Licinia *proskunētē basilis,* and addresses Galla as *proskunētē Augousta.*[82] Likewise, Galla Placidia addresses Pulcheria in a letter as "most holy mistress, *proskunētē* augusta daughter."[83] The adjective *proskunētē* also appears in a letter written by Hilaros the Deacon to Pulcheria, preserved in the proceedings of the Council of Chalcedon. The deacon calls Pulcheria: "Your deserving of *proskunēsis* [*proskunētē*] Piety."[84] In all examples *proskunētē* is part of the empress's title.

The adjective *proskunētē* is usually translated "to be worshiped" when used for the saints, and "venerable" for everyone else.[85] Early Christian writers, such as Cyril of Jerusalem, habitually used it for the Trinity. The importance of the adjective *proskunētē* derives from the specific action it describes. The life of Bishop Porphyry, dated to the fifth century, relates that Porphyry and his companion performed *proskunēsis* during an audience with the empress Eudoxia when she resolved to help them in their mission.[86] The use of *proskunētē* in official correspondence as part of the empress's title would suggest that ceremonial kneeling down or prostration in front of the empress was already an established practice by the mid-fifth century, thus disproving Procopius's testimony.

Additional proof against that testimonial comes from Juliana's portrait in the *Vienna Dioscurides*. The most striking sign of her de facto imperial status is the small female figure, head covered, dressed in white, and kneeling in front of Juliana. A label identifies this figure as *eucharistia technōn,* the "Thankfulness of the arts" (fig. 118). To a contemporary viewer, the performance of *proskunēsis* for Juliana in the miniature would have signaled eloquently both her imperial standing and a gesture of gratitude.

THE CHRISTIAN AUGUSTA AND IMPERIAL VICTORY

The concept of *koinōnia* gradually changed the understanding of imperial victory. Before Constantine, the fecundity of the Augusta, actual or anticipated, forged a connection between the empress and imperial victory. The Roman empress, often syncretized to mother goddesses, was also conceived as a bringer of victory in her assimilation to Venus Victrix and Nikēphoros or Nea Nikēphoros.[87] For instance, on the triumphal relief of Septimius Severus in Leptis Magna (205–9), the Victory crowning the emperor was given the features of Julia Domna. Likewise, the painting in Aquileia (described in the oration of 307) that showed Fausta endowing Constantine with a helmet may be read as an allusion to Fausta assimilated to Venus Victrix.[88] The deified imperial virtue of Victory and the virtues connected to the consequences of imperial victory, such as Pax (peace), Securitas (security), and Salus (well-being, health), were also included in this category.[89] Cicero

remarks that he who brings *salus* is a savior (*sōtēr*).[90] According to this logic, the second-century title *mater castrorum* (mother of the military camps) styled the empress as a source of *salus* and *securitas*.[91] It was translated into visual images of the empress enthroned as a goddess with a scepter and a globe, with the military standards (fig. 44). Some extant reliefs also portray imperial women crowning the emperor with a victory wreath, the usual role of the goddess Victoria.[92] The empress, in her symbolic motherhood of the troops and assimilation to Victoria, was presented as the source of imperial victory.

This conceptualization of victory differs from that of late antique iconography of the empress. On the ivory panels of Florence and Vienna the sacred fecundity of the Augusta and the blessed conditions of imperial victory give way to images advertising the authority of the empress, images that deemphasized her femininity (see figs. 110 and 113).[93] The empress has turned from a symbolic mother of victory into a victorious sovereign. In part, that transformation resulted from the notion that only God was the author of imperial victories, an idea present in the empire before Christianity but intensified by it. Constantine, Eusebius, and Ambrose speak of the emperor's utter dependence on God's favor.[94] Similarly, coins with the *manus dei* (see fig. 103), the hand of god, emphasize the divine origins of imperial victory and power.[95] In a world that accepted such beliefs, the empress could be seen as the source of victory.

In part because faith came to play a more important role in the imperial discourse, the empress was seen as an imperial colleague in victory.[96] Collegiality in imperial victory was not a new idea,[97] but in the fifth century the empress became part of its symbolism, in an assimilation that paralleled the development of Christian celebrations of victory that included prayers and processions.[98] The empress's inclusion in the collegiality of victory was most clearly expressed in coins of the empress Pulcheria (r. 414–53) and other fifth-century empresses. These coins co-opt the Augusta into the concept of imperial victory.[99] The reverses of Pulcheria's solidi from 450–53 show Victory carrying a long cross and the inscription VICTORIA AVGGG (*Victoria augustorum*), victory of the Augusti, where the three G's refer to the number of Augusti recognized by the eastern court (fig. 119). These included Pulcheria's husband Marcian and their western colleague Valentinian III.[100] The third G must be for Pulcheria, who was thus recognized as a member of the imperial college and a victorious sovereign. The use of the G's on coins to indicate the number of the Augusti has been one of the most useful criteria in dating coinage struck in the late fourth century. Although numismatists have presumed that the accuracy of this method decreases with the fifth century and that the inclusion of women in the imperial college is unlikely,[101] the historical context suggests otherwise. Solidi similar to those of Pulcheria with *Victoria augustorum* on the reverse argue for the co-rulership of Verina, Zenonis (r. 475–76), Euphemia (r. 467–72), and Ariadne.[102] In all these cases the three G's can be explained once an empress is added to the equation. Even if by the fifth century the number of the final letters had lost its significance, the plural form and the placement of the inscription clearly made the empress, like the emperor on his coinage, part of the imperial victory (figs. 119 and 120). Acclamations for Ariadne at the

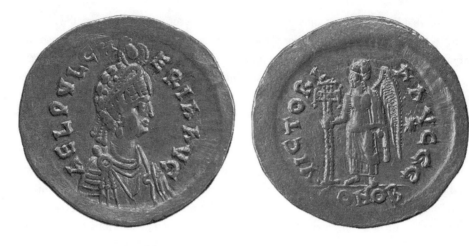

FIGURE 119

Solidus of Pulcheria, Constantinople, 450, gold. Obv.: Bust of Pulcheria, diademed, wearing a chlamys, crowned with a wreath or a diadem by a manus dei (hand of god). Rev.: A winged Victoria holding a long bejeweled cross. Obverse legend: *AEL PVLCHERIA AVG*. Reverse legend: *VICTORIA AVGGG; CONOB* in exergue. *RIC* 10 Marcian 512. BM, 1868,0509.3. ©The Trustees of the British Museum. All rights reserved.

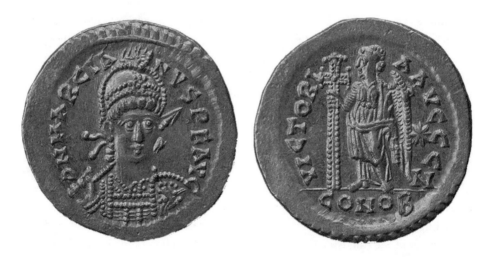

FIGURE 120

Solidus of Marcian, 450–57, gold. Obv.: Bust of Marcian, frontal, wearing military gear, a diadem over helmet, and holding a spear. Rev.: A winged Victoria holding a long bejeweled cross. Obverse legend: *DN MARCIANVS PF AVG*. Reverse legend: *VICTORIA AVGGG; Z; CONOB* in exergue. *RIC* 10 Marcian 509. BM, 1870,0201.1. ©The Trustees of the British Museum. All rights reserved.

accession of Anastasius, whom she selected as the new emperor, hailed her: "Ariadne Augusta, may you conquer!"[103] Likewise, Theophanes reports that at the coronation of Ino/Anastasia, the wife of Justin II's successor, the factions chanted "Anastasia Augusta, tu vincas."[104] The cry "May you conquer!" resonates powerfully with the Constantinian conversion vision, which revealed to him a cross-shaped trophy and a sign "Conquer by this!"[105]

The empress's inclusion in the concept of victory is also present in inscriptions on fortifications. The gates of the citadels at Miletus (Turkey), Cyrrus (Syria), Cuculis/Theodoriana (Tunisia), and Thamugadi/Timgad (Tunisia) displayed inscriptions hailing both Justinian and Theodora.[106] The placement of these inscriptions suggests that these cities considered their protection dependent on both of the Augusti. That this understanding had gained popularity confirms an inscription, on a protective wall (*munitia*) of a town in Africa, that referred to Justin and Sophia as "our most Christian and utterly invincible emperors" (*domini nostri christianissimi et inuictissimi imperatores*).[107]

Such an openly military aspect to the role of the Augusta was revolutionary in view of Roman practices. It reverses Nero's charge against his mother, whose ambition included *consortium imperii*. The closest parallels in the Roman period are Tacitus's account of Agrippina sitting on a dais like the emperor in front of the imperial standards and Julia Mamaea's bronze medallion with the imperial standards, circa 230, hailing her as *mater castrorum et augustorum*.[108] The scarcity of Roman examples demonstrates how innovative and transformative the early Christian developments in female imperial portrayal were.

The parity of costume, of imagery, and of designation between the Christian emperor and the Christian empress helps define imperial *koinōnia* ultimately as collaboration in forging imperial victory. Corroborating evidence comes from several examples: the iconography of the partnership of Leo I and Verina, rendered on their coins; the mosaics, now lost, in the Chalke Gate depicting Justinian and Theodora celebrating military victories together; and the coinage of Justin and Sophia, seated together on the same throne (see fig. 114).[109] The visual parity and the shared throne correspond forcefully to parts of Corippus's description of Justin's succession, recounting how when Justin and Sophia entered the palace, the imperial guards wished a happy reign to the rulers (*imperium felix dominis*), and describing how later the citizenry addressed the pair together, exclaiming, "Rule as equals in eternity!" (*Regnate pares in saecula!*).[110] To address the pair as *domini* (lords) and *pares*, a noun implying equality, was to conceive the Christian imperium as a partnership of a male and a female sovereign. The same notion animates an inscription referring to Justin and Sophia as *hoi kratistoi despotai tēs oikoumenēs* (the most powerful lords of the world).[111]

The striking expansion of the empress's prerogatives differentiated this from the earlier progenitor model of conceptualizing rulers. One of the most important dimensions of imperial *koinōnia* was the empress's role in the imperial succession. Although the Christian Augusta issued no legislation and never led armies, she came to enjoy a unique

responsibility that transformed imperial practice: the Christian empress could, if necessary, legitimate new emperors. The Augustae Constantina (d. 354), Pulcheria, Verina, and Ariadne, by virtue of their rank, bestowed imperial dignity upon men.[112] This was a radical novelty. Succession in the pre-Constantinian period was decided between men; women had no legal role in the process.

Because the source of the Augustae's authority, in each case, remained the traditional title Augusta, the prerogatives of that title must have changed between the first and the fourth centuries. In addition to the consent of the traditional political players required in any succession, a socially acceptable understanding must have emerged to make these successions legitimate. Before Constantine, imperial women, daughters especially, strengthened dynastic alliances between imperial men, but the matter of succession was determined by men alone. Constantine's marriage to Fausta, the daughter of an Augustus, exemplifies the phenomenon. That an Augusta, like an emperor, could elevate new emperors, was an extraordinary innovation.

There were limits to the partnership, including issuing laws (with some exceptions) and personal rapport between the Augusti. According to a late second- to early third-century commentary published in Justinian's *Digest,* the collaboration between the male and female Augusti was limited by the understanding that although the empress enjoyed the "same exceptional rights" as those of the emperor, her rights came from him.[113] This same commentary defined the emperor's position as above the law, the empress's as subject to it. It follows that the empress's "exceptional rights" were contingent upon the emperor's will. The essential personal factor in this definition is reflected in the historical realities.

Harmonious marital relationships (Eudocia and Theodosius II before the rift, Justinian and Theodora, Justin and Sophia), filial relationships (Constantine and Helena, Valentinian III and Galla Placidia), or sibling relationships (Theodosius II and Pulcheria) contributed to the greater public role and authority of empresses. Strife between male and female members of the imperial family commonly ended to the disadvantage of the women. The death of Fausta on Constantine's orders and the stripping of Justa Grata Honoria and Eudocia of imperial privileges, one on her brother's command and the other on her husband's, illustrate this point.[114] Still, notwithstanding the complexities of individual reigns between 324 and 600, the statements in the discourse of imperial founding, including images, court ceremonial, and civic patronage, construed the Augusta as a co-founder of the realm in the current generation along with the reigning Augustus.

CHRISTIANITY AND
THE FOUNDING DISCOURSE

8

CHRISTIAN PIETY AND THE MAKING OF A CHRISTIAN DISCOURSE OF IMPERIAL FOUNDING

Christianity was fundamentally incompatible with traditional Roman religion. Although Constantine did not ban the traditional cults, he dealt them a heavy blow by choosing a Christian edifice for his founder's tomb and by refusing to perform traditional sacrifice. But the position of privilege that the emperor gave the Church did not translate into an easy relationship between church and state. From the start, the bishops resented imperial interference in Church affairs, as well as the blatant self-centeredness of imperial power, its belief in divine right to rule, and pretensions to possessing sacredness.[1] The Church writers endeavored to reformulate and frustrate these traditional beliefs and encroachments on the sacred by arguing vigorously that the emperor and the empress were subservient to God and that Christian piety was the most important of the imperial virtues.

Paradoxically, and contrary to common opinion,[2] Eusebius of Caesarea, who seemed Constantine's most devoted Christian champion, was one of the clerics most defiant and critical of secular authority. Others followed. Guided by the principle that the emperor was a servant of God, they wielded as a weapon their assessment of the emperor's Christian piety. Conditioning imperial rule on Christian piety, however, or finding sacred parallels to the imperial couple opened the door to even more imperial interference in Church affairs, and to the appropriation of Christian symbolism in imperial art and architecture. Fundamental developments in early Christian theology, as well as imperial church commissions, can be understood only in their imperial context.

Constantine's adoption of Christianity precipitated an ideological crisis in the discourse of imperial founders. The emperor not only co-signed a decree ending the persecution of Christians but also started building churches himself and became deeply embroiled in the Church's affairs.[3] Although his churches rivaled the grandest of the imperial baths and basilicas, Constantine did not put his religion ahead of imperial rank.[4] Despite Eusebius' aspirational testimony, in his public image Constantine privileged himself over Christ, both as emperor and founder. The first Christian emperor broke with the old imperial religion. But Constantine did not promote the Christian God at his own expense.[5]

Eusebius's statements notwithstanding, very little in Constantine's statements of power, especially those on the development of Constantinople, indicates that Christianity had determined the emperor's urban planning.[6] Constantine chose to acknowledge his faith as an aspect of his public image as a founder. As has often been remarked, Constantine was a Roman emperor first and a Christian second.[7] That was the traditional way; piety was only one of the core imperial virtues.[8] To be sure, there were churches in imperial residences, and crosses in imperial images. Even so, in the building of palaces or the minting of coins, Christianity seems secondary to the more important task of communicating the temporal authority of earthly rulers. These ideas are at odds with those of Eusebius and Ambrose, both of whom interpreted imperial authority exclusively in religious terms. They believed that Christian piety alone mattered. It underpinned the ruler's right to rule, according to Eusebius, and served as the basis of Constantine and Helena's partnership in founding the Christian monarchy, according to Ambrose. The excessive focus on piety must be understood as an attempt to shape the imperial discourse of founders in opposition to two realities: traditional imperial self-aggrandizement and the pagan *mater-pater patriae* model of the earlier era.

Eusebius introduced Christian piety into the founding discourse in two major works, his *Life of the Emperor Constantine,* written after Constantine's death, in 337, and his oration *In Praise of Constantine* (*Laus Constantini, de laudibus Constantini;* or *Praise*), delivered in 336 in Constantine's presence.[9] Sixty years after Eusebius, Ambrose, in his funerary oration for Theodosius, made piety the defining imperial characteristic through which Helena co-founded the Christian Roman Empire.[10] Works by other Church writers present illuminating but less familiar statements about the Christian imperium: Gregory of Nyssa's funerary oration for the empress Flaccilla (d. 386), John Chrysostom's homily on the translation of relics to Drypia (402), and the *Church History* of Philostorgius.[11] The objectives of those defining it deemphasize the secular dimensions of imperial power and promote instead an ideal based on piety. All these authors cite the relationship between Christian rulers and the divine in interpreting the relationship between church and state. So even though the writings seem largely descriptive and flattering, they are in fact moralizing and prescriptive. The praise they reserve for emperors and empresses masks audacious political objectives regrading the discourse of imperial founding.

EUSEBIUS: CONSTANTINE'S PIETY IN CONTEXT

The writings of Eusebius before and after Constantine's death help define the momentous shift that Christian piety brought to the discourse of imperial founding. The bishop's works had two phases.[12] The later work, his *Life of Constantine,* reflects Eusebius's own views on the emperor, which the bishop could express more freely after Constantine's death.[13] The earlier work, the oration *In Praise of Constantine,* can be viewed as catering to the emperor's beliefs about God's relationship to him.[14] The differences between the works are instructive.

In the *Life,* Eusebius modifies two concepts which he had expounded on in his *Praise:* the emperor's position vis-à-vis God and Constantine's way of honoring his patron deity, or piety. The subtle emendations in the substance of these ideas translate into altered agency. In the oration, Eusebius speaks of Constantine and God as friends who have similar qualities.[15] Overall, he renders the relationship between the emperor and the Christian God in terms similar to those of the coins in the famous series of Constantine with Apollo Sol. These show the emperor in full military attire sharing the obverse with Apollo the Sun (see fig. 71).[16] Emperor and god are shown equal in height, their jugate profiles facing the same direction. The coin portrays them as companions, though the emperor occupies the foreground of the image. By contrast, Eusebius privileges God even as he insists on the affinity between emperor and deity.

agency & narrative?

The bishop couches the likeness in Platonic terms, resorting to the idea of archetypes. The Christian emperor and the empire are earthly manifestations of heavenly archetypes.[17] Constantine models himself after the "archetypal form of the Supreme Sovereign" (*LC* 5.4). He is a man who, having conquered passion, is "wise, good, just, courageous, pious, and God-loving"—in short, a true "philosopher-king [*philosophos basileus*]."[18] The emperor exerted himself to achieve wisdom through prayer and contemplation, recognizing the pettiness of earthly existence even one as exalted as his own.[19] The imperial title Victor recognized the struggle to overcome human passions and model oneself after the Supreme Sovereign.[20] As a consequence of this perfection, Constantine Victor, the Christian philosopher-king, led the souls of humankind to knowledge of God, his act like that of a sacrificing priest and reminiscent of the Good Shepherd.[21] Eusebius thus shows Constantine as a Christ-like sage. With one exception, Eusebius refrains from speaking directly of hierarchies. He refers to the emperor as God's "invincible *therapōn,*" but insists that the emperor delighted in this appellation. In a Christian context *therapōn* is commonly translated as "servant," but it is a noun whose primary meaning is "attendant," companion in arms a as Patroclus was to Achilles.[22] The term also denotes a worshiper of a deity, hence the nuance of being subordinate, and Eusebius's plea for its propriety. In the book of Exodus, Moses is God's attendant (*therapōn*); and this must be how Constantine understood the term when he referred to himself as *therapōn* (*VC* 2.55.1): divinely chosen attendant/helpmate of his patron god.[23]

By contrast, in the *Life,* Eusebius omits the Platonic terminology and recasts the emperor as God's servant. To be sure, he sometimes calls Constantine a "friend of God," one who receives divine favor and protection, particularly in his military victories. But the absence of Platonism subtly lessens the affinity between patron God and emperor.[24] Constantine is no longer the philosopher-king who achieved wisdom in imitation of the heavenly ruler. He may be an "image" of God's monarchical authority, but no longer is he God's counterpart in wisdom or in the leading of souls; he is instead a servant, filled with "fear and reverence," a man who earnestly strives to recompense his patron with wonderful offerings of thanks.[25]

In a revealing passage about the relationship between Constantine and God, the bishop of Caesarea describes the emperor as *therapōn,* stating that the emperor was "a loyal and good attendant [*therapōn*]," someone who confesses himself "a believer [*therapōn*] of the All-sovereign [*pambasileōs*]" (1.6.1). In this work, Eusebius also employs the term for Moses, whom he praises as the "great attendant" (*ton megan theraponta*) (*VC* 1.38.5). But then Eusebius introduces another, explosive, epithet. He insists that Constantine "openly called himself a slave [*doulon*] to God" (*VC* 1.6.1). And then, as if to mitigate this word, meaning bondage, the lowest of social standings, so antithetical to anything any emperor before Constantine could be called, Eusebius waxes lyrical about the wondrous "recompense" that God would bestow on the emperor. He would make him "Lord [*kurion*] and Despot [*despotēn*], the only Conqueror [*nikētēn*] among the Emperors of all time to remain Irresistible and Unconquered, Ever-conquering and always brilliant with triumphs over enemies, so great an Emperor as none remembers ever was before the reports of those of old, so God-beloved [*theophilē*] and Thrice-blessed [*trismakarion*], so truly pious and complete in happiness, that with utter ease he governed more nations than before him, and kept his dominion unimpaired to the very end."[26]

This striking and underappreciated paradox—that a lord (*dominus*) could be called a slave—holds the key to Eusebius's project in the *Life of Constantine. Dominus* (lord, master) referred to the relationship between a master and his slaves.[27] In honorific inscriptions that include imperial titles, the emperor was customarily called *dominus.*[28] To describe the *dominus*/master of the empire as a slave was treasonous and could be made acceptable only because Eusebius makes the imperial rank contingent exclusively on piety. Piety in the *Life* translates into imperial subordination to God. Utter submission to God yields complete control.

Eusebius underscores the idea that Constantine's accomplishments as emperor became possible only by the will of God. The emperor's personal agency and wisdom entirely give way to divine guidance. God, who was on the emperor's mind before battles, ensured his military victories.[29] If we are to trust the bishop's account, Constantine won all his battles not so much because of his bravery or clever military tactics, but because he used the cross, the "saving sign" of God. Even the emperor's title Victor, Eusebius interprets as "the most appropriate surname because of the victory which God had given him over all his enemies and foes."[30] Whereas the *Praise* emphasizes Constantine's

godlike qualities, his deliberate self-perfection, his priestly role, and personal wisdom, the *Life* focuses on divinely sponsored imperial success. The emperor emerges as a tool in God's hands, his likeness to God thus necessarily diminished. In this shift of perspective lies Eusebius's uncensored thinking about the place of emperors in the Christian community: they are God's servants, and they need to earn God's good favor by prayer and acts pleasing to God, such as supplications. Constantine supplicates God in both the *Life* and the *Praise*. But in the *Life* the emperor not only prays but also subjects himself to fasting and "harsh treatment of the body," thereby "winning God's favour for his prayerful pleas that he might have God at his right hand to succour him."[31] In the *Life*, Eusebius also has Constantine bidding priests to pray for him.[32] In short, the *Life* gives precedence to imperial humility and obedience to God, and delegates to minor roles the emperor's wisdom, his likeness to the deity, and his godlike agency.

The assertive rhetoric of humility in Eusebius's *Life* differs from that of Constantine's portrayal of himself in his images or his monuments—even after Constantine embraced Christianity. The bishop conjured a vision of complete surrender to God; the emperor asserted his personal agency. The difference between those opposing views about imperial agency is rooted in Eusebius's thought about the relationship of rulers to the divine.

The bishop's account of the new capital exemplifies the Eusebian goal to "put the emperor in his place." Eusebius knew the capital and had a fairly good idea of what buildings and monuments the emperor constructed in the city.[33] For that reason, his account of Constantine's dedication of Constantinople is striking for its shallowness. Eusebius omits Constantine's baths, the newly embellished Hippodrome, the Baths of Zeuxippus, the Augustaion, the Senate House, and all the rest of the buildings intended to make Constantinople equal to Rome. He also omits the emperor's statue as Apollo the Sun in the middle of his Constantinopolitan forum, a statue that honored the godlike founder Constantine (figs. 71–73)—in short, every project that fulfilled traditional responsibilities of the kind the ancients considered cumulatively grounds for deification.

Instead of describing examples of imperial fashioning and intervention in urban development, Eusebius dwells on the city's Christian character. He speaks vaguely of many martyrs' shrines that the emperor constructed. He writes, "In honoring with exceptional distinction the city which bears his name, [Constantine] embellished it with very many places of worship, very large martyr shrines, and splendid houses, some standing before the city and others in it. By these he at the same time honored the tombs of the martyrs and consecrated "his city to the God of the martyrs."[34] In other words, Eusebius builds a case for Constantinople as a city dedicated to the "God of the martyrs" on the number of churches and on their dedications. But he fails to name any of them, perhaps because there were no impressive churches yet existing in the city. They may have been under construction in 336, the year Eusebius visited, or they may have seemed less significant than the emperor's palace, for instance. The bishop did, however, describe the "emblems of the Good Shepherd," tokens of Christian faith that were set up in fountains in "the middle of squares."[35]

Eusebius's account of the emperor's tomb is another example of how Constantine's piety affected his building. What that building was remains debatable. The controversy is whether the Constantinian edifice was just a round mausoleum or a round mausoleum attached to a church.[36] Eusebius calls the building a temple/shrine (neōs) in a courtyard surrounded by porticoes; it was lofty and covered with marble revetments and had a brilliant roof (VC 4.58–60). Constantine's tomb was surrounded by thēkai (coffins/reliquaries) of the apostles. In Eusebius's interpretation, the emperor wanted to be perceived as one of the apostles. But his description of the arrangement, if not his words, suggest another interpretation, equally possible. The central position of Constantine's coffin allows us to see the emperor not as the thirteenth apostle, but as typologically related Christ.[37] His tomb, like the statue in the forum, showed him as godlike founder. In this case, however, the deity of emulation was the Christian God. In traditional founding discourse, divinity had been the emperor's reward for city founding. After death, the emperor rose like Christ and the sun god to eternal life. The notion that Constantine would ascend to heaven, Christ-like, was something Eusebius wanted to avoid. He subverts the idea of deification by expounding on Constantine's soul uniting with God, even as he describes Constantine's consecratio coin, showing the emperor, riding a chariot, and being pulled bodily to heaven (as is traditional in such images, see fig. 69) by a hand of God (see fig. 86).[38]

Writing after Constantine's death, Eusebius was relatively free to expound his views without second-guessing what Constantine would have considered his most important achievements. (Wouldn't the emperor have expected an adequate coverage of his new city and traditional largesse?) Eusebius's fundamental bias in his narrative of Constantine's life has been neglected because of the bishop's lavish praise. The phrase was presumably meant to soften the sweeping new ideas Eusebius proposes about imperial power, and to divert the reader's attention from the gaps and misinterpretations in his account.[39]

Eusebius also leaves out buildings and events that tarnish Constantine's reputation for piety. He omits the failure of this well-traveled and long-reigning emperor to ever visit Christianity's holy sites. Constantine sent his mother and mother-in-law instead.[40] The bishop omits the temple that Constantine allowed to be constructed in his honor, and the murders of both his eldest son, Crispus, and his wife, Fausta, who died by order of the emperor.[41] Even though in the Life Eusebius paints Constantine as almost saintlike, the bishop obviously knew of his subject's deep flaws.[42] Nevertheless, as a clever politician, he omitted the shortcomings, amplified the pious acts, and twisted some facts to serve his goals.[43] No author could have been more positive about his subject than Eusebius, so sycophantic is his portrayal of Constantine in this work. But the bishop also endeavored to define Constantine's legacy in strictly Christian terms.

Despite his praise and the calculated appearance of objectivity (such as the inclusion of numerous letters), the bishop undermined traditional imperial values, digging at the root of the imperial characteristics that elevated the emperor above other humans: the ability to act. In the Life, Constantine seems to be a pawn in God's hands. By deliberately

ordering and selecting only some of Constantine's accomplishments, Eusebius created an alternative vision of Constantine's reign that was far less complex and appeared far more Christian and pleasing to God than the historical reality he knew so well.

Insofar as it can be reconstructed from Eusebius's writings and other sources, Constantine's piety seems to have followed a traditional approach to honoring his God. He assumed traditional priestly responsibilities. To commemorate his triumph over Maxentius he razed the barracks of the *equites singulares* (the imperial horseguards), who supported his former colleague, and on that spot built the Basilica Constantiniana, also known as the Basilica Salvatoris (the present day Church of St. John the Lateran), a massive church clad in marble,[44] dedicating it to God. The tradition of church building continued the ancient practice that went back to the time of Romulus of rewarding one's deity with spolia and a temple.[45]

Constantine also rejected the tradition of imperial *pietas*. He refused to sacrifice to Capitoline Jupiter, but he felt comfortable playing the role of a *pontifex maximus* as well as Christian *episkopos* (bishop).[46] The emperor worked to reconcile warring Church sects, first the Donatists, and then the Arians. Twice Eusebius refers to him as *episkopos*: "When some were at variance with each other in various places, like a universal bishop appointed by God he convoked councils of the ministers of God. He did not disdain to be present and attend during their proceedings, and he participated in the subjects reviewed, by arbitration promoting the peace of God among all; and he took his seat among them as if he were one voice among many."[47]

Eusebius gives the impression that Constantine debated with the bishops as an equal. In his description of the Council of Nicaea, he reiterates this notion when he quotes Constantine as saying that he was "a fellow worshiper" (*suntherapōn*) at the gathering of bishops.[48] But in reality, Constantine presided over the debates and steered their course.[49] Although not ordained, the emperor appeared as a chief priest. The idea that he oversaw the Church comes across in the numerous letters Constantine sent to the bishops, instructing them to undertake a variety of actions; letter Eusebius quotes in their entirety.[50] Constantine thus pursued his own interpretation of piety, mixing traditional gestures, such as building churches to his patron deity, with new ones, such as summoning and participating in Church councils and heading an organized Church. To judge from these acts, he likely viewed himself as God's archetype, a role that, according to the *Praise*, included leading the souls of believers to God.[51]

Eusebius's main contribution to the discourse of founding was thus his selective use of history to formulate a new way for emperors to interact with the divine—his Christian redefinition of habitual forms of imperial honoring the divine, such as the building of edifices, and manifestations of piety. The bishop can also be credited with steering the discourse of founding to a Christian path. He saw potential for Constantine and Helena to replace the *pater-mater* paradigm. As mother and son, they corresponded perfectly to Christ and his mother, the Virgin Mary.[52] Although he did not explain the rationale for a Christian female founder, he came very close to doing so when he associated Helena's

maternity with that of the Virgin Mary. He portrays Helena as the "Godbeloved mother of a Godbeloved Emperor," a "queen" who honored the pregnancy of the God-bearer (*theotokos*), the mother of the "all-ruling God."[53] The parallelism of the mother-and-son pair is articulated subtly. It is not yet a fully developed theological explanation of power, but it seems remarkable that even after both Helena and Constantine had died, Eusebius considered such a suggestive analogy. That he did so can be read not only as a testimony to Helena's enduring legacy, but also to the need for a Christian framework for imperial rank as held by both women and men. In 324, Fausta, Helena's daughter-in-law, was shown in a guise similar to that of Isis.[54] Helena's numismatic portraits connect her to *pietas*, but the iconography of her reverses suggests pagan divinities. Eusebius laid the groundwork for Helena's remembrance, as he did for Constantine's. In the *Life*, he identifies piety as her main achievement. He presents her life as dedicated to deeds pleasing to God, such as the building of churches on the Mount of Olives and in Bethlehem.[55]

AMBROSE'S *DE OBITU THEODOSII* AND THE EMPIRE'S NEW FOUNDING MYTH

Imperial piety comes across forcefully in Ambrose's funerary oration for Theodosius, in 395, as the single most important characteristic of imperial rank. Ambrose proposed that the Christian monarchy came into being when Helena inserted the relic of the True Cross in Constantine's diadem and the bridle of his horse, "so that the cross of Christ might be adored among rulers."[56] Thereafter all the emperors up to the bishop's time, except Julian, were Christian. There were thus two founders, one female and one male, with the female founder acting on her own initiative rather than in the emperor's stead. As partners, they pursued a common goal. Thus Ambrose genders the discourse of founders differently from Eusebius, who assigns Helena prominent but tightly circumscribed role. Ambrose's origin myth, with its emphases on a woman, a relic, and piety, endeavors to steer the discourse of founders away from emperors and wars. In his argument the relic and the faith it signified would make the empire eternal.[57]

Concrete political circumstances were significant to the content of Ambrose's oration, but only to a point. The bishop's speech, delivered almost sixty years after Constantine's death, pursued political objectives related to the death of Theodosius.[58] The legacy of the polytheistic phase in the discourse of founders also shaped its content. Ambrose's story of the empire's creation competes with that earlier discourse in chronology and in role models. The oration shuns the entire history of the Roman emperors before Constantine, because in the bishop's time, the older Roman traditions were still very much alive.[59] The poetry of the court poet Claudian testifies to their relevance.

Admittedly, Claudian did not have Ambrose's ambitions. Yet because the poet and the bishop measured imperial time differently, they developed divergent models of ideal imperial behavior. Ambrose supplements the exemplary deeds of Helena and Constantine with moralizing stories of Old Testament kings. King Elisha illustrates the power of

prayer, King David the virtue of humility.[60] Josiah and Asa stand for able kings who, like the underage Honorius, succeeded their fathers in childhood.[61] In Ambrose's oration the Christian monarchs seem to have succeeded the Old Testament kings rather than the pagan emperors. By implying that lineage, Ambrose could bypass the traditional notion of rulers as godlike and assert a new one: the emperor, like any other man, depends on God's grace. Ambrose insists, "The man that wins is he who hopes for the grace of God, not he who presumes upon his own strength."[62] Recalling Eusebius's *Life*, the bishop asserts that the emperor Theodosius had prevailed thanks to the superiority of his Christian faith.[63] Addressing the soldiers in the audience, he reassured them: "Where there is faith there is an army of angels."[64]

In presenting the pious Christian ruler and his virtues, Ambrose also identifies a role model that, for empresses, could supplant Livia. Ambrose describes Helena as Constantine's partner in forging the Christian monarchy by recovering the wood and nails of the cross. Putting one of the nails in his diadem and inserting the other nail in the harness of his horse ensured the emperor's victory in Christ.[65] The bishop associates Helena with Mary: "Mary was visited to set Eve free; Helena was visited so that emperors should be redeemed."[66] In her foundational role, the empress resembles Christ's mother. This passage in Ambrose's oration helps explain why an empress would be portrayed as an emperor and not simply as a dynastic matriarch. The bishop made Helena a cofounder, with Constantine, of the Christian state.[67] In doing so, he formulated a Christian alternative to the pagan imperial founding myth. Crucially, this alternative empowered imperial women in unprecedented and concrete ways.

The premise of the epithalamium in which Claudian brought up Livia's jewels was that Aphrodite herself officiated at, and readied the bride for, the wedding.[68] Honorius, inflamed with passion, resembles a young stallion; Maria, innocent of love, resembles a rose. Procreation and the continuation of the dynasty it enables are most desirable. Aphrodite urges Maria, "Go, mate with one who is worthy of thee and share with him an empire [literally: be partner of the imperium, *consors imperii*] co-extensive with the world."[69] In a sense, to rid the founding discourse of Aphrodite, Ambrose had to find an alternative to Livia as the model *consors imperii*. He found that model in Helena and her association to Mary. Thus could he substitute Christian piety for the old ideals of beauty and fecundity.

The notion of the empire's pious female cofounder, typologically related to the Virgin Mary, appeared not only in Ambrose's speech but also in literary accounts that speak of numerous statues of Helena in the city (with or without Constantine, with or without the symbol of the cross) and in Christian iconography that testifies to the close notional parallels between the Augusta and Mary.[70]

GREGORY OF NYSSA AND JOHN CHRYSOSTOM

Other bishops took up in their speeches the idea of piety as the most important imperial characteristic. Two examples, offered here, illustrate the rich undercurrents of these

orations, which once again obscure imperial statements about secular authority. Take Gregory of Nyssa's funerary oration for Flaccilla, the first wife of Theodosius I, composed in 386. It is a curious text that contains almost no biographical information and has little to say about the empress. Gregory does underscore Flaccilla's donations to the needy, which she disbursed with her "right hand which satisfied many wants."[71] And he praises her humility (*tapeinophrosunē*) and Christian piety. No matter how highly Gregory of Nyssa praised Flaccilla's Christian virtues, however, the fact remains that none of those admirable qualities led her to renounce the dignities of her position. Flaccilla's *adventus* in Constantinople, an event the bishop highlights, caused great cheer among the capital's citizens. The empress was greeted with songs of praise, and the most distinguished men escorted her train through the city.[72] The empress on this occasion must have worn her imperial diadem and the *paludamentum*, and she may even have distributed coins minted in her name. The only building in Constantinople associated with Flaccilla is her palace in Regio XI, known as the *palatium Flaccillanum*.[73] For Gregory, piety was the only dimension of Flaccilla's character deserving of praise—an entirely appropriate stance for a funerary oration. But Flaccilla's *adventus* and palace made it clear that pious generosity was neither the only nor the most important manifestation of her imperial authority.

Nonetheless, for bishops, secular deeds remained of secondary significance overall. Another bishop who wrote favorably about Flaccilla was the fifth-century church historian Theodoret of Cyrrhus. In his account, Flaccilla's pious works were addressed to God. Theodoret praised her because she cared for the maimed and the sick like a servant. According to his report, the empress defended her actions to those who attempted to dissuade her from them, saying, "It befits a sovereign to distribute gold; I, for the sovereign power that has been given me, am giving my own service to the Giver."[74] Theodoret thus interprets Flaccilla's actions, however incongruous with her rank, as an offering of thanks to God for her dignified position, echoing Eusebius's explanation of Constantine's subordinate position to God.

If the bishops focused in their writings on imperial piety, they may have done so partly because their office constrained them from making broader comments. Piety was the bishops' domain; their office allowed them to assess it, especially in texts such as funerary orations. And in their role as arbiters in matters of piety, the bishops also dealt with the behavior of living emperors and empresses. John Chrysostom, the golden-mouthed patriarch of Constantinople, famously used that prerogative several times in relation to the empress Eudoxia, the wife of Arcadius (Theodosius I's older son),[75] alternately praising and criticizing the empress.[76] But even when he applauded her actions, John found opportunities to maneuver the dialogue, Eusebian-style, toward putting imperial authority in its place. On January 9, 402, he delivered the oration to commemorate a nighttime procession the empress led to the shrine of St. Thomas in Drypia, about nine miles from Constantinople.[77] John appears to do nothing more than describe a pious event and praise the main organizer, but his objectives were more ambitious. Like Eusebius, with his complex attitude toward Constantine, the bishop critiqued what he noted as flaws in

Eudoxia's piety and encouraged an approach to piety different from the one he saw practiced in the imperial city.

The bishop's oration is one of the homilies he wrote for this event.[78] In it he claims that the empress's procession was a first in the history of Constantinople and that the entire city attended. Although the homily is ostensibly about relics, John is silent about the martyrs to whom they belonged and the place where they were delivered. The empress Eudoxia and the procession itself remain central to his speech, and the relics themselves are all but ignored. The homily is another example of a Church writer endeavoring to educate sovereigns in the pious exercise of imperial power. Devotion to God and humility are key to John's vision. Without stating his purpose clearly, he uses the occasion to describe a notional Christian city, an alternative to Constantinople, the imperial city. For him, the participants in the procession, though speaking in different tongues, formed a unity, "a river of fire," stretching from the imperial city to Drypia.[79]

This new city, bound by Christian devotion, surpasses the one the procession left behind. It is a polis of biblical proportions, with utopian features. Its leader, the pious empress Eudoxia, compares favorably to Miriam, who led the Israelites in a dance after they had crossed the Red Sea. Eudoxia, the new and greater Miriam, unites the multilingual procession as a single people. In the new city delineated by the relic procession, social standing and venerable conventions dissolve. Women, young and old and "softer than wax," leave their sequestered quarters. Magistrates abandon their "carriages, staff bearers, and body-guards" and "[rub] shoulders with the common people." If historically even eunuchs in the palace were not to look upon the empress, here she "has allowed herself to be seen in the crowd in the midst of this vast spectacle." In the new city, spontaneity and lack of pretense prevail over titles and refinement. The Augusta leads in this, as she "casts off all her masks to display with naked enthusiasm her zeal for the holy martyrs." She has "cast off imperium and crown and all the vanity that arises from these in considerable abundance," and "instead of a stole of purple she [has] donned the stole of humility." John claims that Eudoxia alone of all empresses honored martyrs in such a way, by leading a procession of relics, "mingling with the crowd, dispensing [with] her entire retinue, and banishing virtually the entire inequality of her lifestyle to a high degree."

Radical ideas permeate John's sermon, as they do Eusebius's notion that Constantine was God's servant. John both praises an extraordinary public display of imperial humility and uses it to attack social realities in the capital. He does not mention buildings, but the subtext, the paradigm against which he builds his speech, is Constantinople. Besides lamenting how little impact Christianity has had on social mores there, he addresses indirectly Constantinople's urban fabric.

Piety, for John, levels everyone. The procession, he says, emptied the entire city, as its population walked the road to Drypia: the empress, monks, virgins, priests, laymen, slaves, free—"those in authority, and those subject to it, the poor, the wealthy, the strangers, the citizens."[80] This joyous crowd had abandoned the trappings of social standing, ever present

in the city they had left because the imperial family, in fashioning imperial Constantinople, had filled it with markers of social inequality, building hierarchy into the city's urban fabric. In the early fifth century the shrines of the martyrs were not the city's focal points. The city was developed around palaces and their auxiliary buildings. The populace congregated, as in antiquity, at the baths, the porticoes, the grand imperial squares with their triumphal arches and imperial statues, the hippodrome, and various mime theaters.[81] The imperial mansions, ever in need of personnel, provided jobs and a livelihood for the neighborhood around them. John devoted an entire sermon to chastising those who skipped church services to attend theatrical performances and races at the hippodrome.[82] If John was right to claim that this relic procession was a first in the city, then one can surmise that Christianity only very slowly affected the rhythms of life in the capital.[83] Indeed, the procession can be seen as an attempt to quicken the pace of the city's Christianization. In Antioch, John had already had great success with services lasting through the night. He had remarked on the spiritual benefit of the contemplating God in darkness, with only the light of the stars.[84]

Twenty years after John's speech the imperial baths numbered eight, the palaces proper with their auxiliary buildings, fifteen.[85] Standing amid all these physical displays of imperial power were fourteen churches of various size.[86] The centers of public life apparently remained those bound to the imperial identity of the city. Hence, John's utopian vision did come to life, but not in Constantinople.

A year after John's oration, a silver statue to the empress Eudoxia was placed on a porphyry column and, following ancient custom, was celebrated with music and rituals that supposedly disturbed John in the pursuit of his liturgical duties.[87] The statue was dedicated by the city prefect and, that being the case, it must have reciprocated a favor to the city. The lavish expenditure on the material of the statue and the honoring of a mere human were exactly what John had criticized in his homily of 402. He dared to disapprove publicly of the statue and of its dedication—indeed, too publicly, for he gave a sermon (now lost) on the weakness of the female sex that was a veiled critique of the empress. In it John evidently compared Eudoxia to Herodias, the mastermind in beheading John the Baptist.[88] The vocal bishop's critique of the empress went too far, and he was banished from the capital city.[89]

Imperial piety was seen differently by the imperial family and the Church. Whereas for emperors and empresses piety was one component of their public image, Church writers liked to see it as the most desirable quality in a ruler. Therefore minding the authorship of statements concerning imperial piety, of the textual or the visual kind, is extremely important. A final illustration of this point comes from an account in Philostorgius of the empress Eusebia, the wife of Constantius II, and Leontius, the bishop of Tripolis, in Libya.[90] Leontius is said to have been the only bishop who refused to visit and salute the empress, a slight that annoyed her. To entice him to meet with her, she promised him a church and a large sum of money. Leontius replied as follows:

If you have the desire of performing any of these promises which you make to me, my empress, be assured that you will be gratifying your own inclination rather than me. But if you really wish me to come and salute you, I will do so, provided the due and customary reverence for the bishop be shown; I mean, that when I enter the room, you will come down from your lofty throne, and meet me with respect, bending your head down to my hands in order to receive my episcopal benediction. Next, that I shall sit down, and you stand in a respectful attitude; sitting down when I bid you and give you the signal for so doing. If you choose to do all this, I will willingly come to you; but if not, you will never give me presents sufficiently ample and magnificent to induce me to abate one particle of the honour which is due to bishops, and be willing to violate the divine laws of the priesthood.[91]

The bishop, in other words, demanded a reversal of the habitual way a bishop greeted an empress. Instead of kneeling down and then standing before her lofty throne, he told the empress that she herself had to perform those gestures of respect, like everyone else. According to Philostorgius, Leontius also chastised the emperor, her husband, for meddling in the affairs of bishops, saying: "I am ashamed . . . that when the care of military and civil matters has been entrusted to you, you should dictate to bishops in matters which appertain to the office of a bishop alone."[92] Such a bold statement, though it may never have been uttered at all, indicates at least Philostorgius's desire that it should have been. It shows a simmering discontent with imperial protocol and imperial meddling in Church affairs.[93] Though vulnerable to imperial mistreatment, bishops enjoyed popular support and high moral ground that could significantly challenge imperial authority. The riots provoked by Chrysostom's exile testify to the uneasy balance of authority between the imperial ruler and the spiritual leaders of the Church.[94]

Nowhere is the contestation of imperial dominance in the city more evident than in Procopius's description of Constantinople in book 1 of *Buildings*.[95] The work is lavish in its praise of the emperor Justinian and the empress Theodora and seems to spare no detail when it recounts Justinian's generosity to the city of Constantinople. But Procopius, in Eusebian fashion, frames Justinian's accomplishments and earthly position in a particular way in his narrative of the emperor's largesse. He begins his account with the church of Hagia Sophia (532–37), and then records descriptions of all the other churches in Constantinople, first those dedicated to Christ, then those consecrated to the Virgin Mary. His final section discusses Justinian's palaces.

Hagia Sophia dominates his narrative for excellent reasons. But given Procopius's criticism of the imperial pair, its dominance enforces the conclusion that God's houses were the most important part of the city. Procopius writes that Hagia Sophia "soars to a height to match the sky, and as if surging from amongst the other buildings it stands on high and looks down upon the remainder of the city, adorning it, because it is a part of it, but glorying in its own beauty, because, though a part of the city and dominating it, it at the same time towers above it to such a height that the whole city is viewed from there as from a watch-tower."[96]

Contrast this passage to Procopius's description of three of Justinian's palaces, mentioned last. Of the Great Palace he described only the entrance, the famous Chalke Gate and its mosaics, arguing, "We know the lion, as they say, by his claw, and so those who read this will know the impressiveness of the Palace from the vestibule." Procopius says nothing about the rest of the palace. He reports that Justinian built two new palaces, the Jucundianae and the Hieron. Of them he says, "I could never adequately describe in fitting words either their magnificence and their exquisitely detailed workmanship or their massive bulk. It will be sufficient to say simply that they are regal and that they were built under the personal supervision of the Emperor." He elaborates a bit more on the Hieron. Its porticoes, public squares, public baths, the church of the Theotokos, the port, and the open cistern are known only from his description.[97] Procopius thus gives only cursory notice to Justinian's palaces, though by his own admission they were spectacular.

In privileging churches over palaces, Procopius comments on Justinian's position vis-à-vis God, and the relative importance of palaces versus churches. His point overall is that Justinian and the buildings that asserted his imperial rule in the urban fabric must take second place to God's dwellings. That assertion is an important political statement, given that in Procopius's time the imperial palaces in Constantinople numbered about nineteen, and that Procopius describes lavishly every little shrine that Justinian built or restored. By focusing on all twenty-three of the city's churches and shrines, Procopius subtly conveyed the lesser importance of the imperial palaces.

Thus to dismiss the sources that praise emperors and empresses for their piety as unoriginal and servile is to reject the complex realities and concerns that shaped them. Emphasizing a particular kind of piety delineated an ideal, offered a critique, and even created an alternative imperial history. This is not to say that emperors and empresses failed to pursue pious works, but only to suggest that the bishops, and likeminded lay writers who followed them, had their own particular perspective on imperial piety.

In the public sphere, imperial piety did not exist independently from notions of power. For the Augusti, church building eventually became the most important measure of their piety. The chapter that follows examines its history as a statement in the founding discourse and its significance for empresses.

9

CHURCH BUILDING
AND FOUNDING

Building new sanctuaries and restoring old ones counted among the most fundamental duties of an imperial founder. This is abundantly clear whether one reads Augustus's *Res Gestae*, or Procopius's *De aedificiis*. Whether in polytheistic Rome or in late antique Constantinople, building sanctuaries was an expression of imperial piety in the context of imperial authority—not a matter of personal faith. Yet the tendency has been to downplay the significance of the churches built by imperial women and to consider them either pious dynastic gestures, and therefore personal, or more general expressions of power to garner prestige.[1] The framework in which imperial women's churches defined imperial authority has received insufficient attention.

It is impossible to treat any imperial act to please God, however sincere, except as part of the discourse that rationalized and shaped authority. The primary context for imperial patrons and imperial buildings is the discourse of imperial founding. Buildings—baths, temples, churches, public spaces—are statements about founding on a smaller scale. They construe the patron as the guardian of public good, accomplished by renovating old constructions and building new ones. Each type of building erected demonstrates a different side of imperial munificence. Baths and porticoes emblematize civic responsibilities. Churches speak to religious duties. Those engaged in this dialogue—the patrons (speaking through their buildings) and the contemporary observers, religious or secular, writing about these edifices—define and interpret imperial authority. Whether constructed by imperial men or women, church buildings honored the builder and emphasized the rulers' God-given imperial rank, because churches were reciprocated offerings of

thanksgiving to God for divine patronage. By the end of the fourth century, building churches had become an act of civic patronage of greater prestige than the building of baths. This is made clear in textual and epigraphic sources from the fourth to the sixth century. The imperial churches analyzed here illustrate the political dividends of church founding for imperial men and women.

IMPERIAL POWER AND CHURCHES

Church building entered the emperor's repertoire of public commissions under Constantine in Rome, in 312, soon after his victory over Maxentius at the Battle of the Milvian Bridge.[2] The emperor began a widespread campaign of church building in the East after the Council of Nicaea of 325.[3] From the beginning, Helena was Constantine's partner in this endeavor. With or without Helena, Constantine commissioned churches associated with relics and sacred locations, such as St. Peter's in Rome, the Church of the Holy Apostles / Constantine's tomb in Constantinople, and Christ's Martyrium in the Holy Land; victory churches, such as the one in Nicomedia and the Lateran; and cathedral churches such as Antioch's Octagon.[4] All of these were monumental and sumptuously decorated and endowed.

In Rome, all of Constantine's were built outside the city's traditional political and religious center.[5] What did Constantine hope to achieve? The Lateran offers a clear-cut if partial answer: it was built over the razed barracks of Constantine's defeated enemy, Maxentius, as an offering of thanks for victory.[6] The gesture was as Romulean as it was Augustan. Like the earlier victors Romulus and Augustus, Constantine dedicated a sanctuary to his victor-bringing patron deity.

The churches that cannot be classified as victory monuments can be related to the emperor's larger responsibility to God, including care for the Church as an institution and for his fellow worshipers. Constantine explained this obligation: "He (the Highest Divinity) has, by the celestial will, committed the government of all earthly things [to me]. For I shall really and fully be able to feel secure and always to hope for prosperity and happiness from the ready kindness of the most mighty God, only when I see all venerating the most holy God in the proper cult of the catholic religion with harmonious brotherhood of worship."[7]

In other words, God and Constantine enjoyed a reciprocal relationship. In return for God's grace in bestowing the government of all earthly things on him, Constantine watched over the proper worship of God and the harmony of the Church. Proper worship included—in fact, depended on—the building of appropriate places of worship. Constantine's churches in Rome, Constantinople, and other cities of the empire stood as testimony to his dutiful fulfillment of his obligation to preserve his imperial standing and thereby secure the empire in the eyes of God. Imperial patronage of churches was linked to rulers' understanding of the imperium. Church building was both a gift given in return for one's imperial position and a sign of that position.

Alongside this ideological and symbolic dimension, imperial church construction had a more practical aspect that can also be discussed in terms of reciprocity. When Constantine built his first churches in Rome, which bore all the marks of grand public buildings, they may have been considered not gifts to the city of Rome but houses of worship for the Christians of the city.[8] After Christianity became the official religion of the state, at the time of Theodosius I, however, church building could be counted among the public amenities that the emperor customarily provided to the state and not just to the Christian community. When Nicomedia, in Bithynia, was razed by an earthquake and flooded, Theodosius II built "many buildings there, including the public baths, the colonnades, the harbor, the public arena, the Martyrium of St. Anthimos, and all the city's churches."[9] Justinian's building activities in the reconquered provinces were similar. According to Procopius, Justinian's patronage of Carthage, in North Africa, included building or restoring the entire circuit wall, two churches, porticoes on either side of the forum, and a public bath. Theodosius and Justinian thus restored the edifices that enabled the proper functioning of a city and made it complete: churches, baths, and porticoes. The citizens responded to Justinian's largesse by renaming the city after him.[10] Justinian's benefactions make it clear that thanks for imperial buildings, including churches, were an appropriate and reasonable return from the community lucky enough to benefit from imperial largesse.[11]

Once Christianity was declared the only religion of the state, church building became an act of civic responsibility that deserved corresponding rewards. Church building was a token of exchange in the dialogue between the emperor and God and the emperor and the people. It signified the imperium, just as palaces did. It was also part of the imperial largesse, along with baths and porticoes. These two symbolic aspects of constructing a religious foundation were also at play in female imperial patronage of churches.

Imperial women who built churches held themselves to, just as others evaluated them by, the same standards. Starting with Helena, female imperial patronage of churches delineated two circles of reciprocal exchange—between the empress and God and between the empress and the people. The first exchange delineated the empress's offering of an imperial church in thanks to God for her position; thus it expressed the builder's piety. At the same time, the edifice became a token of that position, linking the patron to other imperial builders. In the second exchange, a church was a gift to the community, to be treated like other signs of civic patronage. That is, the patron needed to be commemorated. The greater the original honor, the more lavish the reciprocal gift. Both the original gift (the church) and the reciprocal gifts, from God (anticipated or hoped for) and from the community, were symbolic measures of an empress's political power, and aspiration to such power.

This framework of Helena's enthusiasm for Christianity comes across in Eusebius's discussion of her philanthropy. Helena was the first, but not the only, empress to combine piety and politics in her patronage. In the Christian understanding, imperial power, male or female, was a sign of God's grace.[12] For that reason, an imperial church should

be seen as an emperor's or an empress's offering to God in thanksgiving for their status. This is the message conveyed by preserved imperial dedications in churches. Justinian and Theodora's inscription on the altar of Hagia Sophia, preserved in the twelfth-century history of Cedrenus, reads as follows: "We, your servants (*hoi douloi sou*) Justinian and Theodora, offer to you, O Christ, what is yours from what is yours. May you accept it benevolently, O Son and Word of God who became incarnated and were crucified for us. Keep us in your true faith, and increase and protect this empire that you have entrusted to us for your glory, with the intercession of the holy Mother of God, the ever-virgin Mary."[13] The sovereigns, in other words, presented to God a gift for having appointed them his representatives in the task of increasing the glory of the Christian empire. The prayer links the preservation of the sovereigns with the protection of the empire.

Another inscription, wrapping around the interior of Justinian and Theodora's church dedicated to SS. Sergius and Bacchus, conveys a similar sentiment:

> Other sovereigns, indeed, have honored dead men whose labor was useless. But our scep-tered Justinian, fostering piety, honors with a splendid abode the servant of Christ, Creator of all things, Sergius; whom neither the burning breath of fire, nor the sword, nor other constraints of trials disturbed; but who endured for the sake of God Christ to be slain, gaining by his blood heaven as his home. May he in all things guard the rule of the ever-vigilant sovereign, and increase the power of God-crowned Theodora [see fig. 98], whose mind is bright with piety, whose toil ever is unsparing [in] efforts to nourish the destitute.[14]

Here the imperial couple addresses Sergius to intercede on their behalf with Christ, so that God may protect Justinian's rule and increase the power God granted to Theodora. The offering accompanying this request is a "splendid abode" for Sergius. The inscription draws attention not only to the church, but also to Justinian's and Theodora's piety.

The understanding that an imperial church gives thanks or a pledge in anticipation of future favors is also evident in the inscription in the church the empress Sophia built and dedicated to the healer saints Cosmas and Damian in Constantinople. Probably the church was dedicated soon after the first signs of Justin's disintegrating mental health appeared. In the inscription Sophia presents the church as a gift to Christ and his saints, asking in return for the health of her husband, Justin II, and for his victories over barbar-ians. "I thy attendant [*therapaina*] Sophia, O Christ, offer this gift to thy attendants/ companions [*tois sois therapousin*]. Receive thine own, and to my emperor Justin give in payment therefor victory on victory over diseases and the barbarians."[15]

The second circle of exchange, whereby a church was a gift to the community in which it was erected and required appropriate thanks in return, is more difficult to track. It is evident in the case of Eudoxia's church in Gaza, which was named Eudoxiana in her honor, and in the magnificent manuscript that the town of Honoratai presented to Anicia Juliana in thanks for her church building in that community. Considering the two circles of reciprocal exchange suggests that imperial churches and church donations, by

community was more connected to Empress?

male or female patrons, did far more than express piety. Both activities exemplified a noteworthy fulfillment of imperial duty, whereby the empress paid obeisance to God and thereby secured the empire and her own position. Because church patronage was intimately and ultimately associated with imperial authority, all church building by empresses was political.

Most of these churches have not survived to allow a comprehensive survey. It is possible, however, to analyze in depth several churches, known from excavated remains and/ or literary and epigraphic testimony, to explore their founding and assess the symbolic capital they brought to their patrons. These are Eudoxia's church in Gaza, Galla Placidia's church of St. John the Evangelist in Ravenna, and three of Anicia Juliana's churches in Constantinople and its vicinity.

THE EUDOXIANA IN GAZA

The *Vita Porphyrii*, attributed to Mark the Deacon (fl. fifth century), is the primary source for the history of Eudoxia's church.[16] For many years this document was the only testimony to the building and the document's disputed authenticity cast doubt over the church's very existence. This debate can now be laid to rest with the exciting discovery that the twelfth-century crusader church, now the Grand al-'Omari Mosque in the al-Daraj quarter of the old city of Gaza, was likely built on the site of the Eudoxiana with its ancient columns reused in the construction. The identification does not necessarily mean that the events related in the *Vita Porphyrii* are true. The work's value, its antipagan polemic aside, rests in what it reveals about the function of imperial church building in the late fifth century.

According to this biography, at the end of the year 400, Bishop Porphyry of Gaza journeyed to Constantinople to petition the emperor Arcadius to take action against paganism in his city and to request permission to destroy the Temple of Zeus Marnas in Gaza.[17] Porphyry and his companions managed to get an audience with the empress Eudoxia, who was pregnant at the time.[18] After blessing her and her child, the bishop and his associates promised Eudoxia a boy if she would help them in their petition.[19] The empress zealously embraced their cause. She interceded on their behalf with the emperor but found him unwilling to take action against the taxpaying pagans in Gaza.[20] After the child (a boy, as predicted) was born, Eudoxia contrived a plan to secure a response to Porphyry's request. As the baptismal procession of Eudoxia's son left Hagia Sophia, Porphyry and his companions stopped the man carrying the baby and presented him with a petition specifying their grievances and wishes. The child's bearer, an accomplice in the empress's plan, looked at the petition and announced: "Whatever is in this petition shall be granted."[21] Under the pressure of this promise, Arcadius had to agree to take action against the pagans in Gaza. From then on Eudoxia took a central role in carrying out the baby's will.[22] She arranged for a meeting between Porphyry and the *quaestor sacri palatii* (state treasurer) to draft the necessary legislative act. Then she managed the selection of

a worthy individual to be tasked with destroying the temple and commanding the impe-rial troops to carry out the order. Finally, she took an active part in financing and con-structing the church built on the ruins.[23] While the site was still being cleared, Eudoxia sent letters and a plan (*skariphos*) for the new church, a cross-shaped edifice. The follow-ing year (402) the empress dispatched thirty-two "admirable" columns of green-veined Carystos marble that shone in the church "like emeralds." The church was completed in five years, dedicated "with great pomp" on Easter, and named Eudoxiana in honor of the empress, who by that time was deceased. "Strangers came from all quarters to view the beauty and size of the . . . holy church for it was said to be bigger than any other church of that time"[24]

The legislation and the appointments associated with Gaza's purge of paganism were ascribed to the emperor. But the force behind them was Eudoxia. The cross-shaped church served as a reminder of Christ's victory over death. The shape also recalled other pertinent triumphs: Helena's finding of the True Cross; the triumph of Christianity over paganism, forcefully conveyed by building the church on the ruins of the pagan temple; and the personal triumph of the empress in securing a victory for her faith.[25] The church is also a precious gift to God for Eudoxia's good fortune in securing an heir and ensuring that the imperial position of her family continued. Because of its large size and splendid marble columns, the Eudoxiana stood as a reminder of the empress's generosity. The significance of these columns, whose arrival was joyously celebrated by the citizens of Gaza, can be gleaned from a description of another church in Gaza, St. Stephen. The writer remarks in relation to its beautiful marbles that their purpose was twofold to adorn the church and "praise the donor."[26]

Eudoxia also provided money for a guesthouse and funds to pay the expenses of Christian travelers for up to three days.[27] Gaza's port was an important point of entry into southern Palestine and also a stopping place for ships laden with goods from India and southern Arabia.[28] These travelers ensured that the fame of Eudoxia's sponsorship would spread, embedded in the church's name, the Eudoxiana. The promised son, the primary reason for its construction, disappears from the narrative and the honors.

GALLA PLACIDIA'S ST. JOHN THE EVANGELIST

Like the Lateran, the church of St. John the Evangelist (San Giovanni Evangelista) built by Galla Placidia (b. 388, Augusta 421–50) in Ravenna was an ex voto monument.[29] Galla Placidia, the only child of Galla and Theodosius I, erected the church along with her son, Valentinian, and her daughter, Honoria, to honor the saint for saving them from a storm at sea as they sailed to Constantinople in the spring of 423.[30] Mosaics and inscriptions, now lost but described and recorded in various later sources, provide the historical back-ground for the monument.[31] The mosaics depicted the storm and the miraculous salva-tion by the intercession of John the Evangelist. The depiction of these events was associ-ated with images representing members of the imperial family, as well as the founder,

Constantine.[32] Those family members included Galla Placidia's father, Theodosius I; her half-brothers, Arcadius and Honorius; and Theodosius II with his wife, Eudocia, and their children, Arcadius and Licinia Eudoxia, who was to marry Galla's son, Valentinian III. Undoubtedly, the imperial portraits advertised the illustrious lineage of Galla's family, and the backing of the eastern court.[33] But the inscription next to the imperial portraits connected the vow, curiously, not only to the salvation of Galla and her children from a storm, but also to the entire imperial genealogy that began with Constantine: "Galla Placidia has paid her vow on behalf of herself and for all these."[34]

Galla's inscription seems to refer to the imperial "race" fathered by Constantine. Her miraculous rescue from the storm saved the entire race and proved that she deserved her lofty position despite her tumultuous life. The imperial individuals depicted in her mosaics are connected by the grace of God, bestowed on all of them. Galla's fortunes proved that God had favored her. She had witnessed the sack of Rome by Alaric in 410; lived as a hostage with Rome's plunderers; married their king, Athaulf, in 414; and lost him to assassination and their child to an untimely death.[35] Despite all these earlier tribulations, she ultimately found herself in the position she had expected from birth. And for this, her God-given right to the imperial dignity, she thanked God. Her coinage emphasizes this divine blessing by showing a hand of God holding a wreath over her head.[36]

What symbolic capital Galla Placidia's church of St. John brought her from the people of Ravenna cannot be precisely reconstructed. But her other commissions suggest possibilities. In Ravenna she donated gifts to the city's cathedral, the Basilica Ursiana. She also built or embellished the Church of the Santa Croce (Holy Cross) with a chapel to St. Lawrence,[37] an undertaking that reveals unmistakable links to Helena, the female founder of the Christian empire, and to the relic of the True Cross. The mosaics in Rome's Santa Croce in Gerusalemme also indicate continuity with Helena's undertakings as a builder.[38] Galla's Roman projects were similar to those of other imperial ancestors. She paid for the reconstruction of St. Paul Outside the Walls (San Paolo Fuori le Mura), damaged after a storm.[39] An inscription on the triumphal arch duly commemorated Galla's care for this sanctuary. It appeared just below a similar one that detailed the contributions of Theodosius I and Honorius before her. In other words, by her patronage of churches in Ravenna and Rome, Galla placed herself in a line of imperial patrons of churches stretching back to Constantine and Helena.[40] Galla Placidia's churches, like those of her predecessors, testified to the divine favor she enjoyed, and to her piety for building them. They also presented her as a founder of the cities in which she built.

ANICIA JULIANA'S CHURCHES

Similar conclusions about a female imperial patron and her churches can be drawn from an analysis of Anicia Juliana's churches of St. Polyeuktos, St. Euphemia, and the Virgin Mary in the Honoratai. These churches illustrate the reciprocal relationship between the female founder and God and at the same time provide abundant evidence of the exchange

of thanks between the founder and the community. Although Juliana was not an empress, her sanctuaries illustrate nonetheless the critical role sixth-century churches came to play in defining imperial legitimacy.

Juliana was a woman with a pedigree. She descended from the imperial line of the emperor Theodosius the Great. Her mother, Placidia, was the younger daughter of the emperor Valentinian III (Galla Placidia's son) and Licinia Eudoxia, the daughter of the emperor Theodosius II. Her father, Flavius Anicius Olybrius, the son of an illustrious senatorial family in Rome, became emperor in the West in 472.[41] In 491, at the age of six, Juliana's son served as consul; her husband, Areobindus, was named consul in 506. Juliana herself bore the rank of *patrikia*.[42] Her impressive lineage made her one of the most aristocratic women of her time, one of the last scions of the Theodosian-Valentinian imperial line. Her contemporaries were well aware of her lineage, which alone had the power to legitimate a new emperor. This power was called upon during riots in 512, when the rioters offered the imperial position to her husband. Nevertheless, neither Juliana nor any members of her family were elevated to imperial rank. The tension between what Juliana must have expected as a birthright and the reality of failing to attain it colors the dedication of her churches.

Juliana's church at the Honoratai is known from an inscription in a sixth-century codex, known commonly as the *Vienna Dioscurides*. The verso of folio 6 in this book features a portrait of Anicia Juliana, bordered by an octagonal frame (figs. 117 and 118). Tiny letters written in white pigment on the octagon explain how the manuscript is connected to the church. The codex was a gift to Juliana from the town of Honoratai, a suburb of Constantinople on the Asian side of the Bosphorus, in thanks for her building there *naos kuriou* (a temple of the Lord).[43] Juliana's largesse is thus explicitly connected with a building project. An entry for the period 512–13 in the *Chronographia* (Chronicle) of Theophanes the Confessor (ca. 760–817/818), a work based in part on the earlier ecclesiastical history of Theodore Anagnostes (d. after 527), records Juliana's sponsorship of a church to Mary in Honoratai.[44] The present of the Vienna manuscript thus must date to about the time of that entry.[45] The manuscript's high quality, reflected originally in more than five hundred large-size folios, thirty-eight by thirty-three centimeters, with exquisite paintings of medicinal plants, and its beautifully rendered Greek uncial, bespeak the appropriateness of the codex as a gift for an imperial person.[46]

In the portrait Juliana sits frontally on a gilded *sella curulis* (a chair with folding legs) and dispenses gold coins with her right hand. The coins come from a bag held by a personification labeled Megalopsuchia (Magnanimity), standing to Juliana's right. To her left sits a personification identified as Phronēsis (Purpose/Foresight), who holds a book. No images show a Roman empress distributing money to the populace as Juliana does here. Before Constantine the empress's role as a benefactor (symbolic or actual) was commemorated differently, usually with statues erected in her honor and by assimilations of the empress to deities. Images of the empress's largesse like this one of Juliana appear to be an innovation of the early Christian period.[47] There is one other preserved visual example—the late

fifth- or early sixth-century ivory panel with an enthroned empress extending her right hand in a similar manner (see fig. 113). The mosaic of Theodora in San Vitale shows the empress bringing a gift of a golden chalice (see fig. 109). The iconography of the imperial *liberalitas* traditionally did not include the women of the imperial family. The closest association of an empress with an emperor's liberality is demonstrated by a bronze medallion of Julia Mamaea with Severus Alexander. Its obverse shows Julia Mamaea, and its reverse, her son Alexander, togate, seated on a throne, and emptying a cornucopia, held in both hands. In the front stand four naked little boys. On the emperor's left is Julia Mamaea, standing frontally and carrying a patera; to the right is Minerva, holding a spear. The inscription reads: ABVNDANTIA TEMPORVM ("plenty of the times," or "plenty in our time").

Giving in late antiquity was controlled tightly. During this period three laws were issued to regulate the distribution of senatorial monetary largesse. In general only consuls and emperors had the authority to distribute gold coins. People of lower rank were permitted to give out only small silver coins.[48]

Anicia Juliana was not an Augusta, yet the image presents her as a reigning empress, using the visual language of imperial art and its conventions for indicating generosity, rank, and corresponding honors. The gesture of the open hand with coins flowing out of it is the standard representation of the emperor's liberality, a subject often shown on the reverse of imperial coinage.[49] The iconography closely resembles that of the largesse of Constantine on his fourth-century arch in Rome, and that of the emperor Constantius in a seventeenth-century drawing that copied the *Codex Calendar of 354* (fig. 121).[50] In these images both Constantine and Constantius are seated frontally and each of them extends his right hand to distribute coins. Other marks of imperial distinction include Juliana's headpiece, which is reminiscent of the fleur-de-lis diadems decorating the heads of the empresses from the late fifth- or the early sixth-century ivory panels in Florence and Vienna (see figs. 110 and 113).[51] They differ only in the absence of *prependoulia* (pendant strings of pearls), attached on either side of the empress's diadem. These strings appear in frontal presentations, but are absent from the empresses' portraits in profile.[52] The purple of Juliana's dress, visible at her sleeves, and the figure performing *proskunēsis* likewise signify imperial standing.[53]

The text and personifications chosen for the image also invoke the imperium. According to one restoration, the dedicatory inscription may address Juliana as *anassa*, the Homeric Greek word for queen.[54] This word, in its masculine and feminine forms, appears in other dedicatory inscriptions from the sixth century. It is found in reference for the emperor Justin and his wife Sophia.[55] In Byzantium's later centuries another Byzantine princess Anna Comnena (1083—1153) was referred to as *anassa*.[56] A few emperors, curiously, mostly those called Constantine, are referred to as *anax* (king).[57] Given the context, such a lofty designation as *anassa* for Juliana cannot be dismissed easily.

The two personifications flanking Juliana, Magnanimity and Purpose/Foresight, also have imperial correspondences.[58] Along with the personification of Thankfulness of the Arts prostrated before her, a winged Eros labeled *pothos tēs philoktistou* (desire for her who loves to build) stands by her side and hands Juliana an open book (see fig. 118).[59] The

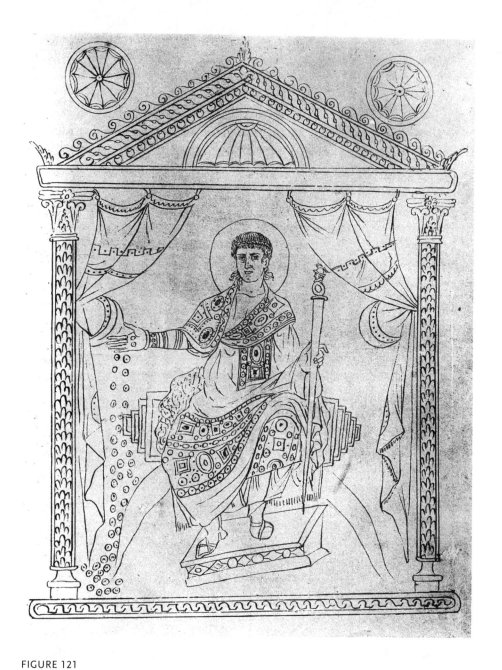

FIGURE 121

Constantius II distributing largesse, from the *Codex Calendar of 354*, Romanus I MS, Barb. Lat. 2154, fol. 13, copy ca. 1600–29. Palazzo Corsini, Inv. 231.549, Rome. Photo credit: Foto Marburg / Art Resource, N.Y.

word *philoktistēs* in the sixth century is used in referring to emperors. It was stamped on the emperor Justinian's bricks.[60] The scenes surrounding the octagon that frames Juliana represent Erotes engaged in building activities, such as the painting of a wall. The rope that forms the octagon and the medallion evokes medieval building techniques.[61] The image and its inscriptions cast Juliana's largesse and church building in imperial terms.[62] She may not have been an empress, but her building spoke of imperial ambitions, expressed through founding. At least her contemporaries saw it that way.

Juliana's imperial ambitions are likewise evidenced by her most famous commission, the church to the martyr Polyeuktos. Strategically located on the Mese, north of the Forum of Constantine, this church is now known only from its foundations and the remains unearthed during excavation in the 1960s (map 7). The substructural remains of this church were dated to the years 508/509 and 511/512, while the body of the church was dated to 517/518 and 520/521.[63] The church was therefore completed sometime after 521. The archeological remains testify to the costly materials and highly specialized labor needed for its completion. These remains include marble window frames, columns once inlaid with precious stones, precious marble and stones of luminous shades, and beautifully carved pilasters. Arches running along the nave were carved with delicate vine tendrils and an inscription extolling the virtues of the builder (fig. 122). Inside each arch stood a peacock with a fanned out tail. By all indications it was a magnificent church—by far the greatest church in Constantinople upon its completion.[64]

It has been argued persuasively that Anicia Juliana herself devised the inscription that wrapped her church, inside and outside (fig. 122).[65] The entablature inscription, chasing the shape of the arches and running continuously along the nave and outside the narthex, described the church and its patron, seeking, like Galla Placidia (Juliana's great-grand-mother) in her mosaics at St. John in Ravenna, to trace her imperial origins. The inscription at the entrance presented the founder following in the steps of Constantine, "the adorner of his Rome"; of Theodosius; and of "many royal ancestors."[66] A mosaic of Constantine's baptism celebrated the first founder in her family tree. The church itself, built downhill from Constantine's Church of the Holy Apostles, must originally have presented itself as a ready parallel to the founder's building (map 7).[67] In the interior, the nave inscription underscored Juliana's extensive church building and her piety: "Not even you yourself know how many god-obedient houses your hand has made." Further down the text continued: "What place [had] not learnt that your mind is full of piety?" The text presented the church as "glittering," and possessing an "elaborate beauty." It stated that the walls of the church "are clothed in numerous metallic veins of colour, like flowery meadows which Nature made to flower in the depth of the rock." In its height the building aspired "to the stars of heaven." The gifts of this and of Juliana's other buildings have already caused "the inhabitants of the whole world [to] sing your works, which are eternally remembered."[68]

Whether these boastful claims were true, we cannot know. What remain important are their political ramifications. The politics behind the inscription and the church itself are in perfect tune with the role of the emperor and the empress as church builders.

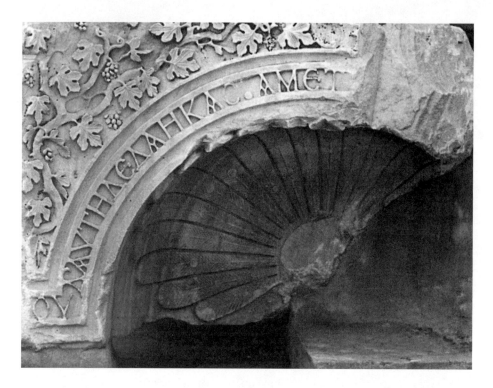

FIGURE 122

Marble arch from the nave entablature of the Church of the Hagios Polyeuktos, showing a detail of the nave inscription, vines, and a peacock's tail, early sixth century, Istanbul. Photo: Author.

Juliana presented herself as an imperial builder who patronized the Christian Church by offering "innumerable (churches) all over the world." These churches brought her "eternal praises" from the populace. In exchange for being such a good steward to his church, Juliana asks God to preserve her, her son, and her son's daughters. Most important, the prayer concludes with a request: "May the ineffable glory [euchos] of the most beneficent family survive as long as the Sun drives its burning chariot."[69]

This last appeal—for everlasting glory for herself and her family of benefactors—in this context quietly suggests (spelling it out would have amounted to treason) that Juliana asked God for the imperial rank.[70] Church dedications, even those of the imperial family, did not usually include requests for glory among the petitions to God. This emphasis on glory is especially uncommon in the genre of church inscriptions for a woman who was not Augusta. Indeed, direct reference in inscriptions to glory in Constantinople appears only once, in an inscription in the apse of Blachernae. This text describes Justin II as the "divine Justin, the husband of Sophia," "to whom Christ granted the restoration of all things, and glory [kleos] in wars."[71]

Yet Juliana's inscription forcefully demands glory. The phrase *gloria romanorum* (glory of the Romans) was frequently inscribed on emperors' coinage to declare that the

emperor, by his deeds, brought glory to the state.[72] Only the coins of the empress Eudoxia, Anicia Juliana's great great-grandmother, featured the same phrase.[73] The glory that the inscription refers to could be interpreted, then, as the imperial rank, which was rightfully Juliana's, as the inscription implies, because of her royal ancestry and her extensive and praiseworthy church building. The most compelling evidence we have that this was the case are two other churches in Constantinople: the Church of the Holy Apostles that stood uphill and communicated visually with Hagios Polyeuktos, and the grandest monument in all Byzantium—the Church of Hagia Sophia in Constantinople, completed fifteen or so years after Juliana's Hagios Polyeuktos (see fig. 1).

The first building at the site of the Church of the Holy Apostles was Constantine's mausoleum.[74] At the time of Juliana, thanks in part to Theodosius I's decisive actions, most of the emperors who ruled since Constantine and their wives were buried in the church.[75] Anicia Juliana belonged to the Theodosian line, but could not be buried at the Holy Apostles, because she was not Augusta. Consequently, her church has been seen as both Juliana's claim for immortality and interpreted as her eventual tomb.[76] Key to this very convincing interpretation are references in the decoration to eternal life, such as peacocks and vines, and more basically the church's unparalleled magnificence.[77] To this line of thought can be added that the mosaics of Constantine, the founder of the Christian monarchy, of Theodosius, and of her many royal ancestors construed Juliana's church as an alternative mausoleum to the Holy Apostles. The fact that Justinian completely rebuilt and expanded the original Church of the Holy Apostles speaks to its importance in his own self-presentation as a founder in the mold of Constantine.[78] Justinian's Holy Apostles featured a dome, an architectural element that some have also proposed for Hagios Polyeuktos, based on textual evidence and the depth of the foundations.[79] Even if Hagios Polyeuktos had no dome, the fact that Justinian put one on the Holy Apostles speaks to his ambition to make the original church better than what it had been, his striving to best his predecessors, including Juliana.[80]

Justinian's competition with Juliana can be detected also in Justinian's Hagia Sophia, which replaced the fifth-century basilica and was completed in five years (532–37). The church was dedicated to God in his aspect of Wisdom.[81] In building it, the emperor competed consciously with the height and beauty of Hagios Polyeuktos.[82] In Procopius's words, Hagia Sophia was a "spectacle of marvelous beauty, [. . . that] adorns the city and dominates it."[83] The interior, like that of Hagios Polyeuktos, featured glittering gold mosaics, precious colored marble revetments, and elaborately carved column capitals. Another sixth-century author saw Hagia Sophia as the symbol of Justinian's imperial authority.[84]

Similarly, Hagios Polyeuktos expressed Anicia Juliana's imperial standing because, as the inscription implies, it was an imperial offering to God and because the gift of this church to Constantinople was an exceptional act of largesse to the imperial city. This gift can be interpreted both as competing with the Holy Apostles and with the Theodosian Hagia Sophia, the city's cathedral by the imperial palace. It can be seen as a gift to the city in return for offering the imperium to her husband, Areobindus, during the riots of

512. Areobindus declined the offer,[85] for reasons that are not clear. He was a general, who between 503 and 504/505 commanded the army of the emperor Anastasius in the East against the Persians.[86] By 512 he may have been too old to get involved in a coup d'état. He may also have hoped that his son Olybrius would succeed the emperor Anastasius, because Olybrius had married the emperor's niece Eirene.[87] At the time of the riots, Anastasius was eighty-two years old and had no children, so it was natural to expect that the imperium would go to his closest relatives.[88] But six years later Anastasius died and Juliana's family was ignored in the imperial succession in favor of the illiterate soldier Justin, the uncle of the future emperor Justinian. With immediate hopes for imperial office gone, church building became Juliana's most powerful weapon in asserting her status. That she may have thought of this political setback of 518 as temporary is reflected in her prayer for glory beyond words—literally, the ineffable glory (*aspeton euchos*) of her excellently wrought family (*aristoponoios genethlēs*).[89]

Juliana's Church of St. Euphemia similarly connected Juliana's family to glory in inscriptions that convey the meaning of the word. One inscription claims that by embellishing this church, Juliana bestowed glory (*kudos*) on her mother and father and her mother's famous mother, the empress Licinia Eudoxia.[90] Another fragment urges the viewer to stop marveling at the glory of men of former times (*proterōn kleos*), whose art gained no fame (*euchos*) comparable to the glory (*kudos*) of Juliana, "who by her work surpassed the skilled design of her ancestors."[91] Whereas the inscription at St. Euphemia asserts that Juliana has already achieved glory for buildings, the one in Hagios Polyeuktos implies that this glory, although recognized at the time, may not have been secured for the future. The concluding lines of the inscription at Hagios Polyeuktos may be read as accompanying a votive offering, Anicia Juliana's prayer to God to secure her continuing glory.

In the context of imperial church building, then, Juliana's glory could mean that the magnitude of her gift to God and the city expressed her wishes that her family continue to bear the imperial purple. In presenting herself as the true imperial benefactor of Constantinople, Juliana testified to her own and her family's eligibility for the imperial rank. Juliana's Hagios Polyeuktos can thus be seen in the framework of imperial patronage and the political dividends it reaped: emphasis on the God-sanctioned position of the builder and thanks from the populace. As the dedicatory text from the *Vienna Dioscurides* proclaims, "Magnanimity allows you to be mentioned over the entire world."[92] Juliana's imperial aspirations in building Hagios Polyeuktos and her other churches invited appropriate response from the emperor Justinian. The praise Juliana accrued from the public was no doubt too loud for Justinian's ears, because in legislation about 527/528 he ordered that no church be repaired or built anew except with imperial funds.[93]

Together the stories, anecdotes, inscriptions, and material remains support the claim that the empresses' liberality in distributing money and constructing their own palaces, public baths, and/or churches expressed their imperial dignity. In the early Byz-

antine understanding of that dignity, women acted on their own behalf, as themselves. Unlike their Roman predecessors, who were considered, almost automatically, beneficent mothers of their fatherland, Byzantine women were not; nor were they compared to goddesses. The Christian empresses had to deliver concrete acts of patronage. Helena's secular and religious undertakings were the turning point in this new development and, remembered imaginatively by succeeding generations, continued to inspire empresses after her. Her role as the imperial partner and co-founder with Constantine of the Christian monarchy gave female imperial authority a new definition that embedded the empresses' agency in the framework of God-given imperial power and the reciprocity it entailed. Everything the imperial women built, from their residences in Constantinople to porticoes and churches, expressed this God-blessed power. But eventually the imperial churches became its primary embodiments. In a sense, that primacy was a victory for the bishops.

As gifts both to God and to the people, imperial churches were inextricably linked with imperial authority. A church expressed simultaneously the patron's gratitude to God for his grace and the worthiness of the patron in God's eyes. Lavish and costly church decorations demonstrated to the patron's contemporaries the resources at her disposal. Church building also provided jobs and steady income for a number of skilled and unskilled workers. Juliana's Hagios Polyeuktos created jobs for at least a dozen years. If the notion of reciprocity that motivated church building was not new, church building as a statement in the discourse of power took time to develop. Only with Hagia Sophia did it become a paramount indicator of imperial power, for reasons that are partly political, partly religious. After almost losing the throne in the Nika riot (532), Justinian had to assert his divinely sanctioned political authority in the strongest terms possible. Constantinople of the sixth century was a Christian city, and its population was passionate about Christian theology to the point of rioting over it.[94] Justinian had to produce at once an ex voto to Christ and an emblem of his legitimacy. Thus he constructed the most magnificent church in the capital and the empire; it had to be more splendid than the one sponsored by a living imperial female founder.

10

THE VIRGIN MARY, CHRIST, AND THE DISCOURSE OF IMPERIAL FOUNDING

The dynamic conversation between emperors, empresses, and Christian bishops about imperial authority affected all parties. Just as the discourse of imperial founding bent to accommodate Christian beliefs, so Christian writings and art absorbed salient aspects of the imperial discourse of founding. Evolving Christian doctrine and the discourse of founding, both pagan and Christian, ultimately shaped the sixth-century iconography and attributes of the Virgin Mary. Relatively obscure in the Gospels and in the earliest Christian iconography, by the sixth century, Mary had been transformed into a resplendent Queen of Heaven. This queen was unlike any other before her, yet she recalled images and characteristics of both empresses and pagan goddesses.[1]

Two images illustrate this gradual yet dramatic transformation. One of the earliest images of Mary is on a fourth-century marble sarcophagus from the cemetery of St. Agnes in Rome (now in the Vatican Museums). It shows together the scenes of the Adoration of the Magi and Daniel in the Lions's Den (fig. 123). The Virgin Mary is dressed simply and seated on chair holding the Child Christ, who receives gifts from three men dressed in oriental attire. The Magi point to a star above the Virgin's head. This relief stands in stark contrast to the sixth-century mosaics of the Basilica of Sant'Apollinare Nuovo in Ravenna (fig. 124).[2] There, in the nave of the church, facing an enthroned Christ (fig. 125), she is the Virgin Mary as a heavenly empress. Mary wears the imperial purple; angels flank her jewel-encrusted throne; and a halo of golden light encircles her head. The facing images of Christ and Mary imply co-rulership. Other sixth-century images of Mary present comparable versions of her queenship.[3]

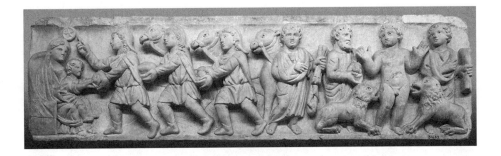

FIGURE 123
The Adoration of the Magi and Daniel in the Lion's Den, fourth century, sarcophagus from the cemetery at St. Agnes. Vatican Museums, Rome. Photo credit: Vanni Archive / Art Resource, N.Y.

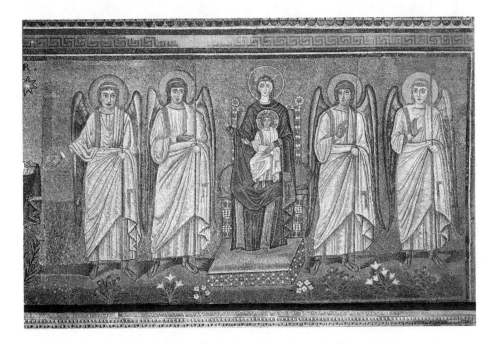

FIGURE 124
The Virgin Mary Enthroned, between angels, sixth-century nave mosaic, Sant'Apollinare Nuovo, Ravenna. Photo credit: Scala / Art Resource, N.Y.

Art historians have long recognized 431–32 as the key years of this iconographic transition. In 432 the Council of Ephesus approved the title Theotokos, or God bearer, for the Virgin by deposing its major opponent, Bishop Nestorius of Constantinople.[4] The designation Theotokos, stemming from contemporary Christological debates on the nature of Christ, became the catalyst for elevating Mary's position. The title Theotokos or God bearer had wide popular support in Constantinople and Alexandria, and was also

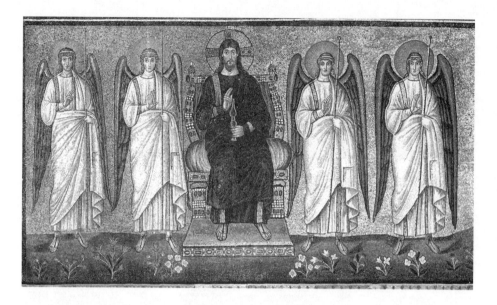

FIGURE 125

Christ sitting on a lyre throne, holding a thunderbolt, flanked by two angels on either side, sixth-century nave mosaic, Sant'Apollinare Nuovo, Ravenna. Photo credit: Cameraphoto Arte, Venice / Art Resource, N.Y.

endorsed by the empress Pulcheria, who, like Mary, was a virgin. Because Pulcheria's virginity (which she retained after her marriage to Marcian) identified her with Mary, scholarship has attributed to that association the first images of Mary that look imperial, the fifth-century mosaics in the Basilica of St. Mary Major (Santa Maria Maggiore) in Rome (fig. 126).[5]

That simple and elegant interpretation misses the point, however. Mary's iconographic metamorphosis cannot be pinned to a single empress. Nor can her beneficent qualities and motherhood be associated only with one or another goddess.[6] In the sixth century, the Virgin Mary's portrayal was shaped by Christian theology, and the pagan and Christian phases of the discourse of imperial founding.

Ambrose's funeral oration for Theodosius I provides an entry into this complex synthesis. When Ambrose made the case for Helena's piety as the foundation of Christian monarchy, he also thought it necessary to compare Helena to both Mary and Eve. He argued that "Mary was visited, so that Eve might be liberated; Helena was visited, so that the emperors might be redeemed."[7] In Ambrose's thinking, Helena was thus equivalent to Mary. Mary's conception absolved Eve's sin; Helena redeemed emperors. This parallel between three mothers—Eve, the mother of humanity; Mary, the mother of God; and Helena, the mother of Constantine—explains the final element of the Christian imperial *koinōnia:* that the discourse of founding in the pre-Christian era required a divine prototype for the empress. Ambrose rendered that traditional idea in terms acceptable to

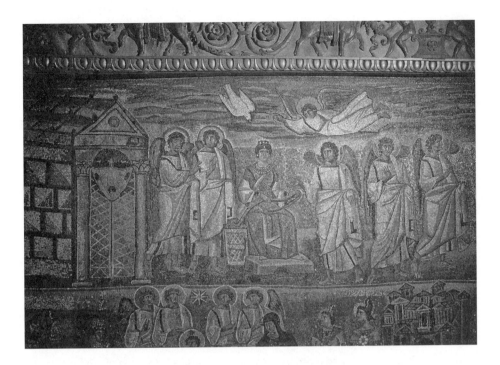

FIGURE 126

The Annunciation, mosaic on the triumphal arch, 432–40, Santa Maria Maggiore, Rome. Photo credit: Nimatallah / Art Resource, N.Y.

divine prototype

Christians. Although Mary was not a goddess—the comparison to Eve underscores her humanity—she was, according to widespread opinion, the one who gave birth to God. She alone had held the Logos in her womb. Bishops like Ambrose and Eusebius, eager to find alternatives to pagan goddesses, found in Christ's mother what they sought. They embraced her enthusiastically, and so did empresses, such as Pulcheria and other empresses.

But the stakes in Pulcheria's defense of Mary differed from those in that of the bishops. Mary's critical role in the Incarnation implicated her into redemption of the female sex, empresses in particular. Pulcheria defended the God bearer Mary because she helped legitimate Pulcheria's worldly position. Mary's relevance to earthly authority, in turn, helped construct heaven as a realm with two sovereigns—Christ the Redeemer of humanity, and Mary, his mother—parallel to the imperial earthly realm. The imaginary heavenly kingdom of a male sovereign and his female counterpart thus mirrored the earthly one. The heavenly and the earthly rulers shared such attributes as thrones, attendants, purple garments, and haloes. But the portrayal of the heavenly sovereigns omitted other trappings of earthly authority, such as scepters and globes. At the same time, the new prominence Mary acquired, from her motherhood, the epithets used to address her, and her iconography, had to negotiate with the legacy of polytheistic mother goddesses and the Roman empresses assimilated to them. Mary's image evolved in the sixth century

level of embrace reveal level of resistence?

together with the Christian discourse of founding, the development of Christian doctrine, and the legacy of paganism. Nevertheless, not all bishops or Christians found it appropriate to link Mary and the empress; nor did all agree that the Virgin had given birth to God, or that Mary was instrumental in the redemption of Eve. Indeed, so many rejected the belief that Mary was the Theotokos that two universal Church councils, the Council of Ephesus and the Council of Chalcedon, were needed to resolve this question.

MARY AND THE LEGACIES OF MOTHERHOOD

One explanation for the vigorous resistance to Mary Theotokos (apart from strictly doctrinal issues) lies in the long-standing connections between imperial mothers and pagan goddesses. Ambrose's connections between Helena and the Virgin Mary, striking as they may at first appear, were in fact easy to make. The pre-Christian tradition of the empress as a goddess-like figure and a mother of divine rulers made this link natural. Inscriptions frequently recognized the maternal role of empresses, making it part of their titles. The powerful mother-son teams of the Severan dynasty commonly did this. Julia Domna was addressed as *pia felix mater* (pious and blessed mother) and *mater Augusti* (mother of the Augustus); Julia Soaemias as *mater domini nostri* (mother of our lord); Julia Mamaea as *hierōtatē mētēr* (most hallowed mother), *mētēr tou kuriou hēmōn* (mother of our lord), *mater sanctissimi Augusti* (mother of the most sacred Augustus), and *mater domini* (mother of the lord).[8] During the reigns succeeding Constantine's the revered status of the emperor's mother continued to be acknowledged. Inscriptions addressed Helena as *genetrix domini nostri Constantini* (female progenitor of our lord Constantine), *procreatrix domini nostri Constantini* (progenitor/parent of our lord Constantine), and *mater domini nostri Constantini* (mother of our lord Constantine).[9] As late as the year 402, the ecclesiastical historian Rufinus of Aquileia described Helena as *regina orbis ac mater imperii* (queen of the world and mother of the empire).[10] The fifth-century Augusta Galla Placidia, another empress with influence like that of Helena's over her son, styled herself as mother (*mētēr*) as part of her official titles.[11] The court poet Merobaudes referred to her as *sacra parens* (sacred mother / female parent).[12]

Although it was not unusual therefore to call the empress mother of the lord or sacred mother, there was general reluctance to refer to the Virgin Mary in this way, especially in the East.[13] Such imperial epithets were employed for Mary much later.[14] The references to the Virgin as *mētēr*, or appeals to her soft, maternal side were uncommon before the Iconoclasm (726–843).[15] The term Theotokos, though doctrinally to the point, is a bit awkward in relating the idea of motherhood. The early Church writers shied away from calling Mary the Mother of God (*mētēr theou*).[16] One argument advanced to explain the reluctance concerns the priorities of theologians in the period before Iconoclasm: they strove to illuminate the Virgin's instrumental role in the incarnation and her intercessory role between humankind and her divine Child.[17] *Theotokos*, more than the appellation *mētēr*, underscores the idea of a womb.[18]

But doctrinal clarity may have been only one of the reasons for avoiding the mother-hood issue. The world of late antiquity was still saturated with the memory of various mother goddesses. For centuries Alexandria, where the epithet Theotokos had been in use long before the Council of Ephesus, had revered the nursing Isis.[19] Approximately fifty years before the Council at Ephesus, the emperor Julian, a lapsed Christian, composed a hymn to the mother of the gods (*Eis tēn mētera tōn theōn*). The emperor described Cybele as a "source" (*pēgē*) of all gods, as "the mother and the spouse" (*tekousa kai sunoikousa*) of Zeus, the "mistress" (*kuria*) of all life, and "the cause of all generation." The goddess gives painless birth, is a maiden (*parthenos*), and is a counterpart to Zeus.[20] Julian was not Christianizing Cybele, rather drawing on existing epithets for the goddess, whom Roman poets before him hailed as *genetrix deorum* (ancestress of the gods), *mater* (mother), *domina* (mistress), and *sacra parens* (holy parent).[21] Because of her virginity, her attributes, and her miraculous maternity, Mary had much, perhaps too much, in common with Greco-Roman goddesses.[22]

A telling point of convergence is the epithet *anthousa* (flowering), which suggests both the abundance of nature and human fecundity. Nature's abundance was associated with goddesses, including Venus and Ceres, traditional paradigms for empresses. In addition, Anthousa was the name of the Tyche of Constantinople, in imitation of the secret name for Rome, Flora.[23] In the *Theodosian Codex,* Constantinople is twice referred to as *florentissima urbs* (most flowering city).[24] Galla Placidia and her daughter-in-law, Licinia Eudoxia, made it part of their titles; so did Maria, the first wife of the emperor Honorius, who styled herself *domina nostra florentissima* (our most flowering lady).[25] In using such epithets, these Christian empresses evoked a number of ancient connotations concerning cities, beauty, and fecundity. The notion of a flowering Augusta can be seen as related to the ancient tradition whereby cities in the empire honored the Augusta as their patron deity.[26] Galla Placidia *domina nostra florentissima* is akin to *Sebastē Dēmētēr Karpoforos* (Augusta Demeter fruit-bearing).[27] The tradition of naming cities continued in the Christian empire: a few Christian Augustae gave their names to cities.[28] Theodora had three cities named after her.[29] The idea of fecundity communicated by the epithet *anthousa* can be found elsewhere. On the occasion of the empress Maria's marriage to Honorius at the end of the fourth century, the poet Claudian referred to Maria as a "laurel beneath the shadow of its parent tree," her mother Serena; the young laurel "gives promise of great branches and thick foliage to come." Claudian also likened the two women to two roses on one stalk.[30] The same idea of the imperial mother and her daughter as flowering plants occurs in Corippus's sixth-century poetry, in a comparison of Sophia and her daughter, Arabia, to a noble tree and its young shoot, growing a shady crown comparable to her mother's, "flourishing with shoots."[31]

The nuances of both flowering and protection in the epithet *anthousa* found their way to the Virgin. The fifth- or sixth-century Akathistos hymn described Mary's womb as bearing good fruit (*eukarpon*).[32] It acclaimed her as a flower (*anthos*), a meadow (*leimōn*), a cultivator (*geōrgos*), and a grower (*phuousa*),[33] as well as a shelter of the world

(*skepē tou kosmou*) and a shade-giving tree, protecting many.[34] The epithet *anthousa* in reference to Mary also appears in the *kontakia* (hymns) of Romanos the Melodist (d. after 555).[35] In the sixth century Mary, assuming in effect the role of a Tyche, was considered a powerful protector of Constantinople and of emperors.[36] Procopius reported that Justinian entrusted the defense of the capital to two sanctuaries of the Theotokos.[37] In an inscription, an official supplicated Mary to guard over Justinian's reign.[38] Sophia prayed to the Virgin to protect the reign of her husband.[39]

The maternal role of the Virgin thus was negotiated in conversation with two powerful legacies of motherhood, that of the mother goddesses of the pre-Christian era and that of the mothers of the divine emperors. Because the identity of the Roman empress was closely linked to female deities, it is difficult to distinguish between the two intertwined channels of influence. The result was that Mary, the major female sacred figure of Christianity, accrued the sacred and beneficent qualities of both goddesses and empresses.

THEOLOGY, GENDER, AND EMPIRE: MARY IN THE WRITINGS OF THE CHURCH FATHERS BEFORE EPHESUS

Had Christianity not become an imperial religion, the idea of the Virgin Mary as queen might not have come into existence. Mary's role in the Incarnation pulled her out of the relative obscurity assigned her by the Gospels.[40] She did not need to be imaged as queen for that role.[41] Mother, yes, but why queen? The need for a divine prototype for the empress is one part of the answer; another relates to late antique discussions of the female gender. A cultural debate about women was folded into the theological debates about the nature of Christ. Those who opposed Mary the Theotokos also accepted the notion of an unredeemed Eve that implied the sinfulness and inferiority of all women.

significance for women

In the debate on theology the main question was whether Mary had given birth to God or to a man. In the Gospel of Luke she is described as a virgin, favored by God, who would bear the *huios theou* (Son of God).[42] But both Mary's motherhood and Christ's sonhood came under fire in the early Church. From the second century to the Council of Ephesus, in 431, which affirmed the designation Theotokos for Mary, Church writers mobilized the Virgin Mary to settle debates on the nature of Christ. This elevated her visibility in Christian theology. In particular Tertullian (ca. 160–ca. 225), Clement (d. ca. 215), Origen (ca. 185–254), Athanasius (295–373), and Ephrem the Syrian (ca. 306–73) highlighted her unique status as the one who carried God in her womb.

The first Christian writer to sing Mary's praises in beautiful and memorable poetry was Ephrem the Syrian. His works were quickly translated into Greek and were mentioned among the texts considered by the Councils of Nicaea and Chalcedon.[43] Ephrem celebrated Mary as a larger-than-life figure, critical to Christ's humanity. He sang of Mary's womb as the place where God wove the garment of salvation.[44] In another hymn he compared Christ's flesh with a "little vest of the Body to Him that covereth all."[45] Mary is a towering figure, who nourishes, quenches thirst, and ensures salvation. One

of the earliest instances of Mary as the Bride of Christ also appears in the hymns of St. Ephrem. He wrote how Christ, the ornament of his mother, adorned Mary with every ornament, "For she was Thy Bride by nature."[46] The influential Syrian hymnodist also elaborated on the idea that Christ was conceived through the Virgin's ear: "Glory to the Voice which became Body, and to the Word of the High One that became Flesh!"[47] Mary's maternity thus provided proof of the full humanity of Christ. Out of her flesh Christ came as a "Son of man," and suffered human passions.[48] Her womb testified to Christ's humanity.[49]

But Mary was also instrumental in defining the divinity of Christ. St. Ephrem praises her for being uniquely blessed with the honor of conceiving and rearing the "Son of the Creator."[50] Athanasius of Alexandria argued that Christ's humanity, made manifest in Mary's womb, was also humankind's link to divinity: "Just as the Lord became a human being when he put on a body, so we human beings, once we have been connected to him by the way of the flesh, are divinized by the Logos, and from that point on we are the heirs of eternal life."[51] The Virgin Mary was the link between spirit and flesh, divinity and humanity, and she also signified the promise of humankind's link to God. In his sermon and elsewhere, Athanasius refers to Mary as the Theotokos.[52] There are earlier instances of this epithet, and by the fourth century it was in common use.[53] Fourth-century writers who use it as a common epithet include Eusebius, Gregory of Nazianzus, Basil of Caesarea, and Gregory of Nyssa.[54]

Implicit in the writings of these men is the understanding of the consubstantiality of the Father and the Son, codified by the ecumenical Council of Nicaea in 325.[55] Although affirmed as official Church doctrines, the relationship between the Father and the Son and the two natures of the Son continued to be disputed, generating movements that came to be recognized as heretical.[56] One major consequence of the Nicene Creed was that Mary officially became both the mother of man and the Mother of God (*Theotokos*, or *mētēr theou*).[57] By the mid-fifth century the Christians in Alexandria customarily called the Virgin Theotokos.[58] The import of that appellation can be summarized in the words of Gregory of Nazianzus: "If anyone does not admit the holy Mary as Theotokos, he is cut off from the Godhead."[59] Before the fourth century, Clement anticipated this logic in calling Mary the Mother of the Lord.[60] The importance of the miracle of the Incarnation, by which Mary carried in her womb the divine and the human natures of Christ, brought her a corresponding place of honor. Athanasius of Alexandria thought of Mary as incomparable in her greatness and as *panagia* (all-holy); Augustine (d. 430) considered her the holiest of creatures; and Jerome saw her as holy and the first among women.[61] Occasionally she was also described as queen (*basilissa*), and mistress (*despoina, kuria*).[62]

Nevertheless, for some Church writers, the exaltation of Mary as the Theotokos brought her too close to being divine in her own right. The all-woman sect of the Kollyridians may have celebrated Mary like a godhead, with an offering of bread, dangerously reminiscent of the Eucharist.[63] Epiphanius of Salamis (d. 403), who reported on this heresy, cautioned that although Mary's body was holy, she was not herself God, and

that although she was "worthy of honor," she was not to be adored. He admonished that "Mary should be honored, but only God should be worshipped."[64] Nestorius, the patriarch of Constantinople from 428 to 435, and the primary opponent of the title Theotokos, voiced the same warnings. He is reported to have exclaimed, "Do not make a goddess out of the Virgin!"[65] Elsewhere he cautioned that immoderate veneration of the Virgin was practiced "at the expense of God the Word."[66] The excessive attention to Mary, which Nestorius must have noticed in the capital, made him nervous precisely because Mary's position as Theotokos put her uncomfortably close to divinity—and too close, perhaps, to some very old traditions. The bishop may have realized that in venerating the Theotokos, the Constantinopolitans of the early fifth century were in danger of according divinity, in a new context, to worthy and/or powerful mortals, including empresses—as in the pagan past.[67] Mary's cultic importance could thus be viewed as seriously undermining the chief tenet of Christianity as a monotheistic religion.

For those amenable to the Theotokos Mary, her maternity had two theological consequences: it connected the divinity and the humanity of Christ, and necessary for the salvation of humankind; and it made Mary, as the bearer of God, though she was a mere woman, the source of salvation for all women who had been tainted by Eve's sin. Related typologies illuminate this gendered understanding of the Virgin's role: Christ as the New Adam, and Mary as the New Eve. The early Church fathers construed Christ as the redeemer of Adam, and Mary as the redeemer of Eve.[68] According to Irenaeus of Lyons (ca. 130–ca. 200): "Adam had to be recapitulated in Christ, so that death might be swallowed up in immortality, and Eve in Mary, so that the Virgin, having become another virgin's advocate, might destroy and abolish one virgin's disobedience by the obedience of another virgin."[69]

Tertullian thought that if the snake seduced Eve with spoken words that she heard with her ears, Mary corrected her sin by conceiving through the ear.[70] Similar ideas appear in one of Ephrem's hymns on the Nativity:

> By means of the serpent the Evil one
> Poured out his poison in the ear of Eve;
> The Good one brought low his mercy,
> And entered through Mary's ear:
> Through the gate by which death entered,
> Life also entered, putting death to death.[71]

Some Christian writers thus viewed Mary as a pivotal figure in humanity's absolution from the original sin of Eve. These same writers also considered Mary the Theotokos. The homilies of Proclus (bishop of Constantinople, 434/437–446), a defender of the Theotokos faction and Nestorius's contemporary, link Eve and Mary and state their importance for women. Proclus delivered the first of them in the Theodosian Hagia Sophia on the occasion of the Virgin's festival.[72] This newly established festival celebrated

the "pride of women and the glory of the female, thanks to the one who was at once mother and virgin." It presented an opportunity to honor all women, virgins and mothers.[73] Being a virgin mother, Mary replaced Eve's sin with hope and salvation. Proclus praised Mary's womb as humanity's liberation from death. In another homily the bishop proclaimed that "on account of Mary all women are blessed. No longer does the female stand accused, for it has produced an offspring which surpasses even the angels in glory." The full healing of Eve, in Proclus's thinking, caused all women of bad reputation (Delilah, Jezebel, and Herodias) to be "struck out of memory."[74]

Another important authority in the Church, Augustine, bishop of Hippo, confirmed the consequence of this thinking in a sermon, professing that had Christ not chosen to become a man and been born of woman "exactly as it had to happen," "women would have lost the hope of being saved": "Both sexes should recognize their own dignity, and both should confess their sins and hope to be saved."[75] Women's salvation was thus possible only because a woman had been the mother of Christ: Mary's status as Theotokos elevated the status of women in general.

Nestorius's own writings suggest that to deny Mary the designation Theotokos and to claim that she gave birth to "the instrument of the Godhead," instead of to the Godhead itself, allots women a lesser position,[76] downgrading Mary's role in the Adam-Christ typology. In the passage where Nestorius mentions the well-known comparison of Christ to Adam, he argues that Adam's debt, paid off by "a son of Adam," had its "start from a woman, and the remission had its start from a woman."[77] There's no mention of Eve's remission of sins or of Mary's giving birth to the Savior.

The theological disputes over the Virgin Mary and their intersection with late antique debates about the female gender shed light on an important episode in the evolving discourse of power: Pulcheria's ardent defense of the Theotokos. Pulcheria was motivated to act in no small part because of the threat the anti-Theotokos theological view posed to women broadly, and to her imperial dignity in particular.

The events that sparked the Theotokos controversy unfolded shortly after Nestorius became patriarch of Constantinople, in 428. As was her custom, Pulcheria arrived at Hagia Sophia to receive the Eucharist with her brother at the altar.[78] Incensed at her boldness, the new bishop barred her from entering the Holy of Holies, provoking the following exchange: "Let me enter according to my custom!" the empress demanded. The bishop retorted: "This place should only be entered by priests." The Augusta tried to argue with him: "But I have given birth to God!" Nestorius quipped: "You have given birth to Satan!" He then proceeded to remove her from the entrance to the altar.[79] Nestorius continued to anger the Augusta by discontinuing the practice of entertaining her and her ladies after communion on Sunday. Moreover, he removed her portrait from above the altar of Hagia Sophia and her robe from the table where it had served as an altar cloth.[80] The bishop thus gained a formidable enemy.

Soon after his altercation with the empress, Nestorius attacked the principle of Mary as Theotokos by proposing that she should be called *Christotokos* (Christ bearer),[81]

thereby implying that Mary's womb did not contain the uncircumscribable Word and assaulting the doctrine of the consubstantiality of the Father and the Son. Nestorius's interpretation was challenged in December 428 or 430, when Proclus, the future bishop of Constantinople and Pulcheria's ally, delivered a most passionate sermon in praise of the Theotokos.[82]

It has been argued that Pulcheria, because of her own virginity and identification with the Virgin, took Nestorius's theological position and his attitude toward her as an affront to her sacral imperial dignity.[83] The patriarch did indeed show insensitivity to Pulcheria's privileges and in later writings even questioned her virginity.[84] But it is significant that the source reporting the episode casts Pulcheria's claims to participate rightfully as her brother's equal in ceremonial privileges not so much on her authority as on having given birth to God. Of course this was not a literal claim, one based on a comparison to Mary through Mary's maternity, but it did relate the two typologically.

What was at stake for Pulcheria in her insistence on Mary as Theotokos was the dignity of the female sex, which was bound up with her own imperial honors. The concept of *koinōnia* would have been diminished, had women been deemed inferior on account of Eve's lingering sin. Hostility to Mary thus translated into hostility to the empress, for whom the Virgin was the prototype.[85] Christ was not a woman—despite all his attributes as the all-powerful, merciful, and redeeming God and Son of man—hence the unique importance for women of Mary's elevation.[86] And hence Pulcheria's odd declaration: "But I have given birth to God!" This enigmatic statement, which might seem even delusional, has been interpreted as invoking Pulcheria's mystical union with Christ and as alluding to liturgical practices in the early Church.[87] But another, more direct interpretation is possible if we consider that Pulcheria claimed, not that she had personally given birth, but that the Redeemer sprang from her sex. Nestorius had banned her from the altar and removed her garment from it because he considered her sex impure: "You have given birth to Satan!". As early as 247 Dionysius, patriarch of Alexandria, wrote that menstruating women should not come to the altar or touch the Eucharist.[88] Canon 44 from the Synod of Laodicea (343–81) forbade women to approach the altar.[89] In the context of these prohibitions, the conflict between the bishop and the empress clearly arose from Pulcheria's womanhood. She spoke not for herself, but for womankind. And when she spoke for all women, she was claiming only what some fathers of the Church had already noted as the key to all women's salvation: Mary's washing away the sin of Eve by carrying the Savior in her womb.

It is telling that the empress Pulcheria employed all her influence to see the dignity of Mary maximized, first by opposing Nestorius, and later by pushing for the Council of Chalcedon of 451.[90] These efforts affirmed Pulcheria's temporal authority by ensuring victory to the theological position most favorable to the current gendered understanding of imperial power. Both of her interventions earned her fitting imperial honors. On July 4, 431, a crowd occupied Hagia Sophia, refusing to leave it until the decision of the Council of Ephesus against Nestorius was read to them and thus enacted.[91] The sit-in crowd

denounced the bishop and demanded punishment of all those who supported him. They insisted that their requests be brought to Theodosius. The following day the gathering also acclaimed the empress Pulcheria a pillar of orthodoxy: "Many years to Pulcheria! She it is who has strengthened the faith! . . . Many years to Pulcheria! Many years to the empress! . . . She has strengthened the faith! . . . Many years to the orthodox one!"[92] The crowd thus bound Pulcheria's orthodoxy to her imperial position in acclamations resembling those reserved for honoring emperors' victories.[93]

Pulcheria's hand in convening the Council of Chalcedon again earned her acclamations, carefully recorded in its proceedings. The Augusta's role included negotiations with bishops, ensuring the peace in the city of Chalcedon (directly across the Bosphorus from Constantinople), and choosing the church where it was convened (St. Euphemia). Twice the acclamations of the assembled clerics reversed the usual order and recognized Pulcheria before her husband, Marcian: "Many years to the Augusta! Many years to the emperor!"[94] This council established as Church dogma the empress's own stand on ecclesiastical matters.[95] On October 25, the day the bishops ratified the new definition of the faith, Marcian and Pulcheria appeared together in the Church of St. Euphemia. The clerics addressed the emperor as the New Constantine and saluted the empress as the New Helena: "You have shown the faith of Helena! You have shown the zeal of Helena! Your life is the security of all! Your faith is the glory of the churches!"[96] These statements illustrate the vitality of Ambrose's ideas of Helena as the guardian of the Christian religion and a woman whose faith was a model for later generations. By honoring the emperor and the empress with the names of the founders of the Christian state, the bishops also affirmed that the Christian monarchy was ruled jointly by an emperor and an empress.

IMAGES OF THE VIRGIN MARY BEFORE AND AFTER EPHESUS

A discrepancy exists between how the Virgin Mary is presented in Christian writings up to the fifth century and how she is depicted in images from the corresponding period. The images grant her a less exalted status than the texts. These modest portrayals of the Virgin during the earlier centuries fall generally into two categories: wall paintings in the catacombs of Rome and reliefs on sarcophagi. The earliest identifiable Marian images in the catacombs have recently been seen as products of later restorations.[97] But the case is far from closed.

Take a painting from the Catacomb of Priscilla in Rome (fig. 127).[98] It represents a veiled woman seated and nursing a baby in her arms.[99] There is a man standing on the left and pointing to a star above the woman's head. There are no identifying inscriptions, and a visitor to the catacombs can easily miss the image. It is fairly small and tucked away on the ceiling of an *arcosolium*, an arched recess above a burial niche. Traditionally, this painting had been interpreted as showing Mary with the Christ Child, because of the star, pointed to by the male figure, traditionally identified as a prophet. The image of the

FIGURE 127
Mary with the Child and a prophet pointing to a
star, ca. 250, 16 (h) x 10½ (w) inches, wall
painting, Catacomb of Priscilla, Rome. Photo
credit: Scala / Art Resource, N.Y.

seated woman flanks (at a ninety degree angle) a more prominent depiction of the Good
Shepherd, carrying a sheep, and flanked by two others. Trees, possibly olives, stand on
either side of the Good Shepherd, and separate him from the seated woman. Below the
arcosolium, on one side of the burial niche are two figures with extended arms in a ges-
ture of prayer; on the other side a standing figure points in the direction of those praying.
Scholars of the images have identified at least three stages in the painting of this pro-
gram, but the final composition dates to the middle of the third century.[100] Whatever
elements were added to the image, they must be understood as a unified program.
Although the star may be a nineteenth-century restoration, the program, as it was con-
ceived of in the fourth century, clearly positioned the Good Shepherd and the seated
woman with child so that the praying figures below them are shown directing their
prayers to them. The presence of lush trees is suggestive of paradise. These elements in
the program cannot be dismissed easily or obviated by the various period hands that
copied the image centuries later.[101] The proximity to the Good Shepherd and the praying
figures still help identify this painting as a very early image of the Virgin Mary. It is in
fact one of the earliest known portraits of the Virgin Mary, completed when empresses
were still being linked to goddesses.[102] The artist depicted Mary as an ordinary woman
nursing the infant Christ.

The scene usually represented on sarcophagi is the Adoration of the Magi.[103] In its
basic elements, this image shows a woman wearing a *maphorion* seated on a high-back
chair, holding a child on her lap (fig. 123). Three men in oriental costumes (long
pants and pointed hats) approach with gifts. The woman's importance is suggested

FIGURE 128

Christ Enthroned, a star above his head, four angels behind the throne, two Magi with gifts on the right, a Magus and Joseph to the left, 432–40, mosaic on the triumphal arch, Santa Maria Maggiore, Rome. Photo credit: Nimatallah / Art Resource, N.Y.

iconographically by the high-back chair and the gift-giving Magi, but there are no markers of royalty.

The images in the Basilica of Santa Maria Maggiore in Rome are the earliest to suggest royal elements.[104] The mosaics on the church's triumphal arch show the Virgin Mary clad in gold and wearing jewels (fig. 126). This church, built and decorated by Pope Sixtus III (r. 432–40),[105] stood on the site of the ancient Temple of Juno Lucina, the goddess protecting childbirth. Pope Sixtus's dedicatory inscription offered the new building *DIGNA SALVTIFERO VENTRE TVO* (worthy of your salvation-bringing womb), *VIRGO MARIA* (O Virgin Mary).[106] The rest of the text poetically described a procession of martyrs/witnesses (*testes*) honoring the Virgin with wreaths, each bearing the instrument of his or her passion. Mary is likewise addressed as *genetrix* (mother, female ancestor), an epithet associated with Venus and applied to empresses from Livia to Helena. It had also been used for the empress Galla Placidia circa 426.[107] The inscription thus emphasizes the Virgin's fecundity, which brought salvation into the world.

The mosaics use established conventions of imperial art to highlight Mary's childbearing and her exalted position.[108] Though the identification of some figures, including Mary, is debatable, the figure of Christ (fig. 128) and the Annunciation scene are beyond

dispute (fig. 126).[109] The mosaics on the triumphal arch present Jesus four times, always as a child, thus dwelling on Christ's dependence upon Mary.

Scholars have looked to sources ranging from the Scriptures and apocryphal literature to the sermons of Pope Leo (r. 440–61) on the Incarnation to explain these images.[110] The problem with claims of specific influence, however, is that Mary's salvation-bearing fecundity and dignity, if not explicitly her royal status, appear to have been widespread ideas. It is difficult to trace them to any single source. Many of the scenes, for example, correspond to passages in the poetry of Ephrem. The mosaics show Mary shining bright in her jeweled dress as the Bride of Christ. They demonstrate Mary's aural conception and depict her spinning a thread, the symbol of Christ's flesh (fig. 126). Angels stand guard and delight in her presence, and martyrs bring her wreaths in recognition of her higher authority.[111] The mosaics therefore communicate some well-established beliefs about Mary, not those of a specific text,[112] though how they do so is original.

The Annunciation is the first scene in the mosaic, occupying the top left corner, and spatially one of the two largest in the four-tiered composition (fig. 126). It represents the Virgin wearing a golden *trabea*, a bejeweled collar, and a diadem with pearls on her head. She sits on a chair and spins a crimson thread, drawing it from a basket to her right. Two angels at the left of the composition make the gesture of speaking, and another, at right, also addresses her. Immediately next to the messenger at right stands another angel, whose slightly turned body connects the first scene compositionally to the representation of an angel addressing Joseph, Mary's husband. A sixth angel descends from heaven and hovers above the Virgin, also making the gesture of speech. Facing the hovering angel, who alone has a solid gold halo, is a white dove, symbolizing the Holy Spirit about to impregnate the spinning Mary. This first image in the mosaic program presents her as a woman of exalted rank, surrounded by heavenly attendants. It offers the key to reading the rest of the mosaics and advances a new visual language for the Virgin.

A woman in gold, identified by the Annunciation scene as Mary, appears in the triumphal arch three more times, always in association with the Child and in the presence of attendants. In the scene next to the Annunciation, on the right half of the triumphal arch, is the scene of Christ's Presentation in the Temple. In it, Mary, still shown wearing a gold dress, holds the baby in her arms, two angels trailing behind. The mosaic below the Annunciation shows the Child enthroned and flanked by the woman in gold on his proper right side and, on his left, by a woman wearing a dark purple *maphorion*, reminiscent of what would become the traditional image of Mary, over a dress of gold fabric (fig. 128).[113] Two of the Magi with their offerings are at the side of the woman in purple, but the third points at a starburst placed directly over the enthroned Child. The star and the Magi seem to belong to a different temporal moment than the woman seated on the right side of the throne. Other markers of that different moment are the four angels, and the enthroned Child. The Magi define the earlier moment as the Adoration of the Magi, which traditionally shows the Child in his mother's lap, as on the sarcophagus from the Vatican (fig. 123). But in Santa Maria Maggiore the Child sits on an impressive bejeweled throne, an attribute of the adult

Christ as a heavenly ruler (see fig. 125). It seems that the artists abandoned convention in order to use the Child as a link between two scenes, the Adoration of the Magi, and another one concerning the woman in purple. If this is correct, it is possible to interpret the woman in purple as the Virgin Mary. On the left to the Child Christ is Mary, the young bride and mother, on the right is Mary the queen of heaven, dressed in the purple, wearing red boots and a golden dress, and seated next to her Son at the court of heaven, indicated by the bejeweled throne and the four angels. The image thus straddles two temporal moments (the Adoration of the Magi and Christ's post-Resurrection glory), two locations (Bethlehem and heaven), and renders visually Mary's two roles: mother of man and mother of God.[114]

The third representation of the young royal Mary is on the right half of the arch (not illustrated). It shows the Child Christ flanked by two angels and addressing a group of men, a scene identified as the Holy Family's arrival in Egypt and Christ converting King Aphrodisius.[115] The royal woman remains a little behind, pointing with her extended right arm toward the Child, as if showing him off. An angel stands guard behind her. The ubiquitous presence of the angelic guard is an important marker of Mary's elevated status. Guards are also common in imperial presentations.[116]

The attire worn by Mary in the mosaics differs from that seen on empresses' imperial coinage in that it lacks the purple *paludamentum*. Nevertheless, Mary's clothing has a parallel in a painting unearthed during excavations at the Lateran.[117] It shows Christ, at left, towering over the emperor Valentinian III and crowning him with wreaths of flowers and leaves, and, at right, his wife, the empress Licinia Eudoxia. Both Valentinian and Eudoxia lift their arms in prayer. Like Mary, Licinia Eudoxia wears a golden-hued *trabea* and a diadem on her head. The princess Eudoxia was betrothed to Valentinian in 424; married to him in 437; and pronounced Augusta two years after her marriage, in 439.[118] The precise date of the painting in the Lateran is not known, but the image offers a clue to the event it commemorates. The wreaths Christ is about to put on the heads of the couple must indicate a blessing for their marriage.[119]

The sixth-century mosaics in Sant'Apollinare Nuovo in Ravenna offer another example of royal bridal attire.[120] Those in the nave of the church depict virgins bringing wreaths to an enthroned Virgin with the Child (figs. 129 and 124). These women also wear golden *trabeae* and jeweled diadems of the type worn by Mary in Santa Maria Maggiore. In his hymn *On Virginity*, Venantius Fortunatus (ca. 530–ca. 600) described the garment of a young virgin after her ascent to heaven and her investiture as a queen through Christ, her Groom and King.[121] The poet, educated in Ravenna, may have been inspired by the mosaics there. The virgin's appearance in his poem is not unlike that of Mary in Santa Maria Maggiore, Eudoxia in the Lateran, and the virgins in Ravenna. In Venantius's poem, the virgin becomes bride and queen simultaneously. Her dress can thus be taken to present that of Mary both as the youthful Bride of Christ and as an imperial princess.[122] The notion of Mary's royalty was further strengthened by an image in the apse of the church, now destroyed, that showed her enthroned.[123] Although the mosaics do not advance radical new understandings of Mary, they are novel as visual expressions.

FIGURE 129

SS. Justina, Felicita, Perpetua, and Vicenza, detail from procession of female saints, sixth-century nave mosaics, Sant'Apollinare Nuovo, Ravenna. Photo credit: Alfredo Dagli Orti / The Art Archive at Art Resource, N.Y.

The traditional explanation for representing Mary in Santa Maria Maggiore as a Byzantine imperial woman points to the fifth-century empress Pulcheria's affirmation of the designation Theotokos and her own personal identification with the Virgin.[124] The problem with tying one empress to the mosaics, however, is the lack of concrete evidence of the intentions of Pope Sixtus. As the local Roman example attests, the imperial-looking Virgin may have been inspired by the iconography of the western court. Mary's royalty could be affirmed in other ways, by emphasizing that she was a descendant of King David and the container for the Word.[125] According to the latter understanding, she was by default a king bearer, and thus a royal mother.

MARY AND THE CHRISTIAN EMPRESS

Mary's imperial standing in the fifth century should be understood broadly as an outcome of two parallel developments: the new visual idiom for female imperial authority that emerged following the conversion of Constantine and the disappearance of female deities,

underscoring the *koinōnia* between the male and the female sovereign, and Marian theology's effects on women, particularly its implications for the Augusta's temporal authority. In other words, the ideological developments that ultimately transformed Mary's iconography did not emerge fully formed out of Pulcheria's reign. Although Pulcheria actively defended the doctrine of the Theotokos Mary, her actions were the culmination of a long process that refashioned the iconography and understanding of female power, both earthly and divine.

Eusebius initiated this process when he felt compelled to praise Helena, prompted by her accomplishments and older notions of imperial power to pursue a more meaningful integration of imperial women into a Christian framework of power. In this, his *Life* differs from the bishop's earlier works, which do not mention Helena. Eusebius perhaps thought to reconcile Helena's public expressions of Christian piety and lofty secular prerogatives, such as her control over the imperial purse, to his male-centered explanation of the Christian imperium in the *Praise*. Given his overall religious slant, it is reasonable to assume that Eusebius would have reached for a theological explanation first. But other ideas were in play. The polytheistic imperial model would traditionally have linked the empress to mother goddesses, thereby celebrating her sacred maternity.[126] Though this connection between deities and the emperor and the empress was closed for Eusebius, he must have had it in mind when he wrote the passages on Helena, mentioned earlier: the Augusta's adoring splendidly the cave of the Nativity,[127] and her reverence for the God bearer (*Theotokos*), the mother of the "all-ruling God."[128]

Ambrose's oration, the second known parallel between Mary and an empress, includes Eve in the association between Helena and Mary. The bishop implies that Helena, like Mary, by divine intervention bore an exceptional son who atoned for the sins of all emperors. Given Ambrose's calculated public persona and his uncompromising superior attitude toward the trespasses of earthly rulers—to quote an apt scholarly assessment "he conquered three emperors in his cathedral at Milan"[129]—it is unlikely that he personally considered emperors, even Constantine, as sons of God. The bishop may have employed these typologies to imply that empresses as mothers should, like Helena, raise Christ-loving emperors, should themselves be pious, and should pay due respect to the Church.[130] But more important, he was also setting up the imperial office as a gendered entity, typologically related to Christ and Mary as a pair.

Where Eusebius hints, Ambrose proclaims, using to advantage a clearly stated typology and a biblical prophecy. Ambrose's comparison between Mary and Helena stands for the beginning of a new era. Unlike Eusebius, Ambrose was able to state this analogy so forcefully because he could rely on what was by then a dominant rhetoric of power that habitually presented women of the imperial family as co-rulers.[131] Pulcheria's statement about giving birth to God and her insistence on taking communion with her brother at the altar express this deeply held conviction of the female gender's importance in imperial authority. The Augusta Pulcheria was not reinventing the connection with the Virgin Mary. That it was already an established notion, current in imperial circles during Pulcheria's time, is proved by the sermon Peter Chrysologus (ca. 380–450) delivered

upon his consecration as bishop of Ravenna, circa 426.[132] In it he regarded the imperial pair as typologically connected to Christ and Mary. Peter claimed that the empress Galla Placidia had given birth to an "august trinity," thereby emphasizing a typological link between the Virgin and Galla, and the imperial family and the Holy Family.[133] The bishop states: "Also present is the mother of the Christian, eternal, and faithful empire herself, who, by following and imitating the blessed Church in her faith, her works of mercy, her holiness, and in her reverence for the Trinity, has been found worthy of bringing to birth, embracing, and possessing an august trinity."[134]

The reverse comparison, with the Virgin shown as an empress, was likewise common. Although the mosaics in Santa Maria Maggiore constitute the first example that has come down to us, there may have been others. By the sixth century the links between the Theotokos and the Augusta had yielded a common understanding that the Virgin Mary should be represented as a queen of heaven. It is no surprise that the Virgin's portrayals owe much to those of the empress.

An icon at the Monastery of St. Catherine on Mount Sinai (fig. 130), founded by Justinian and dedicated to the Theotokos, offers a representative example of a sixth-century Mary.[135] The figure of the Virgin, presented with her infant Son, wears neither bodily adornments nor an imperial diadem. Nonetheless, undeniable similarities in the portrayal of the earthly and heavenly queens countered the evident differences. The icon shows Mary with two military saints and two angels standing guard by her throne, like courtiers in attendance.[136] Mary's garments are dyed the imperial purple, a golden halo illuminates her face, and a hand of God envelops her with golden light just as it blesses the reigns of empresses on coinage. The seat of the Virgin is a high-back throne, seen also in imperial images (see fig. 113). Both queens have haloes of light and wear purple-hued garments (see fig. 109).

They are visually paired with a male sovereign, the emperor for the empress (see figs. 108 and 109) and Christ for the Virgin (see figs. 124 and 125). The empress and emperor appeared together in positions signifying authority, as on the coins of Leo I and Verina and those of Justin and Sophia or in the top image of consular ivory diptychs.[137] On the Chalke Gate in Constantinople, in a most public space, Justinian and Theodora were shown together celebrating a military triumph.[138] These Augusti, each with a retinue, face each other across the apse in the Basilica of San Vitale in Ravenna (see figs. 108 and 109). Christ and his mother appear similarly paired.[139] In Sant'Apollinare Nuovo, also in Ravenna, a sixth-century mosaic of the enthroned Virgin faces a mosaic of the enthroned Christ across the nave (see figs. 124 and 125).[140] Each figure is flanked by angels. A few ivory diptychs, such as the one in Berlin dated to the sixth century, are decorated with Christ on one panel and the Virgin on the other (figs. 131 and 132).

This pairing of the heavenly rulers advances visually the idea that the court on earth imitated the court in heaven, thus connecting Mary typologically to the empress, and suggests that the image of the Augustus and the Augusta as partners, which had been evolving since the fourth century, influenced the sixth-century portrayals of Mary.

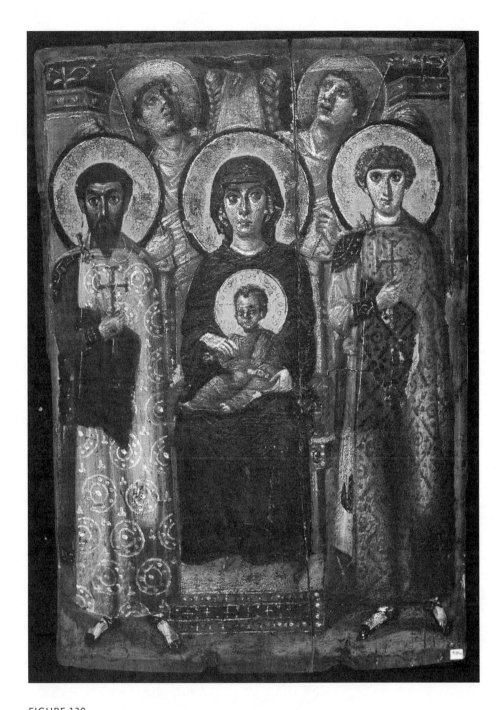

FIGURE 130
The Virgin Mary Enthroned between two male saints and angels, sixth-century icon, encaustic on wooden panel, 70 (h) x 49 (w) cm., Monastery of St. Catherine, Mount Sinai, Egypt. Photo credit: Erich Lessing / Art Resource, N.Y.

FIGURE 131

(left) Christ Enthroned, holding a book in his right hand and blessing with his left, two saints (Paul and Peter) stand next to him, carved ivory panel, sixth century, 29(h) x 13 (w) cm. Skulpturensammlung und Museum für Byzantinische Kunst, Berlin, inv. no. 564, Staatliche Museen, Berlin. Photo: Juergen Liepe. Photo credit: bpk, Berlin / Staatliche Museen / Juergen Liepe / Art Resource, N.Y.

FIGURE 132

(right) The Virgin Mary Enthroned with the Child flanked by two angels, carved ivory panel, sixth century, 29 (h) x 13 (w) cm., Skulpturensammlung und Museum für Byzantinische Kunst, Berlin, inv. no. 565, Staatliche Museen, Berlin. Photo: Juergen Liepe. Photo credit: bpk, Berlin / Staatliche Museen / Juergen Liepe / Art Resource, N.Y.

Royalty

Indeed the royalty of Mary developed more fully in the sixth century. In Church writings before 500 she is addressed only rarely as *basilissa* or *despoina*.[141] The empress, during the same period, in addition to her official title Augusta, was called *basilis, basilissa, basilēis, despoina,* and *despoina tēs oikoumenēs* (mistress of the world).[142] These appellations had corresponding male equivalents, *basileus* (king) and *despotēs tēs oikoumenēs* (lord of the world).[143] As late as the mid-sixth century the empress Sophia and her husband, Justin, were acclaimed as *hoi kratistoi despotai tēs oikoumenēs* (the most powerful lords of the world).[144] Thus the empress's queenship over the entire world remained uncontested. When the Augusta Sophia, however, supplicated the Virgin, at the accession of her husband Justin II, she addressed her as "most holy, mother of the creator of the world, queen of high heaven, at once and uniquely true mother and ever-virgin, and glory of mothers."[145] This prayer asking the Virgin to protect the rule of her husband, the empire, and the lives of the Augusti also asks the Theotokos to subdue "wild people" and usurpers.[146] The prayer and the styling of Sophia as the mistress of the world reveal that there was no competition between the two queens. Each presided over her appropriate sphere, Mary as queen of heaven, Sophia as earthly empress, and this explains why their representations differed iconographically.

Prayers to Mary as a queen of heaven closely resemble requests addressed to the Augusta as a royal person independent of the emperor. Theodoret asked Pulcheria "to show clemency to our unhappy country" and to supply a "remedy" in a case involving a deposed bishop.[147] In March 450 Pope Leo wrote to Pulcheria, asking for her assistance in upholding the title Theotokos for the Virgin Mary.[148] In a second letter to the empress, Leo claimed that the Christian faith would be safe from heresies provided that Pulcheria was present and "prepared by the Lord to defend it." He deemed the defeat of Eutyches, a powerful figure at court and in the monastic communities near Constantinople, "a second victory" of Pulcheria's, asserting that God had "bestowed [on her] a double victory and a double crown."[149]

There are correspondences in the honors due the earthly and the heavenly queens. The first major hymn of the Virgin, the Akathistos, has been regarded as exemplifying the genre of imperial panegyric,[150] because it described Mary's exalted place in language like that used to describe the place of empresses. Both the empress and the Virgin were called *sacra parens*.[151] Those who sought to convey the Augusta's beauty invoked the light of the stars and the moon as well as her sacred aura.[152] In times past the empress's sacred aura evoked such epithets as *sanctissima* (most holy) or *thea* (goddess).[153] In the Christian context it was conveyed by such adjectives as *divina* (divine), *eusebestatē/reuerentissima* (most hallowed), and *aiōnia* (perpetual, eternal), or by such attributes as a halo or a radiate crown (see figs. 109, 115, and 116).[154] Words used to describe the Virgin's sacred persona and otherworldliness included *sanctissima* (most holy), *hagia* (holy), and *panagia* (all-holy).[155] She was seen as a creature of light, implied by her brilliant halo.[156] The Akathistos hymn compared Mary to a "light-bearing torch," "a flash of light," and a "ray of the mystical sun."[157]

The mosaics at Santa Maria Maggiore maintain a careful balance between Mary and her obvious pagan and imperial counterparts. The images show Mary as a mother, but

FIGURE 133

Follis of Fausta, Ticinum, 326, bronze. Obv.: Bust of Fausta r Rev.: Spes standing l, holding a baby in each arm and nursing them. Obverse legend: *FLAV MAX FAVSTA AVG*. Reverse legend: *SPES REI PVBLICAE* (Hope of the State) *PUT* in exergue. H/AM, The George Davis Chase Collection of Roman Coins, Gift of George Davis Chase, Professor of Classics and Dean of Graduate Study at the University of Maine, 1942.176.465. *RIC* 7 Constantine 203. Imaging Department © President and Fellows of Harvard College.

somewhat detached from her child, whom she holds in her arms in only one image. The coins of the empress Fausta that compared her to Hope and Piety embracing children exemplifies the greater tenderness exhibited in representations of empresses, female deities, or empresses assimilated to female deities (figs. 133 and 134).[158] Earlier still, Faustina II as Fecundity engaged actively with her numerous offspring.[159] The mother-hood of Isis in the well-known mother-and-son pair Isis and Harpocrates is manifested in an image of her nursing. Eros, the god of love, is frequently shown gently embracing his mother, Aphrodite.[160] By contrast, the mosaics of the Virgin and Christ in Santa Maria Maggiore lack either intimacy or warmth.[161]

The imperial connotations of Mary's portrait in those mosaics are also qualified (see figs. 124 and 125). The Virgin's dress and jewels copy the attire of an empress, but her angelic guard sets Mary's authority apart from that of the earthly queen. The difference between the empress and the Virgin persists even in the so-called Maria Regina images, most of them from Rome, and dated from the sixth to the eighth century.[162] Each of the two most striking examples, a wall painting from Santa Maria Antiqua and an icon of the Virgin and Child from Trastevere, shows Mary wearing a jeweled crown. Scholars have concluded that the absence of an earthly empress in Rome encouraged such an iconog-raphy.[163] Yet, in both of these images, the angels standing guard over Mary belie any lit-eral adoption of the idiom of earthly rulership. Although artists in Rome, as elsewhere, borrowed from it, the correspondence was not exact. The Virgin Mary, in the Roman

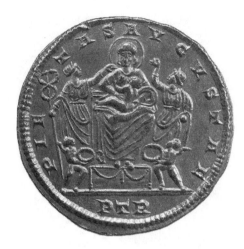

FIGURE 134

Reverse of solidus of Fausta, 324, gold coin. Obv. (not shown): Bust of Fausta, draped, wearing imperial mantle, head, with hair waved and tied back in bun. Rev.: Pietas (Piety), draped, nimbate, seated facing front on throne set on platform decorated with garlands, holding child in lap: to left, Felicitas, draped, standing front, head left, raising left hand and holding caduceus. Obverse legend: *FLAVIA MAXIMA FAVSTA AVGVSTA*. Reverse legend: *PIETAS AVGVSTAE PTR* in exergue. *RIC* 7 Constantine 443. BM, 1896,0608.100. ©The Trustees of the British Museum. All rights reserved.

icons as in the eastern examples, is emphatically the queen of heaven.[164] Most extant images of the enthroned Mary from the sixth century define the kingdom of heaven as her habitat—by the presence of an angelic guard, or abundant vegetation, or generous use of gold.[165] Mary's iconography of royalty remained different from the iconography of earthly rule, and if it varied from place to place, no early Christian images from Constantinople provide evidence of that variation.[166]

The Virgin Mary and the empress had much in common: their authority and identity were bound up with their sacred maternity. These commonalities came into being because the heavenly queen, the Theotokos Mary, became integral to the legitimation of female imperial authority in late antiquity. Two elements were fundamental: the miracle of Mary's God-bearing womb and Mary's key role in Eve's salvation. As a woman and mother, Mary offered hope that all women might be redeemed from Eve's sin. The Virgin's exalted position was essential to empresses negotiating their imperial authority in the absence of goddesses. Thanks to the enduring discourse of founding that mobilized gender in specific ways, Mary came to fill the vacant space in the divine hierarchy. From the fourth to the sixth century she acquired the traits and attributes previously attributed to female deities and to empresses. The process was gradual, its precise history difficult to ascertain.

One traceable element is the effect of Mary's maternity on the iconography of late antique empresses. Mary's salvation-bringing maternity overshadowed the maternity of the empress's in imperial art. Images of the empresses fecundity, such as those on Fausta's coins (see figs. 133 and 134), disappear from imperial coinage. Mary's image as queen of heaven, in contrast, was modeled on the royalty of the empresses. Like them, Mary was envisaged as a sacred ruler, a partner to Christ, the heavenly sovereign. The parallel between the gendered earthly and the gendered heavenly partnership is exemplified in a text describing a church in Constantinople dedicated to the Theotokos

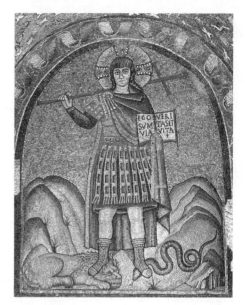

FIGURE 135

Christ dressed in a military attire and a purple chlamys fastened with an imperial fibula, trampling on a lion and a snake, and holding a cross in his right hand. Opened book in his left hand reads: *EGO SVM VERITAS ET VITA* [cross], sixth-century mosaic, Museo Arcivescovile, Ravenna. Photo credit: Scala / Art Resource, N.Y.

in which images of Constantine and Helena were paired with those of Christ and the Virgin.[167]

These conclusions about the Virgin's evolving iconography and cult have implications for scholarly investigations on the origins of early Christian art. The traditional view, argued persuasively by André Grabar and others, maintains that Christian art had been influenced by imperial art.[168] Thomas Mathews's bold challenge asserts the profound indebtedness of Christ's portrayal to the image of Jupiter/Zeus.[169] Succeeding scholarship has endeavored to fine-tune the question of influences.[170] In both schools' views, and in the challenges to them, gender—that is, the female gender (empresses, goddesses, and the Virgin Mary)—has remained at the margins of the debate. I contend that consideration of the powerful and sacred female figures of imperial Rome and early Byzantium leads to a more refined understanding of empire, religion, and art. From this perspective, Grabar's and Mathews's theses are aspects of the same idea, consistently linking the earthly and the celestial realms. An enduring discourse of founding connected the iconographies of deities to the images of rulers. This discourse outlasted paganism, though it remained profoundly indebted to its artistic, religious, and cultural traditions. It linked the emperor to Apollo or to Jupiter and to Christ, ultimately shaping the iconographic as wells as the notional similarities of all these figures and the differences between them. Thanks to this discourse, the emperor (see fig. 74) and the empress (see fig. 116) appeared with Apollo Sol's radiate crown. As late as the sixth century, Christ was shown on a church wall like Jupiter, enthroned and holding the thunderbolt (see fig. 125). Also thanks to this discourse, a mosaic in the Archiepiscopal Palace in Ravenna shows Christ wearing the emperor's military garments and trampling wild beasts, a com-

mon motif on imperial coinage (fig. 135).[171] The same discourse mandated the inclusion of women, associating the empress to ancient goddesses and to Mary, and in the process shaping Mary's iconography and cult. In other words, instead of seeing one-way iconographic connections, or connections focused on particulars, we should think of early Christian art after Constantine as linked organically to the ancient but dynamic discourse of imperial founding.

difference between Roman + Christian narratives

— one narrative vs. many narratives,

etiology: study of cause

CONCLUSION
*Sacredness, Partnership, and Founding
in the San Vitale Mosaics*

For several hundred years an enduring discourse, defined as a set of interconnected ideas that generated statements about power, shaped the presentation of imperial authority in the Mediterranean. This discourse had three major strands: founding, sacredness, and gendered partnership. From the first Augustus onward, each emperor endeavored to fashion himself as his generation's male founder, inaugurating a new golden age. These men imitated and even tried to best the first imperial founder, who had molded himself after the deified founders of the Roman tradition. The emperors' efforts to appear as saviors, protectors, benefactors to capital city and the state, in sum, as fathers of the empire, and the honors given them in return, produced a host of buildings, commemorative statues, coins, and declarations of divinity. These elements constitute the discourse of founding. Thanks in part to late-republican developments—the preexisting Hellenistic discourse of royal founding and Augustus's and Livia's own actions—the discourse about the emperor as founder/augmentor of the state linked him notionally to a female founder. That woman, whether or not she was called Augusta, styled herself and was understood by others as the sacred female founder of the current generation, a mirror image of the first female founder. Despite significant differences in the ambitions and circumstances of individual reigns, the founding myth at the center of this discourse and the ideas that shaped it changed little during the first three imperial centuries.

Constantine's founding of Constantinople, embrace of Christianity, and empowering of his mother, Helena, transformed the central etiological myth in the discourse of founding and laid the groundwork for a potent renovation of imperial presentation and

action. The new pair of founders introduced a novel understanding of the role of the female founder. Previous empresses, though exalted and godlike, possessed very little agency. The imperial women who followed Helena, however, gradually assumed the emperor's insignia of rule and some of his worldly agency in the task of renewing the empire. They shaped Constantinople's emerging urban fabric by building their palaces, baths, porticoes, and churches. The emperor and the empress thus appeared as sacred co-rulers of the empire.

Yet the terms of imperial sacredness had to be renegotiated along Christian lines. Rulers could no longer lay claim to sacredness by assimilating themselves to pagan gods, nor could they style themselves rivals to the Christian God. The portrayal of the Christian rulers, as well as Christian art more generally after Constantine, bears the marks of the complex and contested process of adapting imperial sacredness and female co-rulership to Church doctrine. Christian bishops were most eager to steer the discourse of imperial founding and sacredness toward the exaltation of the Church. They fought to obliterate the pagan legacy and suppress claims of imperial divinity. In this struggle, both the rulers' appearance and the portrayal of the Christian sacred were transformed. The Christian emperor and the Christian Augusta were eventually demoted from the divine pantheon, though they continued to appear sacred by virtue of their divinely bestowed rank, their piety, and their care for the Church.

The discourse of power that presented Roman imperial authority as akin to founding, the new capital in the East, Constantine's religious turn and empowering of his mother, the post-Constantinian changes in female imperial representation and agency, and the gradual accommodation of imperial power discourse to the Christian Church—together defined the shape of cultural production in late antiquity. They reveal the mechanism by which Hellenistic and Augustan ideas lived on into the early Middle Ages. The discourse of imperial founding endured and continued to change. It helps explain such phenomena as Charlemagne's revival of late antique architecture and art and his acclamation as a New Constantine.[1] This discourse also reveals why the Virgin Mary became the supernatural protector of Constantinople.[2] Once exalted as a queen, and therefore a partner to a male ruler, the Virgin Mary became a protector of the Christian monarchy, and assumed the responsibilities of ancient patron city deities.

The neglected continuities and changes that animate this story can be discerned only over the long term, by bridging the divide between the ancient and the early Christian eras that still structures most scholarship. And they can be apprehended only by a heterodox approach to the sources that gives no reflexive priority to the written material but rather sees it as a category of statements, among others from different sources—visual, archeological, architectural, and so forth—in a broader discourse. Considering all the evidence as part of a discourse democratizes the sources.[3] It overcomes persistent and counterproductive priorities and dichotomies that, though sometimes transcended brilliantly by historians and art historians of the late antique period, still exert tremendous influence over scholarship in art history, history, and early Christian studies.[4]

Discourse analysis opens up new perspectives on the subject's role in historical events. An excavation of the deep continuities and logic of the founding discourse over several centuries inevitably deprives individuals—even mighty and transformative individuals like Augustus or Constantine, or powerful women such as Theodora—of some of the agency they are usually accorded. To say so, however, is not to deny either historical contingency or the agency of individuals. Instead, it is to postulate that a single individual or a group cannot act outside the broader discourse or control its outcome.[5] The study of individual and subjective actions is far too narrow heuristically to explain large-scale causality and change. Lessening the significance of individual actions, or rather pinning those actions to the ideas that provoke, frame, constrain, and perpetuate them, reveals their organic connection to a discourse, thus undercutting their originality but making the legacy of those individuals far more likely to be accepted and preserved. Both the Augustan and Constantinian revolutions were characterized by striking innovations. Yet the novelties were still rooted in an existing discourse that channeled their emergence and legitimated their presentation.

Analytically limiting the protean power of individuals (emperors, for instance) has important consequences for women's history. Women, even formidable ones such as the Roman empresses, as subjects of ancient historical inquiry have traditionally fallen outside official narratives and the historical genre overall, because they neither promulgated laws, went to war, nor wrote histories. Moreover, they had little relevance to history as traditionally defined—as a study of high politics, wars, and kings.[6] Only exceptionally pious or outrageously scandalous women "made history."[7] It is difficult to see how women's history, if written from the available ancient histories, would ever have revealed anything beyond the shallow view of women as appendages to men or have offered much beyond sensationalistic stories of treachery and perversion or mind-numbing piety. In the past forty years, women's historians have taken on the challenging task of freeing women's histories from the bias with which the historical sources have encumbered them.[8] The subject of Roman and Byzantine empresses has engaged the creative energies of a score of gifted scholars, whose work has been indispensable to my own study.[9] A few have brought the Byzantine empress into the limelight, creating a small but robust bibliography on the subject.[10] Helena as a historical figure and a legend is now the subject of probing articles and monographs.[11] But none of these important works illuminate the deep continuities between early Byzantium and Rome or the centrality of founding to the conceptualization of imperial authority.

Discourse analysis can provide an antidote to the entrenched predisposition for text over art as a matter of principle as well as necessity. The two are somewhat entwined: because so much ancient art and architecture has disappeared or been destroyed, texts often remain the only evidence of lost or fragmentary objects or of buildings in ruins. Modern scholars approach written texts critically, conceiving of them as anything but transparent and unproblematic.[12] But scholars also often accept written texts as somehow truer to reality or simply more intelligible than visual evidence. Taking a different

tack and considering the varied evidence available as statements in a discourse restores the visual to a place more commensurate with its historical significance. Images, buildings, and urban development actively produced meaning that can be read in the vocabulary and syntax of each genre. They were neither subordinate to nor merely reflective of the written word.

In the discourse of founding, statuary, coins, and palaces were statements at least equal to those made in poetry, histories, and honorific inscriptions. Discourse analysis dethrones celebrated textual sources by Tacitus, Eusebius, Procopius, and others from their reflexively privileged position in scholarship. Because these storied texts, too, are products of a discourse, they cannot be used as standards by which to judge the "truth" of other statements that belonged to it. To illustrate the analytic dividends of this approach, and to underscore the enduring potency of sacredness, partnership, and founding in imperial power discourse, I conclude with one of late antiquity's most magnificent artifacts.

With the exception of Constantine's colossal statue in Rome, no portrayal of late antique Christian rulers is more famous than the imperial panels in San Vitale, Ravenna. Usually dated to 548, they show the emperor Justinian and the Augusta Theodora (figs. 136 and 137).[13] The placement, composition, and iconography indicate that the mosaics were meant as a pair, the ideas they convey discernible in the visual parallel between the two. The panels, located in the sanctuary of the church, face each other. Justinian, adorned with imperial regalia, a gleaming gold halo around his head, stands in the center of a multifigured composition that includes soldiers, courtiers, and clergy.[14] The emperor holds a golden paten in his hands. Theodora, her head surrounded by the same halo of golden light, wears the imperial purple and luxuriously wrought imperial insignia. She stands in the center of the panel with a cortege, two men at its head and a group of women, identified by their fine garments as an elite group. Theodora carries a golden chalice. Though the gift-bearing Augusti seem to be on their way to the same religious ceremony in full imperial regalia, the panels represent them in two different settings. Justinian and his attendants stand on a lush green ground and are surrounded by golden light. The iconography suggests no specific location. Theodora and her attendants, also enveloped by golden light, are located in a concrete place that has a doorway with a curtain, a fountain with bubbling water, a scalloped niche behind the empress, and a wall hanging. The mosaics both delineate a parallel between the emperor and the Augusta and render a difference between them.

The similarity and differences between these mosaics have provoked different interpretations.[15] Some specialists have seen in them the reflection of Justinian and Theodora's real-life partnership and personal circumstances. Others, focusing on the differences in the portrayal and pointing to the misogyny of Church authors, have suggested a pronounced chasm between the role of the emperor and the role of the empress. Another study has argued for the mosaics' significance in Ravennate politics, comparing the images to snapshots of

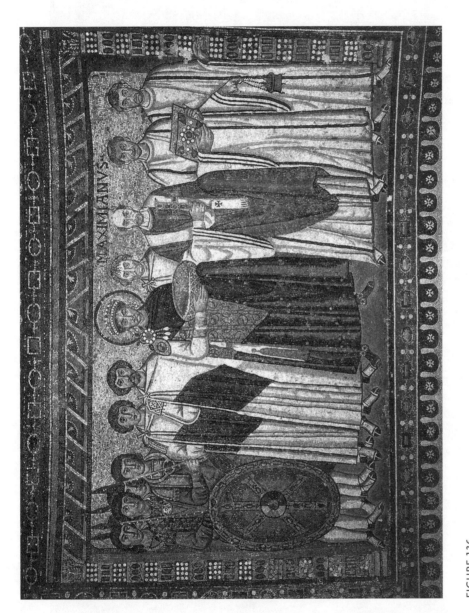

FIGURE 136

The emperor Justinian and attendants, sixth-century mosaic, north wall of the apse, San Vitale, Ravenna. Photo Credit: Alfredo Dagli Orti / Art Resource, N.Y.

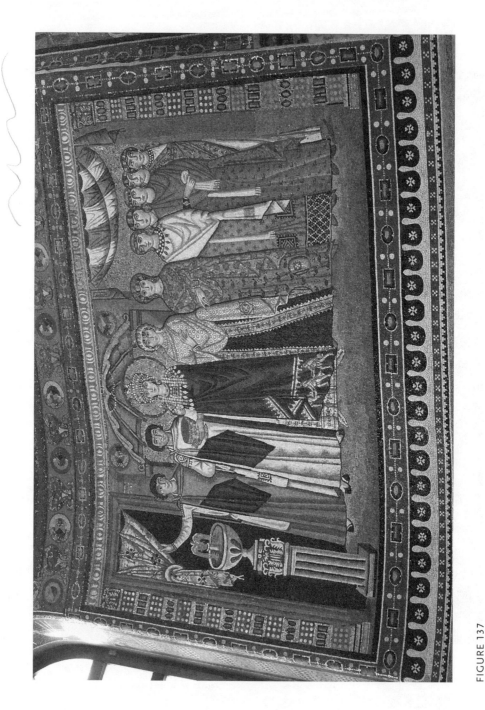

who are those
women?

FIGURE 137

The empress Theodora and attendants, south wall of the apse, sixth-century mosaic, San Vitale, Ravenna. Photo: Brian DeLay.

contemporary worthies. Still other works have discerned in the paired images an indication of the empress's vital public role. Though the images represent actual historical individuals and locations, the mosaics were not snapshots of reality.[16] Their portrayal of individuals is subordinated to ideas. In my reading, the most fundamental among them is that Justinian and Theodora were sacred imperial partners and founders, cast in the mold of Constantine and Helena and worthy custodians of their legacy.

Sacredness may be the most obvious of the three themes. The imperial haloes, the golden backgrounds, and the composition of each portrayal draw attention to the Augusti's sacred status. Except for Christ, St. Vitale, and two angels, Justinian and Theodora are the only figures shown in the sanctuary with haloes of golden light. Those haloes, each outlined in red, set them apart from and above the clergy and the other attendants, their sacredness equal to that of St. Vitale and the angels and surpassed only by that of Christ, whose halo is inscribed with a cross and studded with pearls and jewels. The label above Maximianus's head is almost certainly a later effort to mitigate the unapologetic priority given the imperial couple.[17] But mere inscriptions did nothing to dim the luster of the haloes.[18] Bishops and others contested imperial claims to sacredness, but haloes, the notional relatives of the radiate crown pioneered for Divus Augustus, nonetheless persevered as one of the most enduring signs of imperial standing.

The idea of imperial sacredness is also rendered by clever play with represented and actual space. At either side of the two panels a column studded with colorful jewels is represented. Similar columns are seen in the spaces between the two windows in the presbytery. The mosaic artists employed these bejeweled columns not simply as decorative elements but as features of an actual place that the two parties are about to enter.[19] Because the deacon in Justinian's party extends his hand over the column, as if he were about to pass it and go into that space, the viewer perceives the column as marking an entry into an actual room. Bejeweled columns like those shown framing the imperial parties were found in the archeological excavations at the Church of the Hagios Polyeuktos, and one such column can be seen in an old photograph of the sanctuary of Hagia Euphemia in Constantinople (fig. 138). These columns indicate that both the emperor and the empress are bringing their gifts to the sanctuary area. The images thus present a spatial conundrum, because the parties cannot be about to enter the sanctuary and be there at the same time. This spatial impossibility indicates something about the imperial persons that I think speaks to their rank vis-à-vis the clergy. The haloes suggest that whether the Augusti were outside the sanctuary (as shown on the panels) or inside (as indicated by the placement of the panels), the emperor and the empress are still more sacred and exalted than the clergy.

The textual sources, in sharp contrast, give a deliberately impoverished sense of Justinian and Theodora's sacredness. Take as an example the *Life of St. Sabas,* written by Cyril of Scythopolis (ca. 525–59/69?) in which Cyril relates the visit of St. Sabas to the emperor Justinian, circa 530, as an emissary of the Church of Jerusalem. The description of the meeting between them reverses the priority given the imperial couple over the

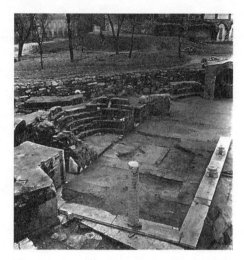

FIGURE 138

Remains of the sanctuary, Church of the Hagia
Euphemia, Istanbul. Photo credit: Nicholas V.
Artamonoff, November 1945. Nicholas V.
Artamonoff Collection, Image Collections and
Fieldwork Archives, Dumbarton Oaks Research
Library and Collection, negative number RA 457.

members of the Church in the San Vitale panels. According to Cyril, when Sabas entered
the reception hall, the emperor was struck by the beams of light emanating like a solar
crown from the holy man's head. In complete disregard of imperial protocol, the emperor
ran up to Sabas and greeted him with *proskunēsis,* the self-debasing greeting that was
reserved for the imperial couple, Christ, Mary, and the saints. Cyril describes Theodora's
reaction in much the same way, insisting she welcomed Sabas with *proskunēsis.*[20] The
empress implored Sabas to pray for her, for she was hoping that the holy man's blessing
would help her conceive a child. He refused her entreaty, insisting that the matter lay in
God's hands. The slight drew no rebuke. On the contrary, the imperial couple showered
the old man with generous gifts: tax remissions, money for a hospital and the restoration
of churches, funds to complete the Nea Church in Jerusalem (dedicated to Mary the
Theotokos), and provision for an architect to help with the complex engineering work.

The whole account strains credulity: that the imperial couple would publicly debase
themselves before provincial clergy; that a supplicant like Sabas would publicly refuse his
empress such a routine kindness; and that he would get everything he came for and more
despite it all. Far more likely Sabas followed protocol diligently, acknowledged the emper-
or's unique status, and blessed the empress effusively. In Procopian fashion, Cyril nar-
rated the meeting to express his own resentment that the imperial couple routinely
received honors reserved for Christianity's holy figures, as well as his disapproval of
Theodora's Monophysitism.

Partnership is as important to the message of the mosaics as sacredness. The place-
ment of the panels, facing each other, and the imperial attributes convey the imperial
partnership of Justinian and Theodora. The Augusti wear corresponding imperial insig-
nia: purple *paludamenta* and bejeweled diadems (though Justinian's is a restoration);
both are in the company of attendants; both stand on a lush green ground and are

surrounded by golden light.[21] The different backgrounds allude to the terms of their ✓✓
partnership.

The emperor, shown at the head of the clergy, the army, and three imperial officials, emerges as a spiritual, military, and administrative leader (fig. 136). Theodora's role yields less readily to interpretation, partly because it is impossible to identify with certainty the references in the images to places (fig. 137). Still, much in the mosaic speaks to Theodora's partnership with the emperor in administering the empire. She is the tallest member of her party even though in real life she was petite; as the reigning Augusta, she towers over everyone else. The image defines her prerogatives in the space represented and in the individuals who accompany her. Like the emperor, Theodora is in two places at the same time. She enters the sanctuary but is simultaneously somewhere else, at a location with a curtain, a fountain, a scalloped niche that frames her figure, and a wall hanging. Some scholars have interpreted the fountain as indicating the atrium of a church.[22] The niche, a regular feature of imperial iconography, has been seen as a way to separate the empress as an aberration—as a woman (and therefore inferior) yet one who wielded power. But, together with the curtain the niche, points to a specific location, most likely, as suggested recently, Theodora's reception hall in the palace.[23] Fountains were found in the atria of many aristocratic Roman houses, and in the imperial palaces. Theodora, like the empresses in the sixth-century ivories discussed in chapter 7 (figs. 110 and 113), stands in full imperial regalia before the throne where she would have sat during audiences, such as the one with St. Sabas. The hanging curtain has been seen as a sign of domesticity, an emblem of Theodora's confinement to the women's quarters.[24] I believe that it identifies the Great Palace in Constantinople as Theodora's location, but does so to underscore her rank rather than her "confinement."[25] To explain that Sabas had entered the palace in Constantinople, Cyril uses the phrase "within the curtain."[26] Theodora, according to his expression, is thus inside the palace, in her own audience hall, standing in front of her throne, which is obscured by her party.

The paired mosaic panels therefore imply that while Justinian leads the army, oversees the administration of the empire, and handles the affairs of the church, Theodora, because she is Augusta, is his partner in the administration of the empire, a task conducted from the palace, and one that often began with petitions made at imperial audiences. Notice that despite the markers of location, the golden light emanating from Theodora's halo extends over the entire party, interrupted only by the niche with her throne. She leads the empress's court.[27] Procopius explains that Theodora held her own audiences. She received magistrates, summoned high-ranking army officers, met with foreign ambassadors, and sent them follow-up letters, urging them to negotiate peace.[28] The two men who accompany Theodora allude to these activities. As has been argued on iconographic and historical grounds, these courtiers are not nameless eunuchs, rather they are high-ranking officials, like those who accompany Justinian.[29] The male courtiers in Justinian's party and in Theodora's wear the same dress: a light-colored chlamys with a purple (rendered dark brown in the

mosaics) patch, a *tablion*, sewn to the front. The precisely defined ages of the individuals (two older men, and one younger man in Justinian's panel, and an older and a younger man in Theodora's) and their distinct physiognomies suggest that the figures in both panels represent real members of an elite class, entrusted with the administration of the empire and serving the emperor and the empress. Inscriptions from churches and fortifications confirm the perception of partnership between the emperor and the empress by hailing Justinian and Theodora together as a pair, as "our Augusti."[30] Such dual acclamations continued the traditional gendered understanding of imperial authority that stretched back to Augustus and Livia and was reinvigorated by Constantine and Helena.

The theme of partnership, so evident in the mosaics, connects organically to the third and final theme, founding. At San Vitale, the creators of the mosaics celebrated the imperial couple's deserved reputation as church founders. The gold paten and the chalice symbolize that generosity.[31] These gifts are not actual objects that the Augusti brought to Ravenna but stand for imperial largesse to Christ, who is shown in the conch of the apse just above them (fig. 139). The trailblazing pattern in imperial Christian giving went back to Constantine and Helena. By the sixth century, Christian Augustae had established themselves as energetic church builders. Justinian and Theodora seem exceptional in the number of churches they constructed together.[32] But their patronage follows an established tradition that includes aspirations to best the original Christian founders of churches.[33]

This tradition comes into view with Justinian's patronage of the Holy Land, something we know of mostly from Procopius and Cyril of Scythopolis, two useful but faulty sources. Procopius gives an inaccurate account of Justinian's patronage because he skips some parts of it.[34] He also refers selectively to Theodora's partnering with Justinian in some construction projects in Constantinople but, as noted earlier, omitted the most important ones, the Hagia Sophia, Hagia Eirene, and SS. Sergius and Bacchus.[35] Neither author mentions Theodora as a co-patron, with Justinian, of the emperor's massive undertakings in Jerusalem and Bethlehem.

Limitations notwithstanding, the written sources describe Justinian's buildings in enough detail to reveal a program with striking allusions to the one followed by Constantine and Helena. In the Holy Land Justinian patronized buildings associated with the first Christian Augusta and Augustus, such as the Church of the Holy Sepulcher. The emperor also restored and expanded the Church of the Nativity in Bethlehem.[36] After the expansion, the building measured 115 meters by 75 meters. Because of its size, it required unusually tall cedars for its roofing, and the area around it was scoured for them.[37] Justinian also left his mark in Jerusalem by constructing a remarkable new church, the Nea. It was destroyed in the early seventh century. The location remained unknown until the 1970s, but it was a massive edifice and a triumph of ancient engineering.[38] The mosaic of Madaba shows how the *cardo*, the central street in Jerusalem, connected the Nea with the Holy Sepulcher (fig. 140).[39] The church was the first in the city dedicated to the Theotokos. It thus can be taken as augmenting the work of the original

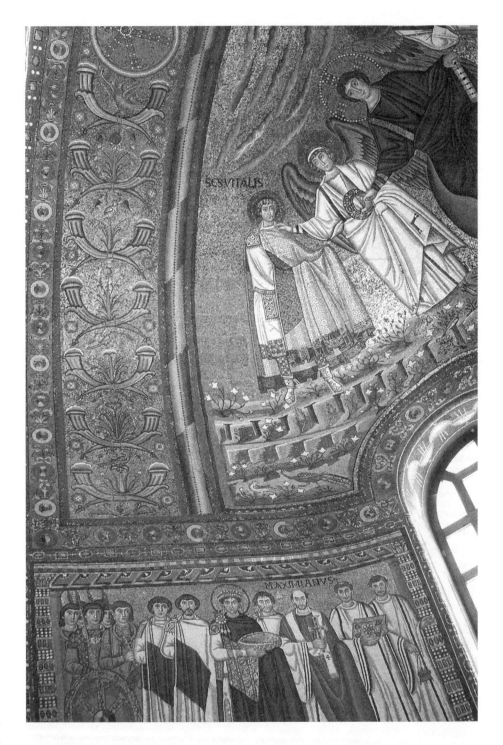

FIGURE 139

Christ Cosmocrator presenting a wreath to St. Vitalis; a design of stacked crossed cornucopias; below: Justinian's court, sixth-century apse mosaic, San Vitale, Ravenna. Photo: Brian DeLay.

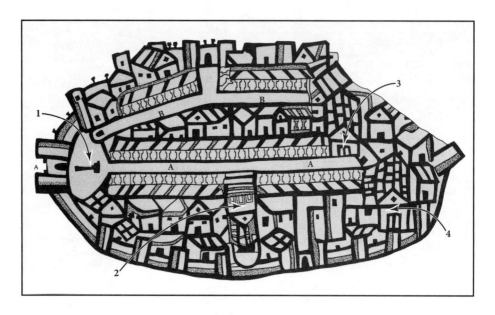

FIGURE 140

Jerusalem in late antiquity, drawing after the Madaba map. A: Cardo Maximus; B: Eastern branch of the Cardo Maximus; 1: Damascus Gate plaza; 2: Church of the Holy Sepulcher; 3: Nea Ecclesia (New Church); 4: Hagia Sion. ©Ancient World Mapping Center.

founder, Justinian's answer to Constantine's Holy Sepulcher. The spatial and notional links between the Nea and the Holy Sepulcher, along with the emperor's patronage of other churches started by the first Christian founders, present Justinian as the New Constantine and Theodora, by association, as the New Helena. *more than real*

Links between the original founders and the new ones emerge with greater clarity elsewhere, in churches where archaeological remains attest to Theodora's co-sponsorship. According to Ambrose's narrative of the founding of the Christian empire, Helena, together with Constantine, made the empire Christian and built churches to glorify God. Fifth-century sources name Helena together with Constantine as the founders and co-founders of the churches in the Holy Land. Thus any joint commissions of the Augusti who followed always evoked the original founders. The interior decoration of Hagia Sophia made a powerful statement about Theodora as a joint patron. The capitals in the Church of the Hagia Eirene, a building that some sources attribute to Constantine, made similar claims.[40] Nothing survives of the Church of the Holy Apostles, so we cannot know if its column capitals were decorated with Justinian's and Theodora's monograms. But according to Procopius, the Church of St. John the Theologian at Ephesus resembled the Holy Apostles in all aspects.[41] Epigraphic evidence reveals that Justinian and Theodora dedicated the Ephesian church jointly, which may also have been the case with the Church of the Holy Apostles in Constantinople.[42] Moreover, Justinian's Holy Apostles, attached to Constantine's original

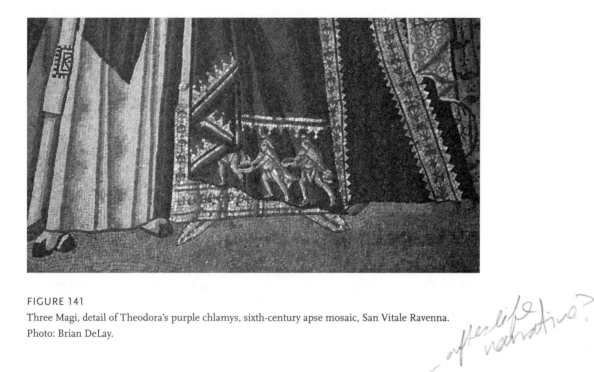

FIGURE 141
Three Magi, detail of Theodora's purple chlamys, sixth-century apse mosaic, San Vitale Ravenna.
Photo: Brian DeLay.

afterlife narrative?

mausoleum, also contained a new cruciform mausoleum for Justinian and Theodora, whose structure, like that of Constantine's mausoleum, featured an altar.[43] Thus as with Augustus and Constantine before him, Justinian laid claim to founding by constructing a new imperial mausoleum.

Justinian's ambition to associate himself with the original founders can also be detected in his restoration of Helenopolis.[44] Procopius reports that the emperor was particularly generous to the city, because it had fallen on hard times, restoring an old bath and constructing a new one, and building an aqueduct that addressed a chronic water shortage, a palace, lodgings for magistrates, and porticoes. He also erected two bridges outside the city and ordered complex engineering works that included shaving off hilltops to ensure the safe passage of travelers and to alleviate danger from flooding. Procopius concludes that he made Helenopolis a prosperous city once again.[45] The reason for such lavish building projects, including an imperial palace, must be sought in the city's enduring link to Helena, the exemplary imperial founder.

The mosaics in Ravenna also claim, subtly, that the Augusti undertook their partnership in pious giving in the manner of Constantine and Helena. The massive monogram of Christ, the Chi Rho, inscribed on the shield that is held in front of the soldiers, refers to Constantine (see fig. 136). It alludes to his putting the monogram of Christ on his military standards, on the weapons of his soldiers, and, as early as 315, on a silver medallion attached to his own helmet.[46] The image of the Three Kings embroidered on Theodora's *paludamentum* refers subtly to Helena, the first imperial pilgrim and patron of the

sacred places of Christian history (fig. 141). Helena's visit, as well as her largesse in the Holy Land, was comparable to the pilgrimage of the Magi to see the baby Jesus. Like the Three Kings, Theodora seems to bring a gift to the Cosmocrator (the Ruler of the Universe), shown in the conch of the apse (see fig. 139). Although Theodora did not visit the Holy Land, casting her as one of the kings alludes to gift giving there. The sixth-century historian Malalas reports that the empress sent to Jerusalem an expensive cross, set with pearls.[47] The Nea Church to the Theotokos in Jerusalem was dedicated in 543, five years before San Vitale, and the mosaics there may refer not just to imperial largesse to God, but to imperial magnanimity in the Holy Land. If so, they imply that the empress co-sponsored it.

The mosaics' assertion of imperial sacredness and imperial partnership ultimately brings into view an act of founding far greater than the construction and sustenance of churches: the founding of a new golden age. On earth, the sovereigns' divinely blessed rule ensures the dawning of a new age of abundance, as indicated by the golden background, the lush green ground under their feet, as well as the flowers and plants decorating the dresses of the women in Theodora's party.

This new golden age stands no comparison, however, to the coming of the Savior, who, like the imperial couple, brings promises of a golden era. The youthful Christ Cosmocrator sits on a blue orb above the imperial panels.[48] With his right hand he holds out a wreath to the Vitalis; in his left hand is a scroll. Two angels flank him. At far right is a bishop, Ecclesius, identified by an inscription, who gives a model of the church to Christ. The arch of the apse is decorated with a band of intersecting cornucopia that converge on a Chi Rho at the apex (see fig. 139). The entire presbytery conjures a dazzling vision of paradise in its decorative program. Its walls and vaults explode with lush green vegetation, vine scrolls, gold, precious gems, and cornucopia. The opulence of this heavenly vision brooks no competition. The imperial promise of a new earthly age of gold is decidedly more modest than the rewards the Savior ensured by his coming.[49]

This contrast between the heavenly ruler and his earthly counterparts thus promotes a particular hierarchy. The decorative program of the presbytery makes a statement that can be contrasted with Eusebius's prescriptive statement about the emperor as a slave of God. At the top of this hierarchy in San Vitale is Christ, who chooses the leaders of the Christian empire. The sacredness of the Augusti places them above ordinary mortals, especially the clergy, as divinely chosen rulers who imitate the universal sovereign. Together the secular rulers give thanks for their rank by endowing the church with lavish gifts. The prerogatives of the earthly rulers are separate from those of the heavenly sovereign, indicating the earthly ones' complete control over their domain. Bishops have a prestigious place in the earthly hierarchy, but their authority yields to that of the emperor.

That the bishops' rewards are mostly spiritual is suggested in the scene of the conch, which is located in paradise. The inclusion of the bishop in this scene suggests that leaders of the Church such as Ecclesius and martyrs such as St. Vitalis would receive their rewards from the universal ruler, but these would not be earthly rewards. Thus the

bishop's position, though seemingly more privileged than that of the imperial couple, is *hmm...* again set lower than imperial rank, with visions of the paradise that awaits him, one might add, as a consolation. There's no competition with the paradise that the heavenly ruler offers or with his authority, because despite the shared attributes of the heavenly ruler and his earthly counterparts, such as the purple color and the golden light, the two realms are clearly demarcated.

Weave through the crowds into the interior of San Vitale, and gaze up at the dazzling figures on the sanctuary's north and south walls. The imperial couple staring back shimmer with the cool brilliance of emerald green, opulent gold, and azure blue. Resplendent, imperial, and serene, Justinian and Theodora command our attention. But tear your gaze away and in the background you can just glimpse other, older figures in the couple's train; figures that may look at first dissimilar, but ones that put them in context. In Justinian's gift-giving, sacred aura, and the promise of the new age he inaugurates, one discerns his immediate predecessors and especially the specter of the first Christian imperial founder, Constantine. Arrayed behind Constantine is the proud line of Roman emperors going back to the first sacred imperial founder, Augustus. Behind mighty Augustus is a long line of Hellenistic kings, many of them living gods, founders of cities and renowned benefactors. Alexander stands prominently in the far distance, the divinized okists of Mediterranean cities behind him, and towering at the end of the line are the Olympian gods, but especially Apollo, the original god of founders. Theodora – vested in imperial authority, proud and startling with the divine light of her halo and confident in her giving, is likewise properly viewed as a late avatar in a deep lineage of female founders. Her immediate Christian predecessors stretch into the distance, all of them darkened by the long shadow of Helena, the first Christian female founder. Behind Helena stand the divine Augustae back to Livia, the first godlike Augusta. Then come the Hellenistic queens, Amastris, Arsinoë, and other founders of cities and bringers of blessings of all kinds. Finally, our line of sight ends with the majestic goddesses, especially Athena and Venus.

The women, men, and gods in this imperial procession often look very different from one another. Theodora at San Vitale is hardly a second Arsinoë or a new Venus. But what bound them, what bound all these hundreds of remarkable men and women, gods and goddesses, was a gendered discourse of power that conceptualized and explained apex political authority through the idiom of founding. Like their illustrious predecessors going back many centuries, then, Theodora and Justinian were first and foremost sacred founders.

NOTES

INTRODUCTION

1. The main sources for the statues in Constantinople are the writings assembled in T. Preger, *Scriptores originum Constantinopolitanarum* (Leipzig: Teubner, 1901, 1907). One of these important texts, the *Parastaseis syntomoi chronikai,* has been translated into English and published with a very useful commentary by Averil Cameron and Judith Herrin. For the ubiquity of imperial statues, see summary in Cameron and Herrin 1984, 48–51. Mosaics with Justinian and Theodora on the Chalke Gate: Procopius, *De aedificiis* (On Buildings) 1.10.13–18. For Procopius's writings I use the Loeb edition and translation by Dewing. Tapestries: Paul the Silentiary, *Descriptio S. Sophiae* (Description of S. Sophia), trans. in Mango 1986, 89. For the diffusion of the images of the late antique empresses, see McClanan 2002, 29–64. On monumental images and "depicting the public body" of the empress, see James 2001, 26–45 and 133–45.

2. Cameron and Herrin 1984.

3. Constantine's statues: Cameron and Herrin 1984, 7, 11, 15, 34, 43, 44a, 52, 53, 56, 57, 58, 60, 68, 68a.

4. Statues of Helena: Cameron and Herrin 1984, ch. 11 (three removed from Hagia Sophia, one of porphyry, one of bronze with silver inlay, and one of ivory).

5. Augustaion: Patria, 1.44, 2.15; Malalas, 321. On the same dedication, see also, *Chronicon Paschale* (Paschal Chronicle), pp. 528–29.

6. Statues of Constantine and Helena: Cameron and Herrin 1984, ch. 16 (in the forum), pp. 78–79; ch. 34 (on the roof of the Milion), pp. 94–95; ch. 43 (of Constantine, Fausta, and Helena), pp. 118–21; ch. 52 (at the Forum Bovis, set by Constantine, both of them

holding a cross), pp. 26–27; ch. 53 (in the Church of the Theotokos, Constantine and Helena and Christ and the Virgin Mary), pp. 28–29; ch. 58 (Philadelphion square, Constantine and Helena seated on thrones with the Constantine's sons), pp. 34–35.

7. For the legend, esp. J. W. Drijvers 1992; Heid 1989, 41–71; Consolino 1985, 161–80. Doubts raised in Borgehammar 1991; Drake 1985a, 1–22. For instance, the later *vitae* of Constantine. See Winkelmann 1987, 623–38.

8. *De obitu Theodosii*, in O. Faller 1955. This oration is discussed in chapter 1 and chapter 8.

9. Sordi 1990, 1–9; J. W. Drijvers 1992, 181–83. For other political dimensions, see also, Angelova 2004, 8–9; 2005, 104–5.

10. The earliest attested source in the East is the tenth-century manuscript of the *Synax-arion of Constantinople*, where Constantine's and Helena's saint's day is given as May 21. The Eastern *vitae* of Constantine and Helena, dated to the eight–ninth centuries, are based on earlier narratives. See Lieu 2007, 304–8.

11. Magdalino 1994, 3–4 (between the seventh and the tenth centuries, Constantine came into his own as a figure of hagiography); Lieu 2007, 305.

12. See the introduction to the volume *New Constantines* in Magdalino 1994, 1–10.

13. Whitby 1994, 83–93. Whitby collects the evidence and proposes that religious standing was one way in which Constantine inspired emulation. He dates the emergence of Constantine as a role model to until after the restoration of the True Cross to Jerusalem in 629. See also Kazhdan 1987, 196–250.

14. With the possible exception of the image in the Church of the Theotokos. But, again, images of emperors and empresses in churches do not imply sainthood. For example, such are the images of Justinian and Theodora in San Vitale, Ravenna, and the now nonextant image of Verina in the Blachernai church. On it see, Cod. Paris. Gr. 1447, fols. 257–58, trans. Mango 1986, 34–35.

15. Constantine is sometimes called "the Great," Helena is just referred to by name. See, Cameron and Herrin 1984, 1, 7, 16, 24, 34. In the commentary, Averil Cameron and Judith Herrin attribute the heightened interest in Constantine following the publication of his *vita* (Cameron and Herrin 1984, 256).

16. Women's historians and art historians have been more attentive to Helena, both as a historical figure and a paradigm for late antique empresses, especially in matters of religious patronage. An important article persuasively argues that the social memory of Helena's piety lived on through public monuments. But the author concludes that "Helena's commissions" and did not last past the fifth century. See Brubaker 1997, 52–75, 64 (for the dating of the influence).

17. *ACO*, 2.1.2, p. 155.

18. Cameron and Herrin 1984, ch. 29, pp. 92–93.

19. The acclamation is: "O, you Justin Augustus, you conquer; many years to the New Constantine!" Constantine Porphyrogenitus, *De cerimoniis* (On the Ceremonies) 1.93, in Reiske 1829, 430.

20. Cameron and Herrin 1984, 81. With commentary on p. 272.

21. See George 1995, 65, 114.

22. The evidence for this is from John of Ephesus, *The Ecclesiastical History*, 3.5 and 3.10 (Tiberius) and 3.9 (Ino). The translation from the Syriac is available at the Tertullian

Project: www.tertullian.org/fathers/ephesus_3_book3.htm (accessed November 14, 2013).

23. Augustus: Vell. Pat., *Hist.* 2.60.1. "Fundator quietis" comes from the Arch of Constantine. See Henzen et al. 1876, 36. This reference is now online at the Arachne website: http://arachne.uni-koeln.de/Tei-Viewer/cgi-bin/teiviewer.php?scan = BOOK-883682–0348_580772 (accessed April 5, 2012). For references on the arch, see below.

24. Højte 2005, 170.

25. See Scott 1986, 1052–75, esp. 1058–59, 1063–69.

26. On the bishops' role in the process, see in particular, Drake 2000, 30–33 and 72–110.

27. Along with statements, the term discourse, in Foucault's definition, also implies the "regulated practice that accounts for a certain number of statements." Foucault 1972, 80. A discourse thus encompasses not only statements, but the conditions that define them and determine how they are used. A discourse is a "body of anonymous, historical rules, always determined in the time and space that have defined a given period, and for a given social, economic, geographical, or linguistic area, the conditions of operation of the enunciative function (that which propels statements into existence)." Foucault 1972, 117.

CHAPTER 1. FOUNDING, POWER, AND AUTHORITY

1. *De obitu Theodosii.* The date is February 25, 395. On the date see Deferrari 1953, 303. Trans. Deferrari 1953, 307–32, and Liebeschuetz 2005, 174–203 (with commentary). For analysis of the oration's genre, see Biermann 1995, 50, 83–86, 103–19. See also, Lunn-Rockliffe 2008, 191–207. Editions and translations of works cited are listed in the bibliography of primary cources. For works before Constantine, I have mostly relied on the Loeb Classical Library, found at the Loeb Classical Library website (www.loebclassics.com) and at the Edonnelly website (www.edonnelly.com/); the Perseus Digital Library (www.perseus.tufts.edu/); and the Lacus Curtius website (http://penelope.uchicago.edu/Thayer/E/Roman/home.htm). The textual sources after Constantine are available most readily at the online Thesaurus Linguae Graecae (TLG), a Digital Library of Greek Literature (www.tlg.uci.edu/) and at the Library of Latin Texts from Brepols (CETEDOC; http://apps.brepolis.net/). Some editions are now also available digitally from the Hathi Trust Digital Library (www.hathitrust.org/). Translations of the Church fathers in English are available at the Christian Classics Ethereal Library (www.ccel.org/fathers.html), the New Advent website (www.newadvent.org/fathers/), and the Tertullian project (www.tertullian.org/). For names, I have followed overall the Latin conventions in the transliteration of personal pronouns. But I have relaxed this convention for both the Greek and Latin place names for locations in Constantinople. Generally, abbreviations or names and works of ancient authors follow the *Oxford Classical Dictionary* (*OCD*). Dates, unless indicated otherwise, are taken from the *OCD*, the ODB, and the *Oxford Dictionary of the Christian Church.*

2. On the development of the legend of Helena's finding of the True Cross, see Drijvers 1992, 95–117, 123–24 (on Ambrose's possible sources), 140–42 (on the reason for choosing Helena as the one who found the cross). While Drijvers holds the prevalent scholarly

opinion, the dissenting view argues that Helena found the True Cross, see Borgehammar 1991. There are a number of scholars, who have studied Eusebius's silence concerning the cross relic, starting with the pioneering study by Harold Drake: Drake 1985a, 1–22. Others include: Hunt 1997, 405–24; Rubin 1982, 79–105.

3. Ambrose, *De obitu Theodosii* 42, trans. Deferrari 1953, 326. Compare with the translation by Liebeschuetz, 198.

4. Ibid., 47, trans. Deferrari 1953, 328, 330.

5. See commentary in Drijvers 1992, 110–11; Liebeschuetz 2005, 199–200.

6. Claudian, *Epithalamium de nuptiis Honorii Augusti* (Epithalamium of Honorius and Maria), 10.13, trans. Platnauer, 242–43.

7. For Romulus and Augustus, a representative example is the episode of the twelve vultures. Augustus saw the birds when he was elected to the consulship; see Suetonius, *Augustus* 95. See also Scott 1925, 82–105; Zanker 1988, 202–7 (Romulus becomes a paradigm for *virtus,* Aeneas for *pietas*); L. R. Taylor 1975, 42–43, 158–59; Wissowa 1971, 155; Beard et al. 1998, 1:182. For Romulus as paradigm, see also Rex 2007, 435–71; Cole 2006, 531–48. For Aeneas and Augustus, the key example is the *Aeneid.* For Augustus's connections to Romulus and Aeneas in the decoration of Augustus's forum, see below and Richardson 1992, s.v. "Forum Augustum or Augusti," 160–62; Steinby 1993–2000, 2:s.v. "Forum Augustum," 293.

8. Tlos (Düver), BAtlas 65 B4 Tlos. See front page map for the location.

9. The inscription is usually dated to the reign of Claudius: see *TAM* 2.549, *SEG* 28.1227, and *CIG* 4240d, at the Searchable Greek Inscriptions website, Packard Humanities Institute, http://epigraphy.packhum.org/inscriptions/main (accessed August 27, 2014). Also see Robert 1978, 35–43. *SEG* gives a slightly different reconstruction than *TAM.* For other variants, see Robert's discussion. Given that in the Greek world sacrifices to the deceased emperor were unusual, and the focus was the living emperor (and empress), this inscription could be Tiberian rather than Claudian. For the Greek cultic practices vis-à-vis death and deification in Rome, see S. R. F. Price 1980, 34.

10. Trans. S. R. F. Price 1984a, 88.

11. For the two meanings, see Liddell et al. 1996, s.v. *sunistēmi* and *genos.*

12. *Senatus Consultum de Pisone Patre* (*SCPP*), III.7.7 in Lott 2012, 156, 157 (translation), 256 (date: 20 C.E.), 307 (commentary). See also discussion in Severy 2000, 318–26 (presents the imperial family as a civic institution), also Severy 2003, 229–31.

13. Discussed in Barker 1996, 437.

14. *OLD,* s.v. "saec(u)lum."

15. Ibid.

16. Verg. *Ecl.* 4.7, 4.9, discussed in Ryberg 1958, 114; Barker 1996, 441–46 (for the connection with race in *Eclogue 4* and in other works). The text of Verg. *Ecl.* 4.4–10, ed. and trans. Fairclough, 48–49 (trans. slightly amended), is:

> Ultima Cumaei venit iam carminis aetas;
> magnus ab integro saeclorum nascitur ordo.
> iam redit et Virgo, redeunt Saturnia regna;
> iam nova progenies caelo demittitur alto.
> tu modo nascenti puero, quo ferrea primum

desinet ac toto surget gens aurea mundo,

casta fave Lucina: tuus iam regnat Apollo.

All subsequent translations from Virgil are by Fairclough.

17. *OLD*, s.v. "tuus." For a discussion of the phrase, see Ryberg 1958, 116 n. 15 (likelihood that it refers to Octavian).

18. Serv. on *Ecl.* 4.4. ("Sibyllini, quae Cumana fuit et saecula per metalla divisit, dixit etiam quis quo saeculo imperaret, et Solem ultimum, id est decimum voluit: novimus autem eundem esse Apollinem, unde dicit 'tuus iam regnat Apollo'"); and Serv. on *Ecl.* 4.10 ("tuus iam regnat Apollo ultimum saeculum ostendit, quod Subylla Solis esse memoravit. Et tangit Augustum, cui simulacrum factum est cum Apollinis cunctis insignibus"). On Servius's commentary, see Fowler 1997, 73–78.

19. "Augustus Caesar, diui genus, aurea condet saecula." *Aen.* 6.792–93.

20. "Alii parentem, alii matrem patriae appellandam." Tac. *Ann.* 1.14. Also see, Dio Cass. 57.12.4.

21. Augustus, *Res Gestae Divi Augusti* 35.1 with commentary in Cooley 2009, 273–75.

22. Augustus: consecrated in September, 14 C.E. See Kienast 1990, 65. Livia's consecration and other dates: Kienast 1990, 83–84. On Livia's possible cultic honors, see Grether 1946, 230–40; Severy 2003, 114 (discussion of the evidence); S. R. F. Price 1984b, cat. no. 5, p. 249 (*temenos* and *naos* for Livia on Lesbos). Tiberius allowed a cult to himself and Livia (Tac. *Ann.* 4.37) on the precedent for cults established in 29 B.C.E. for Julius Caesar and Roma and for Augustus (Dio Cass. 51.20.6–8). At Pergamon, the statue of Livia was placed together with that of Augustus inside the temple of the imperial cult. Her birthday was celebrated together with Augustus's, though not on her calendar birthday, but on the day of her husband's birthday, in September (Fränkel 1895, pp. 262–63, no. 374). For a discussion of the imperial honors (a continuum stretching from humankind to the gods with *divus* being a lower category than *deus*), see S. R. F. Price 1980, 36.

23. Inventory no. 99.109, H. L. Pierce Fund, Museum of Fine Arts, Boston. Livia's dates: b. 58 B.C.E., Augusta 14 C.E., d. 29 B.C.E., deified 42 C.E. Most relevant discussion in this context: Flory 1995, 52–64, 52–53 (on the similarity to Venus and with bibliography on the identification on 53 n. 40 (debate over the male figure). For the date, see: Vollenweider 1966, 75 (Tiberian, 14–20 C.E.); Megow 1987, B19, 256–57 (early Tiberian); Winkes 1982, 137 (between Augustus' death and deification in 14 C.E.). A similar case can be made for a cameo showing Livia with attributes of Ceres/Demeter and Magna Mater (Vienna, Kunsthistorisches Museum, inv. IX.A.95). On it, see, more recently, Kampen 2009, 23–37.

24. Cameos were produced for a closer circle than sculpture, but their iconography, though "richer, more exalted," "draws on the same symbolic language" as does free-standing sculpture. The quote is from Hallett 2005, 170.

25. *LIMC* 1999, 8: nos. 255 and 330; and Rose 1997, cat. 25, pl. 93.

26. Leschhorn 1984, 360–73.

27. Ibid., 360–73. For instance, Jupiter is called *auctor generis, genitor, pater,* and *parens.* See Alföldi 1950–54, 119 (citing the earlier study by J. B. Carter, *Epitheta deorum* (1902), 50 ff.).

28. On Athena as the founder, see Leschhorn 1984, no. 30, 364 with the ancient sources. For an Athenian tetradrachm, see online H/AM 1.1965.1593 (449–420 B.C.E.), at the Harvard Art Museums, www.harvardartmuseums.org/collections (accessed December 12, 2012).

29. Malkin 1987, 204–250.

30. Malkin 1987, 200–206.

31. Wiseman 1974:153–64.

32. See Wiseman 1995, 80–86, 160–68; Wiseman 2013, 242.

33. See Wiseman's point about the profusion of myths before the "imperial" myth in Wiseman 2013, 242.

34. Horsfall 1989, 8–27.

35. Livy, 1.1.4; Verg. *Aen.* 3.18.

36. Ovid, *Metamorphoses* 14.581–608.

37. On the deity Lar Aeneas, see a fourth-century B.C.E. inscription from Tor Tignosa: Guarducci 1956–58, 3–13; Weinstock 1960, 112–18. For a different reading of this inscription, see Georg-Lobe 1970, 1–9. For Jupiter Indiges, see Livy, 1.1.2 and Ov. *Met.* 14.586–608. See also discussion of the deification of Aeneas and Romulus in Fishwick 1987, 1:51–55.

38. On the ambiguity of Romulus as an ideal for emulation, see Herbert-Brown 1994, 49–53. In some versions Romulus fell victim to the Roman senators, who killed him on the site, see Fraschetti 2005, 88–89. On the passage in Livy, see Ogilvie 1965, 84–87.

39. On the identification of Romulus with Quirinus, see Porte 1981, 323–24; Fraschetti 2005, 93–96, 108 (for the date, in the first century B.C.E.). Significantly, while still living, Romulus anticipated that divinity stood in his path. Livy reports that of all the foreign customs the founder admitted in Rome, he preserved the worship of Hercules, who won immortality through his own courage (1.1.7). The living Hercules first received sacrifice at the Ara Maxima, an altar he built himself (1.1.7). No such altar was awarded Romulus before his heavenly ascent. The story of Hercules' Ara Maxima conveniently explained the notion of deification deserved through deeds. On the subject, see also Plut. *Rom.* 27–28 and Livy, 1.1.15. On the myth of Romulus, see discussions in Fishwick 1987, 1:53–54; Grandazzi 1997, 129–30, 143, 146–58, 160–64, 168–75, 199; Fraschetti 2005, 91–96.

40. But see evidence for Cornelia (mother of the Gracchi) as *deus parens,* in Fishwick 1987, 1:53.

41. Varro, *De ling. lat.* 6.20; Servius on *Aen.* 8.636; Cicero, *De re publica* 2.1.7.

42. For the legends of Rome's founding, see Ogilvie 1965, 32–35; Cornell 1995, 57–68; Galinsky 1969, 142–50, 160–64.

43. Habicht 1970, 36; Leschhorn 1984, 204, and 204 n. 1 (number discussed with relevant bibliography).

44. Leschhorn 1984, 354–60.

45. For the Hellenistic kings and their cults, and cultic honors to the founders, see individual chapters in Habicht 1970, esp. 129–243; Leschhorn 1984, esp. 333–44.

46. Hölbl 2001, 92–98.

47. For its use in diplomacy, see Fishwick 1987, 1:11.

48. Leschhorn 1984, 341, emphasizes the service to the state and its renewal, rather than origination.

49. On blurring the distinction between *sōtēr* and *euergetēs*, see Fishwick 1987, 1:27.

50. On Julius Caesar's honors, see Dio Cass. 44.3-6 and Cicero, *Epistulae ad Atticum* 368 (XIV.14).3, with Weinstock 1971, 285-86; Fishwick 1987, 1:53–54, 56–72.

51. On the differences in cult between Rome and the Greek East and the infiltration of Roman practices, see S. R. F. Price 1984b, 74–77. Price emphasizes the independence of the Greek cults. He considers them locally based, versus the centrally based cult of the divi in Rome. For how the Hellenistic tradition of divine kings was adopted for the Roman emperors, see Fishwick 1987, 1:3–97; Noreña 2011, 35–55 (especially on the moral characteristics of the emperor).

52. Plut. *Dem.* 9 with K. Scott 1928, 138–40.

53. Plut. *Dem.* 23 with K. Scott 1928, 143–45. Fishwick 1987, 1:22–23 (given as an example of temple-sharing, *sunnaos*).

54. Plut. *Dem.* 25 and Strabo, 8.

55. Plut. *Dem.* 16, 19, 24. 25, 27, with K. Scott 1928, 150–52 and 157 (Phila), and 152 (Lamia).

56. On this and other examples, see Carney 2001, 218–25 (cults, particularly association to Aphrodite) and 223–27, 228–32 (on polygamy).

57. For the Ptolemies, see Fishwick 1987, 1:13–15; Hölbl 2001, 92–98; P. M. Fraser 1972, 1:213–46.

58. *Sēma* is accepted by most, for instance, see Stewart 1993. The case for the *Sōma* is made on the basis on the manuscript tradition, see Erskine 2002, 163–79. The shape of this tomb is not known, though it has been identified a round tomb on the bases of some lamps, thought to represent Alexandria's harbor and skyline, and a floor map mosaic from Jerash in Jordan (see fig. 24). For these connections, see Bernhard 1956, 129–56.

59. Homer, *Iliad* 24.801.

60. Discussion in Erskine 2002, 164–67.

61. On the napping of the body, see Aelian, *Varia historia* 12.64. See also Diodorus Siculus 18.28.2 and Strabo, 17.1.8. The snatching is discussed in Stewart 1993, 221–25, 370–75, 413–14; and Erskine 2002, 170–71.

62. "There he prepared a precinct worthy the glory of Alexander in size and construction. Entombing him in this and honouring him with sacrifices such as are paid to demigods and with magnificent games, he won fair requital not only from men but also from the gods." Diod. Sic. 18.28.4, trans. Geer, 95. On the cult of Alexander, see P. M. Fraser 1972, 1:214–17, 192–94. See also, Stewart 1993, 224–25, 230, 370–74.

63. On the significance of Alexander for the Ptolemies, see P. M. Fraser 1972, 1:215 ("The dynastic cult originated with the establishment by Sōtēr of a cult of Alexander"), 6–9; Erskine 2002, 172–74; Hölbl 2001, 93–95. On Alexander's cults, see Stewart 1993, 95–102.

64. For the proximity, also see Lucan, 8.694–97.

65. On the founder's cult, see Habicht 1970, 36; P. M. Fraser 1972, no. 4, 1:212; Leschhorn 1984, 204–16.

66. For the dynastic cult, see P. M. Fraser 1972, 1:213–26. Ptolemy I may have had more modest intentions, simply to associate himself with the founder. On the cult of the Ptolemies, see Hölbl 2001, 92–98, esp. 5 ("It is clear, then, that the state cult of Alexander the Great developed into a collective dynastic cult, once the worship of the

individual Ptolemaic couples beginning with Philadelphos was officially added to it"). Against the idea that the tomb became the place of cult, see Taylor 1927, 166. For Roman emperors receiving cultic honors at both their tombs and temples, see Richard 1966, 127–42.

67. *RE*, "Arsinoë," col. 1285; and P. M. Fraser 1972, 2:367 n. 228. Also see, P. M. Fraser 1972, 1:216–18; Hölbl 2001, 94–95.

68. Compare this with P. M. Fraser 1972, 1:218: "Philadelphus' purpose in establishing his own worship, and that of Arsinoë can only be conjectured. The same question may be asked of all Hellenistic monarchs who instituted ruler-cult, and a single answer is not easily given."

69. For Ptolemy I, see fig. 8 (reverse). The octadrachm (H/AM, accession number: 1.1965.2752) with Ptolemy II and Arsinoë on the obverse was minted under Ptolemy II (Svorōnos 1904–8, no. 603). For the type of Ptolemy II decadrachm with Arsinoë (H/AM, accession number: 1933.9), see Svorōnos 1904–8, 408, pl. 15.18. For the Ptolemaic ruler cult as connected to the cult of Alexander, see P. M. Fraser 1972, 1:215, 228; Hölbl 2001, 93.

70. Ammon as himself appeared on Ptolemy's II coinage. The horn can be interpreted as a general symbol of divinity, because Arsinoë was associated with other Egyptian and Greek gods (*RE*, s.v. "Arsinoë 26," col. 1284–86 for her cults). There is, however, a direct connection between Arsinoë and the god Mendes. Mendes's cult originated in Mendes in the Delta and was widespread in Hellenistic Egypt (*OCD*, s.v. "Mendes"). A hieroglyphic inscription from this city and dated to Ptolemy's fifteenth year of reign (271/270 B.C.E.) speaks of the deification of Arsinoë and her entry into the temple of Mendes as a full goddess. It specifies that her statue as a ram was to be placed in all temples and a representation of her to be put with the divine ram images. See summary in Nock 1930, 4. This inscription makes it possible that the horn of Arsinoë was perhaps evoking both of these gods. On the horn of Ammon on Ptolemaic coins featuring Alexander, see Stewart 1993, 231–38. For Ptolemaic and Hellenistic iconography more generally, see Smith 1988.

71. Plutarch, *Alexander* 27.5, with Worthington 2014, 181–82, 267.

72. Stewart 1993, 48–49, 432–36, pls. 8b and 8c, and figs. 76–79, 318–22.

73. Hölbl 2001, 101.

74. The reason for the bestowal of the epithet sōtēr has been disputed by Hazzard 1992, 52–56.

75. *RE*, s.v. "Arsinoë 26," col. 1284–86 for her cults. Also, P. M. Fraser 1972, 228–30. A valuable discussion is in Hölbl 2001, 101–5.

76. Hölbl 2001, 103–4. See also Stephens 2008, 243–48.

77. *RE*, s.v. "Arsinoë 1–17."

78. Burstein 1982; Troxell 1983. Carney makes the distinction between a city founded by a woman and founded in her name and its implication for cult; see Carney 2001, 207–9.

79. On the Hellenistic dynastic cults, see summary in Fishwick 1987, 1:13.

80. Compare with Price's conclusion about the difference between Hellenistic cults and Roman ruler cults. He emphasizes Hellenistic royal interventions in the city, see S. R. F. Price 1984b, 56.

81. Dated to 270?–261/0? B.C. H/AM accession number: 1.1965.2752. See, Svorōnos 1904–8, no. 603, pl. 14.15, Dewing 1985, no. 2752 (for the date), and Troxell 1983, 61. For a different view of the date of Arsinoë's death, see van Oppen de Ruiter 2010, 139–50.

82. Svorōnos, nos. 524–46.

83. Burstein 1982, 211. For Arsinoë, see the essays in Gutzwiller 2005.

84. P. M. Fraser 1972, 1:217–18. Because Ptolemy's mother, Berenice, was also referred to as "Savior," she seems to have shared cultic honors, yet she got her cultic name by association with Ptolemy. For the evidence, see P. M. Fraser 1972, 2:367–68 n. 223. Berenice had also a separate temple. On it, see Hölbl 2001, 94.

85. P. M. Fraser 1972, 1:216.

86. Hölbl 2001, 95.

87. See, Leschhorn 1984, 341; S. R. F. Price 1984b, 56 (compared to the the imperial cult).

88. *RE*, s.v. "Arsinoë 26," col. 1284, Burstein 1982, 211, with bibliography; Hölbl 2001, 101–4.

89. Svorōnos 1904–8, under individual reigns, for instance 141–44 for Ptolemy III, and earlier quoted example, no. 939 and Smith 1988, 13 (for Ptolemy I).

90. For these, see table in Mueller 2006, 13. These throne names were common with other Hellenistic monarchs. *Euergetēs*, originally an epithet for the gods, later applied to founders of cities. For a summary of the origins, see Alföldi 1950–54; Hahn 1994, 26–33.

91. Romulus ac parens patriae conditorque alter urbis . . . appellabatur (Livy, 5.49.7). With discussion and other examples, such as "the second founder" (Plutarch, *Camillus* 1.1), in Alföldi 1950–54, 29–31, 47–49.

92. Plutarch, *Marius* 27.5. On these see Alföldi 1950–54, 28–36, 86–88.

93. Alföldi 1950–54, 80–91 (Camillus is *pater*, Marius is *parens*, Sulla is *pater* and *servator*, Cicero is *parens*, Julius Caesar is *parens*). See also on the epithet *patres* for the Roman senators, Alföldi 1950–54, 28–36, 42–43, 86-88. Cicero: Cicero, *In Pisonem* 3; Cicero, *Pro Sestio* 57 (121); Plutarch, *Cicero* 23.3. Because Cicero claims that Marius should be called a new founder (Cicero, *Pro Rabirio* IX (27), this has been taken to indicate that Cicero had inspired later writers to consider both Romulus and Camillus *parens patriae*. On the view that it's difficult to prove that anyone before Cicero held the title, see Weinstock 1971, 202. Also see Herbert-Brown 1994, 56–57.

94. Cicero, *Post reditum in senatu* 4(8), with Alföldi 1950–54, 125. For the Greek tradition of deification of saviors, see Alföldi 1950–54, 132.

95. Raubitschek 1954, 66–67.

96. Fishwick 1987, 1:55.

97. Dio Cass. 51.20.7–8, with Fishwick 1987, 1:72 (difference with Julius), 88–93 (gradual sacralization of the ruler). For the bestowal of godlike honors to deceased mortals in the late republic, see Koortbojian 2013, 2–4.

98. John Pollini (whose study was published while this MS was under review) independently suggests something similar, relying in part on Alföldi's and other studies. He, however, does not elaborate on founding as a concept, but points to particular similarities between Octavian and Romulus, such as the augural associations and the Romulean imagery in the Ara Pacis and the Forum of Augustus. He concludes that Augustus wanted to present himself as a "second founder." See Pollini 2012, 22–23, 138, 140–45.

99. All references to the *RG* come from: Cooley 2009, 98, 271–72 (commentary). On the *RG*, see also the next chapter.

100. On monarchy and the emperor as monarch in the writings of ancient authors, see Millar 2002, 1:267–70 (reign seen as monarchic); Veyne 1992; Noreña 2012, 6-7 n. 24. Other views: Gruen 2005, 33–51; Wallace-Hadrill 1982, 32–48 (ambivalence in the emperor's position). See also the penetrating reflections on Augustus's restorations in Raditsa 1980, 278–83.

101. Fathers of the fatherland include: Augustus (64), Caligula (85), Claudius (90), Nero (96), Galba (?, 102), Vespasian (108), Titus (111), Domitian (115), Nerva (120), Trajan (122), Hadrian (129), Antoninus Pius (134), Marcus Aurelius (137), Lucius Verus (144), Commodus (147), Pertinax (152), Didus Iulianus (154), Septimius Severus (156), Caracalla (162), Geta (166), Macrinus (169), Elagabalus (172), Severus Alexander (177), Maximinus Thrax (183), Gordian I (188), Pupienus (190), Balbinus (192), Gordian III (194), Philip the Arab (197), Julius Philip (199) Decius (202), Trebonianus Gallus (207), Volusianus (208), Aemilius Aemilianus (210), Valerian (212), Gallienus (215), Claudius Gothicus (228), Quintillus (230), Aurelian (231), Postumus (240), Victorinus (243), Tetricus (244), Tacitus (247), Florianus (249), Probus (250), Carus (254), Numerianus (256), Carinus (257) Diocletian (262), Maximian (268), Carausius (274) Constantius I (276), Galerius (279), Maximinus Daia (284), Maxentius (287), Licinius (290), Constantine (294), Constantius II (309), Julian (318), Valentinian I (322), Valens (325), and Gratian (328). All references are from Kienast 1990.

102. For the savior aspect of emperors, starting with Augustus, and including detested ones (Caligula), see the evidence for coins with "savior" legends discussed in Alföldi 1950–54, 68–79.

103. For Hellenistic-style honors bestowed on Romans before Augustus and outside of Rome, see Fishwick 1987, 1:46–48.

104. Commentary on the *RG*: Cooley 2009, 261–62.

105. Ed. and trans. Rolfe, 1:158–59.

106. Florus, *Epitome rerum romanorum* 2.34.66, ed. and trans. Forster, 350–51.

107. See analysis in Ramage 1987, 47–54 (following Hellegouarc'h's thoughts on *virtus* and *auctoritas*, and *res gestae*). Also Cooley 2009, 256–61.

108. *OLD,* s.v. "augeō," 212–13, and s.v. "auctoritas," 206. Also see note above, and Hellegouarc'h 1963, 295–96.

109. Suet. *Aug.* 28.2, ed. and trans. Rolfe, 190–93.

110. Cooley 2009, 273–75. Romulus as *pater:* Enn. *Ann.* I 2, fr. 113 (Skutsch, fr. 61? [*pater, genitor*]), and Livy, 1, *praef.* On the terms *parens* and *pater* see discussion in Alföldi 1950–54, 80–101. Previous fathers/founders, see notes 91–93.

111. Cooley 2009, 160–61. For the term *princeps*, its relationship to *auctoritas* and examples of its use, see Hellegouarc'h 1963, 327–61. For the convincing argument that there was no such thing as a principate in Augustus's times, see Gruen 2005, 34.

112. For this understanding of *princeps*, see *OLD*, s.v. "princeps."

113. For Augustus as a "father writ large," competing with the notion of a "master," see Roller 2001, 233–46.

114. See above and analysis in Galinsky 1969, 27–29, 51, 141–65 (Romans' dual ancestry from Romulus and Aeneas).

115. On the date (May 12) and description: Ov. *Fast.* 5.545–70, and Dio Cass. 55.5.3 (August 1); with Zanker 1968, 1988, 193–215; Galinsky 1996, 197–213; Kellum 1985, 169–76.

116. See the plan in Beard, North, and Price 1998, 2:81.

117. Zanker 1988, 201–2.

118. On these "elogia," see Frisch 1980, 91–98 (a comparison between the elogia and Augustus's *Res Gestae* suggests that Augustus wanted to present himself as the "restorer of the Republic" [7]); Frank 1938, 91–94 (elogia compared to the list of Roman heroes in the *Aeneid,* but unclear to whom belonged the primacy of the idea, Augustus or Virgil); Rowell 1940, 131–43 (argues for a parallel between the imagines presented at Augustus' funeral and the summi viri on the forum).

119. Richardson 1992, s.v. "Forum Augustum or Augusti," 161; Steinby 1993–2000, s.v. "Forum Augustum," 2:293; Zanker 1988, 195–201, with figs. 150–55.

120. Livy, 1.1.3; Verg. *Aen.* 1.286–88, 6.789–90; Ov. *Met.* 14.583; Dio Cass. 43.22.2-3; Suet. *Iul.* 6.1-2; Weinstock 1971, 5–7. There exists another version for Iulus's ancestry, see summary in Taylor 1975, 58–59.

121. Weinstock 1971, 83–90. A *denarius* minted after Caesar's victory over Pompey at Pharsalus (48 B.C.E.) presents an important testimony to Caesar's appropriation of Venus Victrix as a personal goddess. Its obverse shows a bust of Venus. The reverse represents Aeneas in the nude, fleeing from Troy and carrying his father Anchises on his shoulder, the Palladium in his extended right hand (fig. 11). See H/AM accession number: TL16749.142; *RRC* 458/1. At Pharsalus Caesar put his armies under Venus's protection. His watchword during the battle was "Venus Victrix." Caesar's victory was the best proof of the favor Venus bestowed on him. See also Richardson 1992, s.v. "Venus Victrix, Aedes," 411; Steinby 1993–2000, 5:s.v. "Venus Victrix, Aedes," 120–21. Appian, *Bellum civile* (Civil War) 2.76.

122. It had seemed to some that the poem had inspired Augustus in designing his forum. The correspondences of ideas between the *Aeneid* and the forum are multiple. Some examples for Virgil's influence over artistic interpretations: Rowell 1941, 261–76; Kellum 1981, 127; Zanker 1988, 193–95 (Augustus "borrowed from Vergil's imagery"); Galinsky 1996, 210–12, especially 212 ("the forum . . . it's a monument to Virgil as well as Augustus"). For lost monuments, such as the Forum of Augustus, literary testimony is indispensable, but see Barchiesi's remarks on poetry as "neither independent nor passive in its relationship to political art, but . . . participating in a complex interaction," Barchiesi 2005, 281. Similarly: Galinsky 1996, 222–24. Also see, Zanker 1988, 212–13. Virgil's dates: b. 70 B.C.E., d. 19 B.C.E.

123. The Julian lineage cast as a "new mythology": Zanker 1988, 192–215, esp. 196, 211–12.

124. See Wiseman's point about the profusion of myths before the "imperial" myth in Wiseman 2013, 242. In one version, Aeneas founded Rome with Odysseus. See Solmsen 1986, 93–110, discussing a passage in Dionysius of Halicarnassus, *Antiquities of Rome* 1.72.2. Also, analysis in Fraschetti 2005, 29–31.

125. Romans as descendants of Aeneas: Livy, 1.1.4; Verg. *Aen.* 3.18 (Aeneas is to fashion the name Aeneades), 8.648 (the Romans called "sons of Aeneas"); Strabo, 53 (608C) (the

race of Aeneas to rule over all men); Ov. *Met.* 15.682. Romans as descendants of Romulus: Livy 1.1.7 (Rome named after Romulus); Varro, *De ling. lat.* 5.32.144, 9.27.34 (Rome comes from Romulus); Verg. *Aen.* 1.276–77 (Romulus gave his name to the Romans). On how Romulus is referred to, see also the table in Leschhorn 1984, 379–80.

126. Virgil provides information on the Romulean ancestry, but his emphasis remains on Aeneas. See Verg. Aen. 1.273–74 and Rowell 1940, 1941, 273–74. On Augustus's role in the design, see Plin. *HN* 22.6.13, and Frank 1938, 91–94. Emphasis on the integration and the creation of new mythology, which privileges the Julii: Zanker 1988, 192–215, esp. 196, 211–12.

127. Compare with Kellum: "Whatever the later nuances, however, the original program of the summi viri at the Forum of Augustus were exempla subsumed under one dominant theme—that of Augustus himself." In Kellum 1981, 127.

128. *CIL* 14.4124.1, 2; 10.8067.2. See discussions in Kellum 1985, 127 (Augustus is "culmination of a long line of great men"); Galinsky 1996, 200 ("Augustus' quadriga is "the culminating example"); Zanker 1988, 210–15; Galinsky 1996, 202–7.

129. On the Augustan inflections of Romulus's story, the most obvious example is Livy, who was Augustus's contemporary, and started writing his *History of Rome (Ab urbe condita)* shortly after Actium. The preface to his work explicitly invites comparison of the past to the present age. Livy, *praef.* 4. On this, and Livy's Romulus vis-à-vis Augustus, see discussion in Sailor 2006, 359–65. Sailor argues that "Livy's text and Augustus's own activity converge to associate past and present" (364). Sailor ultimately concludes that Livy was critical to Augustus (369). Others have read Livy's account of Romulus as the paradigm through which Augustus's achievement could be evaluated (Stem 2007, 468). Miles 1988, 185-208, makes the important case for interpreting Roman history as a series of refoundations, in which Augustus's emerges as "less a founder" than Numa and others (199). For the Aeneid as "thoroughly woven into the Augustan context," see Galinsky 1996, 246–53, 246 (quote).

130. The literature on the Augustan inflections of contemporary literature is vast. Those are found in the works of most and best contemporary writers, such as Virgil, Horace, Ovid, Propertius, and Livy. On the relationship between Augustus and the literature of the Augustan age, see the introductory remarks in Barchiesi 2005, 281. See also the essays in Powell 1992; Barchiesi 1997; Putnam 2000. For Augustan inflections in Livy, see Syme 1959; Petersen 1961; Ogilvie 1965; Miles 1988; Stem 2007; Sailor 2006.

131. Livy, 1.1.7; Plutarch, *Romulus* 10.1-2; Suet. *Aug.* 7.2; Dio Cass. 46.46.1; Dionysius of Halicarnassus, 1.87.2–4; *Origo Gentis Romanae* 23.6.

132. Dionysius of Halicarnassus 1.88; Tac. *Ann.* 12.23.2–24.2. I find Fraschetti's discussion on the overlap between the pomerium and the city's first wall convincing. See Fraschetti 2005, 37-38. On the *pomerium*, see Beard et al. 1998, 1:177–81. Also see, Grandazzi 1997, 154–59.

133. On the symbolic significance of this act, see Fraschetti 2005, 96–112.

134. For resonances with Julius Caesar's death and deification, see commentary in Fraschetti 2005, 107–12.

135. Verg. *Aen.* 3.135–45.

136. There was a cult to Apollo Delphinus on Delos. See, Bruneau 1970, 114–39.
137. At the same time, he appears conflicted about it, as gods proper did not have tombs. On this, see Fraschetti 2005, 91–93. For a useful discussion of the evidence on the tombs of Greek founders, see Malkin 1987, 204–40.
138. Fraschetti 2005, 92–93 (Romulean tomb discussion); Malkin 1987, 200–203 (Greek founders); Lott 2012 (with examples).
139. For the *augurium salutis:* Beard et al. 1998, 1:188. For the Romulus-Octavian associations, see also Alföldi 1950–54, 36–37, and note 94. The idea that Augustus refounded the state like Romulus goes back to Mommsen 1971.
140. Augustus closed the temple's doors three times (*RG* 13).
141. From 900,000 or 910,000 four decades earlier the number soared to 4,063,000 Roman citizens (*RG* 8). How the censors arrived at that increase is debated. For a summary, see Lo Cascio 1994:29–30.
142. Date (October 9, 28 B.C.E.): *Inscr. Ital.* 13.2.518–19 (= EJ 53); Dio Cass. 53.1.3. Studies on the temple include: Steinby 1993–2000, 1:54–57 (P. Gross); Hofter 1988, 263–72 (G. Carettoni); Claridge 1998, 128–33; Roccos 1989, 571–88; Kellum 1981, 39–105, 1985, 169–76; Simon 1978, 202–27; Zanker 1983, 21–40.
143. Zanker 1988, 51–52. The ramp is disputed persuasively by Wiseman 2013, 234–68; Wiseman 2014, 546–51.
144. On this and the house's Romulean connections, see Meyboom 2005, 217–63.
145. On Hellenistic palaces and the buildings they contained, see Kutbay 1998; Nielsen 1999.
146. These are discussed in Reeder 1989, 50–62; Zanker 1988, 85–89.
147. Apollo by Scopas (36.23), Diana by Tomotheus (36.32), and Latona by Cephisodotos (36.24).
148. On the date (36 B.C.E.), see Heckster and Rich 2006, 160. The ex voto: Gagé 1955, 479–92. Other studies on the connection: Kellum 1981, 50–53, 1985, 169–76; Zanker 1988, 82–85, 5–9 (victory gives way to piety in the Temple of Apollo); Galinsky 1996, 213–24.
149. For Actius: *Actius hinc traxit Phoebus monumenta,* Prop. 4.6.67. Actiacus: Ov. *Met.* 13.715.
150. For instance, Galinsky 1996, 224 (Augustus anxious to get beyond Actium); Zanker 1988, 85–89 (victory gives way to piety in the Temple of Apollo).
151. The two are Reeder 1989 and Heckster and Rich 2006, 149–68. See also Gurval 1996, who who rejects the excessive connection of the temple to Actium.
152. Reeder 1989, 59–61.
153. Heckster and Rich 2006, 149–68.
154. As, for instance, in Kellum 1985, 172–73; 1981, 47–51.
155. On Delphian Apollo's role in city founding, see Leschhorn 1984, 105–9. For Apollo as founder of cities, see Leschhorn 1984, 109–15.
156. For a discussion of the identification of Apollo with Sol in the Greek world, see Gruppe 1906, 1240–41, and note 3 (briefly); Farnell 1896, 4:137–44. Farnell concludes that Apollo-Helios was "a late by-product in Greek religion rather than the god of the aboriginal cult" (144). For a similar conclusion about the use of Phoebus in Roman literature, see Fontenrose 1939, 439–55. Arguments for the association, see Rehak 2006, 92–94; Galinsky 1967, 619–33; Boyancé 1966, 149–70.

157. See, for instance, Fonterose above.

158. On the same, see also Macrobius, *Saturnalia* 1.17.31.

159. Callimachus, *Hymn to Apollo* (Hymn 2), 55–59, trans. Mair and Mair. This passage is discussed in Malkin 1987, 169–87. Also, see Calame 1990, 277–341. For the cities Apollo founded, see Leschhorn 1984, 360–63. Leschhorn lists twenty-six cities Apollo founded.

160. On Callimachus's influence on the Latin poets: Quintilian, 10.1.58–59. See also discussion of the *Aeneid*'s influences in Horsfall 1989, 8–27.

161. For Mark Antony, see denarii minted in 42 B.C.E. in the East, Banti and Simonneti 1972–, 2:44.115/1. For denarii, dated to around 19–18 B.C.E., showing Octavian as Sol, see Giard and Estiot 1976, pl. VIII.174. Discussion: Pollini 1990, 340–41 (Mark Antony), 351–52 ("the die engravers were not provided with models of sketches of these divinities with the features of Augustus, not were they likewise directed to represent Sol and Honos looking like Augustus" (352).

162. British Museum, 1844,0425.437. See RIC 1 Augustus 124, p.49 (type), RE1 349, p. 62, RR2 4451, p. 36. See also the museum's website.

163. For Augustus's auspicious horoscope, see Suet. *Aug.* 94–95. On the birth sign, see discussion with overview of the literature in Rehak 2006, 72–73.

164. On the Secular Games, see Beard et al. 1998, 1:71–72, 201–6.

165. "Decemviri sacris faciundis," in William Smith, A Dictionary of *Greek and Roman Antiquities* (London, 1875), at LacusCurtius website, http://penelope.uchicago.edu/Thayer/E/Roman/Texts/secondary/SMIGRA*/Decemviri.html (accessed March 13, 2012).

166. Man. *Astron.* 4.773–77. For a discussion of the passage and the dating of *Astronomica*, see Volk 2009, 153–60.

167. The literature on the Ara Pacis is vast. See, more recently, Rehak 2001; Billows 1993; Castriota 1995; Galinsky 1992.

168. On the Sibylline books, see Orlin 1997, 76–115; Beard et al. 1998, 1:62–63.

169. Bright 1978, 70, and also discussion of the poem, 66–92.

170. Tib. *Eleg.* 2.5.

171. *CIL* 6.32323. For the priests organizing the Secular Games, see Beard et al. 1998, 1:203.

172. Beard et al. 1998, 1:198, 205.

173. *RG* 9.1 (*sacerdotum quattuor amplissima collegia*, the four most eminent colleges of priests). These are the *pontifices, augures, quindecemviri, septemviri*, in Cooley 2009, 146. Also Kienast 1990, 62 (41 B.C.E.—*augur*, 37/5 B.C.E. XV-vir s.f.), 64 (12 B.C.E.—*pontifex maximus*).

174. Kearsley 2009, 147–66. On the adoption of oracular emblems, such as the Sphinx for Augustus's seal, see Zanker 1988, 49–50.

175. See commentary in Cooley 2009, 148–49. On Augustus's freedom in religious matters, see Gagé 1981, 570–72.

176. On his avoiding any crucial decisions involving the sitting pontifex maximus, Lepidus, and consultation of the pontifices more generally, see Scheid 2005, 188–91.

177. On new things (*res novae*) as dangerous, see *OLD*, s.v. "*nouus, -a, -o*."

178. The identification of this type with the cult statue is made on the basis of a marble relief from Sorrento. See Roccos 1989, 571–88. The base is reproduced in Roccos 1989,

571–88. On the Scopaic attribution, see Stewart 1990, 1:284, 285, 1977, 93–94. Fragments of the cult statue have now been uncovered. See, Calcani 2009, table 2. The tripod was the seat of the Pythia.

179. For tripods as gifts to Apollo, see chapter 4. For other examples, such as tripods given to Apollo Delphinus at Delos, see Bruneau 1970, 127–28. *LIMC* 1999, 2:pl. 213, "Apollo" 382.

180. For instance, see red-figure amphorae at the Beazley Archive Database, http://beazley. ox.ac.uk (Beazley Archive, vase nos. 3351, 200001, 201894).

181. Augustus dressing as Apollo, see Suet. *Aug.* 70. On emperors and others shown in statuary with divine attributes, see discussion in Hallett 2005, 223–70 (the divine symbolism praises qualities).

182. *RG* 34 in Cooley 2009, 98–99, 262–63, 5 (also carved in stone at the Mausoleum of Augustus).

183. Ov. *Fast.* 3.137–44. For connecting the laurels to the religious authority of the *pontifex maximus*, see Alföldi 1973, 68. For the laurel as *arbor Phoebi*, see Ov. *Fast.* 3.139, with commentary in Frazer 1973, 3:37. For laurels growing on either side of Apollo's sanctuaries and other religious buildings, see Alföldi 1973, 37.

184. On the meaning, see Suet. *Aug.* 7.2.

185. BMCRE, 1: no. 317 (trees only); Mattingly 1923, 1: no. 419.

186. For the Roman context, Galinsky 1996, 216 (considers Apollo "relatively unencumbered by the constraints of previous tradition."). On the Greek: Malkin 1987, 17–91.

187. On the Actian games: Suet. *Aug.* 18.2; Strabo, 7.7.6, with Murray and Petsas 1989, 9–12.

188. Trans. Fairclough, revised Goold, 536–37. For Teucrians as Trojans, see Verg. *Aen.* 1.619–21.

189. On the date, see Propertius, *Elegies*, ed. and trans. Goold, 2.

190. Ed. and trans. Goold, 350–53.

191. OCD, s.v. "pomerium."

192. Whether or not Augustus extended the pomerium has been debated. For a useful summary of the debate, including the relevant literature, see Boatwright 1986, 13–27, esp. 13 n. 1 (skeptics, this number includes Boatwright) and 19 n. 19 (those who argue for a pomerial extension). Boatwright does not examine the numismatic evidence, as discussed by Laffranchi 1921, 18–44. Coin iconography from the years 27 B.C.E., 18 B.C.E., 8 B.C.E. has been taken to indicate three enlargements: Laffranchi 1921, 22–32. On the extensions of the *pomerium*, see Rehak 2006; Poe 1984. For the suggestion that Augustus extended it first into the Campus Martius on the basis of Agrippa's projects there, see Coarelli 1977:842–43. Also see Beard 1986 and Wiseman 1969.

193. Propertius refers to them as *armenta* and *boves*. See Prop. 2.31.

194. Peck 1898, s.v. "Apollo." Online at the Perseus Digital Library at perseus.tufts.edu (accessed December 26, 2014).

195. *RIC* I Augustus 272, pl. 5, *BMCRE* 1:104, nos. 638–43, pl. 15.7; Robertson 1982, 1:50, no. 258, pl. 8; Banti and Simonneti 1972–, 5:145–49, nos. 522–25.

196. For the similarity as "familial resemblance," see Pollini 1990, 350.

197. Laffranchi 1921, 22–32.

198. For instance, an *aureus* from c. 13 B.C.E.: *RIC* I Augustus 402.

199. The *lituus* coins: for instance, *RIC* 1 Augustus 491.

200. On the idea that "the *lituus* as a symbol also connoted a host of specifically religious associations" and "a host of famous individuals and events connected with augury, not least Romulus," see Williams 2007, 147.

201. Beard et al. 1998, 1:182.

202. The evidence, reconstruction, and discussion of the statue's locations and iconography offers the following monograph: Bergmann 1994, fig. 10 (reconstruction). See also, Marlowe 2006, 226–29.

203. Discussion and assembled evidence: Marlowe 2006, 226–29.

CHAPTER 2. THE FOUNDER'S TOMB AND POSTHUMOUS HONORS

1. For Marcellus, see Dio Cass. 53.30.5; Verg. *Aen.* 6.873; *Consol. ad. Liv.* 67–68. Also, see discussion in Hesberg and Panciera 1994, 88–90. For the mausoleum, see Richardson 1992, s.v. "Mausoleum Augusti," 247–49; Kraft 1967, 189–206, 193 (Kraft believes that the motivation for the mausoleum started a few years before 28 B.C.E.); Rehak 2006, 31–62; Reeder 1992, 265–307; Gatti 1934, 457–64; Richard 1970, 370–88; Steinby 1993–2000, s.v. "Mausoleum Augusti: das Monument" (H. von Hesberg), 3:234–37.

2. On the date and references, see Hesberg and Panciera 1994, 95–96 (*Consol. ad Liv.* 67–68, Dio Cass. 54.28.5).

3. Hesberg and Panciera 1994, 72.

4. On the size, see Hesberg and Panciera 1994, 19 (diameter of the lower drum = 300 feet or 88.50m, diameter of the smaller drum = 100 Roman feet or 29.5m).

5. For the comparative size, see Reeder 1992, 269. For the metrics in Roman feet and hypothetical reconstruction of the statue, see Hesberg and Panciera 1994, 28, figs. 47, 49–50.

6. Strabo, 5.3.8, refers to a bronze image (*eikōn chalkē*), but does not describe the statue. It is usually reconstructed as a standing one, though John Pollini has made the intriguing suggestion that it was a quadriga. See Pollini 2012, 252–54. Reconstructions in Richardson 1992, fig. 55, 248; Gatti 1934.

7. LSJ, s.v. "alsos." For the use, see, for instance, Pausanias, 1.30, 2.2, 2.11, 2.15.

8. Dio Cassius refers to *mnēmeion* of Augustus (55.2.3, 64.3.4c), *mnēmeion Augousteion* (63.26.5) *Augousteion* and *hērōon*. Discussed in Reeder 1992, 300–301. Proposed first in Richard 1980, 461–71. On the connection between mausolea and *hērōa*, the classic study is Grabar 1946. See also Johnson 2009b, 186–94.

9. For the dates, see *OCD*, s.v. "Strabo."

10. Studies on that area of the Campus Martius: Rehak 2006, 62–95; Buchner 1982, 1–112 (with maps, photographs of the excavations, and astronomical calculations).

11. The debates and overview of the literature are summarized most succinctly in Reeder 1992, 265–307. See also, Davies 2000, 61–67 (a victory monument); Johnson 2009b, 22 (a *hērōon*, a site for sacrificing, commemorating the emperor's deification), 2009a, 216–39.

12. Kornemann 1938, 81.

13. Kornemann 1921, 93, cited in Kraft 1967, 193.

14. Richard 1970, 382.

15. Dio Cass. 50.3.5, and Richard 1970, 382–83; Syme 1939, 281–82 (on Plancus's sojourn in Egypt with Mark Antony).

16. Bernhard 1956, 129–56; Reeder 1992, 274; Coarelli and Thébert 1988, 788–800. On Augustus's opening the sarcophagus of Alexander and adorning it with a golden crown and flowers, see Suet. *Aug.* 18.1, and Luc. *Phars.* 10.19–24. For other examples of this interest, such as Alexander's image on Augustus's seal, see Suet. *Aug.* 50. Arguing that Augustus was interested in Alexander as a world conqueror, see Gruen 1986, 68–71. For later emperors and Alexander, see Spencer 2002.

17. On the will, see Dio Cass. 50.3.5–4.1; Syme 1939, 283.

18. Kraft 1967, 197.

19. Kraft 1967, 206.

20. See, especially, Reeder 1992.

21. See discussion in Reeder 1992, 276–78; Erskine 2002, 164–67.

22. Bernhard 1956, 129–56.

23. Reeder 1992, 302.

24. On his dates, see Hornblower 1982, 40. On the mausoleum and Mausolus as a city founder, see Hornblower 1982, 223–74, 78–105. The site has been excavated and the results published in Jeppesen et al. 1981– .

25. See Hornblower 1982, 238, 304.

26. Hornblower 1982, 271; Waywell 1978, 16–53 (BM registration no. 1857,220.233 (woman) and BM GR.12–20.232 (man), BM GR.12–20.264 (Apollo). See also the British Museum website, www.britishmuseum.org/explore/highlights/highlight_objects/gr/c/colossal_statue_of_a_man.aspx (accessed October 12, 2011).

27. Hornblower 1982, 271. On the source, *De fluviis* 25, preserved in Plutarch's writings, see Hornblower 1982, 335–36.

28. Malkin 1987, 200–203.

29. Polignac 1995, 143–49. See also Hornblower 1982, 255–56, and note 2 on a *scholion* in Pindar about tombs of founders of cities in the agora. Also, earlier reference to Malkin. For musical, equestrian, and gymnastic games, see Diod. Sic. 16.90.1.

30. Strabo (quoting Kallisthenes), Strabo, 13.59 and Plin. *HN* 5.29.107 (about six towns assigned to Halicarnassus by Alexander) discussed in Hornblower 1982, 81. On Mausolan *synoikism*, see also Hornblower 1982, 78–105. Rejecting the idea of *synoikism*, see book review by Sherwin-White 1984, 254–59.

31. Hornblower 1982, 253–56.

32. Hornblower 1982, 255. In the words of one scholar, "the only certain means of determining whether a dead person is regarded as a "Hero" [i.e., a worshiped mortal] is either when provisions are recorded in a decree or other document for ceremonies to be held at his tomb of a 'Heroic' nature, and are expressly so described, or by the sepulchral inscription on his tomb—in other words, when he is called *hērōs*." See Fraser 1977, 76, quoted in Hornblower 1982, 257 n. 271.

33. On its architectural precedents, see Hornblower 1982, 245–52.

34. Ref. for the sacrifice, see below. On Mausolus venerated as a hero, see Hornblower 1982, 254–55 (cites examples of founders' tombs in the city).

35. Strabo, cited above, and Vitrivius, *De architectura* 2.8.11.

36. On the Hellenization of Rome, see Gruen 1992, 1996; Wallace-Hadrill 2008.

37. Gruen 1992, 316.

38. For the Hellenization of the Roman political discourse: Dvornik 1966, 453–83; Noreña 2011, 49–55. Also see, Bosworth 1999, 1–18.

39. Cole 2006, 531–48.

40. Alföldi 1950–54, 132.

41. On these, see chapter 3.

42. Overall, see the evidence presented in Fishwick 1987, 1:46–48. For an example: Pompey was inspired to build his Roman theater after the one in Mytilene: Plutarch, *Pompeius* 42, with Platner and Ashby 1929, s.v. "Theatrum Pompei". See the LacusCurtius website, http://penelope.uchicago.edu/Thayer/E/Gazetteer/Places/Europe/Italy/Lazio/Roma/Rome/_Texts/PLATOP*/Theatrum_Pompei.html#temple_as_subterfuge (accessed January 16, 2013).

43. Zanker 1988. But see the questions raised in the book review by Galinksy 1994, 175.

44. Gross 1962, 12–14 (on the uncertainty of identifying her portraits on Roman coins). For outside Rome, see bronze coins minted in Alexandria, *RPC* 5053, 5006, and 5086.

45. Such as Cato, for instance. On him, see Gruen 1992, 63–74.

46. For the tradition, according to which Romulus rose heavenward without a trace, no body remained around which to build a tomb, see Fraschetti 2005, 91–93. For the sources, see p. 28.

47. For the argument of a similarity between Aeneas's tomb and Augustus's mausoleum, see Johnson 2009b, 2009a.

48. Leschhorn 1984, 342.

49. For a discussion, see Alföldi 1950–54, 124–38; Dvornik 1966, 489, with additional literature. On benefaction/euergetism, divinity, and imperial rule, see also Gordon 1990, esp. 224. For the link between divinities and kings, see S. R. F. Price 1984b, 32–40.

50. It is not a coincidence that in Tiberius's speech about Augustus' deification, Augustus surpassed both Alexander and Romulus. For Dio Cassius's objectives and biases in his assessment of Augustus, see Reinhold and Swan 1990, 155–73.

51. For instance, the conspiracy of 23 B.C.E. indicates resistance. On it, see Syme 1939, 333–35 (throughout, the book argues for Augustus's elimination of the opposition against him by attacking the nobility). See also, Raaflaub and Samons II 1990, 447–54.

52. On the mausoleum as a "conscious revival of the Trojan tombs," described in the *Aeneid* and the *Iliad,* see Holloway 1966, 173.

53. Lott 2012, 225.

54. Sacrifices to the Manes of Lucius, Gaius, and Germanicus. See *TS* III.5, 140 (Gaius and Lucius) and *TH* I.9, in Lott 2012, 92 and 93 (Gaius and Lucius) and 112–13 (Germanicus).

55. *CIL* 6.702.

56. Tertullian, *De spectaculis* 8.1 with Dagron 2011, 57.

57. For the date of the Caesareum, ca. 26 to 20 B.C.E., see McKenzie 2007, 177. For Arsinoë's cultic honors, see chapter 1.

58. For the size of the statue on the basis of its foundation, see Hesberg and Panciera 1994, 28.

59. On this statue, see Platner and Ashby 1929, s.v. "Columna rostrata augusti." For the suggestion that the type was used in the mausoleum, see Hesberg and Panciera 1994, 28.

60. Bardill 2012, 47.

61. See chapter 3 on the five documents Augustus planned to be read after his death.

62. For the date, see Ramage 1987, 13 (between September 23, 13 C.E. and Augustus' death on August 19, 14 C.E.); Cooley 2009, 3–18 (context of published variants).

63. For the RG see Cooley 2009 (with a detailed commentary); Brunt and Moore 1970; Ramage 1987. For the Ankara inscription, see Crawford and Reynolds 1977; Crawford and Reynolds 1975; Erim and Reynolds 1973. For the newly discovered fragment, Botteri 2003, 261–67.

64. Though epitaphs and Hellenistic and other inscriptions vaguely resemble it. Discussion on the potential precedents: Ramage 1987, 15 ("a unique creation"); Cooley 2009, 30–38; Yavetz 1984, 5 (on Augustus's concern for his legacy before the RG). The text has been interpreted as "the Roman counterpart to Euhemerus" (specifically his treatise "Sacred Record"). This Hellenistic treatise justified deification through conquest and benefaction. See, Bosworth 1999, 1–18.

65. Indeed including or disregarding it has resulted in different interpretations of Augustus's career. On this, see Yavetz 1984, 22–25. See also Ramage 1987, 113, "philosophy of government," and 5 (Tiberius).

66. Yavetz 1984, 1–36; Ramage 1987, 135–43. These and others are discussed in Bosworth 1999, 13 n. 80.

67. For the RG as a bid for deification, see von Wilamowitz-Möllendorff 1886, 623–27, esp. 624.

68. See Bosworth 1999, 1–18.

69. For different views see the scholarship discussed in Yavetz 1984, 8–14 (the Roman plebs), 15–18 (the new generation). On bronze and the authority of bronze tablets, see Meyer 2004, 9, 22, 26, 27, etc.

70. On these organizations, see Gabba 1984, 81–86.

71. See analysis in Williamson 1987, 163–80.

72. RG 8.2—mentions only the census, but says "I revised the membership of the senate three times [senatum ter legi]." With Cooley 2009, 138–39.

73. Pater patriae title: Augustus, Res Gestae 35.1. See also, Suet. Aug. 58.1–2. For the date, see Kienast 1996, 64.

74. Suet. Aug. 7.2: "For when some expressed the opinion that he ought to be called Romulus as a second founder of the city, Plancus carried the proposal that he should rather be named Augustus, on the ground that this was not merely a new title but a more honorable one, inasmuch as sacred places too, and rites are called august (augusta), from the increase (auctus) in dignity, or from the movements or feeding of the birds, as Ennius also shows when he writes: 'Afterwards by augury august illustrious Rome was founded']," trans. Rolfe. For other ancient sources on this title: Scott 1925, 86–88. The fragment from Ennius (on augury and founding) is also preserved in Cic. De div. 1.107–8. On reasons for the incomplete identification with Romulus, see Herbert-Brown 1994, 51–54, 60–62.

75. See analysis in Ramage 1987, 47–54 (following Hellegouarc'h's thought on virtus and auctoritas, and *res gestae*). Also Cooley 2009, 256–61.

76. *RG* 34 in Cooley 2009, 98–99, 262–63, 265 (also carved in stone of the Mausoleum of Augustus).

77. Ov. *Fast.* 3.137–44. For connecting the laurels to sacralization, in part through Apollo's symbolism, see Alföldi 1973, 53–54. For the laurel as *arbor Phoebi*, see Ov. *Fast.* 3.139 with commentary in Frazer 1973, 3:37. For laurels growing on either side of Apollo's sanctuaries and other religious buildings, see Alföldi 1973, 37. Also see, Fowler 1899, 27, 30 (laurels), 131–34, 51–65 (Mars); Mars: Plin. *HN* 18.161.

78. Augustus, *RG* 34. After Augustus the oak wreath would become a standard imperial emblem of the emperor's duty and ability to preserve the commonwealth. In Andreas Alföldi's analysis this attribute lost its outstanding meaning by the time of Trajan; see Alföldi 1950–54, 67–79, esp. 79.

79. Denarius struck at a Spanish mint. Rev: CAESARI (To Caesar) in exergue, triumphal quadriga right obv.: SPQR PARENTI / CONS SVO (The Senate and the People of Rome to its parent savior), legionary eagle, consular robes, and wreath, see *RIC* I Augustus 101, *BMCRE* I: no. 400.

80. Alföldi 1950–54, 115–18. Scott 1925, 90–95. On Augustus's adoptive father, Caesar, and Romulus, see Burkert 1962.

81. Alföldi 1950–54, 80–101. See the incisive discussion on the title and modern approaches to the imperial ruler cult in Stevenson 1998, 257–68.

82. See analysis in Cole 2006, 531–48.

83. Julius Caesar as *divus*, see discussion of existing literature in Fishwick 1987, 1:56–72.

84. Scipio quoted by Cicero in book I of the *De re publica*, trans. in Cole 2006, 538: "As Ennius said after the death of a great king; and at the same time they speak this way to one another: 'Romulus, divine Romulus, what a guardian of the country the gods brought forth in you! Oh father, oh life-giver, oh blood sprung from the gods.' They did not call those whom they justly obeyed 'lords' or 'masters,' and not even 'kings,' but 'guardians of the country,' 'fathers,' 'gods'—and not without reason."

85. Camillus is called "the second founder" (Plut. *Cam.* 1.1), and Marius, "the third founder" (Plut. *Mar.* 27.5). On these see Alföldi 1950–54, 28–36, 86–88.

86. For a similar conclusion about Ovid's comparison between Augustus and Romulus in Ov. *Met.* 15.133–44, see Herbert-Brown 1994, 48–52, esp. "Ovid is saying that Augustus is the greatest 'conditor urbis' and Pater Patriae of them all."

87. For a discussion of the passage and the dating of *Astronomica*, see Volk 2009, 153–60.

88. See also analysis about the titles *pater patriae* and *parens patriae* as bestowed on the "ideal benefactor" in Stevenson 1998, 264–66.

89. Hor. *Carm.* 3.5.

90. FGrH 90 F 125, trans. S. R. F. Price 1980, 28.

91. Speech: Dio Cass. 56.35–56.41; comparing Augustus to Alexander and to Romulus: Dio Cass. 56.36.3.

92. Refers to the preceding sentence as well. Dio Cass. 56.41.9, trans. Cary and Foster, 7:96.

93. Weinstock 1971; Ramage 1985, 223–45.

94. On these, see Syme 1958, 172–88.

95. On the complex relationship between Augustus's patronage of poets and the literary content they produced, see White 2005, 332–37.

96. *Aen* 6.789–96; Williams 2003, 16.

97. Anchises' prophecy of a new golden age (*Augustus Caesar, diui genus, aurea condet/saecula;* Verg. *Aen* 6.789–96).

98. Ed. and trans. F. J. Miller, rev. Goold, 2:416–19.

99. On the refusal to name a successor, and on the adoptions as not marking out a successor, see Gruen 2005, 38, 48.

100. On their honors, see also Dio Cass. 55.9.9–10, 55.9.2, 55.9.4–5, 55.12.

101. On Augustus's adoption of the boys, see Gruen 2005, 44.

102. Stevenson et al. 1982, s.v. "Princeps Juventutis." Accessed through Google Books: https://play.google.com/books/reader?printsec = frontcover&output = reader&id = dIAwAQAAMAAJ&pg = GBS.PA652 (accessed June 25, 2013).

103. Humphries 2008, 92, with an example.

104. For Probus's dates, see Kienast 1996, 250 For the coin, see *RIC* 5/2 Probus 701, 703.

105. See Gruen 2005, 34 ("never occupied a post called the Principate").

106. Compare with Noreña 2011, 37–178.

107. On solar iconography, see Bergmann 1998, 133–230; Letta 1988, 592–624.

108. On this monument, see Coarelli et al. 2000. For Trajan represented as *pater patriae*, see Kampen 2009, 38–63.

109. For the dates, see Kienast 1996, 147–49. The sources include: Dio Cass., *Hist.* 73.15.2–3, 73.15.6; *SHA* Comm. 8.6, 15.7; *RIC* 3 Commodus 247 (dated to 192 C.E.), 629.

110. Bronze medallion, dated to 192, Obverse: L AELIVS AVRELIVS COMMODVS AVG PIVS FELIX. Head of Commodus facing right, wearing lion's skin headdress. Reverse: HERC ROM CONDITORI P M TR P XV—III Emperor, as Hercules (bearded and eyes slightly drooping at the outside corners) advancing to the left, holding club and guiding with his right hand a yoke of oxen; in exergue, COS VII P P. See Gnecchi 1968, 23 and pl. LXXIX, 7; Toynbee 1944, 74.

111. Bergmann 1998, 247–66, 262–64 (Invictus), 265 (golden age and Sol). Thanks to Sol the imperial name Invictus resonated with the third-century emperors. But it has a longer history. It was first attested to Alexander, and there was a statue to Caesar in the temple to Quirinus with an inscription *deo invicto*. Other gods, such as Mars were also called *invictus*. See, Alföldi 1970 (first published 1935), 208; Letta 1988, 593; Bergmann 1998, 263 (other examples and bibliography).

112. On Hercules, see Cornell 1995, 69.

113. For coins minted from 193 to 284, see Manders 2012, 49, 187–220. The table on p. 190 is especially useful.

114. A small number of coins with Mars was minted during the Tetrarchy. See Manders 2012, 116 (fig. 21), 117–19 (Tetrarchy). After the year 69, attention to Mars remained constant, so it cannot be connected to war, see Manders 2012, 119; Noreña 2011, 243.

115. I make no distinction between Sol and Phoebus Apollo, as I noted earlier in the chapter. Coin legends frequently do not supply an identifying legend. For the mixing of the iconography and cult of the deities, see Letta 1988, 593. For the identification of Sol with Apollo, see also Macrob., *Sat.* 1.23.13, and the discussion in Manders 2012, 122 (third-century

coinage), 124 (fig. 22 percentage of sun-god coins by reign), 125, 126 (Sol on imperial coinage in earlier centuries), 127 (Sol and the saeculum aureum), 162–65 (providentia). Manders separates Sol and Apollo, but is ambivalent about doing so (132). For the connection between *aeternitas* and Sol, see also Berrens 2004, 173–76.

116. For the use of this crown of rays in the period between Augustus and Constantine, see Bergmann 1998, 91–289, 264 (regularly since Commodus's reign), 277–90 (Severus to Constantine).

117. For the metaphorical character of the divine attributes, see Bergmann 1998, 33–40; Hallett 2005.

CHAPTER 3. WOMEN AND FOUNDING FROM LIVIA TO HELENA

1. "In familiam Iuliam nomenque Augustum"; Tac. *Ann.* 1.8.

2. For the increasing political significance of republican women: Hillard 1989, 165–82; Kleiner 1992a, 357–67; Dixon 1983, 92–112; Delia 1991, 195–217 (a revisionist view of Dixon and Kleiner); Bauman 1992. See the remarks on the vast numbers of Livia's portraits by comparison to those of Octavia and Julia in Wood 1999, 27–28. Also see the examples assembled in Winkes 1995 (Livia's portraits outnumber Julia's and Octavia's considerably).

3. For *genus* as both "offspring" and "nationality, race," see *OLD*, s.v. "genus," 760.

4. I use the common term empress to designate women who had the title Augusta. Against such use, see Pollini 2012, 127 n. 30.

5. The title *imperator* similarly became part of the imperial titles without requiring a victory. See Dio Cass. 53.17.4. Unlike the Hellenistic royal cults, the Augustan cults "were no longer tied" to activities, such as "requiting [Augustus] for any specific benefactions." See S. R. F. Price 1984b, 56.

6. On this question see the penetrating review of Hall 2014 in Wiseman 2014, 544–51.

7. On it, see Zanker 1988, 61.

8. For Fulvia, see Delia 1991, 197–217; Fraschetti 2001 (first Italian edition 1994), 1–22; Habicht 1975, 85; Babcock 1965, 1–32; Welch 1995, 182–201; Bauman 1992, 83–89.

9. On Fulvia's coinage, see Wood 1999, 41 (coins from Lugdunum in Gaul, Phrygia, and Rome with the legend "Fulvia"); Kleiner 1992a, 359–61; Bartels 1963, 12. This identification has been rejected, see Mattingly 1960, 72 n. 2; Delia 1991, 202–3.

10. H/AM, acc. no. 2002.232.2; *RRC* 3140. The obverse depicts a bust of a woman with wings facing right. Her hair is tightly combed and brought up in a plait. The reverse bears the inscription *Phoulouianōn Zmertori* surrounded by an ivy and flower wreath. The first word translates as the ethnic "of the Fulvians," the second gives the name of the magistrate Zmertorix Philonidou. The date of coins probably falls between Antony's journey to the East in 41 and Fulvia's sudden death in the middle of 40 B.C.E.; see Habicht 1975, 85. On city founding under the empire, see Galsterer-Kröll 1972.

11. On the significance of images in this period, see Zanker 1988, 3–4. Contra: Eder 1990, 84.

12. Discussion: Kleiner 1992a, 361–63; Wood 1999, 44–53.

13. Reproduced is an aureus of 38 B.C.E. References: *RRC* 533/3a and 533.3.1. For another example with conjoined heads, see *RRC* 553*d (online at the BM website:

www.britishmuseum.org/research/collection_online (accessed January 11, 2015). See also the cistophoric tetradrachms minted in the East in 39 B.C.E. In these Antony was represented with the ivy crown of Dionysus: Sutherland 1970, 86–88. Deities discussion in Wood 1999, 48–51.

14. Tac. *Ann.* 5.1.1 (on Livia's lineage), Vell. *Hist.* 2.75.3 and discussion in Barrett 2002, 19–22; Flory 1988, 345–46.

15. For the political utility of marrying Clodia/Claudia and Scribonia, see Syme 1939, Scribonia: 213, 29 n. 7, Clodia/Claudia: 189, 209.

16. Suet. *Tib.* 6, Vell. Pat. *Hist.* 2.75, Dio Cass. 48.15.3. See discussion of the episode in Barrett 2002, 16.

17. Syme 1939, 229.

18. For Octavia in the conflict between Octavian and Mark Antony, see Wyke 1992, 103–12; Bauman 1992, 91–98; Wood 1999, 33.

19. Dio Cass. 49.38.1, 58.2. For other dates, see Kienast 1990, 84. For the honors, see also Bauman 1992, 93–94; Wood 1999, 32; Treggiari 2005, 141–42.

20. Kleiner 1992a, 357–67.

21. Honors similar to those enjoyed by the Vestals, see Purcell 1986, 85.

22. *Consolatio ad Liviam* 356. The meaning of the term is discussed in Purcell 1986, 78–97. On the possibility of this work being composed later than 9 B.C.E., see summary in Barrett 2002, 232–33. The poem has been attributed to Ovid, hence the edition used here is in the works of Ovid.

23. Ovid, for instance, called her *femina princeps*, see Ovid, *Epistulae ex Ponto* 3.1.125–26 and Ov. *Trist.* 1.6.25–27.

24. Tac. *Ann.* 1.14.

25. Dio Cassius notes five documents that Augustus prepared for the senate to be read after his death: his will, instructions for his funeral, the *Res Gestae*, an account of military and administrative matters, and injunctions and commands to Tiberius and to the public, advising to restrict citizenship (Dio Cass. 56.32–33.1). See also Tac. *Ann.* 1.8. A summary of the will: Champlin 1989, 154–65.

26. And only three or four adoptions afterward are attested. See Gardner 1998, 159 and n. 110.

27. On the debate over the significance of the title Augusta, see Barrett 2002, 151–53, 155.

28. Syme 1958, 172–88.

29. On the limitations of women's legal actions, see Gardner 1986, 5–26, 1998, 247–48 (on the exceptions granted mothers of three children).

30. Digest, 50.17.2, with Raepsaet-Charlier 2005; Boatwright 2011, 108, and n. 8.

31. For all Augustus's dates, see Kienast 1990, 61–67. Adoption of Livia: Suet. *Aug.* 101.2. Inscription with Iulia Augusta: *CIL* 2.2038; *RE* 13: s.v. "Livia Drusilla," 900–901. Important studies on Livia: Bartman 1999; Grether 1946; Flory 1993; Flory 1984; Purcell 1986; Winkes 1995.

32. Ov. *Fast.* 1.39–40, and above for other references. See also, Herbert-Brown 1994, 81–82.

33. On the adoption: Tac. *Ann.* 1.3.3, Suet. *Aug.* 64.1, Suet. *Tib.* 15.2, Vell. Pat. *Hist.* 2.103.3, Dio Cass. 55.13.2. For the idea that the adoption alone was not enough for Tiberius to

succeed Augustus, with a discussion of Tiberius's accomplishments, and especially the connection between tribunician power and his succession, see Gruen 2005, 42–50.

34. Tiberius's accession: Tac. *Ann.* 1.11–14; Suet. *Tib.* 22–26; Dio Cass. 57.2.

35. Tac. *Ann.* 1.14, Suet. *Tib.* 50.2, and Dio Cass. 57.12.4.

36. See discussion in Barrett 2002, 153–55.

37. On this correspondence, see Barrett 2002, 155.

38. Audiences: Dio Cass. 57.12, 56.47; and Suet. *Tib.* 50. Letters: Dio Cass. 57.12.2. Livia's cult: Grether 1946, 235–40. For the Gytheion's decree, see *SEG* 11.922, 16.272, and 46.384; and Rose 1997, cat. no. 74, pp. 142–44.

39. See below, note 227.

40. *CIL* 1/2.236, 316; Grether 1946, 235. Usually the empress's name appears after the emperor's.

41. On the temple, see Ov. *Fast.* 5.155–58 (Livia's repairs). Mentioned in the fifth-century *Notitia urbis Constantinopolitanae* (hereafter, *Notitia*). For it see, Platner and Ashby 1929, s.v. "Bona Dea Subsaxana" 85. Accessed through the online version at the LacusCurtius website, http://penelope.uchicago.edu/Thayer/E/Gazetteer/Places/Europe/Italy/Lazio/Roma/Rome/_Texts/PLATOP*/Bona_Dea_Subsaxana.html (accessed June 6, 2012).

42. Macrob. *Sat.* 1.12.25–26.

43. Fest. s.v. "Damium" and "Religiosus" trans. Brouwer 1989, 208–10. And Cic. *Att.* 1.13.3, 14.1–5, 16.1–6 (ceremonies), and Beard, North, and Price 1998, 1:129–30. The fundamental study on the cult is Brouwer 1989, 323–63, 370–72 (summary of the cultic practices), 363–70 (the so-called "Clodius affair," which illustrates the prohibition against men attending, in this case, allegedly Clodius in disguise).

44. *CIL* 11/4.3303, with Rose 1997, cat. 11, pp. 88–89.

45. On Livia's interest in the medicinal properties of plants, see Plin. *HN* 19.92 (a laxative Livia recommended for daily intake), Marcellus Empiricus, *De medicamantis liber* 15.6 (for throat inflammations), and 35.6 (chills and nervous tension), and discussion Barrett 2002, 110–13. On the fig that she cultivated, called the Liviana, see Plin. *HN* 15.70, Macrob. *Sat.* 3.20.1. For the laurels she grew, see above and: Plin. *HN* 15.136–37, Dio Cass. 48.52.3–4, 63.29.3.

46. *CIL* 6.833 records the restoration by Julia Domna and her family, and the original restorer. For the temple, see Champeaux 1987, 1:335–73; Gorrie 2004, 66–67.

47. Ov. *Fast.* 6.639, Dio Cass. 54.23, 55.8, Suet. *Aug.* 29. On the debates about the relationship between the two buildings, the shrine and the portico, see discussion in Flory 1984, 310.

48. The portico was built on land bequeathed to Augustus by Pollio in 15 B.C.E. Dio Cassius says it was dedicated by Livia and Tiberius (55.8.1) to celebrate his triumph; he also notes that Augustus built it for Livia (54.23.5). See Platner and Ashby 1929, s.v. "Porticus Liviae," 423; Richardson 1992, s.v. "Porticus Liviae" 314, fig. 68; Richardson 1976, 62; Flory 1984, 309.

49. Ovid, *Ars amatoria* 1.72, 16–17, with Flory 1984, 309–30; Grether 1946, 226.

50. Ov. *Ars am.* 1.71–72, Plin. *HN* 14.11.

51. Plin. *HN* 14.11.

52. For social harmony and Concordia, especially in Cicero's work, see, Noreña 2011, 132 (with references). For the marital aspects of Concordia, see Flory 1984, 314. For political

readings of Concordia, see summary in Flory 1984, 311. See also Severy 2003, 132–38 (emphasizing Concordia's relevance to civil discord); Levick 1978, 227 (two dimensions of Concordia in the Principate: "harmony in the imperial family and its closest associates" and the "harmony between the Princeps and his wife"); Grether 1946, 226 ([the Shrine to Concordia] "apparently honoring the harmony of the imperial marriage").

53. For this idea, Severy 2003, 135–36. On the wife and mother of Coriolanus, see Dion. Hal. 8.55–56, Plutarch, *Coriolanus* 57; Livy, 2.40.11–12. On the idea that Dionysius may have been influenced by Livia's involvement with the temple, see Flory 1984, 318; Purcell 1986, 88–89 (Livia's role only).

54. Trans. Miller, 2:359.

55. On the absence of Livia from Augustan literature, see Syme 1939, 414 ("the name of Livia is never mentioned by an official poet like Horace").

56. On Plancina's pardon, see *SC de Pisone patre*, line 120, with Severy 2003, 239.

57. Suet. *Aug.* 40.3, with Barrett 2002, 38, 39.

58. *SEG* 39.695. The inscription is from Hermonassa, and dates shortly after 8 B.C.E.

59. *SEG* 58.1472 (Zela).

60. *SC de Pisone patre*, trans. Potter and Damon 1999; Severy 2000.

61. On the dowries, see quote from Dio below. On the fire victims: Barrett 2002, 164.

62. Pomeroy 1982, 120–22, quoting Pugliese Carratelli's study (*ASAA*, 45–46 [1969], n.s., 29–30 [1967–68], 445–53, no. 2).

63. Pomeroy 1982, 121–22.

64. "Alii parentem, alii matrem patriae appellandam." From Tac. *Ann.* 1.14.

65. *Parens patriae*, as was noted above, is essentially synonymous with *pater patriae*. See Alföldi 1950–54, 80–92. Discussion: Barrett 2002, 156–57 (mater on a "lower level" than pater); Severy 2003, 136–37.

66. Translated as *gonea patridos* by Dio Cassius (*Hist.* 57.12.4).

67. Tac. *Ann.* 1.14, trans. Jackson, 2: 270–71. The same passage covers the proposal to call Tiberius "son of Julia." See also, Dio Cass. 57.12; Suet. *Tib.* 50, 1:362–63. The first Augusta to bear it as part of her official titulature was Julia Domna, approximately two hundred years later. This happened sometime before 211, see Kienast 1990, 167.

68. *SC de Pisone patre*, trans. Potter and Damon 1999, 109–20; Severy 2000. On clemency as an imperial virtue, see most recently Noreña 2011, 50–51.

69. "Hoti te ouk oligous sfōn esesōkei, kai hoti paidas pollōn etetrofei koras te pollois sunexededōkei . . . " From Dio Cass. 58.2.3, trans. E. Cary, 7:186–87.

70. See comments in Temporini 1978, 77.

71. For summaries for her honors, see *RE*, s.v. "Livia Drusilla," col. 900–927. Also see Severy 2003, 131–32, 242; Barrett 2002, 158–60, 164–65.

72. On the lictor, see discussion in Barrett 2002, 160.

73. Dio Cass. 60.22.2; *BMCRE* I: nos. 76–78, 130–31; Flory 1984, 321.

74. Dio Cass. 58.2.

75. Dio Cass. 58.2.

76. Dio Cass. 58.2.3, 58.3a.6. Also, see Kleiner 1990, 508–14 (argues for a connection between the arch and Livia's proposed deification).

77. For the dedications, such as *Iustitia, Pietas, Pax, Salus,* implying complimentary qualities, see summary table Mikocki 1995, 125; Barrett 2002, 258–302 (portraits and incriptions); Bartman 1999, 199–211 (inscriptions); Winkes 1995, 81–207 (catalog of her portraits); Alexandridis 2004, 287–93 (assimilation to goddesses).

78. Hahn 1994, 27, 53, 322; Pythodoris: no. 91, Dynamis: no. 92, Thasos: no. 4, *ILS* 8784, Assos: no. 93, *IGR* 4.250.

79. See Temporini 1978, 62–63. See LSJ, s.v. "kosmos," for the meaning as the inhabited world. The authors list an inscription for Nero, *ho tou pantos kosmou kurios* (the lord of the entire universe), *SIG* (Sylloge Inscriptionum Graecarum) 814.31. Trajan too is *kosmou sōtēr kai euergetēs* (savior and benefactor of the universe), see *AE* 1991.1478. Of the same category is *genetrix orbis,* discussed by Temporini 1978, 62–64, but here included under the discussion on Venus Genetrix.

80. Mylae (Sicily): Livia's cult there may have resulted from Octavian's victory near the city in 36 B.C.E. against Sextus Pompey; see *CIG* 2.333. Cyzicus: She was *sunnaos* with Athena Polias, see *IGR* 4.144. Larisa: *IG* 12.2.333; Samos: *IGR* 4.982–84; Aphrodisias: *CIG* 2.2815, see Grether 1946, 241; Hahn 1994, Mylae: no. 72, Cyzicus: no. 97, Samos: no. 25, Aphrodisias, no. 8, Chios: no. 3, Athens and Attaleia: 56, Thess., *IG* 9.2.333. Also see, Hahn 1994, 38–42, 56–65; Nock 1930, 36.

81. *IG* 912.333 (*SEG* 28.505e); Grether 1946, 242; Hahn 1994, 56 n. 72.

82. *IGR* 4.982–84; Hahn 1994, 40, 56–57, nos. 24–27.

83. *IGR* 4.144; Grether 1946, 242; Nock 1930, 30; Alexandridis 2004, 292.

84. *IGR* 4.144; Nock 1930, 30, 43; Hahn 1994, 56–57, no. 97; Mikocki 1995, no. 107.

85. See note above.

86. *SEG* 2.696; Hahn 1994, 57 and 102 n. 438.

87. Lozano 2004, 178, with the references and analysis.

88. Mikocki has assembled fifty-eight assimilations for nineteen empresses. See table in Mikocki 1995, 125.

89. For Tyche and Fortuna, see *LIMC* 8/1:115–41. For Fortuna and Tyche in Rome, see Champeaux 1987.

90. The primary example from Rome is the Templum Urbis (the City's Temple), the temple of Venus and Roma, the Fortuna of Rome. Outside Rome we find Dionysus, the patron god of Teos (Ionia) shown on the obverse of a coin from that city and wearing the turreted crown. This attribute indicates that as a city god Dionysus was also the city's Tyche. See BMC, Ionia, no. 56, p. 317. Dionysus was known as *ho tēs poleōs theos Dionusos* (Dionysus, the god of the city).

91. Tsountas, *Arch. Eph.* 1892, 24, no. 6, quoted in Leschhorn 1984, no. 89, 373.

92. "Ioulia Sebastē hē tou ethnous kai tēs poleōs Tychē"; in Grether 1946, 240–41; Rose 1997, cat. no. 74; Hahn 1994, nos. 87 and 12 (statue with a similar inscription). Before Livia, Arsinoë was associated with Agathe Tyche, see Tondriau 1948 and chapter 1.

93. See the discussion of empresses' assimilation of divine attributes as a way to underscore qualities in Hallett 2005, 230–40. For Livia's assimilations to Venus, see Mikocki 1995, 168–69; Hahn 1994, 327.

94. *CIL* 2.2038; Mikocki 1995, no. 120, 28–29. Mikocki emphasizes the importance of Venus for the dynasty. Temporini makes a case for understanding *genetrix orbis*

as *parens orbis,* on the basis of similar epithets used for the emperor; see Temporini 1978, 62.

95. See *RPC* 73; Mikocki 1995, no. 121; Temporini 1978, 61.

96. The legend reads: PERM DIVI AVG COL ROM.

97. The coins from Spain may have been intended as a response to Tiberius's decision not to allow the building in Further Spain of a temple to himself and Livia by the cities of Further Spain (Tac. *Ann.* 4.37; Grether 1946, 240). Instead the city honored the god Augustus, and Livia as Venus Genetrix.

98. *SEG* 54.1557 (Old Paphos) and *SEG* 15.532 (Chios), with Hahn 1994, 327; Mikocki 1995, 168–69; Alexandridis 2004, 291.

99. Wood 1999, 121–22.

100. Cameo: Alexandridis 2004, no. 50. Statue: Paris, Louvre, accession number MS 1242 (Ceres Borghese), see Mikocki 1995, no. 32; Richter 1971, no. 503; Wood 1999, 119, fig. 43; Alexandridis 2004, 290 (Ceres/Demeter, with earlier references), 126, no. 28, pls. 8.1 and 9.1.

101. Mikocki 1995, nos. 1–45.

102. Near Malta, *CIL* 10.7501 = *ILS* 121; Ephesus: *SEG* 4.515; Cyzicus: *SEG* 33.1055. See also an inscription from Aphrodisias in Caria, *theas Ioulias neas Demetros.* Respectively in Mikocki 1995, nos. 1, 6, 5. See also Mikocki 1995, nos. 2, 7–45.

103. Mikocki 1995, 18–21, 125, assessing most of the imperial women from Livia to Helena, has calculated that 185 identified with Ceres/Demeter, 105 with Juno/Hera, and 81 with Venus/Aphrodite.

104. Tripolis, Museum, Inv. 208/54, 2.98 m. The statue is considered to date from the late Tiberian to the early Claudian period. See, Alexandridis 2004, 290, Kat. Nr. 37, 130–31, Taf. 9.4; Bartman 1999, 107, cat. 74 (fig. 85); Zanker 1988, fig. 185, 234; Hallett 2005, 242; Wood 1999, 121–22. See also Kleiner et al. 1996, 97–98.

105. On coins, Aeternitas holds the busts of Sol and Luna, in *BMCRE* 2:48, no. 271 and *LIMC:* I, s.v. Aeternitas, no. 2.5, pl. 180 with Bergmann 1998, 271.

106. Bartman 1999, cat. 71 (fig. 41), cat. 72 (fig. 91), cat. 73 (fig. 102), and cat. 74 (fig. 85).

107. On these coins see, *RIC* I Tiberius 33–37, 71 and Barrett 2002, 295–300.

108. Hallett 2005, 167 n. 12.

109. See, for instance, the reverse of a bronze dupondius from the British Museum, dated ca. 41–42 C.E., with the legend DIVA AVGVSTA, in Bartman 1999, fig. 104.

110. These Augustae include: Livia (84), Agrippina (94), Antonia Minor (88), Poppaea (99), Claudia (100), Flavia Julia (114), Domitia Longina (118), Marciana (125), Plotina (126), Matidia (126), Vibia Sabina (132), Faustina I (136), Faustina II (141), Lucilla (145), Bruttia Crispina (150), Plautilla (165), Julia Domna (167), Julia Paula (173), Julia Aquilia Severa (174), Annia Faustina (174), Julia Soaemias Bassiana (175), Salustia Orbiana (179), Julia Maesa (181), Julia Mamaea (180), Herennia Etruscilla (204), Cornelia Supera (210), Salonina (219), Sulpicia Dryantilla (221), Ulpia Severina (233), Zenobia (238), Magnia Urbica (258), Galeria Valeria (282), Helena (300), Fausta (301), and Constantina (313). All references are from Kienast 1990.

111. That is, in the period 249–83, from Herennia Etruscilla to Magnia Urbica. See note above.

112. Empresses who were *mater patriae:* Julia Domna (167), Julia Aquilia Severa (174), Marcia Otacilia Severa (199), Ulpia Severina (233), and Magnia Urbica (258). All references are from Kienast 1990. The titles *mater augusti* or *mater caesaris* were bestowed on the following women: Antonia II (88), Agrippina II (94), Julia Domna (167), Annia Faustina (174), Julia Soaemias (175), Otacilia Severa (199), Herennia Etruscilla (204), and Helena (300). All references are from Kienast 1990.

113. *SHA Marc. Aurel.* 26. *BMCRE* 4: nos. 929–31 (coins) and Kienast 1990, 141 (date).

114. Other women who were *mater castrorum:* Julia Domna (167), Julia Aquilia Severa (174), Julia Mamaea (180), Julia Maesa (181, not official) Marcia Otacilia Severa (199), Herennia Etruscilla (204), Cornelia Salonina (219), Ulpia Severina (233), Magnia Urbica (258), and Galeria Valeria (daughter of Diocletian, wife of Galerius) (282). *Mater senatus* was given to: Julia Domna (167), Julia Aquilia Severa (174), Julia Mamaea (180), Julia Maesa (181, not official) Marcia Otacilia Severa (199), Ulpia Severina (233), Magnia Urbica (258). All references are from Kienast 1990.

115. *CIL* 6/4/3.36934.

116. *BMCRE* 5, nos. 11–12, 469, 472; *mater castrorum*, ibid., nos. 56, 789–90.

117. Julia Aquilia Severa (174), Julia Mamaea (180), Julia Maesa (181), Otacilia Severa (199), Ulpia Severina (233), and Magnia Urbica (258). All references are from Kienast 1990.

118. On these see chapter 6.

119. Portus: Pons Matidiae, *AE* 1975.137. For the Basilica Matidiae et Marcianae, see *Descriptio XIIII regionum urbis Romae*, 556.

120. *CIL* 6.997 = *ILS* 324, with Gorrie 2004, 71–72.

121. No inscription names Julia Domna as the sole initiator of building activities, but there's indirect evidence that some projects were her own. See Gorrie 2004, 65–71.

122. Gorrie 2004, 65–71.

123. Cascella 2013, 73–86.

124. Faustina I: *SHA Anton. Pius* 8.1; Faustina II: *SHA Marc. Aurel.* 26.6; Julia Mamaea: *SHA Severus Alexander* 57.7 and Ramsey 1936, 480–83.

125. Hahn 1994, no. 106; Rose 1997, cat. no. 95.

126. Hahn 1994, no. 146.

127. See Hahn 1994, 342–43.

128. Smith 1988, 24–26.

129. Hahn 1994, no. 218.

130. *IGR* 4.64 = *IG* 12/2.204, with Hahn 1994, no. 107.

131. Overall: Hahn 1994, 27. Antonia Minor (nos. 109, 112); Statilia Messalina (no. 240); Domitia (nos. 244, 260): *thea sebastē [euergetis]* (Brykos, Car.), *[euerget]is* (Lindos, Rhodes); Matidia II (nos. 278–79): *euergetis* (Delphi and Patara, Lycia); Sabina (nos. 280, 289): *thea sebastē euergetis* (Ephesus), and *idia thea kai euergetis* (Patara, Lycia), in Hahn 1994. The reconstruction of Sabina as a recipient of an inscription as *euergetis* in *IG* 2/3.2.1088 (Athens) is now rejected; see *SEG* 41.67.

132. *Sōtēr: AE* 1999.1458 (of Sparta), 1999.1462, 1999.1459 (with *euergetēs*) and 1999.1479 (with *euergetēs*), 1999.1481 (with *ktistēs*), and 1999.1608 (with *ktistēs*).

133. BMC, Moesia, no. 175–79, p. 41; Mikocki 1995, no. 379. For a slightly different example than the one shown here, see Mikocki 1995, cat. no. 379, p. 205. Now, also online at the RPC online database: http://rpc.ashmus.ox.ac.uk/coins/757/ (accessed March 6, 2014).

134. *SEG* 34.184. In *SEG* 34.186 the entire imperial family is addressed as saviors. See also Oliver 1940.

135. For this presentation, see Zanker 1988, 215–23.

136. *CIL* 3.7156, 7157, with Nock 1930, 40, and Hahn 1994, no. 104.

137. *IGR* 4.206; Nock 1930, 30–31; Rose 1997, 163.

138. *RE*, s.v. "Venus," col. 871.

139. See the various volumes of *BMCRE* and *RIC* and the statistic compiled by Temporini 1978, 100–104. See also Alexandridis 2004, tab. 5 (inscriptions), and tables for coins, under individual empresses. For calculations of frequency of Venus's presence on imperial coinage, see table in Noreña 2011, 336–37 (silver), 342–43 (bronze).

140. See above. *BMCRE* 1:98–99, 599–601, pl. 14, 16–17; and *LIMC* 8: nos. 198 and 202.

141. *RE*, s.v. "Venus," col. 866; *LIMC* 8:200, no. 48.

142. *BMCRE* 5:cxxxi, nos. 55, 48, respectively.

143. Julia's traditional coin types may also have endeavored to emphasize her Romanness, see Lusnia 1995, 139. Julia was born in Emesa, Syria, (ca. 170) and her father, Julius Bassianus, was priest of the god Elagabal. Neue Pauly, s.v. "Iulia 12;" Kienast 1990, 167.

144. *BMCRE* 5: nos. 11–12, 469, 472; *mater castrorum*, ibid., nos. 56, 789–90.

145. Boatwright 1987, 131–33; Richardson 1992, s.v. "Venus et Roma, Templum,"409; Steinby 1993–2000, s.v. "Venus et Roma, Aedes, Templum," 5:121–23. On the type, see Kleiner 1981, 512–44; Kousser 2007, 673–91.

146. Dio Cass. 71.31. "Auctores generis Venerem Martemque fatemur, Aeneadum matrem Romulidumque patrem," in van Heck 2002, no. 209.4.

147. Fittschen and Zanker 1985, 1:69, no. 64, pl. 74–75; Mikocki 1995, no. 385. H/AM, acc. no. 1976.40.468; *BMCRE* 4: nos. 999–1000, 543.

148. For the popularity of Mars and Venus at the times of the Antonines attributed to imperial use of the foundation myths of Rome: Aymard 1934, esp. 196.

149. For the children, see Kienast 1990, 139–40.

150. Grether 1946, 242, with n. 120; Flory 1984, 319. Similarly, the statues of Mars and Venus, could be interpreted as a desire to present the honorees as the ancestors of their families. For the statues of this type, see Kleiner 1981.

151. *Pan. Lat.* 7.6, ed. R. A. B. Mynors, trans. in Nixon and Rodgers 1994, 200.

152. Angelova 2004, 7.

153. Plin. *HN* 6.4.11, 2:344–45; *RE*, s.v. "Livia Drusilla," col. 914.

154. Josephus, *Bellum Iudaicum* 4.7.6, 3:128–29; *RE*, s.v. "Livia Drusilla," col. 914; Galsterer-Kröll 1972, 47 n. 15.

155. Hahn 1994, 304–5.

156. Josephus, *Antiquitates Judaicae* 18.27, 9:24–25; Galsterer-Kröll 1972, 47.

157. Galsterer-Kröll 1972, Domna, 69–70, and also 82, and Salonina, 85.

158. Overall on city founding in the Roman Empire, see Galsterer-Kröll 1972.

159. Tyche/Fortuna followed only Ceres, Juno, and Venus in the number of empresses presented in her guise. Mikocki 1995, 125. Also see Alexandridis 2004, tab. 4 (inscriptions).

160. Mikocki 1995, no. 249; Alexandridis 2004, pl. 3.4, cat. no. 97; Wood 1999, 276–78.

161. BMC, Attica, nos. 239–40, 145; BMC, Peloponnesus, nos. 244–45, 56; Mikocki 1995, nos. 449–50. As the turreted crown was also an attribute of Ceres/Cybele (Cybele is

called castle-crowned in Verg. *Aen.* 5.95) and Rome, and as the cornucopia appears in the hands of other deities this creates some ambiguity in unidentified by inscription images. For instance, a head wearing a mural crown from a statue of Domitilla I or II is variously interpreted as Tyche/Fortuna or Cybele, Mikocki 1995, no. 264. For other examples, see Mikocki 1995, Livia, nos. 53 and 101, Agrippina II, nos. 198, 200, 209.

162. *IG* 7.572; Hahn 1994, no. 241. See also Hahn 1994, nos. 258, 259.

163. BMC, Pontus, no. 18.

164. Marcianopolis: *SEG* 28.598–99; Mikocki 1995, nos. 370–71. Thera: *IG* 13.3.325; Mikocki 1995, 372.

165. For Nicaea (Bithynia), in BMC, Pontus, no. 38.

166. BMC, Galatia, nos. 81–82, 258; Mikocki 1995, no. 414.

167. Broneer 1935, 178, line 12.

168. Julia Domna associated with Tychai: in Caesarea (Cappadocia), see BMC, Galatia, no. 258; in Pessinius, see ibid., no. 22; in Damascus, see ibid., no. 11; in Smyrna (Ionia), see BMC, Ionia, no. 385.

169. I. Histriae, no. 89; Mikocki 1995, no. 414; Kettenhofen 1979, 107. The same epithet is used for Julia Maesa, Kettenhofen 1979, 149.

170. *BMCRE* 5: nos. 333, 334, 87, pl. 15.4, 5.

171. *Roma Aeterna*: *BMCRE* 3: nos. 707, 329, pl. 60.20.

172. Dio Cass. 78.18.2–3, trans. quoted below from Cary, 9:327.

173. BMC, Pontus, no. 14, 154. The reverse depicts a two-story building, across front of building *Neikaieōn*. Alexandria also referred to her as *Sebastē*, see Hahn 1994, 178.

174. See Veyne 1962, 61. For cultic honors, see entries for individual empresses in Hahn 1994, Livia: 109–10; Valeria Messalina: 77; Claudia Antonia: 83–84; Nero's family: 218; Flavia Domitilla: 30; Iulia Titi as *diva:* 33; Domitia Longina: 43–44; Plotina as *diva* only: 57; Matidia I as *diva* only: 66; Sabina: 77, 90; Sabina with Hadrian: 82, 85; Domitia Paulina, 302. There was temple to Antoninus Pius and Faustina II in Sardis, and possibly a temple (*naos*) to Faustina II in Pergamum, see (with bibliography), S. R. F. Price 1984b, 260, 53. For the Severan empresses, see Kettenhofen 1979, Julia Domna: 98–106; Julia Maesa: 49; Julia Mamaea: 63.

175. See above, note 38.

176. Hahn 1994, 177.

177. *IGR* 4.328, 464, 476 (*sunthronos*). See Veyne 1962, 61; Nock 1930, 24; Mikocki 1995, 44 and nos. 235–37.

178. Broneer had some doubts about the restoration of the word birthday in the first publication of this inscription by Anton von Premestein; see Broneer 1935, 178–84; Nock 1930, 34–35, on its interpretation.

179. *CIL* 10.444; Lightman and Lightman 2000, s.v. "Domitia Longina," 88. Domitia had a priestess at Termessos; see *IGR* 3.441; K. Scott 1936, 84. For Domitia's divine honors in Tanagra, see Veyne 1962, 60–63.

180. For Livilla, see note 177; *SEG* 6.646 (Claudia Antonia), quoted in Veyne 1962, 61 n. 5. See also Veyne's discussion on pp. 60–63. Livia's cult in Attaleia: *SEG* 2.696. Pergamum: S. R. F. Price 1984b, 56.

181. Paul Veyne has argued that these cities had acquired imperial permission for the cultic tributes, on the basis of Gytheion's request for Livia. He calls these permissions "une petite comédie." See Veyne 1962, 62.

182. *RE*, s.v. "Livia Drusilla," col. 906–7. The connection between divine honors, identification with divinities pointed out for Livia and other imperial women has been scrutinized by Hahn, who points out the cases when travel was or was not a factor for these honors, see Hahn 1994, 178 (was not for Valeria Messalina), 218 (was not for most of the women of the Neronian family, rather generosity from the emperor), 224 (some of Messalina's honors probably followed from her likely presence at Nero's side during his travels to Greece), 244 (Domitia's honors as euergetis not connected to travel), 287–88 (Sabina's and Hadrian's honors may not be necessarily connected to travel in the East). Also see Veyne 1962, 65–67, who sees provincial dedications to the imperial family as a matter of course, similar to gifts to the gods, an expression of loyalty.

183. BMC, Troas, nos. 193, 204; Hahn 2004, no. 120.

184. Ibid., 204; Hahn 2004, nos. 117–19.8;

185. Pottier and Hauvette-Besnault, *Bull. Corr. Hell.* 4, p. 423, quoted in BMC, Troas, 204.

186. Hahn 1994, 224. Also, see discussion in Lozano 2007, 148. See also Rose 1997, 137, cat. no. 67 (quoted below).

187. A similar one later issued in Rome, see *RIC* 2 Hadrian 826.

188. Hahn 1994, 285.

189. Yourukova 1996.

190. Dio Cass. 58.2.1–2.

191. The roster of the *divae* includes: Drusilla (87), Livia (84), Poppaea Sabina (99), Claudia (100), Flavia Domitilla I (113), Flavia Domitilla II (114), Flavia Julia (114), Marciana (125), Plotina (126), Matidia (126), Vibia Sabina (132), Faustina I (136), Faustina II (141), Julia Domna (167), and Julia Maesa (181), Caecilia Paulina (185), and Mariniana (214). All references are from Kienast 1990. Some deifications in the first century, such as that of Nero's wife and daughter were considered "erratic," that is with no obvious "didactic points"; Gradel 2002, 348. The last diva was Mariniana, the wife of Valerian, deified after his succession to the throne; see Kienast 1990, 214.

192. Wood 1999, 213.

193. Wood 1999, 212.

194. "He had divine honors voted to his grandmother Livia and a chariot drawn by elephants in the Circensian procession, like that of Augustus, and public offerings to the shades of his parents," Suet. *Claud.* 11, trans. John Rolfe, 2:23. See also, Wood 1999, 250.

195. Scott 1936, 45–48.

196. Hadrian was declared Trajan's adopted son only posthumously, see *SHA Hadr.* 4.9–10, 1:12–15. On the memory of Trajan and Plotina under Hadrian and their temple and posthumous coinage, see Boatwright 1987, temple to the deified Trajan and Plotina: 92–93; Temporini 1978, coinage: 106–10.

197. Agrippina: Tac. *Ann.* 14.11; Domitia: Scott 1936, [83]; Julia Soaemias: Dio Cass. 80.20.2, 9: 476–79; for other references, see *PIR* 4/3: s.v. "Iulia Soaemias Bassiana Augusta," nos. 704, 324–25. Julia Mamaea: Hdn. 6.9.6–7, 2:142–45; *PIR* 4/3: s.v. "Iulia Avita Mamea Augusta," nos. 649, 308.

198. Empresses who suffered *damnatio memoriae:* Agrippina II (95), Crispina, wife of Com-
modus (150), Plautilla, wife of Commodus (165), Julia Soaemias Bassiana, wife of
Elagabalus (175), Iulia Mamaea, mother of Alexander Severus (later revoked, 180), Julia
Maesa, sister of Julia Domna (later revoked, 181), Herennia Etruscilla, wife of Decius
(204) ?Cornelia Supera, wife of Aemilius Aemilianus (210), Magnia Urbica, wife of
Carinus (258). All references are to Kienast 1990.

199. *BMCRE* 1:21, nos. 104–5, pl. 4.2 (Diana/Julia); *RIC* 1 Augustus 403, pl. 7 (Diana); and
Robertson 1982, 1:9, no. 46 (Diana/Julia). For identifying the goddess as bearing Augus-
tus's features, see Pollini 1990, 354–55.

200. Ephesus: *RPC* 2600; *SNG* Copenhagen 362; Smyrna: *RPC* 2466; Smyrna: *RPC* 2097;
Thrace: *RPC* Alabanda: *RPC* 2816/1. The coins of Magnesia ad Sipylum (Lydia) show
Livia and Augustus on the obverse and Gaius and Lucius on the reverse. This composi-
tion suggests that the Livia was the woman represented on the Roman coins that cele-
brated the adoption, not Julia, Augustus's daughter.

201. For Sol-Luna, see above coin of Colonia Romula. The coin with the legends Theos
Sebastos (*ΘΕΟΣ ΣΕΒΑΣΤΟΣ*)-Thea Sebasta (*ΘΕΑ ΣΕΒΑΣΤΑ*) was minted in Byzantium
during Tiberius's reign: *RPC* 779/1, *BM* 1872, 0709.34, *BMC* Tauric Chersonese,
p. 99.61. For why Theos and Thea do not correspond to *divus* and *diva*, respectively, see
the analysis of Lozano 2007, 141–51.

202. On the similarities and their political significance, see Kleiner 2005, 212 ("Although not
related by blood, Livia, Octavia, and Julia were clones with one another, and Gaius and
Lucius Caesar looked as if they could be sons of Marcellus as readily as the offspring of
Marcus Agrippa").

203. Saller 1994, 83; 1984, 344, with examples.

204. Tac. *Ann.* 1.42; Livy, 3.44.3; and Saller 1994, 82.

205. *LIMC:* 1, s.v. Aeternitas, no. 2.5, pl. 180. On coins, Aeternitas holdings the busts of Sol
and Luna, in *BMCRE* 2:48, no. 271 and *LIMC:* 1, s.v. Aeternitas, no. 2.5, pl. 180 with
Bergmann 1998, 271. Sol assimilated to Apollo and Luna to Diana: Hor. *Carmen saecu-
lare* 1–3, 33–6.

206. *BMCRE* 1: nos. 52–55, 11–12, pl. 39. Discussion in Bergmann 1998, 175–81.

207. Poppaea: *BMCRE* 1:clxxiii; *RIC* 1 Nero 44. Messalina: Sydenham 1920, 126. Bergmann
1998, 178–79 (on why not Augustus and Livia, the date and the Augusta represented),
179–81 (what the reverse could mean).

208. See chapter 1.

209. Rose 1997, 137 (text and translation; here slightly amended).

210. See discussion in Bergmann 1998, 271–72.

211. Oppian, *Cynegetica,* 1.1–7 with Bergmann 1998, 273–74.

212. From the Roman mint: Tiberius and Livia (fig. 40): The mint of Caesaroaugusta (fig.
41) in Spain issued a coin, featuring Tiberius on the obverse, with his titles, and dated
to the year of his fourteenth tribunician power. The reverse shows a seated female hold-
ing a patera and a scepter. The legend reads *IVLIA AVGVSTA, H/AM,* acc. no.
1942.176.86; *RPC* 341 and 123. This helps identify the seated woman in coins without
the identifying legends (fig. 40). Nero and Agrippina II: *RIC* 1 Nero 1–4, 607–12 (Nero
obverse, Agrippina reverse). Claudius and Agrippina (fig. 66): BM 1927,0105.1. Domi-

tian and Domitia (fig. 67): *BMCRE* 2: no. 58. Trajan and Plotina: *BMCRE* 3: no. 51. Severus and Domna: jugate, reverse of *aurei* of Severus, *BMCRE* 5: no. †, 185, no. *, 196; also on aureus of Caracalla, ibid., no. 260, 204, pl. 33.8; *denarius* of Caracalla: ibid., no. 275, 207; face to face: ibid., no. *, 360 (the reverse shows Caracalla and Geta). Caracalla and Plautilla (fig. 68): *BMCRE* 5: nos. 390, 233. Severus Alexander and Julia Mamaea: ibid., 6, nos. 539, 166. Trajan Decius and Etruscilla: *RIC* 4/3 130. For more examples, including other media, and discussion, see Bastien 1992, 2:666–68 (emperor and empress facing), 2:652–53 (conjoined).

213. The major reason for the provincial mints to mint coins is to replenish the existing money supply in response to a specific need, such as a building, festival, an emperor's succession; see Harl 1987, 19.

214. *RPC* 1567–70.

215. There was a temple to the imperial cult at Ephesus, and hence the more regular minting of coins. On the cult, see Price 1984b, 254.

216. Stag: BMC, Ionia, nos. 203–4, 212; bee: ibid., no. 213; cult statue: ibid., no. 196.

217. BMC, Ionia, no. 213. For a similar iconography, see *RPC* 2459.

218. Hahn 1994, 194, 205–6 (for another example).

219. For Augustus and Livia on a coin of Clazomenae (Ionia) with Livia as Thea, see BMC, Ionia, no. 119, 31; for the same pair on a coin of Apamea (Bithynia), see *RPC* 2097; Mikocki 1995, no. 50. For Caligula and Antonia Minor on coins of Thessaloniki, see *RPC* 1573–75; Mikocki 1995, no. 154. For Nero and Agrippina I on a coin of Nicaea (Bithynia), see BMC, Pontus, nos. 16, 154. For Nero and Poppaea on a coin, see BMC, Pontus, nos. 9, 53. For Antoninus Pius and Faustina I on a coin of Alexandria, see Mikocki 1995, no. 345. For Philip and Otacilia Severa on a coin of Antioch, see BMC, Galatia, nos. 539, 217. For Caracalla and Plautilla on a coin of Laodicea ad Mare, see BMC, Galatia, nos. 95, 260. For Gordian and Tranquillina on a coin of Seleucia ad Calycadnum in Cilicia, see BMC, Lycaonia, nos. 47–49, 139; Mikocki 1995, 477.

220. See above, and Domitian and Domitia on a coin of Smyrna, see BMC, Ionia, no. 305; Mikocki 1995, no. 276. For the same pair on coins of Alexandria, see BMC, Alexandria, nos. 282, 292, 333; Mikocki 1995, nos. 277 and 278. Also on a coin from Rhodes: Mikocki 1995, no. 285. For Hadrian and Sabina on coins from Aelia Capitolina, see BMC, Palestine, nos. 4–5, p. 83. For the same couple on a coin from Alexandria, see Mikocki 1995, no. 302. See also a coin from Seleucia ad Calycadnum (Cilicia) in BMC, Lycaonia, nos. 17, 131. See also a coin with Hadrian and Sabina from Mopsus, ibid., no. 14, p. 106, and also Mikocki 1995, 315–16. For Trajan Decius and Etruscilla on a coin together, see BMC, Arabia, no. 37, 132; Mikocki 1995, 482.

221. BMC, Palestine, nos. 95–97, 24, and nos. 99, 25, respectively.

222. *SHA Marc. Aurel.* 19.8–9.

223. For Verus's dates, see Kienast 1990, 143–45.

224. Rose 1997, nos. 71, 86, and 115 (Augustus and Livia), no. 66 (Augustus and Marcus Agrippa and Livia), nos. 51, 124, and 129 (Augustus, Tiberius, Livia), nos. 8, 26, 99, 102, 113, and 123 (Tiberius and Livia), no. 87 (Tiberius, Julia I, Drusus), no. 20 (Caligula and Drusilla), nos. 72, 73 and 94 (Claudius and Agrippina), no. 67 (Nero and Statilia Messalina), no. 109 (Nero and Poppaea).

225. Marcus and Faustina II: Dio Cass. 72.31.1–2, 9:52–55; Hadrian and Plotina: *AE* 1939.190; Hahn 1994, no. 318. For the Mars-Venus statuary groups, see Kleiner 1981, 512–44; Kousser 2007, 673–91.

226. Gytheion: *SEG* 11.922–23, with Rose 1997, 142–44. Acraephia (Boetia, Greece): *IG* 7/1.2713, with Rose 1997, 137 (English translation); Lozano 2007, 148 (discussion). Athens: *IG* 2/2.1076.

227. On this assimilation, see Mikocki 1995, 23–25, and Hahn 1994 under individual empresses. On the cult of Jupiter, see Fears 1981a.

228. See, for instance, Mikocki 1995, cat. no. 61: *CIL* 9.1023, cat. no. 63: *IG* 9.2.333, and cat. no. 64: *IGR* 4.319. See also Prudentius (348–after 405) referring to *Caesareum Iovis* and *Livia Iuno*, discussed in Grether 1946, 230 n. 42.

229. "Veneris formam mores Iunonis habendo"; Ov. *Pont.* 3.1.117–18, *Fast.* 1.650 (Livia shares the bed of "mighty Jupiter"); Grether 1946, 229.

230. Hadrian and Sabina: *AE* 1933.89; Hahn 1994, 288–89, no. 311. Septimius Severus and Julia Domna: *AE* 1949.109; Mikocki 1995, no. 419.

231. Mikocki 1995, no. 357.

232. Augustus and Livia, Grether 1946, 235 and n. 76, and 242. In general: Temporini 1978, 44–45.

CHAPTER 4. THE CHRISTIAN FOUNDERS
CONSTANTINE AND HELENA

1. All references are to the edition of Winkelmann 1975 (hereafter Euseb. *VC* (for *Vita Constantini*). Translations are taken (modified where indicated) from Cameron and Hall 1999 (hereafter Cameron-Hall), a translation relying on the Winkelmann's revised edition.

2. *VC* 1.28–29; trans. Cameron-Hall, 80–81. The entire vision: Euseb. *VC* 1.28–32; Cameron-Hall, 204–13 (commentary). The episode of the vision is omitted in Eusebius's account of the battle against Maxentius in his *HE* 9.9.2–8. The bishop claims that he learned about the vision from Constantine (*VC* 1.28); Cameron-Hall, 204–6 (commentary). The *VC* version of the vision differs from the near contemporary testimony of Lactantius, *De mortibus persecutorum* 44. In Lactantius, Constantine learns about the sign in a dream. The sign is described somewhat, but not named "labarum." On the vision, see also, T. G. Elliott 1991, 163 ("The fact that the conversion is not mentioned at all in the panegyric on Constantine delivered by Eusebius on the occasion of the tricennalia is a clear indication that the conversion theme could not be produced until the emperor was safely dead"). See also discussion in Barnes 1981, 43, 2011, 76–80 (who notices references to a celestial vision); Potter 2013, 150 ff., 329; Cameron-Hall, 204–13 (commentary and discussion of Eusebius's account); Harries 2012, 109–11.

3. Euseb. *VC* 3.43–46.

4. Examples include, but are not limited to: Grégoire 1930–31; Drake, 1985a, 1–22; Elliott 1991, 162–71.

5. Eusebius's narrative about the vision of the Milvian Bridge remains central to the question of the emperor's faith even when Eusebius is examined critically. See Barnes 2011, 74–80 (Barnes recognizes that Eusebius "slides over interval of two years" and thereby

combines the vision of ca. 310 with a dream). Van Dam 2011, 95–100 (accepts somewhat unproblematically Eusebius's admission that he relied on the emperor's memories years after the event and at the same time recognizes that Eusebius embroidered the story to conform to his earlier writings). Voices against the historicity of the conversion story: Grégoire 1930–31; Elliott 1991, 162–71; Potter 2013. Useful summary of the scholarship on Constantine in Lenski 2006a, 5–10. For the relationship between Constantine's self-image, Eusebius's narrative, and other sources, see Bardill 2012, 159–202.

6. Recently, T. Barnes has considered "coins, inscriptions and monuments" "inarticulate evidence" (Barnes 2011, 17). This chapter offers arguments against such a position. For instance, the minting of coins was tightly controlled and responded to developments such as victories and elevations. On the changing messages of the Constantinian coinage during the Tetrarchy and afterward, see Kent 1957, 16–77. For controlling the message on imperial coinage overall, especially in the period 69 to 235, see Noreña 2011, 242–62; for the period 193-284, see Manders 2012. The *Book of Ceremonies* informs us that when Anastasius became emperor, immediately painters and mint-masters took their instructions (*De cerimoniis* 1.92, trans. Moffatt and Tall 2012, 1:422). For such Constantinian monuments as his forum in Constantinople or his statue in the Basilica of Constantine, I assume that the emperor had an active say in their design on the precedent of Augustus's interventions in his forum. On it, see chapter 1. It would be a mistake to assume that Constantine had no say in the design of his forum, or that his buildings and urban development were "inarticulate."

7. Examples of single founder view point: See Alföldi 1948; Bardill 2012; Barnes 2011; Dagron 2003; Grant 1994; MacMullen 1969; Van Dam 2007; . Potter 2013. On Constantine's travels, see Barnes 1982, 68–80. See also J.W. Drijvers 1992, 181–83. Major works on late antique women include: Holum 1982; James 2001; McClanan 2002; Herrin 2000, 2001; Garland 1999. Important scholarship on the history of women that has inspired this study includes the works of Averil Cameron, Elizabeth Clark, Gillian Clark, Judith Herrin, Sarah Pomeroy, Charlotte Roueche, Gloria Ferrari Pinney, Mary Taliaferro Boatwright, Natalie Boymel Kampen, Diane Kleiner, Susan Matheson, Ioli Kalvrezou, and others.

8. *ACO* 2.1.2, trans. Price and Gaddis 2005, 2:240. Verina too was called "the orthodox Helena" when she crowned her brother Basiliscus in *Parastaseis syntomoi chronikai* 29, trans. Cameron and Herrin 1984, 92–93. So was also Sofia, wife of Justin II. In a poem, the sixth-century Latin poet Venantius Fortunatus compares Justin II to Constantine and Sofia to Helena. Trans. in George 1995, 65, p. 114. Another pair of a new Constantine and a new Helena includes Tiberius and his wife, Ino, who, after their coronation, were acclaimed as Constantine and Helena. The evidence for this is from John of Ephesus, *The Ecclesiastical History* 3.5 and 3.10 (Tiberius) and 3.9 (Ino). The translation from the Syriac is available at the Tertullian Project website, www.tertullian.org/fathers/ephesus_3_book3.htm (accessed November 27, 2013). Emperors acclaimed as "New Constantines" include Justin I; see Constantine Porphyrogenitus, *De cerim.* 1.93, trans. Moffat and Tall 2012, 1:430. See also discussion in Whitby 1994, 83–93. Also, see discussion above.

9. Statues of Helena: *Parastaseis syntomoi chronikai* 11, trans. Cameron and Herrin 1984, 71–73, three removed from Hagia Sophia, one of porphyry, one of bronze with silver

inlay, and one of ivory). Statues of Constantine and Helena: *Parastaseis syntomoi chronikai* 16, trans. Cameron and Herrin 1984, 78–79 (in the forum); 34, trans. Cameron and Herrin 1984, 94–95 (on the roof of the Milion); 43, trans. Cameron and Herrin 1984, 118–21 (of Constantine, Fausta, and Helena); 52, trans. Cameron and Herrin 1984, 126–27 (at the Forum Bovis, set by Constantine, both of them holding a cross); 53, trans. Cameron and Herrin 1984, 129 (in a church of the Theotokos, Constantine, and Helena, and Chirst and the Virgin Mary); 58, trans. Cameron and Herrin 1984, 134–35 (the Philadelphion square, Constantine and Helena seated on thrones with Constantine's sons).

10. On the variations and continuity of the message in the later empire, see, for example, Noreña 2011, 295–97. For continuity in the message in the period afterward, see Manders 2012.

11. For instance, Alföldi 1970. The persistent idea about the divine election of the emperor: Fears 1977. Consistently showing emperors with divine attributes: Hallett 2005, 248–54.

12. See chapter 3 and Hahn 1994, Mikocki 1995, and Alexandridis 2004.

13. Broadly: Weber 2000 and Potter 1994. Constantine's pagan vision in: *Pan. Lat.* 6 (7).21–22. Christian vision: Euseb. *VC* 1.28–32. The literature on Constantine and the vision is vast. Recent monographs of Constantine include: Alchermes 1998; Bardill 2012; Barnes 2011; Drake 2000; Hartley 2006; Maraval 2011; Odahl 2010; Stephenson 2009; Van Dam 2007, 2001. Other important works include: Barnes 1981; Lenski 2012.

14. Suggested by Pelliccioni 1975; Krautheimer 1983, 15. On the Lateran as part of an imperial palace, see Brandt 2001, 109–14. For the Lateran basilica, known as Basilica Constantiniana, see *LP* 34.9.52 (Mommsen) with Duchesne 1981, 1:172 (text) and 191 (commentary).

15. Constantine as bishop: Straub 1967, 37–55. For Constantine portrayed in Eusebius as a New Moses, a typology embracing his secular and priestly responsibilities, see Rapp 1998, 685–95.

16. Constantine abandons the rugged soldier look of the Tetrarchs, association to Jupiter and Hercules, and the like.

17. Bastien 1992, 1: 31–32 (with a discussion with earlier literature). Constantine first appeared beardless on coinage when he was still Caesar but made more dramatic changes after 312.

18. Alföldi 1963, 51, with figs. 60, 63, 64 and 274 (Probus).

19. *RIC* 5.2 Constantius 650. A bronze coin minted in Trier, in 295. The obverse shows a radiate draped cuirassed bust of Constantius, the reverse depicts Sol standing, right hand raised, left holding a globe, captive at feet. Obverse legend: CONSTANTIVS NOB CAES. Reverse legend: CLARITAS AVGG; PTR in exergue. See also Smith 1997, 188–89.

20. On the forum and Constantine's statue, see Soc. 1.17; *Patria*, 2.45, 3.11, 3.132; Zosimus, *Historia nova* 2.30.4; *Chron. Pasch.*, pp. 528–29. See also, Bardill 2012, 99–109; Bassett 2004, 68–71, cat. no. 109, pp. 192–204 (with other references); Wallraff 2001a, 261–62; Bergmann 1998, 284–87; Dagron 1974, 40 ff.; Müller-Wiener 1977, 255–57.

21. On the rays, see discussion in Fowden 1991, 125–31 (the rays are first mentioned in Malalas, 320, trans. Jeffreys and Jeffreys 1986, 174, a cross relic is noted in Soc. 1.17). For the procession of Constantine's statue at the founding day of the city, see Bauer

2001, 32–37. Also, see Bardill 2012, 28–36 with fig. 22 (showing the image of the base with a relief of Constantine's head with a solar crown), 106–9. Against reconstructing the statue with rays: Barnes 2011, 23–25. This seems unlikely in light of the sources and the fact that the Peutinger map may not be copying correctly the original, especially as a recent study demonstrates that the map was medieval. See, Albu 2005, 136–48. Eusebius cannot be considered reliable on this matter either, given his objective to present Constantine as pious and Christian as possible. On Eusebius, see chapter 8.

22. *BMCRE* I: no. 633 for the Augustan coin. For the Vespasian coin, see *RIC* 2 Vespasian 119. Vespasian also minted coins with a Capricorn, Augustus's sign. See, *RIC* 2 Vespasian 118.

23. On this, see Marlowe 2010, 199–219.

24. For instance, the renewal of cities mentioned in *Pan. Lat.* 6(7).22.5, trans. Nixon, 252 and 252 n. 99, commentary.

25. Paulinus, *Carmina* 19.329–42. Translation: "When Constantine was founding the city named after himself, and was the first of the Roman kings to proclaim himself a Christian, the godsent idea came to him that since he was embarking on that splendid enterprise of building a city which would rival Rome, he should likewise emulate Romulus' city with a further endowment—he would eagerly defend its walls with the bodies of the apostles." Trans. Walsh 1975, 142.

26. Philostorgius, 2.9 reports a *limitatio* of the boundary with a lance discussed in Bassett 2004, 22–23.

27. On Alexander's spear-won territories, see Diod. Sic. 17.17.2. See also Hammond 1988, 389–90. For the Doryphoros Alexander and its significance, see Stewart 1993, 161–71, esp. 167: "These spear-bearing Alexanders asserted his authority over his 'spear-won' land of Asia with economy and precision: they proclaimed it as his personal territory given him by the gods." On the idea that divine characteristics imply praise, see Hallett 2005, 259–70. For another comparison between Constantine and Alexander, see *Pan. Lat.* 12.5.1–4, with Nixon and Rodgers 1994, 303 n. 31 and n. 32.

28. See note 8, above, the Acts of Council of Chalcedon. The discussion that follows challenges the notion that Constantine flourished as an imperial paradigm only after the seventh century, a notion that is mostly based on direct use of Constantine's name, and less so on symbolic acts that approximate Constantine's. See the summary essay by Magdalino 1994, 1–10, esp. 3–4. On the phenomenon of Constantine becoming a figure of hagiography, see Kazhdan 1987, 196–250. For the turning point in the relationship to Constantine's memory as dated to Tiberius's reign (578–82), but consolidated later in the seventh century, see Whitby 1994, 83–93. For connections between Eusebius's presentation of Constantine and Socrates' and Sozomenos's portrayal of Theodosius II, see Harries 1994, 35–44.

29. On this, see Straub 1967, 37–55. On imperial legislation, favoring the Christian church, see Barnes 2011, 131–35.

30. On the Senate House, see *Chron. Pasch.*, p. 529 with Whitby and Whitby 1989, 16. Some Roman senators followed Constantine to Rome. On the senate, see *Origo Constantini Imperatoris* 30. The senate was of second rank, according to the *Origo*, the senators being called *clari*, rather than *clarissimi*. But, see on making new *clarissimi*, Euseb. *VC* 4.1.2.

On the senators' lodgings, see Zosimus, *Historia nova* 2.31.3. See also Heather 1994, 11–33; Barnes 1981, 257; Jones 1964, 1:106–7, 1:523–62; Dagron 1974, 120–24, esp. 124 (based on the expression "Constantine's senate" infers inferiority of Constantinople's senate); Cameron-Hall, 310. Constantine's political reforms in Rome also included disbanding the praetorian guard (*Pan. Lat.* 12.21.3; 4.33.6; Zos. 2.17.2; Aurelius Victor, *Liber de Caesaribus* 40.25, making the imperial mint mobile (Bruun 1961). For his reforms of the senate: *Pan. Lat.* 4.35.2 and Ammianus Marcellinus, 21.10.8 with Salzman 2002; Marlowe 2010, 216. For Constantine's innovative legislation, see Dillon 2012.

31. With the exception of course of Septimius Severus, the first emperor to build in Byzantium. On the city before Constantine, see Dagron 1974, 13–19.

32. *Chron. Pasch.*, pp. 528–29, and Mango 1959, 46.

33. *Origo* 2.2; Ambrose, *De obitu Theodosii* 42. Ambrose calls her *stabularia*, female innkeeper, with Liebeschuetz 2005, 198.

34. For the diadem, see Euseb. *VC* 4.66. He refers to it as *diadēma*. Coinage dates its introduction to 325. See, Alföldi 1963, 93; Angelova 2004, 3; Bastien 1992, 1:143–64. The *Chronicon Paschale* also mentions it (*Chron. Pasch.*, p. 529). On Constantine's iconography also see Hannestad 2001, 93–107.

35. Euseb. *VC* 4.66, refers to the diadem and the purple as imperial emblems.

36. Euseb. *VC* 3.42–44.

37. Euseb. *VC* 3.44.

38. For how the bishops joined the conversation: Drake 2000 (especially as, first, recipients of imperial coercion, and, second, as turning the tables by positioning themselves as evaluators of imperial conduct); Rapp 2005 (in various capacities, spiritual, civic, practical). For the common intellectual basis, shared by emperors and bishops alike, compelling argued, see Elm 2012.

39. *Pan. Lat.* 7 (6), 21, 22 (on this temple of Apollo). Translation and commentary, see Nixon 1994, 248–51 (translation), notes 91–95 (commentary with discussion of the literature). On the vision, see discussion in MacMullen 1968; Barnes 1981, 36; Rodgers 1980, 259–78 (parallels with Augustus); Weiss 2003 (first published 1993), 237–59; Van Dam 2011, 61–81 (Constantine's memories about the vision) and 2–100 (Eusebius's evolving accounts about the vision); and Barnes 2011, 78–79.

40. *Pan. Lat.* 7 (6), 21, trans. Nixon 1994, 248 with n. 91.

41. *Pan. Lat.* 7 (6), 21.4.

42. *Pan. Lat.* 7 (6), 21.4–5, trans. Nixon 1994, 248–50, 250 n. 93. On this case of intertextuality, and Constantine's connection to Augustus, see Rodgers 1980, 269–73.

43. *Pan. Lat.* 7 (6), 21.4, trans. Nixon 1994, 248–50, 248 n. 92. Also see, Rodgers 1980, 268–69.

44. On this coinage, see Nock 1947, 102–16; Alföldi 1964, 10–16; Wallraff 2001a, 260. For examples, see *RIC* 7 Constantine 5–20, 32–34, 44–47, etc. among many others, minted in various places. Also see, Hartley 2006, cat. no. 89. Solidus minted in Ticinum. Obverse: Constantine and Apollo Sol, COMIS CONSTANTINI AVG.; Reverse: *Liberalitas* with LIBERALITAS XI IMP IIII COS PP, pp. 145–45.

45. Smith 1997, 187–208; Bardill 2012, 90–91 (with the sources).

46. Euseb. *VC* 1.28–32.

47. The coins continued to be minted at least until 325. See *RIC* 7 Constantine 49 p. 685; Alföldi 1964, 10–16; Wallraff 2001a, 260.

48. Peirce 1989, 387–418; Elsner 2000, 149–84; Holloway 2004, 19–50; Marlowe 2006; Lenski 2008, 204–57; Bardill 2012, 94–109.

49. Marlowe 2006, 229–33.

50. Roccos 1989, 571–88 (for Apollo Palatinus); Steinby 1993–2000, 1:86–91.

51. The meaning of this famous phrase has been discussed at length by various scholars. I take *instinctus* as "instigation" and "inspiration." See *OLD*, s.v. "instinctus." Barnes refers to the phrase as a "contemporary cliché." See Barnes 1981, 308 n. 24 (citing *Pan. Lat.* 12, 11.4). Lenski takes it as suggestive of the ritual of *evocatio*, following in part from translating *instinctu* as "goading." See Lenski 2008, 204–57. For discussions stressing the ambiguity, MacMullen 1969, 111–20 (the vagueness of the phrase "bridg[ed] the gap between paganism and Christianity"); Grant 1994, 152–55 (Constantine was Christian, but wanted to ensure harmony among his subjects); and Bardill 2012, 223. For the inscription, see *CIL* 6.1139 = *ILS* 694. "Imp. Caes. Fl. Constantino maximo / p.f. Augusto S.P.Q.R. / quod instinctu divinitatis mentis / magnitudine cum exercitu suo / tam de tyranno quam de omni eius / factione uno tempore iustis / rempublicam ultus est armis / arcum triumphis insignem dicavit [To the Emperor Caesar Flavius Constantinus Maximus, P(ius) F(elix) Augustus, the Senate and People of Rome dedicated this outstanding arch of triumph, because by the instigation/inspiration of the divinity and by greatness of his mind, and with his army, he avenged the state with righteous arms against both the tyrant, and all of his faction, at one and the same time]."

52. Cic. *De div.* 1.12.1–10, 1.34.7–12, 1.66.1–4, 1.64.4–10, 1.6.12, 1.18, and 2.11.

53. Cic. *De div.* 1.6.12, 1.18, 1.12.1–10, 1.34.7–12, 1.66.1–4, 1.64.4–10, and 2.11. Most of these are discussed in Hall 1998, 653–56.

54. Cic. *De div.* 1.34.

55. E. Marlowe emphasizes the connection to Apollo but neglects its potential to be treated as an Apollonian prophecy: Marlowe 2006, 235–37. L. Hall draws attention to the meaning of the phrase, nevertheless, understands it in the context of a "shared vocabulary of religious experience." In other words, it would have been acceptable to both Christian and pagans. See Hall 1998, 670.

56. Cic. *De div.* 1.34. *Instinctus* and *afflatus* are virtual synonyms. *OLD*, s.v. "afflatus," 5. "A poetic or other impulse considered as divinely imparted, inspiration." *OLD*, s.v. "instinctus," 1. "Instigation, prompting. b (applied to divine instigation) 2. Excitement, enthusiasm, inspiration."

57. Digeser 2004, 58. Her examples include Plutarch's *De defectu oraculorum* and his *Pythiae oraculis Or.* 63–65.

58. For "inspired oracles," see Potter 1994, 37–40, and earlier Cic. *De div.* 1.6.12, 1.18, and 2.11.

59. Golden age: Optatian, 3.12, 14.19, 15(3).5. Light: Optatian, 19(4).2 (*lux aurea saeculi*), 19(4).12 (*Romula lux*), 15(3).14 (*lux pia Romulidum*), 7(23).12 (*lux alma*), 15(3).14 (*lux aurea Romae*). I thank John N. Dillon for drawing my attention to Optatian, for

providing the references to Sol, cited below, with rough translations, and for his generous advice. On the dates of Optatian's poetry see Barnes 1975, 173–86; and Edwards 2005, 447–66. For the finer points of dating, see Barnes and Edwards, cited above. See also Bardill 2012, 104.

60. Optatian, 12.6 and 18.25.
61. *VC* 1.31. As noted in the commentary to the *VC*, the vision Eusebius describes does not include a Chi-Rho, but the standard does. So it must be inferred that the monogram was an addition not the actual vision. See Cameron-Hall, 207. For a similar reading of Lactantius's *caeleste signum dei*, see Barnes 2011, 79.
62. For the reasoning and dates, Barnes 1975, 174.
63. Euseb. *VC* 3.54.2.
64. Tripods: Euseb. *VC* 3.54.2 with Bassett 2004, 224–27.
65. On the obelisks, Bardill 2012, 154–57.
66. Zosimus, *Historia nova* 2.31, also Euseb. *VC* 3.54, Soc. 1.16, *Patria* 2.79, gathered and discussed in Bassett 2004, 230–31. This is may be the one Zosimus reports as decorated with a statue of Apollo on top of it. Ancient references to the tripod of Plataea also include Thucydides 1.32.2, 3.57.2. See commentary by R. W. Macan online at the Perseus Digital Library, www.perseus.tufts.edu/hopper/text?doc=Perseus%3Atext%3A1999.04.0038%3Abook%3D9%3Achapter%3D81 (accessed December 2, 2014).
67. For how the Pythia delivered the oracles, see Amandry 1950, 41–56 (no evidence for frenzy); Fontenrose 1978, 224–25.
68. See chapter 1.
69. On the ass and keeper, see Bassett 2004, 62, cat. no. 122. On Mark Antony as associated with the East in a negative way, see Zanker 1988, 46–47. On how the collection at the Hippodrome projected power in a more general way, see Bassett 1991, 89–90, 2004, 89.
70. Philostorgius, 2.9.
71. See notes 2 and 61.
72. Weiss 2003, 237–59. The work develops an idea proposed earlier. See, for instance, discussion in Jones 1962, 85–106. Strong endorsment and contextualiztion in Barnes 2011, 74–80.
73. See Weiss 2003, 252–53. Also see, MacMullen 1969, 112; Wallraff 2001a; Potter 2013, 155–59.
74. *Oratio ad coetum sanctorum* 18. The work, originally written in Latin and then translated into Greek by professional interpreters was appended to the *Vita Constantini* by Eusebius (*VC* 4.32). Edition of the oration: Heikel 1902, 149–92. Trans.: Edwards 2003, 1–62. Discussion: Drake 1985b, 335–49 n. 2 (with literature and discussion of its authenticity); Drake 1989, 43–51; 2000, 292–306, 293 (because translated into Greek was likely delivered in the East), 299 (providence), 298–301 (pluralism and toleration); Barnes 1976, 414–23; 1981, 75; Hanson 1973, 505–11; Digeser 2004, 67–68; Edwards 1995, 379–87. For the dating to 325, see Barnes 2011, 113–18.
75. Trans. Edwards 2003, 40–41.
76. *Oratio ad coetum sanctorum* 18.2.
77. *Oratio ad coetum sanctorum* 18 and 19. See commentary in Edwards 2003, 40–47.

78. "But when they praise my service, which commenced with the inspiration of God, do they not confirm that God is the cause of my feats? Absolutely." *Oratio ad coetum sanctorum* 26. Trans. Edwards 2003, 61. Also on the oration as a call to religious toleration, see Drake 2000, 298–99.

79. *Pan. Lat.* 6 (7), 21.4.

80. See Nixon's commentary in Nixon 1994, 248 n. 91 (referring to a study by Müller-Rettig). Lactantius, *De mortibus persecutorum* 44, heavenly vision reference noticed by Barnes 2011, 79.

81. *Patria* 2.18.

82. Weiss 2003, 249–51.

83. Potter 1994, 39–40, discussing Aelius Aristides, *The Sacred Tales* 3.10–12.

84. Potter 1994, 55, referring to Origen and Lactantius.

85. On the palace as a complex, see Angelova 2014, 97–99.

86. On the Augustaion, see *Patria* 1.44, 2.15; *Chron. Pasch.*, pp. 528–29.

87. For the Constantinian development of the city, see Dagron 1974; Mango 1985, 23–36; Müller-Wiener 1977, 19–23; Bassett 2004, 22–26. Sarah Bassett makes an elegant case for how the decoration of the Zeuxippus Baths made a case for Constantinople's equality with Rome. See Bassett 1996, 491–506.

88. On the churches, see Euseb. *VC* 3.47, 4.58–60; and Krautheimer 1983, 56 (only the Holy Apostles was completed). Hagia Sophia was dedicated in 360 by Constantius. Hagia Irene: Soc. 1.16; Holy Apostles: Soc. 1.16; Soz. 2.34; and Theod. Lect. 14.21; Archangel Michael: Soz. 2.3.10; Theod Lect. 14.21. Hagios Mokios: Theod. Lect. 14.21; *Patria* 3.3; Barnes 1981, 222. Hagios Akakios: *Patria* 3.18, it is mentioned also in Soc. 4.21, 6.23; Mango 1985, 35–36; Dagron 1974, 388–89. Hagia Sophia is also attributed to Constantine, but the attribution is late, see Theophanes, *Chronographia* 24 (with Mango and Scott 1997, 37, 40 n. 24). Soc. 2.43 gives the builder as Constantius (consecrated in 360 "in the 10th consulship of Constantius"). See also *Chron. Pasch.*, p. 544 (attributes foundations to Constantine, inauguration to Constantius), and discussion in Dagron 1974, 397–400; Krautheimer 1983, 50, fig. 42; Janin 1964, 107–8; Armstrong 1967, 1–9.

89. Bassett reproduces the *Tabula Peutingeriana* and a cameo showing Constantine with the Palladion, see Bassett 2004, pls. 19 and 22. On the statue, also see Bergmann 1998, 284–87; Bardill 2012, 104–9.

90. On the radiant crown, see Soc. 1.17; *Patria* 1.45a; Malalas, 321, *Chron. Pasch.*, pp. 528, 573. The Tabula Peutingeriana shows a nude figure holding a spear and a globe in his outstretched right hand. See Bassett 2004, pl. 19, 192–97 (with the literary sources). For images online of the *Tabula Peutingeriana*, see Bibliotheca Augustana, www.hs-augsburg.de/~harsch/Chronologia/Lspost03/Tabula/tab_intr.html (accessed September 19, 2014).

91. For the drawing, see Bardill 2012, figs. 22 and 23.

92. Wallraff 2001a, 261. As Wallraff points out, dating this dedication to before 324 is based on the faulty premise that Apollo Sol fades from Constantine's public image after 324.

93. On the Holy Apostles: Krautheimer 1983, 56–60; Dark and Özgümüş 2002, 393–413; Bardill 2012, 381–84. Now, on the sarcophagus, see Johnson 2009b, 116–18.

94. For its similarity to other mausolea, see Mango 1990, 54–55. Also see, Johnson 2009b, 119–29.

95. The debate about the plan of the edifice is summarized in Mango 1990, 51–61.

96. See *VC* 4.60.3. *Thēkai* could mean either relic containers or coffins. The same term is used by Sozomen to indicate a coffin and a relic container. See, Soz. 9.2.11–15 (coffin), 9.2.17 (relic container). Also on the *thēkai,* see Johnson 2009b, 120. On the sarcophagus, see proposal in Bardill 2012, 187–94.

97. Euseb. *VC* 4.60.2. With Mango 1990, 51–61; Johnson 2009b, 123–28 ("Constantine had planned a building that blurred the distinction between a church and a mausoleum.").

98. Euseb. *VC* 4.59.

99. For the names, see, for instance, *Notitia* 237. The structures in the Kōnstantinianai are discussed in Dagron 1974, 401–4; Janin 1964, 372–73; Krautheimer 1983, 58; Prinzing and Speck 1973, 179–81.

100. For the palace at Spoleto, see Ćurčić 2010, 26–42 (Split), fig. 14. And also, Marasović and Marasović 1968, 10–25.

101. La Regina 2001–8, s.v. "Maxentius Praedium (via Appia)," 4:49–59. Also, Johnson 2009b, 86–93, figs. 62–68.

102. For Christ with the apostles, see the apse mosaic from ca. 390 in Santa Pudenziana, Rome. On the association with Christ, see Krautheimer 1983, 62–67. For a similar conclusion about the Savior and Constantine, see Bardill 2012, 126.

103. Euseb. *VC* 4.60.

104. See discussion in Dagron 2003, 139–43: "Constantine's Holy Apostles was, therefore, an attempt to reconcile an imperial cult and a Christian cult, at the price of a double anomaly that all the skill of Eusebios cannot quite conceal."

105. Julian reports that Constantine's veterans worshiped him as god. See Julian, *Or.* 1.8 A. Aurelius Victor also reports that for Constantine's abolition of crucifixion as a death penalty he was considered either a founder (*conditor*) or god (*deus*). In Aurelius Victor, *Liber de Caesaribus* 41, trans. and commentary H. W. Bird, 49 and 190 (commentary). Also, the solar symbolism and the cult to the Constantine's family, see Wallraff 2001a, 263–64.

106. On the name (Constantine wanted it named after himself): Euseb. *VC* 3.48, Jul. *Or.* ("In Praise of Constantius," 1.5 (named after Constantine's family (*genos*), Soz. 2.3.2. See also discussion on the founding of Constantinople (New Rome or Second Rome): Dagron 1974, 19–29 (suggests that it was as dynastic capital of the Constantian dynasty); Bühl 1995, 35–40 (the author decides that the founding of Rome was unlike any other city, and adopts instead of "new" or "second" Rome, "Neben-Roma"). Also on the founding, emphasizing its Christian aspects, see Bardill 2012, 251–54.

107. For the Tetrarchic tombs as avoiding the dynastic type of mausoleum, see Johnson 2009b, 58.

108. On the emperors and empresses buried there, see Grierson 1962, 3–63; Croke 2010, 241–64.

109. *ACO* 2.1.2, trans. Price and Gaddis 2005, 2:240.

110. On the emulation, see Brubaker 1997, 52–75.

111. Steinby 1993–2000, 1: fig. 116.

112. For Helena's dates, see Drijvers 1992, 59, 73. But see discussion on the date the cross was found, and on the date of Helena's journey in Borgehammar 1991, 130–39. He suggests that Helena traveled to Palestine around 324–25, and that the cross must have been discovered in the spring of 325. Borgehammar bases his rationale in part on Eusebius's lack of "reliable chronological framework" in the *VC* (Borgehammar 1991, 134.). M. Sordi proposes that the cross was found between 333–37, on the basis in part on Cyril's letter; see Sordi 1990, 5.

113. A succinct summary for the early history in Borgia et al. 2008b, 1–2.

114. Colli 1996, 808–9.

115. Barnes 1982, 68–80.

116. For the history and archeological excavations at the palace, see Colli 1996, 771–815; Borgia et al. 2008a, 18–41; Borgia et al. 2008b, 1–17; Steinby 1993–2000, s.v. "Sessorium," 4:304–8; Barbera 2000, 104–12; Richardson 1992, s.v. "Sessorium," 361–62; Colini 1955, 137–77. The area around the palace in pre-Constantinian times included Amphiteatrum Castrense, the baths later called Helenae, a big hippodrome and perhaps a temple of Elagabalus; see Steinby 1993–2000, 4:305, 1:fig. 116, 3:fig. 7, 384.

117. "Item in basilica sanctorum Petri e Marcellini donum dedit . . . fundum Laurentum iuxta formam cum balneum et omnem agrum a porta Sossoriana usque ad via Penestrina a via itineris Latinae usque ad montem Gabum, possessio Augustae Helenae." *LP* 67 (Mommsen) and Duchesne 1981. Trans., slightly amended, by Davis 2000, 24. See La Regina 2001–8, s.v. "Helenae Augustae possessio," 3:44–45. For the whole donation, *LP* 65–66 (Mommsen) and Duchesne 1981, 1:182–83 (text), 198–99 (commentary). On Helena's tomb in the church, *LP* 66 (Mommsen) and Duchesne 1981, 1:182. For the Sessorian Palace, see Steinby 1993–2000, s.v. "Sessorium," 4:304–8; Duchesne 1981, 1:198–99.

118. Rasch et al. 1998, 8; and Tafel 69 (but the eastern boundaries of this map are hypothetical).

119. Mons Gabus: perhaps this is Gabii/Cabios on the Peutinger map, segment grid 5B1: www.cambridge.org/us/talbert/talbertdatabase/TPPlace1311.html. OmnesViae: Roman Routeplanner website (OmnesViae.org, accessed July 25, 2012) locates this place in the area of current day Osteria dell'Osa (Italy). The corresponding place in Pleiades (Ancient Places) is http://pleiades.stoa.org/places/422932 (access date July 25, 2012). The distance from the Porta Maggiore to Osteria dell'Osa on maps.google.com is 15.6 km.

120. Platner and Ashby 1929, s.v. "Via Latina."

121. Palladino 1996, 855–71; Borgia et al. 2008b, 12–17; Colini 1955, 141–48. In the sixteenth century Andrea Palladio drew a ground plan of the bath and its cistern. It is reproduced in Palladino 1996, fig. 2.

122. Palladino 1996, 870–71 (for the reasons of their public character); Borgia et al. 2008b, 14–17 (additional arguments).

123. *CIL* 6.1136; Borgia et al. 2008b, 13–17; Palladino 1996, 855–71; Steinby 1993–2000, s.v. "Thermae Helenae," 5:59; Drijvers 1992, 47–48; Richardson 1992, s.v. "Thermae Helenae," 393.

124. Merriman 1977, 436–43. See also Borgia et al. 2008b, 13–14 (on the cistern). For the history of Roman aqueducts, their capacity, and role in sustaining the Roman lifestyle, see Taylor 2000.

125. *LP*, 61.25–26 (claims Constantine was the builder); Duchesne 1981, 1:196. See also, Brubaker 1997, 58; Krautheimer 1986, 50; 1983, 23, 29.

126. Steinby 2001–8, s.v. "Hierusalem Basilica," 3:27–28. For the date, established on the basis of brick-work, the patron, and *LP* see Krautheimer 1937–77, 1:167, 191–92; Steinby 2001–8, s.v. "Hierusalem Basilica," 3:27–28, esp. ; Colli 1996, 771–815; Colini 1955, 154–59.

127. For Helena's ability to enter without being seen, see Colli 1996, 782.

128. Borgia et al. 2008b, 1–2, and fig. 1.

129. *Gesta Xysti purgationis*, *PL* suppl., 3.1250, with Steinby 2001–8, s.v. "Hierusalem Basilica," 3:27. On Helena's finding of the cross, see Ambrose's oration, above, for the Helena legend, see Sordi 1990, 1–9; Drijvers 1992; Pohlsander 1995.

130. *LP* 61 (Mommsen), Duchesne 1981, 1:196, and *Gesta Xysti purgationis*, *PL* suppl., 3.1250.

131. True Cross: Soz. 2.1.2, p. 47. Crucifixion site: Ambrose, *De obitu Theodosii* 41; Rufinus, 10.7.14–15. Christ's tomb: Soc. 1.17.1. On the place of her death, see discussion and sources in Johnson 2009b, 211–12.

132. *LP* 61.25–26.

133. In 386 Ambrose sought relics to dedicate the Basilica Ambrosiana. See Ambrose, *Ep.* 77.1. Ambrose described it in a letter to his sister, Marcellina. This is *Ep. 77* (Maur. 22). Trans. Liebeschuetz 2005 (*Epistula 77* [Maur. 22] to Ambrose's sister, Marcellina), 204–12.

134. Eusebius does not mention Rome by its name. He calls it "the imperial city," his habitual name for Rome. See Cameron-Hall, 345. For Rome as her burial place, see also Johnson 1992, 147–50. Rome is mentioned as well in the ancient vitae of Constantine and Helena. See Borgehammar 1991, 72 with n. 53. The texts are *BHG* (Bibliotheca hagiographica graeca) 364, 365z, and 366a, edited by Winkelmann 1987, 623–38.

135. On the chronology, see note above.

136. On the relationship between church building, cult of the martyrs and their remains, see discussion with the evidence in Maraval 2002, 65; 1985, 251–410 (extensive catalog of martyria); Yasin 2009, 153 (relationship between altars and relics); Limberis 2011, 9–52.

137. *LP* 65–66 (Mommsen) and Duchesne 1981, 1:182–83, 198–99; La Regina 2001–8, 3: fig. 103; Krautheimer 1937–77, 2:191–204. Also see Tschira and Deichmann 1957, 44–110, 76–77 (Helena's gifts to the building suggest that she was involved in the building).

138. Before 324 Constantine controlled only the western part of the empire. Krautheimer 1937–77, 2:192 (coin), 202 (brick stamps and donations, basilica). Also, see summary in Johnson 2009b, 110–18.

139. *LP* 54–56, 65–67, 58–60 (Mommsen), respectively, Lateran (4,390 solidi), St. Peter and Marcellinus (3,754 solidi), St. Peter's (3,718 solidi, my calculation). St. Agnes was Constantia's mausoleum. See also, La Regina 2001–8, s.v. "Helenae basilica, ecclesia, mausoleum, rotunda," 3:46–47; Duchesne 1981, 1:191–93 (Lateran), 1:182–83 (SS. Marcellinus and Peter), 1:176–78 (St. Peter's).

140. Krautheimer 1937–77, 2:202. R. Krautheimer and the church's excavators Friedrich Deichmann and Arnold Tschira all agree that the mausoleum must have been built for Constantine. One of their arguments is that the porphyry sarcophagus with battle

scenes, used for Helena, must have been intended for Constantine and his family. This indeed may have been Constantine's intention very early in his reign. But immediately after September 18, 324 (the abdication of his co-emperor Licinius after his defeat at the battle of Chrysopolis), on November 8, 324, he began the construction of the new capital on the Bosphorus (Alföldi 1948, 92–104); Dagron 1974, 32–33, with a discussion of the sources; Barnes 1982, 68–82, on the dates). G. Dagron argues that plans for a new capital may have been under way much earlier, to judge from the emperor's few brief stays in Rome between 313 and 326 (Dagron 1974, 77–78). Thus, even if SS. Marcellinus and Peter was initially meant as his mausoleum, it was no longer so after November 324.

141. On Constantine's travels, see Barnes 1982, 68–80.

142. Peter and Marcellinus were martyred in Rome between 303 and 305, see Krautheimer 1937–77, 2:191.

143. *Thēkai* were most likely relic containers. The same term is used by Sozomen to indicate a coffin and a relic container. See, Soz. 9.2.13 (coffin), 9.2.17 (relic container). Indeed, in the fifth century a imperial mausoleum was constructed in St. Peter's, suggesting that the church may have been deemed appropriate for an imperial tombs. That this may have been the case from its foundation has been suggested without explanation by Krautheimer 1937–77, 5:178–80, 180–81 (on the mausoleum for Honorius, and his wives, Maria, and Thermantia); Johnson 2009b, 167–74. The presence of relic containers at such an early date (Constantinian) may be considered suspect, given imperial legislature against the digging of tombs. On this see Mango 1990, 51, referring to *Cod. Theod.* 9.17.4, 9.7 (a. 386). But it is the fact that relics were indeed deposited in the Holy Apostles, their deposition usually dated to the years 356 (Timothy) and 357 (Luke and Andrew, *Chron. Pasch.*, p. 542), see Mango 1990, 52–54. However, three consular lists date these translations to 336. See Whitby and Whitby 1989, 33 n. 102.

144. On these, see La Regina 2001–8, s.v. "Helenae basilica, ecclesia, mausoleum, rotunda," 3:45–46.

145. For the whole donation, LP 65–66 (Mommsen); on Helena's tomb in the church, LP 66. For the Sessorian Palace, see Steinby 1993–2000, s.v. "Sessorium," 4:304–8; Duchesne 1981, 1:198–99.

146. LP 66 n. 22 (Mommsen) and Duchesne 1981, 1:183–84. Also mentioned in Tschira and Deichmann 1957, 76–77; Brubaker 1997.

147. Compare with Justinian's buildings in Carthage, where he built a palace-church, another one to a local saint, a bath, and porticoes, and rebuilt the circuit wall of the city, see Procop. *Aed.* 6.5.8.

148. Tiftixoglu 1973, 75. See note 112 above on Helena's dates.

149. Malalas, 321; *Patria* 1.44, 2.15; Mango 1959, 42–47.

150. Müller-Wiener 1977, 216–18.

151. *Parastaseis syntomoi chronikai* 34, 16 (respectively), trans. Cameron and Herrin 1984, 95 and 79–81.

152. Ibid., 58, trans. Cameron and Herrin 1984, 135.

153. Ibid., 52, trans. Cameron and Herrin 1984, 127.

154. Ibid., 43, trans. Cameron and Herrin 1984, 119–20.

155. Other imperial statues, see Cameron and Herrin 1984, 49. For instance, at the Milion were later placed statues of Sophia, Arabia and another Helena, equestrian statues of Arcadius and Theodosius II. On those, see *Parastaseis syntomoi chronikai* 35–35a, trans. Cameron and Herrin 1984, 95. At the Augustaion, statues of Eudoxia, Julian, etc. See *Parastaseis syntomoi chronikai* 31, trans. Cameron and Herrin 1984, 93.

156. See Theod. Lect. 131–33, which describes a miracle in the bath of Helena near her palace. On this account are based the relevant passages in the *Chronicle of Theophanes the Confessor* (ca. 800) (Theophanes 142; Mango and Scott 1997, 218), and an oration of John of Damascus (early eighth century) (*De imaginibus* (*Or.* 3), *PG* 94:1388–93). This oration is partially translated in Mango 1986, 35–36. On the baths, Janin 1964, 131.

157. Procopius, *De bellis* 1.24.30 and John of Damascus, *De imaginibus* (*Or.* 3), quoted in Theod. Lect. 131.

158. The Peribleptos Monastery was founded in 1031; see Müller-Wiener 1977, 200. On the palace see, Tiftixoglu 1973.

159. Tiftixoglu 1973, 83. Two other possible founders are Hellenios, a state official (governor of Cappadocia Secunda after 372, *vicarius urbis* in 386), and a younger Helena (wife of Julian [355–60] and daughter of Constantine and Fausta). *PLRE*, s.v. "Hellenius 1, Hellenius 2," 1:413; Tiftixoglu 1973, 74–75.

160. Tiftixoglu 1973, 83.

161. *Patria* 3.1–19; Berger 1988, 656.

162. *Synaxarium mensis octobris* 13.1–4.

163. Krautheimer 1986, 75; Müller-Wiener 1977, s.v. "s. Menas," 186–87.

164. *Patria* 3.82; with additional bibliography and discussion, see Janin 1953, 288–89.

165. Krautheimer 1986, 75; Müller-Wiener 1977, s.v. "s. Menas," 186–87.

166. Krautheimer 1986, 75.

167. Paulinus of Nola, *Epistle* 31, 4, trans. Walsh, 129 (Helena used money of the imperial treasury to built the churches at the sites of the Incarnation, Passion, Resurrection, and Ascension); Sulpicius Severus, 2.33.2 (Helena built the basilicas at the sites of the Passion, Resurrection, and Ascension); Rufinus, 10.8.20 (Helena built a temple on the site where she found the cross); Soc. 1.17.7, 1.17.11 (Helena built a church on the site where she found the cross and called it "New Jerusalem"). "New Jerusalem" is how Eusebius refers to the Martyrium in Jerusalem, see Euseb. *VC* 3.33.1.

168. Tiftixoglu 1973, 79–83.

169. *Patria* 3.4 with 3.136 and commentary, p. 318 n. 140.

170. The evidence suggests that the praetorian prefect Cesarius (395–97) built the church. See, Soz. 9.2; *PLRE*, s.v. "Fl. Caesarius 6," 1:171; Tiftixoglu 1973, 57–58; Holum 1982, 137.

171. *ACO* 2.1.2, trans. Price and Gaddis 2005, 2:240.

172. Ambrose, *De obitu Theodosii* 45.

173. Soz. 9.2.

174. The procession must have taken place between January 9, 400 (Eudoxia's elevation to the rank of Augusta), and either January 10, 402 (birth of her son and heir Theodosius II, who is not mentioned but may have been involved), or slightly later, before the break between John and Eudoxia. This is discussed in Holum 1982, 56 n. 35; Mayer and Allen

2000a, 85–86, 10. The text of the oration is in *PG* 63:467–72; trans. in Mayer and Allen Homily 2000a. For the processions in the capital, see more recently, Bauer 2001, 27–62.

175. Soz. 9.2.

176. Marcellinus Comes, s.a. 439.

177. For Pulcheria's piety, see Soz. 9.1, 9.3; Theodoret, 5.36, Soc. 7.22.

178. On the discord, see Holum 1982, 191–92.

179. If so, the translation of the relics of the Forty Martyrs most likely occurred either between 434 and 439 or soon after Eudocia's return in 439.

180. Philostorgius, 2.12. See also, Jerome, *Chronicon*, s.a. 327; *Chron. Pasch.*, p. 527, with Whitby and Whitby 1989, 15; Theophanes, *Chronographia* 28, trans. Mango and Scott 1997, 44. T. Barnes dates the foundation to January 7, 328, on the anniversary of Lucian's martyrdom, see Barnes 1982, 9, 77 and n. 130. Lucian was a presbyter in Antioch and an esteemed translator of the Old Testament. He was considered the teacher of Arius and some of his most eminent followers. On Lucian, see Jerome, *De viris illustribus* 77; Euseb. *HE* 9.6; Rufinus, 9.6. Teacher of Arians: Theodoret, 1.3.

181. A city in Palestine and the province Helenopontus also carried her name, see Euseb. *VC* 4.61; Jer. *Chron.* s.a. 327, Soc. 1.17.1, Soz. 2.2.5, 2.34.2 (city where Constantine received baptism before he died); for the province, Justinian, *Nov.* 28, available online at the Annotated Justinian Code: www.uwyo.edu/lawlib/blume-justinian/ajc-edition-2/ novels/1-40/novel%2028_replacement.pdf (accessed January 8, 2015). From *PLRE*, s.v. "Fl. Iulia Helena 3," 1:410. C. Mango disputes the identification of Drepanum with Helenopolis, see Mango 1994, 147. See the analysis on why traditionally accepted Drepanum should be substituted with Drepana, as well as a discussion of chronology in Burgess and Witakowski 1999, 203–4.

182. Jerome attributes the founding to Constantine. Jerome's wording is repeated in the *Chronicon Paschale*, according to which the city was found in January 7, 328. See Barnes 1982, 9 n. 40. On Jerome's chronicle see, Burgess 2002.

183. On cities named after members of the imperial family in late antiquity, see Jones 1964, 1:719–20. Also see, Burgess and Witakowski 1999, 203–4.

184. *RE*, s.v. "Helena 2," 2821.

185. On the decline of this town before Justinian, see Procop. *Aed.* 5.2.11. See also Mango 1994, 147, 50 (site badly chosen).

186. Euseb. *VC* 3.43. See commentary in Cameron-Hall, 293–94. On the Eusebian silences regarding Golgotha and the True Cross, see Drake 1985a, 1–22; Rubin 1982, 181–99; Walker 1990, 127–30; Hunt 1997, 405–24; Borgehammar 1991, 93–122.

187. Sozomen (2.1–2) attributes the discovery of the cross to the empress, but the basilica at Golgotha to Constantine. See also, Rufinus, 10.8, Soc. 1.17, and Theodoret, 1.18.7.

188. "Sub praesentia matris suae"; *Itinerarium Egeriae* 25.

189. A special ceremony associated with the relic of the cross was observed during the Encaenia festival in Jerusalem. See Maraval 1982, 37.1–2, pp. 284–86. See also, Wilkinson 1999, 136–37. See also Drake 1985a, 7 n. 22.

190. For the *Praise* (hereafter in the notes *LC*), I refer to the edition of Heikel 1902. Translation and commentary in Drake 1976. The omission has been argued in Drake 1985a, 1–22. Cyril of Jerusalem made the first direct reference to Golgotha as part of the New

Jerusalem. Cyril of Jerusalem mentioned the relic in the letter to the emperor Constantius I, dated to ca. 350, and his sermons. For Cyril's letter see below. Cyril mentioned the relic also in his *Catecheses* 4 and 10, dated 348 or 350. For a discussion of the *Catecheses*, see Borgehammar 1991, 87–90; Drijvers 1992, 89–90. For the *Catecheses*, see also Yarnold 2000a, 100; 2000b, 127.

191. Paulinus of Nola, *Epistle* 31, 4. Translated in Walsh 1967, 2:125–33, 129 (quotes), 327 (on the date).

192. Euseb. *VC* 3.42, trans. Cameron-Hall, 137. Eusebius's omission of the Crucifixion and the cross relic has been attributed to episcopal rivalry, theological, and political concerns. For Eusebius's silences, see Rubin 1982, 87–94; Borgehammar 1991, 93–122; Drake 1985a, 6–11; Walker 1990, 189–90 (on the caves); Wilken 1992b, 736–60.

193. Euseb. *VC* 3.42; Cameron-Hall, 137. For analysis of the political motivations of Helena's travels, see Drijvers 1992, 64–76. Drijvers is the first to argue against Helena's trip as a pilgrimage by pointing out its official aspects. For the view of this visit as an escape, see Lenski 2004, 114–15.

194. Euseb. *VC* 3.44; Cameron-Hall, 138.

195. Ibid.

196. Here I refer to Livia's intercession for a Gaul to receive citizenship, and to the trial against Piso's wife, Plancina. On these, see chapter 3.

197. Compare with Hunt 1997, 418 (her journey undertaken as "an agent, a representative of the ruling power," and therefore she was not mentioned in the building activities in Jerusalem). Also, compare with the alimentary programs established in empresses' names. See chapter 3.

198. See also, Drijvers 1992, 68.

199. Trans. Cameron-Hall, 139.

200. Herodian, 5.3.10–11.

201. Drijvers 1992, 65–67.

202. Drijvers 1992, 69.

203. This grandchild was born to his son Crispus and his wife Helena, *Cod. Theod.* 9.38.1 (October 30, 322).

204. See *Cod. Theod.* 9.38.1–12.

205. For a discussion of the shield, see Hölscher 1967, 102–12. Against the four virtues as a "canon," see Wallace-Hadrill 1981, esp. 310, with a summary on *Clementia*. Seneca wrote a treatise *De clementia*, addressed to Nero. See recent discussion of the imperial virtues and their Hellenistic precedents in Noreña 2011, 37–100.

206. On the emperor's virtue of *liberalitas*, see Noreña 2011, 82–92.

207. John of Ephesus, *The Ecclesiastical History* 3.5, www.tertullian.org/fathers/ephesus_3_book3.htm (accessed November 23, 2013).

208. Ibid., 3.10 and 3.9.

CHAPTER 5. CONSTANTINE'S AND HELENA'S LEGACY IN THE ORGANIZATION OF PUBLIC SPACE

1. Empresses, such as Livia, however, had villas outside the city; see Gabriel 1955; Guzzo, Motto, and Fergola 2000. Alexander Severus added to the sprawling complex on the

Palatine apartments for his mother Julia Mamaea, named after her. On them, see *SHA Severus Alexander* 26. This chapter reflects and elaborates on the conclusions of my article, Angelova 2014, 83–103.

2. The archeological evidence for the Great Palace, indeed for the twenty-one or so fifth- and sixth-century late antique imperial residences, including the Great Palace, is slim. This number includes the four *palatia* and eight imperial *domus* mentioned in the *Notitia*, the palace of Leo at St. Mamas, the palace at the Hebdomon, the Blachernai Palace, the two palaces named after Sophia, the palace at the Deuteron, the Hieron palace, the Helenianai palace, and the Great Palace. On these, see *Notitia*, 230–41; Janin 1964, 106–22 (Great Palace), 134 (Sophia palace), 153 (the other Sophia palace), 139–40 (Hebdomon), 141 (St. Mamas), 148–50 (Hieron). On the Helenianai, see Tiftixoglu 1973. For the Blachernai Palace, see Mango 1998. Rice and St. Andrews University. Walker Trust. 1958. See also, the valuable summaries and discussion in McCormick 2000, 139–42; Kostenec 2004.

3. On the connection between palaces and baths, see Yegül 1992, baths part of imperial and episcopal palaces, 319–20, on Avars requesting Justin II to provide them with an architect to build a palace and a bath, 321 n. 56; Ward-Perkins 1984, on episcopal palace baths in Ravenna, 135–36. See also, Ćurčić 1993.

4. Euseb. *VC* 3.49 (on the palace) with Cameron-Hall, 140; Malalas, 320–21 with Jeffreys and Jeffreys 1986, 173–74; *Chron. Pasch.*, p. 528, or s. a. 328, trans. and commentary Whitby and Whitby 1989, p. 16.

5. For Constantine's development of Constantinople, see above. It has been argued that late antique palaces, among them the Daphne palace in Antioch on the Orontes, present a break with the palatial complex in Rome, in that they appear to be "self-sufficient," "fortified" cities within a city, cut off from the rest. Crucial to this thinking is Libanius's description of the Daphne in Antioch and the fortification at Split, see Ćurčić 1993, 68–69, and esp. 72.

6. *Anecdota* 4.6, 15.27, trans. Dewing, 44–45, 184–85.

7. On the palace in Tiberius's time and his renovations, see John of Ephesus, *Ecclesiastical History* 3.23, accessed online at www.tertullian.org/fathers/ephesus_3_book3.htm (accessed April 5, 2013); Rice 1958; Mango 1959, 12.

8. Const. Porph. *De cerim.* 1.37 (ceremonies); Vogt 1935, 1/2:120; Kostenec 2004, 11–13; Janin 1964, 119; Berger 1988, 263–64. A similar association between an imperial residence and a hippodrome we also find at the villa of Maxentius at the via Appia in Rome. See La Regina 2001–8, s.v. "Maxentius Praedium (via Appia)," 4:49–59.

9. Hesychius of Miletus in the *Patria* 3.129 (in use since the times of Constantine I until Eirene (780–802) for chariot races).

10. On the remains see also the map in Bardill 1997, fig. 2 (Bardill). The chief source for the Great Palace is the *Book of Ceremonies*. On the porticoes, McCormick 2000, 140.

11. For the similarities, see Malalas, 320; Jeffreys and Jeffreys 1986, 173–74. These similarities have been interpreted as "ideological," see Kostenec 2004, 5. For the development of the Roman imperial palace from Augustus until the sixth century, see Steinby 1993–2000, s.v. "Palatium," 4:22–40.

12. Treggiari 1975, 49–57.

13. Treggiari 1975, 53.

14. In the late republic only three or four other households maintained a staff that numerous, see Treggiari 1975, 57; Garlans 1992.

15. For a discussion and summary of how scholarship has referred to imperial residences in a historical perspective, see Duval 1987, 464–68.

16. *PLRE*, s.v. "Olympiodorus (of Thebes) 1," 2:798–99; Blockley 1983, 205 (translation). See comments in Sodini 2003, 35–36.

17. On self-sufficiency as an older Roman ideal, see Treggiari 1975, 48–77. Also, on Rome, Machado 2012, 136–60.

18. Libanius, *Or.* 11 ("Oration in Praise of Antioch"), trans. Downey 1959, 674–77. This is discussed in Ćurčić 1993, 68.

19. Libanius, *Or.* 11, trans. Downey 1959, 677.

20. Krautheimer 1986, 70–71, fig. 30.

21. On a private garden and apartments, see John of Ephesus, *Eccesiastical History* 3.23, accessed online at www.tertullian.org/fathers/ephesus_3_book3.htm (accessed April 5, 2013). St. Stephen was used for imperial marriages. See, Vogt 1935, 16–17.

22. See summary in McCormick 2000, 140–42.

23. For the evidence of porticoes around the Augustaion, see Procop. *Aed.* 1.10.5, 1.10.10; Mango 1959, 46. On the passage between the Great Palace and the Zeuxippus baths, see Mango 1959, 40.

24. Libanius, *Or.* 18.139, trans. Bowersock 1978, 72. See also, Amm. Marc. 22.3.10–12, 22.4.

25. Malalas, 441 with Jeffreys and Jeffreys 1986, 256; Theophanes, *Chronographia* 186, with Mango and Scott 1997, 285.

26. *Cod. Theod.* 6.35–36.

27. McCormick 2000, 140. Also on the palace, see Deliyannis 2010, 55–58.

28. Treggiari 1975, 57–59.

29. Treggiari 1975, 49.

30. The *Notitia* uses domus for the plural and the singular.

31. "Ad domum dominae ac venerabilis Augustae Pulcheriae germanae nostrae seu nobilissimarum sororum pietatis nostrae pertineat." *Cod. Theod.* 13.1.21.

32. *Vita St. Olympiadis*, quoted in Mango 1959, 55. This may be the *tribunalium*. On it, see Duval 1987, 471–72.

33. Mango 1993, 127. These identifications have been questioned; see Bardill 1997.

34. Mango 1993, 127–28.

35. See Bassett 2004, 257, with discussion of what *domus* is, and the existing literature.

36. Wallace-Hadrill 2003, 10–13. For similar conclusions, reached independently from this author, and about Rome, see Machado 2012, 136–60.

37. Blockley 1983, 205.

38. Wallace-Hadrill 2003, 13–14.

39. John Matthews believes that the document records an earlier "configuration of the city." The rationale for this, in his opinion, is the length given for the city, a measurement which must have been taken from the Constantinian walls rather than the new Theodosian walls, mentioned in the text. See Matthews 2012, 84. I take this measurement as a mistake, like the ones present in the summary count of the document (compare the number of palaces, for instance). The introduction, mentioning the author's ambi-

tion for exactness, "inspection of all [the city's] quarters," the new walls, the phrase stating the "surpassing of the founder of the city" (*supra conditoris*), as well as, the inclusion of all the fifth-century palaces and mansions, indicate that the document did not reflect an older configuration, but a new one. The introduction alludes that the author was the first one to undertake such a description of the city.

40. For the date, see *ODB*, s.v. "*Notitia urbis Constantinopolitanae*," 3:1496; Berger 1997. For a translation and commentary of the *Notitia* now see, Matthews 2012, 85–115.

41. *Notitia*, 230–43.

42. Paul Magdalino has suggested that the palace of Flaccilla was the same as the imperial palace near the Holy Apostles. See Magdalino 2001.

43. See Magdalino 2001, 55–57.

44. *Notitia*, 238 (Flaccilla), 230 (Placidia). The *Notitia* lists five in the summary count, but only four under the individual regions.

45. For the title, see *ODB*, s.v. "Nobelissimos," 3:1489–90.

46. For those, see Müller-Wiener 1977, 124–25, 238; Mango 1993, 127–28. For arguments, questioning the identification of the archeological remains considered to have belonged to these palaces, see Bardill 1997.

47. As argued in Magdalino 2001, 53–69.

48. *Notitia*, 230.

49. The legal codes of Theodosius and Justinian referred to it as *sacrum palatium* (sacred palace) and *theion palation* (divine palace). Treitinger 1969, 50–51.

50. Corippus calls Hagia Sophia the house of God, and the Sophianae the house of the emperor. See, Corippus, *In laudem* 4.285–88, ed. and trans. Antès, 84, with commentary (205–7) and translation (115–16), in Cameron 1976. On churches as sanctuaries, see a law promulgated on April 7, 431, by Theodosius II and Valentinian III, *Cod. Theod.* 9.45.4. Consecration rites: Just. *Nov.* 131.7.

51. The view of the sea as desirable and subject of regulations, see Just. *Nov.* 63; Julian of Ascalon, 52.1–2.

52. Quoted in Freely and Çakmak 2004, 41–42.

53. Six emperors were crowned there: Valens in 384, Arcadius in 383, Honorius in 393, Theodosius II in 402, Maurice in 582, and Phocas in 602; see Janin 1964, 139–40. Cistern: Janin 1964, 205–6. See Janin 1964; Lenski 2002, 24–25.

54. For the Fildami reservoir, see Crow, Bradill, and Bayliss 2008, 132–37. For a photograph, see the University of Edinburgh, School of History, Classics and Archaeology website, www.shc.ed.ac.uk/projects/longwalls/Water/images/Cisterns/Fildami/Fildami1.htm (accessed September 19, 2012).

55. *Chron. Pasch.*, p. 598 with trans. Whitby and Whitby 1989, 91 and 91 n. 96; *Patria* 3.266; Janin 1964, 141.

56. There was the Circus Varianus at Helena's palace in Rome, but it was not in use in the fourth century. For it, see above and Steinby 1993–2000, s.v. "Sessorium," 4:305, and 3: fig. 190. The Circus Maximus was located near Pulcheria's residence in Regio III, *Notitia*, 232. The Great Palace; Leo I's palace of St. Mamas; perhaps also the Hormisdas palace of Justinian; and Justin II's palace, the Deuteron, featured racehorse tracks. Great Palace: Janin 1964, 183–94; Mango 1959. Leo I: *Patria* 3.159; Dagron 1974, 317; Janin

1964, 194–96, 141 (palace). Justinian: The Church of SS. Sergius and Bacchus was built near by the Hormisdas palace. Constantine Porphyrogenitus reports of a hippodrome in front of the church; see *De cerim.* 1.69. See also Janin 1964, 195. Justin: John of Ephesus, *Ecclesiastical History* 3.24, accessed online at www.tertullian.org/fathers/ephesus_3_book3.htm (accessed April 5, 2013). See also: Cameron 1980a.

57. On the importance of the hippodrome as a political institution, see Cameron 1976, 157–92, 237–96; Dagron 1974, 318–47, esp. 343–47. Hippodromes at Roman imperial palaces were not exclusively used for sports. Kostenec mentions three such race tracks (Domus Augustana, Domitian's Albanum Palace, and Hadrian's villa at Tivoli), see Kostenec 2004, 11.

58. *Cod. Theod.* 7.10. 1–2. The first was issued in 405 by Arcadius, Honorius and Theodosius II, the second in 407 amends it to allow for the housing of judges in palaces, far from the road.

59. The senator Origenes reportedly said: "Moreover we have other palaces, both Placillianae and the palace named from Helen, which this emperor should make his headquarters and from there he should carry on the war and attend to the ordering of all other matters in the best possible way." Procop. *Bell.* 1.24.30, trans. Dewing; *Chron. Pasch.*, p. 624 (the insurgents got imperial token from the palace of Flaccilla); Theophanes, *Chronographia* 185.

60. Procop. *Bell.* 1.24.30.

61. *Notitia,* 237–38.

62. *PLRE,* s.v. "Arcadia 1," 2:129; *hē de Arkadia ektise kai ton oikon tou agiou Andreou epiklēn ta Arkadias* (But Arcadia founded as well the Church of St. Andreas called that of Arcadia), *Chron. Pasch.*, p. 566 with trans. Whitby and Whitby 1989, 56; Janin 1964, 312, 1953, 31. Against such a connection between a name in the genitive and the neutral definite article in the nominative, *ta,* Berger 1988, 170–71. But this can be countered with the example from the house of Marina, a building which was recorded as *Marina de ton oikon ektise tōn Marinēs (Chron. Pasch.* p. 566). In other words, the mansion in question is in *ta Marinēs.* By the same logic a church *ta Arkadias* means that it was situated in that neighborhood.

63. According to some suggestions, the church should be identified with St. Andrew *en tē Krisei,* southwest of St. Mokios, in the westernmost part of the city, but there is nothing to confirm such attribution. Janin 1964, 312.

64. *Notitia,* 230; *Chron. Pasch.*, p. 566 with Whitby and Whitby 1989, 56.

65. Marcellinus Comes, s.a. 394 *Patria* 3.25; *PLRE,* s.v. "Flavius Arcadius 5," 1:99; Berger 1982, 145.

66. *Notitia,* 230.

67. Marina was not an Augusta, see *PLRE,* s.v. "Marina 1," 2:723. For *ta Marinēs,* see entry for 396 in *Chron. Pasch.*, p. 566, trans. Whitby and Whitby 1989, 56. Janin 1964, 385. For the palace, see Theophanes, *Chronographia* 235, 237, 240, 294 ("palace of Marina"). On Marina's properties, see Holum 1982, 131–32. For the argument that the bath in Marina's palace was restored by Leo VI, see Mango 1991–92. For the bath of Leo VI, see Magdalino 1988.

68. Compare, Regio I: 230; Regio II: 231; Regio III: 232; Regio IV: 233; Regio V: 234; Regio VI: 235; Regio VII: 236; Regio VIII: 236; Regio IX: 237; Regio X: 238; Regio XI: 238, etc.

The individual lists by Region observe the same sequence for numerous items shared by more than one region, including bakeries. The order is *vici, domus, porticus, balneae, pistrina publica, pistrina privata, gradus, macella, collegiati,* and *vicomagistri. Notitia,* 230-41.

69. *Notitia,* 230, 241.

70. *Patria* 3.25. This attribution is dismissed as unhistorical in Janin 1953, 410. See also, Berger 1988, 433.

71. *Notitia,* 232, 238.

72. For the residences in this *regio,* see Magdalino 2001, 53–69.

73. Marcell. Com., s.a. 439, p. 17.

74. Marcell. Com. s.a. 453, p. 21.

75. Marcell. Com. s.a. 453, p. 21. Procopius describes St. Lawrence on a bay as *epiprosthen* [before/facing] the Blachernai quarter. See Procop. *Aed.* 1.6.3, pp. 60–61. See also discussion on the location in Berger 1988, 529–31. Berger does not address Müller-Wiener's findings.

76. Bekker 1838, p. 339.

77. Müller-Wiener 1977, D4/3, p. 370. And Müller-Wiener 1977, D4/16. The distance is about 150 m. on the *Lageplan* of Müller-Wiener.

78. Papadopoulos 1927, 58–63.

79. Müller-Wiener 1977, 21, abb. 2.

80. *Notitia,* 238.

81. "In the time of these consuls (Eustatius and Agricola) water was let into the cistern of the lady Pulcheria Augusta"; *Chronic. Pasch.,* p. 578, trans. Whitby and Whitby 1989, 68. A well-preserved underground water reservoir, described by Janin in the vicinity of Sivaslitekesi of present-day Istanbul, has been identified as Pulcheria's cistern, but there is no other evidence for this besides its proximity to Pulcherianai. This cistern measures 29.10 m. in length and 18.70 m. in width. It has twenty-eight columns, forty domes covering it, each 8.5 m. in diameter. On it, see Janin 1964, 210.

82. *Notitia,* 238.

83. *PLRE,* s.v. "Domitius Modestus," 1:605–8; Janin 1964, 209–10.

84. For instance, the Harbor of Sophia before its reconstruction in the sixth century was known as that of Julian, after its original builder. *Chron. Pasch.,* p. 700; Janin 1964, 231–32, esp. 232.

85. These are cisterns D 6/1 and D 6/3, see Müller-Wiener 1977, 282. There's a third cistern in that neighborhood. On it, see Crow, Bardill, and Bayliss 2008, 148, map 14.

86. *Notitia,* 238–39.

87. Müller-Wiener 1977, 54–55. The measurement was taken from the Müller-Wiener *Lageplan* map with a ruler. The distance is from the closest cistern to the column was 8 mm., the equivalent of 80 m. in a scale of 1:10,000. The distance between the cisterns is 20 m.

88. For an example in which a dedicator (the Roman Senate) defined the location of a building (the Arch of Constantine) to amplify its effect with respect to Rome's topography and existing structures, see Marlowe 2006, 223–42.

89. The four streets that now converge on the column suggest that the likelihood that a square was associated with it. See remarks on the location of the column with respect to the city's topography in Berger 1988, 330–31.

90. *Anth. Pal.* 1.10; Malalas, 407;. The mansion has not been found. Harrison 1986, 1:5.

91. This residence, as perhaps the one of Galla Placidia and the mansion of Arcadia, may have been inherited by Juliana through her mother and therefore must have allowed for her construction activities in this part of the city. See Magdalino 2001, 58–60.

92. *Anth. Pal.* 1.13; *Chron. Pasch.,* p. 594; Janin 1953, 419–20.

93. Trans. Paton, 13.

94. That this is Regio X has been argued in Magdalino 2001, 58. Magdalino also argues that Juliana's mansion those of the other Theodosian women, as well as those of Olympias and Promotos, as part of an "aristocratic neighborhood" on the north side of the Mese. The same study considered this neighborhood located away from the rest of the 636 "lower-class" households (*domus*). Magdalino 2001, 57–58.

95. Commercial activity took place in the immediate surroundings of Hagia Sophia around the residence of Olympias, see Mango 1993, 127.

96. Gregory of Tours, *De gloria martyrum* 102, trans. Van Dam 1988, 125.

97. *Anth. Pal.* 1.10.43 and 1.10.70–73; trans. Paton, 1:9 (baptism) and 11 (Constantine as a model), respectively. In light of Anicia Juliana's unwavering Orthodox position during the reign of Anastasius, this mosaic may have been intended to affirm the righteousness of her beliefs. See Fowden 1994.

98. Procop. *Aed.* 1.11.21.

99. *Anth. Pal.* 9.820–21 (epigram Justinian as the builder); Procop. *Aed.* 1.3.10 (location); Procopius, *Anecdota* 15.36–39 (palace and sea dangers); Janin 1964, 148–49. For the cistern, Janin 1964, 206.

100. *Patria* 3.37; Corippus, *In laudem,* 1.97–111 (palace and its view towards the sea) with commentary (132–33) and translation (89) in Cameron 1976. The two palaces, named after Sophia, are discussed in Cameron 1980a, 1980c. See also, Janin 1964, port: 231–32; 1943, 120–21.

101. *Patria* 2.62, 3.37; Janin 1964, 231.

102. *Patria* 1.68, 2.623; with Janin 1943, 128.

103. Janin 1953, 454 (Pantaleimon), 466–70 (Sergius and Bachus), 500 (Forty Martyrs), 240 (Theotokos).

104. Janin 1943, 129–30; 1953, 284–85. Theophanes ignored Sophia's patronage, and the church is attributed to Justin II; see Theophanes, *Chronographia* 243, trans. Mango and Scott 1997, 359. For this church, see chapter 9. The epigram reads: "I thy servant Sophia, O Christ, offer this gift to thy servants. Receive thine own, and to my emperor Justin give in payment thereof victory on victory over diseases and the barbarians"; *Anth. Pal.* 1.11, trans. Paton.

105. Theophanes, *Chronographia* 243, with trans. and commentary by Mango and Scott 1997, 359.

106. For the date, established on the evidence of a poem of Agathias, see Cameron 1980c. The poem, dated to 566–67, mentions it and therefore it was already built at the time. Justinian died in November 565.

107. *Anth. Pal.* 9.657, trans. Paton (here with slight changes), 3:365; Janin 1964, 153.

108. Corippus, *In laudem* 4.284–90, with translation (115–16) and commentary (204–5) in Cameron 1976.

109. Corippus, *In laudem* 4.285–88, translated by Cameron as: "There are two wonderful things imitating the glorious sky, (285) founded by the advice of God, the venerable temple and the glorious building of the new Sophianae"; Cameron 1976, 116–17.

CHAPTER 6. IMPERIAL WOMEN AND CIVIC FOUNDING

1. But see below on the possibility that Faustina commissioned the baths in Miletus.
2. For definitions of the portico as a form with a survey of the literature, see Frakes 2002, 15–21.
3. In Constantinople, porticoed streets covered extensively the streets. See Mundell Mango 2001, 29–30, 44–45 (for Constantinople).
4. Fagan 1999, 24–29.
5. But see evidence for the collection of statues at the Zeuxippus bath in Bassett 2004, 98–120, 160–85.
6. Just. *Nov.* 149, trans. Blume, online at the Annotated Justinian Code, www.uwyo.edu/lawlib/blume-justinian/ajc-edition-2/novels/141-168/novel%20149_replacement.pdf (accessed January 7, 2015). It is discussed in Yegül 1992, 321. On the burden of heating the baths, see Jones 1967, 253. On the heating of the baths, kept overnight, see Nielsen 1990, 17.
7. For instance, Carthage: see Procop. *Aed.* 6.5.8–11. Justinian had the same building priorities when he founded Justiniana Prima (ibid.). See also a testimony to his patronage in Byllis, Feissel 2000, 92.
8. For Octavia and Livia, see chapter 3. Galla Placidia's Porticus Placidiana was a two-hundred-meter structure. See Meiggs 1973, 169.
9. For Livia's portico, see chapter 3. For Octavia's portico, see Richardson 1992, s.v. "Porticus Octaviae," 317–18; Steinby. Porticus Liviae: Flory 1984, "Shrine to Concordia," 318; Wood 1999, 78–79; Richardson 1992, s.v. "Porticus Liviae," 314; Steinby 1993–2000, s.v. "Porticus Liviae," 4:127–29. On Vipsania's portico, see Richardson 1992, s.v. "Porticus Vipsania," 319–20.
10. Ov. *Ars am.* 1.69–70; Suet. *Aug.* 29.4 (says the real builder was Augustus); Plin. *HN* 34.31 (*Octaviae opera*); 35.37.114, 35.40.139. For other references, see Richardson 1992, s.v. "Porticus Octaviae," 317; Steinby 1993–2000, s.v. "Porticus Octaviae," 4:139–45.
11. Plutarch, *Marcellus*, 30.6 (Bibliotheca Porticus Octaviae), Plin. *HN* 36.28 (curia), and Plin. *HN* 35.114, 36.22 (schola).
12. Plin. *HN* 34.31, 35.114, 35.139, 36.15, 22, 24, 35.
13. Plin. *HN* 36.15. He calls the building repeatedly *Octaviae opera*.
14. Plin. *HN* 36.24.
15. Dio Cass. 55.8.3–4; Richardson 1992, s.v. "Porticus Vipsania," 319–20; Steinby 1993–2000, s.v. "Porticus Vipsania," 4:151–53.
16. Tacitus, *Historiae* 1.31.
17. Plin. *HN* 3.17 and Martial, 1.108.1–4.
18. Richardson 1992, s.v. "Porticus Pompeii," 318–19.
19. On Galla Placidia, see Oost 1968; Sivan 2011.

20. Summaries of her building activities, as they were known in the ninth century, are found in Agnellus, *Liber Pontificalis ecclesiae Ravennatis*. See Deliyannis 2004, 27, 41–42.

21. *CIL* 9.276c = *ILS* 818.3–4 = *ILCV* 20c, a–b. The mosaics are lost. See Brubaker 1997, 53–54; Amici 2000, 22, 31, 33–39.

22. Brubaker 1997, 61.

23. For the partially preserved inscription on the architrave and a statue, whose inscription reads AD ORNATVM PORTICVS PLACIDIANAE (for the decoration of Porticus Placidiana), see Meiggs 1973, 169. See picture of the inscription and transcription at the Ostia: Harbor City of Ancient Rome website, www.ostia-antica.org/portus/to55.htm (accessed September 19, 2014).

24. Nero: *RIC* 1 Nero 182; Trajan: *RIC* 2 Trajan 632.

25. For the location, *Notitia*, 231. Trans. Dewing, 88–91.

26. Procopius's narrative postdates Theodora's death, but this does not mean that the portico was erected posthumously. The *Buildings* is dated to the 550s. See Cameron 1985, 86. Theodora continued to receive recognition after her death as in the curtains in Hagia Sophia, mentioned in chapter 9.

27. Fagan 1999, 98 ff., 262–63 (*CIL* 11.4090).

28. On naming conventions of bath buildings outside Rome, see Fagan 1999, 171–72 (He argues that a bath named after an emperor does not necessarily indicate that it was paid for by him, but that dedicating a bath to the emperor elevated the status of the building. He also notes that in nonimperal commissions, the patron gave his of her name to the baths). A special case in the naming conventions is the Bath of Faustina at Miletus. Fagan reasons that the name and an inscription of renovation suggest that Faustina II, the wife of Marcus Aurelius, "is as good a candidate for initial constructor as any, but her actions would represent a break with the immediate past, when imperial women made no known financial outlays for public purposes. . . . In any case, the name of a bath is insufficient grounds for deducting imperial agency in it construction." But he also notes that following the renovation, the bath was renamed after Makarios. This to me confirms the pattern of naming the building after the sponsor. Moreover, this would have been the only public bath dedicated to an empress. When a city sought imperial prestige, they dedicated their baths either to the emperor alone, or more rarely to the imperial family. See Fagan 1999, Faustina's baths: 315/316+, pp. 153–54; in honor of domus divina: 104, p. 265 (*CIL* 13.5661); to the Severan family: 90, p. 260 (*IRT* 396). For the other bath, see a commemorative inscription dedicated to Marcia Otacilia Severa, wife of Philip the Arab, given her in honor of her own restoration of her bath and *domus*. On this see, Fagan 1999, 109, p. 267 (*CIL* 3.8113).

29. For examples of statues of patrons commemorating their building or restoration of baths, see Fagan 1999, 35+, p. 243 (*IRT* 103a), 95+, p. 261 (*CIL* 10.5917 = *ILS* 1909), 114+, p. 269 (*CIL* 8.828 = *ILS* 5713), 141+, p. 282 (*CIL* 10.349), 151+, p. 284 (*CIL* 9.3677 = *ILS* 5684). For other examples, see *Syntomoi chronikai* 29, in Cameron and Herrin 1984, 93 (a small gilded statue of Euphemia near the Church of St. Euphemia, an edifice she built herself).

30. *CIL* 6.1136 (bath), *CIL* 6.1134–35 (statues). Discussion in Merriman 1977.

31. John of Ephesus, *Ecclesiastical History* 3.24. At the Tertullian Project website of works of the early Church fathers: www.tertullian.org/fathers/ephesus_3_book3.htm (accessed April 5, 2011).

32. The work is known as *Historia arcana* (Secret History) or *Anecdota* (Unpublished things). The viciousness of Procopius's attacks, however, contrasts sharply with Theodora's image as a virtuous and pious woman offered by John of Ephesus (ca. 507–586/88) in his *Lives of the Eastern Saints* or the scholar and administrator John Lydus (490–ca. 565?). For John of Ephesus, see his *Lives of the Eastern Saints, PO:* 19/2, 499; for instance, he calls Theodora "the Christ-loving queen." On this, see analysis in McClanan 2002, 99–101; 1996, 50–72. For Lydus's presentation of Theodora, see Lydus, *De magistratibus populi romani* 3.69, trans. Maas 1992, 95. For a Theodora's biography, see Garland 1999, 11–39.

33. Whitby 2000.

34. For the epigraphic material compared to Procopius's testimony, see Feissel 2000, nos. 9–10, 90. For a comparison between Malalas's account of Theodora's patronage in Antioch and Procopius's text, see Feissel 2000, 95; McClanan 2002, 94, 105. It must be noted, however, that these exclusions did not prevent him from flattering the empress; see his description of her statue below.

35. See, Feissel 2000, no. 9, 90.

36. Trans. in Mango 1986, 89.

37. On the inscription, Cedrenus, 1:677.14–19; *CIG* 4.8643; Feissel 2000, no. 10, 90.

38. As, for instance, in the artistic partnership between Christo and Jeanne-Claude.

39. Procop. *Aed.* 1.2.13 with Feissel 2000, no. 11, 91.

40. Kautzsch 1936, 177–78, pl. 36, figs. 367a–b (Justinian), figs. c, e (Theodora). And also, Feissel 2000, no. 5, 89.

41. John of Ephesus, *Lives of the Eastern Saints, PO*, 18/2:677–78, discussed in McClanan 2002, 100–101. See also, Bardill 2000.

42. Procop. *Aed.* 1.1.24–78.

43. Malalas, 423, with Jeffreys and Jeffreys 1986, 243.

44. Procop. *Aed.* 6.5.10–11.

45. Procop. *Aed.* 5.1.4–6.

46. The *Chronicon Paschale* notes that the city prefect Theodosius built (*ektisen*) the Augustaion. *Chron. Pasch.*, p. 593, with Whitby and Whitby, 84–85. This may indicate that the prefect built porticoes or renovated the square, including its porticoes.

47. Procop. *Aed.* 1.10.

48. In this it is similar to Porticus Miliariae, the porticus associated with Nero's Domus Aurea Richardson 1992, s.v. "Porticus Miliariae," 315, Suetonius, *Nero* 31.1).

49. Theophanes, *Chronographia* 300, with Mango and Scott 1997, 430.

50. Mundell Mango 2001, 45.

51. Richardson 1992, s.v. "Porticus Thermarum Traianum," 319, "Porticus Europae," 313.

52. Yegül 1992, figs. 352, 343, 335. Another example of a bath associated with a portico is the bath of Junia Rustica from Cartima, see Fagan 1999, *CIL* 2.1956 = *ILS* 5512, 71+, p. 253 (the baths and porticoes are on her own property). For other examples, see the extensive list with bibliography, translations, and commentary in Fagan 1999, 121+, p. 272 (*AE* 1937.119/20).

53. The count is based on the *Notitia,* 242. For Sophia's baths, see Theophanes, *Chrono-graphia* 243, with Mango and Scott 1997, 359 (for the years 569/570); Janin 1964, 222.

54. On the baths, see Janin 1964, 220, 355.

55. Anastasian baths: Amm. Marcell. 26.6.14; *PLRE* s.v. "Anastasia 1," 1:58; ibid., s.v. "Ammianus Marcellinus 15," 1:547–48.

56. It has been suggested that a head in Copenhagen, found in Constantinople, near the Baths of Anastasia depicted the sister of Constantine. But as there were no coins minted in her name, this attribution to Anastasia is not secure; see Wegner 1984, 3/4:150.

57. Soc. 4.9 and Soz. 6.9.

58. Carosian baths: *Notitia,* 235. *Chronic. Pasch.,* pp. 556, 560, trans. Whitby and Whitby 1989, 45, 48. This bath perhaps can be identified with the Kalendarhane baths; see Nielsen 1990, cat. no. 387. A bath dedicated by Valens in Anastasia's name: Soc. 4.9, see above. See also Janin 1964, 219. A discussion on these two baths, Berger 1982, 149–50.

59. *Notitia,* 235.

60. Notitia, 233; Berger 1982, 148–49.

61. Theophanes, *Chronographia* 243, trans. Mango and Scott 1997, 359. Janin 1964, 222. On the Baths of Sophia, see chapter 5.

62. *Anth. Pal.* 9.803. Alternatively, the statues may have continued the old tradition of displaying statues in baths, as prominent public spaces. For this practice, see Nielsen 1990.

63. For these in the centuries before Constantine and Helena, see the Baths of Faustina in Miletus (see above) and the bath-gymnasium complex in Sardis dedicated to the imperial family, including Julia Domna, see Nielsen 1990, C.306 (Miletus) and C.315 (Sardis); Yegül 1986.

64. Helena and Theodora had access to the imperial treasury; the three daughters of Arcadius likely relied on the income from their estates. For Helena, see Euseb. *VC* 44; Theodora: Malalas, 441; Arcadius' daughters: see here p. 151.

65. Hemelrijk 2004, 210–11 (on the rarity of female patrons, but her list includes inscriptions of builders named patronus or patrona), 235–41 (evidence). Fagan's comprehensive list provides more dedications by women and joint dedications by a woman and a man. See Fagan 1999, father and daughter: 78+, p. 255 (*CIL* 2.3361 = *ILS* 5688), a woman builder: 253, *CIL* 2.1956 = *ILS* 5512, 151+, p. 284 (*CIL* 9.3677 = *ILS* 5684), 165+, p. 288 (*AE* 1979.352), 179, p. 294 (*CIL* 10.5918 = *ILS* 406), 187+, pp. 296–97 (*AE* 192145), 321+, p. 340 (*IGR* 4.1378), 324+, pp. 341–42 (*AE* 974.618), 325+, pp. 342–43 (*SEG* 26 [976/977] 474), husband and wife: 159+, p. 286 (*CIL* 11.7285 = *ILS* 8996), 161+, p. 287 (*CIL* 3.7380 = *ILS* 5682), 164+, pp. 287–88 (*CIL* 11.3932 = *ILS* 5770), 327+, p. 343 (*IGLS* 4.1490).

66. Dunbabin 1989, 32; Ward 1992, 125–47, esp. 146–47.

67. Tertullian, *Apologeticus* 42.2 trans. G. Rendall, 190–91; and John Chrysosom, *Homiliae* 18.4, *PG* 59:118, quoted in Nielsen 1990, 148.

68. Number of baths in Constantinople in the *Notitia*: 8 *thermae,* 153 *balnea,* see Seeck, 242.25–243.39.

69. Yegül 1992, 318–20.

70. On this tradition, legislation against it and its practice in early Byzantium, see Berger 1982, 39, 44; Nielsen 1990, 1:147. See especially the perceptive discussion on mixed bathing in Fagan 1999, 24–29.

71. Berger 1982, 39–41.

72. In its denunciation of mixed bathing, the Church continued the legislative attempts of emperors, see Nielsen 1990, 148. On the connection between churches and monasteries, and healing springs with baths, see Berger 1982, 72–84; Nielsen 1990, 59 n. 150.

73. Jones 1967, 253 (last mention of ephebic training was in 323); Yegül 1992, 320. The educational aspect was more characteristic of the East, see Fagan 1999, 75–76.

74. Richardson 1992, 393. On the bath, also Steinby 1993–2000, 5: s.v. "Thermae Helenae," 59.

75. See discussion in Dunbabin 1989, 12–14.

76. *Anth. Pal.* 9.607–9 A, 611, 616, 619, 623, 626, 634, 637, 638.

77. *Anth. Pal.* 9.609, trans. Paton, 3:339.

78. Projecta box, see Shelton 1981, pl. 11.

79. For an image of the Piazza Armerina mosaic, see Dunbabin 2001, fig. 138. On the portico, see chapter 5.

80. *Anth. Pal.* 9.613. The *Palatine Anthology* has preserved an epigram which extols the beauty of the Bath of Maria. The author of the epigram is not known, making this evidence hard to date or locate. It probably refers to a bath built by Maria, the wife of the emperor Honorius. *Anth. Pal.* 9.613, but not identified by Janin 1964, 221.

81. John Chrysosom, *Sermo cum iret in exsilium*, PG 52:437. Trans. in Holum 1982, 77. On it see, Mayer 2005, 88, 170, 424, 279. Kelly argues that the sermon represents a redaction of a sermon delivered in the three-day period after the decision of the Oak Synod (September 403), which exiled Chrysostom. See Kelly 1995, 229–31.

82. Procop. *Anecdota*, 15, trans. 177.

83. Chattering: Libanius, 4.523.5–524.5, and John Chrys., *In Principium Jejuni, etc.*, PG 56:536 (though the homily is spurious), quoted in Berger 1982, 38–39, 65. Ascetics frequenting the public baths: Evagrius, *Historia ecclesiastica* 1.21. See also John Moschus, Wortley 1992, 138.

84. Malalas, 441, with Jeffreys and Jeffreys 1986, 256; Theophanes, *Chronographia* 186, with Mango and Scott 1997, 285. See also McClanan 2002, 104–5.

85. On this manuscript, see below. A facsimile with a commentary: Mazal 1998.

86. Berger 1982, 72.

87. For evidence on men and women bathing there together in the fourth century: Yegül 1992, 317. For the practice in general, see Fagan 1999, 24–9.

88. Di Segni 1997, 228–33.

89. See discussion and bibliography in Di Segni 1997, 188–89.

90. Di Segni 1997, 233.

91. It was placed in the wing adjacent to the one with the renovation inscription.

92. Di Segni 1997, 185. On the location, see Hirschfeld 1997, 102–16.

93. Trans. Di Segni 1997, 229–30. All translations come from Di Segni's study.

94. On Eudocia's poetry, see Ludwich 1897; Usher 1998.

95. The visit to the springs most likely occurred during Eudocia's first pilgrimage to the Holy Land (438–39), see discussion in Di Segni 1997, 232–33. Eudocia also built near Jerusalem a church and a cistern for the pilgrims. See Hirschfeld 1990.

96. Marcell. Com. 2.85, discussed in Clark 1990; Holum 1982; Hunt 1982; Lenski 2004.

97. Berger 1982, 72–84.

98. Const. Porph. *De cerim.* 2.12, trans. Moffat and Tall, 551–56 and trans. (French) Vogt 1935, 1:137–42. See also, Janin 1964, 124; Papadopoulos 1928, 100–103.

99. Theod. Lect. 102; Theophanes, *Chronographia* 105 (dates it to the beginning of the Marcian's reign), trans. Mango and Scott 1997, 162. Others claim it was a joint undertaking with Marcian. Discussion in Janin 1953, 169. Procopius attributes the church's building to Justinian and to the time before he became emperor; see Procop. *Aed.* 1.3.3–5, 7:39. *Anth. Pal.* 1.3, 1:2, identifies Justin I as the first builder and Justin II as the one who restored it. Mango 1998.

100. *Cod. Paris. Gr.* 1447, fols. 257–58, trans. Mango 1986, 34–35. See also, Janin 1953, 169; Papadopoulos 1928, 104–6.

101. For Verina's and Ariadne's actions, see Mango 1998, 64–65. See his discussion on the evidence of attributing the church to Pulcheria found in Theodore Lector and Theophanes; Mango 1998, 65–66. Between 475 and 476 Verina took refuge from her brother Basiliscus in the *euktērion* (oratory) of Blachernai, while Ariadne helped a cousin of hers to obtain an appointment there as lector.

102. Janin 1964, 124.

103. *Suda* 1:187–88. On the Blachernai, see also Mango 1998, 61–76.

104. *Patria* 3.75; Janin 1964, 218. But this evidence is considered confusing the bath with the church of the Soros. The accepted testimony is that of Cedrenus, who records the bath at Blachernai as begun by Tiberius in 581 and completed by his successor Maurice. Cedrenus, 1:690, 694.

105. *Anth. Pal.* 1.121, trans. Paton, 1:55.

106. See the reference to Theodore Anagnostes above. The affinity between springs and churches shows up as well in the sanctuary of the Theotokos at Pege (Spring). Procopius describes the site's natural beauty, its dense cypress grove, "a meadow abounding in flowers," "a park abounding in beautiful shrubs, and a spring bubbling silently forth with a gentle stream of sweet water" as "especially suitable to a sanctuary." In Procop. *Aed.* 1.3.3, trans. Dewing, 40–41.

107. For precedents of baths associated with empresses, see notes 28 and 63 above.

108. Suet. *Aug.* 73.

109. Gnecchi 1912, 1:141, pl. 28, no. 12. For the medallion, also see Bühl 1995, 11–12 (with earlier studies on the date). The date of 330 was suggested by Stryzygowski 1893, 141–53, on the basis of the entry for 330 in the *Chronicon Paschale* (529) that Constantine wore the diadem for the fist time at the founding of the city. On the type, see also the recent study by Ramskold and Lenski 2012, 31–58, 31 n. 1, for the minting occasion with previous literature, 32 (type 9 in the catalog, based on the officina S).

110. Themistius, *Or.* 4.52a, discussed in Whitby 2000, 54.

111. On the possible meaning of the legend of this coinage and the date's rationale, see Grierson 1988; Kent 1992. J. Kent refers to the type as "the most abundant and least attractive" of Theodosius's *solidi* (ibid., 190).

112. John Chrys. *Homilia dicta postquam reliquiae martyrum* 72, trans. in Mayer and Allen 2000a, 91.

113. John Chrys. *Homilia dicta postquam reliquiae martyrum* 72, trans. in Mayer and Allen 2000a, 91. See also Holum 1982, 56–58, esp. 58.

114. John Chrys. *Homilia dicta postquam reliquiae martyrum* 72, trans. in Mayer and Allen 2000a, 89 n. 8.

CHAPTER 7. *KOINŌNIA*: THE CHRISTIAN FOUNDERS' LEGACY IN THE SYMBOLISM OF AUTHORITY

1. LSJ, s.v. "koinōnia." This chapter expands my article, Angelova 2004.

2. Euseb. *VC* 2.56.1 (fellowship), 1.43.2 (marriage).

3. Euseb. *VC* 1.17.1 (colleagues); Hdn. 1.8.3 (how Marcus Aurelius made Lucius Verus his partner in the empire, *koinōnon tēs basileias*).

4. Menander Rhetor, *Peri epideiktikōn* (*Treatise 2: The Imperial Oration*), 376.11–12, ed. and trans. D. A. Russell and N. G. Wilson, 90–91. Russel and Wilson 1981, xl, date the treatise to the reign of Diocletian.

5. Julian, *Or.* 3.114c, trans. 1:304. This formulation is all the more important, because Eusebia was not given the title Augusta. For the date of the oration, see Tougher 1998, 109, and n. 19.

6. Holum first drew attention to this formulation in Themistius's oration for Theodosius I (ca. 384), *Or.* 19.228b, and Gregory of Nyssa's funerary oration for Flaccilla from the year 386, *Oratio funebris in Flaccillam imperatricem*, ed. Migne, *PG* 46:877–91. This oration is also published in Spira 1967. It is discussed and partially translated in Holum 1982, 41, including n. 106, and 44. See also the translation by C. McCambly at the Gregory of Nyssa Home Page www.sage.edu/faculty/salomd/nyssa/ (accessed December 22, 2011).

7. John Chrysosum, *Homilia dicta postquam reliquiae martyrum*, *PG* 63:472; trans. Mayer and Allen 2000a, 91.

8. See chapter 6.

9. Paulinus 1998, 2:736–77. On the relationship, expressed in a similar language, reflecting Paulinus's writing, see Sulpicius Severus, *Chronicles* 2.33. For commentary and a French translation, see de Senneville-Grave 1999, 435.

10. Just. *Nov.* 8.1, trans. F. H. Blume online at Annotated Justinian Code: www.uwyo.edu/lawlib/blume-justinian/ajc-edition-2/novels/index.html (accessed January 5, 2015). See also Pazdernik 1994, 266–67; McCormick 2000, 146.

11. Drijvers 1992, 41. The precise date might be November 8, 324, when Constantius became Caesar. See Barnes 1982, 9 and n. 39.

12. Kalavrezou 2003, cat. no. 16. For the type: *RIC* 7 Constantine 465, p. 206. On the coinage of Helena with the diadem see Robertson 1982, 5: pl. 61.H.3–H.17, pp. 255–57. Examples of Fausta diademed are rarer, see *RIC* 7 Constantine 459–60. This rarity can be explained with her death on Constantine's orders in 326.

13. Euseb. *VC* 4.66 and *Chron. Pasch.*, p. 529 with Whitby and Whitby 1989, 17.

14. Decoration: Alföldi 1963, 144–45; Holum 1982, 33 n. 100. Imperial attributes: Delbrueck 1933, 58–66. Also see: James 2001, 105. See also Drijvers 1992, 42–43, with bibliography.

15. Fausta's death on Constantine's orders ended her role in making a new symbolic language. But abundance evidence indicates that she was honored similarly to Helena. Statues in Constantinople continued to represent her. Luxurious medallions were minted to celebrate her fecundity. For the statues, see *Parastaseis syntomoi chronikai* 7, 43 in Cameron and Herrin 1984, 65, 119. For, instance, see the gold medallion (fig. 134), dated to 324, at the British Museum 1896,0608.100. All these indicate that had Fausta been alive, she would have shared in the honors and prerogatives bestowed on Helena.

16. This empress is considered to be the first to wear a true imperial diadem as it features ribbons; see Holum 1982, 32–34.

17. As with Helena, the hair covers it partially and the overall impression is that the jeweled band was intentionally integrated into the empress's hairdo. This fashioning demonstrates that a woman's hairdo by its style offered opportunities for variations.

18. *RIC* 9 Theodosius 48 and 49, and 55; Kent 1978, nos. 718–20.

19. For the *paludamentum* and its uses by women, see Bastien 1992, 1:237, 2:637–40. Bastien argues that on coinage some empresses were shown wearing both the *palla* (a woman's garment covering the head) and the *paludamentum*. Despite difficulties which is which, he nevertheless claims that some Roman empresses wore the *paludamentum* with or without a fibula (ibid., 2:641–42). These included, in his view, Julia Domna (ibid., 3: pl. 79.5), Etruscilla (ibid., 3: pl. 96.4), Salonina (ibid., 3: 107.2), Severina (ibid., 3:116.6), Magnia Urbica (ibid., 3:130.6), and Galleria Valeria (3:154.1–2). It is significant that all of these women were *mater castrorum*; see chapter 3.

20. Suetonius, *Claudius* 26–27; Kienast 1996, 91–92.

21. Plin. *HN* 33.19.63; Tac. *Ann.* 12.56–57. For commentary, see Kaplan 1979, 1:413–14 and n. 12.

22. Tac. *Ann.* 12.37; Kaplan 1979, 413.

23. Tac. *Ann.* 14.11. On Agrippina's ambition for sovereignty, see Bauman 1992, 181–89.

24. See chapter 3.

25. Alföldi 1970 (first published 1935), 263.

26. Verg. *Aen.* 4.262–64.

27. On the military significance of the *paludamentum*, see also Varro, *De ling. lat.* 7.37 and Bastien 1992, 1:235–56.

28. Constantine: *Pan. Lat.* 6(7), 3, trans. Nixon, 230 with 228 n. 31. For the sources, see *PLRE*, s.v. "Fl. Val. Constantinus 4," 1:223–24; Lenski 2006b, 59–75; Maraval 2011, 38–40.

29. Euseb. *VC* 4.66.

30. Justin II: Corippus, *In laudem* 2.118–20, ed. and trans. (French) S. Antès, 37–38. See also the commentary in Cameron 1976, 159–60. For another example on the significance of the imperial purple, see Ammianus Marcellinus's description of Julian's elevation to the rank of Caesar in *Histories* 15.8.15.

31. John Chrys. *Homilia dicta postquam reliquiae martyrum*, *PG* 63: 469 with in Holum 1982, 57 and Mayer and Allen 2000, 85–92 (translation of the entire homily). On similar evidence for Flaccilla, see Holum 1982, 34 n. 102.

32. For a similar solidus, see Grierson and Mays 1992, 273; Kalavrezou 2003, cat. no. 29.

33. For a different view on the message of the mosaics that downplays Theodora's importance, see Barber 1990, 22, and 36–37. On the mosaics, especially Theodora's, see also McClanan 2002, 121–37; Mathews 1971, 146–47; Elsner 1995, 187; Stevenson, Smith, and Madden 1982, 385–87. And also, Deliyannis 2010, 223–50. Justinian's diadem is restored.
34. Alföldi 1970, pls. 6.1, 6.4, 12.4 and 14.7, respectively.
35. Alföldi 1970, 230–33.
36. Priscus, *Fragmenta* 15, discussed in Holum 1982, 1; Bury 1919, 6, 9.
37. Agapetos, *Ekthesis*, PG 86/1:1164.
38. Corippus, *In laudem* 3.130–31.
39. Grierson and Mays 1992, nos. 582–86.
40. Corippus, *In laudem* 4.270–73.
41. Volbach 1976, table 27, no. 51 or 52. On these ivories and a discussion on their date, see Angelova 2004, 12 n. 44.
42. Grierson and Mays 1992, nos. 359–60, and nos. 64–69; Bastien 1992, 2:498–510.
43. Alföldi 1970, 235–37, pl. 8.6. Coin of Hadrian receiving a globe from Jupiter: *RIC* 2 Hadrian 109; *aureus* of Hadrian with Trajan handing him over the globe: *RIC* 2 Hadrian 2–3.
44. *RG* 6.2 and Cooley 2009, 132–33, and fig. 13.
45. Globe only: Constantius I (pl. 10.3–4), Valens (pl. 15.1, pls. 16.1, 16.3). With the scepter: medallions of Probus (pl. 3.16), Constantine (pl. 7.17), in Gnecchi 1968, 1.
46. Grierson and Mays 1992, Arcadius: no. 70, Anthemius: nos. 901–25.
47. Lobell 2008. At Archaeology Archive, the Archaeological Institute of America www.archaeology.org/0801/topten/imperial_standards.html (accessed November 18, 2011).
48. Procop. *Aed.* 1.2.11–12, trans. Dewing, 35. For the *globus cruciger* as an imperial attribute see also, Bastien 1992, 2:527–28.
49. Bellinger and Grierson 1966, 1: nos. 195–262.
50. James deems these 'ambiguous symbols'. See James 2001, 140.
51. Although the ivory of Ariadne in Vienna is not included in the writings about the lyre-back throne, it should be counted in this category. The design of the back is reminiscent of the one on the seat of Christ in the narthex mosaic of Hagia Sophia. On the throne, see Breckenridge 1980–81, 247–60; Cutler 1975, 5–52.
52. Alföldi 1970, 248–49, pl. 14.1.
53. Philostorgius as recorded in the *Suda lexicon*, s.v. "Leontios," 254.
54. "Nobilitat medios sedes Augusta penates, quattuor eximiis circumuallata columnis, quas super ex solido praefulgens cymbius auro immodico, simulans conuexi climata caeli, immortale caput soliumque sedentis obumbrat, ornatum gemmis, auroque ostroque superbum. Quattuor in sese nexos curuauerat arcus." From Corippus, *In laudem* 3.191–200, ed. and trans. Antès (French), 60–61. My translation is informed by the French translation and the English translation by A. Cameron. The verb *curuauerat* poses a difficulty as it is in the singular, whereas the arches are in the plural. For commentary on the passage, see Cameron 1976, 188.
55. See Mathews 1993, 106.
56. Alföldi 1970 (first published 1935), 243–44; Hallett 2005, 166–72.
57. Hallett 2005, 166.

58. Gnecchi 1968, no. 1, pl. 25.1, p. 50. For a better photograph, Kent 1978, no. 474. An exception is the Missorium of Theodosius in Real Academia de la Historia, Madrid, reproduced in Leader-Newby 2004, fig. 1., 12.

59. Alföldi 1970, 243, pl. 6.1, 8.18. Alföldi refers to Herodian's description of a imperial "throne" at the games and in the senate. Hdn. 1.8.4 (Lucilla), 1.9.3 (Pertinax seated in the Senate House).

60. Alföldi 1970, 243–45. On the history of the *sella curulis* and its types in Roman times, see Wanscher 1980, 121–90. See also, Schäfer 1989, 24–196.

61. Alföldi 1970, pl. 16.1–2, and 245.

62. See also a colossal statue of Constantine I from the Basilica Nova (ca. 315–30), where the emperor was depicted seated, Kleiner 1992b, 438, figs. 399, and 400–401. See also a medallion of Constantine with his sons celebrating the founding of Constantinople, Alföldi 1970, pl. 16.1–2.

63. Valentinian I and Gratian: *RIC* 9 Valentinian and Gratian no. 16.a, p. 16. Gratian: ibid., no. 9.a, p. 159. For Arcadius and Leo I, see respectively Grierson and Mays 1992, Arcadius: no. 61 and 70, Leo I: no. 533. See also an ivory diptych showing two enthroned emperors, Volbach 1976, table 19, no. 35. There is also an example of two enthroned empresses, see *RIC* 10 Anthemius pp. 194–95.

64. Procop. *De bellis* 4.9.4; *Anecdota* 12.21.

65. Corippus, *In laudem* 1.269–71.

66. Galla Placidia: Grierson and Mays 1992, nos. 291–94; *RIC* 10 Valentinian III 2009, although Kent (author of *RIC* 10) interprets the figure as an emperor. Minted in Ravenna 426–ca. 430. Licinia Eudoxia: Grierson and Mays 1992, no. 970.

67. Malalas, 357, trans. Jeffreys, and Jeffreys 1986, 194–95; this is a passage found only in the *Tusculan Fragments* (*PG* 85: 1807–24).

68. Compare with other views: James 2001, 166 (emperor's deputy); Herrin 2000, 3–35 (imperial feminine); Holum 1982, 3 (imperial dominion of women).

69. Euseb. *VC* 3.44.

70. Julian, *Or.* 3, 344–45.

71. Ibid.

72. Grain fund: *Chron. Pasch.*, p. 585 with Whitby and Whitby 1989, 75 and n. 251; Baths of Valens: Evagrius, 1.20, trans. Whitby 2000, 47. See also, Holum 1982, 186, and note 46; James 2001, 156.

73. *Chron. Pasch.*, p. 585 with Whitby and Whitby 1989, 74. Preserved in the *Tusculan Fragments* only; see Jeffreys and Jeffreys 1986, 195.

74. Holum 1982, 189. Eudoxia's participation in the procession to Drypia has also been seen as *adventus;* see MacCormack 1981, 65. A general discussion of *adventus:* Mac-Cormack 1981, 17–88.

75. Malalas, 441, trans. Jeffreys and Jeffreys 1986, 256; Theophanes, *Chronographia* 186, trans. Mango and Scott 1997, 285 (adds the poorhouses and monasteries).

76. *PLRE*, s.v. "Iuliana 3," 2:635–36. For her dates, I follow Capizzi 1968. She must have been born after her mother's return from captivity in 461/462. Capizzi puts her death between 527 and 529 (ibid., 225). The manuscript has been reproduced most recently with commentary by Mazal 1998, fol. 6v, 25–27. For a facsimile: Gerstinger 1965–70.

See also: Kiilerich 2001; von Premestein 1903; Connor 2004, 94–116; Brubaker 2002, though she interprets Juliana's patronage as aristocratic and feminine; Connor 1999; Harrison 1989.

77. Inscription on the MS: Mazal 1998.

78. On *proskunēsis* and the variety of actions summarized by this term, see Treitinger 1969, 84–94. For women and *proskunēsis*, discussing a passage of Procopius's *Secret History,* see Connor 2004, 129–31. The author dates the practice to the sixth century on account of Procopius's displeasure at performing it for Theodora. In addition, the *Palatine Anthology* has preserved a remark by Menander Protector (flourished late sixth century) commenting the reverence of Eudocia (wife of Theodosius II) for the Tomb of Christ at Jerusalem (*Anth. Pal.* 1.105). The sixth-century author commented: the empress, "who is done *proskunēsis* by all people [*he pasin anthrōpoisi proskunoumenē*], did *proskunēsis* to the tomb of the One [*proskunei d'henos tafon*]" (trans. Paton, 1:45).

79. Treitinger 1969, 84–94. Claudius banned it as a reaction to Caligula's use of it, for instance, see Dio Cass. 60.5.4.

80. Treitinger 1969, 84–94.

81. LSJ, s.v. "proskuneō," 1518.

82. Seeck 1991, 385. Also see, *ACO* 2.1.1, p. 7, line 26 (Galla Placidia), 2.1.1, p. 8, line 2 (Galla Placidia), .

83. *ACO* 2.1.1, p. 50, line 5.

84. *ACO* 2.1.1, p. 49, line 5.

85. See Lampe 1961, s.v. "proskunētos."

86. "Hoi de episkopoi akousantes prosekunēsan." From Grégoire and Kugener 1930, 42–43.

87. Aymard 1934, 178–96; Gagé 1933, 21. For assimilations to Venus Victrix: Julia Domna: *RIC* 4/1 Septimius Severus 581; Plautilla: *RIC* 4/1 Caracalla 368; Magnia Urbica: *RIC* 5/2 Carinus 342; Galeria Valeria: *RIC* 6 Galerius 36, 43, 67, 71; for photographs not necessarily of the same examples, see Kent 1978, Julia Domna: plate 110, no. 381, Magnia Urbica: plate 147, no. 560, and Galeria Valeria: plate 154, no. 601. Aymard and Gagé do not distinguish between Venus Genetrix and Victrix. Iconographically, there is no consistency in the representation of the two types, although Victrix seems to be most often represented holding armor. The coin of Julia Domna cited above (no. 381) combines elements of both Genetrix and Victrix. See *RE*, s.v. "Venus," col. 866; *LIMC* 8: 200, no. 48; and Weinstock 1971, 83–87. *Nikēphoros* is an epithet introduced for deities holding a Victory, e.g., Athena or Venus; see Weinstock 1971, 100. The following empresses were Nikēphoros: Livia, Iulia (Livilla), and Drusilla the Younger. See Hahn 1994, 44, 171, 398, and 403.

88. *Pan. Lat.* 7, 6, trans. Nixon 1994, 198–99.

89. The assimilation to Victory probably began with Fulvia during her marriage to Mark Antony when she was presented with wings on an *aureus* from around 42–40 B.C.E., and on a silver quinarius. See chapter 3 and Wood 1999, 41–44 and fig. 1. See also fig. 18. Empresses assimilated to Victoria/Nike: Antonia, Agrippina II, Poppaea, Domitia, Faustina II, Julia Domna, Julia Mamaea, Ulpia Severina. See Mikocki 1995, 125.

Imperial victory was seen as the prerequisite for the preservation of the social order and its desirable states, Fears 1981b, 812–13. Therefore, empresses were also assimilated to Securitas (Hahn 1994, 401), Felicitas, Salus, Concordia (Mikocki 1995, 125).

90. *Verr.* 2.2.154. The concept is discussed in Noreña 2011, 141.

91. Just over half of the empresses from Faustina the Younger (147–75) to Helena received this title. For the first coin with this title, minted posthumously for Faustina the Younger, see *BMCRE* 4: pl. 67.15. The other women bestowed with this title are: Julia Domna, Julia Mamaea, Julia Maesa, Julia Soaemias, Marcia Otacilia Severa, Herennia Etruscilla, Cornelia Salonina, Ulpia Severina, Magnia Urbica, and Galeria Valeria. See Kienast 1990, 141 (Faustina II), 167 (Julia Domna), 180 (Julia Mamaea), 181 (Julia Maesa), 175 (Julia Soaemias), 199 (Marcia Otacilia Severa), 204 (Herennia Etruscilla), 219 (Cornelia Salonina), 233 (Ulpia Severina), 258 (Magnia Urbica), 282 (Galeria Valeria).

92. Reliefs of Agrippina and Nero from Aphrodisias, dated to 54, see Open Educational Resources: http://open.conted.ox.ac.uk/resources/images/nero-and-agrippina (accessed May 13, 2012).

93. Angelova 1998, 26–44; James 2001, 139–40.

94. Constantine, *Oratio ad coetum sanctorum*, 26. On Eusebius and Ambrose, see chapter 8.

95. For the visualization of this idea, see coinage showing an emperor or an empress crowned by a hand of God. *Manus dei* coinage: Constantius medallion showing Constantine crowned by the hand of god Gnecchi 1968, 1: pl. 12). For the empresses, see Grierson and Mays, *LRC*, nos. 273–94 (Eudoxia), nos. 436–43 (Pulcheria), nos. 454–59 (Eudocia), nos. 593–94 (Verina), p. 180 (Zenonis), nos. 817, 824–28, 834 (Galla Placidia), no. 866 (Honoria), no. 872 (Licinia Eudoxia). See also Holum 1982, 65–66, with bibliography on the iconographic origins n. 71; Alföldi 1970 (first published 1935), 173–74.

96. On imperial victory, see McCormick 1986, 111–18.

97. On the colleagiality of imperial victory, see McCormick 1986, 111–19.

98. For examples (Theodosius II and Anastasius), see McCormick 1986, 111–18.

99. Pulcheria's implication in imperial victory through the "Long-Cross Solidi" has been lucidly argued by Holum 1982, 109–10, 122, 129–30, etc. I emphasize not so much the Augusta's sharing of an identical reverse with the emperor (Holum's argument), but her inclusion in the imperial college and victory through the inscription on the *solidi* from 450–53.

100. A similar suggestion, but for the inclusion of Pulcheria in *Concordia Augustorum*, was made by J. W. E. Pearce, in *RIC* 9:206 n. Grierson and Mays also indicate that Pulcheria might have been responsible for it: Grierson and Mays 1992, 152. But elsewhere Grierson and Mays (1992, 86) deem that possibility "out of the question: Augustae were never treated as Augusti in such computations."

101. Lafaurie 1958, 280–90; Grierson and Mays 1992, 85–86.

102. *Solidus* of Verina (Augusta 457–94, wife of Leo I): Grierson and Mays 1992, no. 593 and pp. 170–71; Kalavrezou 2003, no. 33. Given that coins were usually struck upon the elevation to the title of Augusta, i.e., in this case in the beginning of Leo's reign in 457, and that minting of Verina's coins after his death in 474 was unlikely, the other two Augusti in this computation should be Leo I and either Majorian (457–61) or Anthemius (467–72); solidus of Euphemia (Augusta 467–72, daughter of Marcian and wife of

Anthemius): Grierson and Mays 1992, no. 933. The three G's probably referred to Euphemia, Anthemius, and Leo I, their colleague in the East; solidus of Zenonis (Augusta 475–76, wife of Basiliscus): Jean Tolstoï 1968, 1: no. 94, p. 167; Kent 1978, no. 781. The Augusti included besides Euphemia were her husband Basiliscus and their son Marcus; solidus of Ariadne (Augusta ?474–513/15): the dating of Ariadne's coinage to the second reign of her first husband Zeno (476–91) and possibly to the beginning of the reign of her second husband Anastasius (491–518) complicate the computation. In both cases, the imperial line passed to Zeno and Anastasius through association with her. But the only recognized emperor in the West in this period was Julius Nepos (474–80), so Ariadne's coinage was most likely minted around 476 and it served to strengthen Zeno's claim to imperial power after the usurpation by Basiliscus.

103. *De cerim.* 92, trans. Moffatt and Tall, 419, slightly amended.
104. Theophanes, *Chronographia* 249 (579/580) in Mango and Scott 1997, 370.
105. Euseb. *VC* 1.28.2.
106. Feissel 2000, nos. 38, 51, 72, and 74 (respectively). The ramparts at Heliopolis similarly acclaim both of the Augusti (ibid., no. 47).
107. *ILCV* 1.27.
108. Tac. *Ann.* 12.37, and Gnecchi 1968, 2: pl. 100.9.
109. Coins of Leo I and Verina: see Grierson and Mays 1992, 164–66 (nos. 582–86). Chalke mosaics: Procop. *Aed.* 1.10.16; coins of Justin and Sophia: see above. To these can be added the consular diptych of Clementius from 513 with Anastasius and Ariadne flanking a cross, the diptych of Justin with Justinian and Theodora on either side of Christ, Volbach 1976, plate 7, no. 15, and plate 17, no. 33. We can also include the now lost apse mosaics of St. John the Evangelist in Ravenna with Arcadius and Eudoxia and Theodosios II and Eudokia flanking the bishop Peter Chrysologus; see Rizzardi, Angiolini Martinelli, and Robino 1996, fig. 13, p. 120. Also the curtains in Hagia Sophia with Justinian I and Theodora: Paulus Silentiarius, *Descr. S. Sophiae,* trans. in Mango 1986, 81. See also: the cross of Justin and Sophia: Bergman, DeGrazia et al. 1998, no. 1a.; and the excellent discussion in McClanan 2002, 163–68, figs. 7.4 and 7.5. Verina manifested her sovereignty when she issued rescripts in her name; see Jones 1964, 1:229.
110. Corippus, *In laudem* 1.203, 2.172, ed. Antès, 26. It is probable that the prominence of Sophia in the poem can be attributed to her commissioning of the poem, as A. Cameron has argued, but I doubt that the empress could have influenced the wording of her relationship with the emperor, or that the flattery could have violated the status quo to the offense of the court. See Cameron 1980b. Overall for Sophia, see Garland 1999, 40–57.
111. Preisigke 1931, 70.
112. In Photius's telling, Constantina was able to elevate Veteranis to the rank of Caesar on account of her title Augusta. See, Philostorgius, 49.9–12. For Pulcheria choosing Marcian, see Marc. Com. s.a. 450; *Chron. Pasch.,* p. 590; Theophanes, *Chronographia* 103. For Verina, see Malalas, 388, trans. Jeffreys and Jeffreys, 216. For Ariadne, see *Chron. Pasch.,* p. 607; Malalas, 392, trans. Jeffreys and Jeffreys, 220.
113. "The Emperor is not bound by statues. The Empress no doubt is bound, at the same time the Emperor generally gives her the same exceptional rights as he enjoys himself."

A comment by the jurist Iulius Paulus (fl. late second century to the early third) on the *lex Iulia et Papia 13*, in the *Digest* 1.3.31, trans. in Justinian 1904, 22.

114. Justa Grata Honoria: Prisc. *Frg.* 5; Marc. Com. s.a. 434; Holum 1982, 1; Bury 1919. Eudocia: Prisc. *Frg.* 8; Marc. Com. s.a. 444 (stripped of her royal attendants). See also Holum 1982, 194.

CHAPTER 8. CHRISTIAN PIETY AND THE MAKING OF A CHRISTIAN DISCOURSE OF IMPERIAL FOUNDING

1. For these interferences, see, the letters of Constantine to the bishops, for instance, the one he sent to the Council of Tyre, preserved in Euseb. *VC* 4.42, or his dealing with Christian heterodoxy. For an erudite treatment of the subject of Constantine's dealing with the bishops, his "consensus politics" in dealing with heterodoxies, see Drake 2000, 238–57.

2. For Eusebius' positive assessment of Constantine, see most recently Bardill 2012, 372–76.

3. On the decree's date, see Barnes 1982, 71. For the Edict of Milan for religious toleration and its innovative language, see analysis in Drake 2000, 193–98.

4. See Drake 2006, 112–32; Drake 2000, 299–305 (advises against separation of political from religious thinking, indeed for the primacy of the political, and the need for consensus); Van Dam 2007, 10–11 (on Christianity as Constantine's underlying concern in existing literature).

5. For example: Baynes 1972, 4. The opinion goes back to Burckhardt 1853.

6. Euseb. *VC* 3.47.4–49.

7. For instance, on Constantine's legislation, see MacMullen 1969, 194–204. On his buildings and actions in Rome, both in consideration of the pagan elites: Krautheimer 1983, 35–40. Similarly: Grant 1994, 152–55; Straub 1967, 46–47. Contra with an emphasis on the role of Christianity: Barnes 1981, 275 ("After 312 Constantine considered that his main duty as emperor was to inculcate virtues in his subjects and to persuade them to worship God."). For dynasty as his priority over religion, the "one commitment that he would not compromise," see more recently Van Dam 2007, 125–29, quote 59, with earlier literature in 126 n. 55.

8. See, for instance, most recently, Noreña 2011, 46–47.

9. All references from the *Life of Constantine* are to the edition of Winkelmann 1991. Translations are taken from Cameron-Hall. See also the translation of Bagster 1890. For the *Praise* (hereafter in the notes *LC*), I refer to this edition: Heikel 1902. Translation and commentary in Drake 1976.

10. All references are to the edition of Faller 1955. Translations are taken from Liebeschuetz 2005 and from Deferrari 1953. See also, Mannix 1925.

11. Gregory of Nyssa, *Oratio funebris in Flaccillam imperatricem* 877–91. This oration is also published in Spira 1967. It is discussed and partially translated in Holum 1982, 23. See also the translation by Casimir McCambly at the Gregory of Nyssa website: www.sage. edu/faculty/salomd/nyssa/ (accessed May 13, 2012). Chrys. *Homilia dicta postquam reliquiae martyrum*, 467–72, trans. Mayer and Allen 2000a, 70–74. Philostorgius: The passage from his history in question survives in the Suda, 254. Trans. E. Walford and

available on the Tertullian Project website on the works of the early Church fathers www.
tertullian.org/fathers/philostorgius.htm (accessed March 4, 2012).

12. Eusebius's changing views, especially, about the relic of the True Cross, have been
discussed in Drake 1985a, 1–22. My analysis in this chapter has a different emphasis
and a broader scope.

13. See Barnes 1989, 94, 6–8, 102–16; 1981, 267–71. See also Cameron 1997, 145–74; 1983,
71–88; 2000, 72–88; Leo 1990, 312–13 (mixture of panegyric and history). On the his-
torical elements, see Barnes 1981; Carriker 2003, 286–98. On the encomiastic elements
of ancient biographies, see Cox 1983, xiii–xiv. For the "mirror of princes," see Drijvers
2004. For Eusebius's evolving views, see Van Dam 2011, 82–100.

14. The standard study on the *Praise*, along with a translation and commentary, remains
Drake 1976.

15. Euseb. *LC* 2.1, 2.2, 2.3, 2.4, 5.1 (friend of God). On the qualities, see particularly 5.4
(Constantine "Victor" as the archetype of the Supreme Sovereign).

16. On this coinage, see Nock 1947, 102–16; Alföldi 1964, 10–16; Wallraff 2001, 126–43.
For examples, see *RIC* 7 Constantine 20, 34, 45, 99, 133, among others.

17. Euseb. *LC* 3.5–6 (monarchy related to monotheism, one God the archetype for the
monarchical form of government), 5 (the earthly ruler mirrors the divine), 4.2 (the
earthly kingdom mirrors the divine). For Eusebius's attitude toward Platonism (posi-
tive), see *Praeparatorio evangelica* XI.pref. 2–3, XI.8.1, XIII.4.3 with Karamanolis, George,
"Numenius," *Stanford Encyclopedia of Philosophy*, ed. Edward N. Zalta, http://plato.
stanford.edu/archives/fall2013/entries/numenius/ (accessed November 18, 2013).

18. Euseb. *LC* 5.4, trans. Drake 1976, 89 with 150 n. 8.

19. Euseb. *LC* 5.4–5, trans. Drake 1976, 89.

20. Euseb. *LC* 5.4: "Really a Victor is he who has triumphed over the passions which have
overcome mankind, who has modelled himself after the archetypal form of the Supreme
Sovereign, whose thoughts mirror its virtuous rays, by which he has been made perfectly
wise, good, just, courageous, pious, and God-loving. Truly, therefore, is only this man
a philosopher-king, who knows himself and understands the showers of every blessing
which descend on him from outside, or rather, from heaven," trans. Drake 1976, 89.

21. Euseb. *LC* 2.5, trans. Drake 1976, 86.

22. *LC* 7.12. Meaning: LSJ, s.v. "therapōn." Drake remarks that "literally [*therapōn* means]
'servant', but conveying in a military context a more personal relationship." He suggests
"client" as "a more Roman equivalent," but notes that it "conveys the wrong connotations
in modern English" (Drake 1976, 166 n. 11). For other instances, see *VC* 2.2.3 and 4.71.2.

23. See Cameron-Hall, 192–93; and *Exodus* 4.10.3, 14.31.3, and 33.11.3.

24. Euseb. *VC* 1.38, p. 35 (power from god, divinely aided), 1.52.1, 3.1.1, 4.46.1 ("friend of
God"); 3.26.6, p. 96 ("friend of the all-ruling God"); 4.71.2, p. 150 ("his worshipper/
attendant/helpmate [*theraponta*]").

25. "Having made him an image [*eikona*] of his own monarchical reign"; Euseb. *VC* 1.5,
trans. Cameron-Hall, 69. See also commentary in Cameron-Hall, 187. Servant and slave:
VC 1.6. Fear and reverence/piety: *VC* 3.10.4. Constantine's compensation, his offerings
in thanksgiving are mentioned multiple times. Constantine's churches, for instance,
exemplify this.

26. Euseb. *VC* 1.6, trans. Cameron-Hall, 69.

27. For the history of the term *dominus* and its uses, see Noreña 2011, 293–97 (with the history of the term and its uses, and its frequency).

28. See Noreña 2011, 294.

29. Euseb. *VC* 1.39, 2.9, 2.13, 2.19.

30. Euseb. *VC* 2.19, trans. Cameron-Hall, 102.

31. Euseb. *VC* 2.14, trans. Cameron-Hall, 100 (quotes). Euseb. *LC* 5.5, trans. Drake 1976, 89–90 (prayers).

32. Euseb. *VC* 4.14.2.

33. *VC* 3.47–49.

34. Euseb. VC 3.48, trans. Cameron–Hall, 140, 297–98 (commentary).

35. Euseb. *VC* 3.49, trans. Cameron-Hall, 140.

36. On the Holy Apostles at the time of Constantine, see Euseb. *VC* 4.58–60. The two sides of the debate are: Mausoleum only: Mango 1990, 51–61. Mausoleum and church: Krautheimer 1964, 224–29. Translated in Krautheimer 1969, 27–34.

37. Constantine as Christ-like, see Krautheimer 1983, 66–67.

38. Euseb. *VC*, 4.64.2. 1.2.2–3. For a different view, see Bardill 2012, 376. On the *consecratio* coins, also Bardill 2012, 376–80. Compare also with Commodus's medallion, fig. 30.

39. Such as his silences on Golgotha. On them: Drake 1985a, 1–22; Rubin 1982, 181–99; Walker 1990, 127–30; Hunt 1997, 405–24; Borgehammar 1991, 93–122.

40. See Lenski 2004, 113–24.

41. On these, see Woods 1998, 70–86; Potter 2013, 244–45.

42. Discussion of the saintly and panegyrical aspects, Barnes 1989; Cameron 2000.

43. Elliott 1991. Cameron and Hall's commentary provides a detailed analysis of Eusebius' twisting of facts and omissions. See Cameron-Hall. On Eusebius's revisions, for instance, see Van Dam 2011, 82–100.

44. Pelliccioni 1975; Krautheimer 1983, 15; Hunt 2003, 105–24. On Constantine's Roman projects, see also Marlowe 2010, 199–220.

45. See chapter 1. Another church that also seems to have been constructed as a victory monument was the church he commissioned in Nicomedia. This city was burned during the Great Persecution of Diocletian, and so the church in Eusebius's words was "a monument of victory over his enemies." See Euseb. *VC* 3.50, trans. Cameron-Hall, 140, 299.

46. Euseb. *VC* 1.44, 4.24. On the sacrifice, and for the *pontifex maximus*, see Straub 1967, 37–55. The sources for the sacrifice include *Pan. Lat.* 12.19 with trans. and commentary by Rodgers 1994, 322–24 (the author is not explicit about the sacrifice, simply states that Constantine went to the palace quickly after the battle with Maxentius). Directly stated refusal to sacrifice: Zosimus, 2.29.5 with Paschoud 1971, 2:219–24 and Paschoud 1971a, 334–54. On the date of the refusal, 312 or 315, see also Straub 1967, 41–42 (based on *Pan. Lat.* 12.9); Nixon and Rodgers 1994, 323–24 n. 119; Krautheimer 1983, 36, 131–32 n. 30. For a law, dating this refusal to after 324, see Barnes 1984, 69–72; Bradbury 1994, 120–39. See also discussion by A. Lee in Lenski 2006, 172–77. On the question whether the emperor was also a priest, see Dagron 2003, esp. 1–10 (argues that one should not presume a distinction between church and state, draws attention to the Old Testament connection between emperor and priest at the expense of the pagan *pontifex*

maximus), 127–57 (on Constantine's intentions, especially as revealed by Eusebius in the description of the Holy Apostles). For sacrifice and religious developments more generally, see Caseau 1999, 21–59.

47. Euseb. *VC* 1.44, trans. Cameron-Hall, 87.4.24 (Constantine calls himself bishop).

48. Euseb. *VC* 3.12, trans. Cameron-Hall, 126.

49. Euseb. *VC* 3.10–14.

50. Such as Euseb. *VC* 3.52–53 (letter to the bishops of Palestine).

51. Euseb. *LC* 2.5.

52. See Spieser 2002, 593–604, esp. 603–4 (on the asexuality of Mary and Helena).

53. *VC* 3.43.2, p. 102; *VC* 3.43.4, p. 102; trans. Cameron-Hall, 138; *VC* 3.42.1. On this passage, see Walker 1990, 188–89.

54. Gold medallion, dated to 324, at the British Museum 1896,0608.100. See fig. 134.

55. On Helena's actions, see chapter 4.

56. *De obitu Theodosii* 48, trans. Liebeschuetz 2005b, 200.

57. *De obitu Theodosii*. The date is February 25, 395. On the date see Deferrari 1953, 303. See also the recent translation in Liebeschuetz 2005a, 174–77. For an analysis of its genre, see Biermann 1995, 50, 83–86, 103–19. Lunn-Rockliffe 2008, 191–207.

58. Sordi 1990, 1–9; Consolino 1985, 161–80.

59. Consider the *Codex Calendar of 354*, composed about four decades before the oration. On it, see Salzman 1990, 43 (martyrs not noted in the civil calendar of Rome), 132 (sixty-nine days of celebrations dedicated to the imperial family), 143 (imperial cult flourished in the fourth century).

60. Ambrose, *De obitu Theod.* 10, 27.

61. *De obitu Theod.* 15.

62. *De obitu Theod.* 25, trans. Liebeschuetz 2005b, 189.

63. *De obitu Theod.* 7, trans. Deferrari 1953, 310.

64. *De obitu Theod.* 10, trans. Deferrari 1953, 311.

65. Signs for the significance of horse trappings and other armor-related accessories and their relation to military achievements, the troops, and the empress possibly go back to Livia and a large number of bronze plaques, which probably represent her with her sons, Tiberius and Drusus, see Bartman 1999, 82–86, and fig. 67. The ones from the Christian period may all be playing with the prophecy of Zechariah 14:20. For instance, Serena presented her son-in-law Honorius with a horse bridle, see Claudian, *De zona equi regii missa Honorio Augusto a Serena* 48 (70), trans. Platnauer. See also the *miliarense* of Constantine depicting him on the obverse with a plumed helmet with the Chi Rho, holding the reigns of his horse, while the reverse shows him addressing the cavalry, *RIC* 7:36; Kent 1978, no. 648. The cross, but especially the nails, have been seen as the fulfillment of a prophecy in Zechariah (14:20) about the coming of Christian rule. On this with relevant literature, see Drijvers 1992, 110.

66. *De obitu Theod.* 47, trans. Liebeschuetz 205b, 200. The Theosodian empresses' interest in Mary may have precipitated this comparison. On the interest of the Theodosian and other empresses and the Virgin, actual and legendary, see Warner 1983, 86–87, 291.

67. I analyze this text in a study I'm preparing on the Helena legend and the relic of the True Cross.

68. See chapter 1.
69. "i, digno nectenda viro tantique per orbem | consors imperii!" Claudian, *Epithalamium* 289–90, trans. Platnauer.
70. On the statues, see Cameron and Herrin 1984, 70–72, 78, 94, 118–21, 126, 134–35. For the parallels, see chapter 9.
71. "*Hē poluarkēs dexia*"; *In Flaccillam* 480. The translation is slightly amended from Holum's, see Holum 1982, 23.
72. *In Flaccillam* 481–82. It is discussed as *adventus* in Holum 1982, 25.
73. *Notitia*, 238. It has been argued convincingly that this palace must be identified with the one in the *Kōnstantinianai*, near the Holy Apostles. See Magdalino 2001, 67.
74. Theodoret, *Hist. Eccl.* 5.18; trans. Jackson, 3: 145.
75. On her see: Wendy Mayer, "Aelia Eudoxia" in *De Imperatoribus Romanis: An Online Encyclopedia of Roman Emperors*, hosted at Loyola University, Chicago, www.roman-emperors.org/indexxxx.htm (accessed March 4, 2013); and Holum 1982, 48–78.
76. Soc. 6.18.4–5.
77. For the location, yet to be identified, see Mayer and Allen 2000a, 85; Janin 1964, 445. For a hypothesis, see Mayer 2005, 157.
78. The following day he delivered another sermon in the presence of the emperor: *Homilia dicta praesente imperatore* (CPG 4441.2). On the two sermons, see Mayer 2005, 102, 370, 385.
79. All translations of this homily, here and in the paragraph that follows, are from Mayer and Allen 2000a, 86–92, 88 ("river of fire"), 86–91.
80. Mayer and Allen 2000a, 86.
81. For the vitality of the ancient lifestyle into the Christian era, see Roueché 1989.
82. *Contra ludos et theatra* (CPG 4441.7, "New Homily No. 7"), discussed in Mayer 2005, 102; Kelly 1995, 131. Translated in Mayer and Allen 2000b, 119–25.
83. Kelly suggests that John's *Contra ludos et theatra* may be the cause for imperial legislation banning games and spectacles on Sunday. See Kelly 1995, 131.
84. Kelly's discussion: Kelly 1995, 137 (*In Oziam homilia* 1.1, *Commentaria in psalmos* 3.1).
85. See the *Notitia*, cited above, on the numbers.
86. Ibid.
87. It was erected in 403. Soc. 4.18; Soz. 8.20; Ammianus Marcellinus s.a. 403; Zos. 5.23; Theophanes, *Chronographia* 79. For the inscription at the base of the statue see *CIL* 3.736 and Gottwald 1907, 274–76. Socrates and Sozomen see the festivities around the statue as the last straw in Eudoxia's conflict with the bishop. The statue is also mentioned in the *Parastaseis syntomoi chronikai* 31, in Cameron and Herrin 1984, 93, 206–7 (commentary and bibliography); Müller-Wiener 1977, 52; Mango 1959, 56–59; Holum 1982, 76–77; Mango 1951, 63.
88. John Chrys. *Sermo antequam iret in exsilium*, PG 52:431, with Soc. 6.18.4–5, Soc. 6.15, and Soz. 8.18. Discussion of the conflict and the exile: Holum 1982, 74–75; Kelly 1995, 211–12, 228–32. Palladius claims that John also called Eudoxia Jezebel. See Palladius, 51.4. Discussion: Kelly 1995, 228–29.
89. Kelly 1995, 211–12.
90. Philostorgius in the Suda, 254.

91. Trans. Walford. At the Tertullian Project website: www.tertullian.org/fathers/philostor-gius.htm (accessed October 12, 2013).

92. Ibid.

93. On the discontent, especially related to imperial burials at the Holy Apostles, and why Constantine was made a saint in the church, see Dagron 2003, 142–43.

94. For the riots and Chrysostom's conflict with the empress, see Holum 1982, 69–78.

95. For a different interpretation, see Elsner 2007, 33–57.

96. Procop. *Aed.* 1.27, trans. Dewing, 13.

97. *Anth. Pal.* 8.820–21 (epigram Justinian as the builder); Procop. *Aed.* 1.3.10 (location); Procop. *Anec.* 15.36–39 (palace and sea dangers); Janin 1964, 148–49. For the cistern, Janin 1964, 206.

CHAPTER 9. CHURCH BUILDING AND FOUNDING

1. On church building and imperial victory, see Hunt 2003. For power and prestige and church building, see James 2001, 153–59. On Christian philanthropy and church building, see McClanan 2002, 93–106, 1996. For the imperial virtue of philan-thropy, see Holum 1982, 26–30. For individual women and church building in light of dynasty, see Harrison 1989; Oost 1968; Rizzardi, Angiolini Martinelli, and Robino 1996.

2. The Roman churches: Krautheimer 1983, 7–40, esp. 15. Also see Hunt 2003.

3. For the churches in the East the major source is Euseb. *VC* 3.29–53. For the Roman churches, the main source is the *Liber Pontificalis* 34. See Duchesne 1981, 1:170–201. For the churches of Constantine, see Krautheimer 1986, 39–67.

4. Eusebius on the "New Jerusalem" and the Savior's Martyrium *VC* 3.33; Cameron-Hall, 284–87. See also Wilken 1992a, 96, 1992b, 749–50; and Wharton 1995, 85–100. Con-stantinople's churches: Krautheimer 1983, 47–61. Nicomedia: Euseb. *VC* 3.50.1, with commentary in Cameron-Hall, 299. Antioch: Euseb. *VC* 3.50.2 with Cameron-Hall, 299; Krautheimer 1986, 75–78.

5. For the debate about the status of these buildings as public or private, see Hunt 2003, 105–24; Krautheimer 1983, 12–40.

6. Euseb. *VC* 1.39. See also the analysis in Krautheimer 1983, 12–15, 127 n. 4; Hunt 2003, 105–24.

7. Trans. Jones 1962, 96–97. See also Straub 1967, 48. Barnes 1981 interprets it as a "political manifesto," 75.

8. Krautheimer defines them as public in a practical sense, but private in a legal: Krauthe-imer 1983, 25–40.

9. Malalas, 363, trans. Jeffreys and Jeffreys, 198–99.

10. Procop. *Aed.* 6.5.8, trans. Dewing, 381.

11. See for instance Procop. *Aed.* 6.6.6–7, trans. Dewing, 385; or ibid., 1.9.8, trans. Dewing, 89. The most common way in antiquity and still in Justinian's time was to reciprocate a gift by erecting an honorary statue with an appropriate inscription. None of these has survived from Constantinople, although literary evidence suggests that there were many statues of emperors and empresses in the city. Procopius associates closely a statue of

Justinian with his most famous commission, the cathedral Hagia Sophia (Procop. *Aed.* 1.2.1–13, trans. Dewing, 33–37).

12. For the visualization of this idea, see coinage showing an emperor or an empress crowned by a hand of God. *Manus dei* coinage: Constantius medallion showing Constantine crowned by the hand of god Gnecchi 1968, 1: pl. 12). For the empresses, see Grierson and Mays 1992, nos. 273–94 (Eudoxia); nos. 436–43 (Pulcheria); nos. 454–59 (Eudocia); nos. 593–94 (Verina); p. 180 (Zenonis); nos. 817, 824–28, 834 (Galla Placidia); nos. 866 (Honoria); no. 872 (Licinia Eudoxia). See also Holum 1982, 65–66, with bibliography on the iconographic origins n. 71; Alföldi 1970 (first published 1935), 173–74.

13. Cedrenus, 1:677, trans. Cesaretti 2004, 284; Feissel 2000, no. 10, 90.

14. Trans. van Millingen 1912, 73. The translation is slightly amended for clarity. Studies on the church and epigram include Croke 2006, 25–63; Shahid 2003, 467–80; Bardill 2000, 1–11; Connor 1999, 511; Mango 1976, 385–92 (with a summary of the earlier debates).

15. *Anth. Pal.* 1.11, trans. Paton, 1:12. The translation is slightly amended. For *therapōn* as attendant, companion, see chapter 8 and Drake 1975, 166 n. 11.

16. *ODB*, 2: s.v. "Mark the Deacon," 1302. This authorship and the date of this document have been questioned on the basis of two discrepancies in the narrative: the name of the bishop of Jerusalem in 392 and the date of Theodosius II's baptism. See: Grégoire and Kugener 1930, 1–cxi; Halkin 1931, 155–56. Grégoire and Kugener consider this work, though not written by Mark the Deacon, as faithfully reflecting the conditions of the early fifth century. It was edited in the sixth century to its present form, omitting the later years of Porphyry's activities, which were considered heterodox. One study has considered the church as the one dedicated to St. Sergius. See Saliou 2005, 180–85, 183 n. 79. However, Eudoxiana has been identified in recent excavations, conducted by Moain Sadeq. The reports have not yet been published, but the director of those excavations kindly shared his findings with me in an email, dated May 24, 2014. See also www.telegraph.co.uk/news/worldnews/middleeast/palestinianauthority/1364119/Gaza-Muslims-dig-up-their-Christian-roots.html. On Gaza's transformation in late antiquity, see also Wharton 1995, 100–104.

17. Holum 1982, 54–56.

18. *Vita Porphyrii* 38–40, ed. and trans. (French, *Vie de Porphyre*) Grégoire and Kugener 1930, 32–34. See also an English translation of the same text in G. F. Hill 1913.

19. *Vita Porph.* 31, 42; *Vie de Porphyre*, Grégoire and Kugener 1930, 31, 36.

20. *Vita Porph.* 41; *Vie de Porphyre*, Grégoire and Kugener 1930, 35.

21. *Vita Porph.* 44–49; *Vie de Porphyre*, Grégoire and Kugener 1930, 37–41. Also trans. in Holum 1982, 55.

22. Theodosius II became emperor after his baptism four days later, on January 10, 402. For the date with bibliography, see Holum 1982, 55, n. 31.

23. *Vita Porph.* 50 (legislation), 51 (the Augusta commanded the selection of a worthy man for the job), 53 (she gave money for the church); *Vie de Porphyre*, Grégoire and Kugener 1930, 41, 42, 43.

24. *Vita Porph.* 75–92, trans. Mango 1986, 31–32. See also *Vita Porph.* 84 (columns), 92 (church completed, named, etc.); *Vie de Porphyre*, Grégoire and Kugener 1930, 66, 71.

25. The church may have been modeled after the Holy Apostles in Constantinople; see Krautheimer 1986, 158.

26. Trans. Mango 1986, 69.

27. *Vita Porph.* 53; *Vie de Porphyre,* Grégoire and Kugener 1930, 44.

28. See Hirschfeld 2004, 63.

29. *CIL* 11.267a: "Galla Placidia augusta cum filio suo Placido Valentiano augusto e filia sua [Iusta] Grata Honoria augusta liberationis pernicul(or)um maris votum solvunt." Also: Deliyannis 2004, 151. For very useful summary of the primary and secondary sources on this monument, see Amici 2000, 13–55.

30. For the date of the storm, see Oost 1968, 177; Sivan 2011, 89.

31. See the references listed in Amici 2000, 15.

32. *CIL* 9.276c = *ILS* 818.3–4 = *ILCV* 20 c, a–b. For Agnellus, see Deliyannis 2004, 151. For the mosaics described first by Agnellus in the ninth century, in two anonymous sermons, and then again in the sixteenth century, the church, the relationship between the various imperial individuals to Galla Placidia, see Brubaker 1997, 54–55; Deliyannis 2010, 64–72; Amici 2000, 31; Sivan 2011, 164–66. Amici lists and comments on all the sources. Also, on Ravenna, especially the baptisteries, see Wharton 1995, 105–47; Simson 1948; Deichmann, Bartl, and Boehringer 1995.

33. Brubaker 1997, 54–55; Rizzardi, Angiolini Martinelli, and Robino 1996, 112; Deliyannis 2010, 70; Sivan 2011, 166.

34. Trans. Oost 1968, 274. Also, Brubaker 1997, 54.

35. On her life, see Oost 1968; Sivan 2011.

36. Grierson and Mays 1992, nos. 817 (Ravenna from 421–22); no. 824 (Constantinople from 424–25); no. 825 (Aquileia from 425); no. 826 (Rome from 425–26); nos. 827–88 (Ravenna, from 426–30).

37. On her patronage of Ravenna, see *Agnellus: Liber Pontificalis ecclesiae Ravennatis,* trans. Deliyannis 2004, 148–51. Also see, Oost 1968, 273–78; Deliyannis 2010, 62–74; Sivan 2011, 162–68.

38. Brubaker 1997, 61.

39. The first shrine over the tomb of Paul was, according to the *Liber Pontificalis,* erected at the suggestion of Pope Silvester by Constantine. See: *Liber Pontificalis,* ed. T. Mommsen, 60.11–12. See also, Krautheimer 1986, 87–89; Oost 1968, 269–70. Then a big basilica was completed around 400. It was begun by Galla's father Theodosius I and completed by Honorius. See: Krautheimer 1983, 104. Also see Brubaker 1997, 55.

40. A letter to Theodosius II, written at the insistence of Pope Leo I, also shows her regard for Constantine; in it she refers to Christianity as the faith of Constantine. See *Epistula ad Theodosium Augustum* and *Epistula ad Pulcheriam,* quoted and partially translated in Oost 1968, 289–90, and 290 n. 133.

41. *PLRE,* s.v. " Flavius Olybrius," 2:796.

42. *PLRE,* s.v. " Areobindus," 2:143–44. On her rank, Capizzi 1968, 221. On the dignity in general, see *ODB,* s.v. "Patrikios," 3:1600.

43. This church no longer exists. Mazal 1998, 26.

44. Theophanes, *Chronographia* 157–58, trans. Mango and Scott 1997, 239. See also, Theod. *Lect.* 144: "Iouliana de hē periphanestatē, he ktisasa ton hieron naon tēs theotokou en

tois Honōratois." The manuscript was a collection of several books that were produced separately and bound together. On this, see Gamillscheg 2007, 187–93. Earlier observations on the different quality of the prefatory miniatures, including Juliana's portrait, include: Gerstinger 1965–70, 1.

45. This traditional dating has been questioned recently by Müller 2012, 103–9.

46. On the number of folios, see Mazal 1998, 6. It weighs fourteen pounds. On this, see Brubaker 202, 191.

47. *BMCRE*, 4: no. 610*, 174. The obverse of another bronze medallion shows the facing busts of the emperor and his mother; the reverse shows Liberalitas (the personification of Liberality) (*BMCRE* 4: no. 322, 146, reverse inscription: *LIBERALITAS AVGVSTI III*; *SC* (left and right), low in field). The inscription connects this largesse to the consulship of Alexander in the year 226 c.e. Liberalitas appears also on the reverse of denarii of Mamaea with Liberalitas, ibid., nos. 994–95*, 212). Mamaea's role in her son's largesse remains unclear, however.

48. *Cod. Theod.* 15.9.1 from 384 limited the distribution by private individuals of silk garments, ivory diptychs, and presents of gold; see Mommsen and Krueger 1962, 825. A law of Marcian from 452 prohibited nonimperial consuls from distributing largesse; see Justinian 1899. This right was reinstituted by Justinian (November 105 in Justinian, *Corpus iuris civilis*), but the largesse was restricted to silver coins. See summary of this imperial legislation in Leader-Newby 2004, 42 n. 102–3.

49. Brilliant 1963, 170–72, figs. 4.16–4.21.

50. For Constantine's largesse, see Nash 1961, 1: fig. 108, 110. For the arch: Steinby 1993–2000, s.v. "Arcus Constantini," 1:86–91. This drawing of Constantius is from Romanus 1 MS, Barb. Lat. 2154, fol. 13, Biblioteca Vaticana, Rome. For calendar in its cultural context and reproductions of most of its drawings, including the consular largesse of Constantius, see Salzman 1990, and fig. 13.

51. Though the third leaf has been broken from the diadem of the Vienna empress. See fig. 113.

52. See statue of Aelia Flaccilla (?) in Cabinet des Médailles, Paris, and head of Theodora (?) in Castello Sforzesco, Milan, Connor 2004, figs. 4, 26, respectively. For coins: Grierson and Mays 1992, no. 593.

53. Kiilerich 2001, 175–76. For the imperial significance of the purple color, see Reinhold 1970.

54. For the proposal, see von Premestein 1903, 111. For other options, such as *patrikia*, see Croke 2006, 56 n. 158.

55. *Anth. Pal.* 9. 657; Janin 1964, 153. *Anax* is also used for Justin I (*Anth. Pal.* 1.97) also in a church dedication. There is a much earlier example of the word *anassa* used for a Roman woman, benefactor of Patara in Greece; see Adak 1996, esp. 129–31.

56. *CIG* 4.8719.

57. Theophilos: *CIG* 4.8672; Constantine V: *CIG* 4.8785; Constantine VI: *CIG* 4.8782; Michael II: *CIG* 4.8795; Constantine VII: *CIG* 4.8784.

58. See discussion in Kiilerich 2001, 178. For the use of the word *megalopsuchos* together with *philoktistēs* in reference to emperors, see Malalas, 232, 283, 306, 342. He used it for the emperors Tiberius, Commodus, Diocletian and Valens. The Greek word *phronēsis*

has a variety of meanings, ranging from purpose, intention, thought, and judgment to practical wisdom and prudence in government and affairs. See LSJ, s.v. "phronēsis." In the patristic texts it is used in the sense of intellect, understanding, and wisdom; see Lampe 1961, s.v. "phronēsis."

59. For this translation of the label, rather than "desire of she who loves to be," see Juethner 1904, 314–15, and the LSJ, s.v. "pothos."

60. Five of the uses of the word *philoktistēs* after the historian Malalas refer to the sixth-century emperor Justin II, suggesting perhaps the popularity of this epithet in the sixth century and its copying by later historians. These include Theophanes Confessor, who uses the word together with *megalopsuchos* (*Chronographia*, 241); Cedrenus, in whose text it is connected with the epithet *megalopsuchos* (generous) (1:680); Symeon Logothetes links it to *megalodōros* (bountiful) (*Chronicon* 132). In Joel's *Chronographia* it is paired with *megalodōrotatos*, the giver of greatest gifts (*Chronographia* 45). On the bricks, in Messembria (Thrace), stamped with the inscription *Ioustinianou tou philoktistou* (of Justinian, who loves to build), see Feissel 2000, no. 24, 93, p. 103.

61. I thank Alicia Walker for drawing my attention to this possibility. It should be noted, though, that the practice of roping building designs did not become common until after the seventh century, according to Ousterhout 1999, 58–63.

62. For Juliana shown as an emperor, see Kiilerich 2001, 185–86. The largesse depicted on this panel is also visually associated with representations of consular largesse as shown on a number of ivory diptychs, given as presents by the new consul. Juliana herself was by law a woman of consular rank, because she was married to a consul. A few leaves of her husband's consular diptychs of extraordinary quality remain. On consular women, see Ulpian in the *Digest* 1.9.1, Justinian 1904, trans. C. H. Monro, 1:42. For Areobindus's diptychs, see Volbach 1976, nos. 8–14, pp. 32–34. Juliana's miniature features other tokens of consulship present as well in Areobindus's diptychs and the portrait of Constantius. These consular tokens are the consular *trabea* (an outer garment), woven in golden thread, and Juliana's gilded curule chair. It has been argued that the consular attributes by the fourth century had become standard imperial tokens of rule (Alföldi 1970 [first published 1935], 151–52). The other elements in this image, discussed in the text, make the message imperial, not consular.

63. Bardill 2004, 62–64 and 111–16.

64. Literature on the church and its patron include: Bardill 2006, 339–70; Whitby 2006, 159–88; Connor 2004, 106–15; Kiilerich 2001, 81–90; Connor 1999, 479–527; Fowden 1994, 274–84; Milner 1994, 73–82; Harrison 1989; Harrison and Firatli 1966, 223–48; Mango and Ševcenko 1961, 243–47.

65. Connor 1999.

66. *Anth. Pal.* 1.10, trans. Paton, 1:9.

67. *Anth. Pal.* 1.10.70–73, trans. Paton, 1:11; Harrison 1986, 1: fig. A, 4.

68. *Anth. Pal.* 1.10.20–40, trans. Paton, 1:9.

69. Ibid.

70. For a reading of Anicia Juliana's patronage in aristocratic terms, see Brubaker 2002.

71. *Anth. Pal.* 1.2, trans. Paton (here slightly changed), 1:2.

72. Grierson and Mays 1992, nos. 164, 165, 174, 175, 182–84, 187 (Arcadius), nos. 703–5, 709, 711 (Honorius), no. 377 (Theodosius II).

73. Grierson and Mays 1992, nos. 291–94, from the mints in Constantinople, Nicomedia, and Alexandria.

74. On this monument, see chapter 4.

75. For Theodosius: Croke 2012, 241–64.

76. Connor 2004, 107–15.

77. Connor 2004, 110–15.

78. Procop. *Aed.* 1(2).4. 19–23.

79. Harrison 1986, 406–11; 1989, 127–34.

80. Against the hypothesized dome, see the convincing case made by Bardill 2006, 360–62.

81. Description of Hagia Sophia in Procop. *Aed.* 1.1.27, trans. Dewing, 7:13.

82. Most scholars note the competition. See, for instance, more recently, Connor 2004, 116–17; Bardill 2006.

83. Procop. *Aed.* 1.1.27, trans. Dewing, 13.

84. Romanos the Melodos cited (562/563) in Whitby 2000, 47.

85. Theophanes, *Chronographia* 157–59, trans. Mango and Scott 1997, 238–242, n. 17.

86. *PLRE*, "Areobindus," 2:143–44.

87. *PLRE*, "Areobindus", 2:143–44, s.v. "Magna," 2:700; s.v. "Irene," 2: 626.

88. *PLRE*, s.v. "Anastasius," 2:78–80.

89. *Anth. Pal.* 1.10. Her son may have participated in some way in the Nika revolt of 532, because he was afterwards exiled and his property confiscated. In 533 he was exonerated and his property returned. For Olybrius, see Malalas, 478; Harrison 1986, 1:5.

90. *Anth. Pal.* 1.11.

91. *Anth. Pal.* 1.17, trans. Paton, 1:15.

92. Trans. Kiilerich 2001, 171.

93. Procop. *Aed.* 1.8.5, trans. Henderson, 7:71; and Just. *Nov.* 67, Justinian 1899. This is noted in Kiilerich 2001, 183–84.

94. For instance, those instigated by John Chrysostom's exile or the Council of Ephesus on the Theotokos question. On these see the compelling discussion in Holum 1982, 74–78, 147–74.

CHAPTER 10. THE VIRGIN MARY, CHRIST, AND THE DISCOURSE OF IMPERIAL FOUNDING

1. On the queenly Virgin Mary, see Lawrence 1924–25, 148–61; Nilgen 1981, 3–33; Cormack 2000, 93. For the connections between Byzantine empresses and the Virgin Mary, see Holum 1982, 142–45, 153–54; James 2001, 91–92 (specifically for Pulcheria's relation to the Virgin, but not overall); Spieser 2002, 593–604, esp. 603 (the Theotokos model for "female sanctity," Pulcheria exemplifies the model, the image of the legendary Helena formed at the same time as the Theotokos, Helena-Theotokos parallel); Cooper 1998, 31–43. The conclusions reached in this chapter elaborate on ideas first developed in the following: Angelova 1998, 2005. I have presented my core ideas on the relation of the Virgin and the empress at the Byzantine

Studies Conference, Cambridge, Mass., October 2000 ("The Ivories of Ariadne in the Context of Female Imperial Ideology in Early Byzantium"), and at the symposium Byzantine Women: New Perspectives, Harvard University, March 2003 ("The Empress and the Virgin Mary: The Iconography of Female Power in Early Byzantium"), and in other forums.

Angelova

2. Volbach and Hirmer 1962, fig. 152. Deliyannis 2010, 152–60 and 146–51 on Sant'Apollinare Nuovo overall.

3. Such as the apse mosaics in the Basilica Eufrasiana, the tapestry from Cleveland, and ivory diptychs. On these, respectively, Terry and Maguire 2007; Pelikan 1990; Volbach 1976, figs. 127, 131, 142, 145, and 156 (the Virgin Mary seated on a throne and surrounded by a retinue). For the presence of this image in both East and West, see Cormack 2000, 93. Also see, Stevenson et al. 1982, 192–214.

4. For the relevant canons of the council, see Ehrman and Jacobs 2004, 259–61; Tanner 1990, 38–74 (full proceedings).

5. For the argument usually applied to the mosaics in the Santa Maria Maggiore, see Spain 1979, 530 (with earlier literature, going back to 1690); Brenk 1975, 48. For the imperial impetus to the Virgin's cult, see Holum 1982; Angelidi 1998; Spieser 2002, 603–4; Peltomaa 2001, 72–73. On sources for such connections, see Holum 1982, 141–43, 153–54. Pulcheria's connection to Marian veneration has been challenged by Cameron 2004, 9–11; Peltomaa 2001, 51 n. 10, 51–52, 57 n. 53. On the debate of Pulcheria's role, see summary in Shoemaker 2008, 71–72. For the debates at Ephesus, see Price 2008, 89–104.

6. Isis: Mathews 2005, 3–12. Tyche: Limberis 1994, 124–42; Pentcheva 2006, 20–21; Herrin 2000. On the connection between Cybele and the Virgin, see Borgeaud 1996.

7. "Visitata est Maria, ut Euam liberaret, uisitata est Helena, ut redimerentur imperatores." Ambrose, *De obitu Theodosii* 47.

8. Julia Domna: *AE* 1982.921, 321; Julia Soaemias: *AE* 1987.1130; Julia Mamea: *AE* 1971.430, *AE* 1996.1413, *AE* 1982.799, *AE* 1986.376. On the title *pia felix*, found also in the coinage of Salonina, Severina, Galla Placidia, Licinia Eudoxia, Justa Grata Honoria, and Euphemia, as suggestive of these women's greater role in the imperial succession, see Callu 2000, 206–7. On the continuity between the Roman and Christian period through the motherhood of the empress, esp. with relationship to Helena and Mary, see Spieser 2002.

9. *Genetrix: CIL* 6.1134, 1135, 36950; *procreatrix: CIL* 10.517 = *ILS* 1.708; *mater: CIL* 9.2446, *CIL* 10.1483.

10. Rufinus, *HE* 10.8, trans. Amidon 1997, 18.

11. *He eusebestatē kai anthousa aiōnia basilis kai mētēr;* in *ACO* 2.1.1.30–31.

12. Trans. and discussed in Barnes 1974, 315–17.

13. Pre-Ephesian examples include Constantine's oration to the saints (11.9) and a poem by Gregory of Nazianzus, *Carmina moralia* 8.22–24 (*PG* 37: col. 650–51). In the Latin West, *Theotokos* was rendered *mater Dei* and *mater genetrix/genitrix*.

14. Among the earliest references is *he mētēr tou Kuriou* in the Apocryphal Gospels; see above. *Mētēr theou:* Athanasius, *Sermo in annuntionem deiparae, PG* 28: 940.34–35. *Sacra parens:* Sedulius, *Carmen Paschale* 2.63, *PL* 19:599A, in Barré 1939, 137. *Genetrix*

dominatoris: Peter Chrysologus, *Sermo 142. De annun. D. Mariae Virginis, PL* 52:579 C, quoted in Barré 1939, 136. For *Dei genetrix Maria,* a sixth-century inscription in Santa Maria Antiqua in Rome, see Ihm 1960, 146.

15. Kalavrezou 1990, 165–68.

16. Kalavrezou 1990, 168.

17. Kalavrezou 1990, 167–68.

18. For how Mary's womb relates to the Incarnation, compare Nestorius to Proclus. Nestorius: "That which was formed in the womb is not in itself God." See Nestorius, *First Sermon Against the Theotokos,* trans. Norris 1980, 130. On Nestorius, questioning the reliability of the Letter to Cosmas, see Price 2004, 31–38. Proclus considers Mary's womb as the loom of the flesh, see Proclus, *Hom.* 4, ed. and trans. Constans 2003, 231, and commentary in 315–51.

19. On Isis: *LIMC* 5/1:777–78; 5/2:514–16 (figs. 216, 218, 219, 223, 225, 227, 228, 229, 230, 231, 233, 234, 236, 238). For the similarity in the iconography, see Mathews 2005, 3–12.

20. Julian, *Oratio* 5, trans. Wright, 1:463. On the political, philosophical, and theological significance of this hymn, see Elm 2012, 118–36, esp. 132–33 with reference to Christ's mother.

21. Carter 1902, 27 with the references.

22. For other examples, see Limberis 1994, 133–35. See also, Borgeaud 1996, 169–83.

23. Anthousa: Malalas, p. 320; *Chron. Pasch.* p. 528; trans. Whitby and Whitby 1989, 16. See commentary in Dagron 1974, 40, 44–6; Limberis 1994, 17. The secret name of Rome: the secret was not divulged. The hypothesis that it was Flora belongs to the sixth-century writer John Lydos (*De mens.* 4.73). On this see, Rüpke 2007, 134.

24. *Cod. Theod.* 7.8.14 (427), 15.2.4 (389).

25. *ILCV* 1.15.

26. See chapter 3.

27. Mikocki 1995, no. 6, 152, in reference to Livia.

28. These include Eudoxia and Verina; see Galsterer-Kröll 1972, 51, 54. Also Helena: see Eusebius, *VC* 4.61.1.

29. Theodora had two cities named after her Theodorias. Both Theodorias were in North Africa. See Procop. *Aed.* 6.5.12–13, trans. Dewing, 382, and Cesaretti 2004, 294. There was a third city, in Mysia, also named after her, Theodoropolis; see Procop. *Aed.* 4.7.5–6, trans. Dewing, 281.

30. Claudian, *Epithalamium de nuptiis Honorii Augusti* 10.244–47, trans. 1:260–61.

31. *In laudem,* trans. Cameron 1976, 95–96.

32. *Akathistos hymnos* δ.3, ed. Trypanis 1968, 33. The whole hymn is translated and analyzed in Limberis 1994, 149–58, 92–97 (commentary). On the hymn, see Wellesz 1959. The portions cited from the hymn are not from its later additions. For a date in the fifth century, see Peltomaa 2001, 113–14.

33. *Akathistos hymnos* ιγ.6, ε.12, 8, 9, ed. Trypanis 1968, 35, 4.

34. *Akathistos hymnos* ια.13, ιγ.11, ed. Trypanis 1968, 34.

35. Romanos, 12.4.6, ed. and trans. (French) in Grosdidier de Matons 1965, 122–23. More recently on Romanos's hymns, see Krueger 2005, 159–88.

36. On the Virgin as Tyche of Constantinople: Cameron 1978; Limberis 1994, 130–32; Mango 2000. See also, Pentcheva 2006, 18–19.

37. Procop. *Aed.* 1.3.9, trans. Dewing, 40–41.

38. *AE* 1989.657.

39. Corippus, *In laudem* 2.52, ed. S. Antès, 36. Discussion: Cameron 1980b, 12–13.

40. On Mary in the Gospels, see Brown 1978. For Mary's roles in the New Testament, see Maunder 2008, 23–39. For the argument that Mary did not have a special dignity elevating her above all other women, but that her role was embedded in the "natural family from which Jesus comes," see Perkins 1999, 304–306. See also on Mary and Christian theology the useful summary in Pelikan 1990, 121–82 ("Humanity Made Divine: Mary the Mother of God"). Arguing for a cult to Mary earlier than the fifth century apart from Christology: Shoemaker 2008, 71–88.

41. But see the analysis arguing for a connection between Wisdom in rabbinic literature, the mother of the Messiah in the Revelation, the royal mothers in the Hebrew tradition, and Mary in Barker 2011, 91–108. Still, it must be remembered that the Judaism, like Christianity, developed doctrinally for part of its hisotry in a Greco-Roman world.

42. Luke 1:35, in Aland, Aland, and Karavidopoulos 1981, 152. In the period after the apostolic fathers and the Council of Nicaea (325) the rising interest in the life of Christ drew attention to his mother, who began to appear frequently in the apocryphal writings such as the widely popular infancy narrative known today as the *Protevangelium of James*. For others apocryphal writings, see Gambero 1999, 33–42. The critical edition of the Protevangelium is de Strycker 1961. English translation in Elliott 1993. On other "noncanonical Christian writings," see Elliott 2008, 57–70.

43. Ephrem as a teacher of correct doctrine about Mary: mentioned in Theodoret, *Ep.* 151, trans. Schaff and Wace, 332; Ephrem's writings used to defend Church dogma at the Council of Chalcedon: see Photius, *Bibliothēkē* 228, ed. and trans. Henry, 4:227–28. She is both "the palace where dwells the mighty King of kings," the "new heaven," "the stem of the cluster of grapes," and "the spring, whence flowed living water for the thirsty." In Ephrem, *Homily on the Nativity* 12, in Brock 1984.

44. Ephrem, *Homily on the Nativity* 12, trans. in Brock 1984.

45. *Rhythm the Twelfth*, trans. in Morris 1847.

46. *Rhythm the Eighth*, trans. in Morris 1847. See also, "Thou, that sowedst Thyself in the Belly of Thy Mother," *Rhythm the Tenth*, trans. in ibid., 48. Ephrem was the first to call Mary the Bride of Christ: see Gambero 1999, 117.

47. *Rhythm the Third*, trans. in Morris 1847.

48. On the Son of man (*ho huios tou anthropou*), see Luke 19:10, in Aland, Aland, and Karavidopoulos 1981, 222. See also Tertullian, *On the Flesh of Christ*, trans. in Norris 1980, 71.

49. Tertullian, *De Carne Christi* (*On the Flesh of Christ*), trans. in Norris 1980, 64–72. See also Gambero 1999, 63–65.

50. Morris 1847, 37. He is deemed to deserve the title "Marian Doctor"; see Gambero 1999, 108. He praised the "Wise one, who reconciled and blended the Divine will with the Human Nature. One from above and one from below, He mingled the Natures as

medicines, and being the Image of God, became man." Ephrem, *Rhythm the Sixth*, in Morris 1847, 34.

51. Athanasius, *Oratio contra Arianos* 3 (Oration against the Arians), trans. in Norris 1980, 93–94.

52. Athanasius, *Oratio contra Arianos* 3, 14.2.5, 29.1.4, 33.2.3, 33.4.1; *Vita Antonii*, 36.16; *Expositiones in Psalmos*, PG 27:565.37.

53. Notably Origen (ca. 185–254). See *Scholia in Lucam (fragmenta e cod. Venet. 28)*, PG 17:321.8. For the suggestion that the epithet Theotokos was in common use by the Council of Nicaea in 325, see Price 2008, 90.

54. Euseb. *VC* 3.43.2; *Commentaria in Psalmos*, PG 23:1344.11; *In cantica canticorum interpretatio* 3.533.11; *Supplementa ad quaestiones ad Stephanum*, PG 22:972.49. Gregory of Nazianzus: *Epistulae theologicae*, Ep. 101, 16.1; *De filio* (Or. 29), 4.14; Gregory of Nyssa: *Oratio in diem natalem Christi*, PG 11:36.32; Ep. 3, 24.3; *De virginitate* 14.1.24, 19.1.6, and Basil of Caesarea: Ep. 360, 1.6; *In sanctam Christi generationem*, PG 31:1460.28.

55. For the creed, see Tanner 1990, 1:5.

56. The Arianism at which it was directed continued to be an important issue into the late fourth century. As for instance the disputes between Ambrose and Justina, see Theodoret, *Hist. Eccl.* 5.13; Ambrose, *Ep. 20*, *Ep. 21*, and *Sermo contra Auxentium de basilicis tradendis*, ed. PL 16: col. 1007A–1081C. On Arianism, see Cross and Livingstone 1997, s.v. "Arianism," 99–100. Another influential heretical movement was Monophysitism; see Cross and Livingstone 1997, s.v. "Monophysitism," 1104–5.

57. On Mary mother of God and mother of man: Theodore of Mopsuestia, *De Incarnatione* (On the Incarnation), book 12, trans. in Norris 1980, 121. Mother of God: Athanasius, *Oratio contra Arianos* 3, in Norris 1980, 91, 92. Theotokos: Euseb. *VC* 3.43.2, p. 95; Cyril, Ep. 3, trans., 273.

58. Gambero 1999, 243.

59. Ep. 101, PG 37:177 C–180 A, trans. Gambero 1999, 162.

60. Gambero 1999, 70–71.

61. See, respectively, Gambero 1999, 106 (Athanasius), 225 (Augustine), 12 (Jerome).

62. Ephrem, *Sermo in pretiosam et vivificam crucem*, ed. K. G. Phrantzoles, 4:72.12–13, 4:129–54 (*Despoina, Theotokos*); Ephrem, *Prayer 8*, ed. Phrantzoles, 6:153.5–6 (*Despoina, Theotokos Parthenos, Mētēr Theou*); Basil, Ep. 46, in Y. Courtonne, 1:4.16 (*Despoina*). In the Coptic apocryphal Gospels Mary is called *Theotokos*, queen, fountain, mother of the Lord, Our Lady and our succourer, see Robinson 1896. A fifth-century kontakion refers to Mary as queen; see "On the Virgin Mary," in Trypanis 1968, 159–64, ß. This last instance has been noted by Cameron 1978. Barré has seen a tripartite movement in the royalty of Mary: mother of Christ who is King, mother of King, and, finally, queen, which was not clearly professed before the fifth century. See Barré 1939, 139–45.

63. Epiphanius, *Panarion*, trans. in Epiphanius 1994, 620–21. This heresy is discussed in Gambero 1999, 122; Limberis 1994, 118. See also the analysis in Shoemaker 2008, 78 (Mary was venerated as a saint).

64. PG 79:9; 42:753D, trans. in Gambero 1999, 128.

65. Loofs 1914, 31–32. See also Holum 1982, 154–55, and a similar warning by John of Damascus, discussed by Limberis 1994, 140–41.

66. Trans. in Constans 2003, 65–66.

67. A contemporary of Nestorius, Isidore of Pelusium (d. ca. 435) wrote on the association between the Mother of God and the mother of the gods, indicating that this link was current in the early fifth century. For discussion, see Belting 1994, 32–33.

68. Romans 5:14 was the basis for the typology Adam-Christ. On Eve and Mary, see the writings of Ephrem, Cyril of Jerusalem (d. 387), Amphilochius of Iconium (d. after 394), Epiphanius of Salamis (d. 403), John Chrysostom (d. 407), discussed in Gambero 1999, Ephrem: 116–17; Epiphanius: 124–28; Cyril of Jerusalem: 135; Amphilochius: 169; John Chrysostom: 179; Jensen 2004, 28–42.

69. *Proof of the Apostolic Preachings*, trans. in Gambero 1999, 55.

70. Tertullian, *De Carne Christi* 17, trans. in Jensen 2004, 45.

71. Ephrem, *Hymn on the Nativity*, trans. Brock 1984. For another Eve-Mary comparison connected with spinning, see Epiphanius of Salamis, *Panarion* 78.18.1–4, trans. in Constans 2003, 332–33.

72. The festival was around the time of the Nativity, probably on December 26, 430; see Constans 2003, 135.

73. Constans 2003, 59, 136–39.

74. Proclus, *Hom.* 5, trans. in Constans 2003, 261.

75. *Sermo* 51, trans. in Gambero 1999, 230. See discussion on the tension between virgins and married women in the Latin West in Cooper 1998, 38–41.

76. Nestorius, *First Sermon Against the Theotokos*, trans. in Norris 1980, 125.

77. Nestorius, trans. in Norris 1980, 126–28.

78. The whole episode is masterfully brought to life in Holum 1982, 153. It is based on a letter, dated to ca. 430. On the date, see Holum 1982, 153. For the letter, *Lettre à Cosme*, ed. and trans. in Nau 1910, 362–66. On the authenticity of this document, see discussion and bibliography in Holum 1982, 153–54 n. 35. See also another interpretation in Cooper 1998. For Nestorius, see Anastos 1962.

79. *Lettre à Cosme*, trans. in Nau 1910, 363–64. Here I use the English translation from the French by K. Cooper in: Cooper 1998, 31. Pulcheria's statement is discussed below.

80. *Lettre à Cosme*, trans. in Nau 1910, 363. Also see Holum 1982, 153. On the Virgin's relationship to Christ as a typological related to cloth making, and the possible implications for understanding Pulcheria's garment covering the altar, see Constans 2003, 348–58. For the cloth relics of the Virgin in Constantinople, see Carr 2001, 59–94. For images suggestive of those relics, see Maguire 2011, 39–47.

81. On the events leading up to his pronouncement, Holum 1982, 154.

82. Proclus, *Hom.* 1, ed. and trans. in Constans 2003, 136–56. The date is interpreted either as Christmas 428 (see Holum 1982, 155–56) or Christmas 430 (see Holum 1982, 155–56; Constans 2003, 57–58).

83. Holum 1982, 142, 145–46.

84. Nestorius 1978 (repr. from 1925 Oxford ed.). On other sources questioning Pulcheria's virginity, see Holum 1982, 153 n. 32. For promiscuity as an element of negative rhetoric against Pulcheria and her womanly influence, see Cooper 1998, 34–35.

85. For a similar conclusion, evaluating challenges to Pulcheria's imperial authority on the ground of her sex as an insult to the New Eve, see Holum 1982, 145–54.

86. Jensen 2004, 42–43.

87. For Pulcheria's mystical union with Christ, modeled after Atticus's writings, see Holum 1982, 141–42, 153–54. On women in the liturgy of the Nativity, see Cooper 1998, 39–42.

88. Canons of Dionysius of Alexandria, 2, trans. in Dionysius 1956, 600. This became a canon only at the Council of Trullo (692).

89. The date for this synod is uncertain; see Percival 1956, 124, 153.

90. On Pulcheria's role, see Holum 1982, 157, 170–71, 182, 199, 209–16.

91. For the date, and the whole episode, see Holum 1982, 170.

92. *ACO* 1.1.3.14, trans. Holum 1982, 170.

93. For victory connotations, esp. the Virgin as "new source of victory," see Holum 1982, 174. For imperial acclamations, see chapter 7.

94. Holum 1982, 209–15. For the acclamations, *ACO* 2.1.2.124.12, also 1.70.39 in *RE*, s.v. "Pulcheria 2," 1961. Trans. Holum 1982, 215.

95. For the Council of Chalcedon, see Price and Gaddis 2005, 2:183 (date), 202–3 (creed), 203 (condemnation of Nestorius).

96. *ACO* 2.1.2.155.11.

97. Parlby 2008, 41–56.

98. Du Bourguet 1966, fig. 68: Catacomb of Priscilla, Mary with the Magi (200–250), fig. 69: Catacomb of Priscilla, Mother and child (250s), fig. 88: Catacomb of SS. Peter and Marcellinus, Mary between two Magi.

99. Du Bourguet 1966, fig. 67. See also Wellen 1961, 16–20. This identification has now been challenged on the basis of drawings of the image by early explorers of the catacombs. See Parlby 2008, 41–56. The star does not appear in these early drawings and Parlby also points out to other differences, such as the woman's hair.

100. Parlby 2008, 42–43.

101. The phenomenon of period hands affects equally all copyists, not just those of the nineteenth century. Contra, Parlby 2008, 47.

102. Du Bourguet 1966, fig. 67. See also, Wellen 1961, 16–20.

103. Wellen 1961, 20–25. See also, Volbach and Hirmer 1962, fig. 37 (Sarcophagus of Adelphia, dated ca. 340); Jensen 2004, fig. 11 (Trinity Sarcophagus). For the prophet, sometimes identified with Isaiah: this is based on a passage from the Gospel of Mathew (1:23), which interprets a prophecy by Isaiah ("God with us" or Immanuel) as prefiguring the birth of Jesus Christ.

104. On the connection between the mosaics and the council's decision, see Wellen 1961, 94. See also the literature cited in Spain 1979, 530 n. 56. See also Brenk 1975.

105. *Liber Pontificalis*, ed. Mommsen, 97. Krautheimer 1937–77, 3:1–60; 1986, 89–90, 468 n. 46; Sieger 1987; Spain 1979.

106. The first two lines of this inscription proclaim: "Virgo Maria, tibi Xystus noua tecta dicaui | digna salutifero munera ventre tuo"; see *ILCS* 1.976. It is translated (English) in van der Meer and Mohrmann 1958, 85. The location of this inscription is not known, though fragments of the first line were seen before 1588 over the portals of the west

wall. For bibliography see Spain 1979, 532 n. 68. Brenk 2010 neglects the inscription. See my review Angelova 2011, 244–47.

107. *CIL* 6.1134–35, 6.36950, commentary in Drijvers 1992, 45–47.

108. On the imperial connections in general, Brenk 1975, 12–13, 28–30; Grabar 1936, 209–30.

109. See the discussion of the interpretation of S. Spain in Sieger 1987, 84; Spain 1979, 535–39.

110. Leo's sermons: Sieger 1987. For Old Testament and apocryphal interpretations, see bibliography in Spain 1979, 519 n. 4 and n. 7.

111. A symbolic reading argues for spinning as symbolizing the spinning the flesh of Christ; see Steigerwald 1999, 109. On Mary's womb as the loom of the flesh, see Proclus, *Hom.* 4, ed. and trans. Constans 2003, 231, and commentary in 315–51. See also, Constans 1995.

112. S. Spain even questions their connection to the decision of the Council of Ephesus; see Spain 1979, 534 n. 69.

113. The woman wearing the purple *maphorion* has been identified as Anna, Rachel, Salome, a Sibyl, Ecclesia, and the Virgin; see bibliography in Spain 1979, 534 n. 70. The woman in gold has been identified as Sarah; see Spain 1979, 535–40.

114. Compare with Rubery 2008, 164.

115. Brenk 1975; Grabar 1936; Spain 1979, 520 (against).

116. For a comparison between Mary's heavenly attendants and an emperor with his courtiers: Constantine on his triumphal arch in Rome in Nash 1961, 1: fig. 110. See also Theodosius I on a silver missorium, Volbach and Hirmer 1962, fig. 53.

117. For the excavation report, see Scrinari 1989, fig. 11, 2215.

118. *PLRE* 2: s.v. "Licinia Eudoxia 2," 410–12.

119. For newlywed couples as *estephanōmenoi* (wreathed), see Lib. *Or.* 33.29, in LSJ, s.v. "stephanoō." In the later Byzantine period images of Christ placing his hands on the heads of the emperor and the empress have also been interpreted as a blessing; see Kalavrezou-Maxeiner 1977, 314–15.

120. For the mosaics and the church and its two sixth-century phases, see Deliyannis 2010, 158–66, 166–67 (Magi restored above the waist).

121. *De virginitate*, trans. (German) and discussed in Steigerwald 1999, 101.

122. For a different view, see Steigerwald 1999, 104, 108–11. On Mary as the bride of Christ, see Gambero 1999, 296–97, 300–301, and the *Akathistos Hymnos*. Ephrem was the first to call Mary Christ's spouse in *Hymn on the Nativity* 11, trans. McVey 1989, 131–32. Peter Chrysologus was the first Latin Father to do so; see *Sermo* 146.3–5, *PL* 52:592, trans. in Gambero 1999, 300–301. See also, Gregory Nazianzen, *Sermo* 35, *PG* 1177C–1181A, trans. in Gambero 1999, 166–67.

123. Destroyed in the fourteenth century; see Spain 1979, 518.

124. Holum 1982, 141–42; Limberis 1994, 60, 112.

125. "The Lord God will give to him the throne of his father, David . . . " Luke 1:32 in Aland, Aland, and Karavidopoulos 1981, 152.

126. See, chapter 3.

127. Euseb. *VC* 3.43.2. See chapter 8.

128. Euseb. *VC* 3.43.2–4, *VC* 3.42.1, trans. Cameron-Hall, 138. On this passage, see Walker 1990, 188–89.

129. McLynn 1994, xviii, i–xviii (on the calculated public image).

130. Ambrose could have had in mind two imperial women: Serena and Justina. Ambrose may have also been warning against the errant ways of the Arian Justina, the wife of the emperor Valentinian I. On her, see *PLRE* I: s.v. "Iustina," 488–89. A few years earlier the bishop and Justina had a clash over the religious education of her young son, the prince Valentinian II, and the bishop's authority over the churches in Milan. Ambrose famously ignored imperial orders and refused to let the Arians have their own church in the city. See Theodoret, *Hist. Eccl.* 5.13, trans. Jackson, 3:141. Also, Ambrose, *Ep.* 20, *Ep.* 21, and *Sermo contra Auxentium de basilicis tradendis,* ed. *PL* 16: col. 1007A–1081C.

131. For instance, Paulinus, *Ep.* 31, 4, pp. 271.

132. For his dates, see the discussion in Palardy 2004, 6–12.

133. "Adest ipsa etiam mater christiani perennis et fidelis imperii, quae dum fide, opere misericordiae, sanctitate in honore trinitatis beatam sectatur et imitatur ecclesiam, procreare, amplecti, possidere, augustam meruit trinitatem. Sic remuneratur trinitas in sui amore et ardore feruentes, ista meruit ut daret sibi honorem, gauderet quod sibi fecit ei dei gratia religionem consimilem. Ista meruit ut genitricis dignitas per genetricem redundaret in posteros." From *PL*:52, col. 557A–557B. Also present is the mother of the Christian, eternal, and faithful empire herself, who, by following and imitating the blessed Church in her faith, her works of mercy, her holiness, and in her reverence for the Trinity, has been found worthy of bringing to birth, embracing, and possessing an august trinity. This is how the Trinity rewards those who are fervent in their love and zeal for him. She has been found worthy of giving honor to herself and rejoicing that the grace of God has made for her an object of devotion like him." From Peter Chrysologus, *Sermo* 130, trans. in Palardy 2004, 8. The last sentence can be translated thus: "She deserved the honor of mother [genetrix], for [her] motherhood [per genetricem] overflowed in the following generations."

134. See preceding note.

135. Procop. *Aed.* 5.8.5, trans. Dewing, 356–57.

136. Sinai icon: For other images of Mary enthroned, see also a tapestry in Cleveland, in Vassilaki 2000, pl. 170; Weitzmann 1979, no. 477, pl. 14. See as well Mary in Sant'Apollinare Nuovo, Ravenna, and St. Demetrius, Thessaloniki, reproduced in Vassilaki 2000, fig. 46 and fig. 47. See also the bronze ampullae from the Holy Land in the Cathedral of Monza, in Conti 1983, 18–22. The Virgin is surrounded by angels in Santa Maria Maggiore and the Berlin diptych (Volbach 1976, no. 137.) and a diptych from Etschmiadzin (Volbach 1976, 142.)

137. See chapter 7.

138. Procop. *Aed.* 1.10.13–18.

139. Angelova 1998, 45–96.

140. For the royal connotations of these mosaics, see Deliyannis 2010, 171 with n. 167 (with earlier bibliography on the subject).

141. *Despoina Theotoke:* Ephrem, ed. Phrantzoles, 4:72.12–13, 94.7–9, 4:153.5–6; *despoina:* Basil, *Ep.* 46, 4.16. *Despoina,* however, is a more general term, being applied to

Athena by Julian, and Olympias by John Chrysostom. On it term see also, Barré 1939, 137.

142. *Basilis:* Helena in Euseb. *VC* 3.43.2; Flaccilla in Gregory of Nyssa, *Oratio funebris in Flaccillam imperatricem* 481; *basilissa:* Helena in *AE* 1993.1552, Eudocia in *AE* 1996.1415; *basilēis:* Eudocia in *SEG* 40.184 = *AE* 1991.1453.

143. For emperors, see *AE* 1976.657, *AE* 1978.809, and *AE* 1979.602b. It was also used for Justinian; see *SEG* 41.1501.

144. Preisigke 1931, 70.

145. Corippus, *In laudem* 2.46–69, trans. Cameron (English), 95; ed. and trans. Antès (French), 35–36: "Uirgo creatoris genetrix Sanctissima mundi, / excelsi regina poli, specialiter una / uera parens et uirgo manens."

146. The panegyric of course makes Justin the natural successor of Justinian, ignoring the reality of his seizing the vacant throne because of his close proximity. Justinian had two more nephews, one of which, another Justin, was a general at the time. He was later executed. See Jones 1964, 304.

147. Theodoret, *Ep.* 43, trans. Schaff and Wace, 3:264.

148. Leo, *Ep.* 60, *PL* 50:54.873; trans. Hunt, 132–33.

149. Leo, *Ep.* 79, *PL* 50:54.910; trans. Hunt, 144–47. Eutyches refused to recognize the formulation "two natures" for Christ. On him, see Holum 1982, 199–201. Pulcheria, however, was not the only empress in communication with the pope, who himself sought empresses' help on doctrinal matters. Galla Placidia and her daughter-in-law, Licinia Eudoxia, also corresponded in their name with Pope Leo. The princess Anicia Juliana, a staunch Orthodox, also wrote to the pope, and housed his envoys in her house. See Fowden 1994. The Council of Ephesus also credited Pulcheria with Eutyches' downfall; see the acclamations translated and discussed in Holum 1982, 215. Also see, Price and Gaddis 2005.

150. Limberis 1994, 92–97. On the hymn, proposing to date it to the fifth century, see Peltomaa 2001, 49–114.

151. See above, n. 12 (empress), n. 14 (Virgin).

152. Eusebia, compared to the moon in Julian, *Oratio* 3, trans. Wright, 1:292. Licinia Eudocia (star) and Justa Grata Honoria (moon) in Merobaudes: Barnes 1974. Sophia and her daughter compared to the light of the moon: see Corippus, *In laudem* 2.72–74, trans. Cameron 1976, 95–96; ed. and trans. Antès, 36.

153. *Sanctissima:* Julia Mamaea (with Alexander Severus) in *AE* 1982.799, Orbiana in *AE* 1973.413, and Cornelia Salonina in *AE* 1982.272. For *thea*, see Hahn 1994, 401–2.

154. *Theosebestatē:* Helena in Eusebius, *VC* 3.43.2; *divina: Notitia*, 242; *eusebestatē/reverentissima:* Theodora in Just. *Nov.* 8.1; *aiōnia:* Galla Placidia and Licinia Eudoxia, see *ACO* 2.1.1.30–31, 2.1.1.21–22. For the halo: Theodora in San Vitale (see fig. 109); coins of Fausta as Pietas (see fig. 134) and Licinia Eudoxia as Salus (see fig. 116), see Kent 1978, no. 641R and 757. See also a coin of Galla Placidia as Salus, reproduced in MacCormack 1981, pl. 60.

155. *Sanctissima:* Corippus, *In laudem* 2.52, ed. Antès, 35; *hagia* and *panagia:* see above, n. 60.

156. Halo of Mary: see examples, cited above.

157. *Akathistos hymnos*, trans. Limberis 1994, 157.

158. With other examples and discussion, see Kalavrezou 1990, 166.

159. *BMCRE* 4: nos. 939–41, 535, pl. 73.5.

160. *LIMC* 8/2:215–16 (figs. 246, 247, 257).

161. On this, see Kalavrezou 1990, 166–67.

162. Lawrence 1924–25, 148–61; Nilgen 1981, 3–33; Pentcheva 2006, 21–26; Herrin 2000, 18; Barber 2000, 255–60.

163. Nilgen 1981, 3–33; Pentcheva 2006, 21 (questioning the rationale for presuming the absence of Maria Regina iconography in the East).

164. For a similar conclusion, see Cormack 2000, 93.

165. Angelic guard: Santa Maria Antiqua fresco, ivories (Volbach 1976, 27, 131, 137, 142, 145, 156), textiles (Cleveland tapestry), mosaics (Basilica Eufrasiana in Porec, Sant'Apollinare Nuovo in Ravenna, Church of St. Demetrius at Thessaloniki, Church of the Virgin Angeloktisti at Kition on Cyprus), for these see overview in Vassilaki 2000, 91–97 (by Robin Cormack); Cormack 2000, the icon from Sinai (Vassilaki 2000, cat. no. 1.)

166. Compare with Pentcheva 2006, 21.

167. *Parastaseis syntomoi chronikai* 53, in Cameron and Herrin 1984, 129, 240 (commentary).

168. Grabar 1936.

169. Mathews 1999.

170. See, for instance, Elsner 1998; Elsner 1995. See also the articles in Brandt and Steen 2001.

171. Deliyannis 2010, 190–96 (the mosaics date to the episcopacy of Peter II of Ravenna (494–520).

CONCLUSION

1. On Charlemagne's revival and claim: Krautheimer 1942, 1–38.

2. For the Virgin as protector, most succinctly: Mango 2000, 17–26.

3. For a recent example of a hierarchical approach to the sources, one that exemplifies the trend, see Pollini 2012, 94–97 (official vs. unofficial), 146; Barnes 2011, 16–26 (textual vs. iconographic, etc. material evidence).

4. In history, this transcendence is best exemplified in the work of Peter Brown, and late antique historians more broadly. See especially P. R. L. Brown 1978, 1989, 1995; Elm 2012; McCormick 1986; Salzman 1990; Dvornik 1966. Art historians who admirably straddle the pagan-Christian chronological divide include, for example, Elsner 1995; Leader-Newby 2004; Maguire 1987, 1999; Mathews 1999; Yasin 2009; Bowes 2008; Wharton 1995.

5. Jäger 2001, 37.

6. For instance, the penetrating analysis of Kelly 1984.

7. The phrase is a quotation from Laurel Thatcher Ulrich, who has a book bearing the same title: Ulrich 2007.

8. On the frustrations, see James 1977, 123–39.

9. An early groundbreaking article stands ahead of its time: Grether 1946, 222–52. More recently: Alexandridis 2004; Barrett 2002; Bartman 1999; Flory 1984, 1993; Hahn 1994; Jenkins 2009; Mikocki 1995; Purcell 1986; Winkes 1995; Wyke 1992.

10. Angelidi 1998; Connor 2004; Garland 1999; Herrin 2001, 2000; Hill 1999; Holum 1982, 2003; James 2001; McClanan 2002; Spieser 2002.

11. Borgehammar 1991; Brubaker 1997, 52–75; Drijvers 1992; Brubaker and Tobler 2000; Mango 1994; Merriman 1977; Lenski 2004, 113–24; Pohlsander 1995.

12. Some pertinent examples, from different viewpoints: Feissel 2000, 81–104; McClanan 1996, 50–72; Krueger 2005, 191–92.

13. The church was dedicated in 548, the mosaics must have been completed earlier, perhaps 544–45. The most recent publications on these mosaics include Deliyannis 2010, 223–50; Bassett 2008, 49–57; McClanan 2002; Treadgold and Treadgold 1997, 708–23; James 2001; McClanan 1996, 50–72; Elsner 1995, 160–89; Barber 1990, 19–40.

14. The inscription above the bishop's head "Maximianus" is slightly older that the original mosaics. On this, see Treadgold and Treadgold 1997.

15. For a succinct summary, see McClanan 2002, 121–30.

16. On this point, see McClanan 2002, 127–28. This is true of art more generally. See, for instance, the erudite analysis of wall painting on Greek vases: Ferrari Pinney 2002.

17. See note 15.

18. Contra Elsner 1995, 180.

19. Contra Treadgold and Treadgold 1997.

20. Cyril of Scythopolis, *Vita Sabae*, 173, trans. in Price 1991, 183.

21. For the restoration, see Treadgold and Treadgold 1997.

22. Barber 1990.

23. For her separate court and reception hall, see Procop. *Anec.* 15.27. For the identification as the palace, see Maguire 2006, 5–6.

24. For instance, Barber 1990, 38.

25. For the confinement: Maguire 2006, 7.

26. Cyril of Scythopolis, *Vita Sabae*, 173, trans. in Price 1991, 183.

27. Overall on the empress's court, its ceremonial responsibilities, representation, and identity, see McClanan 2002, 134–35.

28. Procop. *Anec.* 15.13–16 (magistrates), 15.27 (a patrician), 30.24 (ambassadors), 2.32–36 (peace negotiations).

29. McClanan 2002, 128, 134–35.

30. Feissel 2000, no. 35 (Church of John of Ephesus); no. 38 (Gate of the Citadel, Miletus); no. 47 (ramparts in Hierapolis); no. 51 (Gate of the Citadel, Cyrrhus); no. 53 (Hospice and Oratory of St. Job, Bostra); no. 69 bis (Monastery dedicated to the Theotokos, Sinai); no. 72 (Fortifications, Cuculus (Theodorias); no. 74 (Fortifications, Thamugadis). On SS. Sergius and Bacchus, see also Mango 1976, 385–92 (with discussion of the earlier literature).

31. For the symbolic character of these gifts, see Deliyannis 2010, 241.

32. These are Hagia Sophia, Hagia Eirene, SS. Sergius and Bacchus, St. John at Ephesus. On them see chapter 6. Column capitals with their monograms were found in all of these churches as well as dedication inscriptions related to joint sponsorship in SS. Sergius and Bacchus and St. John, and on an altar in Hagia Sophia, for which see chapter 6. For the monograms see Feissel 2000, nos. 4–5 (SS. Sergius and Bacchus), nos. 9–10 (Hagia Sophia), no. 11 (Hagia Eirene), nos. 34–35 (St. John).

33. On that tradition, see above, chapters 4, 5, 6, and 9. See also James 2001, chap. 9; McClanan 1996, 50–72; Brubaker 1997, 52–75 (the emulation of Helena fizzles out before sixty century).

34. The exhaustive comparison is Feissel 2000, 81–104.

35. For an in-depth analysis of Procopius, see McClanan 1996, 50–72.

36. Bacci and Bianchi, e5–e26.

37. Some of these original cedars survive. See, Bernabei and Bontadi 2012, e54–e60.

38. Procop. *Aed.* 5.6. and Tsafrir 2000, 149–64. Its location was determined by an inscription on a cistern, see Avigad 1977, 145–51.

39. Tsafrir 2000, 150–51.

40. Feissel 2000, no. 11.

41. Procop. *Aed.* 5.1.4–6.

42. See *Anth. Pal.* 1.91. The epigram speaks of St. John (at Ephesus) as crowning Justinian and "admirable Theodora" "by the command of Christ." Trans. Paton, 1:59. Feissel 2000, no. 35.

43. Procop. *Aed.* 1(2).4 and Grierson 1962, 6–7.

44. Procop. *Aed.* 5.2.

45. Ibid.

46. Silver medallion Constantine from Ticinum (Pavia), see image online at Staatliche Münzsammlung München's website: www.staatliche-muenzsammlung.de/ highlights_06.html (accessed May 24, 2014).

47. Malalas, *Chronographia*, p. 243.

48. The mosaics were restored; for a useful summary, see Deliyannis 2010, 223–50.

49. For the cornucopia as the emblems of the Justinianic golden age, see Elsner 1995, 183.

BIBLIOGRAPHY

PRIMARY SOURCES

Acta conciliorum oecumenicorum (Decrees of the Ecumenical Councils). Ed. E. Schwartz. Berlin: n.p., 1927–32.

———. Ed. G. Albergio et al. Trans. N. Tanner. 2 vols. Vol. 1, *Nicaea I to Lateran V*. Washington, D.C.: Georgetown University Press, 1990.

The Acts of the Council of Chalcedon. Trans. with introductions and notes by R. Price and M. Gaddis. 3 vols. Liverpool: Liverpool University Press, 2005.

Agnellus. *Liber Pontificalis*. Trans. D. M. Deliyannis. *The Book of Pontiffs of the Church of Ravenna*. Medieval Texts in Translation. Washington, D.C.: Catholic University of America Press, 2004.

Akathistos hymnos. In *Fourteen Byzantine Cantica*, ed. C. A. Trypanis, 17–39. Vienna: Institut für Byzantinistik der Universität Wien, 1968.

Ambrose of Milan. *Epistula 77* (Maur. 22). *Letter on the Discovery of the Relics of Gervasius and Protasius (to Ambrose's sister, Marcellina)*. Trans. and commentary J. H. W. G. Liebeschuetz. In *Ambrose of Milan: Political Letters and Speeches*, trans. with an introduction and notes by J. H. W. G. Liebeschuetz, with the assistance of Carole Hill, 204–22. Liverpool: Liverpool University Press, 2005.

———. *De obitu Theodosii*. Ed. O. Faller. In *Le orazioni funebri = Orationes funebres, Sancti Ambrosii opera*, 7 vols., 371–401. CSEL 73. Vienna: Hoelder-Pichler-Tempsky, 1955.

———. *Oration on the Death of Theodosius I (De obitu Theodosii)*. Trans. R. J. Deferrari. In *Funeral Orations by Saint Gregory Nazianzen and Saint Ambrose*, 307–32. Fathers of the Church: A New Translation. New York: Fathers of the Church, 1953.

————. *Oration on the Death of Theodosius I*. Trans. and commentary J. H. W. G. Liebeschuetz. In *Ambrose of Milan: Political Letters and Speeches*, trans. with an introduction and notes by J. H. W. G. Liebeschuetz with the assistance of Carole Hill, 177–203. Liverpool: Liverpool University Press, 2005.

————. *Sermo contra Auxentium de basilicis tradendis* (= Ep. 75a). Ed. M. Zelzer. *Epistulae et acta* (1982), 82–107.

L'année épigraphique. Revue des publications épigraphiques relatives a l'antiquité romaine. Paris: Presses Universitaires de France, 1888– .

Appian. *Roman History*. Ed. and trans. H. White. 4 vols. Cambridge, Mass.: Harvard University Press, 1958.

Athanasius. *Expositiones in Psalmos*. PG 27:60–545, 548–89.

————. *Oratio III contra Arianos*. Ed. K. Metzler and K. Savvidis. *Athanasius: Werke, Band I. Die dogmatischen Schriften, Erster Teil, 3. Lieferung*, 305–81. Berlin: W. de Gruyter, 2000.

————. *Orations against the Arians (Orationes contra Arianos)*. Trans. partly in Norris 1980, 83–102.

————. *Vita Antonii*. Ed. and trans. G. J. M. Bartelink, *Athanase d'Alexandrie, Vie d'Antoine*. Sources Chrétiennes 400, 124–376. Paris: Éditions du Cerf, 2004.

Augustus. *Res Gestae Divi Augusti The Achievements of the Divine Augustus (Res Gestae Divi Augusti)*. Ed., trans., and commentary P. Brunt and J. M. Moore. Repr. with corrections, Oxford: Oxford University Press, 1970.

————. *Res Gestae Divi Augusti*. Ed., trans., and commentary by A. Cooley. Cambridge: Cambridge University Press, 2009.

Aurelius Victor. *Liber de Caesaribus of Sextus Aurelius Victor*. Trans. with an introduction and commentary by H. W. Bird. Liverpool: Liverpool University Press, 1994.

Basil of Caesarea. *Epistulae; Saint Basile*. Ed. and trans. Y. Courtonne. *Lettres*. 3 vols. Paris: Les Belles Lettres, 1957–66.

————. *In sanctam Christi generationem*. PG 31:1457–76.

Bibliotheca hagiographica graeca. 3 vols. Ed. F. Halkin. Brussels: Société des Bollandistes, 1957.

Callimachus. *Hymn to Apollo* (Hymn 2). Ed. and trans. A. W. Mair and G. R. Mair. In *Lycophron, Aratus. Hymns and Epigrams. Lycophron: Alexandra. Aratus: Phaenomena*, 48–59. Cambridge, Mass.: Harvard University Press, 1921.

Cassius Dio, Cocceianus. *Dio's Roman History*. Trans. E. Cary and H. B. Foster. 9 vols. Cambridge, Mass.: Harvard University Press, 1961.

Cedrenus, Georgius. *Compendium historiarum*. 2 vols. Bonn: E. Weber, 1838–1939.

Chronicon Paschale. Ed. L. Dindorf. Bonn: E. Weber, 1832.

————. *Chronicon Paschale, 284–628 A.D.* Trans. with a commentary by M. Whitby and M. Whitby. Liverpool: Liverpool University Press, 1989.

Cicero. *De divinatione*. In *On Old Age; On Friendship; On Divination*, ed. and trans. W. A. Falconer, 220–540. Cambridge, Mass.: Harvard University Press, 1923.

Cicero. *In Pisonem*. In *Pro Milone; In Pisonem; Pro Scauro; Pro Fonteio; Pro Rabirio postumo; Pro Marcello; Pro Ligario; Pro Rege Deiotaro*, ed. and trans. N. H. Watts, 140–261. Cambridge, Mass.: Harvard University Press, 1931.

————. *Post reditum in senatu.* In *Pro archia; Post reditum in senatu; Post reditum ad Quirites; De domo sua; De haruspicum responsis; Pro Plancio,* ed. and trans. N. H. Watts, 48–131. Cambridge, Mass.: Harvard University Press, 1923.

————. *Pro Rabirio.* In *Pro lege Manilia; Pro Caecina; Pro Cluentio; Pro Rabirio Perduellionis Reo,* ed. and trans. H. G. Hodge, 366–416. Cambridge, Mass.: Harvard University Press, 1927.

————. *Pro Sestio.* In *Pro Sestio; Vatinium,* ed. and trans. R. Gardner, 36–239. Cambridge, Mass.: Harvard University Press, 1958.

Claudian. *De consulatu Stilichonis.* In *Works,* 1:364–93,

————. *Epithalamium de nuptiis Honorii Augusti (Epithalamium of Honorius and Maria).* In *Works,* 1:240–67. Cambridge, Mass.: Harvard University Press, 1922.

————. *Laus Serenae.* In *Works,* 2:238–57.

————. *Panegyricus de sexto consulatu Honorii Augusti.* In *Works,* 2:70–123.

————. *De zona equii regii.* In *Works,* 2:274–77.

————. *Works.* 2 vols. Ed. and trans. M. Platnauer. Cambridge, Mass.: Harvard University Press, 1922.

Codex Theodosianus. Ed. T. Mommsen and P. Krueger. 3 vols. Berlin: Weidmann, 1962.

————. *The Theodosian Code and Novels, and the Sirmondian Constitutions; A Translation with Commentary, Glossary, and Bibliography by Clyde Pharr, in Collaboration with Theresa Sherrer Davidson and Mary Brown Pharr.* Introduction by C. Dickerman Williams. New York: Greenwood Press 1952.

Consolatio ad Liviam. In Ovid, *Art of Love; Cosmetics; Remedies for Love; Ibis; Walnut-tree; Sea Fishing; Consolation,* ed. and trans. J. H. Mozley, rev. G. P. Goold, 323–58. Cambridge, Mass.: Harvard University Press, 1929.

Constantine. *Oratio ad coetum sanctorum.* Ed. I. A. Heikel. In Eusebius, *Werke,* 9 vols., *Band 1: Über das Leben Constantins: Constantins Rede an die heilige Versammlung; Tricennatsrede an Constantin,* 151–92. Die Griechischen Christlichen Schriftsteller 7. Leipzig: Hinrichs, 1902.

————. *Oratio ad coetum sanctorum.* Trans. M. Edwards. In *Constantine and Christendom: The Oration to the Saints; The Greek and Latin Accounts of the Discovery of the Cross; The Edict of Constantine to Pope Silvester,* 1–62. Liverpool: Liverpool University Press, 2003.

Constantine Porphyrogenitus. *The Book of Ceremonies (De cerimoniis aulae Byzantinae).* 2 vols. Trans. A. Moffatt and M. Tall with the Greek edition of the Corpus Scriptorum Historiae Byzantinae (Bonn: n.p., 1829). Canberra: Australian Association for Byzantine Studies, 2012.

————. *De cerimoniis.* In *Pophyrogènéte, Constantin VII: Le livre des cérémonies,* 3 vols., ed. and trans. A. Vogt. Paris: Les Belles Lettres, 1935.

Coptic Apocryphal Gospels: Translations Together with the Texts of Some of Them. 1896. Trans. F. Robinson. Cambridge: Cambridge University Press.

Corippus (Flavius Cresconius Corripus). *In laudem Iustini Augusti minoris, libri IV.* Trans. A. Cameron. London: Athlone, 1976.

————. *In laudem Iustini Augusti minoris Eloge de l'empereur Justin II.* Ed. and trans. Serge Antès. Collection des Universités de France. Paris: Les Belles Lettres, 1981.

Corpus inscriptionum graecarum. Ed. A. Boeckh et al. Berlin: Deutsche Akademie der Wissenschaften zu Berlin, 1828–77.

Corpus inscriptionum latinarum. Berlin: G. Reimerum, 1862.

Cyril of Alexandria. *Epistula* 3. Trans. J. McGuckin. "The Third Letter of Cyril to Nestorius." In *St. Cyril of Alexandria: The Christological Controversy, Its History, Theology, and Texts*, 200–214. Supplements to Vigiliae Christianae. Leiden: Brill, 1994.

Cyril of Jerusalem. *Catechesis* 4 and *Catechesis* 10. Trans. E. Yarnold. In *Cyril of Jerusalem*, 97–111, 119–28. New York: Routledge, 2000.

Cyril of Scythopolis. *Kyrillos von Skythopolis*. Ed. E. Schwartz. Leipzig: Hinrichs, 1939.

———. *Lives of the Monks of Palestine by Cyril of Scythopolis*. Trans. R. Price. Introduction and notes by J. Binns. Kalamazoo, Mich.: Cistercian Publications, 1991.

Descriptio XIIII regionum urbis Romae. Ed. H. Jordan. In *Topographie der Stadt Rom in Alterthum.* Berlin: Weidmannsche Buchhandlung, 1871–1907.

Dio Cassius. *Roman History*. 9 vols. Ed. and trans. E. Cary and H. B. Foster. Cambridge, Mass.: Harvard University Press, 1914–27.

Diodorus Siculus. *Library of History, Volume IX: Books 18–19.65*. Ed. and trans. R. M. Geer. Cambridge, Mass: Harvard University Press, 1947.

Dionysius of Alexandria. *Canons*. Trans. H. Percival. In *The Seven Ecumenical Councils: The Apostolical Canons*, ed. Philip Schaff and Henry Wace, 594–615. Grand Rapids, Mich.: Eerdmans Publishing, 1956.

Ennius (Quintus Ennius). *The Annals of Quintus Ennius*. Ed. with introduction and commentary by Otto Skutsch. Oxford: Clarendon Press, 1985.

Ephrem. *Ephrem the Syrian: Hymns*. Preface by John Meyendorff. Trans. Kathleen E. McVey. Classics of Western Spirituality. New York: Paulist Press, 1989.

———. *The Harp of the Spirit: Eighteen Poems of Saint Ephrem*. Trans. Sebastian Brock. Studies Supplementary to Sobornost 4. San Bernardino, Calif.: Borgo Press, 1984.

———. *Precatio 5 ad Dei matrem*. In *Sancti patris nostri Ephraem Syri opera omnia*, ed. K. G. Phrantzoles, 6:370–78. Thessaloniki: To Perivoli tis Panagias, 1995.

———. *Precatio 6 ad Dei matrem*. In *Sancti patris nostri Ephraem Syri opera omnia*, ed. K. G. Phrantzoles, 6:379–86. Thessaloniki: To Perivoli tis Panagias, 1995.

———. *Precatio 8 ad Dei matrem*. In *Sancti patris nostri Ephraem Syri opera omnia*, ed. K. G. Phrantzoles, 6:394–98. Thessaloniki: To Perivoli tis Panagias, 1995.

———. *Sermo in pretiosam et vivificam crucem*. In *Sancti patris nostri Ephraem Syri opera omnia*, ed. K. G. Phrantzoles, 4:129–54. Thessaloniki: To Perivoli tis Panagias, 1992.

———. *Select Works of St. Ephrem the Syrian, Translated Out of the Original Syriac*. Trans. J. B. Morris. Oxford and London: H. H. Parker and F. and J. Rivington, 1847.

Epiphanius of Salamis. *The Panarion of Epiphanius of Salamis: Books II and III (Sects. 47–80, De Fide)*. Trans. F. Williams. Ed. J. M. Robinson and H. M. Klimkeit. Nag Hammadi and Manichaean Studies. Leiden: Brill, 1994.

Eusebius. *In cantica canticorum interpretatio*. Ed. J. B. Pitra, *Analecta sacra spicilegio Solesmensi parata*, 3:530–37. Venice: St. Lazarus Monastery, 1883.

———. *Historia ecclesiastica (HE)*. Ed. G. Bardy. *Eusèbe de Césarée: Histoire ecclésiastique*. 3 vols. Sources Chrétiennes 31, 41, 55. Paris: Éditions du Cerf, 1:1952; 2:1955; 3:1958 (repr. 3:1967)]; 1:3–215; 2:4–231; 3:3–120.

———. *Ecclesiastical History*. Trans. A. C. McGiffert. In *Nicene and Post-Nicene Fathers, Second Series*, vol. 1, ed. Philip Schaff and Henry Wace. Buffalo, N.Y.: Christian Literature Publish-

ing, 1890. Rev. and ed. for New Advent by Kevin Knight, www.newadvent.org/fathers/2501 .htm (accessed March 26, 2015).

———. *De laudibus Constantini* (*LC*). Ed. I. Heikel. In Eusebius, *Werke*, 9 vols., 1:195–259. Leipzig: J. C. Hinrichs, 1902.

———. *De laudibus Constantini* (*LC*). Trans. H. Drake. *In Praise of Constantine: A Historical Study and New Translation of Eusebius' Tricennial Orations*, 83–127. Berkeley: University of California Press, 1976.

———. *Praeparatorio evangelica*. Ed. K. Mras. In Eusebius, *Werke*, 9 vols., vol. 8, *Die Praeparatio evangelica*, 43.1:1954; 43.2:1956]: 43.1:3–613; 43.2:3–426. Die Griechischen Christlichen Schriftsteller 43.1 and 43.2. Berlin: Akademie Verlag.

———. *Praeparatorio evangelica*. Trans. E. H. Gifford. *Eusebius of Caesarea: Praeparatio Evangelica (Preparation for the Gospel)* (1903). Online at the Tertullian Project Website: www.tertullian.org/fathers/eusebius_pe_00_intro.htm (accessed March 26, 2015).

———. *Supplementa ad quaestiones ad Stephanum*. PG 22:957–76.

———. *Vita Constantini* (*VC*). Ed. F. Winkelmann. In Eusebius, *Werke*, 9 vols., vol. 1.1, *Über das Leben des Kaisers Konstantin*, 3–151. 2nd ed. Berlin: Akademie Verlag, 1991.

———. *Vita Constantini* (*VC*). Trans. and commentary A. Cameron and S. G. Hall. *Eusebius: Life of Constantine*. Oxford: Oxford University Press, 1999.

Evagrius. *Historia Ecclesiastica The Ecclesiastical History of Evagrius with the Scholia*. Trans. and ed. J. Bidez and L. Parmentier. London: Methuen, 1898.

———. *The Ecclesiastical History of Evagrius Scholasticus*. Trans. with an introduction M. Whitby. Liverpool: Liverpool University Press, 2000.

Exodus. Ed. A. Rahlfs, *Septuaginta*, Vol. 1. 9th ed. Stuttgart: Württemberg Bible Society, 1935 [repr., 1971]:86–158.

———. Trans. L. Perkins. *A New English Translation of the Septuagint*. Oxford: Oxford University Press, 2007.

Festus. *De verborum significatu*. Ed. and partial trans. Brower 1989.

Florus. *Epitome rerum romanorum*. In Florus, *Epitome of Roman History*. Ed. and trans. E. S. Forster. Cambridge, Mass.: Harvard University Press, 1929.

Fragmenta historicum graecorum. Ed. K. Müller. Paris: Firmin-Didot, 1841–70.

The Greek Anthology (Anthologia graeca). 4 vols. Ed. and trans. W. R. Paton. Cambridge, Mass.: Harvard University Press, 1971.

Gregory of Nazianzus. *Carmina moralia*. PG 37:521–968.

———. *Epistolae theologicae*. Ed. and trans. P. Gallay, *Grégoire de Nazianze: Lettres théologiques*, 36–94. Sources Chrétiennes 208. Paris: Éditions du Cerf, 1974.

Gregory of Nyssa. *De virginitate*. Ed. and trans. M. Aubineau, *Grégoire de Nysse: Traité de la virginité*, 246–560. Sources Chrétiennes 119. Paris: Éditions du Cerf, 1966.

———. *Epistulae*. Ed. G. Pasquali. In *Gregorii Nysseni: Opera*, vol. 8.2, 2nd ed., 3–95. Leiden: Brill, 1959.

———. *De filio*. Ed. J. Barbel, *Gregor von Nazianz: Die fünf theologischen Reden*, 170–216. Düsseldorf: Patmos-Verlag, 1963.

———. *Oratio funebris in Flaccillam imperatricem*. Ed. A. Spira. In *Gregorii Nysseni: Opera*, ed. A. Spira, 9.1:475–90. Leiden: Brill, 1967.

———. *Oratio funebris in Flaccillam imperatricem*. Trans. C. McCambly. At the Gregory of Nyssa homepage, www.sage.edu/faculty/salomd/nyssa/ (accessed March 26, 2015).

———. *Oratio in diem natalem Christi*. Ed. F. Mann, *Die Weihnachtspredigt Gregors von Nyssa: Überlieferungsgeschichte und Text*, 263–92. Münster: n.p., 1975.

Gregory of Tours. *Glory of the Martyrs (De gloria martyrum)*. Trans. with an introduction by R. Van Dam. Liverpool: Liverpool University Press, 1988.

Herodian. *History of the Empire after Marcus*. Ed. and trans. C. R. Whittaker. 2 vols. Cambridge, Mass.: Harvard University Press, 1969.

Hesychius. *Hesychii Alexandrini lexicon*. Ed. K. Latte et al. Copenhagen and others: Munksgaard, 1953–2009. Accessed through the *TLG (Thesaurus linguae graecae)*, http://stephanus.tlg.uci.edu/ (accessed March 26, 2015).

Horace. *Odes and Epodes*. Ed. and trans. N. Rudd. Cambridge, Mass.: Harvard University Press, 2004.

Inscriptiones graecae. 13 vols. Berlin: G. Reimer, 1873.

Inscriptiones graecae ad res romana pertinentes. Ed. R. Cagnat, J. Toutain, et al. 3 vols. Paris: Leroux, 1906–27.

Inscriptiones latinae Christianae veteres. 4 vols. Ed. E. Diehl. Berlin: Weidmann, 1961–67.

Inscriptiones latinae selectae. 3 vols. Ed. H. Dessau. Chicago: Ares Publishers, 1979.

The Inscriptions of Roman Tripolitania. Ed. J. M. Reynolds and J. B. Ward Perkins, in collaboration with S. Aurigemma at al. Rome: British School at Rome, 1952. Enhanced electronic reissue by G.Bodard and C. Roueché (2009). Available online at Inscriptions of Roman Tripolitania: http://inslib.kcl.ac.uk/irt2009/.

Itinerarium Egeriae. Ed. O. Prinz. Heidelberg: Carl Winter, 1960.

———. *Egeria's Travels: Newly Translated, with Supporting Documents and Notes*, trans. J. Wilkinson, 107–64. 3rd ed. Warminster, England: Aris and Phillips, 1999.

Jerome. *Lives of Illustrious Men (De viris illustribus). Chronicle (Chronicon)*. Trans., ed., and commentary R. Pearse, at the Tertullian Project website, www.tertullian.org/fathers/jerome_chronicle_00_eintro.htm (accessed March 26, 2015).

———. Trans. E. C. Richardson. At the Christian Classics Ethereal Library, www.ccel.org/ccel/schaff/npnf203.v.i.html (accessed March 26, 2015).

Joel. *Chronographia*. Ed. I. Bekker. *Ioelis chronographia compendiaria*. Corpus Scriptorum Historiae Byzantinae. Bonn: E. Weber, 1836.

John Chrysostom. *Homilia antequam iret in exsilium*. PG 52:427*–32.

———. *Homilia cum iret in exsilium*. PG 52:435*–38.

———. *Homilia dicta postquam reliquiae martyrum (Homily after the Remains of the Martyrs)*. PG 63:467–72.

———. *Homily after the Remains of the Martyrs Etc*. Trans. W. Mayer and P. Allen. In *John Chrysostom*, ed. C. Harrison, 85–92. London: Routledge, 2000.

John of Ephesus. *Ecclesiastical History*. Trans. R. Payne Smith (1860). Transcribed R. Pearse and made available at the Tertullian Project website, www.tertullian.org/fathers/ephesus_0_preface.htm (accessed March 26, 2015).

———. *Lives of the Eastern Saints*. Trans. in *Patrologia Orientalis (PO)*, 17/11 (11–307), 318/302 (513–698), 319/301 (153–285), 319/302 (153–275). Paris: Firmin-Didot, 1923–25.

John Lydus. *Liber de mensibus*. Ed. R. Wünsch. Stuttgart: Teubner, 1967.

Josephus. *Antiquitates Judaicae*. Ed. and trans. H. Thackeray. In Josephus, *Jewish Antiquities*, 9 vols. Cambridge, Mass.: Harvard University Press, 1930.

———. *The Jewish War (Bellum Iudaicum)*. Ed. and trans. H. Thackeray. Cambridge, Mass.: Harvard University Press, 1927.

Julian. *Oratio 1 (Panegyric in Honor of Constantius II)*. In Julian, *Orations 1–5*, ed. and trans. W. Wright, 1–128. Cambridge, Mass.: Harvard University Press, 1913.

———. *Oratio 3 (In Praise of Eusebia)*. In Julian, *Orations 1–5*, ed. and trans. W. Wright, 274–345. Cambridge, Mass.: Harvard University Press, 1913.

———. *Oratio 5 (On the Mother of the Gods)*. In Julian, *Orations 1–5*, ed. and trans. W. Wright, 443–503. Cambridge, Mass.: Harvard University Press, 1913.

Julian of Ascalon. Ed. C. Saliou. *Le traité d'urbanisme de Julien d'Ascalon: Droite et architecture en Palestine au VIe siècle*. Travaux et Mémoires 8. Paris: De Boccard, 1996.

Justinian. *Corpus iuris civilis*. 2nd ed. 3 vols. Ed. R. Schoell, T. Mommsen, and W. Kroll. Berlin: Weidmann, 1900–1905.

———. *The Digest of Justinian*. Trans. C. H. Monro. Cambridge: Cambridge University Press, 1904.

———. *Novellae*. Trans. F. H. Blume. Online at Annotated Justinian Code, www.uwyo.edu /lawlib/justinian-novels/ (accessed March 26, 2015).

Lactantius. *De mortibus persecutorum*. Ed. and trans. J. L. Creed. Oxford: Clarendon Press, 1984.

Leo I. *Epistles 60 and 79*. Trans. Brother E. Hunt. In *Saint Leo the Great*, 132–33, 144–47. New York: Fathers of the Church, 1957.

Libanius. *Oratio 11*. "Libanius' Oration in Praise of Antioch (Oration XI)." Trans. G. Downey. *Proceedings of the American Philosophical Society* 103 (5) (October 15, 1959): 652–86.

Liber pontificalis. Ed. T. Mommsen. Monumenta Germaniae Historica. Berlin: 1898.

———. *Le Liber pontificalis: Texte, introduction et commentaire*. Trans. and ed. L. Duchesne. 3 vols. Paris: De Boccard, 1981.

———. *The Book of Pontiffs: The Ancient Biographies of the First Ninety Roman Bishops to A.D. 715*. Trans. R. Davis. Rev. ed. Liverpool: Liverpool University Press, 2000.

Livy. *Ab urbe condita. History of Rome*. 14 vols. Ed. and trans. B. O. Foster. Cambridge, Mass.: Harvard University Press, 1919–59.

Lucan. *The Civil War (Pharsalia)*. Ed. and trans. J. D. Duff. Cambridge, Mass.: Harvard University Press, 1928.

Malalas, John. *Ioannis Malalae chronographia*. Ed. L. A. Dindorf. Corpus Scriptorum Historiae Byzantinae 14. Bonn: E. Weber, 1831.

———. *The Chronicle of John Malalas*. Trans. E. Jeffreys, M. Jeffreys, R. Scott, and B. Croke. Byzantina Australiensia 4. Melbourne: Australian Association for Byzantine Studies and Department of Modern Greek University of Sydney, 1986.

Manilius. *Astronomica*. Ed. and trans. G. P. Goold. Cambridge, Mass.: Harvard University Press, 1977.

Marcellinus Comes. *The Chronicle of Marcellinus: A Translation and Commentary*. Ed. T. Mommsen. Trans. B. Croke. Sydney: Australian Association for Byzantine Studies, 1995.

Martial. *Epigrams, Volume I: Spectacle, Books 1–5.* Ed. and trans. D. R. Shackleton Bailey. Cambridge, Mass.: Harvard University Press, 1993.

Menander Rhetor. *Peri epideiktikōn (Treatise 2).* Ed., trans., and commentary D. A. Russell and N. G. Wilson. In *Menander Rhetor,* 77–225. 1st ed. Oxford: Clarendon Press, 1981.

Moschus, John. *The Spiritual Meadow (Pratrum spirituale).* Trans. John Wortley. Cistercian Studies Series 139. Kalamazoo, Mich., and Spencer, Mass.: Cistercian Publications, 1992.

Nestorius. *Lettre à Cosme.* In *Le livre d'Héraclide de Damas,* trans. P. Bejan, M. Brière, and F. Nau, 363–64. Paris: Letouzey et Ané, 1910.

———. *Nestorius: The Bazaar of Heracleides.* Trans. G. R. Driver and Leonard Hodgson. 1925. Repr., New York: AMS Press, 1978.

New Testament. *Greek-English New Testament.* Ed. B. Aland, K. Aland, and J. Karavidopoulos. Stuttgart: Deutsche Bibelgesellschaft, 1981.

Notitia urbis Constantinopolitanae (Notitia). Ed. O. Seeck. In *Notitia dignitatum: Accedunt notitia urbis Constantinopolitanae et latercula provinciarum,* 229–43. Frankfurt: Minerva, 1962.

Odyssey. 2 vols. Ed. and trans. A. T. Murray. Rev. ed. G. E. Dimock. Cambridge, Mass: Harvard University Press, 1919.

Oppian. *Cynegetica.* Ed. and trans. A. W. Mair. In *Oppian, Colluthus, Tryphiodorus,* 2–198. Cambridge, Mass.: Harvard University Press, 1928.

Optatian (P. Optatianus Porphirius). *Carmina.* Ed. L. Müller. Leipzig: Teubner, 1877.

———. *Carmi di Publio Optaziano Porfiro.* Ed. and trans. G. Polara. Turin: Unione Tipografico-Editrice Torinese, 2004.

Origo Constantini imperatoris (Lineage of Constantine). In Ammianus Marcellinus, *History, Volume III: Books 27–31. Excerpta Valesiana,* 508–29. Ed. and trans. J. C. Rolfe. Cambridge, Mass.: Harvard University Press, 1939

Ovid. *Ars amatoria.* In *Art of Love; Cosmetics; Remedies for Love; Ibis; Walnut-tree; Sea Fishing; Consolation,* ed. and trans. J. H. Mozley, rev. by G. P. Goold, 13–175. Cambridge, Mass.: Harvard University Press, 1929.

———. *Fasti.* Ed. and trans. J. G. Frazer. Rev. by G. P. Goold. Cambridge, Mass.: Harvard University Press, 1931.

———. *Metamorphoses.* 2 vols. Ed. and trans. F. J. Miller. Rev. by G. P. Goold. Cambridge, Mass.: Harvard University Press, 1916.

———. *Ex Ponto.* In *Tristia; Ex Ponto,* ed. and trans. A. L. Wheeler, rev. by G. P. Goold, 264–490. Cambridge, Mass.: Harvard University Press, 1924.

———. *Tristia.* In *Tristia; Ex Ponto,* ed. and trans. A. L. Wheeler, rev. by G. P. Goold, 2–262. Cambridge, Mass.: Harvard University Press, 1924.

Palladius. *Palladii dialogus de vita S. Joanni Chrysostomi.* Ed. P. R. Coleman-Norton. Cambridge: Cambridge University Press, 1928.

Panegyrici Latini. Ed. R. A. B. Mynors, with translation and commentary by C. E. V., Nixon and B. S. Rodgers. *In Praise of Later Roman Emperors: The Panegyrici Latini; Introduction, Translation, and Historical Commentary, with the Latin Text of R. A. B. Mynors.* Transformation of the Classical Heritage 21. Berkeley: University of California Press, 1994.

——— 4 (10). *Panegyricus Nazarii dictus Constantino (Panegyric of Constantine by Nazarius).* In *Panegyrici Latini,* trans. Rodgers 343–85, ed. Mynors, 608–28.

———— 6 (7). Panegyricus *Constantino Augusto* 6 (7) *(Panegyric of Constantine).* In *Panegyrici Latini*, trans. Nixon 218–53, ed. Mynors, 572–84.

———— 7 (6). *Panegyricus Maximiano et Constantino (Panegyric of Maximian and Constantine).* In *Panegyrici Latini*, trans. Nixon, 191–210, ed. Mynors, 564–71.

———— 12. *Panegyricus Constantino Filio Constantii (Panegyric of Constantine Augustus).* In *Panegyrici Latini*, trans. Rodgers, 343–85, ed. Mynors, 594–607.

Patria. Untersuchungen zu den Patria Konstantinupoleos. Trans. and commentary A. Berger. Poikila Byzantina 8. Bonn: R. Habelt GMBH, 1988.

————. *Accounts of Medieval Constantinople: The Patria.* Ed. and trans. A. Berger. Cambridge, Mass.: Harvard University Press, 2013.

Patrologiae cursus completus: Series graeca. Ed. J.-P. Migne. Paris, 1857–66.

Patrologiae cursus completus: Series latina. Ed. J.-P. Migne. Paris, 1844–64.

Patrologia orientalis. Turnhout, Belgium: Brepols.

Parastaseis syntomoi chronikai. Ed. and trans. A. Cameron and J. Herrin. *Constantinople in the Early Eighth Century: The "Parastaseis Syntomoi Chronikai"; Introduction, Translation, and Commentary.* Leiden: Brill, 1984.

Paulinus of Nola. *Carmina.* Ed. W. Hartel. In *Sancti Pontii Meropii Paulini Nolani Carmina.* Corpus Scriptorum Ecclesiasticorum Latinorum 30. Prague: Tempsky, 1894.

————. *Epistle 31.* Trans. P. G. Walsh. In *Letters of St. Paulinus of Nola*, 125–33. Westminster, Md.: Newman Press, 1967.

————. *Epistula 31.* In *Epistulae. Briefe*, ed. N. Brox and S. Döpp, 2:732–45. Fontes Christiani 25.2. Freiburg: Herder, 1998.

————. *The Poems of St. Paulinus of Nola.* Trans. and annotated by P. G. Walsh. Ancient Christian Writers 40. New York: Newman Press, 1975.

Pausanias. *Description of Greece.* 5 vols. Ed. and trans. W. H. S. Jones. Cambridge, Mass.: Harvard University Press, 1918.

Peter Chrysologus. *Sermo 130 (In consecratione episcopi).* In *PL* 52:556a–557b.

————. *Sermons.* Trans. W. B. Palardy. In *St. Peter Chrysologus: Selected Sermons*, vol. 2 of *The Fathers of the Church: A New Translation.* Washington, D.C.: Catholic University of America Press, 2004.

Philostorgius. *Historia Ecclesiastica (fragmenta ap.* Photium). Ed. F. Winkelmann (post J. Bidez). *Kirchengeschichte.* 3rd ed. Die Griechischen Christlichen Schriftsteller. Berlin: Akademie Verlag, 1981.

————. *Epitome of the Ecclesiastical History, compiled by Photius, Patriarch of Constantinople.* Trans. E. Walford. London: H. Bohn, 1855. Available online at: the Tertullian Project website: www.tertullian.org/fathers/philostorgius.htm (accessed March 26, 2015).

Photius. *Bibliothèque (Bibliothēke).* 9 vols. Ed. and trans. R. Henry. Paris: Les Belles Lettres, 1959.

Pliny. *Natural History.* 10 vols. Ed. and trans. H. Rackham, W. H. S. Jones, and D. E. Eichholz. Cambridge, Mass: Harvard University Press, 1938–62.

Plutarch. *Alexander.* In *Lives, Volume VII: Demosthenes and Cicero; Alexander and Caesar*, ed. and trans. B. Perrin, 223–440. Cambridge, Mass.: Harvard University Press, 1919.

————. *Aristides.* In *Lives, Volume II: Themistocles and Camillus; Aristides and Cato Major; Cimon and Lucullus*, ed. and trans. B. Perrin, 209–300. Cambridge, Mass.: Harvard University Press, 1914.

————. *Cicero*. In *Lives, Volume VII: Demosthenes and Cicero; Alexander and Caesar*, ed. and trans. B. Perrin, 81–210. Cambridge, Mass.: Harvard University Press, 1919.

————. *Demetrius*. In *Lives, Volume IX: Demetrius and Antony; Pyrrhus and Gaius Marius*, ed. and trans. B. Perrin. Cambridge, Mass.: Harvard University Press, 1920.

————. *Marcellus (Marc.)*. In *Lives, Volume V: Agesilaus and Pompey; Pelopidas and Marcellus*, ed. and trans. B. Perrin, 435–521. Cambridge, Mass.: Harvard University Press, 1917.

————. *Marius*. In *Lives, Volume IX: Demetrius and Antony; Pyrrhus and Gaius Marius*, ed. and trans. B. Perrin, 463–600. Cambridge, Mass.: Harvard University Press, 1920.

————. *Romulus*. In *Lives, Volume I: Theseus and Romulus; Lycurgus and Numa; Solon and Publicola*, ed. and trans. B. Perrin, 89–187. Cambridge, Mass.: Harvard University Press, 1914.

Polybius. *The Histories*. Trans. W. R. Paton. Cambridge: Harvard University Press, 1954.

Proclus of Constantinople. *Homilies* 1, 2, 4, 5. Ed. and trans. N. Constans. In *Proclus of Constantinople and the Cult of the Virgin in Late Antiquity*, 136–47, 164–79, 226–37, 256–65. Leiden: Brill, 2003.

Procopius. *De aedificiis Buildings*. In *The Works of Procopius*, trans. H. B. Dewing. Cambridge, Mass.: Harvard University Press, 1962.

————. *Anecdota. The Anecdota or Secret History (Anec.)*. Ed. and trans. H. B. Dewing. Cambridge, Mass.: Harvard University Press, 1935.

————. *De bellis. History of the Wars*. 7 vols. Ed. and trans. H. B. Dewing. Cambridge, Mass.: Harvard University Press, 1919–28.

Procopius of Gaza. *Panegyriques de l'empereur Anastase Ier*. Trans. Alain Chauvot. Ed. Géza Alföldy and Johannes Straub. Antiquitas: Abhandlungen zur alten Geschichte 35. Bonn: Dr. Rudolf Habelt, 1986.

Propertius. *Elegies*. Ed. and trans. G. P. Goold. Cambridge, Mass.: Harvard University Press, 1990.

Prosopographia imperii romani. Ed. L. Petersen. Berlin: W. de Gruyter, 1966.

Protevangelium of James. Ed. and trans. E. Strycker. *La forme la plus ancienne du Protévangile de Jacques*. Brussels: Société des Bollandistes, 1961.

Quintilian. *The Orator's Education, Volume IV: Books 9–10*. Ed. and trans. D. A. Russell. Cambridge, Mass: Harvard University Press, 2002.

Romanos. *Cantica*. Ed. and trans. J. Grosdidier de Matons. *Romanos le mélode: Hymnes*. Sources Chrétiennes 110. Paris: Éditions du Cerf, 1965.

Rufinus of Aquileia. *Historia Ecclesiastica, Rufini Continuatio*. Ed. T. Mommsen. In Eusebius, *Werke*, vol. 9.2, *Eusebii Caesarensis, Historia Ecclesiastica, Rufini Continuatio*, 9 vols. Leipzig: J. C. Hinrichs, 1902.

————. *The Church History of Rufinus of Aquileia, Books 10 and 11*. Trans. P. Amidon. New York: Oxford University Press, 1997.

Scriptores originum Constantinopolitanarum. Ed. Theodor Preger. Leipzig: B. G. Teubner, 1989.

Senatus consultum (SC) de Pisone Patre (Decree of the Senate Condemning Piso). Ed. and trans. D. S. Potter and C. Damon. *The "Senatus Consultum de Cn. Pisone Patre: Text, Translation, Discussion." American Journal of Philology* 120 (1) (Spring 1999):13–42.

Servius (Maurus Servius Honoratus). *In Vergilii carmina comentarii*, ed. G. Thilo and H. Hagen, Georgius Thilo. Leipzig: Teubner, 1881. Online at the Perseus Digital Library:www.perseus .tufts.edu (accessed March 26, 2015).

SHA (Scriptores historiae Augustae). *Antoninus Pius*. In *Historia Augusta*, 3 vols., ed. and trans. D. Magie, 1:101–31. Cambridge, Mass.: Harvard University Press, 1921–32.

———. *Aurelian*. In *SHA* 3:192–293.

———. *Caracalla*. In *SHA* 2:2–31.

———. *Commodus*. In *SHA* 1:265–314.

———. *Elagabalus*. In *SHA* 2:104–77.

———. *Hadrian*. In *SHA* 1:3–82.

———. *Macrinus*. In *SHA* 2:48–81.

———. *Marcus Aurelius*. In *SHA* 1:133–206.

———. *Severus Alexander*. In *SHA* 2:178–312.

Socrates. *Historia Ecclesiastica. Socrate de Constantinople, Histoire ecclésiastique (Livres I–VII)*. Ed. and trans. P. Maraval and P. Périchon, 477:44–262; 493:18–258; 505:22–354; 506:20–158. Paris: Éditions du Cerf, 2004–7.

———. *The Ecclesiastical History of Socrates Scholasticus (Historia Ecclesiastica)*. Trans. in *NPNF*, 2:1–178. Edinburgh and Grand Rapids, Mich.: T and T Clark and Eerdmans Publishing, 1989.

Sozomen. *Historia Ecclesiastica*. Ed. J. Bidez and G. C. Hansen. *Sozomenus, Kirchengeschichte*. Die Griechischen Christlichen Schriftsteller 50. Berlin: Akademie Verlag, 1960.

———. *The Ecclesiastical History of Sozomenus, from A.D. 323–425 (Historia Ecclesiastica)*. Trans. in *NPNF*, 2:179–427. Edinburgh and Grand Rapids, Mich.: T and T Clark and Eerdmans Publishing House, 1989.

Strabo. *Geography*. 8 vols. Ed. and trans. H. L. Jones. Cambridge, Mass: Harvard University Press, 1917–32.

Suda. Ed. Adler. *Suidae lexicon*. 5 vols. Stuttgart: Teubner, 1971.

Suetonius. *Divus Augustus*. In *Lives of the Caesars*, 1:121–287.

———. *Divus Claudius*. In *Lives of the Caesars*, 2:1–83.

———. *Divus Iulius*. In *Lives of the Caesars*, 1:1–119.

———. *Tiberius*. In *Lives of the Caesars*, 1:289–401.

———. *Lives of the Caesars*. 2 vols. Ed. and trans. J. C. Rolfe. Introduction by K. R. Bradley. Cambridge, Mass.: Harvard University Press, 1914.

Sulpicius Severus. *Chroniques*. Ed. and trans. G. de Senneville-Grave. Sources Chrétiennes 441. Paris: Éditions du Cerf, 1999.

Supplementum epigraphicum graecum. Amsterdam: J. C. Gieben, 1923– .

Sylloge inscriptionum graecarum. 3rd ed. Ed. F. H. von Gaertringen. Leipzig: S. Hirzelium, 1915–24.

Symeon Logothetes. *Chronicon*. Ed. I. Bekker, *Leonis Grammatici chronographia*, 3–331. Corpus Scriptorum Historiae Byzantinae. Bonn: E. Weber, 1842.

Synaxarium mensis octobris. Ed. H. Delehaye, 95–184. Acta Sanctorum 62. Brussels, 1902. Repr., Wetteren, Belgium: Imprimerie Cultura, 1985.

Tacitus. *Annals and Histories*. 5 vols. Ed. and trans. C. H. Moore and J. Jackson. Cambridge, Mass.: Harvard University Press, 1931.

Tertullian. *Apologeticus.* In *Apology; De spectaculis,* 2:2–227. Cambridge, Mass.: Harvard University Press, 1960.

———. *De spectaculis.* In *Apology; De Spectaculis; Minucius Felix: Octavius,* ed. and trans. T. R. Glover, Gerald H. Rendall, 230–302. Cambridge, Mass.: Harvard University Press, 1931.

———. *On the Flesh of Christ (De carne Christi).* Trans. in Norris 1980, 64–72.

Themistius. *Oratio 4 and Oratio 19.* In *Themistii Orationes,* ed. W. Dindorf, 59-74, 275–84. Hildesheim: Georg Olms Verlagsbuchhandlung, 1961.

Theodore Anagnostes (Theod. Lect.). *Historia Ecclesiastica.* Ed. G. C. Hansen. *Theodoros Anagnostes Kirchengeschichte.* Die Griechischen Christlichen Schriftsteller der ersten Jahrhunderte Neue Folge 3. Berlin: Akademie Verlag, 1971.

Theodoret. *Epistle 43.* In *NPNF,* 3:264. Grand Rapids, Michigan: Eerdmans Publishing, 1953.

———. *Epistle 151.* In *NPNF,* 3:325–32. Grand Rapids, Michigan: Eerdmans Publishing, 1953.

———. *Historia Ecclesiastica. Kirchengeschichte.* Ed. L. Parmentier and G. C. Hansen. 3rd ed. Berlin: Akademie Verlag, 1998.

———. Trans. B. Jackson. In *The Ecclesiastical History, Dialogues, and Letters of Theodoret,* in *NPNF,* 3:33–159. Grand Rapids, Mich.: Eerdmans Publishing, 1892.

Theophanes. *Chronographia.* 2 vols. Ed. C. de Boor. Leipzig: n.p., 1883.

———. *The Chronicle of Theophanes Confessor: Byzantine and Near Eastern History, A.D. 284–813.* Trans. C. A. Mango, R. Scott, and G. Greatrex. Oxford and New York: Clarendon Press and Oxford University Press, 1997.

Theophanes Continuatus. *Chronographia.* In *Theophanes Continuatus, Ioannes Cameniata, Symeon Magister, Georgius Monachus,* ed. Ed. I. Bekker. Corpus Scriptorum Historiae Byzantinae. Bonn: E. Weber, 1838

Tibullus. *Poem 2: The Installation of Messalinus.* In Catullus and Tibullus, *Pervigilium Veneris,* ed. and trans. F. W. Cornish, J. P. Postgate, J. W. Mackail, rev. by G. P. Goold, 270–79. Cambridge, Mass.: Harvard University Press, 1913.

Varro. *On the Latin Language (De lingua latina).* 2 vols. Ed. and trans. R. G. Kent. Cambridge, Mass.: Harvard University Press, 1938.

Velleius Paterculus. In *Compendium of Roman History (Res Gestae Divi Augusti).* Ed. and trans. F. W. Shipley. Cambridge, Mass.: Harvard University Press, 1924.

Venantius Fortunatus. *Carmina.* In *Poèmes: Venance Fortunat; texte établi et traduit par Marc Reydellet,* ed. and trans. M. Reydellet. 3 vols. Paris: Les Belles Lettres, 1994–2004.

———. *Carmina.* In *Venantius Fortunatus: Personal and Political Poems,* trans. J. W. George. Liverpool: Liverpool University Press, 1995.

Vergil. *Aeneid.* In *Eclogues; Georgics; Aeneid: Books 1–6,* ed. and trans. H. R. Fairclough, rev. by G. P. Goold, 261–560. Cambridge, Mass.: Harvard University Press, 1916.

———. *Aeneid: Books 7–12. Appendix Vergiliana.* Ed. and trans. H. R. Fairclough. Rev. by G. P. Goold. Cambridge, Mass.: Harvard University Press, 1918.

———. *Eclogae.* In *Eclogues; Georgics; Aeneid: Books 1–6,* ed. and trans. H. R. Fairclough, rev. by G. P. Goold, 23–96. Cambridge, Mass.: Harvard University Press, 1916.

Vita Porphyry. In *Marc le Diacre: Vie de Porphyre,* ed. and trans. Henri Grégoire and M.-A. Kugener. Paris: Les Belles Lettres, 1930.

———. *The Life of Porphyry, Bishop of Gaza, by Mark the Deacon.* Trans. with introduction and notes G. F. Hill. Oxford: Clarendon Press, 1913.

Vitruvius. *On Architecture (De Architectura)*. 2 vols. Ed. and trans. F. Granger. Cambridge, Mass.: Harvard University Press, 1931.

Zosimus. *Zosimus: Histoire nouvelle (Historia nova)*. 3 vols. Ed. and trans. F. Paschoud. Collection des Universités de France 401. Paris: Les Belles Lettres.

SECONDARY SOURCES

Adak, M. 1996. "Claudia Anassa—Eine Wohltäterin aus Patara." *Epigraphica Anatolica* 27:127–42.

Aland, B., K. Aland, and J. Karavidopoulos, eds. 1981. *Greek-English New Testament*. Stuttgart: Deutsche Bibelgesellschaft.

Albu, E. 2005. "Imperial Geography and the Medieval Peutinger Map." *Imago Mundi* 57 (2):136–48.

Alchermes, J. 1998. "Constantinople and the Empire of New Rome." In *Heaven on Earth: Art and the Church in Byzantium*ed, ed. L. Safran, 13–38. University Park: Pennsylvania State University Press.

Alexandridis, A. 2004. *Die Frauen des römischen Kaiserhauses: Eine Untersuchung ihrer bildlichen Darstellung von Livia bis Iulia Domna*. Mainz: P. von Zabern.

Alföldi, A. 1948. *The Conversion of Constantine and Pagan Rome*. Trans. H. Mattingly. Oxford: Clarendon Press.

———. 1950–54. *Der Vater des Vaterlandes im römischen Denken*. Darmstadt: Wissenschaftliche Buchgesellschaft.

———. 1970. [1935.] *Die monarchische Repräsentation im römischen Kaiserreiche, mit register von Elisabeth Alföldi-Rosenbaum*. Darmstadt: Wissenschaftliche Buchgesellschaft.

———. 1973. *Die zwei Lorbeerbäume des Augustus*. Vol. 14, *Antiquitas*. Bonn: R. Habelt.

Alföldi, M. 1963. *Die Constantinische Goldprägung. Untersuchungen zu ihrer Bedeutung für Kaiserpolitik und Hofkunst*. Mainz: Verlag des Römisch-Germanischen Zentralmuseums.

———. 1964. "Die Sol Comes-Münze vom Jahre 325." In *Mullus: Festschrift Theodor Klauser*, ed. A. Stuidber and A. Hermann, 10–16. Münster: Aschendorff.

Amandry, P. 1950. *La mantique apollinienne à Delphes: Essai sur le fonctionnement de l'oracle*. Bibliothèque des Écoles Françaises d'Athènes et de Rome 170. Paris: E. de Boccard.

Amici, A. 2000. "Imperatori *divi* nella decorazione musiva della chiesa di San Giovanni Evangelista." *Ravenna: Studi e Ricerche* 7 (1):13–55.

Amidon, P. R. 1997. *The Church History of Rufinus of Aquileia, Books 10 and 11*. New York: Oxford University Press.

Anastos, Milton. 1962. "Nestorius Was Orthodox." *Dumbarton Oaks Papers* 16:117–40.

Angelidi, C. 1998. *Pulcheria: La castità al potere*. Trans. D. Serman and ed. G. Passerelli. Donne d'Oriente e d'Occidente. Milan: Jaca.

Angelova, D. 1998. "The Ivories of Ariadne and the Construction of the Image of the Empress and the Virgin Mary in Late Antiquity." Master's thesis, Southern Methodist University.

———. 2004. "The Ivories of Ariadne and Ideas about Female Imperial Authority in Rome and Early Byzantium." *Gesta* 43 (1):1–15.

———. 2005. "Gender and Imperial Authority in Rome and Early Byzantium, First to Sixth Centuries." Ph.D. diss., Harvard University.

———. 2011. Review of Beat Brenk, *The Apse, the Image, and the Icon: An Historical Perspective of the Apse as a Space for Images* (Reichert, 2010). In *Jahrbuch der Österreichischen Byzantinistik*, vol. 61:244-47.

———. 2014. "Stamp of Power: The Life and Afterlife of Pulcheria's Buildings." In *Byzantine Images and Their Afterlives: Essays in Honor of Annemarie Weyl Carr*, ed. L. Jones, 83–104. Farnham, England: Ashgate.

Armstrong, G. 1967. "Constantine's Churches." *Gesta* 6: 1–9.

Aufstieg und Niedergang der römischen Welt: Geschichte und Kultur Roms im Spiegel der neueren Forschung. 1972- . Ed. H. Temporini. Berlin: W. de Gruyter.

Avigad, N. 1977. "A Building Inscription of the Emperor Justinian and the Nea in Jerusalem (Preliminary Note)." *Israel Exploration Journal* 27 (2):3.

Aymard, J. 1934. "Vénus et les impératrices sous les derniers Antonins." *Mélanges de l'École Française de Rome* 51 (1–5):178–96.

Babcock, C. L. 1965. "The Early Career of Fulvia." *American Journal of Philology* 86 (1):1–32.

Bacci, M., and G. Bianchi. 2012. "Historical and Archaeological Analysis of the Church of the Nativity." *Journal of Cultural Heritage* 13 (4): e5-e26.

Bagster, S. 1890. *The Life of Constantine by Eusebius, Together with the Oration of Constantine to the Assembly of the Saints and the Oration of Eusebius in Praise of Constantine.* Rev. translation with prolegomena and notes by E. C. Richardson. New York: Christian Literature Company.

Banti, A., and L. Simonetti. 1972–79. *Corpus nummorum romanorum.* 18 vols. Florence: A. Banti.

Barber, C. 1990. "The Imperial Panels of San Vitale: A Reconsideration." *Byzantine and Modern Greek Studies* 14:19–40.

———. 2000. Early Representations of the Mother of God. In *Mother of God: Representations of the Virgin in Byzantine Art*, ed. M. Vassilaki, 253–61. Milan: Skira.

Barbera, M. 2000. Dagli *Horti Spei Veteris* al *Palatium Sessorianum*. In *Aurea Roma: Dalla città pagana alla città cristiana*, ed. S. Ensoli and E. L. Rocca, 104–12. Rome: "L'Erma" di Bretschneider.

Barchiesi, A. 1997. *The Poet and the Prince: Ovid and Augustan Discourse.* Berkeley: University of California Press.

———. 2005. "Learned Eyes: Poets, Viewers, Image Makers." In *The Cambridge Companion to the Age of Augustus*, ed. K. Galinsky, 281–305. Cambridge: Cambridge University Press.

Bardill, J. 1997. "The Palace of Lausos and Nearby Monuments in Constantinople: A Topographic Study." *American Journal of Archaeology* 101 (1):67–95.

———. 2000. "The Church of St. Sergius and Bacchus in Constantinople and the Monophysite Refugees." *Dumbarton Oaks Papers* 54:1–11.

———. 2004. *Brickstamps of Constantinople.* Oxford: Oxford University Press.

———. 2006. "A New Temple for Byzantium: Anicia Juliana, King Solomon, and the Guilded Ceiling of the Church of St. Polyeuktos in Constantinople." In *Social and Political Life in Late Antiquity*, ed. A. Gutteridge, W. Bowden, and C. Machado, 339–72. Leiden: Brill.

———. 2012. *Constantine: Divine Emperor of the Christian Golden Age.* Cambridge: Cambridge University Press.

Barker, D. 1996. "'The Golden Age Is Proclaimed'? The Carmen Saeculare and the Renascence of the Golden Race." *Classical Quarterly* 46 (2):434–46.

Barker, M. 2011. "Wisdom Imagery and the Mother of God." In *The Cult of the Mother of God in Byzantium: Text and Images*, ed. L. Brubaker and M. Cunningham, 91–108. Farnham, England: Ashgate.

Barnes, T. D. 1974. "Merobaudes on the Imperial Family." *Phoenix* 28 (3):314–19.

———. 1975. "Publilius Optatianus Porfyrius." *American Journal of Philology* 96 (2) (Summer 1975):173–86.

———. 1976. "The Emperor Constantine's Good Friday Sermon." *Journal of Theological Studies* 27 (2):414–23.

———. 1981. *Constantine and Eusebius*. Cambridge, Mass.: Harvard University Press.

———. 1982. *The New Empire of Diocletian and Constantine*. Cambridge, Mass.: Harvard University Press.

———. 1984. "Constantine's Prohibition of Pagan Sacrifice." *American Journal of Philology*. 105:69–72.

———. 1989. "Panegyric, History, and Hagiography in Eusebius' *Life of Constantine*." In *The Making of Orthodoxy: Essays in Honor of Henry Chadwick*, ed. R. Williams, 94–123. Cambridge: Cambridge University Press.

———. 2011. *Constantine: Dynasty, Religion, and Power in the Later Roman Empire*. Blackwell Ancient Lives. Chichester, England: Wiley-Blackwell.

Barré, H. 1939. "La royauté de Marie pendant les neuf premiers siècles." *Recherches de Science Religieuse* 29:129–62.

Barrett, A. 2002. *Livia: First Lady of Imperial Rome*. New Haven, Conn.: Yale University Press.

Bartels, H. 1963. *Studien zum Frauenporträt der augusteischen Zeit: Fulvia, Octavia, Livia, Julia*. Munich: Feder.

Bartman, E. 1999. *Portraits of Livia: Imaging the Imperial Woman in Augustan Rome*. Cambridge: Cambridge University Press.

Bassett, S. G. 1991. "The Antiquities in the Hippodrome of Constantinople." *Dumbarton Oaks Papers* 45:87–96.

———. 1996. "Historiae custos: Sculpture and Tradition in the Baths of Zeuxippos." *American Journal of Archaeology* 100 (3):491–506.

———. 2004. *The Urban Image of Late Antique Constantinople*. Cambridge: Cambridge University Press.

———. 2008. "Style and Meaning in the Imperial Panels at San Vitale." *Artibus at Historiae* 57:49–57.

Bastien, P. 1992. *Le buste monétaire des empereurs romains*. Wetteren, Belgium: Numismatiques Romaines.

Bauer, F. A. 2001. "Urban Space and Ritual: Constantinople in Late Antiquity." In *Imperial Art as Christian Art: Christian Art as Imperial Art*, ed. J. R. Brandt and O. Steen, 27–62. Rome: Bardi.

Bauman, R. A. 1992. *Women and Politics in Ancient Rome*. London: Routledge.

Baynes, N. H. 1972. [1930.] *Constantine the Great and the Christian Church*. Raleigh Lecture on History, 1929. London: H. Milford.

Beard, M. 1986. "The Pomerial Extension of Augustus." *Historia* 35:13–27.

Beard, M., J. North, and S. Price. 1998. *Religions of Rome*. 2 vols. Cambridge: Cambridge University Press.

Bekker, I. 1838. *Theophanes Continuatus, Ioannes Cameniata, Symeon Magister, Georgius Monachus.* Corpus Scriptorum Historiae Byzantinae. Bonn: E. Weber.

Bellinger, A. R., and P. Grierson. 1966. *Catalogue of the Byzantine Coins in the Dumbarton Oaks Collection and in the Whittemore Collection: Anastasius to Maurice (491–602).* Dumbarton Oaks Catalogs. Washington, D.C.: Dumbarton Oaks Center for Byzantine Studies.

Belting, H. 1994. *Likeness and Presence: A History of the Image before the Era of Art.* Chicago: University of Chicago Press.

Berger, A. 1982. *Das Bad in der byzantinischen Zeit.* Miscellanea Byzantina Monacensia 27. Munich: Institut für Byzantinistik und neugriechische Philologie der Universität.

———. 1988. *Untersuchungen zu den Patria Konstantinupoleos.* Poikila Byzantina 8. Bonn: R. Habelt GMBH.

———. 1997. "Regionen und Strassen im frühen Konstantinopel." *Istanbuler Mitteilungen* 47:349–414.

Bergman, R. P., D. DeGrazia, and S. N. Fliegel. 1998. *Vatican Treasures: Early Christian, Renaissance, and Baroque Art from the Papal Collections; An Exhibition in Honor of the Sesquicentenary of the Diocese of Cleveland.* Cleveland: Cleveland Museum of Art.

Bergmann, M. 1994. *Der Koloss Neros: Die Domus Aurea und der Mentalitätswandel im Rom der frühen Kaiserzeit.* Trierer Winckelmannsprogramme 13. Mainz: P. von Zabern.

———. 1998. *Die Strahlen der Herrscher: Theomorphes Herrscherbild und politische Symbolik im Hellenismus und in der römischen Kaiserzeit.* Mainz: P. von Zabern.

Bernabei, M., and J. Bontadi. 2012. "Dendrochronological Analysis of the Timber Structure of the Church of the Nativity in Bethlehem." *Journal of Cultural Heritage* 13: e54–e60.

Bernhard, M.-L. 1956. "Topographie d'Alexandrie: Le tombeau d'Alexandre et le Mausolée d'Auguste." *Revue Archéologique* 47:129–56.

Berrens, S. 2004. *Sonnenkult und Kaisertum von den Severern bis zu Constantin I. (193–337 n. Chr.).* Stuttgart: F. Steiner.

Biermann, M. 1995. *Die Leichenreden des Ambrosius von Mailand: Rhetorik, Predigt, Politik.* Hermes 70. Stuttgart: F. Steiner.

Billows, R. 1993. "The Religious Procession of the Ara Pacis Augustae: Augustus' *Supplicatio* in 13 B.C.E." *Journal of Roman Archaeology* 6:80–92.

Blockley, R. 1983. *The Fragmentary Classicizing Historians of the Later Roman Empire: Eunapius, Olympiodorus, Priscus, Malchus.* ARCA Classical and Medieval Texts, Papers, and Monographs 10. Liverpool: F. Cairns.

Boatwright, M. T. 1986. "The Pomerial Extension of Augustus." *Historia* 35:13–27.

———. 1987. *Hadrian and the City of Rome.* Princeton, N.J.: Princeton University Press.

———. 2011. "Women and Gender in the Forum Romanum." *Transactions of the American Philological Association* 141 (1):105–41.

Borgeaud, P. 1996. *La mère des dieux: De Cybèle à la Vierge Marie.* Librarie du XXe Siècle. Paris: Éditions du Seuil.

Borgehammar, S. 1991. *How the Holy Cross Was Found: From Event to Medieval Legend.* Ed. L. Eckerdal and J. A. Hellström. Bibliotheca Theologiae Practicae 47. Stockholm: Almquist and Wiksell International.

Borgia, E., et al. 2008a. "*Horti Spei Veteris* e *Palatium Sessorianum:* Nuove acquisizioni da interventi urbani, 1996–2008." Part 2, 18–41 (PDF). *Journal of Fasti Online*, www .fastionline.org/docs/FOLDER-it-2008-124 (accessed March 26, 2015).

———. 2008b. "*Horti Spei Veteris* e *Palatium Sessorianum:* Nuove acquisizioni da interventi urbani, 1996–2008." Part 1, 1–17 (PDF). *Journal of Fasti Online*, www.fastionline.org/docs /FOLDER-it-2008-124 (accessed March 26, 2015).

Bosworth, B. 1999. "Augustus, the *Res Gestae*, and Hellenistic Theories of Apotheosis." *Journal of Roman Studies* 89:1–18.

Botteri, P. 2003. "L'integrazione mommseniana a 'Res gestae Divi Augusti' 34, 1 'Potitus rerum omnium' e il testo greco." *Zeitschrift für Papyrologie und Epigraphik* 144:261–67.

Bowersock, G. W. 1978. *Julian the Apostate*. Cambridge, Mass.: Harvard University Press.

Bowes, K. D. 2008. *Private Worship, Public Values, and Religious Change in Late Antiquity*. Cambridge: Cambridge University Press.

Boyancé, P. 1966. "L'Apollon solaire." In *Mélanges d'archéologie, d'épigraphie et d'histoire offerts à Jérôme Carcopino*, ed. J. Carcopino, 149–70. Paris: Hachette.

Bradbury, S. 1994. "Constantine and the Problem of Anti-Pagan Legislation in the Fourth Century." *Classical Philology* 89 (2):120–39.

Brandt, J. R. 2001. "Constantine, the Lateran, and Early Church Building Policy." In *Imperial Art as Christian Art, Christian Art as Imperial Art*, ed. J. R. Brandt and O. Steen, 109–14. Rome: Bardi.

Brandt, J. R., and O. Steen, eds. 2001. *Imperial Art as Christian Art, Christian Art as Imperial Art*. Acta ad Archaeologiam et Artium Historiam Pertinentia. Rome: Bardi.

Breckenridge, J. D. 1980–81. "Christ on the Lyre-Back Throne." *Dumbarton Oaks Papers* 34–35:247–60.

Brenk, B. 1975. *Die frühchristlichen Mosaiken in Santa Maria Maggiore zu Rom*. Wiesbaden: F. Steiner.

———. 2010. *The Apse, the Image, and the Icon: An Historical Perspective of the Apse as a Space for Images*. Spätantike, frühes Christentum, Byzanz 26. Wiesbaden: Reichert.

Bright, D. 1978. *Haec Mihi Fingebam: Tibullus in His World*. Leiden: Brill.

Brilliant, R. 1963. *Gesture and Rank in Roman Art: The Use of Gestures to Denote Status in Roman Sculpture and Coinage*. New Haven, Conn.: Yale University Press.

Broneer, O. 1935. "Excavations on the North Slope of the Acropolis in Athens, 1933–1934." *Hesperia* 4 (2):109–88.

Brouwer, H. H. J. 1989. *Bona Dea: The Sources and a Description of the Cult*. Études Préliminaires aux Religions Orientales dans l'Empire Romain 110. Leiden: Brill.

Brown, P. R. L. 1978. *The Making of Late Antiquity*. Carl Newell Jackson Lectures, 1976. Cambridge, Mass.: Harvard University Press.

———. 1989. *The World of Late Antiquity*. New York: W. W. Norton.

———. 1995. *Authority and the Sacred: Aspects of the Christianisation of the Roman World*. Cambridge: Cambridge University Press.

Brown, R. E., ed. 1978. *Mary in the New Testament*. Philadelphia: Fortress.

Brubaker, L. 1997. "Memories of Helena: Patterns of Imperial Female Matronage in the Fourth and Fifth Centuries." In *Women, Men and Eunuchs: Gender in Byzantium*, ed. L. James, 52–75. London: Routledge.

———. 2002. "The Vienna Dioskorides and Anicia Juliana." In *Byzantine Garden Culture*, ed. H. M. Anthony Littlewood and Joachim Wolschke-Bulmahn, 189–214. Washington, D.C.: Dumbarton Oaks Research Library and Collection.

Brubaker, L., and H. Tobler. 2000. "The Gender of Money: Byzantine Empress of Coins (324–802)." *Gender and History* 12 (3):527–94.

Bruneau, P. 1970. *Recherches sur les cultes de Délos à l'époque hellénistique et à l'époque impériale*. Bibliothèque des Écoles Françaises d'Athènes et de Rome 217. Paris: Boccard.

Buchner, E. 1982. *Die Sonnenuhr des Augustus: Nachdruck aus RM 1976 und 1980 und Nachtrag über die Ausgrabung 1980/1981*. Mainz: P. von Zabern.

Bühl, G. 1995. *Constantinopolis und Roma: Stadtpersonifikationen der Spätantike*. Akanthus Crescens 3. Zurich: Akanthus.

Burckhardt, J. 1853. *Die Zeit Constantin's des Grossen*. Basel: Druck und Verlag der Schweighauser'schen Verlagsbuchhandlung.

Burgess, R. 2002. "Jerome Explained: An Introduction to His *Chronicle* and a Guide to Its Use." *Ancient History Bulletin* 16 (1–2):1–32.

Burgess, R. W., and W. Witakowski. 1999. *Studies in Eusebian and Post-Eusebian Chronography*. Stuttgart: F. Steiner.

Burkert, W. 1962. "Caesar und Romulus-Quirinus." *Historia* 11:356–76.

Burnett, A. M., M. Amandry, and P. Pau Ripollès, eds. 1998. *Roman Provincial Coinage*. London and Paris: British Museum and Bibliothèque Nationale, 1998. Also online at Roma Provincial Coinage, http://rpc.ashmus.ox.ac.uk/ (accessed March 26, 2015).

Burrow, J. A. 2008. *A History of Histories: Epics, Chronicles, Romances, and Inquiries from Herodotus and Thucydides to the Twentieth Century*. 1st. U.S. ed. New York: Alfred A. Knopf.

Burstein, S. 1982. "Arsinoe II Philadelphos: A Revisionist View." In *Philip II, Alexander the Great and the Macedonian Heritage*, ed. W. L. Adams and E. N. Borza, 197–212. Lanham, Md.: University Press of America.

Bury, J. R. 1919. "Justa Grata Honoria." *Journal of Roman Studies* 9:1–13.

Calame, C. 1990. "Narrating the Foundation of a City: the Symbolic Birth of Cyrene." In *Approaches to Greek Myth*, 277–341. Baltimore: Johns Hopkins University Press.

Calcani, G. 2009. *Skopas di Paros*. Maestri dell'Arte Classica 2. Rome: G. Bretschneider.

Callu, J.-P. 2000. "Pia Felix." *Revue Numismatique* 155:189–207.

Cameron, A. 1976. *In laudem Iustini Augusti minoris, libri IV*. Trans. A. Cameron. London: Athlone.

———. 1978. "The Theotokos in Sixth-Century Constantinople." *Journal of Theological Studies* 29 (1):79–108.

———. 1980a. "The Artistic Patronage of Justin II." In *Continuity and Change in Sixth-Century Byzantium*, ed. A. Cameron. London: Variorum Reprints. Originally published in *Byzantion* 50 (1980).

———. 1980b. "The Empress Sophia." In *Continuity and Change in Sixth-Century Byzantium*, ed. A. Cameron. London: Variorum Reprints. Originally published in *Byzantion* 45 (1975).

———. 1980c. "Notes on the Sophiae, the Sophianae, and the Harbour of Sophia." In *Continuity and Change in Sixth-Century Byzantium*, ed. A. Cameron. London: Variorum Reprints. Originally published in *Byzantion* 37 (1968).

———. 1983. "Eusebius of Caesarea and the Rethinking of History." In *Tria Corda: Scritti in onore di Arnaldo Momigliano,* ed. E. Gabba, 71–88. Biblioteca di Athenaeum 1. Como: Edizioni New Press.

———. 1985. *Procopius and the Sixth Century.* Berkeley: University of California Press.

———. 1997. "Eusebius' *Vita Constantini* and the Construction of Constantine." In *Portraits; Biographical Representation in the Greek and Roman Literature of the Roman Empire,* ed. M. J. Edwards and S. Swain, 145–74. Oxford: Clarendon Press.

———. 2000. "Form and Meaning: The 'Vita Constantini.'" In *Greek Biography and Panegyric in Late Antiquity,* ed. T. Hägg, P. Rousseau, and C. Høgel, 72–88. Transformation of the Classical Herritage 31. Berkeley: University of California Press.

———. 2004. "The Cult of the Virgin in Late Antiquity: Religious Development and Myth-Making." In *The Church and Mary,* ed. R. N. Swanson, 1–21. Studies in Church History 39. Woodbridge, Suffolk, England: Boydell Press.

Cameron, A., and S. G. Hall, trans. and commentary. 1999. *Eusebius: Life of Constantine.* Oxford: Oxford University Press.

Cameron, A., and J. Herrin. 1984. *Constantinople in the Early Eighth Century: The "Parastaseis Syntomoi Chronikai"; Introduction, Translation, and Commentary.* Leiden: Brill.

Cameron, Al. 1976. *Circus Factions: Blues and Greens at Rome and Byzantium.* 1st ed. Oxford: Clarendon Press.

Cancik, H., and H. Schneider, eds. 1996–2003. *Der Neue Pauly: Enzyklopädie der Antike.* Stuttgart: J. B. Metzler.

Capizzi, C. 1968. "Anicia Juliana (462 ca.–530 ca.): Ricerche sulla sua famiglia e la sua vita." *Rivista di Studi Bizantini e Neoellenici,* n.s., 5 (15):191–226.

Carney, E. 2001. *Women and Monarchy in Macedonia.* Norman: University of Oklahoma Press.

Carr, A. W. 2001. "Threads of Authority: The Virgin Mary's Veil in the Middle Ages." In *Robes and Honor: The Medieval World of Investiture,* ed. S. Gordon, 59–93. New Middle Ages. New York: Palgrave.

Carriker, A. 2003. *The Library of Eusebius of Caesarea,* Supplements to Vigiliae Christianae 67. Leiden: Brill.

Carter, J. B. 1902. *Epitheta deorum quae apud poetas latinos leguntur.* Leipzig: Teubner.

Cascella, S. 2013. "Matidia Minor and Suessa Aurunca." In *Hadrian: Art, Politics, and Economy,* ed. T. Opper, 73–88. British Museum Research Publication 175. London: British Museum Research Publication.

Lo Cascio, E. 1994. "The Size of the Roman Population: Beloch and the Meaning of the Augustan Census Figures." *Journal of Roman Studies.* 84:23–40.

Caseau, B. 1999. "Sacred Landscapes." In *Late Antiquity: A Guide to the Postclassical World,* ed. P. Brown and G. W. Bowersock, 21–59. Cambridge, Mass.: Harvard University Press.

Castriota, D. 1995. *The Ara Pacis Augustae and the Imagery of Abundance in Later Greek and Early Roman Imperial Art.* Princeton, N.J.: Princeton University Press.

A Catalogue of the Greek Coins in the British Museum. Ed. G. F. Hill. Bologna: A. Forni, 1965.

Cesaretti, P. 2004. *Theodora: Empress of Byzantium.* Trans. R. M. Giammanco. New York: Mark Magowan Book and Vendome Press.

Champeaux, J. 1987. *Fortuna: Recherches sur le culte de la Fortune à Rome et dans le monde romain des origines à la mort de Caesar.* 2 vols. Collection de l'École Française de Rome 64. Paris: École Française de Rome.

Champlin, E. 1989. "The Testament of Augustus." *Rheinisches Museum für Philologie* 132 (2):154–65.

Claridge, A. 1998. *Rome: An Oxford Archaeological Guide.* Oxford: Oxford University Press.

Clark, E. A. 1990. "Patrons, Not Priests: Gender and Power in Late Ancient Christianity." *Gender and History* 2 (3):253–73.

Coarelli. F. 1977. "Il Campo Marzio occidentale: Storia e topografia. *Mélanges de l'École Française de Rome* 89:807–46.

Coarelli, F., and Y. Thébert. 1988. "Architecture funéraire et pouvoir: Reflexions sur l'Hellénisme numide." *Mélanges de l'École Française de Rome* 100 (2):761–818.

Coarelli, F., et al. 2000. *The Column of Trajan.* Rome: German Archaeological Institute.

Cole, S. 2006. "Cicero, Ennius, and the Concept of Apotheosis at Rome." *Arethusa* 39 (3):531–48.

Colini, A. M. 1955. "Horti Spei Veteris: Palatium Sessorianum." *Memorie della Pontificia Accademia* 7:137–77.

Colli, D. 1996. "Il palazzo Sessoriano nell'area archeologica di S. Croce in Gerusalemme: Ultima sede imperiale a Roma?" *Mélanges de l'École Française de Rome* 108 (2):771–815.

Connor, C. L. 1999. "The Epigram in the Church of Hagios Polyeuktos in Constantinople and Its Byzantine Response." *Byzantion* 69:479–527.

———. 2004. *Women of Byzantium.* New Haven, Conn.: Yale University Press.

Consolino, F. E. 1985. "Il significato dell'*inventio crucis* nel De obitu Theodosii." *Annali della Facoltà di Lettere e Filosofia* 5:161–80.

Constans, N. 1995. "Weaving the Body of God: Proclus of Constantinople, the Theotokos, and the Loom of the Flesh." *Journal of Early Christian Studies* 3 (2):169–94.

———. 2003. *Proclus of Constantinople and the Cult of the Virgin in Late Antiquity,* ed. J. den Boeft. Supplements to Vigiliae Christianae 66. Leiden: Brill.

Conti, R. 1983. *Il Tesoro: Guida alla conoscenza del Tesoro del Duomo di Monza.* Monza: Museo del Duomo di Monza.

Cooper, K. 1998. "Constesting Nativity: Wives, Virgins and Pulcheria's *Imitatio Mariae.*" *Scottish Journal of Religious Studies* 19 (1):31–43.

Cormack, R. 2000. "The Mother of God in Apse Mosaics." In *Mother of God: Representations of the Virgin in Byzantine Art,* ed. M. Vassilaki, 91–105. Milan: Skira.

Cornell, T. 1995. *The Beginnings of Rome: Italy and Rome from the Bronze Age to the Punic Wars (c. 1000–264 B.C.).* Routledge History of the Ancient World. London: Routledge.

Cox, P. 1983. *Biography in Late Antiquity: A Quest for the Holy Man.* Berkeley: University of California Press.

Crawford, M. 1974. *Roman Republican Coinage.* London: Cambridge University Press.

Crawford, M., and J. Reynolds. 1975. "The Publication of the Prices Edict: A New Inscription from Aezani." *Journal of Roman Studies* 65:160–63.

———. 1977. "The Aezani Copy of the Prices Edict." *Zeitschrift für Papyrologie und Epigraphik* 26:125–51.

Croke, B. 2006. "Justinian, Theodora, and the Church of Saints Sergius and Bacchus." *Dumbarton Oaks Papers* 60:25–63.

———. 2010. "Reinventing Constantinople: Theodosius I's Imprint on the Imperial City." In *The Tetrarchs to the Theodosians: Later Roman History and Culture, 284–450 C.E.*, ed. S. McGill, C. Sogno, and E. Watts, 241–64. Cambridge: Cambridge University Press.

Cross, F. L., and E. A. Livingstone, eds. 1997. *The Oxford Dictionary of the Christian Church.* Oxford: Oxford University Press.

Crow, J, J. Bardill, and R. Bayliss. 2008. *The Water Supply of Byzantine Constantinople.* London: Society for the Promotion of Roman Studies.

Ćurčić, S. 1993. "Late Antique Palaces: The Meaning of Urban Context." *Ars Orientalis* 23:67–90.

———. 2010. *Architecture in the Balkans from Diocletian to Süleyman the Magnificent.* New Haven, Conn.: Yale University Press.

Cutler, A. 1975. *Transfigurations: Studies in the Dynamics of Byzantine Iconography.* University Park: Pennsylvania State University Press.

Dagron, G., ed. 1974. *Naissance d'une capitale: Constantinople et ses institutions de 330 à 451.* Preface by P. Lemerle. 1st ed. Bibliothèque Byzantine 7. Paris: Presses Universitaires de France.

———. 2003. *Emperor and Priest: The Imperial Office in Byzantium.* Cambridge: Cambridge University Press.

———. 2011. *L'hippodrome de Constantinople: Jeux, peuple et politique*, Bibliothèque des Histoires. Paris: Gallimard.

Dark, K., and F. Özgümüş. 2002. "New Evidence for the Byzantine Church of the Holy Apostles from Fatih Camii, Istanbul." *Oxford Journal of Archaeology* 21 (4):393–413.

Davies, P. J. E. 2000. *Death and the Emperor: Roman Imperial Funerary Monuments, from Augustus to Marcus Aurelius.* Cambridge: Cambridge University Press.

Deichmann, F. W., F. Bartl, and J. Boehringer. 1995. *Frühchristliche Bauten und Mosaiken von Ravenna.* 2nd ed. Ravenna, Hauptstadt des spätantiken Abendlandes. Wiesbaden: F. Steiner.

Delbrueck, R. 1933. *Spätantike Kaiserporträts von Konstantinus Magnus bis zum Ende des Westreichs.* Berlin: W. de Gruyter.

Delia, D. 1991. "Fulvia Reconsidered." In *Women's History and Ancient History*, ed. S. B. Pomeroy, 197–217. Chapel Hill: University of North Carolina Press.

Deliyannis, D. M. 2010. *Ravenna in Late Antiquity.* Cambridge: Cambridge University Press.

Dewing, A. 1985. *The Arthur S. Dewing Collection of Greek Coins.* Ed. L. Mildenberg and S. Hurter. New York: American Numismatic Society.

Di Segni, L. 1997. "The Greek Inscriptions of Hammat Gader." In *The Roman Baths of Hammat Gader*, ed. Y. Hirschfeld, 185–266. Jerusalem: Israel Exploration Society.

Digeser, E. D. 2004. "An Oracle of Apollo at Daphne and the Great Persecution." *Classical Philology* 99 (1):57–77.

Dillon, J. N. 2012. *The Justice of Constantine.* Ann Arbor: University of Michigan Press.

Dixon, S. 1983. "A Family Business: Women's Role in Patronage and Politics at Rome 80–44 B.C.E." *Classica et Mediaevalia* 34:91–112.

Downey, G. 1959. "Libanius' Oration in Praise of Antioch (Oration XI)." *Proceedings of the American Philosophical Society* 103 (5):652–86.

Drake, H. A. 1976. *In Praise of Constantine: A Historical Study and New Translation of Eusebius' Trincennial Orations*. Classical Studies 15. Berkeley: University of California Press.

———. 1985a. "Eusebius on the Cross." *Journal of Ecclesiastical History* 36:1–22.

———. 1985b. "Suggestions of Date in Constantine's Oration to the Saints." *American Journal of Philology* 106 (3):335–49.

———. 1989. "Policy and Belief in Constantine's 'Oration to the Saints.'" *Studia Patristica* 21–22:43–51.

———. 2000. *Constantine and the Bishops: The Politics of Intolerance*. Ancient Society and History. Baltimore: Johns Hopkins University Press.

———. 2006. "The Impact of Constantine on Christianity." In *The Cambridge Companion to the Age of Constantine*, ed. N. Lenski, 111–36. Cambridge: Cambridge University Press.

Drijvers, H. J. W. 2004. "Eusebius' *Vita Constantini* als Vorstenspiegel *Lampas*." *Tijdschhrift voor Nederlandse Classici* 37 (3):161–64.

Drijvers, J. W. 1992. *Helena Augusta: The Mother of Constantine the Great and the Legend of Her Finding of the True Cross*. Brill's Studies in Intellectual History 27. Leiden: Brill.

Du Bourguet, P. 1966. *Early Christian Painting*. Compass Books. New York: Viking Press.

Dunbabin, K. M. D. 1989. "Baiarum Grata Voluptas: Pleasures and Dangers of the Baths." *Papers of the British School at Rome* 57:6–46.

———. 2001. *Mosaics of the Greek and Roman World*. Cambridge: Cambridge University Press.

Duval, N. 1987. "Existe-t-il une structure palatiale propre à l'Antiquité tardive?" In *Le système palatial en Orient, en Grèce et à Rome: Actes du colloque de Strasbourg, 19–22 juin 1985*, ed. L. Edmond, 463–90. Leiden: Brill.

Dvornik, F. 1966. *Early Christian and Byzantine Political Philosophy: Origins and Background*. Dumbarton Oaks Studies 9. Washington, D.C.: Dumbarton Oaks Center for Byzantine Studies.

Eder, W. 1990. "Augustus and the Power of Tradition: The Augustan Principate as the Binding Link between Republic and Empire." In *Between Republic and Empire: Interpretations of Augustus and His Principate*, ed. K. A. Raaflaub and M. Toher, 71–122. Berkeley: University of California Press.

Edwards, J. S. 2005. "The Carmina of Publius Optatianus Porphyrius and the Creative Process." In *Studies in Latin Literature and Roman History*, ed. C. Deroux, 12:447–66. Brussels: Collection Latomus.

Edwards, M. J. 1995. "The Arian Heresy and the Oration to the Saints." *Vigiliae Christianae* 49 (4):379–87.

Elliott, J. K. 1993. *The Apocryphal New Testament*. Oxford: Clarendon Press.

———. 2008. "Mary in the Apocryphal New Testament." In *Origins of the Cult of the Virgin Mary*, ed. C. Maunder, 57–70. New York: Burns and Oates.

Elliott, T. G. 1991. "Eusebian Frauds in the 'Vita Constantini.'" *Phoenix* 45 (2):162–71.

Elm, S. 2012. *Sons of Hellenism, Fathers of the Church: Emperor Julian, Gregory of Nazianzus, and the Vision of Rome*. Transformation of the Classical Heritage 49. Berkeley: University of California Press.

Elsner, J. 1995. *Art and the Roman Viewer: The Transformation of Art from the Pagan World to Christianity*. Cambridge: Cambridge University Press.

———. 1998. *Imperial Rome and Christian Triumph: The Art of the Roman Empire*, A.D. 100–450. Oxford: Oxford University Press.

———. 2000. "From the Culture of Spolia to the Cult of Relics: The Arch of Constantine and the Genesis of Late Antique Forms." *Papers of the British School at Rome* 68:149–84.

———. 2007. "The Rhetoric of Buildings in the *De Aedificiis* of Procopius." In *Art and Text in Byzantine Culture*, ed. L. James, 33–57. Cambridge: Cambridge University Press.

Ehrman, B., and A. Jacobs. 2004. *Christianity in Late Antiquity, 300–450 C.E.: A Reader*. New York: Oxford University Press.

Erim, K. T., and J. Reynolds. 1973. "The Aphrodisias Copy of Diocletian's Edict on Maximum Prices." *Journal of Roman Studies* 63:99–110.

Erskine, A. 2002. "Life after Death: Alexandria and the Body of Alexander." *Greece and Rome* 49 (2):163–79.

Fagan, G. G. 1999. *Bathing in Public in the Roman World*. Ann Arbor: University of Michigan Press.

Farnell, L. R. 1896. *The Cults of the Greek States*. 5 vols. Oxford: Clarendon Press.

Fears, J. R. 1977. *Princeps a diis electus: The Divine Election of the Emperor as a Political Concept at Rome*. Rome: American Academy.

———. 1981a. "The Cult of Virtues and Roman Imperial Ideology." *Aufstieg und Niedergang der Römischen Welt* 2.17 (2):827–948.

———. 1981b. "The Theology of Victory at Rome: Approaches and Problems." *Aufstieg und Niedergang der Römischen Welt* 2.17 (2):736–826.

Feissel, D. 2000. "Les édifices de Justinien au témoignage de Procope et de l'épigraphie." *Antiquité Tardive* 8:81–104.

Ferrari Pinney, G. 2002. *Figures of Speech: Men and Maidens in Ancient Greece*. Chicago: University of Chicago Press.

Fishwick, D. 1987. *The Imperial Cult in the Latin West: Studies in the Ruler Cult of the Western Provinces of the Roman Empire*. 4 vols. Études Préliminaires aux Religions Orientales dans l'Empire Romain 145–48. Leiden: Brill.

Fittschen, K., and P. Zanker. 1985. *Katalog der römischen Porträts in den Capitolinischen Museen und den anderen kommunalen Sammlungen der Stadt Rom; Kaiser- und Prinzenbildnisse*. 2 vols. Mainz: von Zabern.

Flory, M. B. 1984. "'Sic exempla parantur': Livia's Shrine to Concordia and the Porticus Liviae." *Historia* 33:309–30.

———. 1988. "*Abducta Neroni Uxor:* The Historiographical Tradition on the Marriage of Octavian and Livia." *Transactions of the American Philological Association* 118:343–59.

———. 1993. "Livia and the History of Public Honorific Statues for Women in Rome." *Transactions of the American Philological Association* 123:287–308.

———. 1995. "The Symbolism of Laurel in Cameo Portraits of Livia." *Memoirs of the American Academy in Rome* 40:43–68.

Fontenrose, J. E. 1939. "Apollo and Sol in the Latin Poets of the First Century B.C." *Transactions of the American Philological Association* 70:439–55.

———. 1978. *The Delphic Oracle: Its Responses and Operations, with a Catalogue of Responses*. Berkeley: University of California Press.

Foucault, M. 1972. *The Archaeology of Knowledge and the Discourse of Language*, trans. A. M. S. Smith. New York: Pantheon.

Fowden, G. 1991. "Constantine's Porphyry Column: The Earliest Literary Allusion." *Journal of Roman Studies* 81:119–31.

———. 1994. "Constantine, Sylvester, and the Church of St. Polyeuktos in Constantinople." *Journal of Roman Archaeology* 7:274–84.

Fowler, D. 1997. "The Virgil Commentary of Servius." In *The Cambridge Companion to Virgil*, ed. C. Martindale, 73–78. Cambridge: Cambridge University Press.

Fowler, W. W. 1899. *The Roman Festivals of the Period of the Republic: An Introduction to the Study of the Religion of the Romans*. London: Macmillan.

Frakes, J. 2002. "Framing Public Life: The Portico in Roman Gaul." Ph.D. diss., Columbia University.

Frank, T. 1938. "Augustus, Vergil, and the Augustan Elogia." *American Journal of Philology* 59 (1):91–94.

Fränkel, Max. 1895. *Altertümer von Pergamon: Die Inschriften von Pergamon*. Berlin: W. Spemann.

Fraschetti, A. 2001. [1994, in Italian.] "Introduction" to *Roman Women (Roma al femminile)*, ed. A. Fraschetti. Trans. L. Lappin. Chicago: University of Chicago Press.

———. 2005. *The Foundation of Rome*. Trans. M. J. Hill and K. Windle. Edinburgh: Edinburgh University Press.

Fraser, P. M. 1972. *Ptolemaic Alexandria*. 3 vols. Oxford: Clarendon Press.

———. 1977. *Rhodian Funerary Monuments*. Oxford: Clarendon Press.

Frazer, J. G. S. 1973. *Fastorum libri sex: Commentary with Translation of Ovid's "Fasti."* Hildesheim: G. Olms.

Freely, J., and A. Çakmak. 2004. *Byzantine Monuments of Istanbul*. Cambridge: Cambridge University Press.

Frisch, P. 1980. "Zu den Elogien des Augustusforums." *Zeitschrift für Papyrologie und Epigraphik* 39:91–98.

Gabba, E. 1984. "The Collegia of Numa: Problems of Method and Political Ideas." *Journal of Roman Studies* 74:81–86.

Gabriel, M. M. 1955. *Livia's Garden Room at Prima Porta*. New York: New York University Press.

Gagé, J. 1933. "La théologie de la victoire impériale." *Revue Historique* 171:1–43.

———. 1955. *Apollon romain: Essai sur le culte d'Apollon et le développement du "ritus Graecus" à Rome des origines à Auguste*. Paris: de Boccard.

———. 1981. "Apollon impérial: Garant des 'Fata Romana.'" *Aufstieg und Niedergang der Römischen Welt* 2.17 (2):561–630.

Galinsky, K. 1967. "Sol and the Carmen Saeculare." *Latomus* 26:619–33.

———. 1969. *Aeneas, Sicily, and Rome*. Princeton Monographs in Art and Archaeology 40. Princeton, N.J.: Princeton University Press.

———. 1992. "Venus, Polysemy, and the Ara Pacis Augustae." *American Journal of Archaeology* 96:457–75.

———. 1994. "Culture and National Identity in Republican Rome by Erich S. Gruen." *American Journal of Archaeology* 98 (1):175–76.

———. 1996. *Augustan Culture: An Interpretive Introduction*. Princeton, N.J.: Princeton University Press.

Galletier, E. 1949. *Panégyriques latin*. 3 vols. Collection des Universités de France. Paris: Belles Lettres.

Galsterer-Kröll, B. 1972. "Untersuchungen zu den Beinamen der Städte des Imperium Romanum." *Epigraphische Studien* 9:44–145.

Gambero, L. 1999. *Mary and the Fathers of the Church.* 1st English ed. Trans. T. Buffer. San Francisco: Ignatius.

Gamillscheg, E. 2007. "Das Geschenk für Juliana Anicia." In *Byzantina Mediterranea: Festschrift für Johannes Koder zum 65. Geburtstag,* ed. K. Belke, 187–95. Vienna: Böhlau.

Gardner, J. F. 1986. *Women in Roman Law and Society.* London: Croom Helm.

———. 1998. *Family and Familia in Roman Law and Life.* Oxford: Clarendon Press.

Garland, L. 1999. *Byzantine Empresses: Women and Power in Byzantium, A.D. 527–1204.* London: Routledge.

Garlans, A. 1992. "Cicero's Familia Urbana." *Greece and Rome* 39 (2):163–72.

Gatti, G. 1934. "Il Mausoleo di Augusto: Studio di riconstruzione." *Capitolium* 10:457–64.

Georg-Lobe, H. 1970. "Lare Aineia?" *Mitteilungen des Deutschen Archäologischen Instituts* 77:1–9.

George, J. W. 1995. *Venantius Fortunatus: Personal and Political Poems.* Liverpool: Liverpool University Press.

Gerstinger, H. 1965–70. *Dioscurides: Codex Vindobonensis Med. Gr. 1 der Österreichische Nationalbibliothek.* 2 vols. Graz.

Giard, J.-B., and S. Estiot. 1976. *Bibliothèque nationale: Catalogue des monnaies de l'Empire romain.* Paris: La Bibliothèque.

Glare, P. G. W, ed. 2002. *Oxford Latin Dictionary.* Combined ed. Oxford: Clarendon Press.

Gnecchi, F. 1912. *I medaglioni romani.* 3 vols. Milan: V. Hoepli, 1912.

———. 1968. *I medaglioni romani.* Bologna: Forni.

Gordon, R. 1990. "The Veil of Power: Emperors, Sacrifices, and Benefactors." In *Pagan Priests: Religion and Power in the Ancient World,* ed. M. Beard and J. North, 201–31. Ithaca, N.Y.: Cornell University Press.

Gorrie, C. 2004. "Julia Domna's Building Patronage: Imperial Family Roles and the Severan Revival of Moral Legislation." *Historia* 53 (1):61–72.

Gottwald, J. "La statue de l'impératrice Eudoxie a Constantinople." *Échos d'Orient* 10 (1907):274–76.

Grabar, A. 1936. *L'empereur dans l'art byzantin.* Variorum Reprint B3. London: Variorum Reprints.

———. 1946. *Martyrium: Recherches sur le culte des reliques et l'art chrétien antique.* 2 vols. Paris: Collège de France.

Gradel, I. 2002. *Emperor Worship and Roman Religion,* Oxford Classical Monographs. Oxford: Clarendon Press.

Grandazzi, A. 1997. *The Foundation of Rome: Myth and History.* Ithaca, N.Y.: Cornell University Press.

Grant, M. 1994. *Constantine the Great: The Man and His Times.* New York: Scribner's.

Grégoire, H. 1930-1931. "La 'conversion' de Constantin." *Revue de l'Université de Bruxelles* 36:231-72.

Grether, G. 1946. "Livia and the Roman Imperial Cult." *American Journal of Philology* 47 (3):222–52.

Grierson, P. 1962. "The Tombs and Obits of the Byzantine Emperors (337–1042)." *Dumbarton Oaks Papers* 16:3–63.

———. 1988. "An Enigmatic Coin Legend: IMP XXXXII on Solidi of Theodosius II." *Situla* 26:279–84.

Grierson, P., and M. Mays. 1992. *Catalogue of Late Roman Coins in the Dumbarton Oaks Collection and in the Whittemore Collection: From Arcadius and Honorius to the Accession of Anastasius.* Dumbarton Oaks Catalogs. Washington, D.C.: Dumbarton Oaks Research Library and Collection.

Gross, W. H. 1962. *Iulia Augusta.* Göttingen: Vanderhoeck und Ruprecht.

Gruen, E. 1992. *Culture and National Identity in Republican Rome.* Cornell Studies in Classical Philology 52. Ithaca, N.Y.: Cornell University Press.

———. 1996. [1990.] *Studies in Greek Culture and Roman Policy.* Berkeley: University of California Press.

———. 2005. "Augustus and the Making of the Principate." In *The Cambridge Companion to the Age of Augustus,* ed. K. Galinsky, 33–52. Cambridge: Cambridge University Press.

Gruppe, O. 1906. *Griechische Mythologie und Religionsgeschichte.* Handbuch der klassischen Altertums-Wissenschaft 5.2. Munich: Beck.

Guarducci, M. 1956–58. "Cippo latino arcaico con dedica ad Enea." *Bullettino del Museo della Civiltà Romana* 19:3–13.

Gurval, R. A. 1996. *Actium and Augustus: The Politics and Emotions of Civil War.* Ann Arbor: University of Michigan Press.

Gutzwiller, K. J., ed. 2005. *The New Posidippus: A Hellenistic Poetry Book.* New York: Oxford University Press.

Guzzo, P. G., D. Motto, and L. Fergola. 2000. *Oplontis: La villa di Poppea.* 1st ed. Milan: F. Motta.

Habicht, C. 1970. [1956.] *Gottmenschentum und griechische Städte.* 2nd ed. Ed. E. Burck and H. Diller. Zetemata: Monographien zur klassischen Altertumwissenschaft. Munich: C. H. Beck'sche.

———. 1975. "New Evidence from the Province of Asia." *Journal of Roman Studies* 65:64–91.

Hahn, U. 1994. *Die Frauen des römischen Kaiserhauses und ihre Ehrungen im griechischen Osten anhand epigraphischer und numismatischer Zeugnisse von Livia bis Sabina.* Ed. A. Furtwängler, F. Hiller, and P. R. Franke. Saarbrücker Studien zur Archäologie und alten Geschichte 8. Saarbrücken: Saarbrücker Druckerei und Verlag.

Halkin, F. 1931. "Review of Marc le Diacre, Vie de Porphyre, évêque de Gaza: Texte établi, traduit et commenté, by Henri Grégoire and M.-A. Kugener (Paris: Les Belles Lettres, 1930)." *Analecta Bollandiana* 49:155–60.

Hall, L. J. 1998. "Cicero's *Instinctu Divino* and Constantine's *Instinctu Divinitatis:* The Evidence of the Arch of Constantine for the Senatorial View of the 'Vision' of Constantine." *Journal of Early Christian Studies* 6 (4):647–71.

Hallett, C. 2005. *The Roman Nude: Heroic Portrait Statuary, 200 B.C.–A.D. 300.* Oxford Studies in Ancient Culture and Representation. Oxford: Oxford University Press.

Hammond, N. G. L. 1988. "The King and the Land in the Macedonian Kingdom." *Classical Quarterly* 38 (2):382–91.

Hannestad, N. 2001. "The Ruler Image of the Fourth Century." In *Imperial Art as Christian Art: Christian Art and Imperial Art,* ed. J. R. Brandt and O. Steen, 93–107. Rome: Bardi.

Hansen, G. C. 2004. *Historia ecclesiastica = Kirchengeschichte*. Vol. 73.1–4. Fontes Christiani. Turnhout, Belgium: Brepols.

Hansen, G. C., and M. Širinjan, eds. 1995. *Sokrates, Kirchengeschichte*. Berlin: Akademie Verlag.

Hanson, R. P. C. 1973. "The 'Oratio ad sanctos' Attributed to the Emperor Constantine and the Oracle at Daphne." *Journal of Theological Studies* 24 (2):505–11.

Harl, K. W. 1987. *Civic Coins and Civic Politics in the Roman East, A.D. 180–275*. Berkeley: University of California Press.

Harries, J. 1994. "Pius Princeps: Theodosius II and Fifth-Century Constantinople." In *New Constantines: The Rhythm of Imperial Renewal in Byzantium, 4th–13th Centuries*, ed. P. Magdalino, 35–44. Aldershot, England: Ashgate.

———. 2012. *Imperial Rome, A.D. 284–363: The New Empire*. Edinburgh History of Ancient Rome. Edinburgh: Edinburgh University Press.

Harrison, R. M. 1986. *Excavations at the Saraçhane in Istanbul*. 2 vols. Princeton and Washington D.C.: Princeton University Press and Dumbarton Oaks.

———. 1989. *A Temple for Byzantium: The Discovery and Excavation of Anicia Juliana's Palace-Church in Istanbul*. 1st ed. Austin: University of Texas Press.

Harrison, R. M., and N. Firatli. 1966. "Excavations at the Saraçhane in Istanbul: Second and Third Preliminary Reports." *Dumbarton Oaks Papers* 20:223–48.

Hartley, E., ed. 2006. *Constantine the Great: York's Roman Emperor*. Marygate, England: York Museums and Gallery Trust and Aldershot, Hampshire.

Hazzard, R. A. 1992. "Did Ptolemy I Get His Surname from the Rhodians?" *Zeitschrift für Papyrologie und Epigraphik* 93:52–56.

Heather, P. 1994. "New Men for New Constantines." In *New Constantines: The Rhythm of Imperial Renewal in Byzantium, 4th–13th Centuries*, ed. P. Magdalino, 11–33. Aldershot, England: Ashgate.

van Heck, A. 2002. *Breviarium urbis Romae antiquae*. Leiden: Brill.

Heckster, O., and J. Rich. 2006. "Octavian and the Thunderbolt: The Temple of Apollo Palatinus and Roman Traditions of Temple Building." *Classical Quarterly* 56:149–68.

Heid, S. 1989. "Der Ursprung der Helena-Legende im Pilgerbetrieb Jerusalems." *Jahrbuch für Antike und Christentum* 32:41–71.

Hellegouarc'h, J. 1963. *Le vocabulaire latin des relations et des partis politiques sous la République*. Publications de la Faculté des Lettres det Sciences Humaines de l'Université de Lille 11. Paris: Les Belles Lettres.

Hemelrijk, E. A. 2004. "City Patronesses in the Roman Empire." *Historia* 53 (2):209–45.

Henzen, W., et al. 1876. *Inscriptiones urbis Romae latinae*. Berlin: G. Reimerum.

Herbert-Brown, G. 1994. *Ovid and the Fasti: An Historical Study*. Oxford Classical Monographs. Oxford and New York: Clarendon Press and Oxford University Press.

Herrin, J. 2000. "The Imperial Feminine in Byzantium." *Past and Present* 169:3–35.

———. 2001. *Women in Purple: Rulers of Medieval Byzantium*. London: Weidenfeld and Nicolson.

von Hesberg, H., and S. Panciera. 1994. *Das Mausoleum des Augustus: der Bau und seine Inschriften*. Vol. 108, Abhandlungen Bayerischen Akademie der Wissenschaften, Philosophisch-Historische Klasse. Munich: Verlag der Bayerischen Akademie der Wissenschaften.

Hill, B. 1999. *Imperial Women in Byzantium, 1025–1204: Power, Patronage, and Ideology*. Women and Men in History. New York: Longman.

Hill, G. F. 1913. *The Life of Porphyry*, Bishop of Gaza. Oxford: Clarendon Press.

Hillard, T. 1989. "Republican Politics, Women, and the Evidence." *Helios* 16 (2):165–82.

Hirschfeld, Y. 1990. "A Church and Water Reservoir Built by the Empress Eudocia." *Liber Annuus* 40:287–94.

———. 1997. "Description of the Architectural Remains." In *The Roman Baths of Hammat Gader,* ed. Y. Hirschfeld, 54–162. Jerusalem: Israel Exploration Society.

———. 2004. "The Monasteries of Gaza: An Archaeological Review." In *Christian Gaza in Late Antiquity,* ed. B. Bitton-Ashkelony and A. Kofsky, 61–88. Jerusalem Studies in Religion and Culture. Leiden: Brill.

Hofter, M. R. 1988. *Kaiser Augustus und die verlorene Republik: eine Ausstellung im Martin-Gropius-Bau, Berlin, 7. Juni–14. August 1988.* Mainz: P. von Zabern.

Højte, J. M. 2005. *Roman Imperial Statue Bases: From Augustus to Commodus.* Aarhus Studies in Mediterranean Antiquity 7. Aarhus: Aarhus University Press.

Hölbl, G. 2001. *A History of the Ptolemaic Empire.* London: Routledge.

Holloway, R. R. 1966. "The Tomb of Augustus and the Princes of Troy." *American Journal of Archaeology* 70 (2):171–73.

———. 2004. *Constantine and Rome.* New Haven, Conn.: Yale University Press.

Hölscher, T. 1967. *Victoria Romana: Archäologische Untersuchungen zur Geschichte und Wesensart der römischen Siegesgöttin von den Anfängen bis zum Ende des 3. Jhs. n. Chr.* Mainz: P. von Zabern.

Holum, K. G. 1982. *Theodosian Empresses: Women and Imperial Dominion in Late Antiquity.* Berkeley: University of California Press.

———. 2003. "Empresses and Power in Early Byzantium by Liz James." *Speculum* 78 (4):1324–26.

Hornblower, S. 1982. *Mausolus.* Oxford: Clarendon Press.

Hornblower, S., and A. Spawforth, eds. 1996. *The Oxford Classical Dictionary.* Oxford: Oxford University Press.

Humphries, M. 2008. "From Usurper to Emperor: The Politics of Legitimation in the Age of Constantine." *Journal of Late Antiquity* 1 (1):82–100.

Hunt, E. D. 1982. *Holy Land Pilgrimage in the Later Roman Empire, A.D. 312–460.* Oxford: Clarendon Press.

———. 1997. "Constantine and Jerusalem." *Journal of Ecclesiastical History* 48:405–24.

———. 2003. "Imperial Building at Rome: The Role of Constantine." In *"Bread and Circuses": Euergetism and Municipal Patronage in Roman Italy,* ed. K. Lomas and T. Cornell, 105–24. London: Routledge.

Ihm, C. 1960. *Die Programme der christlichen Apsismalerei von vierten Jahrhundert bis zur Mitte des achten Jahrhunderts.* Wiesbaden: F. Steiner.

Jäger, S. 2001. "Discourse and Knowledge: Theoretical and Methodological Aspects of a Critical Discourse and Dispositive Analysis." In *Methods of Critical Discourse Analysis,* ed. M. M. Ruth Wodak, 32–62. London: Sage Publications.

James, L. 1997. "Goddess, Whore, Wife, or Slave: Will the Real Byzantine Empress Please Stand Up?" In *Queens and Queenship in Medieval Europe,* ed. A. Duggan, 123–40. Boston: Boydell and Brewer.

———. 2001. *Empresses and Power in Early Byzantium.* Women, Power, and Politics. London: Leicester University Press.

———. 2005. "The Empress and the Virgin in Early Byzantium: Piety, Authority, Devotion." In *Images of the Mother of God: Perceptions of the Theotokos in Byzantium,* ed. M. Vassilaki, 145–52. Aldershot, England: Ashgate.

Janin, R. 1943. "Topographie de Constantinople byzantine: Le port Sophien et les quartiers environnants." *Études Byzantines* 1:116–51.

———. 1953. *Les églises et les monastères.* Paris: Institut Français d'Études Byzantines.

———. 1964. *Constantinople byzantine: développment urbain et répertoire topographique.* 2nd ed. Archives de l'Orient Chrétien 4a. Paris: Institut Français d'Études Byzantines.

Jeffreys, Elizabeth, and Michael Jeffreys. 1986. *The Chronicle of John Malalas.* Trans. Elizabeth Jeffreys, Michael Jeffreys, Roger Scott, and Brian Croke. Byzantina Australiensia 4. Melbourne: Australian Association for Byzantine Studies and Department of Modern Greek University of Sydney, 1986.

Jenkins, T. E. 2009. "Livia the Princeps: Gender and Ideology in the *Consolatio ad Liviam.*" *Helios* 36 (1):1–25.

Jensen, R. M. 2004. "The Fall and Rise of Adam and Eve in Early Christian Art and Literature." In *Interpreting Christian Art: Reflections on Christian Art,* ed. H. J. Hornick and M. C. Parsons, 25–52. Macon, Ga.: Mercer University Press.

Jeppesen, K., et al. 1981– . *The Maussolleion at Halikarnassos: Reports of the Danish Archaeological Expedition to Bodrum.* Copenhagen: In Commission at Gyldendalske Boghandel, Nordisk Forlag.

Johnson, M. J. 1992. "Where Were Constantius I and Helena Buried?" *Latomus* 51 (1):145–50.

———. 2009a. "The Mausoleum of Augustus: Etruscan and Other Influences on Its Design." In *Etruscan Italy: Etruscan Influences on the Civilizations of Italy from Antiquity to the Modern Era,* ed. J. F. Hall, 217–39. Provo, Utah: Brigham Young University.

———. 2009b. *The Roman Imperial Mausoleum in Late Antiquity.* Cambridge: Cambridge University Press.

Jones, A. H. M. 1962. *Constantine and the Conversion of Europe.* New rev. ed. New York: Collier Books.

———. 1964. *The Later Roman Empire, 284–602: A Social, Economic, and Administrative Survey.* 2 vols. Norman: University of Okhaloma Press.

———. 1967. [1940.] *The Greek City from Alexander to Justinian.* 2nd ed. Oxford: Clarendon Press.

Jones, A. H. M., J. R. Martindale, and J. Morris. 1971–92. *The Prosopography of the Later Roman Empire.* 3 vols. Cambridge: Cambridge University Press.

Juethner, J. 1904. Review of Anton Premerstein, *Anicia Iuliana im Wiener Dioskorides-Codex. Zeitschrift für die Österreichischen Gymnasien* 55:314–15.

Kalavrezou, I. 1990. "Images of the Mother: When the Virgin Mary Became Meter Theou." *Dumbarton Oaks Papers* 44:165–72.

———, ed. 2003. *Byzantine Women and Their World.* Cambridge, Mass., and New Haven, Conn.: Harvard University Art Museums and Yale University Press.

Kalavrezou-Maxeiner, I. 1977. "Eudokia Makrembolitissa and the Romanos Ivory." *Dumbarton Oaks Papers* 31:305–25.

Kampen, N. B. 2009. *Family Fictions in Roman Art.* Cambridge: Cambridge University Press.

Kaplan, M. 1979. "Agrippina Semper Atrox: A Study in Tacitus' Characterization of Women." In *Studies in Latin Literature and Roman History,* ed. C. Deroux, 410–17. Collection Latomus 164. Brussels: Latomus.

Karamanolis, G. "Numenius." *Stanford Encyclopedia of Philosophy.* Ed. E. N. Zalta. Available online at http://plato.stanford.edu/archives/fall2013/entries/numenius/ (accessed November 18, 2013).

Kautzsch, R. 1936. *Kapitellstudien; Beiträge zu einer Geschichte des spätantiken Kapitells im Osten vom vierten bis ins siebente Jahrhundert.* Studien zur spätantiken Kunstgeschichte 9. Berlin: W. de Gruyter.

Kazhdan, A. P. 1987. "'Constantin imaginaire': Byzantine Legends of the Ninth Century about Constantine the Great." *Byzantion* 57:196–250.

Kearsley, R. 2009. "Octavian and Augury: The Years 30–27 B.C." *Classical Quarterly,* n.s., 59 (1):147–66.

Kellum, B. A. 1981. "Sculptural Programs and Propaganda in Augustan Rome: The Temple of Apollo on the Palatine and the Forum of Augustus." Ph.D. diss., Harvard University.

———. 1985. "Sculptural Programs and Propaganda in Augustan Rome: The Temple of Apollo on the Palatine." In *The Age of Augustus,* ed. R. Winkes, 169–76. Providence, R.I.: Brown University Press.

Kelly, J. 1984. *Women, History, and Theory: The Essays of Joan Kelly.* Chicago: University of Chicago Press.

Kelly, J. N. D. 1995. *Golden Mouth: The Story of John Chrysostom, Ascetic, Preacher, Bishop.* Ithaca, N.Y.: Cornell University Press.

Kent, J. P. C. 1957. "The Pattern of Bronze Coinage under Constantine I." *Numismatic Chronicle and Journal of the Royal Numismatic Society,* 6th series (17):16–77.

———. 1978. *Roman Coins with Photographs by M. Hirmer and A. Hirmer.* New York: H. N. Abrams.

———. 1992. "IMP XXXXII COS XVII P P: When Was It Struck and What Does It Tell Us?" In *Florilegium Numismaticum: Studia in Honorem U. Westermark Edita,* ed. H. Nilsson, 189–96. Stockholm: Svenska Numismatiska Föreningen.

Kettenhofen, E. 1979. *Die syrischen Augustae in der historischen Überlieferung: Ein Beitrag zum Problem der Orientalisierung,* ed. A. Alföldi et al. Antiquitas 24. Bonn: R. Habelt.

Khazdan, A., ed.-in-chief. 1991. *The Oxford Dictionary of Byzantium.* 3 vols. Oxford: Oxford University Press.

Kienast, D. 1990. *Römische Kaisertabelle: Grundzüge einer römischen Kaiserchronologie.* 2nd ed. Darmstadt: Wissenschaftliche Buchgesellschaft.

Kiilerich, B. 2001. "The Image of Anicia Juliana in the Vienna Dioscurides: Flattery or Appropriation of Imperial Imagery?" *Symbolae Osloenses* 76:169–90.

Kleiner, D. E. 1981. "Second-Century Mythological Portraiture: Mars and Venus." *Latomus* 40:512–44, pls. 18–27.

———. 1992a. "Politics and Gender in the Pictorial Propaganda of Anthony and Octavian." *Echos du Monde Classique / Classical Views* 36, n.s., 11:357–67.

———. 1992b. *Roman Sculpture.* Yale Publications in the History of Art. New Haven, Conn.: Yale University Press.

————. 2005. "Semblance and Storytelling in Augustan Rome." In *The Cambridge Companion to the Age of Augustus*, ed. K. Galinsky, 197–233. Cambridge: Cambridge University Press.

Kleiner, D. E., S. B. Matheson, Yale University Art Gallery, San Antonio Museum of Art, and North Carolina Museum of Art. 1996. *I Claudia: Women in Ancient Rome*. New Haven, Conn.: Yale University Art Gallery.

Kleiner, F. 1990. "An Extraordinary Posthumous Honor for Livia." *Athenaeum* (1):508–14.

Kornemann, E. 1921. *Mausoleum und Tatenbericht des Augustus*. Leipzig: Teubner.

————. 1938. "Zum Augustusjahr: Octavians Romulusgrab." *Klio* 31:1–11.

Kostenec, J. 2004. "The Heart of the Empire: The Great Palace of the Byzantine Emperors Reconsidered." In *Secular Buildings and the Archaeology of Everyday Life in the Byzantine Empire*, ed. K. Dark, 4–36. Oxford: Oxbow Books.

Kousser, R. 2007. "Mythological Group Portraits in Antonine Rome: The Performance of Myth." *American Journal of Archaeology* 111 (4):673–91.

Kraft, K. 1967. "Der Sinn des Mausoleums des Augustus." *Historia* 16 (2):189–206.

Krautheimer, R. 1937–77. *Corpus basilicarum cristianarum Romae*. 5 vols. Rome and New York: Pontificio Istituto di Archeologia Romana and New York University Press.

————. 1942. "The Carolingian Revival of Early Christian Architecture." *Art Bulletin* 24:1–38.

————. 1964. "Zur Kontantins Apostelkirche in Konstantinopel." In *Mullus: Festschrift Theodor Klauser*, ed. A. Hermann, T. Klauser, and A. Stuiber, 224–29. Münster: Aschendorff.

————. 1969. *Studies in Early Christian, Medieval, and Renaissance Art*. New York and London: New York University Press and University of London Press.

————. 1983. *Three Christian Capitals: Topography and Politics*, Una's Lectures 4. Berkeley: University of California Press.

————. 1986. *Early Christian and Byzantine Architecture*. 5th ed. New Haven, Conn.: Yale University Press.

Krueger, D. 2005. *Writing and Holiness: The Practice of Authorship in the Early Christian East*. Divinations. Philadelphia: University of Pennsylvania Press.

Kutbay, B. L. 1998. *Palaces and Large Residences of the Hellenistic Age*. Studies in Classics 108. Lewiston, N.Y.: Edwin Mellen Press.

Lafaurie, J. 1958. "Le trésor de Chécy (Loiret)." In *Trésors monétaires et plaques-boucles de la Gaule romaine: Bavai, Montbouy, Chécy*, ed. J. Gricourt et al. Gallia Supplement 12. Paris: Centre National de la Recherche Scientifique.

Laffranchi, L. 1921. "Gli ampliamenti del pomerio di Roma nelle testimonianze numismatiche." *Bullettino della Commissione Archeologica Comunale di Roma* 47:18–44.

Lampe, G. W. 1961. *A Patristic Greek Lexicon*. Oxford: Clarendon Press.

Lane Fox, R. 1987. *Pagans and Christians*. New York: Alfred A. Knopf.

La Regina, A., ed. 2001–8. *Lexicon topographicum urbis Romae: Suburbium*. 5 vols. Rome: Quasar.

Lawrence, M. 1924–25. "Maria Regina." *Art Bulletin* 7:148–61.

Leader-Newby, R. E. 2004. *Silver and Society in Late Antiquity: Functions and Meanings of Silver Plate in the Fourth to the Seventh Centuries*. Aldershot, England: Ashgate.

Lenski, N. E. 2002. *Failure of Empire: Valens and the Roman State in the Fourth Century* A.D. Berkeley: University of California Press.

————. 2004. "Empresses in the Holy Land: The Creation of a Christian Utopia in Late Antique Palestine." In *Travel, Communication, and Geography in Late Antiquity: Sacred and Profane*, ed. L. Ellis and F. L. Kinder, 113–24. Aldershot, England: Ashgate.

————. 2006a. Introduction to *The Cambridge Companion to the Age of Constantine*, ed. N. Lenski, 1-13. Cambridge: Cambridge University Press.

————. 2006b. "The Reign of Constantine." In *The Cambridge Companion to the Age of Constantine*, ed. N. Lenski, 59–90. Cambridge: Cambridge University Press.

————. 2008. "Evoking the Pagan Past: *Instinctu divinitatis* and Constantine's Capture of Rome." *Journal of Late Antiquity* 1 (2):204–57.

————, ed. 2012. *The Cambridge Companion to the Age of Constantine*. Rev. ed. Cambridge: Cambridge University Press.

Leo, F. 1990. *Die griechisch-römische Biographie nach ihrer literarischen Form*. 2nd reprint of the Leipzig 1901 ed. Hildesheim: G. Olms.

Leschhorn, W. 1984. *Gründer der Stadt: Studien zum einem politisch-religiösen Phänomen der griechischen Geschichte*. Ed. O. Lende and P. Steinmetz. Palingenesia: Monographien und Texte zur klassischen Altertumschaft 20. Wiesbaden: F. Steiner.

Letta, C. 1988. "Helios-Sol." In *Lexicon iconographicum mythologiae classicae*. Zurich: Artemis.

Levick, B. 1978. "Concordia at Rome." In *Scripta Nummaria Romana: Essays Presented to H. Sutherland*, ed. K. A. G. Carson and C. Kraay, 217–33. London: Spink and Son.

Lexicon iconographicum mythologiae classicae. 1981–97. Ed. H. C. Ackermann and J.-R. Gisler. Zurich: Artemis.

Lexicon topographicum urbis Romae. 1993–2000. 6 vols. Ed. E. M. Steinby. Rome: Quasar.

Liddell, H. G., R. Scott, and H. S. Jones. 1996. *A Greek-English Lexicon*. Oxford: Clarendon Press.

Liebeschuetz, J. H. W. G., ed. 2005. *Ambrose of Milan: Political Letters and Speeches*. Translated Texts for Historians 43. Liverpool: Liverpool University Press.

Lieu, S. 2007. "Constantine in Legendary Literature." In *The Cambridge Companion to the Age of Constantine*, ed. N. Lenski, 298–324. Cambridge: Cambridge University Press.

Lightman, M., and B. Lightman. 2000. *Biographical Dictionary of Ancient Greek and Roman Women: Notable Women from Sappho to Helena*. New York: Checkmark Books.

Limberis, V. 1994. *Divine Heiress: The Virgin Mary and the Creation of Christian Constantinople*. London: Routledge.

————. 2011. *Architects of Piety: The Cappadocian Fathers and the Cult of the Martyrs*. New York: Oxford University Press.

Lobell, J. A. 2008. "Imperial Standards, Palatine Hill, Rome." *Archaeology* 61 (1). Available online at archive.archaeology.org/0801/topten/imperial_standards.html (accessed March 26, 2015).

Loofs, F. 1914. *Nestorius and His Place in the History of Christian Doctrine*. Cambridge: Cambridge University Press.

Lott, J. B. 2012. *Death and Dynasty in Early Imperial Rome: Key Sources, with Text, Translation, and Commentary*. Cambridge: Cambridge University Press.

Lozano, F. 2004. "Thea Livia in Athens: Redating 'IG' II² 3242." *Zeitschrift für Papyrologie und Epigraphik* 148:177–80.

———. 2007. "Divi Augusti and Theoi Sebastoi: Roman Initiatives and Greek Answers." *Classical Quarterly* 57 (1):139–52.

Luce, T.J. 1990. "Livy, Augustus, and the Forum Augustum." In *Between Republic and Empire: Interpretations of Augustus and His Principate*, ed. K.A. Raaflaub and M. Toher, 123–38. Berkeley: University of California Press.

Ludwich, A. 1897. *Eudociae Augustae; Procli Lyci; Claudiani carminum Graecorum reliquiae: accedunt Blemyomachiae fragmenta*. Bibliotheca Scriptorum Graecorum et Romanorum Teubneriana. Leipzig: Teubner.

Lunn-Rockliffe, S. 2008. "Ambrose' Imperial Funeral Sermons." *Journal of Early Christian Studies* 59 (April):191–207.

Lusnia, S.S. 1995. "Julia Domna's Coinage and Severan Dynastic Propaganda." *Latomus* 54 (1):119–39.

Maas, M. 1992. *John Lydus and the Roman Past: Antiquarianism and Politics in the Age of Justinian*. London: Routledge.

MacCormack, S. 1981. *Art and Ceremony in Late Antiquity*. Berkeley: University of California Press.

Machado, C. 2012. "Aristocratic Houses and the Making of Late Antique Rome and Constantinople." In *Two Romes: Rome and Constantinople in Late Antiquity*, ed. L. Grig and G. Kelly, 136–60. Oxford: Oxford University Press.

MacMullen, R. 1968. "Constantine and the Miraculous." *Greek, Roman, and Byzantine Studies* 9 (1):81–96.

———. 1969. *Constantine*. New York: Dial Press.

Magdalino, P. 1988. "The Bath of Leo the Wise." *Dumbarton Oaks Papers* 42:97–118.

———. 1994. Introduction to *New Constantines: The Rhythm of Imperial Renewal in Byzantium, 4th–13th Centuries*, ed. P. Magdalino, 1–10. Aldershot, England: Ashgate.

———. 2001. "Aristocratic Oikoi in the Tenth and Eleventh Regions of Constantinople." In *Byzantine Constantinople: Monuments, Topography and Everyday Life*, ed. N. Necipoglu, 53–69. Leiden: Brill.

Maguire, H. 1987. *Earth and Ocean: The Terrestrial World in Early Byzantine Art*. Monographs on the Fine Arts 43. University Park: Pennsylvania State University Press.

———. 1999. "The Good Life." In *Late Antiquity: A Guide to the Postclassical World*, ed. G.W. Bowersock, P. Brown, and O. Grabar, 238–57. Cambridge, Mass.: Harvard University Press.

———. 2006. "The Empress and the Virgin on Display in Sixth-Century Art." In *Proceedings of the 21st International Congress of Byzantine Studies, London*, ed. E. Jeffreys, 1:1-13. Aldershot: Ashgate.

———. 2011. "Body, Clothing, and Metaphor: The Virgin in Early Byzantine Art." In *The Cult of the Mother of God in Byzantium: Texts and Images,* ed. L. Brubaker and M. Cunningham, 39–47. Birmingham Byzantine and Ottoman Studies. Farnham, England: Ashgate.

Malkin, I. 1987. *Religion and Colonization in Ancient Greece*. Studies in Greek and Roman Religion 3. Leiden: Brill.

Manders, E. 2012. *Coining Images of Power: Patterns in the Representation of Roman Emperors on Imperial Coinage, A.D. 193–284*. Leiden: Brill.

Mango, C.A. 1951. "The Byzantine Inscriptions of Constantinople: A Bibliographical Survey." *American Journal of Archaeology* 55 (1):52–66.

———. 1959. *The Brazen House: A Study of the Vestibule of the Imperial Palace of Constantino-ple*. Copenhagen: I kommission hos Munksgaard.

———. 1976. "The Church of Sts. Sergius and Bacchus Once Again." *Byzantinische Zeitschrift* 68 (2):385–92.

———. 1985. *Le développement urbain de Constantinople, IVe–VIIe siècles*. Paris: Diffusion de Boccard.

———. 1986. *The Art of the Byzantine Empire, 312–1453: Sources and Documents*. Medieval Academy Reprints for Teaching 16. Toronto: University of Toronto Press.

———. 1990. "Constantine's Mausoleum and the Translation of Relics." *Byzantinische Zeitschrift* 83:51–61.

———. 1991–92. "The Palace of Marina, the Poet Palladas, and the Bath of Leo VI." In *Euprosynon: Aphieroma ston Manole Chatzedake*, ed. E. Kypraiou, 321–30. Archaiologikou Deltiou 46. Athens: Ekdose tou Tameiou Archaiologikon Poron kai Apallotrioseon.

———. 1993. "The Development of Constantinople as an Urban Centre." In *Studies on Constantinople*, 117–36. Aldershot, England: Variorum.

———. 1994. "The Empress Helena, Helenopolis, Pylae." *Travaux et Mémoires* 12:143–58.

———. 1998. "The Origins of the Blachernae Shrine at Constantinople." In *Radovi: Acta XIII Congressus Internationalis Archeologiae Christianae*, ed. E. Marin and V. Saxer, 2:61–76. Vatican City: Pontificio Istituto de Archeologia Cristiana; Split: Arheoloski Muzej.

———. 2000. "Constantinople as Theotokoupolis." In *Mother of God: Representations of the Virgin in Byzantine Art*, ed. M. Vassilaki, 17–26. Milan: Skira.

Mango, C. A., and R. Scott. 1997. *The Chronicle of Theophanes Confessor*. Trans. C. M. and R. Scott. Oxford: Clarendon Press.

Mango, C. A., and I. Ševcenko. 1961. "Remains of the Church of St. Polyeuktos at Constanti-nople." *Dumbarton Oaks Papers* 15:243–47.

Mannix, M. D. 1925. *Sancti Ambrosii Oratio De Obitu Theodosii: A Text, Translation, Introduction, and Commentary*. Patristic Studies 9. Washington, D.C.: Catholic University of America.

Marasović, J., and T. Marasović. 1968. *Diocletian Palace*. Belgrade: Zora.

Maraval, P., ed. 1982. *Égérie: Journal de voyage (itinéraire)*. Sources Chrétiennes 296. Paris: Éditions du Cerf.

———. 1985. *Lieux saints et pèlerinages d'Orient: Histoire et géographie des origines à la conquête arabe*. Histoire. Paris: Éditions du Cerf.

———. 2002. "The Earliest Phase of Christian Pilgrimage in the Near East (before the 7th Century)." *Dumbarton Oaks Papers* 56:63–74.

———. 2011. *Constantin le grand: Empereur romain, empereur chrétien, 306–337*. Paris: Tallandier.

Marlowe, E. 2006. "Framing the Sun: The Arch of Constantine and the Roman Cityscape." *Art Bulletin* 88 (2):223–42.

———. 2010. "*Liberator urbis suae:* Constantine and the Ghost of Maxentius." In *The Emperor and Rome*, ed. B. Ewald and C. F. Noreña, 199–220. Cambridge: Cambridge University Press.

Mathews, T. F. 1971. *The Early Churches of Constantinople: Architecture and Liturgy*. University Park: Pennsylvania State University Press.

———. 1993. *The Clash of Gods: A Reinterpretation of Early Christian Art.* Princeton, N.J.: Princeton University Press.

———. 1999. *The Clash of Gods: A Reinterpretation of Early Christian Art.* Rev. exp. ed. Princeton, N.J.: Princeton University Press.

———. 2005. "Isis and Mary in Early Icons." In *Images of the Mother of God,* ed. M. Vassilaki, 3–12. Aldershot, England: Ashgate.

Matthews, J. 2012. "The *Notitia Urbis Constantinopolitanae.*" In *Two Romes: Rome and Constantinople in Late Antiquity,* ed. L. Grig and G. Kelly, 81–115. Oxford Studies in Late Antiquity. Oxford: Oxford University Press.

Mattingly, H. 1962. *Coins of the Roman Empire in the British Museum.* London: British Museum.

Mattingly, H., C. H. Sutherland, et al. 1923–84. *Roman Imperial Coinage.* 10 vols. Vol. 1: Augustus to Vitellius, by H. Mattingly and E. A. Sydenham; vol. 2: Vespasian to Hadrian, by H. Mattingly and E. A. Sydenham; vol. 3: Antoninus Pius to Commodus, by H. Mattingly and E. A. Sydenham; vol. 4/1: Pertinax to Geta, by H. Mattingly and E. A. Sydenham; vol. 4/2: Macrinus to Pupienus by H. Mattingly, E. A. Sydenham, and C. H. V. Sutherland; vol. 4/3: Gordian III-Uranius Antoninus by H. Mattingly, E. A. Sydenham, and C. H. V. Sutherland; vol. 5/1: Valerian I–Florian, by P. H. Webb; vol. 5/2: Probus–Amandus by P. H. Webb; vol. 6: From Diocletian's reform (A.D. 294) to the death of Maximinus (A.D. 313), by C. H. V. Sutherland; vol. 7: Constantine and Licinius, A.D. 313–37, by P. M. Bruun; vol: 8: The family of Constantine I, A.D. 337–64, by J. P. C. Kent; vol. 9: Valentinian I–Theodosius I, by J. W. E. Pearce; vol. 10: the divided empire and the fall of the western, A.D. 395–491, by J. P. C. Kent. London: Spink and Son.

———. 1965. *Coins of the Roman Empire in the British Museum.* London: British Museum.

———. 1960. *Roman Coins from the Earliest Times to the Fall of the Western Empire.* 2nd rev. ed. London: Methuen.

Maunder, C. 2008. "Origins of the Cult of the Virgin Mary in the New Testament." In *Origins of the Cult of the Virgin Mary,* ed. C. Maunder, 23–40. New York: Burns and Oates.

Mayer, W. 2005. *The Homilies of St. John Chrysostom, Provenance: Reshaping the Foundations.* Orientalia Christiana 273. Rome: Pontificio Istituto Orientale.

Mayer, W., and P. Allen. 2000. *John Chrysostom.* Early Church Fathers. London: Routledge.

Mazal, O. 1998. *Der Wiener Dioskurides: Codex medicus graecus 1 der Österreichischen Nationalbibliothek.* 2 vols. Glanzlichter der Buchkunst 8. Graz, Austria: Akademische Druck- und Verlagsanstalt.

McClanan, A. L. 1996. "The Empress Theodora and the Tradition of Women's Patronage in the Early Byzantine Empire." In *The Cultural Patronage of Medieval Women,* ed. J. H. McCash, 50–72. Athens: University of Georgia Press.

———. 2002. *Representations of Early Byzantine Empresses: Image and Empire.* New York: Palgrave Macmillan.

McCormick, M. 1986. *Eternal Victory: Triumphal Rulership in Late Antiquity, Byzantium, and the Early Medieval West.* Cambridge and Paris: Cambridge University Press and Éditions de la Maison de Sciences de l'Homme.

———. 2000. "The Emperor and Court." In *Late Antiquity: Empire and Successors, A.D. 425–600,* ed. A. Cameron, B. Ward-Perkins, and M. Whitby, 133–63. Cambridge Ancient History 14. Cambridge: Cambridge University Press.

McKenzie, J. 2007. *The Architecture of Alexandria and Egypt, c. 300 B.C. to A.D. 700.* New Haven, Conn.: Yale University Press.

McLynn, N. 1994. *Ambrose of Milan: Church and Court in a Christian Capital.* Berkeley: University of California Press.

van der Meer, F., and C. Mohrmann. 1958. *Atlas of the Early Christian World.* Trans. M. F. Hedlund and H. H. Rowley. London: Nelson.

Megow, W.-R. 1987. *Die Kameen von Augustus bis Alexander Severus.* Berlin.

Meiggs, R. 1973. *Roman Ostia.* 2nd ed. Oxford: Clarendon Press.

Merriman, J. F. 1977. "The Empress Helena and the Aqua Augustea." *Archaeologia Classica* 29 (2):436–46.

Meyboom, P. 2005. "The Creation of an Imperial Tradition: Ideological Aspects of the House of Augustus." In *The Manipulative Mode: Political Propaganda in Antiquity; A Collection of Case Studies,* ed. K. A. E. Enenkel and I. L. Pfeijffer, 217–63. Mnemosyne Supplement 261. Leiden: Brill.

Mikocki, T. 1995. *Sub specie deae: Les impératrices et princesses romaines assimilées à des déesses; Étude iconologique.* Supplementi alla RdA 14. Rome: G. Bretschneider.

Miles, Gary. 1988. "Maiores, Conditores, and Livy's Perspective on the Past." *Transactions of the American Philological Association* 118:185–208.

Millar, F. 2002. *Rome, the Greek world, and the East.* 3 vols. Ed. H. Cotton and G. M. Rogers. Studies in the History of Greece and Rome. Chapel Hill: University of North Carolina Press.

van Millingen, A. et al. 1912. *Byzantine Churches in Constantinople.* London: Macmillan.

Milner, C. 1994. "The Image of the Rightful Ruler: Anicia Juliana's Constantine Mosaic in the Church of Hagios Polyeuktos." In *New Constantines: The Rhythm of Imperial Renewal in Byzantium, 4th–13th Centuries,* ed. P. Magdalino, 73-82. Aldershot, England: Ashgate.

Mommsen, T. 1971. *Römisches Staatsrecht.* Darmstadt: Wissenschaftliche Buchgesellschaft.

Mueller, K. 2006. *Settlements of the Ptolemies: City Foundations and New Settlement in the Hellenistic World.* Studia Hellenistica 43. Paris: Peeters.

Müller, A. 2012. "Ein vermeintlich faster Anker." *Jahrbuch der Österreichischen Byzantinistik* 62:103–9.

Müller-Wiener, W. 1977. *Bildlexicon zur Topographie Istanbuls.* Tübingen: Ernst Wasmuth.

Mundell Mango, M. 2001. "The Porticoed Street at Constantinople." In *Byzantine Constantinople: Monuments, Topography, and Everyday Life,* ed. N. Necipoğlu, 29–51. Leiden: Brill.

Murray, W. M., and P. M. Petsas. 1989. *Octavian's Campsite Memorial for the Actian War.* Vol. 79.4. Philadelphia: American Philosophical Society.

Nash, E. 1961. *Pictorial Dictionary of Ancient Rome.* 2 vols. New York: Frederick A. Praeger.

Nau, F. 1910. *Le livre d'Héraclide de Damas.* Paris: Letouzey et Ané.

Nestorius. 1978. [Oxford, 1925.] *Nestorius: The Bazaar of Heracleides,* trans. G. R. Driver and L. Hodgson. New York: AMS Press.

Nielsen, I. 1990. "Thermae et Balnea: The Architecture and Cultural History of Roman Public Baths." Ph.D. diss., Aarhus University Press.

———. 1999. *Hellenistic Palaces: Tradition and Renewal.* 2nd ed. Studies in Hellenistic Civilization 5. Aarhus, Denmark: Aarhus University Press.

Nilgen, U. 1981. "Maria Regina: Ein politischer Kultbildtypus." *Römisches Jahrbuch für Kunstgeschichte* 19:1–33.

Nixon, C. E. V., and B. S. Rodgers. 1994. *In Praise of Later Roman Emperors: The Panegyrici Latini; Introduction, Translation, and Historical Commentary, with the Latin Text of R. A. B. Mynors.* Transformation of the Classical Heritage 21. Berkeley: University of California Press.

Nock, A. D. 1930. "Sunnaos theos." *Harvard Studies in Classical Philology* 41:1–62.

———. 1947. "The Emperor's Divine Comes." *Journal of Roman Studies* 37 (Parts 1 and 2):102–16.

Noreña, C. F. 2011. *Imperial Ideals in the Roman West: Representation, Circulation, Power.* Cambridge: Cambridge University Press.

Norris, R. A. 1980. *The Christological Controversy.* Trans. R. Norris. Ed. W. G. Rusch. Sources of Early Christian Thought. Philadelphia: Fortress Press.

Odahl, C. M. 2010. *Constantine and the Christian Empire.* 2nd ed. Roman Imperial Biographies. London: Routledge.

Ogilvie, R. M. 1965. *A Commentary on Livy, Books 1–5.* Oxford: Clarendon Press.

Oliver, J. H. 1940. "Julia Domna as Athena Polias." In *Athenian Studies,* ed. W. S. Ferguson's students, 521–30. Harvard Studies in Classical Philology Supplementary 1. Cambridge, Mass.: Harvard University Press.

Oost, S. I. 1968. *Galla Placidia Augusta: A Biographical Essay.* Chicago: University of Chicago Press.

van Oppen de Ruiter, B. 2010. "The Death of Arsinoe II Philadelphus: The Evidence Reconsidered." *Zeitschrift für Papyrologie und Epigraphik* 174:139–50.

Orlin, E. M. 1997. *Temples, Religion, and Politics in the Roman Republic.* Mnemosyne Supplements 164. History and Archaeology of Classical Antiquity. Leiden: Brill.

Ousterhout, R. 1999. *Master Builders of Byzantium.* Princeton, N.J.: Princeton University Press.

Palladino, S. 1996. "Le terme Eleniane a Roma." *Mélanges de l'École Française de Rome* 108 (2):855–71.

Papadopoulos, J. 1927. "L'Église de St. Laurent et les Pulchériana." *Studi Bizantini* 2:58–63.

———. 1928. *Les palais et les églises des Blachernes.* Thessalonica: Société Commerciale et Industrielle de Macédoine.

Parlby, G. 2008. "The Origins of Marian Art in the Catacombs and the Problems of Identification." In *Origins of the Cult of the Virgin Mary,* ed. C. Maunder, 41–56. New York: Burns and Oates.

Paschoud, F. 1971a. "Zosime 2,29 et la version paienne de la conversion de Constantin." *Historia* 20 (2–3):334–53.

Pauly, A., G. Wissowa, and W. Kroll. 1903–78. *Real-Enzyklopädie der klassischen Altertumswissenschaft.* Repr., Munich: Druckenmüller, 1962–87.

Pazdernik, C. 1994. "'Our Most Pious Consort Given to Us by God': Dissident Reactions to the Partnership of Justinian and Theodora, A.D. 525–548." *Classical Antiquity* 13 (2):256–81.

Peck, H. T. 1898. *Harpers Dictionary of Classical Antiquities.* Online at Perseus Digital Library website, perseus.tufts.edu.

Peirce, P. 1989. "The Arch of Constantine: Propaganda and Ideology in Late Roman Art." *Art History* 12 (4):387–418.

Pelikan, J. 1990. *Imago Dei: The Byzantine Apologia for Icons.* A. W. Mellon Lectures in the Fine Arts 1987; Bollingen Series 35, 36. Princeton, N.J.: Princeton University Press.

Pelliccioni, G. B. 1975. "Le nuove scoperte sulle origini del Battistero Lateranese." *Memorie: Atti della Pontificia Accademia romana di archelogia* 12:7–138.

Peltomaa, L. M. 2001. *The Image of the Virgin Mary in the Akathistos Hymn.* Medieval Mediterranean 35. Leiden: Brill.

Pentcheva, B. V. 2006. *Icons and Power: The Mother of God in Byzantium.* University Park: Pennsylvania State University Press.

Percival, H., P. Schaff, and H. Wace, eds. 1956. *The Seven Ecumenical Councils. NPNF* 14. Grand Rapids, Mich.: Eerdmans Publishing.

Périchon, P., P. Maraval, and G. C. Hansen, eds. 2004. *Socrate de Constantinople: Histoire ecclésiastique.* Sources Chrétiennes 1. Paris: Éditions du Cerf.

Perkins, P. 1999. "Mary in the Gospels: A Question of Focus." *Theology Today* 56 (3):297–306.

Petersen, H. 1961. "Livy and Augustus." *Transactions of the American Philological Association* 92:440–52.

Piranesi, G. 1745. *Varie vedute di Roma antica e moderna.* Rome: Fausto Amidei.

———. 1756. *Le antichità romane.* 4 vols. Rome: Angelo Rotilj.

Platner, S. B., and T. Ashby. 1929. *A Topographical Dictionary of Ancient Rome.* London: Oxford University Press.

Poe, J. P. 1984. "The Secular Games, the Aventine, and the Pomerium in the Campus Martius." *Classical Antiquity* 3 (1):57–81.

Pohlsander, H. 1995. *Helena: Empress and Saint.* Chicago: Ares Publishers.

Polignac, F. d. 1995. *Cults, Territory, and the Origins of the Greek City-State.* Chicago: University of Chicago Press.

Pollini, J. 1978. "Studies in Augustan 'Historical' Reliefs." Ph.D. diss., University of California, Berkeley.

———. 1990. "Man or God: Divine Assimilation and Imitation in the Late Republic and Early Pricipate." In *Between Republic and Empire: Interpretations of Augustus and His Prinicipate,* ed. K. A. Raaflaub and M. Toher, 334–63. Berkeley: University of California Press.

———. 2012. *From Republic to Empire: Rhetoric, Religion, and Power in the Visual Culture of Ancient Rome.* 1st ed. Oklahoma Series in Classical Culture 48. Norman: University of Oklahoma Press.

Pomeroy, S. B. 1982. "Charities for Greek Women." *Mnemosyne* 35 (1–2):115–35.

Porte, D. 1981. "Romulus-Quirinus, prince et dieu, dieu des princes: Étude sur le personnage de Quirinus et sur son évolution, des origines à Auguste." *Aufstieg und Niedergang der römischen Welt* 2 (17.1):300–342.

Potter, D. S. 1994. *Prophets and Emperors: Human and Divine Authority from Augustus to Theodosius.* Revealing Antiquity 7. Cambridge, Mass.: Harvard University Press.

———. 2013. *Constantine the Emperor.* New York: Oxford University Press.

Powell, A. 1992. *Roman Poetry and Propaganda in the Age of Augustus.* London: Bristol Classical Press.

Preger, T., ed. 1901. *Scriptores originum Constantinopolitanarum.* Bibliotheca scriptorum Graecorum et Romanorum Teubneriana. Leipzig: Teubner.

Preisigke, F. 1931. *Wörterbuch der griechischen Papyruskunden mit Einschluss der griechischen Inschriften, Ausschriften, Ostraka, Mumienschilder usw. aus Ägypten.* Ed. E. Kiessling. Vol. 3. Berlin: Selbstverlag der Erben.

von Premestein, A. 1903. "Anicia Juliana im Wiener Dioskorides-Kodex." *Jahrbuch der kunsthistorischen Sammlungen des allerhöchsten Kaiserhauses* 24:108–24.

Price, R. 2004. "Marian Piety and Nestorian Controversy." In *The Church and Mary*, ed. R. N. Swanson, 31–38. Studies in Church History 39. Woodbridge, Suffolk, England: Boydell.

———. 2008. "The Theotokos and the Council of Ephesus." In *Origins of the Cult of the Virgin Mary*, ed. C. Maunder, 89–104. New York: Burns and Oates.

Price, R., and M. Gaddis. 2005. *The Acts of the Council of Chalcedon.* 3 vols. Ed. S. Brock. Liverpool: Liverpool University Press.

Price, S. R. F. 1980. "Between Man and God." *Journal of Roman Studies* 70:28–43.

———. 1984a. "Gods and Emperors: The Greek Language of the Roman Imperial Cult." *Journal of Hellenic Studies* 104:79–95.

———. 1984b. *Rituals and Power: The Roman Imperial Cult in Asia Minor.* Cambridge: Cambridge University Press.

Prinzing, G., and P. Speck. 1973. "Fünf Lokalitäten in Konstantinopel: Das Bad Konstantinianai, die Paläste Konstantianai und ta Konsta, das Zeugma, das Eptaskalon." In *Studien zur Frühgeschichte Konstantinopels*, ed. H.-G. Beck, 179–227. Munich: Institut für Byzantinistik und Neugriechische Philologie der Universität.

Purcell, N. 1986. "Livia and the Womanhood of Rome." *Proceedings of the Cambridge Philological Society*, n.s., 32:78–105.

Putnam, M. 2000. *Horace's "Carmen Saeculare": Ritual Magic and the Poet's Art.* New Haven, Conn.: Yale University Press.

Raaflaub, K. A., and L. J. Samons II. 1990. "Opposition to Augustus." In *Between Republic and Empire: Interpretations of Augustus and His Principate*, ed. K. A. Raaflaub and M. Toher, 417–54. Berkeley: University of California Press.

Raditsa, L. F. 1980. "Augustus' Legislation Concerning Marriage, Procreation, Love Affairs, and Adultery." *Aufstieg und Niedergang der Römischen Welt* 2 (13):278–339.

Raepsaet-Charlier, M. T. 2005. "Les activités publiques des femmes sénatoriales et équestres sous le Haut-Empire romain." In *Senatores populi Romani: Realität und mediale Präsentation einer Führungsschicht; Kolloquium der Prosopographia Imperii Romani vom 11.-13. Juni 2004*, ed. W. Eck and M. Heil, 169–212. Stuttgart: F. Steiner.

Ramage, E. S. 1985. "Augustus' Treatment of Julius Caesar." *Historia* 34 (2):223–45.

———. 1987. *The Nature and Purpose of Augustus' 'Res gestae.'* Historia 54. Stuttgart: F. Steiner.

Ramsey, H. 1936. "Government Relief during the Roman Empire." *Classical Journal* 31 (8):479-88.

Ramskold L., and N. Lenski. 2012. "Constantinople's Dedication Medallions and the Maintenance of Civic Tradition." *Numismatische Zeitschrift* 119:31–58.

Rapp, C. 1998. "Imperial Ideology in the Making: Eusebius of Caesarea on Constantine as 'Bishop.'" *Journal of Theological Studies*, n.s., 49:685–95.

———. 2005. *Holy Bishops in Late Antiquity: The Nature of Christian Leadership in an Age of Transition.* Berkeley: University of California Press.

Rasch, J. J., et al. 1998. *Das Mausoleum der Kaiserin Helena in Rom und der "Tempio della Tosse" in Tivoli.* Spätantike Zentralbauten in Rom und Latium 3. Mainz: P. von Zabern.

Raubitschek, A. E. 1954. "Epigraphical Notes on Julius Caesar." *Journal of Roman Studies* 44:65–75.

Reeder, J. C. 1989. "Agyeius and Baluster: Aniconic Monuments in Roman Art." Ph.D. diss., Brown University.

———. 1992. "Typology and Ideology in the Mausoleum of Augustus: Tumulus and Tholos." *Classical Antiquity* 11 (2):265–307.

Rehak, P. 2001. "Aeneas or Numa? Rethinking the Meaning of the Ara Pacis Augustae." *Art Bulletin* 83 (2):190–208.

———. 2006. *Imperium and Cosmos: Augustus and the Northern Campus Martius*, ed. J. G. Younger. Madison: University of Wisconsin Press.

Reinhold, M. 1970. *History of Purple as a Status Symbol in Antiquity*. Collection Latomus 116. Brussels: Latomus.

Reinhold, M., and P. M. Swan. 1990. "Cassius Dio's Assessment of Augustus." In *Between Republic and Empire: Interpretations of Augustus and His Principate*, ed. K. A. Raaflaub and M. Toher, 155–73. Berkeley: University of California Press.

Reiske, J. J., ed. 1829. *Constantini Porphyrogeniti imperatoris de cerimoniis aulae Byzantinae libri duo*. Corpus Scriptorum Historiae Byzantinae 1. Bonn: E. Weber.

Rex, S. 2007. "The Exemplary Lessons of Livy's Romulus." *Transactions of the American Philological Association* 137 (2):435–71.

Rice, D. T. 1958. *The Great Palace of the Byzantine Emperors, Second Report*. Edinburgh: Edinburgh University Press.

Richard, J.-C. 1966. "Tombeaux des empereurs et temples des 'divi': Notes sur la signification religieuse des sépultures impériales à Rome." *Revue de l'Histoire des Religions* 170:127–42.

———. 1970. "'Mausoleum': D'Halicarnasse à Rome, puis d'Alexandrie." *Latomus* 29:370–88.

———. 1980. "Les funérailles des empereurs romains aux deux premiers siècles de notre ère: Essai de mise au point." *Klio* 62:461–71.

Richardson, L. 1976. "The Evolution of the Porticus Octaviae." *American Journal of Archaeology* 80 (1):57–64.

———. 1992. *A New Topographical Dictionary of Ancient Rome*. Baltimore: Johns Hopkins University Press.

Richter, G. M. A. 1971. *Engraved Gems of the Romans: A Supplement to the History of Roman Art, Part II*. Edinburgh: R. and R. Clark.

Rizzardi, C., P. Angiolini Martinelli, and P. Robino. 1996. *Il Mausoleo di Galla Placidia a Ravenna: The Mausoleum of Galla Placidia Ravenna*, Mirabilia Italiae 4. Modena, Italy: Franco Cosimo Panini.

Robert, L. 1978. "Les conquêtes du dynaste lycien Arbinas." *Journal des Savants*. 1 (1–2):3–48.

Robertson, A. 1982. *Roman Imperial Coins in the Hunter Coin Cabinet, University of Glasgow*. Oxford: Oxford University Press.

Roccos, L. J. 1989. "Apollo Palatinus: The Augustan Apollo on the Sorrento Base." *American Journal of Archaeology* 93 (4):571–88.

Rodgers, B. 1980. "Constantine's Pagan Vision." *Byzantion* 50:259–78.

Roller, M. 2001. *Constructing Autocracy: Aristocrats and Emperors in Julio-Claudian Rome*. Princeton, N.J.: Princeton University Press.

Rose, C. B. 1997. *Dynastic Commemoration and Imperial Portraiture in the Julio-Claudian Period*. Cambridge Studies in Classical Art and Iconography. Cambridge: Cambridge University Press.

Roueché, C. 1989. *Aphrodisias in Late Antiquity: The Late Roman and Byzantine Inscriptions.* 1st ed. JRS Monographs 5. London: Society for the Promotion of Roman Studies.

Rowell, H. T. 1940. "The Forum and Funeral 'Imagines'of Augustus." *Memoirs of the American Academy in Rome* 17:131–43.

———. 1941. "Vergil and the Forum of Augustus." *American Journal of Philology* 62 (3):261–76.

Rubery, E. 2008. "Pope John VII's Devotion to Mary: Papal Images of Mary from the Fifth to the Early Eight Centuries." In *The Origins of the Cult of the Virgin Mary,* ed. C. Maunder, 155–200. New York: Burns and Oates.

Rubin, Z. 1982. "The Church of the Holy Sepulchre and the Conflict between the Sees of Caesarea and Jerusalem." *Jerusalem Cathedra* 2:79–105.

Rüpke, J. 2007. *Religion of the Romans.* Trans. and edited by R. Gordon. Cambridge: Polity.

Ryberg, I. S. 1958. "Vergil's Golden Age." *Transactions and Proceedings of the American Philological Association* 89:112–31.

Sailor, D. 2006. "Dirty Linen, Fabrication, and the Authorities of Livy and Augustus." *Transactions and Proceedings of the American Philological Association* 136 (2):329–88.

Saliou, C. 2005. "L'orateur et la ville." In *Gaza dans l'antiquité tardive: Archéologie, rhétorique et histoire; Actes du colloque international de Poitiers, 6–7 mai 2004,* ed. C. Saliou, 2:171–95. Salerno: Helios.

Saller, R. 1984. "'Familia, Domus,' and the Roman Conception of the Family." *Phoenix* 38 (4):336–55.

———. 1994. *Patriarchy, Property, and Death in the Roman Family.* Cambridge: Cambridrge University Press.

Salzman, M. R. 1990. *On Roman Time: The Codex-Calendar of 354 and the Rhythms of Urban Life in Late Antiquity.* Transformation of the Classical Heritage 17. Berkeley: University of California Press.

———. 2002. *The Making of a Christian Aristocracy: Social and Religious Change in the Western Roman Empire.* Cambridge, Mass.: Harvard University Press.

Schäfer, T. 1989. *Imperii insignia, sella curulis und fasces: zur Repräsentation römischer Magistrate.* Mitteilungen des Deutschen Archaeologischen Instituts, Roemische Abteilung Supplementary issue 29. Mainz: P. von Zaben.

Scheid, J. 2005. "Augustus and Roman Religion: Continuity, Conservatism, and Innovation." In *The Age of Augustus,* ed. K. Galinsky, 175–93. Cambridge: Cambridge University Press.

Scott, J. W. 1986. "Gender: A Useful Category of Historical Analysis." *American Historical Review* 91 (5):1053–75.

Scott, K. 1925. "The Identification of Augustus with Romulus-Quirinus." *Transactions of the American Philological Association* 56:82–105.

———. 1928. "The Deification of Demetrius Poliorcetes: Part I." *American Journal of Philology* 49 (2):137–66.

———. 1936. *The Imperial Cult under the Flavians.* Stuttgart: W. Kohlhammer.

Scrinari, V. S. M. 1989. "Contributo all'urbanistica tardo antica sul Campo Laterano." In *Actes du XIe Congrès International d'Archéologie Chrétienne, Lyons, Vienne, Grenoble et Aouste (21–28 Septembre 1986),* ed. N. Duval, 3:2201-20. Studi di Antichità Cristiana 41. Vatican: Pontifico Istituto di Archeologia Cristiana.

Seeck, O., ed. 1962. "Notitia urbis Constantinopolitanae." In *Notitia dignitatum: Accedunt notitia urbis Constantinopolitanae et latercula provinciarum*, 229–43. Frankfurt: Minerva.

———. 1991. *Regesten der Kaiser und Päpste für die Jahre 311 bis 476 n. Chr.* Stuttgart: J.B. Metzlersche Verlagsbuchhandlung.

de Senneville-Grave, G., ed. 1999. *Sulpice Sévère: Chroniques*. Sources Chrétiennes 441. Paris: Éditions du Cerf.

Severy, B. 2000. "Family and State in the Early Imperial Monarchy: The Senatus Consultum de Pisone Patre, Tabula Siarensis, and Tabula Hebane." *Classical Philology* 95 (3):318–37.

———. 2003. *Augustus and the Family at the Birth of the Roman Empire*. New York: Routledge.

Shahid, I. 2003. "The Church of Sts. Sergios and Bakhos at Constantinople: Some New Perspectives." In *Byzantium: State and Society; In Memory of Nikos Oikonomides*, ed. A. Laiou, and E. K. Crysos, 467–80. Athens: National Hellenistic Research Foundation.

Shelton, K. 1981. *The Esquiline Treasury*. London: British Museum.

Sherwin-White, S.M. 1984. "Review: Mausolus." *Classical Review* 34 (2):254–59.

Shoemaker, S.J. 2008. "The Cult of the Virgin in the Fourth Century: A Fresh Look at Some Old and New Sources." In *Origins of the Cult of the Virgin Mary*, ed. C. Maunder, 71–88. New York: Burns and Oates.

Sieger, J.D. 1987. "Visual Metaphor as Theology: Leo the Great's Sermons on the Incarnation and the Arch Mosaics at S. Maria Maggiore." *Gesta* 26 (2):83–91.

Simon, E. 1978. "Apollo in Rom." *Jahrbuch des Deutschen Archäologischen Instituts* 93:202–27.

von Simson, O.G. 1948. *Sacred Fortress: Byzantine Art and Statecraft in Ravenna*. Chicago: University of Chicago Press.

Sivan, H. 2011. *Galla Placidia: The Last Roman Empress*. Women in Antiquity. Oxford: Oxford University Press.

Smith, M.D. 1997. "The Religion of Constantius I." *Greek, Roman, and Byzantine Studies* 38:187–208.

Smith, R.R.R. 1988. *Hellenistic Royal Portraits*. Oxford Monographs on Classical Archaeology. Oxford and New York: Clarendon Press and Oxford University Press.

Smith, W. 1890. *A Dictionary of Greek and Roman Antiquities*. London: John Murray. Available online at the Perseus Digital Library: www.perseus.tufts.edu/.

Sodini, J.-P. 2003. "Archaeology and Late Antique Social Structures." In *Theory and Practice in Late Antique Archaeology*, ed. L. Lavan and W. Bowden, 25–56. Late Antique Archaeology 1. Leiden: Brill.

Solmsen, F. 1986. "Aeneas Founded Rome with Odysseus." *Harvard Studies in Classical Philology* 90:93–110.

Sordi, M. 1990. "La tradizione dell'*inventio crucis* in Ambrogio e in Rufino." *Rivista di Storia della Chiesa in Italia* 44:1–9.

Spain, S. 1979. "'The Promised Blessing': The Iconography of the Mosaics of S. Maria Maggiore." *Art Bulletin* 61 (4):518–40.

Spencer, D. 2002. *The Roman Alexander: Reading a Cultural Myth*. Exeter: University of Exeter Press.

Spieser, J.-M. 2002. "Impératrices romaines et chrétiennes." *Travaux et mémoires* 14:593–604.

Steigerwald, G. 1999. *Purpurgewänder biblischer und kirchlicher Personen als Bedeutungsträger in der frühchristlichen Kunst.* Bonn: Borengässer.

Steinby, E. M., ed. 1993–2000. *Lexicon topographicum urbis Romae.* 6 vols. Rome: Quasar.

Stem, R. 2007. "The Exemplary Lessons of Livy's Romulus." *Transactions of the American Philological Association* 137 (2):435–71.

Stephens, S. 2008. [2005.] "Battle of the Books." In *The New Posidippus: A Hellenistic Poetry Book,* ed. K. Gutzwiller, 229–48. Oxford: Oxford University Press.

Stephenson, P. 2009. *Constantine: Unconquered Emperor, Christian Victor.* London: Quercus.

Stevenson, S. W., C. R. Smith, and F. W. Madden. 1982. *A Dictionary of Roman Coins, Republican and Imperial.* London: B. A. Seaby.

Stevenson, T. R. 1998. "The 'Divinity' of Caesar and the Title *Parens Patriae.*" In *Ancient History in a Modern University,* ed. T. W. Hillard et al., 1:257–68. Grand Rapids, Mich.: Ancient History Documentary Research Centre.

Stewart, A. F. 1977. *Skopas of Paros.* Park Ridge, N.J.: Noyes Press.

———. 1990. *Greek Sculpture: An Exploration.* 2 vols. New Haven, Conn.: Yale University Press.

———. 1993. *Faces of Power: Alexander's Image and Hellenistic Politics.* Hellenistic Culture and Society 11. Berkeley: University of California Press.

Straub, J. 1967. "Constantine as KOINOS EPISKOPOS: Tradition and Innovation in the Representation of the First Christian Emperor's Majesty." *Dumbarton Oaks Papers* 21:37–55.

de Strycker, E. 1961. *La forme la plus ancienne du Protévangile de Jacques.* Subsidia Hagiographica 33. Brussels: Société des Bollandistes.

Stryzygowski, J. 1893. "Die Tyche von Konstantinopel." *Analecta:*141–53.

Sutherland, C. H. V. 1970. *The Cistophori of Augustus.* Special Publication 5. London: Royal Numismatic Society.

Svorōnos, Iōannēs. 1904–8. *Ta nomismata tou kratous tōn Ptolemaiōn.* 4 vols. Athens: P. D. Sakellariou.

Sydenham, E. 1920. *The Coinage of Nero.* New York.

Syme, R. 1939. *The Roman Revolution.* 1960 ed. Oxford: Oxford University Press.

———. 1958. "Imperator Caesar: A Study in Nomenclature." *Historia* 7 (2):172–88.

———. 1959. "Livy and Augustus." *Harvard Studies in Classical Philology* 64:27–87.

Talbert, R. J. A. 1984. *The Senate of Imperial Rome.* Princeton, N.J.: Princeton University Press.

Taylor, L. R. 1927. "The Cult of Alexander at Alexandria." *Classical Philology* 22 (2):162–69.

———. 1975. [1931.] *The Divinity of the Roman Emperor.* Philadelphia: Porcupine Press.

Taylor, R. 2000. *Public Needs and Private Pleasures: Water distribution, the Tiber River and the Urban Development of Ancient Rome.* Rome: "L'Erma" di Bretschneider.

Temporini, H. 1978. *Die Frauen am Hofe Trajans: Ein Beitrag zur Stellung der Augustae im Principat.* Berlin: W. de Gruyter.

Terry, A. B., and H. Maguire. 2007. *Dynamic Splendor: The Wall Mosaics in the Cathedral of Eufrasius at Poreč.* 2 vols. University Park: Pennsylvania State University Press.

Tiftixoglu, V. 1973. "Die Helenianai nebst einigen anderen Besitzungen im Vorfeld des frühen Konstantinopel." In *Studien zur Frühgeschichte Konstantinopels,* ed. H.-G. Beck, 49–120. Munich: Institut für Byzantinistik und Neugriechische Philologie der Universität.

Tolstoï, Jean. 1968. [1912–14.] *Monnaies byzantines.* 2 vols. Amsterdam: Adolf M. Hakkert.

Tondriau, J.-P. 1948. "Les souveraines lagides en déesses, au IIIe siècle avant J.-C." *Études de papyrologie* 7:1–15.

Tougher, S. 1998. "In Praise of an Empress: Julian's 'Speech of Thanks to Eusebia.'" In *The Propaganda of Power*, ed. M. Whitby, 105–23. Mnemosyne Supplement 183. Leiden: Brill.

Toynbee, J. M. C. 1944. *Roman Medallions*. Numismatic Studies 5. New York: American Numismatic Society.

Treadgold, I. A. and W. Treadgold 1997. "Procopius and the Imperial Panels of S. Vitale." *Art Bulletin* 79 (4):708–23.

Treggiari, S. 1975. "Jobs at the Household of Livia." *Proceedings of the British School at Rome* 43:48–77.

———. 2005. "Women in the Time of Augustus." In *The Cambridge Companion to the Age of Augustus*, ed. K. Galinksy, 130–50. Cambridge: Cambridge University Press.

Treitinger, O. 1969. *Die oströmische Kaiser- und Reichsidee nach ihrer Gestaltung im hofischen Zeremoniell*. 3rd ed. Bad Homburg vor der Hohe: H. Gentner.

Troxell, H. 1983. "Arsinoe's Non-Era." *American Numismatic Society Museum Notes* 28:35–70.

Trypanis, C. A. 1968. *Fourteen Early Byzantine Cantica*. Ed. H. Hunger. Wiener Byzantinische Studien 5. Vienna: Institut für Byzantinistik der Universität Wien.

Tsafrir, Y. 2000. "Procopius and the Nea Church in Jerusalem." *Antiquité Tardive* 8:149–64.

Tschira, A., and F. W. Deichmann. 1957. "Das Mausoleum der Kaiserin Helena und die Basilika der heiligen Marcellinus und Petrus an der Via Labinicana vor Rom." *Jahrbuch des Deutschen Archäologischen Instituts* 72:44–110.

Ulrich, L. T. 2007. *Well-Behaved Women Seldom Make History*. New York: Alfred A. Knopf.

Usher, M. D. 1998. *Homeric Stitchings: the Homeric Centos of the Empress Eudocia*. Greek Studies: Interdisciplinary Approaches. Lanham, Md.: Rowman and Littlefield.

Van Dam, R. 1988. *Gregory of Tours: Glory of the Martyrs*. Liverpool: Liverpool University Press.

———. 2007. *The Roman Revolution of Constantine*. New York: Cambridge University Press.

———. 2011. *Remembering Constantine at the Milvian Bridge*. New York: Cambridge University Press.

Vassilaki, M. 2000. *Mother of God: Representations of the Virgin in Byzantine Art*. 1st ed. Milan and Athens: Skira and the Benaki Museum.

Veyne, P. 1962. "Les honneurs posthumes de Flavia Domitilla et les dédicaces grecques et latines." *Latomus* 21:49–98.

———. 1992. *Bread and Circuses: Historical Sociology and Political Pluralism*. Trans. O. Murray. London: Penguin Books.

Vogt, A. 1935. *Constantin VII Pophyrogénète, Le livre des cérémonies*. 4 vols. Collection Byzantine. Paris: Les Belles Lettres.

Volbach, W. F. 1976. *Elfenbeinarbeiten der Spätantike und des frühen Mittelalters*. 3rd ed. Mainz: P. von Zabern.

Volbach, W. F., and M. Hirmer. 1962. *Early Christian Art*. New York: H. Abrams.

Volk, K. 2009. *Manilius and His Intellectual Background*. Oxford: Oxford University Press.

Vollenweider, M.-L. 1966. *Die Steinschneidekunst und ihre Künstler in spätrepublikanischer und augusteischer Zeit*. Baden-Baden: Grimm.

Walker, P. W. L. 1990. *Holy City, Holy Places? Christian Attitudes to Jerusalem and the Holy Land in the Fourth Century*. Oxford: Oxford University Press.

Wallace-Hadrill, A. 1981. "The Emperor and His Virtues." *Historia* 30 (3):298–321.

———. 1982. "Civilis Princeps: Between Citizen and King." *Journal of Roman Studies* 72:32–48.

———. 2003. "*Domus* and *Insulae* in Rome: Families and Housefuls." In *Early Christian Families in Context: An Interdisciplinary Dialogue,* ed. D. Balch and C. Osiek, 3–18. Grand Rapids, Mich.: Eerdmans Publishing.

———. 2008. *Rome's Cultural Revolution.* Cambridge: Cambridge University Press.

Wallraff, M. 2001a. "Constantine's Devotion to the Sun after 324." *Studia Patristica* 34:256–69.

———.2001b. *Christus verus Sol: Sonnenverehrung und Christentum in der Spätantike.* Jahrbuch für Antike und Christentum 32. Münster: Aschendorffsche Verlagsbuchhandlung.

Wanscher, O. 1980. *Sella curulis: The Folding Stool; An Ancient Symbol of Dignity.* Copenhagen: Rosenkilde and Bagger.

Ward, R. B. 1992. "Women in Roman Baths." *Harvard Theological Review* 85 (2):125–47.

Ward-Perkins, B. 1984. *From Classical Antiquity to the Middle Ages: Urban Public Building in Northern and Central Italy, A.D. 300–850.* Oxford Historical Monographs. Oxford: Oxford University Press.

Warner, M. 1983. *Alone of All Her Sex: The Myth and Cult of the Virgin Mary.* New York: Random House.

Waywell, G. B. 1978. *The Free-Standing Sculptures of the Mausoleum at Halicarnassus in the British Museum: A Catalogue.* London: British Museum Publications.

Weber, G. 2000. *Kaiser, Träume und Visionen in Prinzipat und Spätantike.* Historia 143. Stuttgart: F. Steiner.

Wegner, M. 1984. "Die Bildnisse der Frauen und des Julian." In *Das spätantike Herrscherbild von Diokletian bis zu den Konstantin-Söhnen, 284–361,* ed. H. P. L'Orange, 3:141–64. Das Römische Herrscherbild. Berlin: Mann.

Weinstock, S. 1960. "Two Archaic Inscriptions from Latium." *Journal of Roman Studies* 50:112–18.

———. 1971. *Divus Julius.* 1st ed. Oxford: Oxford University Press.

Weiss, P. 2003. [1993.] "The Vision of Constantine." *Journal of Roman Archaeology* 16 (1):237–59.

Weitzmann, K., ed. 1979. *Age of Spirituality: Late Antique and Early Christian Art, Third to Seventh Century; Catalogue of the Exhibition at the Metropolitan Museum of Art, November 19, 1977, through February 12, 1978.* New York: Metropolitan Museum of Art.

Welch, K. E. 1995. "Antony, Fulvia, and the Ghost of Clodius in 47 B.C." *Greece and Rome* 42 (2):182–201.

Wellen, G. A. 1961. *Theotokos: eine ikonographische Abhandlung über das Gottesmutterbild in frühchristlicher Zeit.* Utrecht: Het Spectrum.

Wellesz, E. 1959. "The 'Akathistos': A Study in Byzantine Hymnography." *Dumbarton Oaks Papers* 9–10:141–74.

Wharton, A. J. 1995. *Refiguring the Postclassical City: Dura Europos, Jerash, Jerusalem, and Ravenna.* Cambridge: Cambridge University Press.

Whitby, M. 1994. "Images for Emperors in Late Antiquity: A Search for New Constantine." In *New Constantines: The Rhythm of Imperial Renewal in Byzantium, 4th–13th Centuries,* ed. P. Magdalino, 83–93. Aldershot, England: Ashgate.

———. 2000. "Procopius' 'Buildings,' Book I: A Panegyrical Perspective." *Antiquité Tardive* 8: 45–57.

———. 2006. "The St. Polyeuktos Epigram (AP 1.10): A Literary Perspective." In *Greek Literature in Late Antiquity: Dynamism, Didacticism, Classicism*, ed. S. F. Johnson, 159–88. Aldershot, England: Ashgate.

Whitby, M., and M. Whitby, eds. 1989. *Chronicon Paschale, 284–628 A.D.* TTH 7. Liverpool: Liverpool University Press.

White, P. 2005. "Poets in the New Milieu: Realigning." In *The Cambridge Companion to the Age of Augustus*, ed. K. Galinsky, 321–39. Cambridge: Cambridge University Press.

von Wilamowitz-Möllendorff, U. 1886. "Res Gestae Divi Augusti." *Hermes* 21 (4):623–27.

Wilken, R. L. 1992a. *The Land Called Holy*. New Haven, Conn.: Yale University Press.

———.1992b. "Eusebius and the Christian Holy Land." In *Eusebius, Christianity, and Judaism*, ed. H. Attridge and G. Hata, 736–60. Detroit: Wayne State University Press.

Wilkinson, J. 1999. *Egeria's Travels: Newly Translated, with Supporting Documents and Notes*. 3rd ed. Warminster, England: Aris and Phillips.

Williams, J. 2007. "Religion and Roman Coins." In *A Companion to Roman Religion*, ed. J. Rüpke, 143–63. Blackwell Companions to the Ancient World. Oxford: Blackwell Publishing.

Williams, M. F. 2003. "The *Sidus Iulium*, the Divinity of Men, and the Golden Age in Virgil's *Aeneid*." *Leeds International Classical Studies* 2 (1):1–29.

Williamson, C. 1987. "Monuments of Bronze: Roman Legal Documents on Bronze Tablets." *Classical Antiquity* 6 (1):160–83.

Winkelmann, F. 1987. "Die älteste griechische hagiographische Vita Konstantins und Helenas." In *Texte und Textkritik*, ed. J. Dummer, 623–38. Berlin: Akademie Verlag.

Winkes, R. 1982. "Der Kameo Marlborough: Ein Urbild der Livia." *Archäologische Anzeiger* 97:131–38.

———. 1995. *Livia, Octavia, Iulia: Porträts und Darstellungen*. 1st ed. Ed. T. Hackens and R. Holloway. Publications d'Histoire de l'Art et d'Archéologie de l'Université Catholique de Louvain 82; Archaeologica Transantlantica 13. Providence, R.I., and Louvain-la-Neuve: Art and Archaeology Publications, Collége Érasme.

Wiseman, T. P. 1969. "The Census in the First Century B.C." *Journal of Roman Studies* 59 (1–2) (1969): 59-75.

———. 1974. "Legendary Genealogies in Late-Republican Rome." *Greece and Rome* 21–22 (October):153–64.

———. 1995. *Remus: A Roman Myth*. Cambridge: Cambridge University Press.

———. 2013. "The Palatine, from Evander to Elagabalus." *Journal of Roman Studies* 103 (November):234–68.

———. 2014. "Archaeology and History: The House of Augustus." *Journal of Roman Archaeology*. 27:544–51.

Wissowa, G. 1971. *Religion und Kultus der Römer*. 2nd ed. Handbuch der klassischen Altertums-Wissenschaft 4–5. Munich: Beck.

Wood, S. 1999. *Imperial Women: A Study in Public Images, 40 B.C.–A.D. 68*. Mnemosyne: Bibliotheca Classica Batava, Supplementum 194. Leiden: Brill.

Woods, D. 1998. "On the Death of the Empress Fausta." *Greece and Rome* 45 (1):70–86.

Worthington, I. 2014. *By the Spear: Philip II, Alexander the Great, and the Rise and Fall of the Macedonian Empire*. Oxford: Oxford University Press.

Wortley, J. 1992. *The Spiritual Meadow (Pratrum Spirituale) by John Moschos (Also Known as John Eviratus)*, trans. J. Wortley. Cistercian Studies Series 139. Kalamazoo, Mich.: Cistercian Publications.

Wyke, M. 1992. "Augustan Cleopatras: Female Power in the Age of Augustus." In *Roman Poetry and Propaganda in the Age of Augustus*, ed. A. Powell, 98-140. London: Bristol Classical Press.

Yasin, A. M. 2009. *Saints and Church Spaces in the Late Antique Mediterranean: Architecture, Cult, and Community*. Greek Culture in the Roman World. Cambridge: Cambridge University Press.

Yavetz, Z. 1984. "The *Res Gestae* and Augustus' Public Image." In *Caesar Augustus: Seven Aspects*, ed. F. Millar and E. Segal, 1-36. Oxford: Clarendon Press.

Yegül, F. K. 1986. *The Bath-Gymnasium Complex at Sardis: With Contributions by Mehmet C. Bolgil and Clive Foss*. Cambridge, Mass.: Harvard University Press.

———. 1992. *Baths and Bathing in Classical Antiquity*. New York and Cambridge, Mass.: Architectural History Foundation and MIT Press.

Yourukova, J. 1996. "Deification of the Empress Julia Domna on the Coins of the Towns of Thrace." *Makedonski Numizmaticki Glasnik* 2:63–69.

Zanker, P. 1968. *Forum Augustum: Das Bildprogramm*. Monumenta Artis Antiquae 2. Tübingen: E. Wasmuth.

———. 1988. *The Power of Images in the Age of Augustus*. Jerome Lectures 16. Ann Arbor: University of Michigan Press.

———. 2004. "Der Apollontempel auf dem Palatin: Ausstattung und politische Sinnbezüge nach der Schlacht von Actium." In *Città e architettura*. Analecta Romana Instituti Danici, suppl. 10:21–40.

INDEX

Page numbers in italics refer to illustrations. Notes are not included in this index.

Galla Placidia (Augusta, daughter of Theodo-
 sius I): as Anthousa, 239; church founding
 of, 164, 223, 224–25; church inscriptions
 of, 224, 225; decoration of churches,
 158–59; with diadem, 194; emulation of
 Helena, 164, 166; enthroned, 193, 194;
 imperial family of, 224–25; John the
 Evangelist's intercession for, 224, 225;
 largesse of, 225; motherhood titles of, 238;
 numismatic portraits of, 225; palace of, 152,
 155, 156; patronage of Church of St. John
 the Evangelist, 223, 224–25; portico in
 Portus, 164; as *proskunētē*, 199; at sack of
 Rome, 225
Gaza, purge of paganism from, 223, 224
gender: in Christian art, 130, 252, 258; in
 Christian doctrine, 242–45; in discourse of
 founding and authority, 5–6, 9–10, 105,
 107, 118, 244, 251, 261–62, 257–58, 270; in
 imperial partnerships, 261; in Roman
 Christian founding discourse, 5–6, 9–10,
 184, 212, 251, 257–58, 270; in Roman
 imperium, 60
Gesta Xysti purgationis, on Helena's Santa Croce
 (Rome), 137
globus cruciger, 191; imperial symbolism of, 189,
 190, 191, 192
gloria romanorum, and empresses, 230–31
goddess-progenitors: disappearance of, 250;
 empresses as, 67, 93, 113, 198, 237, 238,
 239, 246, 247, 251, 255, 256, 259
golden age (same as new age), the coming of:
 and Augustus, 21, 34, 35, 36, 37, 43, 60;
 Commodus, 63; Constantine, 115, 121, 124,
 130; and Fausta, 92; and Justinian and
 Theodora, 279; and Nero, 102; and Roman
 emperors, 64, 112, 261; and Sol, 34, 36, 43,
 64, 124; 274
Grabar, André, 258
Grand al-'Omari Mosque (Gaza), 223. *See also*
 Eudoxiana
Great Palace (Constantinople), 119, 148–52;
 archaeological remains of, 149; Augustaion
 and, 1, 129, 140, 141, 172; Chalke Gate, 218;
 as a complex, 148–50; design of, 153;
 destruction by fire, 154; dimensions of,
 149; growth of, 148; hippodrome of,
 148–49; imitations of, 153; versus Palatine

complex, 151; *palatini* (residents) of, 150;
 Procopius on, 218; public/private uses of,
 150, 151; sacred aura of, 153; and similarities
 to other imperial residences, 150; staff of,
 150; textual evidence for, 149; women's
 quarters of, 148. *See also* imperial
 buildings, Roman Christian
Gregory of Nyssa: funerary oration for Flaccilla,
 183, 206, 214; on Virgin Mary Theotokos,
 241
Gregory of Tours, life of St. Polyeuktos, 159

Hadrian (emperor): as Apollo Sol, 43; renewal
 under, 62; Temple of Venus Felix, 90
Hagia Eirene, Church of (Constantinople), 129,
 270; exterior of, 169; Theodora's contribu-
 tions to, 167, 167–68
Hagia Sophia, Church of (Constantinople), 1, 2,
 129, 270; Justinian and Theodora's
 inscription in, 167, 168, 222; Justinian's
 building of, 231; Procopius on, 217;
 Theodora's contributions to, 167–68;
 Theodosian, 231; Virgin's festival and,
 242–43
Hagios Andreas ta Arkadias, Church of
 (Constantinople), 155
Hagios Iōannēs hai Arkadianai, Church of
 (Constantinople), 155
Hagios Polyeuktos, Church of (Constantinople),
 225; archaeological remains of, 229;
 construction of, 159, 229, 233; inscriptions
 of, 229–31, 230, 232; Juliana's commission-
 ing of, 229–32; Juliana's tomb at, 231;
 mosaic of Constantine, 229; political
 aspects of, 229
Helena (Augusta, mother of Constantine):
 amnesty for prisoners, 145, 146; associa-
 tion with Virgin Mary, 211–12, 213, 236,
 238, 251; attributes of power, 185; as
 Augusta, 184; background of, 118; building
 programs of, 120, 134, 137, 139, 140–44,
 172, 220, 225, 270, 272; as co-founder, 213,
 233; control over imperial purse, 251; death
 of, 140; empresses' emulation of, 3, 4, 160,
 164, 166, 172; exemplary actions of, 134–35;
 finding of True Cross, 2–3, 4, 9, 142, 143,
 144, 164, 212, 213, 224; in founding
 discourse, 5–6, 9, 66, 120, 261; funeral of,

Juliana, 231, 232; co-rulership with Theodora, 201, 267–69, 270, 272; counsel of spouse to, 184; depiction with haloes, 265, 267; diadem of, 268; *Digest*, 202; *globus cruciger* of, 191; imperial authority of, 231; largesse of, 217; leadership role of, 269, 270; legitimacy of, 233; marital harmony of, 202; mausoleum of, 273; palaces of, 218; *paludamentum* of, 187, 268; patronage of Holy Land, 270; political authority of, 233; rebuilding of Church of the Holy Apostles, 231; relationship with God, 218; restoration of Helenopolis, 273; sacredness of, 267–68; San Vitale mosaic of, 187, 188, 252, 264, 265, 267–70; sponsorship of buildings, 167–68, 169; and St. Sabas, 268

koinōnia (partnership): changing concepts of, 198; divinity of empresses in, 236; between imperial couples, 183, 251; in imperial iconography, 184; John Chrysostom on, 183–84; scepter as symbol of, 187–88
Kollyridians, celebration of Virgin Mary, 241–42
Kore Sōteira (patron goddess of Cyzicus), Faustina II as, 88

Lactantius, on Constantine's vision, 127, 128
Lamia (courtesan), benefactions of, 15, 16
Laodice II, Queen: benefactions of, 74
largesse: Augustus's, 56; for Christ, 270; to churches, 195; Constantine's, 210; control of, 227; and divine lineage, 87; of empresses, 86–87, 227, 232–33; Flaccilla's, 214; gesture of, 192, 195; iconography of, 227; imperial dignity through, 232–33; of imperial women, 145, 146, 180, 194; Justinian's, 217; through church building, 221; in the *Vienna Dioscurides*, 195, 196, 197
laurels: on coinage of Augustus, 39, 57; sacred to Apollo, 39, 121, 122
Lausus (mansion, Constantinople), 151
Lawrence, St., Church of: Pulcheria's construction of, 156
Leo, Pope: Pulcheria's aid to, 255
Leo I (emperor): co-rulership with Verina, 201; palace of, 154; patronage of Blachernae, 179

Leontius (bishop of Tripoli): chastising of Constantius II, 217; and Eusebia, 216–17
Lepidus (pontifex maximus), 37
Libanius: on Daphne palace, 149–50; on Great Palace, 150; on women's bathing, 176
Liberalitas, on Constantine's coinage, 114
Liber Pontificalis: Constantinian donations in, 136, 139; on Sessorian Palace, 137; on True Cross, 138
Licinia Eudoxia (Augusta, wife of Valentinian III): as Anthousa, 239; building activities of, 158; depiction with Christ, 249; with diadem, 195; enthroned, 194, 195; as *proskunētē*, 198; radiate crown of, 193–94, 195, 258
Licinius (emperor), persecution of Christians, 145
Livia (Augusta, wife of Augustus): on Ara Pacis Augustae, 35; association with Tychai, 77; Augustus's adoption of, 66–67, 71, 72; cameo portrait of, 12, 13, 78, 78, 79; as *Cereri Iuliae Augustae*, 79; Christian alternatives to, 213; civic benefactions of, 72–75, 83, 84; connection to Venus, 12, 12–13, 14, 64, 76, 77–78; construction of public buildings, 84; as correlate to Helena, 13; cult at Gytheion, 72, 96; cult at Tlos, 10–11; cultic honors of, 76–77, 97; death of, 72; dedications to, 75–76; deification of, 12, 74, 81, 97, 98; as Demeter/Ceres, 77, 78, 78, 79, 80; empresses' emulation of, 166; enthroned, 81, 82, 83, 193; first husband of, 69–70; as founder, 6, 10–11, 21, 67, 72, 76–77, 83; freedom from *tutela*, 70, 71; funeral of, 75; in guise of goddesses, 67, 83, 193; as Hera, 106; as Hersilia, 74, 75; honorifics of, 12–13, 66, 75–76; honors of, 10–11, 14, 22, 66, 70, 71–72, 107; household of, 149, 151; imperial lineage of, 10, 11, 12; inscriptions of, 77, 79; interest in plants, 72; as Julia Augusta, 66, 71, 72, 77–78, 82, 83; as *mater patriae*, 72, 75, 79, 80, 81; numismatic portraits of, 51, 77, 77–78, 99; pairing with Augustus, 79, 81, 99, 100, 100–101, 101; patronage of cities, 76–77; personal interventions by, 74, 75; portico of, 162, 164; as priestess of Augustus, 75; public

Livia (Augusta, wife of Augustus) *(continued)*
image of, 67, 70, 71; renewal of state, 81;
repair of temples, 72–73, 75; as *Romana
princeps,* 71; as Roman progenitor, 13, 14,
21, 71, 75, 76, 77–83; scepter of, 188; as
Sebastē Nikēphoros, 76; senatorial
deliberations on, 74, 75–76; as *Thea
Archegetis Roma,* 76–77; as *thea euergetis,*
76; during Tiberius's reign, 72; travel with
Augustus, 97
Livilla (wife of Drusus), as Venus Genetrix, 89
Liviopolis (Pontus), 93
Livy: on Aeneas, 28, 51; on Romulus, 27, 113
Lucian, Saint: relics of, 143
Lucilla Augusta, enthroned, 193
Lysimachus, King, coinage with Alexander's
portrait of, *17, 18*

Macrinus (emperor), downfall of, 145
Malalas (historian), 274
Julia Mamaea (Augusta, mother of Severus
Alexander), 86
Manilius (astronomer), on founding of Rome,
34
Marcellinus and Peter, SS., Church of: cemetery
basilica of, 138; Constantine's donation to,
136, 139; mausoleum of Helena in, *138,
138–39*
Marcellinus Comes, chronicle of, 155, 156
Marcellus (nephew of Augustus), 46, 47
Marcian (emperor): as New Constantine, 3, 112,
135, 245; numismatic portraits of, *200;*
political marriage of, 157
Marciana (Augusta, sister of Trajan, grand-
mother of Sabina), 86; city named for, 93
Maria (wife of Honorius), as Anthousa, 239
Marina (sister of Pulcheria): buildings of,
154–55; residences of, 151, 152
Marinēs neighborhood (Constantinople), 155
Marius, as founder, 21, 58
Mars: father of the Roman people, 14, 90; father
of Rome's founder, 64; 24, 25, 74, 89,
91–92, 106; on Roman coinage, 64; with
Venus as founders of the Roman people 14,
24, 89, 90, *92*
Martina (Augusta, wife of Heraclius), named
Augusta in the Augustaion, 172
Mary. *See* Virgin Mary

Matidia Minor (Augusta), 88, building program
of, 86
Mausoleum of Augustus, 29, *45,* 115; Augustus's
career on, 44; conceptual framework for,
48; decorative program of, 46, 52–53;
dimensions of, 46; dynastic aspects of,
46–47; function of, 59; grove around, 46,
52; location of, 46; and Mausoleum of
Constantine, 133; occupants of, 52, 54;
precedents for, 47, 52; projection of
certainty, 52; *Res Gestae Divi Augusti* on, 44,
53–59; sacrifices at, 52; scholarship on,
46–47; shape of, 53; symbol of founding,
52, 53–54, 64; and tomb of Alexander, 51
Mausoleum of Constantine, 44, 159, 205, 220;
apostles' reliquaries in, 130, 210; Augusti
buried in, 133; completion of, 134; Eusebius
on, 210; and Holy Sepulcher, 133; site of,
139, 231; symbol of founding, 118, 129. *See
also* Holy Apostles, Church of
Mausoleum of Halicarnassus, 44, 47–51, *48;* as
a city founder's tomb, 51; decorative
program of, 48, 50; dynastic aspects of, 48;
as *hērōon,* 49; and Mausoleum of
Augustus, 47–48; sacrificial remains at, 50;
shape of, 46, 47; size of, 48; statues of, *50;
temenos* of, 50
Mausolus (founder of Halicarnassus), 49;
royalty of, 51
Maxentius (emperor): Constantine's defeat of,
135, 211, 220; Villa of, 131, *132*
Maximianus, in San Vitale mosaic, *265, 267*
Megalopsuchia (Magnanimity), personification
of, 226
Menander Rhetor, 183
Merobaudes (poet), on Galla Placidia, 238
Milion (Constantinople), 140; public images on,
1
Milliarium Aureum (Rome), 140
Milvian Bridge, Battle of, 111, 121, 220
Modestus, cistern of (Constantinople), 156
monarchs, Hellenistic: divine honors for, 15;
founding discourse of, 21; as progenitors,
14–15
Monastery of St. Catherine (Mt. Sinai), Virgin
Mary icon of, 252, *253*
monuments: paired couples on, 105–6, *106;*
spreading of imperial religion, 145

thrones, Roman Christian, *192, 192–93;*
canopied, 193, 194; symbolism of, 193
Tiberius (emperor): Augustus's adoption of, 60,
61, 72; enthroned statues of, *82;* funeral
oration for Augustus, 59; as *Iuliae filius,*
72; legitimacy of, 72; and Livia's honors,
75–76; numismatic portraits of, 79, *80,*
81, 82
Tibullus, on priests of Apollo, 36
time: and ethnogenesis, 34; and generation, 11;
pre-Christian measurement of, 10
tombs: of city founders, 51; of deified rulers, 52;
legitimation of authority, 52; royal cults at,
51; symbolism of, 44. *See also* Mausoleum
of Augustus; Mausoleum of Constantine
Trajan (emperor): deification of, 97; as founder,
62; numismatic portraits of, *98*
True Cross: entry into Constantinople, 142;
fragments of, 212; Helena's finding of, 2–3,
4, 9, 142, 143, 144, 164, 212, 213, 224; *Liber
Pontificalis* on, 138
Tychai: of Constantinople, 180–81, *181,* 239;
imperial women associated with, 77,
93–95, *94, 95*

Valens, Baths of: Eudocia's rebuilding of, 195
Valentinian (emperor), 188
Valeria Messalina (wife of Claudius): as
Demeter Karpophoros, 96; mural crown
of, *93, 94*
Venantius Fortunatus: on the dress of virgins,
249; *On Virginity,* 249
Venus: assimilation with empresses, 88–89,
239; on Augustan coinage, 24, *26;*
alternatives to in the Christian founding
discourse, 213; as founding mother of the
Roman people, 14, 24, 25, 90, 92; as joint
founder with Mars, 14, 24, 25, 90, 92; as
Julio-Claudian ancestress, 89; Livia's
connection to, 12, *12–13,* 14, 64, 76, 77–78;
marble statue of, *12, 13;* as *princeps generis,*
23–24; on Roman coinage, 89, 90, *90–92,*
91, 92
Venus Felix: association with Fausta, 90, 92; on
coinage, *91, 92*
Venus Genetrix, 14, 78; association with
Drusilla, 97; association with empresses,
88–89; attributes of, 89

Venus Victrix: on coinage, 89, *89, 91,* 92;
empresses as, 198
Verina (Augusta, wife of Leo I): co-rulership of,
199, 201; emulation of Helena, 3, 4;
imperial practices of, 202; patronage of
Blachernae, 179; scepter of, 188
Victoria (goddess), *186;* Constantine and, 121;
imperial women as, 199; virtues connected
with, 198; winged, 199, *200*
victory, imperial: God as author of, 199;
Christian Augustae and, 198–99, 201–2
Vienna Dioscurides: dedicatory text from, 232;
portrait of Anicia Juliana, 195–197, *196,*
197, 198, 226–27
Vipsania Polla (sister of Agrippa), portico of, 84,
162, 164
Virgil: on Apollonian age, 121; on Augustan
divinity, 60; celebration of Apollo Helios,
34; depiction of Augustus, 11, 24; founding
narratives of, 11, 36; *Fourth Eclogue,* 11, 128
Virgin Mary: Akathistos hymn to, 239, 255;
angelic guard of, 235, 249, 257; as Anthousa,
240; attributes of, 234; and Augustae, 213;
aural conception of, 241, 242, 248; authority
of, 256; as *basilissa,* 255; as Bride of Christ,
241, 248, 249; Christian empresses and,
250–52, 255–59; Christ's dependence on,
248; church in the Honoratai, 225, 226;
descent from David, 250; and earthly
hierarchies, 237; epithets of, 237; fecundity
of, 247; festival of, 242–43; in foundation
discourse, 238; as *genetrix,* 247; and
Greco-Roman goddesses, 239; Helena's
association with, 211–12, 213, 236, 238, 251;
imperial counterparts of, 255–56; imperial
status of, 249–50, 252, 255, 256; interces-
sory role of, 238; linking between spirit and
flesh, 241; as *mētēr,* 238; motherhood and,
238–40, 241; as mother of man, 249; and
nature of Christ, 240–44; pagan counter-
parts of, 255–56; panegyric hymns to, 255;
pre-Ephesus writings on, 240–45; as
protector of Constantinople, 262; as Queen
of Heaven, 234, 240, 249, 252, 255, 256–57;
role in Incarnation, 237, 240, 241; as sacred
ruler, 257; sixth-century writings on, 245; as
source of salvation, 242; spinning, 237, 248;
transformations to, 234–35, 237–38